Gustave Le Gray

1820–1884

Sylvie Aubenas

with contributions by
Anne Cartier-Bresson
Joachim Bonnemaison
Barthélémy Jobert
Claude Schopp
Mercedes Volait
Henri Zerner

Edited by Gordon Baldwin

The J. Paul Getty Museum Los Angeles

Getty Publications
1200 Getty Center Drive
Suite 500
Los Angeles California 90049-1682
www.getty.edu

This volume was originally published under the same title in a French edition (Paris: Bibliothèque nationale de France / Gallimard, 2002) to accompany the exhibition *Gustave Le Gray, photographe (1820-1884),* organized by the Bibliothèque nationale de France and presented in the Mansart and Mazarine galleries at its Richelieu location, Paris, from March 19 to June 16, 2002. The present volume was produced to accompany an abridged version of this exhibition, *Gustave Le Gray, Photographer,* at the J. Paul Getty Museum, Los Angeles, from July 9 to September 29, 2002.

Publisher
Christopher Hudson

Editor in Chief
Mark Greenberg

Project Manager
Dinah Berland

Manuscript Editor
Nomi Kleinmuntz

Design Coordinator
Jim Drobka

Compositor
Hespenheide Design

Translators: John Goodman for the essays by Joachim Bonnemaison, Anne Cartier-Bresson, Barthélémy Jobert, and Léon Maufras, and catalogue entries; Sharon Grevet for the essays by Sylvie Aubenas, Sylvie Aubenas and Mercedes Volait, and Claude Schopp; and Stephen C. Pinson for the essay by Henri Zerner.

Type composed in Corporate and Plantin
Printed by Snoeck-Ducaju & Zoon, Ghent, Belgium

FRONT COVER: Gustave Le Gray, *The Great Wave, Sète*, ca. 1856, albumen print from two collodion-on-glass negatives, 13¼ × 16 inches (339 x 415 mm). The J. Paul Getty Museum.

BACK COVER: Gustave Le Gray, *Self Portrait,* ca. 1856-1859, albumen print from a collodion-on-glass negative, 8 × 6½ inches (205 × 164 mm), oval. Department of prints and photography, Bibliothèque nationale de France, Paris.

Library of Congress Cataloging-in-Publication Data

Aubenas, Sylvie.
 Gustave Le Gray, 1820–1884 / Sylvie Aubenas ; with contributions by Anne Cartier-Bresson ... [et al.] ; edited by Gordon Baldwin ; [Translators: John Goodman, Sharon Grevet, Stephen C. Pinson].
 p. cm.
 "This volume was originally published under the same title in a French edition (Paris: Bibliothèque nationale de France / Gallimard, 2002) to accompany the exhibition 'Gustave Le Gray, photographe (1820–1884),' organized by the Bibliothèque nationale de France and presented in the Mansart and Mazarine galleries at its Richelieu location, Paris, from March 19 to June 16, 2002. The present volume was produced to accompany an abridged version of this exhibition, 'Gustave Le Gray, Photographer,' at the J. Paul Getty Museum, Los Angeles, from July 9 to September 29, 2002." — T.p. verso.
 Includes bibliographical references and index.
 ISBN 0-89236-671-0 (pbk.) — ISBN 0-89236-672-9 (hardcover)
 1. Photography, Artistic — Exhibitions. 2. Le Gray, Gustave, 1820–1884 — Exhibitions. I. Baldwin, Gordon, 1939– II. J. Paul Getty Museum. III. Title.
 TR647 .L397 2002
 770'.92—dc21

2002001386

Contents

8 Foreword
Deborah Gribbon

9 Preface
Jean-Pierre Angremy

11 Gustave Le Gray, Between Shadow and Light
Sylvie Aubenas

Part 1 The Life of Gustave Le Gray

17 The Youth of a Painter
Sylvie Aubenas

31 Barrière de Clichy: A "University" of Photography
Sylvie Aubenas

87 Boulevard des Capucines: The Glory of the Empire
Sylvie Aubenas

157 The Unfinished Odyssey
Claude Schopp

175 The Flight into Egypt: An Exile without Return
Sylvie Aubenas and Mercedes Volait

Part 2 The Work of Gustave Le Gray

209 Gustave Le Gray, Heliographer-Artist
Henri Zerner

233 From the Point of View of Painting
Barthélémy Jobert

255 To Unite Science with Art
Sylvie Aubenas

275 The Expansive Soul of Gustave Le Gray:
The Panorama
Joachim Bonnemaison

287 The Negatives of Gustave Le Gray in the
Bibliothèque Historique de la Ville de Paris
Anne Cartier-Bresson

297 On Photographic Collaboration: Firmin Eugène
Le Dien and Gustave Le Gray
Sylvie Aubenas

315 From One Century to the Next: The Fate of
Le Gray's Work in Photographic Collections
Sylvie Aubenas

Appendixes

329 Chronology
Sylvie Aubenas

336 Biographical Essay, 1860
Léon Maufras

342 Death-Date Inventory

344 Signatures, Notes, and Commercial Marks

346 Catalogue Entries

384 Manuscript Sources
388 Published Sources
391 Bibliography
394 Index
402 Illustration Credits

Acknowledgments

First of all, gratitude is extended to Marc Smith.

At the Bibliothèque nationale de France, thanks go to Jean-Pierre Angremy, Laure Beaumont-Maillet, Christophe Beslon, Viviane Cabannes, Pierrette Crouzet, Thierry Grillet, and Pierrette Turlais; in collections management, Michel Melot; and at the J. Paul Getty Museum, Weston Naef and Gordon Baldwin.

Particular thanks are offered to those whose constant aid and support allowed this project to be carried through to completion: Pierre Apraxine, Dominique Carré, Sylviane de Decker, Pierre Fournié, Marie-Thérèse and André Jammes, Hans P. Kraus Jr., Patrick Lamotte, Catherine Mathon, Hélène Pinet, Inès and Serge Plantureux, Michael S. Sachs, Claude Schopp, the Société française de photographie, Roger Taylor, the late Roger Thérond, and Suzanne Winsberg.

Finally, it is a pleasure to mention all of those who gave their time and provided their assistance with long and difficult research: Florence Aubenas, Quentin Bajac, Dominique Barjot, Robin P. Barlow, Marc Bascou, Bruno de Bayser, Martin Becka, Sylvain Bellenger, Nelly Benchetrite, Philippe Bérard, Laurent Bernard, Pierre Bizeau, Mattie Boom, Claude Bouret, Emmanuelle Brugerolles, Gérard Burel (Chairman of the Orne Regional Council), Katia Bush, Marie-Thérèse Caille, Denis Canguilhem, Anne Cartier-Bresson and the Photographic Conservation and Restoration Workshop of the City of Paris, Jean-Loup Champion, Patrick Clervoy, Marie-Sophie Corcy, Marie-Laure Crosnier-Leconte, Malcolm Daniel, Jean-Pierre Darel, Liza Daum, the late Fouad Debbas, Roxane Debuisson, Arnaud Delas, Jérôme Delatour, Xavier Demange, Frances Dimond, Jean-Philippe Dumas, Marc Durand, Dominique Escartin, Bertrand Eveno, Audrey and Alain Flamand, Michel Fleury, Dominique de Font-Réaulx, Jacques Foucart, Jean-Pascal Foucher, Daniela Gallo, David R. M. Gaimster, James A. Ganz, Philippe Garner, Nicole Garnier,

Stéphane Garrion, Nadine Gastaldi, Denis Geoffroy-Dechaume, Thierry Gervais, Pauline Girard, François Giustiniani, Michel Guerrin, André Gunthert, Maria Morris Hambourg, Violet Hamilton, Françoise Hamon, Mark Haworth-Booth, Françoise Heilbrun, Manfred Heiting, Sarah Hermanson, Peter and Ruth Herzog, Ken Jacobson, Françoise and Bertrand Jestaz, Steven Joseph, Serge Kakou, Jacques Kuhn-Munch, Geneviève Lacambre, Hélène Lafon-Couturier, Baudoin Lebon, Yves Lebrec, Marc Le Coeur, Guillaume Le Gall, Isabelle Le Masne de Chermont, Carole Lenfant, François Lepage and Paule Charbonneau-Lepage, Pierre-Yves Le Pogam, Sylvie Le Ray, Gérard Lévy, Pierre-Yves Machault, Ezra Mack, Françoise Maison, Bernard Marbot, Lee Marks, Brigitte Massé, Father Vincent Mistrih, Jean Luc Monterosso, Jean-Jacques Naudet, Marie-Dominique Nobécourt, Isabel Ortega, Mireille Pastoureau, Françoise and Alain Paviot, Marie Pessiot, Petros F. Petropoulos, A. Picarle, Michel Poivert, Maxime Préaud, Tamara Préaud, Marie-Laure Prévost, Paul Prouté, Jean-Baptiste de Proyart, Jill Quasha, Jean-Charles de Ravenel, Éric Reinhardt, Pierre-Lin Renié, Françoise Reynaud, Pierre-Marc Richard, Benoît Rivero, Hervé Robert, Denis Roche, Paul-Louis Roubert, Chantal Rouquet, Marie-Pierre Salé, Jean-Yves Sarazin, Josiane Sartre, Philippe Sénéchal, Bruno Sepulchre, Arlette Sérullaz, Nina Siag, Dietmar Siegert, Marie-France Smith, Jacques Sol, Hélène Sorbé, Howard Stein, Philip Stokes, Sam Stourdzé, Rachel Stuhlmann, Astrid and Éléonore Thérond, Gilbert Thil, president of the Orne Historical and Archeological Society, Benoît Tuleu, Maria Umali, Sophie Vanden Abeele, Dominique Versavel, Georges Vigne, Florence Viguier, Jean-Marie Voignier, Anne Laure Wanaverbecq, Michael Wilson, Isabelle Wybo-Wehrli, and all those who asked to remain anonymous.

The choice of works presented at the Paris exhibition and the research necessary for this book were accomplished with the collaboration of the Médiathèque du Patrimoine, Paris.

Lenders to the exhibitions at the Bibliothèque nationale de France and the J. Paul Getty Museum

Amsterdam
Rijksmuseum
Museum Willet-Holthuysen

Austin, Texas
The Gernsheim collection,
 Harry Ransom Humanities Research
 Center, The University of Texas at Austin

Los Angeles, California
The J. Paul Getty Museum

Paris
Conservatoire national des arts et métiers—
 Musée des Arts et Métiers
Médiathèque du Patrimoine
Musée Carnavalet
Musée d'Orsay
Société française de photographie

Rouen
Musée des Beaux-Arts

Sèvres
Bibliothèque de la Manufacture
 nationale de Sèvres

Williamstown, Massachusetts
The Sterling and Francine Clark Art Institute

Private collections
Gary Edwards, Washington, D.C.
Gilman Paper Company, New York
Manfred Heiting, Amsterdam
Gérard Lévy, Paris
Jay H. McDonald, Santa Monica
Roger Thérond, Paris

Lenders to the exhibition at the Bibliothèque nationale de France only

Alençon
Departmental Archives of Orne,
 the Orne Historical and Archeological
 Society collection

Compiègne
Musée national du Château de Compiègne

London
Victoria and Albert Museum

Montauban
Musée Ingres

Nantes
Centre des archives diplomatiques

Paris
Bibliothèque de l'Institut
Bibliothèque du musée des Arts décoratifs
Bibliothèque historique de la Ville de Paris
Musée des Monuments français

Tel Aviv
Tel Aviv Museum of Art

Troyes
Musée des Beaux-Arts

Private collections
Andrew Daneman, Copenhagen
Audrey and Alain Flamand, France
Marie-Thérèse and André Jammes, Paris
Pierre-Marc Richard, Paris
Michael S. Sachs, Westport, Connecticut
Howard Stein, New York
Suzanne Winsberg, New York

We also thank those collectors who asked to remain anonymous.

The authors

Sylvie Aubenas is chief curator for the department of prints and photography at the Bibliothèque nationale de France, where she is in charge of nineteenth-century photography. She has collaborated on numerous exhibitions, including *Nadar, Les années créatrices: 1854–1860* at the Musée d'Orsay (1994), and has organized *La révolution de la photographie instantanée* (1996), *Charles Aubry, photographe* (1996), *L'art du nu au XIXe siècle* (1997), *Degas, photographe* (1999), and *Voyage en Orient* (2001) at the Bibliothèque nationale de France. She is also the author of numerous articles on nineteenth-century photography.

Anne Cartier-Bresson is a Patrimoine Photographique curator; she directs the Photographic Conservation and Restoration Workshop of the City of Paris. In addition to her doctoral thesis, *Les Papiers salés: Altérations et restauration des premières photographies sur papier* (1985), she has published "L'histoire des photographies et les leçons de la technique," in the catalogue *Portrait d'une capitale, de Daguerre à William Klein* (1992); the introduction to the catalogue of the exhibition *Paris sous l'objectif, 1885–1994* (1998), which she organized, and the essay "Photographic Breakthroughs in Hungary, between Aperture and Tradition," in the catalogue for the exhibition *Les percées de la photographie en Hongrie, entre ouverture et tradition* (2001), which she co-organized.

Joachim Bonnemaison, photographer-collector engineer, is a designer of panoramic cameras. A historian of panoramic photography, he developed a system for classifying panoramic photographs. As an author and collector, he has taken part in numerous exhibitions and publications: *Panoramas, photographies, 1850–1950*, with Régis Durand (1989), *Papiers peints panoramiques*, edited by Odile Nouvel-Kammerer (1990), and *Sehsucht: Das Panorama als Massenunterhaltung im 19. Jahrhundert* (1994). The Getty Research Institute acquired the Bonnemaison panorama collection.

Barthélémy Jobert is a specialist in eighteenth- and nineteenth-century prints and nineteenth-century French painting, Delacroix in particular. A graduate of the École normale supérieure, he is a professor of the history of modern art at the University of Grenoble II Pierre Mendès-France. His publications include *Delacroix* (1997), *Delacroix, le trait romantique* (1998), and *Delacroix, souvenirs d'un voyage dans le Maroc* (1999). He is working on a history of nineteenth-century French painting in collaboration with Bruno Foucart, to be published by Gallimard in 2002.

Claude Schopp received his Ph.D. in humanities and has devoted himself to restoring Alexandre Dumas to favor by publishing the biography *Alexandre Dumas. Le génie de la vie* (1985) and numerous critical editions of his works, including eleven volumes in the Bouquins collection (1989–1993), and *La San Felice, Les Mohicans de Paris, Olympe de Clèves* in the Quarto collection (1996, 1998, 2000). A novelist, he recently published *The Grand Sonata* (1999) and *Deauville noir… et passe* (2001). His most recent publication is *Viva Garibaldi! Une odyssée en 1860* (2002), Alexandre Dumas's hitherto unpublished story of the 1860 journey in which Le Gray participated.

Mercedes Volait, a research scientist at the National Center for Scientific Research, URBAMA Center for Study and Research on the Urbanization of the Arabic World, works essentially on architecture and urban planning in nineteenth- and twentieth-century Egypt. Her publications include *L'Égypte d'un architecte, Ambroise Baudry (1838–1906)* with Marie-Laure Crosnier Leconte (1998); she edited *Le Caire–Alexandrie, architectures européennes, 1850–1950* (2001), and wrote, in collaboration with Ghislaine Alleaume, "L'Âge des mutations: XIXe–XXe siècles," in *Le Caire,* ed. André Raymond (2000).

Henri Zerner, a professor of the history of art and architecture at Harvard University, is a specialist in French Renaissance art and nineteenth-century art. He has published, with Charles Rosen, *Romantisme et Réalisme: Les mythes de l'art au XIXe siècle* (1986) and "Delacroix, la photographie, le dessin," *Quarante-huit / Quatorze* (journal of the Musée d'Orsay), no. 4 (1992).

In the illustration captions, the abbreviation "cat." in brackets refers to the corresponding number in the "Catalogue Entries."

Foreword

Gustave Le Gray must be counted among the most important French photographers of the nineteenth century because of his technical innovations, his role as the teacher of other noted photographers, the variety of his subject matter, and the extraordinary imagination he brought to picture making. His subjects ranged from studies of Romanesque and medieval architecture to portraiture of the French imperial family, from atmospheric landscapes closely related to the work of the Barbizon school of painters to the dazzling seascapes and cloud studies that made him famous. Le Gray photographed French troops on summer field maneuvers, made splendid views of Paris, and created majestic images of the monuments of Egypt, where he spent the last twenty-four years of his colorful life. The depth of visual intelligence he brought to all of these subjects, coupled with his extraordinary finesse as a printer of his negatives, assures him an exalted place in the photographic pantheon.

This publication accompanies an exhibition at the J. Paul Getty Museum of one hundred of Le Gray's photographs. These were drawn from the much larger exhibition—the most important and comprehensive view of Le Gray's work to date—created by and held at the Bibliothèque nationale de France. The Los Angeles installation was the product of an ongoing and fruitful partnership between the Getty and the Bibliothèque nationale, with the gracious help of Jean-Pierre Angremy, President of the Bibliothèque. I am grateful to the institutions and private collectors who permitted their work to be shown in Los Angeles as well as in Paris. I particularly thank the Sterling and Francine Clark Art Institute, the Gernsheim Collection of the Harry Ransom Humanities Research Center at the University of Texas at Austin, Jay H. McDonald, and Gary Edwards, who loaned work solely to the Getty.

The exhibition is largely due to the extraordinary and untiring efforts of Sylvie Aubenas of the department of prints and photography at the Bibliothèque nationale, to whom I am indebted. I am grateful to the Getty staff whose hard work and enthusiasm for this project have guaranteed the success of the exhibition in Los Angeles. First among these is Gordon Baldwin, Associate Curator of Photographs, who not only selected and organized the Getty exhibition but also edited this catalogue. I also want to acknowledge Weston Naef, Quincy Houghton, Marc Harnly, and Merritt Price, all of whom contributed their time and considerable talents to this project.

This catalogue was first published in French to accompany the exhibition in Paris. The Bibliothèque nationale de France generously granted permission for this English-language edition, and I thank Mme Aubenas and the other authors—Anne Cartier-Bresson, Joachim Bonnemaison, Barthélémy Jobert, Claude Schopp, Mercedes Volait, and Henri Zerner—for their texts; John Goodman, Sharon Grevet, and Stephen C. Pinson for their translations; Mark Greenberg and Dinah Berland at Getty Publications for shepherding this publication into print; and Nomi Kleinmuntz for copyediting.

From the time when the Getty first began to collect photographs in 1984, Le Gray's work has been one of its most important nineteenth-century holdings. A small exhibition of his images was held at the museum in Malibu in 1988. It's a delight to now have the opportunity to present a larger sampling of his work.

Deborah Gribbon
Director, The J. Paul Getty Museum

Preface

At a time when photography is attracting the ever-increasing interest not just of art historians, curators, and collectors but of the public at large, and at a time when renewed enthusiasm for the masters of nineteenth-century French photography has again glorified the name of Gustave Le Gray, it may be beneficial to recall the origins of the exhibition that the Bibliothèque nationale de France is now devoting to this great artist. Conceived four years ago and far from being in response to a sudden infatuation that was still barely perceptible, this project was, above all, intended to gather and present the fruits of a long-ripening process. The department of prints and photography of the Bibliothèque nationale de France, which now holds the largest existing collection of these highly prized works, has been collecting them for more than a century and has been progressively showing them for twenty-five years.

Le Gray himself, on the eve of his departure for his one-way trip to the Near East, bequeathed to us, through the copyright registration process, his four most important pieces, four masterpieces selected by him for posterity. His prints were then amassed by the hundreds from the collections of architect Alfred Armand, Georges Sirot, Gabriel Cromer, Émile Le Senne, the Egyptologist Prisse d'Avennes, and the painter Zuber-Buhler, and through the judicious selections made by successive curators, until the acquisition in 2001 of seventeen unknown works produced in Egypt.

We pay tribute to Bernard Marbot, Chief Curator, for having been the first, through the various exhibitions that he organized beginning in 1976, to bring to the fore these treasures and the crucial role played by Le Gray in his day, presenting by turns the chemist who invented the waxed-paper negative, the reporter at the camp at Châlons, the manipulator of clouds, and the inspired artist at Fontainebleau. It was this effort, patiently carried forward by Sylvie Aubenas, that made it possible for the present retrospective to follow up on the one presented in 1987 at the Art Institute of Chicago, which traveled to the Musée d'Orsay. We are fortunate that this latest Parisian exhibition can be in turn hosted by the J. Paul Getty Museum, which has always accorded Le Gray a select position in a collection that has been built with exigency and eclecticism.

At a time, finally, when there is the prospect of fruitful exchanges between the specialized departments at the Bibliothèque nationale de France and the newly created Institut national d'histoire de l'art, this exhibition and book are exemplary, combining as they do the skills of different specialists, not just in photography, but in painting, engraving, and literature as well. Thus Gustave Le Gray—Beaux-Arts student; admirer of the beauty of Italy and the Near East; assiduous visitor to the prints department; friend of painters, curators, and writers; and, finally, peerless photographer—deserves to embody the productivity of such collaborative work.

Jean-Pierre Angremy
de l'Académie française
President, Bibliothèque nationale de France

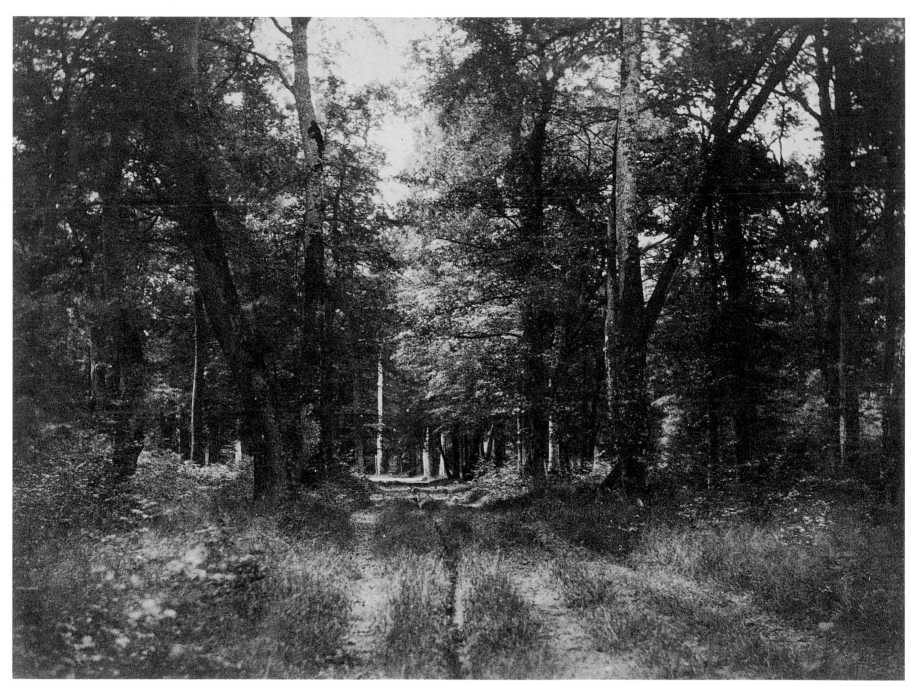

1 Gustave Le Gray. *View of Bas-Bréau, Forest of Fontainebleau*, 1852 (cat. no. 76).

Gustave Le Gray, Between Shadow and Light

Sylvie Aubenas

In his memoirs of 1888, Philippe de Chennevières, former director of the Beaux-Arts, recalled his trip to Cairo in 1869 and evoked his final meeting with "that poor devil," an exiled photographer whom he had known in Paris nearly twenty years earlier—Gustave Le Gray. He was still laughing at the memory of the "strange vicissitudes" that had befallen the photographer and expressed a wish for a "Vasari of photographers" to write an account for posterity. Unfortunately, that Vasari never arrived; none of the numerous eyewitnesses who could have recorded the history of the pioneers of the new art took the initiative. Compared to the survey of biographical information bequeathed to historians of the Renaissance by that Tuscan painter, the only direct accounts of Le Gray are the belated, egocentric, and irremediably muddled reminiscences of Félix Nadar.

Today, monographic studies are more indispensable than ever for providing a factual basis to the history of photography. These have multiplied over the past twenty years, starting with several felicitous cases in which there were a preserved documentary record, family papers, and rarely even a studio archive, documents, and photographs. This is what has allowed Nadar, Charles Nègre, Henri Le Secq, and Alphonse Poitevin to become better known. There remain the host of photographers, great and small—unlike Nadar, who created his own myth—who had neither the foresight to write of their own lives nor the good fortune to have their papers and works survive without many losses. Of those, even the dates of their births and deaths are often unknown.

Among them, Gustave Le Gray represents an extreme case. He led a chaotic existence, or rather two successive and distinct existences—the first in the bright light of Parisian success and the second in the obscurity of exile—and his records have twice been lost. Added to this is a veritable *damnatio memoriae*. A bankrupt fugitive who abandoned wife and children, Le Gray was in turn repudiated and silently passed over by society and by his true heirs, a generation of photographers, the most eminent of whom he had taught. Described in successful times as "good and trusting," "upright and particular,"[1] though plagued with "wasteful habits"[2]—always a dangerous quality in commerce—he became a failure and then an object of scandal. With the exception of a few allusions that are condescending at best, he is absent from memoirs written after his disappearance. He was not mentioned again until 1892, when it was learned that he had died nearly ten years before. Memories suddenly activated the elderly Nadar, who accorded Le Gray a fraternal epitaph: "He was an industrious and remarkably intelligent seeker, a generous soul, and, above all, an honest man."[3] The shared opinion of those who had known him must have been closer to the pragmatic judgment of Maxime Du Camp: "wasteful, idle, very imprecise [. . .]; if he had not been scatterbrained, he would have made his fortune."[4] But the most striking symbol of the social death inflicted upon him by his bankruptcy is a unique and until now unknown necrology, an antemortem exculpatory obituary that he owed to a true friend, Léon Maufras. This indispensable document, as somber as it is informative, dates to 1860, the very eve of Le Gray's exile, nearly twenty-five years before his actual death.[5]

Once the memory of the man had been erased, his work, made to transcend time, both because of the strength of its formal properties and through its exceptionally meticulous chemistry, was bound to resurface sooner or later. Collectors were the first to become aware of its singularity, even before Le Gray fully came to light again in the late 1980s. Research originally conducted in diverse places, in France as well as in the United States, converged in a first retrospective held in Chicago, New York, and Paris, in 1987–1988, accompanied by a monograph by Eugenia Parry Janis, which has been the authoritative text to date. Public curiosity was aroused a second time, in the fall of 1999, when a portion of the Marie-Thérèse and André Jammes collection was spectacularly dispersed. An admirable print of *The Great Wave, Sète* then became "the most expensive vintage photograph in the world," the "hundred-guilder wave." Shortly thereafter, the Paris exhibition of the Roger Thérond collection also featured the artist and allowed visitors to see several unknown masterpieces. It so

1 Letter from wife of J.-C. Langlois, February 22, 1856, in F. Robichon and A. Rouillé, *Jean-Charles Langlois, la photographie, la peinture, la guerre: Correspondance inédite de Crimée (1855-1856)* (Nîmes, 1992).

2 Letter from J.-C. Langlois to his wife, March 4, 1856, in F. Gerber, C. Nicaise, and F. Robichon, *Un aventurier du Second Empire: Léon Méhédin, 1828-1905* (Rouen, 1992), 114.

3 F. Nadar, *Quand j'étais photographe* (1900; rev. ed., Arles, 1998), 96.

4 Letter from Du Camp to Lovenjou, August 31, 1892, Institut de France, Library, Lovenjoul correspondence, G 1169, case 16.

5 L. Maufras, "Étude biographique" (Biographical study), in *Le Monte-Cristo* (January 5, 1860) 594-98 (translated in the appendix to this volume). This is the only contemporary source of such scope concerning the man, apart from the dispersed, disparate, and sometimes unexpected documents of Le Gray's atypical life that are scattered through various archives: the disorganized young man, to prove his age and bachelor status, left his college diploma and a personal letter from his mother (the only one that has been preserved) in his marriage record in Rome; the habitual debtor is revealed in Paris as well as Cairo by the traces of his legal entanglements; at the end of his life, the presumed bigamist saw the annulment of his son's birth certificate, which was full of wrong information.

happened that the decision, made in 1997 by the Bibliothèque nationale de France, to devote a new exhibition to Gustave Le Gray coincided with an unexpected surge of interest.

It is indeed rare for an institution to choose to devote a major exhibition to a topic so recently addressed by others. The brevity of the interval that had elapsed is a measure of the rapidity with which new works and information can still come to light in photography. Some of what remained to be discovered about Le Gray emerged, prompting a more thorough study, including the surfacing of three wonderful nudes, among the most beautiful that the nineteenth century has left us, by an artist who had been previously relegated to only a few specialties—seascapes, landscapes, and architectural views. The research since then has brought to light whole new sides of his work. Discoveries, attributions, and reattributions have broadened our vision of the photographer, his place in his time, his subjects, and his style. Gustave Le Gray, whose previously known works would have sufficed for the glory of several artists, is still being discovered. He is now known as a daguerreotypist; among his portraits are several masterpieces that inaugurated the style that Nadar would perfect. Even from his Near Eastern exile, about which so little is known, prints of very diverse subjects have come to light, some of which (recent acquisitions by the Bibliothèque nationale), though made in the early 1860s, seem through their immediacy and freedom of handling to have invented modern photography—the snapshot, photojournalism, and even to some extent "humanistic" photography. The growing interest in Le Gray's images could not fail to extend to the personality of the artist. Indeed, there is scarcely another nineteenth-century photographer whose work was so closely linked to the unfolding of his life: the work it forms; simultaneously, its raison d'être, its main theme; and its illustration. Although any art critic must be careful of "biographic illusion," in Le Gray's case, it is accurate to assert that the better one knows the work, the better one understands the man, and vice versa. Le Gray's life—that shattered life, full of gaps—has always fascinated due to its very mystery, and what once scandalized his contemporaries has since added to his artistic aura. People love meteoric geniuses whose lives end in obscurity in exotic climes. Le Gray's end (half his adult life) is even more paradoxical and singular in that his work, imprinted with the rigor and grandeur of a classicist amidst the romantics,

bore no trace of the ill-fated artist; on the contrary, it made him the favorite of scientists, the wealthy, and the powerful. Doesn't further biographic research run the risk of dissipating the allure of these mysteries?

Le Gray's life is a novel. To tell it, one must dare to be trite because his story, with its great hopes, brilliant successes, and sudden downfall, resembles a tissue of trite fictions. The uncertainty of many of its circumstances seems tailor-made to encourage a historian's temptation to fictionalize, and Eugenia Parry Janis turned this to the best possible account by composing, from the sources and works that were available at the time, a biography as sensitive as it is scholarly. But the more the documents and evidence accumulate, the more the outlines of the man supersede those of the character one had been inclined to imagine. The figure of this son of the middle class, who devoted himself to the fine arts, buoyed along by the spirit of the romantic generation and then by the prosperity of the empire, progressively torn between his obsession for art and the constraints of family and commerce, bankrupted by idealism and a flightiness of character, and finally liberating himself from his burdens by infamous action, is, without retouching, that of a fictional hero. Émile Zola might have dissected this unredeemed character, a victim of his passion, of money, and of society—unless he had found the story already too laden with stereotypes, symbols, and vicissitudes. After all, once the new episodes are incorporated, it is less a novel about human society than the script for a spectacular melodrama. You be the judge.

Prologue: How did he come to the Beaux-Arts? By fleeing the study of law and causing his old father chagrin. Act 1: Voyage to Rome, artistic bedazzlement, experimentation with photography, love, and a precipitous marriage. His parents have dark forebodings. The Revolution arrives; the artist, giving all to his vocation, does not mount the barricades but frequents the Louvre and the print division of the Bibliothèque nationale de France. His talent attracts attention, and high society throngs his studio, which has become a school. Louis-Napoléon Bonaparte commissions Le Gray to do his first official portrait as head of state, and the empire becomes the photographer's hour of glory. But money gets mixed up in it: the backers who had staked money on him grew weary of his whims and broke off with him. His colleagues and disciples rush in to share the spoils. End of Act 1. A vaudevil-

lian, heroic-comedy interlude: a luxury cruise with Alexandre Dumas, including a revolution in Sicily with Garibaldi and a femme fatale disguised as a boy, who stirs up passions on board. A falling out and an abandonment in the middle of the Mediterranean. Act 2 is somber but exotic: massacres in Lebanon, the court of the pasha, pyramids and camels, a voyage on the Nile. Exile haunted by remorse in the form of recurrent veristic scenes: the dissolution and disappearance of the abandoned family, death of the last remaining friend and the loving mother (the creditors, ever on the lookout, descend on the inheritance). . . . Then the final scene with its orientalist decor: the heat of Cairo in July, a bare-bones Moorish dwelling, a hookah, a beautiful young Greek woman, and an infant. The old artist expires, surrounded by his chemistry manuals, his crates of negatives, and his canvases. In the sunlit courtyard, between four Arab benches, a final bit of heavy symbolism: a large easel and a camera tripod.

It is impossible to hide the fact that there are still many blank spots on this canvas, despite all the documents already known or recently discovered that have been assembled. Above all, we know nothing of Le Gray's painting; no canvas has yet been identified, although he painted throughout his entire life. There is nothing to indicate that this work was of great quality, but knowledge of it would be invaluable for a better understanding of an artist who always called himself a painter and whose photographs bear the stamp of a profoundly pictorial way of thinking.[6]

However, it is precisely this essential link between the man and his work—above and beyond the events of a lifetime—that the authors emphasize here: artistic ambition, the application to photography of the fundamentals of art learned from Paul Delaroche, at the Louvre, and in Rome, and then developed in constant interaction with contemporary painters. Le Gray's photographs, as cerebral as they are sensitive, are distinguished from all others, in their making and their printing, by the perfection of daring balances and by an indefatigable pursuit of "effect." They are initially striking due to their variety of tones and often the power of their chiaroscuro, but they rely at least as much on an inspired and skillful combination of lines, planes, and volumes. In his portraits, this pursuit more often results in elegance than in psychological depth, but it is incomparably effective in his landscapes and architectural photography. It secretly links the views of

Romanesque churches, the seascapes, the military maneuvers at the camp at Châlons, the Fontainebleau underbrush, and the nudes with recurrent characteristics: the framing that envelops a compact volume or, to the contrary, opens onto the infinite; the implacable horizontals as a foundation; the always rethought calculation of proportions and layering of planes, simultaneously opened up and unified by a long diagonal, by a patch of sunlight, by a seemingly insignificant detail that brings the entire field into focus. This luminous geometry, transfigured by chemistry with the unprecedented nuances that Le Gray imposed on it, is, at the end of the "strange vicissitudes," all that counts.

By further exploring the life and work of Le Gray, without claiming to deliver a definitive portrait, the authors hope to better provide, between shadow and light, as Nadar's well-known saying goes, "the most familiar and the most favorable likeness, the intimate likeness."[7] But beyond that, a better understanding of the rise, the fall, and the work of the most gifted photographer of his time means also clarifying the ambition and destiny of a generation that gave photography its golden age. Le Gray's central role at the crossroads of art, science, commerce, and power in the genesis of the world of photography under the Second Empire, and even the elevation of photography to the rank of art, provides a framework for posing historical and artistic questions that go beyond the individual. Not the least of these is that of style in photography, comprising technique as much as aesthetics. Between the master and his disciples, attributions may be tricky to determine. Some of Le Gray's students, unknown until now, are to be discovered. This publication brings forward the exemplary case of Firmin Eugène Le Dien, an amateur who is absent from the exhibitions of his time and the author of travel photographs printed in collaboration with his teacher that are of such high quality it has been tempting to attribute them to the latter. This is just one illustration of what occurred for several years around Le Gray—an intermingling of aspiring photographers, artists, and a society whose works it will never be possible to entirely reassemble, most of which have disappeared without a trace, but whose role was fundamental to the technical and artistic development of photography.

6 The single probable exception to this vacuum is a panorama of the ruins of Baalbek painted over a photograph (fig. 312), though it is not very incisive for judging a painter.
7 *Revendication de la propriété exclusive du pseudonyme Nadar. . .* Imperial Court of Paris, 1st Division, hearing of December 12, 1857, page *o*.

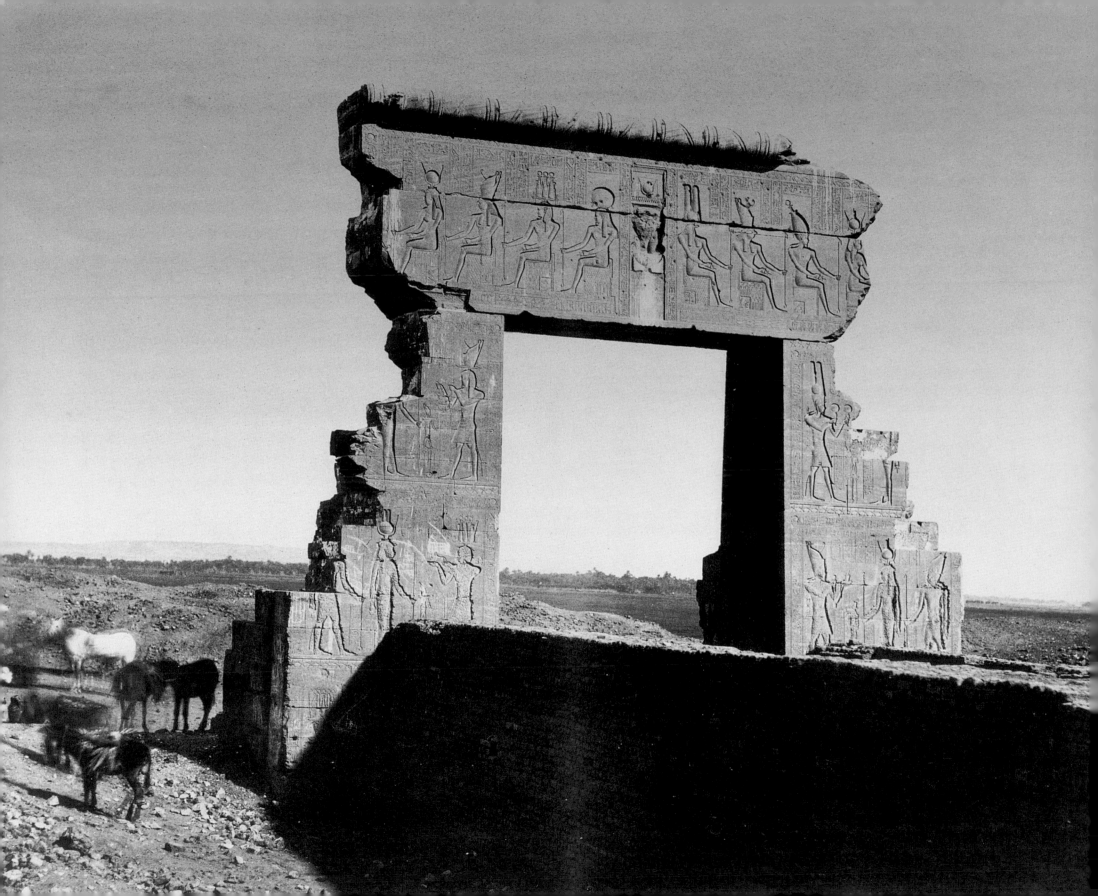

2 Gustave Le Gray. *Pylon of the Temple of Hathor, Dendera*, 1867 (cat. no. 208).

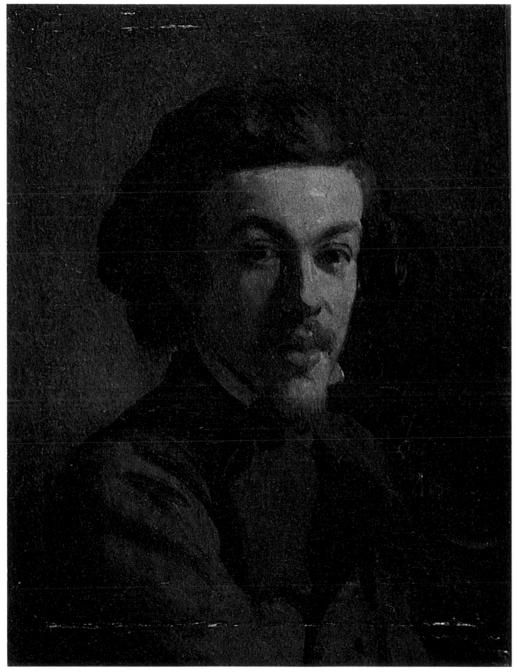

3 Henri Le Secq. *Portrait of Gustave Le Gray*, 1844 (cat. no. 1).

The Youth of a Painter

Sylvie Aubenas

After enjoying extraordinary renown and recognition in Paris within his profession, if not fortune and fame—which had not yet begun to smile on photographers, Gustave Le Gray spent the end of his life in total solitude and neglect. His life began, however, in the most typical and ordinary way.

Origins

Le Gray was born on August 30, 1820, on the outskirts of Paris—in Villiers-le-Bel,[1] near Écouen—as the soon-to-be-cosseted only child of a prosperous merchant couple. He was an exact contemporary of Charles Nègre and Félix Nadar, and two years the junior of Henri Le Secq. Along with these three, the Bisson brothers (Louis-Auguste, b. 1814, and Auguste-Rosalie, b. 1826), Édouard Baldus (b. 1813), and the Englishman Roger Fenton (b. 1819), Le Gray was part of the generation that in the 1850s would elevate photography to a fine art.

His father, Jean-Martin Legray,[2] owned a haberdashery at 341, rue Saint-Denis[3] and had married Catherine Eulalie Gay in December 1806 at the nearby church of Saint-Nicolas-des-Champs.[4] Jean-Martin Legray was born about 1770 in Bordeaux,[5] which meant he was past fifty when Gustave was born. The grandfather, Pierre Legray, who had been a tax collector, died prior to 1806, but his widow, the former Françoise Navaille, was still living in Bordeaux.[6] We know nothing of the circumstances under which Jean-Martin left Bordeaux and became a haberdasher in Paris.

Gustave's mother, who was born August 7, 1785, was the daughter of a *passementier* (a dealer in fabric trimmings) who resided at 21, rue Saint-Denis. Her brother, also a passementier, had set up shop at number 309 on the same street. The couple's social milieu was thus entirely homogeneous, consisting of haberdashers and passementiers who, since the Renaissance, had densely populated the full length of rue Saint-Denis, from the butcher's quarter on the banks of the Seine to porte Saint-Denis. It is possible that Jean-Martin Legray met his future wife while working for her father.

At first the young couple lived close by, at 10, rue de la Grande-Truanderie, near the church of Saint-Eustache, in the working-class neighborhood of Les Halles. Gustave was born in the house on rue du Gué in Villiers-le-Bel, where his maternal grandparents had moved and which his parents would inherit in 1827. By 1822 they had become somewhat affluent, which allowed them to purchase a spacious house at 233, grande rue du Faubourg-Saint-Antoine for the sum of twenty-nine thousand francs. Then, in Villiers-le-Bel, where they eventually retired permanently, they repeatedly bought and sold houses, outbuildings, and small plots of land. They participated in frequent borrowing and lending among their neighbors.[7] They lived the life of the prosperous, small property owners described in Balzac's *The Human Comedy*. The inventories made after the death of Gustave's father (1855)[8] and then his mother (1861)[9] give us a glimpse of the house on rue de l'Abreuvoir in Villiers-le-Bel, with its garden and outbuildings. If not luxurious, it was at least respectably middle-class and comfortable, with armchairs, clocks, a gaming table, chandeliers, and mahogany chests. At the back of the courtyard was their son's studio.

From Villiers-le-Bel to Paris

Gustave Le Gray was the "sole and belated fruit of a cloudless union, within which this double circumstance made him the object of tenderness without compare, and all the greater for being undivided."[10] His meticulous education reflects the hopes that must have been placed in this long-awaited offspring, who was endowed with manifest intellectual abilities. In 1839, in Paris, he obtained what was then an uncommon degree, the bachelor of letters, which was the "stamp of the middle class."[11] This opened to him the prospect of an honorable career that was not to be in haberdashery. "His father . . . envisioned a notarial career for him; thus, as soon as he had completed his studies, he found a place for him as a clerk with the town scrivener; but young Le Gray had no vocation for civil law, and he sketched on the legal pages more often than he used them for the contracts for which they were intended."[12] Said "scrivener," who probably kept his young clerk on until 1841,[13] was

1 Villiers-le-Bel vital statistics, Departmental Archives of Val-d'Oise (Pontoise).
2 Le Gray's father and mother always wrote their surname as a single word, while Gustave, as far back as we can trace his signature (1844), split it in two. Therefore, the latter spelling is used throughout, although both forms may be found in documents.
3 Lease to J.-M. Legray of a shop at 341, rue Saint-Denis, November 18, 1806, National Archives, Records of the Central Paris Solicitors' Archives XCIII, 278.
4 Reconstructed vital statistics, Archives of Paris.
5 His exact date of birth was not found.
6 Marriage contract between Jean-Martin Legray and Catherine Eulalie Gay, November 26, 1806, National Archives, Records of the Central Paris Solicitors' Archives XXII, 177.
7 Records of the Lechat law office, 1832–1850, Departmental Archives of Val-d'Oise, 2 E 21250.
8 Liquidation of the estate of J.-M. Legray, February 28, 1855, Departmental Archives of Val-d'Oise, 2 L 21077.
9 Estate inventory of Catherine Eulalie Gay, May 11, 1861, Departmental Archives of Val-d'Oise, 2 E 2110.
10 L. Maufras, "Étude biographique," *Le Monte-Cristo* (January 5, 1860): 594–98 (translated in the appendix to this volume).
11 Marriage of Le Gray, Historical Archive of the Vicariate of Rome, Marriages, 1st Solicitor's Office (Angelo Monti), 1844, vol. 3, file 72.
12 Maufras, "Étude biographique."
13 Le Gray is mentioned as a solicitor's clerk, living with his parents, in the list of names of the inhabitants of Villiers-le-Bel, 1841, Departmental Archives of Val-d'Oise, 9 M 990/1.

sue such a career. He wanted to be an artist, because this condition revealed to him an entire world, a chaos in his mind, but already glimpsed by him through his ardent love of form and his great admiration for the masterpieces that he could visit each time he went to Paris. . . . Le Gray prevailed over the notions of his father—who conceded only with great reluctance—and, a bit like Balzac, he came to Paris and entered the atelier of Paul Delaroche, one of the great painters of the day.[14]

Unlike many of the tragic figures immortalized in the pages of Henri Mürger, Aurélien Schanne, Nadar, and other survivors of the bohemian culture, Le Gray was neither disowned nor disinherited. In devoting himself to painting, he was assured, if not of the approval, then at least of the unfailing tolerance and financial support of his elderly parents.

In early 1842, at age twenty-one, he could be found living at 170, rue du Faubourg-Saint-Denis, as a student of Paul Delaroche at the École des beaux-arts and a student copyist at the Louvre.[15] It was then, in Delaroche's studios, that he gained a foothold in the milieu that was to be his and entered into his important lifelong friendships. It was there that he met Le Secq (fig. 4),[16] Nègre,[17] and Jean-Léon Gérôme,[18] among many other artists (Maufras mentions Yvon, Barre, Alfred Arago, and Michel Carré [fig. 5]). It is interesting to note that, of these first three friends—all, like him, painters—two would become great photographers. For the third, Gérôme, photography would always hold a special—if not central—importance; he often used it to document his work and especially to make his work known.[19]

4 Henri Le Secq. Engraved self-portrait, ca. 1860.

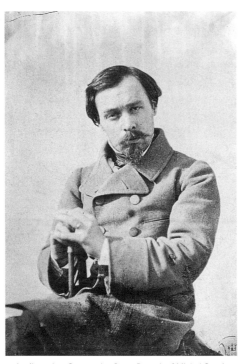

5 Attributed to Gustave Le Gray. *Portrait of Michel Carré*, ca. 1849/50 (cat. no. 16).

From Paris to Rome

In the summer of 1843, after a hazing gone wrong that resulted in the death of a student, Delaroche was obliged to close his studio.[20] He decided to leave Paris and spend a year in Rome. He left in October and remained there until November of 1844. Some of his students followed suit. Le Gray preceded his master, having left France in the summer of 1843; Gérôme followed in October; and Le Secq joined them later, in October of 1844.

Maufras provides the following description:

[Le Gray's] thoughts soon changed direction, and one morning, with a staff and a sack as his only baggage, he set out, by way of Switzerland, for Rome, that land of the arts, to wrest the secrets from the canvases of the great masters, and also to visit the remains of the cradle of

14 Maufras, "Étude biographique."
15 National Museum Archives, Louvre, *LL 7, February 24, 1842.
16 Cf. E. P. Janis and J. Sartre, *Henri Le Secq, photographe de 1850 à 1860*, exh. cat. (Paris, 1986).
17 Cf. F. Heilbrun and P. Néagu, *Charles Nègre photographe, 1820–1880*, exh. cat. (Paris, 1980).
18 No written trace remains of the relationship between Gérôme and Le Gray.
19 See G. M. Ackerman, R. Bigorne, and P.-L. Renié, *Gérôme & Goupil: Art et entreprise*, exh. cat. (Paris and Pittsburgh, 2000).
20 E. P. Janis, *The Photography of Gustave Le Gray*, exh. cat. (Chicago and London, 1987), 23.

Edme Lechat, Villiers-le-Bel's solicitor, for whom the Legrays were good customers. So Gustave started out as the quintessential middle-class son—so often found in art history, and in bohemian life in particular—a young man programmed for a laborious social climb, who throws off the yoke of a dull future for an uncertain but exhilarating career as an artist.

His first biographer, attorney Léon Maufras, made a convincing case for his preordained fate, from childhood, as an artist and a scholar. The classic *puer/senex* archetype has scarcely changed since Vasari applied it to Giotto (which does not prove it false): "He attracted attention in early youth with his passion for drawing and his prodigious penchant for serious subjects treated in science books that one would have thought beyond the reach of a boy his age." Such an early vocation could not be ignored but was in clear conflict with the biases of his environment:

[L]ike all old men, Le Gray's father remained deaf to the aspirations of his son, who in vain, more than once, requested permission to pur-

civilization. He traveled throughout Italy, sowing here and there small watercolors and pastiches of things ancient for which wealthy travelers were already paying very high prices, which provided him with sufficient funds to pay for his peregrinations.[21]

Le Gray actually made the trip (which constituted a second hiatus after the discontinuation of his legal studies), on foot through the Alps during the summer of 1843 and remained in Switzerland until October. He was in Florence the same month, and finally arrived in Rome in December.[22] A letter from his mother, the sole trace of family correspondence that has been found, dated January 1844 and sent general delivery to Florence,[23] is a touching display of affection and maternal anxiety:

> My dearest, you know well that I cannot be happy far from you, that I am having a great deal of trouble becoming accustomed to your absence, but that, since you seem happy, I am somewhat consoled, because I hope that you will achieve your desired goal; you tell me that two years will pass quickly; for you, who are young, that is true, but for your mother, who is no longer young, they will seem long indeed, [but] I must be patient.[24]

She continued by advising him to write a kind word to his father. The bohemian uprooting cited by Maufras was far from total, and the subsidies mentioned in another passage in the letter were appreciable: 150 francs per month. Now Gustave could finally forget rue Saint-Denis and solicitor Lechat, as well as the house and garden in Villiers-le-Bel, when he set off for Italy—a great rite of initiation for a young artist of his day.

After an excursion of several weeks to Naples, he returned to Rome in February 1844, staying on the Via del Corso, in the parish of San Giacomo in Augusta, a short distance from the Piazza del Popolo, in a neighborhood where Caneva had his studio and where there was no scarcity of artists. The Académie des beaux-arts was being built right behind the hospital of San Giacomo, and the Villa Medici was a few minutes' walk away.

Marriage

There, something unexpected occurred. On May 12, 1844, exactly three months after his return from Naples, Gustave Le Gray married Palmira Maddalena Gertrude Leonardi,[25] a working-class girl, born March 23, 1823. He did not wait for the required certificates or his parents' consent and obtained an exemption from making the public proclamations of his intentions to marry. The reason cited

was the Frenchman's imminent return to his country: "Giovanni Battista Gustavo Le Grè [*sic*] and Palmira Leonardi wish to be joined in h[oly] matrimony with dispatch, since the groom must return to his home in Paris in a few days, as attested by his own parish priest; therefore, so that their desire may not be in vain and so as not to deprive the bride of a respectable status, they beseech Your Excellency, for these just reasons, to dispense with the usual bans."[26] This indeed seems to be a an excuse, since Le Gray did not leave Rome for more than a year. Perhaps he used the pretext of an impending departure to avoid pressure from the Leonardi family. In that event, he only hastened the fate he was seeking to escape.

As indicated in the marriage application, the fiancés lived "under the same roof in San Giacomo in Augusta,"[27] perhaps residing at the same address, 37 Via del Corso, with Palmira's family: her parents, Luigi and Annunziata, her four brothers and sisters—Federico, Augusto, Ulisse, and Luisa—and her half brother, Achille Chiodi, the son of her mother's first marriage.[28] The father called himself a *viaggiatore*[29] (peddler). The half brother described himself as a sculptor. The mother, who previously had sold canes and walking sticks, attended to the housework. Likewise, Palmira "fa i lavori di casa" (cleaned house).[30] We can easily imagine her doing

21 Maufras, "Étude biographique."
22 Passports of French citizens arriving in Rome, Archives of the Ministry of Foreign Affairs (Nantes), Rome, Embassy to the Holy See, register 695.
23 Marriage of Le Gray, Historical Archive of the Vicariate of Rome.
24 Ibid.
25 These names are given here in their Italian form (the only remaining documents give them in French or in Latin).
26 Marriage of Le Gray, Historical Archive of the Vicariate of Rome.
27 Ibid.
28 Rome census of 1844, source cited in Janis, *Photography of Gustave Le Gray*, 152, n. 11 (the place where these records are maintained should probably be corrected to: Rome, State Archive).
29 Marriage of Le Gray, Historical Archive of the Vicariate of Rome.
30 Ibid.

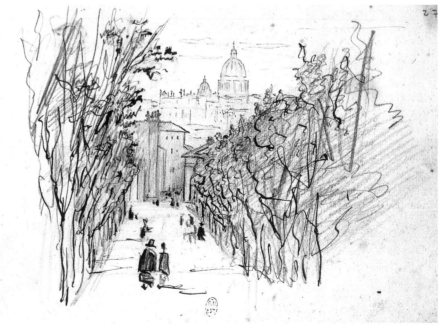

6 Henri Le Secq. *View of Rome*, Sketchbook 1844–1845 (cat. no. 239).

31 Ibid.

32 Record of marriage certificate, September 23, 1845, including a translation into French of the Italian marriage certificate, Villiers-le-Bel vital statistics, Departmental Archives of Val-d'Oise.

33 Letter from Du Camp to Lovenjoul, August 31, 1892, Institut de France, Library, Lovenjoul correspondence, G 1169, case 16.

34 In the play by Molière, Sganarelle, an affluent middle-aged man, is burning to marry the pretty but poor Dorimène. Realizing that she is motivated by self-interest, is already unfaithful, and offers him only a marriage of convenience, he gives up. But her father, Alcantor, seizing the opportunity to rid himself of an impudent and extravagant daughter, assigns his son, Alcidas, the task of giving Sganarelle the choice between a duel and marriage. Frightened, the fiancé decides, "All right then, I'll marry, I'll marry."

35 F. Nadar, *Quand j'étais photographe* (1900; rev. ed. Arles, 1998), 85.

36 Nadar, *Quand j'étais photographe*, 93.

37 Death certificate dated July 27, 1858, Villiers-le-Bel vital statistics, Departmental Archives of Val-d'Oise.

38 Archives of the ministry of Foreign Affairs (Nantes), Rome, Embassy to the Holy See, register 696; record of marriage certificate, September 23, 1845, Villiers-le-Bel vital statistics, Departmental Archives of Val-d'Oise.

39 Records of the Lechat law office, instrument dated September 3, 1845, Departmental Archives of Val-d'Oise, 2 E 21250. The repayment is documented in an instrument dated October 25, 1854. After a first extension in 1850, which reset the deadline for payment of the debt for September of 1855, it is likely that Jean-Martin Legray wanted to settle it before his death.

40 Archives of the ministry of Foreign Affairs (Nantes), Rome, Embassy to the Holy See, registers 696, 697.

small favors for the young foreign artist, washing his laundry, and so on. The two young people soon became intimate, and Le Gray also developed a familiarity with others in the large Leonardi family, particularly with the sculptor half brother. The statements by the witnesses to the marriage, the father and half brother, bear witness (although in terms dictated by the form) to the "close friendship" that had been established with the young painter.[31]

The lack of French witnesses[32] emphasizes the impression of a hasty and discreet ceremony, the reasons for which are not certain. Was it love at first sight for a classic beauty? The exhilaration of a young artist uprooted to the Eternal City sometimes produced such sudden effects. Delaroche, who had arrived in Rome in October of 1843, himself became engaged by early December to Louise, the daughter of Horace Vernet (then the director of the Villa Medici), and was married the following month. However, in Le Gray's case, in addition to haste, there was also an inequality of station.

Might there have been some pressure to protect the young woman's honor, perhaps, or a trap set by an indigent family for an unwitting young foreigner? A half century later, Maxime Du Camp corroborates the least romantic hypothesis:[33] "Gustave Le Gray tried his hand at painting . . . with a mediocre result. He went to Rome, was caught with his laundress—a beautiful girl—and was obliged to marry her, somewhat, if not entirely, like Sganarelle in *The Forced Marriage*."[34] Du Camp is never sentimental or compassionate, but the sequence of events and the eventual disaster for the Le Gray family do not belie his version. Having taken lessons with Le Gray in 1849, Du Camp was familiar with the household and the stories that may have been circulating among the artists.

While it is true the couple had many children—at least six born between 1845 and 1858—it was not a happy marriage. Was Nadar also alluding to this when he described Le Gray around 1850 as a "very young family man, relentlessly struggling with an obsessive need to produce, the predicament of having to earn a living, and private sorrow"[35] and again at the time of his departure for the Near East, "drowning in all manner of sorrow, at the edge of despair"?[36] Along with his financial troubles, the successive deaths of his four daughters would be enough to explain these allusions, but the manner in which Le Gray abandoned his wife and two surviving sons in 1860, who never heard from him again, must also be taken into account. Even in the article by Maufras—who, prior to this dra-

matic turn of events (Le Gray's flight), attributes to Le Gray every moral virtue—the attributes of the good husband and father are lacking, and the family does seem conspicuously absent. Admittedly, this pseudo-obituary states, "His intimates mourned him more than anyone, for they alone knew the full extent of their loss," but the perhaps intentionally ambiguous formula seems to refer to close friends at least as much as family. Maufras himself subsequently clarifies, "His heart worshiped only friendship."

Since he was tied at a young age to the type of woman whom his peers took willingly as a model or even as a mistress, but almost never as a wife, and with a large dependent family but no fortune, it seems plausible that Le Gray soon came to feel the full weight of such a burden. A photograph—the only one of her—shows Palmira circa 1858, seated dreamily in the large studio on the boulevard des Capucines, dressed in white lace. Hers is a pensive beauty; she is somewhat emaciated, with a Mediterranean face, big eyes, and very black hair (fig. 7). When Le Gray met her in 1844, she must have resembled the painting of Herodias that Delaroche had completed in July 1843, just prior to leaving Paris.

Extended Sojourn in Rome

June 4, 1845, a first child was born, a girl, Elvire Françoise Eulalie (fig. 8).[37] The following month, the little family left Rome for Paris, primarily to introduce Palmira to her in-laws, and to have the Roman marriage and the consent of the elder Legrays recorded by the French authorities.[38] However, it was also an occasion to secure the future by borrowing the sum of 5,000 francs from a Parisian pharmacist, Louis Girault, a neighbor in the countryside at Villiers-le-Bel; this debt would not be repaid until more than ten years later, by Gustave's parents.[39] Gustave needed that amount—a considerable one for a young man of his station—to finance his return to Rome and his life there, and perhaps to come to the aid of Palmira's large family, until he was able to meet these needs himself. This was the first ill-considered debt, long before the loan of 100,000 francs taken out in 1856 that was to seal his fate.

The young couple left Paris for Rome in October 1845 and did not return permanently until March 1847.[40] Le Gray's Italian adventure lasted nearly four consecutive years—twice the amount of time he had originally expected. During these four years, he must have painted, mingled with young artists of various nationalities,

and observed and studied painting, architecture, color, and the light that would stay with him for the rest of his life. Of all this, there remains only a fragment, a small portrait of him by his friend Le Secq in 1844 (fig. 3); he is depicted looking joyful, with a romantic forelock and a wide red scarf around his neck.

The material conditions of his sojourn, with the 150 francs a month from his parents and the 5,000-franc nest egg to last two years, were scarcely different from those of young artists who had won the Prix de Rome. The latter received room and board at the Villa Medici for a similar four- or five-year period, plus an annual stipend of 1,200 francs.[41] The simultaneous presence in Rome of Le Secq, Gérôme, Du Camp, and Le Dien[42] do not keep us from speculating about other friendships he may have made there, particularly with the boarders at the Villa Medici. However, the names of those who were there at the time[43] do not allow us to establish any connections, since none of them reappears subsequently in Le Gray's life. Therefore, we cannot determine in precisely what circles he may have moved, if he was not fully absorbed by his own work and by his family life (a second daughter was born in 1846).[44]

Initial Experiments with Photography

If we rely on Maufras's biographical study—with its wealth of stories provided by the subject himself—as a basis for that period, we find a personality that was out of the ordinary in many respects. But, more important, we discover that Le Gray was becoming a photographer much earlier than had been thought; until now, there has been general agreement that this new vocation dated to his definitive return to Paris. According to Maufras, Le Gray, far from sharing the eccentricity and insouciance exhibited by the young painters of his day, apparently led an austere and studious life, which seems to have led him straight to photography:

> He was a frequent visitor to the libraries of Milan and Rome and it was perhaps there, upon reading pages by Leonardo da Vinci about attempts to obtain images in a camera obscura, that he resolved to study the

41 Regarding the Villa Medici during that period, see É. Robbe, "Correspondance de Jean-Victor Schnetz, directeur de l'Académie de France à Rome, de 1841 à 1846 et de 1853 à 1866," annotated ed. (Paleographic archivist diploma thesis, École nationale des chartes, 2001); summary in École nationale des chartes: *Positions des thèses* . . . (2001), 171–77.
42 Regarding Le Dien, see Aubenas, "On Photographic Collaboration: Firmin Eugène Le Dien and Gustave Le Gray" (this volume).
43 Robbe, "Correspondance de Jean-Victor Schnetz," vol. 2: 657–61.
44 Elvire Mathilde Julie Miriam Le Gray, born in Rome, August 10, 1846, reconstructed vital statistics, Archives of Paris.

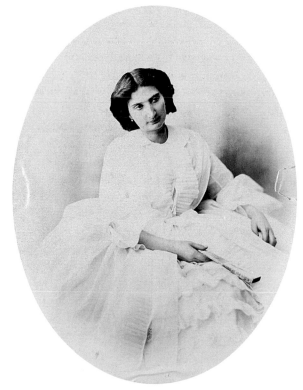

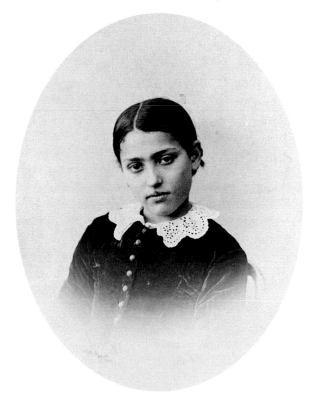

7 Gustave Le Gray. *Portrait of Mme Le Gray*, ca. 1858.

8 Gustave Le Gray. *Portrait of Eulalie Le Gray*, 1858.

45 Maufras, "Étude biographique."
46 Nadar, *Quand j'étais photographe*, 85.
47 Ibid., 82.
48 Janis, *Photography of Gustave Le Gray*, 153, n. 20.
49 Conserved in the département des Manuscrits (MSS), Bibliothèque nationale de France (BNF).
50 Cf. Aubenas, "Alphonse Poitevin (1819–1882), photographe et inventeur . . ." (Paleographic archivist diploma thesis, École nationale des chartes, 1987), particularly vol. 1, 45–49 and 88–90; summary in École nationale des chartes, *Positions des thèses . . .* (1987), 19–30.
51 Ibid. vol. 1: 87–88.
52 Maufras, "Étude biographique."
53 Notebooks of Alphonse Poitevin conserved in the département des Estampes et de la photographie, Bibliothèque nationale de France.

new discovery of Daguerre, then almost in its embryonic stage; in any event, from that moment forward he added to his work—first as a distraction but soon as a new study that would seduce him more and more—the application of Daguerre's principle. . . . Henceforth he had only one ambition, *to unite science with art;* but for that, it would be necessary to delve into chemistry. . . . He was not the least bit frightened by this dual syllabus, and, without ceasing to copy Michelangelo and Raphael, he devoted a part of his nights to all manner of alembics and retorts.[45]

So, almost from the outset of his career, Le Gray combined the abilities of both a painter and a photographer / chemist—the artist and the scientist—that would be his forte. Even without being a genius with a paintbrush, on his return to France, where he became established as a painter, and soon after as a photographer, he enjoyed the prestige of a complete artistic training, from the École des beaux-arts to a Roman sojourn. In the eyes of the artists, from critics to gifted amateurs, this personal legitimacy immediately distinguished him from the smooth-talking and imprecise boulevard daguerreotypists who were the target of caricaturists in the 1840s. Like Nadar, Le Gray was one of those men who gave photography its stamp of nobility, not only through their talents, but through their connections and "references" suitable for inspiring confidence in an intellectual and social elite that immediately challenged the future and dignity of the new medium.

Before this, with respect to his shift to photography, there was only the much later and ever vague testimony of Nadar:

> He had always been attracted to chemistry, and painting did not cause him to abandon the laboratory next to his studio, where he pursued the secrets of making permanent, immutable colors, whose manufacture he felt had been left for too long to the avaricious indifference of merchants. It was on this stretch of his "Road to Damascus" that he was suddenly illuminated by the beam that was first lighted by Poitevin. If there was one among us who would be caught up by Niépce's marvelous discovery, it was he. Photography whistled at him and Le Gray came running. . . . The die was cast: nothing remained of the painter, save the taste developed by study, a habituation, a knowledge of form, the habit of the effects and dispositions of light, not to mention a long-standing knowledge of chemical agents and reactions, all of which now served the photographer.[46]

This colorful recollection, written in 1892, seems to attribute to Alphonse Poitevin an influence on Le Gray's chemistry research. Elsewhere Nadar writes that Le Gray had given up painting to propagate Poitevin's paper process,[47] but Eugenia Parry Janis closely examined these assertions and found them to have no verifiable foundation.[48] It can be confirmed that Poitevin's well-preserved correspondence[49] reveals no direct relationship between the two men. After living in Paris from 1839 to 1842, Poitevin did not return to live there until 1855; in the meantime, he pursued his research in photographic chemistry from 1847 to 1855 as an engineer at the saltworks in Montmorot and then in Gouhenans, in Franche-Comté.[50] It is just possible that Le Gray got wind of Poitevin's work through one of the scientists who encouraged it—Arago, Becquerel, or Balard—or through his articles in the proceedings of the Académie des sciences.

Janis notes that Le Gray's research was of a different nature, apart from any hypothetical experimentation in photomechanical reproduction. However, the experiments described by Maufras establish an exact parallel with the very first work done by Poitevin in Paris as early as 1842,[51] of which Le Gray may have been aware prior to 1847:

> For four years, he lived in Rome the life of a medieval Benedictine monk, seeking in all kinds of combinations an agent that might be substituted for mercury, which was ever dangerous to use but absolutely necessary to fix the image obtained on the metal plate, and also to eliminate this plate and replace it with another that would preserve the image and make possible multiple reproductions of it.[52]

This is indeed a question of photomechanical printing, which broadens the scope of our presumptions.

It is also plausible that in 1848 Poitevin thought about using collodion, which had been discovered in 1847, to bind silver salts to a glass plate, but this remained at the hypothetical stage, since he was unable to obtain collodion where he was.[53] This appears to be another tenuous link to Le Gray's first important discovery.

As for Nadar, writing fifty years later, we should not expect great accuracy from him, and there is nothing to even indicate that he gave any special thought to Le Gray's Roman period. From his statements, which seem to assign Poitevin the role of tutelary genius

rather than personal contact, we particularly derive a convergence, in that generation's memory, of indefatigable research by the two men who personified the epitome of the scientist-photographer.

Return to Paris, between Painting and Photography

After his return to Paris, while living at 27, quai des Grands-Augustins, Le Gray at first continued to lead the life of a young painter. He had enrolled again at the Louvre, still as a student of Delaroche,[54] then at the Cabinet des estampes (print department) of the Bibliothéque royale (French Royal Library),[55] and he exhibited at the Paris Salon of 1848. In fact, his first two entries, submitted February 22 of that year, were initially rejected by the jury. On February 24, King Louis-Philippe was overthrown. Five days later, Jeanron, the director of the Louvre, proposed that all paintings that had been submitted that year be unconditionally accepted, since the political circumstances had created an awkward position for the jury. So Le Gray witnessed the miraculous inclusion of his two paintings—*Farmers of the Roman Campagna Closing Off a Side Road for the Flock* and *Portrait of Madame H. de V.*—in the "circle of the chosen."[56] His submissions in 1850 and 1852 were again rejected,[57] and, in the end, his work was accepted only once, for the 1853 exhibition. So, around 1847/48, and at least until 1853, there was a transitional period that was very fertile for photographic production, in which Le Gray sought to assert himself both as a painter and as a photographer, another parallel with artists such as Nègre, Le Secq, Baldus, and Julien Vallou de Villeneuve.

The first episode of Le Gray's career as a photographer, recounted several years later, actually dates to shortly after his return to Paris: "M. Le Gray recalls that, in 1847, he did experiments with M. Arago to capture on a [daguerreotype] plate the black spots that appear on the sun."[58] How did it occur to Arago, director of the Paris Observatory—who solemnly announced the invention of photography in 1839—to call upon this young artist to help him capture the eclipse of October 9, 1847, on a daguerreotype plate? He probably knew about the research Le Gray had conducted in Rome through his son, Alfred, one of Le Gray's companions from Delaroche's studio. The only other attested foray by Le Gray into the field of the scientific application of photography occurred ten years later and involved the photography of another eclipse, that of March 15, 1858. A print that was published at the time in *Le Monde illustré* is, unfortunately, the only trace we have of these two astronomical experiments.[59]

Daguerreotypes

Until recently, Le Gray's beginnings have been associated with photography on paper. An avowed vocation dating back to his sojourn in Rome necessarily leads us to the daguerreotype. However, a letter sent in 1889 to the Société française de photographie by photographer E. Moutrille[60] provides the missing link between the two techniques. Mentioning the first great invention by Le Gray, the waxed-paper negative, the letter demonstrates in passing that, on the date of this fortuitous discovery, Le Gray was routinely making daguerreotypes. The information had been reported to Moutrille at least thirty-five years earlier (ca. 1850–1855), by an associate of Le Gray's by the name of O. Mestral. "This is what Mestral told me: While working one day with Le Gray, with whom he was in daily contact, he accidentally placed a bar of white wax on the bromine container they used for daguerreotypes, which they often made." This providential accident must have occurred around

9 Gustave Le Gray. *Portrait of Pol Le Coeur*, 1848 (cat. no. 5).

54 November 16, 1847, National Museum Archives, Louvre, *LL8.
55 February 10, 1848.
56 An actual note on the first painting: "The building at left is an outbuilding of the home of Pope Julian III, outside the Porta del Popolo, architecture by Vignole," in other words, the Villa Giulia (a few minutes from Le Gray's lodgings in Rome). *Explication des ouvrages de peinture . . . exposés au Musée national du Louvre le 15 mars 1848* (Paris, 1848), 203, nos. 2828 and 2829.
57 See H. Zerner, "Gustave Le Gray, Heliographer-Artist" (this volume).
58 *Bulletin de la Société française de photographie* 2 (April 1856): 118.
59 *Le Monde illustré* (March 20, 1858): "Our print shows the heliographic silhouette of two major [phases of the eclipse]. We owe these to a photographer, who is both a scientist and an artist."
60 "Séance du 7 juin 1889," *Bulletin de la Société française de photographie* (1889). 143–45. The author is deeply grateful to Bernard Marbot for informing her of this document.

10 Gustave Le Gray. Daguerreotype of Gérôme's painting *Anacreon, Bacchus, and Cupid*, 1848 (cat. no. 6).

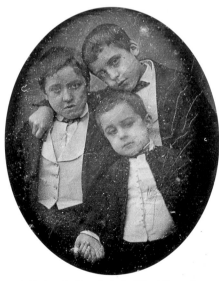

11 Gustave Le Gray. *Portrait of Three Young Boys* (cat. no. 7).

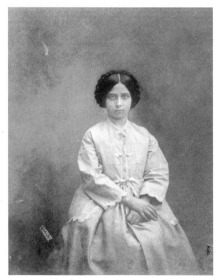

12 Gustave Le Gray. *Portrait of Princesse Françoise*(?), ca. 1848.

1850, since the resulting process—the waxed-paper negative—once perfected, was used by Le Gray in 1851 and published the following year.[61] This major document is sufficient to fully confirm that Le Gray's interest dates back to the era of the daguerreotype.

While nothing remains of Le Gray's Roman works, his first subsequent known works are actually plates from the 1847/48 period. Two of these may be dated as 1848. We have a portrait of the son of architect Charles Le Coeur; young Pol Le Coeur (fig. 9), a student at the Henri IV *lycée*, smiles kindly and spontaneously at the lens. Then there is a reproduction of a painting by his friend Gérôme, *Anacreon, Bacchus, and Cupid*, exhibited at the 1848 Paris Salon and immediately purchased by the State for the Musée de Toulouse (it was photographed prior to its transfer there; fig. 10). It bears a signature written by hand with a stylus on the daguerreotype plate: "Gustave Le Gray d'après Gérôme" (Gustave Le Gray after a work by Gérôme). The choice of Le Gray to handle the difficult task of reproducing a large-format canvas on a full-plate daguerreotype and the exceptional technical quality of the results prove that this was no first attempt.

Other portraits date back to that period, and already the models belonged to polite society, as well as to Le Gray's inner circle. There is one of three unidentified young boys—obviously of wealthy origin—in uniform (fig. 11), and a portrait of a girl—known because of an albumen print copy of it in the album of Queen Marie-Amélie (at the château de Chantilly)—which may depict Princess Françoise (fig. 12).[62] Most important are the portraits of Henri Le Secq and his parents (figs. 14, 15), also difficult to date with accuracy because of the long-standing friendship between the two men.

Unfortunately, the very handsome portrait of Le Secq is known only through a heliogravure print (fig. 13). Its composition reflects a particularly studied carelessness and an almost Mannerist sense of gesture. Le Secq poses informally, seated sideways on an armchair, with the smile of a cheerful companion. The props he holds in his hand—a folded note and a top hat, as well as the crumpled handkerchief slipping from his pocket—are used with an understanding of naturalism learned from the beautiful portraits that Delaroche was painting at the time (notably that of the comte de Pourtalès, 1846, Musée du Louvre).

14 Gustave Le Gray. *The Mother of Henri Le Secq*, ca. 1848 (cat. no. 4).

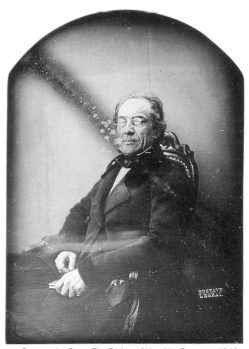

15 Gustave Le Gray. *The Father of Henri Le Secq*, ca. 1848 (cat. no. 3).

13 Gustave Le Gray. *Portrait of Henri Le Secq*, ca. 1848 (cat. no. 2).

Far from being the random attempts of a beginner, these are the relics of a technique that had already been mastered, early works in an oeuvre. These portraits are even already signed with a little two-line stamp, "GUSTAVE/LE GRAY," that are also to be found, either dry or inked, at the bottom of his calotypes of the following years. It remains only to be determined whether these were the pastime of a well-received painter or the paid commissions of a recognized professional.

Although these plates cannot be dated by elements evident in the images, we can assume without much risk that they were made around 1847/48. While it is difficult to provide an accurate time frame, it is clear that from 1848 Le Gray gradually gave himself over to the study of photography on paper and that his production of daguerreotypes could hardly have gone beyond that date. Thus, he changed techniques during the same period as did other contemporary photographers, such as Nègre, who had briefly tried his hand at daguerreotypy in the fall of 1847.[63]

61 See S. Aubenas, "To Unite Science with Art" (this volume).
62 Identification suggested by Hervé Robert.
63 Heilbrun and Néagu, *Charles Nègre photographe*, 21.

64 *Catalogue de la deuxième exposition annuelle des oeuvres des artistes et amateurs français et étrangers* . . . (Paris, 1857), 2, reprinted in *Catalogues des expositions organisées par la Société française de photographie: 1857–1876,* vol. 1 (Paris, 1985).
65 Francis Wey, "Comment le soleil est devenu peintre," *Musée des familles* (July 20, 1853): 292.

66 Cf. I. Jammes, *Blanquart-Évrard et les origines de l'édition photographique française* . . . (Geneva and Paris, 1981); Heilbrun and Néagu, *Charles Nègre photographe;* and A. Jammes and E. P. Janis, *The Art of French Calotype; with a Dictionary of Photographers, 1845–1870* (Princeton, 1983).
67 See Aubenas, "To Unite Science with Art."

First Works on Paper

Le Gray's first mentioned work on paper dates back to 1848. In 1857 the Société française de photographie exhibited, as a historical piece, "a positive from a negative on collodionized paper, taken in 1848, depicting the studio of M. Gérôme" (present location unknown).[64]

In fact, it is plausible that Le Gray was not interested in photography on paper during his Roman sojourn, even though it already existed. The negative-positive process invented in 1840 by Englishman William Henry Fox Talbot had been, in France, in the words of Edmond de Valicourt, "smothered in infancy," in favor of the apparent perfection of the daguerreotype. "Photography on paper was more or less ignored until late 1846. At the beginning of the following year, it suddenly aroused the attention of heliographers and, in the space of a few weeks, the uproar it made was as conspicuous as the previous lack thereof."[65]

Thanks to the improvements made by Guillot-Saguez and especially by Blanquart-Évrard, artistic and scientific circles finally, in 1847, made an impassioned discovery of the paper negative. This made it possible to generate multiple positive proofs, which were much more in keeping with the current needs and aesthetic sensibility than was the existing daguerreotype.[66] Prints on Whatman or Canson paper, with their rich and varied hues and their edges softened by the texture of the negative, could finally be placed in portfolios alongside ink and pencil sketches, watercolors, color washes, stump drawings, tracings, and engravings.

According to Moutrille, Le Gray's invention of the waxed-paper process was guided and supported by Victor Regnault. This chemist, a member of the Académie des sciences, had been Talbot's first defender; Regnault had tested Talbot's process along with Hippolyte Bayard and Calvert Jones in Paris in 1843. A regular user of the calotype technique, starting in 1847, thanks to Blanquart-Évrard's improvements, Regnault was truly an ideal mentor for Le Gray's initial works. Thus, in an album bequeathed by Regnault to the Société française de photographie, we find Le Gray's experimental calotypes along with those of his predecessors, Talbot, Guillot-Saguez, and Blanquart-Évrard (figs. 16, 17). These proofs, which date from about 1849, are the product of the experiments that preceded Le Gray's first technical treatise, which is discussed in greater detail later.[67]

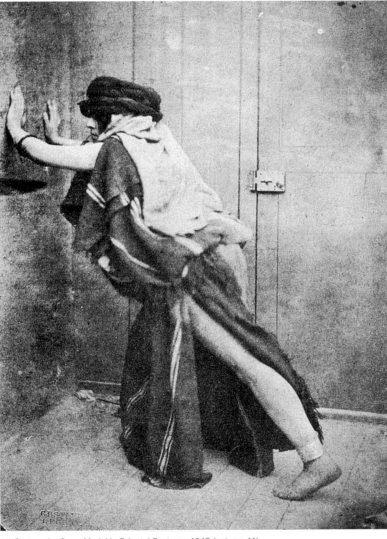

16 Gustave Le Gray. *Model in Oriental Costume,* 1849 (cat. no. 11).

It was also in 1848 that Le Secq made his first calotype portraits, which include a very interesting series of portraits of Le Gray in a wide variety of poses and attires, part artist, part dandy.[68] These recurrent sittings, where technical experimentation seems still to have prevailed over aesthetic endeavor, are a perfect reflection of the closeness between these two men. After his marriage in July, Le Secq settled at 35, quai Bourbon, a short distance from the quai des Grands-Augustins where Le Gray lived. Nègre resided at 49, quai de l'Horloge prior to moving to 21, quai Bourbon the following year (fig. 19). These three addresses, located between the Louvre and the École des beaux-arts, with their northern exposures, provided perfect conditions for artists' studios, and, as neighbors, the three friends were able to work together under the best possible conditions.

Rue de Richelieu: First Students

In 1849 Le Gray moved into a spacious fifth-floor apartment at 110, rue de Richelieu, overlooking the street. Since that same apartment was subsequently leased to the photographer Bruno Braquehais in 1853, it may be assumed that it had adequate light and was no doubt already outfitted as a studio. The excessively high rent—thirteen hundred francs per year—is a measure of the ambitions that Le Gray was beginning to harbor.[69] His new address in an elegant neighborhood at the corner of the Grands Boulevards—a place of transit and promenade, teeming with daguerreotypists' studios—clearly establishes his decision to make a profession of photography, and thus to abandon painting, at least for a while.

Furthermore, while he had moved away from his friends Nègre and Le Secq, he was now closer to Mestral[70]—who had settled nearby at 48, rue Vivienne that year[71]—and, beginning in 1850, lived across the hall from his colleagues Mayer and Pierson.

The most noteworthy event of this sojourn on the rue de Richelieu was the arrival of his first-but-not-least students, Léon de Laborde and Maxime Du Camp (fig. 18). This was the start of an activity that would soon become essential to Le Gray. In the summer of

68 Janis, *Photography of Gustave Le Gray*, 26–27. These portraits, as well as others of Le Secq and Mestral, are conserved in a privately held album that was unfortunately not accessible to the author.
69 Archives of Paris, assessment rolls, D1 P4, box 953; Le Gray, *Traité pratique de photographie sur papier et sur verre* (Paris, 1850), 2.
70 Regarding the relationship between Le Gray and Mestral at that time, see Aubenas, "Barrière de Clichy: A 'University' of Photography" (this volume).
71 Archives of Paris, assessment rolls, D1 P4, box 1224. At that same time, Guillot-Saguez lived at no. 36 on that same street.

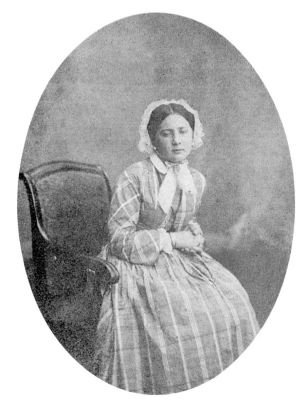

17 Gustave Le Gray. *Portrait of a Young Woman*, 1849 (cat. no. 9).

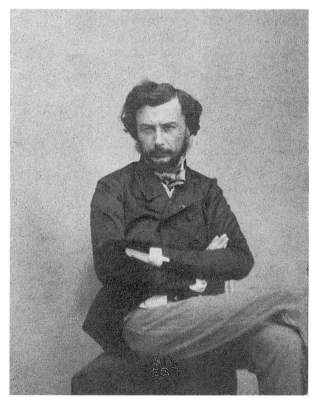

18 Attributed to Gustave Le Gray. *Portrait of Maxime Du Camp*, 1849 (cat. no. 15).

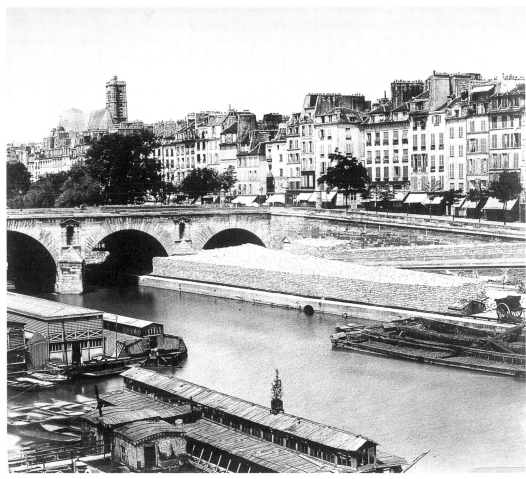

19 Charles Nègre. *The Pont Marie and the Quai des Célestins Seen from the Quai d'Anjou, Paris*, ca. 1855 (cat. no. 238).

1849, even before he wrote any of his manuals or perfected any of the substantial improvements that he was to make to photographic processes, teaching was the sign of the technical mastery of photography on paper for which he was beginning to gain recognition.

June 4, 1849, was the opening of the Paris Exposition des produits de l'industrie (Exhibition of Industrial Products), where Le Gray exhibited some of his prints. Léon de Laborde, a member of the jury and reporter for photography, took notice of him. Whether or not they had previously met, this was an opportunity for the artist to show off not only the quality of the results that he was achieving but, more generally, the scope of his abilities and the services he was prepared to offer. Laborde's report was enthusiastic:

> This young painter has applied himself to the subjects that were part of his earliest studies, to portraits and the reproduction of paintings and works of art. . . . The paintings that he has copied and the objets d'art that he has reproduced are masterpieces of inestimable quality and flattering precision. . . . Endowed with rare intelligence and invaluable perseverance, he felicitously combines all of the qualities that will advance his art [and], better still, he most generously shares his successful methods, thereby acquiring claim to the esteem of the artists and the favor of the jury, which awarded him a bronze medal.[72]

Early on, this nascent photography had aroused the keenest interest of the Laborde family as well as of Laborde's entourage, in particular his relatives the Delessert and the Bocher families.[73] Philippe de Chennevières (fig. 20) specifically mentions the case of Léon de Laborde:

> There was no system for reproducing works of art or the natural appearances of things that did not arouse his curiosity, and from the outset, he was fascinated with photography. Were not he, his nephew, Édouard Delessert, and Édouard's cousin, Benjamin Delessert, among the first pupils of Le Gray—the most adept practitioner of those early times?[74]

So, meeting Le Gray rekindled a former passion for Laborde, and an immediate friendship was struck up between the two men. In August 1849 Le Gray signed portraits of Léon de Laborde and of his niece, Cécile Delessert. Other, unsigned, portraits from the same period depict Laborde's closest relatives: his wife, his children, his sister, Aline Bocher, and her children.[75] The oldest of these portraits, dating from September and October 1849, must be attributed to Laborde himself, others perhaps to Delessert and Bocher. It was the beginning of personal photography, with Le Gray as its driving force.

However, Laborde was not thinking solely of immortalizing his wife and children. In addition to being a curator at the Louvre, an eminent archaeologist and historian of Renaissance art, and a member of the Académie des inscriptions et belles-lettres (French Academy of Inscriptions and Humanities), he had various official, political, and administrative responsibilities. His multifaceted curiosity led him to travel to the Near East, as well as to study the history of engraving and printing. He was at the hub of all the hopes that had, from the start, been placed in photography as an auxiliary to the arts and sciences.

In 1850 Laborde proposed to the minister a futuristic program: a full photographic inventory of all public collections. This program was to begin with the Louvre (ten thousand exposures), which would have cost a mere fifteen thousand francs and represented eighteen months of work.[76] It is blatantly obvious that this report—too visionary not to have been immediately buried by the bureaucracy—had been inspired by his conversations with Le Gray, whose reproductions of works of art had been exhibited the previous year and whose rates corresponded exactly with the indicated budget: "An ordinary print costs 1.00 franc, a good print from 1.50 to 2.00 francs."[77]

In late October of 1849 Le Gray's second student, Du Camp, left France for Egypt[78] in the company of Gustave Flaubert, "after taking several lessons in photography from M. Gustave Le Gray."[79] Du Camp, too, must have heard talk at the exhibition or in the salons about this young artist ready to "share his methods." He probably obtained the address from Laborde himself, who must have regretted the fact that photography had not yet existed when he'd made his own trip to the Near East (1830); Laborde, in his report of September 7, 1849, to the Académie des inscriptions[80] concerning Du Camp's future trip, emphasized the utility of photography:

> The particular nature of photography, its indisputable exactitude and meticulous precision, down to the most incidental details, give value to all that it produces. It would be impossible to determine what is most particularly deserving of copying, since a sheet of paper occupies so little space in a portfolio [and] a process that lasts three seconds is so quickly accomplished, that we would be tempted to recommend that the traveler copy everything he sees.[81]

The support of a man like Laborde, at the center of a powerful network of societal and institutional connections, would allow a young artist like Le Gray, with a family and, until then, an unstable income, to give free rein to his dreams of prosperity.[82] However, this promising interlude ended abruptly with two family tragedies. A few days apart, on September 6 and 10, 1849, the third Le Gray daughter, Julie Octavie, and then the second, Elvire Mathilde,[83] died, no doubt of cholera.[84] It was probably at that time, and in any event before the end of the year, that the couple and their eldest daughter, Eulalie, the only surviving child at the time, fled the neighborhood and went to live on the outskirts of Paris, at 7, chemin de ronde, barrière de Clichy.

This new step would be decisive in the evolution of Le Gray's career as a photographer, an inventor, and a teacher of photography. It was within this framework that he set up his life for his remaining ten years in Paris.

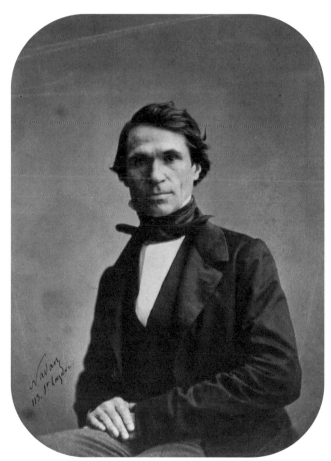

20 Félix Nadar, *Portrait of Philippe de Chennevières*, ca. 1855–1859.

72 Jury report, published in *La Lumière* (March 2, 1851): 14.
73 Regarding these family ties, see X. Darcos, *Prosper Mérimée* (Paris, 1998), and C. Bocher, *Mémoires de Charles Bocher (1816–1907), précédés des Souvenirs de famille (1760–1816)*, 2 vols. (Paris, 1907).
74 P. de Chennevières, *Souvenirs d'un directeur des Beaux-Arts* (Paris, 1888).
75 Private collection.
76 Chronicles of Alexandre de Laborde, private collection.
77 Séance de la Société héliographique, *La Lumière* (March 21, 1851).
78 Passport of Maxime Du Camp, issued in Paris, October 24, 1849, Institut de France, Library, MS 3720, vol. 1, file 1.
79 *La Lumière* (August 28, 1852): 144.
80 Jomard, Reinaud, de Saulcy, and Laborde (judge), "Rapport de la commission nommée par l'Académie des inscriptions pour rédiger les instructions du voyage de M. Maxime Du Camp," Institut de France, Library, MS 3720, vol. 1, file 1, fols. 19–23.
81 Ibid.
82 It is not known if the rue de Richelieu move preceded or followed the meeting with Laborde.
83 Reconstructed vital statistics, Archives of Paris. This is the only existing reference to Julie Octavie, which contains no date of birth or lineage, but everything points to the fact that she was indeed the daughter of Gustave Le Gray and his third, since the first two were separated by only fourteen months.
84 This very epidemic drove Jean-François Millet from Paris; he was taken in at the Ganne de Barbizon Inn by Célestin Nanteuil and Louis Boulanger.

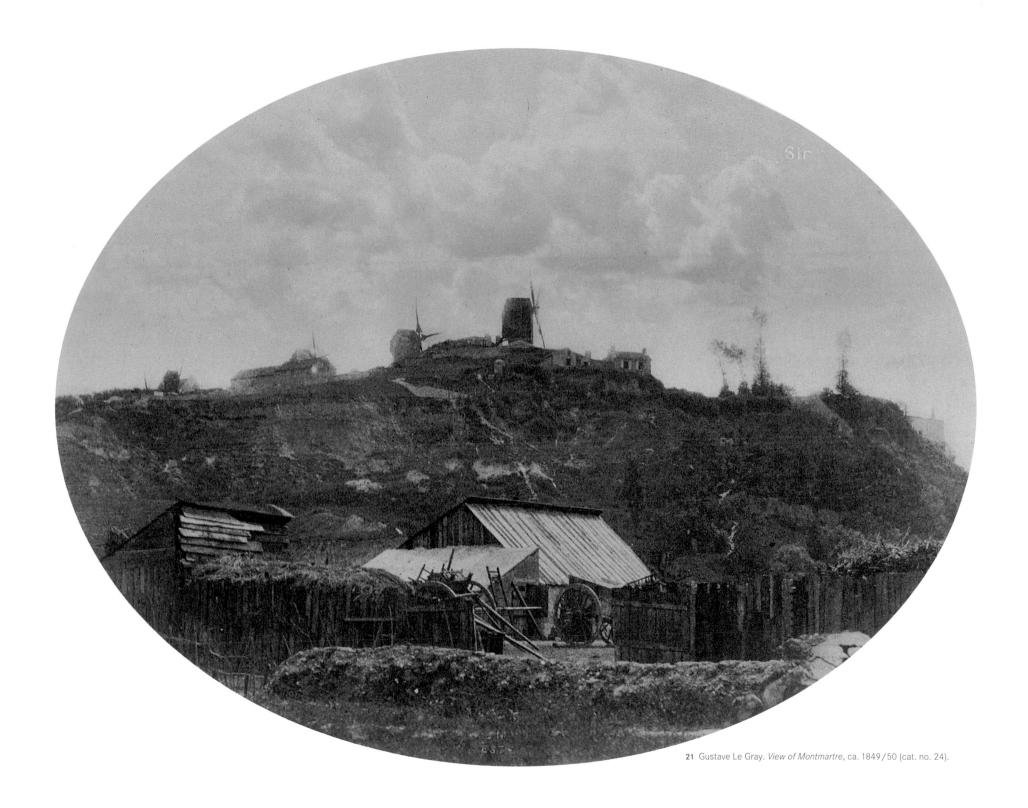

21 Gustave Le Gray. *View of Montmartre*, ca. 1849/50 (cat. no. 24).

Barrière de Clichy: A "University" of Photography

Sylvie Aubenas

We would no longer recognize the place to which Le Gray moved in the fall of 1849, but it has been preserved for us in various shots taken by the photographer himself and by his students. The house at 7, chemin de ronde, barrière de Clichy, was located in the first arrondissement of Paris (now the seventeenth), at the site where the boulevard des Batignolles now opens onto the place de Clichy. Across the road stood the old Paris city wall, from which—a few dozen steps away—one could exit through the customs house, built by the architect Ledoux and demolished in 1860. "Far from the center of the modern Babylon,"[1] adjacent to the former Tivoli estate and facing the Montmartre windmills, he could enjoy some fresh air and open space, without being too far from his clientele, since it was just a few minutes on foot to the grand boulevards.[2]

The house was a roomy and bright building (fig. 22), freestanding on all sides, outfitted from the beginning as artists' studios. The front faced north, toward the city wall, and its first and second floors were lined with immense windows. The roof was flat, which may have allowed Le Gray to make use of a portion of it, since the abundant light was ideal for making contact prints. The rear was occupied by apartments. The general appearance of this plain but well-kept building, with its unpretentious bas-reliefs and its wooden doors with diagonal crossbars, suggests that it dated from about 1820.[3]

A succession of artists—mostly painters, it seems—lived at this site, sometimes crossing paths. Alexandre Guillemin (1817–1880), a student of Gros, lived there in December 1842.[4] Marcel Verdier (1817–1856), a student of Ingres, resided there at least from 1848 through 1854.[5] Joseph Fernand Boissard de Boisdenier, a friend of Baudelaire's and of Théophile Gautier's, moved there in April 1849 and remained there until 1852.[6] Auguste Legras lived there at least between April 1855 and 1860.[7] In addition, a sculptor, Aimé Millet, apparently also had his studio there in 1851.[8]

It was not just a new address. It was also the place where Le Gray would reorder his life based on a new direction for his career as an artist—that of photographer and researcher. On these spacious premises, removed from the center of Paris, with its miasmas and riots, he was simultaneously able to house his family, pursue his experiments, teach, and make prints for other photographers. He would not leave these premises until his departure from France, even when he opened his luxurious studio on the boulevard des Capucines in the spring of 1856. On the contrary, he maintained his home there, and his family continued to live there. His first business card at the boulevard des Capucines location bore the following note: "Photographic printing house and chemistry laboratory, 7, chemin de ronde, barrière de Clichy" and other, even later, documents mention that address.[9]

The Teacher

As Maufras says, "Le Gray, ceding to numerous requests, opened his laboratory to the public and admitted students into his studio."[10] What these students, first and foremost, were seeking was technical

1 L. Maufras, "Étude biographique," *Le Monte-Cristo* (January 5, 1860): 594–98 (translated in the appendix to this volume).
2 For more on this neighborhood, see F. Lazare and L. Lazare, *Dictionnaire administratif et historique des rues et monuments de Paris* (1855; reprint, Paris, 1994). The wall and its inner and outer walkways were absorbed in 1864 by the construction of the boulevard des Batignolles.
3 It was not possible to determine when it was built. The house was demolished around 1865/70 to make room for no. 7, boulevard des Batignolles, which was in turn demolished and then rebuilt. The parcel where the house stood had already appeared, as such, in Jacoubet's map (1826–37), as well as in the contemporary survey by Vasserot (National Archives, F31 45, fol. 241). In Le Gray's day, the building was owned by Achille Naquet. Thanks are extended to Michel Fleury, Roxane Debuisson, the Archives of Paris, and M. Sol and M. Picarle from the Service technique de la documentation foncière of the City of Paris for their assistance.
4 Département des Manuscrits (MSS), Bibliothèque nationale de France (BNF), NAF 24379, fol. 176–77: received December 29, 1842. Guyot de Fère, in his *Annuaire biographique des artistes français, peintres, sculpteurs . . .* (Paris, 1842), containing the addresses of all the major artists in Paris, does not give this address for any artist.
5 National Museum Archives, Louvre, *KK 19, summaries of works exhibited at the Salon of 1848 and artist files. In a letter from 1854, he was still residing on the chemin de ronde; the following year he was at 26, rue de Fleurus. Regarding Verdier, see *Les Élèves d'Ingres*, exh. cat. (Paris, 2000), 200–201.
6 C. Baudelaire, *Œuvres complètes*, ed. Claude Pichois, vol. 2, *Répertoire des artistes*, (Paris, 1976), 1571; National Museum Archives, Louvre, *KK 20, summaries of works exhibited at the Salon of 1849; G. Lacambre, "Tableaux religieux de Boissard de Boisdenier," *Revue de l'art*, no. 27 (1975): 52–58.
7 National Museum Archives, Louvre, *LL 4, registers of student-artist cards, leaves of absence; National Archives, F21 521 B; T. Reff, *The Notebooks of Edgar Degas: A Catalogue of the Thirty-Eight Notebooks in the Bibliothèque nationale and Other Collections* (Oxford, 1976), notebook 16 (Degas noted this address ca. 1860). Previously, I had erroneously assumed *Legras* was a misspelling of *Le Gray*, still unaware that the house had been inhabited by many artists.
8 Letter from Maxime Du Camp to Lovenjoul, August 31, 1892: "In late 1851, returning from a voyage, I found him [Le Gray] living on the boulevard des Batignolles in a big house where, if I am not mistaken, the sculptor Millet had his studio." Institut de France, Library, Lovenjoul correspondence, G 1169, case 16.
9 Particularly, the articles of incorporation of the limited partnership Le Gray et Cie, recorded in Paris on August 28, 1857. Archives of Paris, D31 U3, box 204, and D32 U3, register 36, excerpt 2174. Almanach Bottin, 1851–59.
10 Maufras, "Étude biographique."

22 Gustave Le Gray or his circle. *The Studio at the Barrière de Clichy*, ca. 1851–1854 (cat. no. 29).

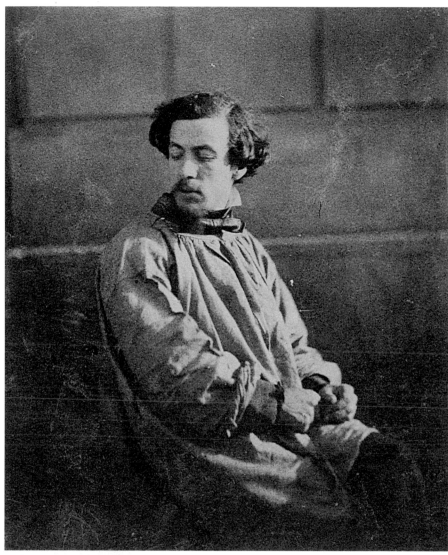

23 Gustave Le Gray(?). Self-portrait(?) of Le Gray in front of his studio, ca. 1851–1854.

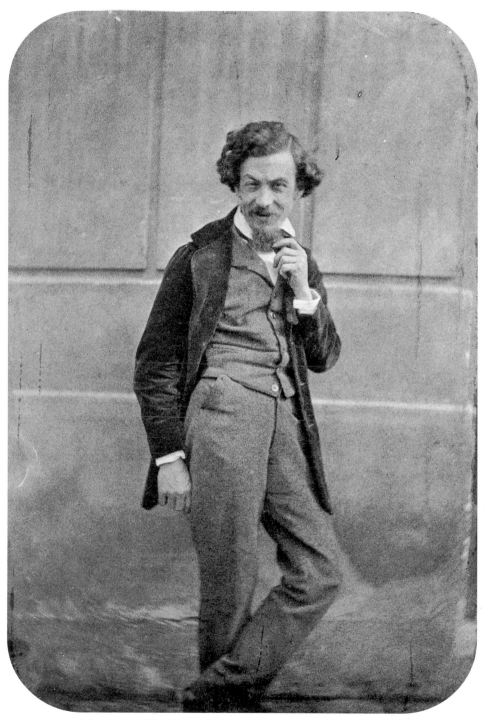

24 Gustave Le Gray(?). Self-portrait(?) of Le Gray in front of his studio, ca. 1851–1854.

25 Olympe Aguado. *Standing Self-Portrait with His Brother Onésipe*, 1853 (cat. no. 227).

knowledge from a practitioner who could teach them more than they could learn from the many brochures illustrating the latest processes, where nonchemists were often out of their depth. Le Gray not only gave them his own formulas but showed them the essentials, the tricks of the trade. However, the beauty of the results that he achieved must have been, more than anything else, what attracted those who harbored artistic ambitions in photography. The simple dissemination of the waxed-paper-negative and collodion processes could have been accomplished through a variety of channels; from the point of view of posterity, above all, the "university" of the barrière de Clichy taught high aesthetic standards and the uncompromising adaptation of an infinite variety of technical resources for the purpose of fundamental artistic creativity.

It is known that Laborde and Du Camp began studying with Le Gray in the summer of 1849, at the rue de Richelieu. The long list of Le Gray's students undoubtedly derived from encounters and conversations that took place that summer. It is impossible to provide here an individual account of each of them and how they came to be there, but Laborde and Du Camp were indeed the precursors and, perhaps, the initiators of a veritable craze.

The time was right. In the late spring of 1851 Le Gray was selected by the commission des Monuments historiques (the Historic Monuments Commission), to participate in the Mission héliographique (a photographic expedition), which would further enhance his reputation. More generally, that year was the culmination of a renewed interest in photography, especially on paper. It witnessed the birth of the Société héliographique (the Heliographic Society) and the magazine *La Lumière*, which contributed to propagating and bringing together the most diverse of neophytes. Among the members of the society—in addition to Le Gray, Henri Le Secq, Mestral, and Emmanuel Peccarère—were scholars such as Edmond Becquerel and Léon de Laborde; writers such as Champfleury; artists such as Eugène Delacroix, Jules Ziegler, and Désiré Albert Barre (a fellow student of Le Gray's at Delaroche's studio); worldly men such as Aguado, the comte d'Haussonville, and the vicomte Vigier; and senior officials such as Eugène Durieu and Frédéric Bourgeois de Mercey. Several of them began to find their way to the barrière de Clichy during this same period.

Who sought out whom? Whatever the case, after those first students at the rue de Richelieu, an ever larger number of novices

steadily arrived at Le Gray's studio. The first edition of his manual (June 1850), which began with the proclamation, "The entire future of photography is on paper,"[11] ended with an advertisement:

I implement these processes daily at my large photography studio at 7, chemin de ronde, barrière de Clichy; I therefore urge those persons who might be impeded by some difficulty to visit me there. It will be my pleasure to furnish them with the information they may be lacking, and to show them my collection of prints made using these processes.[12]

This invitation, which, in this initial wording, seems to offer readers a new service, would be repeated, word for word, in subsequent editions but supplemented in the edition of 1851 as follows: "and executed both by myself and by the students whom I have

11 G. Le Gray, *Traité pratique de photographie sur papier et sur verre* (Paris, 1850), 1.
12 Ibid., 41–42.

26 Gustave Le Gray and/or Odet de Montault. *Portrait of Odet de Montault*, ca. 1854 (cat. no. 30b).

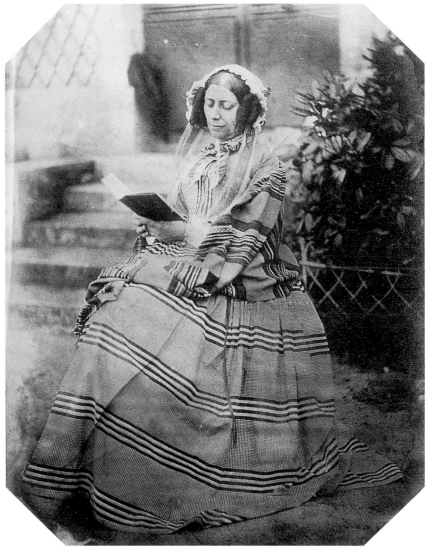

27 Odet de Montault. *Portrait of the Vicomtesse de Montbreton*, ca. 1854.

13 Le Gray, *Nouveau traité théorique et pratique de photographie sur papier et sur verre . . .* (Paris, 1851), 85.
14 Le Gray, *Photographie: Nouveau traité théorique et pratique . . .* (Paris, 1854), 141.
15 Maufras, "Étude biographique."
16 Member of the administrative committee of the Société française de photographie in 1854, cited in Le Gray, *Photographie: Nouveau traité* (1854), 29.
17 In 1857, at the second exhibition of the Société française de photographie, he exhibited a "series of prints from the early days of the daguerreotype and from the Talbot process."
18 Member of the Société française de photographie.
19 Nègre noted, in late 1853, having met him at Le Gray's studio, Notebook 6 of Charles Nègre, private collection.
20 Promissory note to Le Gray, signed Félix Tournachon, for payment of his brother's lessons, December 18, 1853, *Revendication de la propriété exclusive du pseudonyme Nadar*, 5, printed document, EST, BNF. Département des Estampes et de la Photographie.
21 *Le Photographe*, no. 1 (November 19, 1857): 1.
22 He participated in certifying the absence of Mme Le Gray on April 27, 1882: "M. Alexandre Janneau, person of independent means, residing in Paris, Passy, at 60 rue de Passy," Archives of Paris, D3 U1, packet 489.
23 P. de Chennevières, *Souvenirs d'un directeur des Beaux-Arts* (Paris, 1888), 46.

trained."[13] In the final edition, published in 1854, "the students" became "the numerous students."[14]

These students were distinguished not only by their number, but also by birth, wealth, or, especially, talent (and sometimes all three). Many of them were destined to become illustrious names in the annals of photography. The atmosphere of this social and artistic crucible is more suggestive of a studio at the Beaux-Arts than a salon.

This advanced school, which was one of the most frequented in Paris, shone with a brilliance that is still remembered.

The most aristocratic hands from the capital and from abroad came, without compunction, to dirty themselves there with silver nitrate. . . . Scientists and artists came there in droves as well. . . . The old students made the *new* ones undergo what is known in all schools

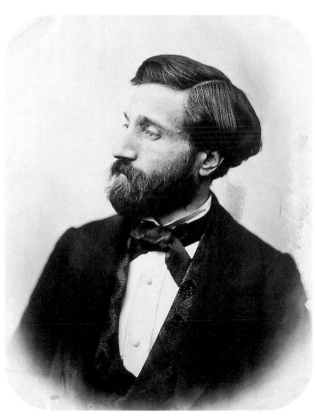

28 Alexandre Janneau. *Self-Portrait*, ca. 1858.

of this kind as *pranks*. Sometimes a beginner tried to reproduce a piece of furniture or a painting, and renewed his efforts ten times in succession without obtaining anything; in the end, like the monkey in the fable, he noticed that he had forgotten to light his lantern—in other words, that he had neglected to add a lens to his camera. Sometimes another was made to wash his hands in a silver nitrate solution, which gave them an unattractive black tone that revealed itself to the aston-ished eyes of the victim only the next day. These jokes, harmless for the most part, were often carried out under the very nose of the mas-ter, who was so absorbed in his experiments that he almost always failed to notice.[15]

So, among the first arrivals—as attested either by contemporary documents (notably that by Maufras) or by surviving works—were Le Secq, Nègre, Mestral, Édouard Bocher (the brother-in-law of Léon de Laborde), Firmin Eugène Le Dien (a friend of Charles Bocher's, the brother of Édouard), Eugène Piot, Victor Place, Olympe Aguado (fig. 25), Édouard and Benjamin Delessert, the marquis de Béranger, the vicomte Vigier, John B. Greene, Félix Avril, Peccarère, the comte d'Haussonville, Sauveur, Girard, and solicitor emeritus Jules Clément,[16] followed by Boissard de Boisdenier.[17]

Then, in an order that is somewhat difficult to determine, came the vicomte Odet de Montault[18] and his mother-in-law the vicomtesse de Montbreton (figs. 26–27 and 29), Tranchant, Léon Méhédin, the lithographer Adolphe Bilordeaux, the painter Lodoïsch Crette Romet, the mysterious Englishman W. H. G., a Rothschild, La Beaume, the duc de Montesquiou, the comte Branitski,[19] the comtesse d'Essertein, Mlle Dosne, Badeigts de Laborde, Dumas de Lavince, Félix Nadar, his brother Adrien Tournachon,[20] Mayall, Gueybbard, Mugnier, Courtais, Delatre, Henri de La Blanchère, Édouard de Latreille,[21] Léon Delaporte, Eugène Colliau, and Alexandre Janneau (fig. 28).[22]

The regulars might run into acquaintances who had come to have their portraits made. Philippe de Chennevières, Le Gray's patron for the exhibitions of 1851–1853, wrote, "I remember having seen Benjamin Delessert printing negatives in Le Gray's studio, on the boulevard [*sic*] de Clichy, in 1852, on a day when we went there to pose as a group of friends, Jules Buisson, Gustave Le Vavasseur, Anatole de Boulet, and myself."[23] In fact, a series of three varia-tions of this deliberately informal group portrait still exists. Taken outdoors in front of the studio door—sitting, leaning on their

29 Gustave Le Gray and/or Odet de Montault. *View from the Studio*, ca. 1854 (cat. no. 30a).

elbows, side by side, smiling, and relaxed—these writers, united by their Norman lineage and their years of private schooling, provide a striking example of Le Gray's abilities as a portraitist—a far cry, indeed, from the more formal portraits of his later commercial period on the boulevard des Capucines (figs. 30, 32).

Numerous portraits, taken in the same courtyard in front of the studio, depict the students themselves or friends who dropped by. They evoke both the great effervescence and the amiable freedom that reigned there for several years. In these portraits, we see Eugène Piot leaning on his camera (fig. 33); the vicomte Odet de Montault, a cigar in his mouth, resting casually against the frame of the big studio door (fig. 26); the painter Léon Delaporte looking like the wan dandy (fig. 37); the delegate from Calvados, Félix Avril, surly and ill at ease (fig. 35); and even a road worker

24 *Revendication,* g.

(fig. 36), since the street was being repaved at the time. Finally, Le Gray himself appears in a chemical-stained smock, sitting, eyes closed, in the sun or, in another image, aiming a Mephistophelean smile at a student's lens (figs. 23, 24).

The master was well paid for his courses, although he did give some individuals a "discount price." Nadar, before falling out with his brother Adrien, arranged for him to take photography lessons in 1853 from that "illustrious man, among the most distinguished, since the invention of photography, M. Gustave Le Gray."[24] During the later legal battle between the Tournachon brothers, the elder specified the costs by producing the following note:

In response to your request for information, my dear Nadar, regarding the photography lessons that you had me give your young brother and regarding the amount of my honoraria, I must say that, out of esteem

 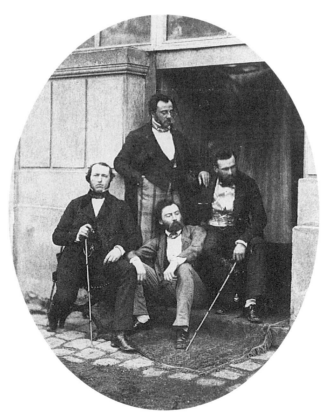 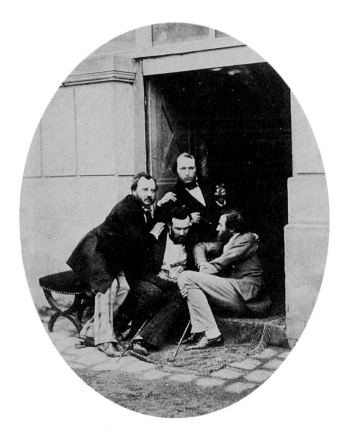

30–32 Gustave Le Gray. Three group portraits: Philippe de Chennevières, Jules Buisson, Gustave le Vavasseur, and Anatole de Boulet, 1852 (cat. no. 19).

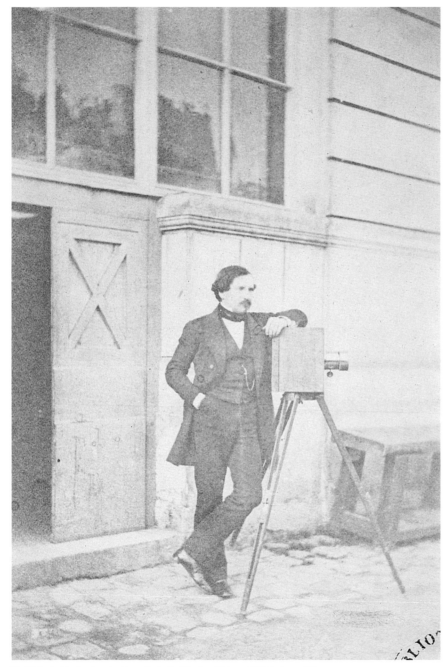

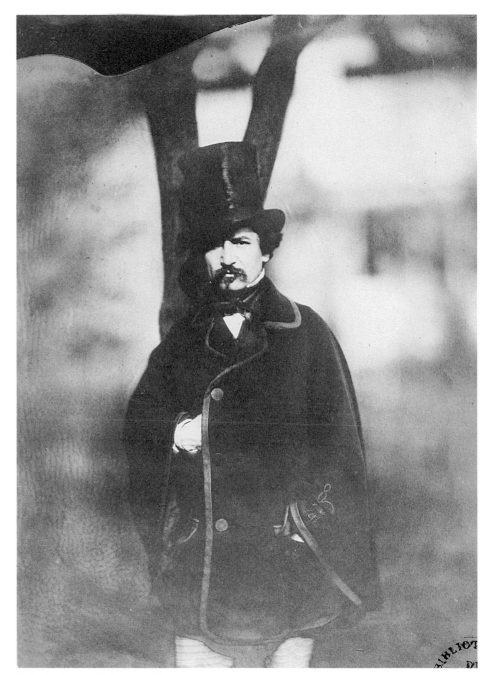

33 Attributed to Gustave Le Gray. *Portrait of Eugène Piot*, ca. 1851 (cat. no. 18).

34 Eugène Piot. *Self-Portrait*, ca. 1851.

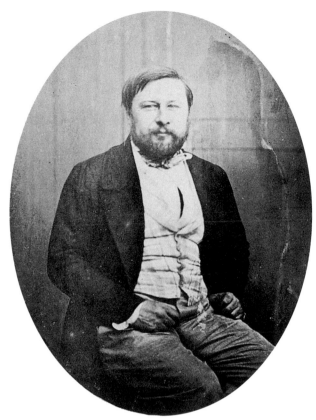

35 Gustave Le Gray. *Portrait of Félix Avril*, 1849 (cat. no. 8).

36 Gustave Le Gray. *Portrait of a Road Mender*, ca. 1851–1854.

37 Gustave Le Gray. *Portrait of Léon Delaporte*, ca. 1851–1854.

25 Ibid.

for you, I had him pay only 200 francs, instead of the 400 that I charge my other students, etc. etc. GUSTAVE LE GRAY.[25]

It is clear that only wealthy amateurs, or future professional photographers willing to make such a sizable investment, frequented the studio.

While only some fifty students have been documented by name, there must have been others. Teaching was probably the photographer's primary source of income for several years, at a time when many wanted to become involved in photography on paper and when studios equipped to train professionals, such as that of Bertsch and Arnaud, for example, were a rarity. The host of artists that Le Gray initiated would provide a decisive contribution to the vigorous expansion of the profession in Paris between 1852 and 1855.

The Author of Manuals

Through his teaching activity, his share in the discussions of the Société héliographique reported by *La Lumière,* and the filing of sealed envelopes with the Académie des sciences in 1851, Le Gray was also at the center of the technical discussions that fascinated scientists and amateurs. During that same period, from the spring of 1850 through 1854—between the founding of the Société héliographique and the founding of the Société française de photographie—he published, in quick succession, four technical treatises, documents essential to the history of photographic processes. These make it possible to track the development of Le Gray's work, particularly his two major inventions, the waxed-paper negative and the collodion-on-glass negative. The 43-page brochure of June 1850 became, by May 1854, a 387-page treatise, and

38 Gustave Le Gray or his circle. *View from the Studio Roof*, ca. 1851–1854 (cat. no. 26).

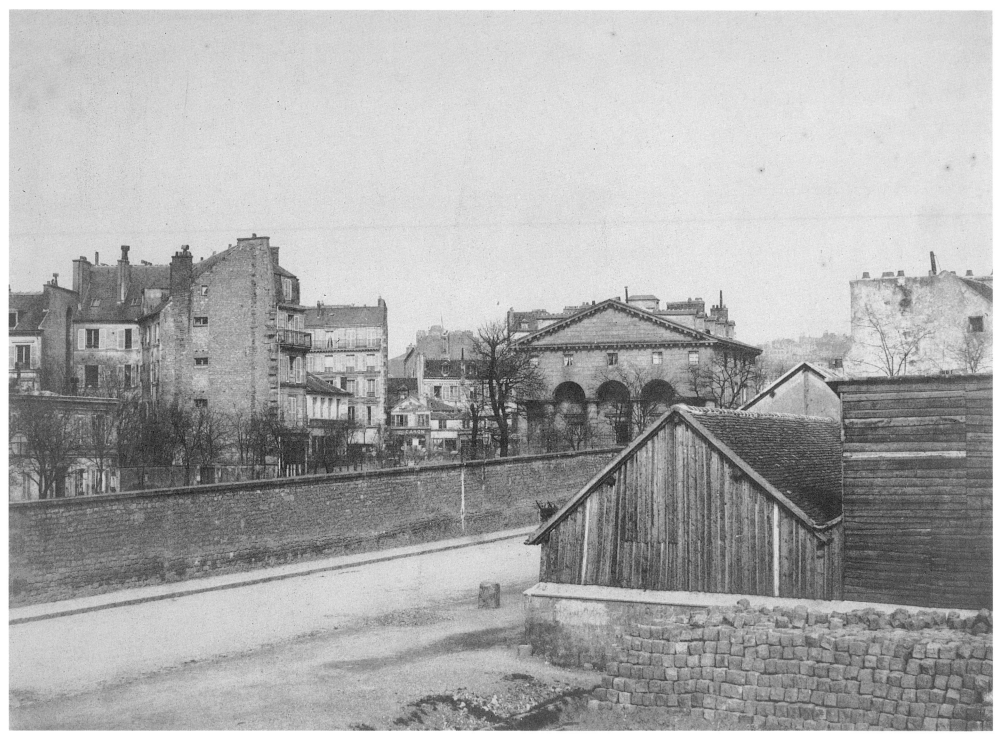

39 Gustave Le Gray or his circle. *View from the First Floor of the Studio*, ca. 1851–1854 (cat. no. 28).

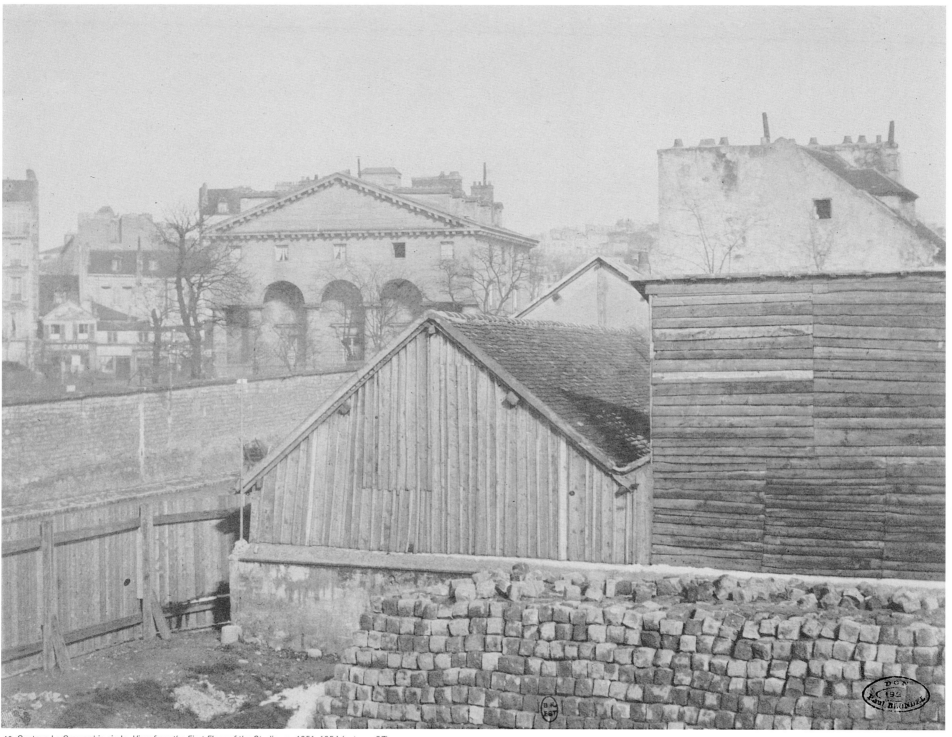

40 Gustave Le Gray or his circle. *View from the First Floor of the Studio*, ca. 1851–1854 (cat. no. 27).

English translations soon followed in England and the United States.[26]

Among the various aspects of photographic chemistry in these publications, Le Gray provided a detailed study of the printing of positive proofs and the variety of hues that can be imparted to them (these technical aspects are examined at greater length later).[27] Furthermore, the treatises contain Le Gray's sole remarks about the relationship between photography and art, apart from a few statements in *La Lumière*. In the 1850 edition, a short foreword indicates, somewhat vaguely, his intentions:

> The broad application, of which I have been capable for several years, of photographic processes as a method of scrupulously reproducing nature in all its aspects: landscapes, monuments, portraits, and reproductions of paintings and drawings, has made it clear to me their immense importance to art, and the need for an unfailingly reliable method to facilitate their use by both artist and amateur.[28]

In subsequent editions, he more explicitly asserts the ambition that he cherished for photography:

> Its influence on painting will be immense in scope; at the same time that it clarifies for the painter problems in his art, it refines the taste of the public by habituating it to seeing nature reproduced with complete fidelity, and often with effects of exquisite taste and feeling.[29]

From these statements emerges a compelling concept of the medium, whose artistic nature is implicit:

> It is my deepest wish that photography, instead of falling within the domain of industry, of commerce, will be included among the arts. That is its sole, true place, and it is in that direction that I shall always endeavor to guide it. It is up to the men devoted to its advancement to set this idea firmly in their minds.[30]

Le Gray's thoughts on the future of photography, his clear-sightedness as to the artistic potential of the medium, his insistence on the subordination of technique to effect thereafter placed him

26 For publication information on all the French and English editions produced during this period, see "Published Sources" (this volume).
27 See S. Aubenas, "To Unite Science with Art" (this volume).
28 Le Gray, *Traité pratique*, 1.
29 Le Gray, *Photographie: Nouveau traité théorique et pratique . . .* (Paris, [1852]), 1–3.
30 Ibid., 70–71.

41 Gustave Le Gray. *Landscape with Rocks, Fontainebleau*, 1849 (cat. no. 13).

42 Gustave Le Gray. *Landscape with Rocks, Fontainebleau*, 1849 (cat. no. 12).

in a doubly awkward position—with respect to the commercial photographers of his time who, caught up in the "industrial folly," pursued immediate profits through mass production,[31] but also with respect to the theoreticians who saw photography as a servant of science, a servant whose future lay in its simplicity, its accuracy, and its objectivity. To them, the artist was an intruder in the field, and they reproached him—sometimes brutally—for the amateurism of his chemical prescriptions, which could not, they said, be carried out successfully based on the directions that he published.[32] Though a scientist in the eyes of the artists, Le Gray seemed too much the artist, in a pejorative sense, in the eyes of the proponents of pure science.

Nevertheless, he shaped the ideas shared by the wealthy and cultivated amateurs who frequented his studio. The beauty and richness of French production in those years, rightly summed up by André Jammes and Eugenia Parry Janis in *The Art of French Calotype*,[33] are not the fruits of a fortuitous coincidence or a sensibility that was "in the air." It is truly the work of a school of artists whose formal requisites and technical mastery were grounded in the convictions and the know-how developed and passed on by Gustave Le Gray.

The Fontainebleau Excursionists

Simultaneously with his experiments and his teaching, Le Gray pursued his personal work. There, too, he behaved like a painter and differentiated himself from the commercial photographers of the boulevards. He took portraits, as we will see, but, most of all, made views of the forest of Fontainebleau, which he regularly crisscrossed starting in 1849.

Years later, in 1860, Dumas mentioned Le Gray's interest in botany,[34] and we are tempted to draw a parallel with his love for the forest. For the 1850 exhibition, he submitted photographs (in vain, since they were rejected by the jury), including *View of Bas-Bréau, Main Road from Chailly to Fontainebleau*, and *The Chateau at Fontainebleau with Reflecting Pool*, as well as reproductions of two

31 This is the topic of E. A. McCauley, *Industrial Madness: Commercial Photography in Paris, 1848–1871* (New Haven and London, 1994).
32 E. P. Janis, *The Photography of Gustave Le Gray*, exh. cat. (Chicago and London, 1987), called attention to these controversies.
33 A. Jammes and E. P. Janis, *The Art of French Calotype, with a Critical Dictionary of Photographers, 1845–1870* (Princeton, 1983).
34 See C. Schopp, "The Unfinished Odyssey" (this volume).

43 Attributed to Gustave Le Gray. *Boulders with Man Seen from the Back, Fontainebleau*, 1849 (cat. no. 14).

44 John B. Greene, *View of the Forest of Fontainebleau*, 1852 (modern print from original negative).

45 John B. Greene, *Trees near the Road to Chailly, Forest of Fontainebleau*, 1852 (cat. no. 232).

46 Gustave Le Gray. *Trees along the Road to Chailly*, 1852 (cat. no. 65).

35 Just one was signed by Le Gray, but the three others are very similar in style. The registry of the Ganne Inn in Barbizon records the stay of Charles Nègre in October 1849, but neither Le Gray nor Le Secq was ever registered.

36 But the person is too distant to identify. Collection of Marie-Thérèse and André Jammes. Le Gray's presence in Fontainebleau with Greene is also indicated by a negative by Greene that is very similar to a

Le Gray photograph from the same period.
37 *L'Âge d'or de la photographie française,* sale cat. (Paris, Drouot-Richelieu, June 1, 1990), nos. 47 and 48.

paintings of Fontainebleau by his comrades from Delaroche's studio, Pierre-Antoine Labouchère and Jean-Léon Gérôme.

Le Gray must often have been accompanied on these excursions. Four small and fairly primitive views in the archives of Nègre and of Le Secq are the possible evidence of joint photographic expeditions with Le Gray (figs. 41, 43).[35] While, on principle, Le Gray excluded all human presence from his landscapes, Eugenia Parry Janis has discerned, in the depths of some undergrowth, an unobtrusive camera on its tripod (fig. 55). This could be interpreted as a signature, a metonymic cameo appearance by Le Gray as subject, photographing in the forest. But from a practical point of view, an appreciation of symbolism is scarcely sufficient to have convinced an excursionist to burden himself with two cameras. On the contrary, this is undeniable evidence of the simultaneous presence of at least one other photographer—which must redirect the interpretation of the symbol in the picture, referring us back to the friend, an artistic partnership. A parallel is clear in a paper negative by one of his students, the young American John B. Greene. In this case, there are two white tents set up side by side, at the edge of a path, and the friend himself is visible in the distance (fig. 44).[36] Another probable example of joint expeditions is two views, dated 1853, of the forest of Fontainebleau by another student, Alexandre Janneau, in a style that is extremely close to Le Gray's.[37]

The pictures from this period, all made from waxed-paper negatives, show rapid gains in assurance. A comparison between his initial shots—a rare testimony to his apprenticeship in photography (fig. 49)—and the dazzling virtuosity achieved only a short time later in larger-format works, shows how he came to the fore as the leading calotypist.

Other photographers of the same period made images of places, trees, and rocks famed for their picturesque charm, plunging into the depths of the woods like Eugène Cuvelier, or enlivening their views with strollers among the trees like Marville. Le Gray, however, surveyed the pathways to select his viewpoints based on his own criteria, which combined his personal perceptions of the places, his knowledge of motifs chosen by painters, and his idea about the manner in which photography, with its small format and limited tonalities, can convey the feeling of nature.

Admittedly, photographic technology had its limits, which prevented it from tackling certain themes popularized by engravers working from paintings by Diaz de la Peña and others: foxes at bay

47 A. Mouilleron. *Lying in Wait*, lithograph after a painting by Narcisse Diaz, 1856.

48 Gustave Le Gray. *Study of a Tree Trunk*, ca. 1855–1857 (cat. no. 94).

49 Gustave Le Gray. *Fontainebleau Landscape*, ca. 1852.

50 Achille Devéria. *Study of Rocks at Fontainebleau*, graphite drawing, ca. 1840.

38 Le Gray, *Photographie: Nouveau traité* (1852), 1–2.

or hunting dogs on the run. Le Gray was not interested in scenes of peasant life in the manner of Millet, nor in reflections on ponds, nor in the spectacular rock formations at Macherin or Franchard. It was, above all, trees that drew his attention: individually, in groves (figs. 53, 55), bordering sunken lanes, or accentuating the dust-whitened vanishing trace of the cobbled road to Chailly. From these, he printed studies where the architecture of the image and the play of light are vital ingredients.

The extraordinary accuracy of the waxed-paper negative made it possible to render the details of the foliage while preserving a hint of blur, a softness that allows the eye to absorb the image in its entirety without becoming tired or distracted by excessive detail. The calotype responds wonderfully to that "theory of sacrifice" that Le Gray (and Delacroix and Nadar, as well) felt must be extended from painting to photography to avoid too harsh a reality: "From my point of view, the artistic beauty of a photographic print, on the contrary, nearly always lies in sacrificing certain details so as to produce an impression that sometimes achieves the most sublime art."[38]

It was on these studies, strongly anchored in the pictorial trends of the time, particularly in those of the Barbizon school, that his reputation as a landscape photographer was built, destined to reach its apogee with his seascapes.

An Underrated Portraitist

We note—and are even astonished—that the smallest share of Le Gray's income at this time stemmed from the very thing that constituted the entire business of most of his colleagues: portraiture. Practiced by the boulevard daguerreotypists in the 1840s and then, starting in the mid-1850s with the purveyors of the *carte-de-visite* portrait, the commercial "calling card" portrait, which only an inspired few such as Nadar, Carjat, Crémière, and Adam-Salomon could rescue from banality. The carte-de-visite certainly represented everything with which Le Gray did not wish to compromise himself, everything that was detrimental to the new art he defended.

It has been said—and Le Gray's contemporaries were the first to do so, albeit somewhat more subtly—that portraiture was the Achilles' heel of his art. This judgment is justified primarily by the mediocrity of the mass production from his studio between 1856 and 1859. However, other prints (heretofore often misattributed) force us to revise this and to conclude that Le Gray wasn't much

51 Gustave Le Gray. *Boulder at Cabat, l'Épine Crossroads*, 1852 (cat. no. 77).

52 Gustave Le Gray. *The Road to Mont-Girard*, 1852 (cat. no. 75).

53 Gustave Le Gray. *Trees along the Road to Chailly*, 1852 (cat. no. 64).

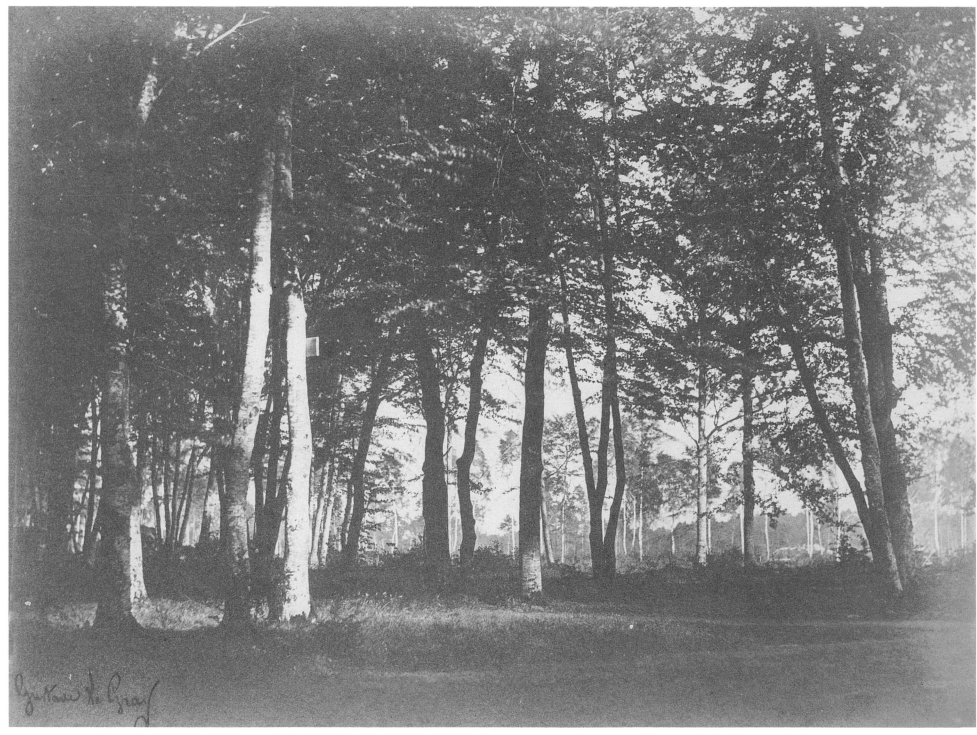

54 Gustave Le Gray. *Curtain of Trees, Fontainebleau*, 1852 (cat. no. 78).

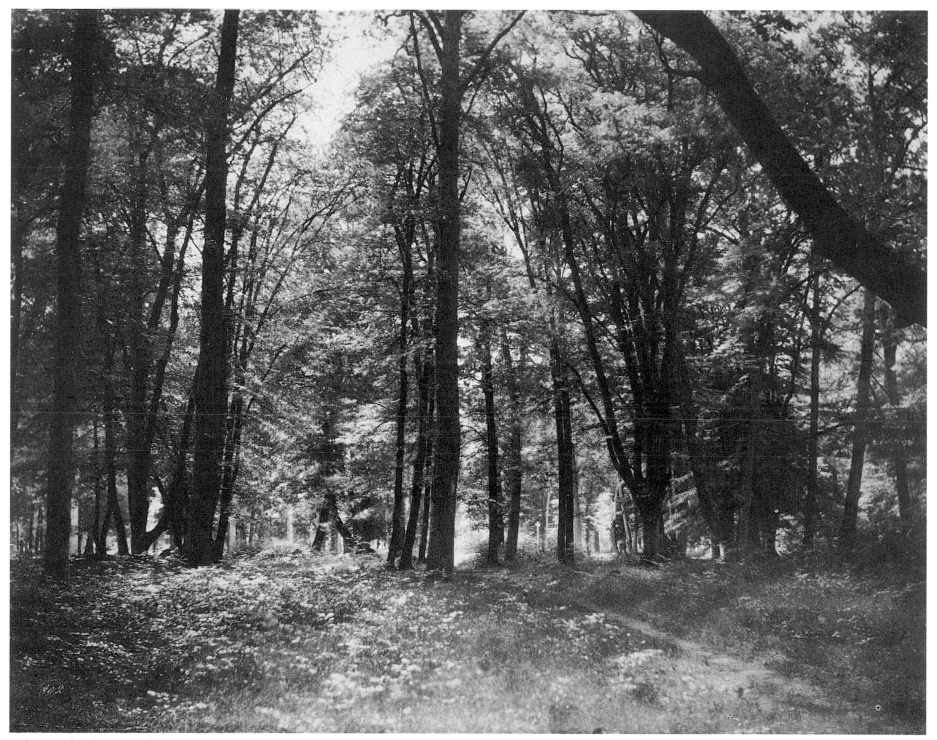

55 Gustave Le Gray. *Forest Scene, Fontainebleau*, 1852 (cat. no. 66).

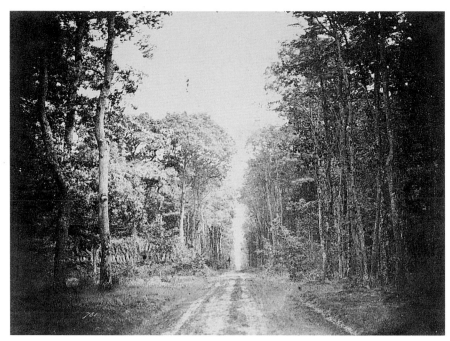

56 Gustave Le Gray. *Forest Road, Fontainebleau*, 1852.

57 Gustave Le Gray. *View of the Forest, Fontainebleau*, 1852.

interested in portraits, although he had a thorough mastery of their artistry and style. It is likely that he preferred to treat this genre in paint, as witnessed by his submissions to the salons and his later Egyptian work. Henri de Lacretelle explicitly wrote in 1852, "M. Le Gray also does beautiful photographic portraits when he does not wish to do these in oil."[39]

A splendid daguerreotype portrait of Le Secq, taken by Le Gray around 1848, is his first known success in that genre. Around 1850 he also made a sparingly delineated calotype silhouette of dramatist Edmond Cottinet (fig. 58), leaning dreamily against a wall. In addition, the completely different, powerful bust of the sculptor Clésinger (fig. 59), exhibited at the 1855 Universal Exposition, is worth noting. Paul Périer made the following comment on that work on behalf of the Société française de photographie:

We know that M. Le Gray does not make portraiture his primary occupation, but this does not prevent him from excelling at it when the occasion arises. The one of Clésinger, were not a few parts of the image a bit dark, would be perfect in every way. The dynamic head and aquiline profile of the sculptor are exquisitely rendered by the proud attitude, the firm regard, the brilliance of the light, and the overall intensity of the execution.[40]

This portrait is well known but had been incorrectly attributed. Until now, it has been published on more than one occasion as a masterpiece by Nadar, and even as an exemplar of his best work.[41] The explanation for this confusion is that the work was known only through a copy made around 1880 in Nadar's studio and then incorporated into his bank of negatives to be marketed. However, a print signed by Le Gray[42] has now enabled us to establish the link with Paul Périer's review, and all doubt has finally been eliminated by checking the notebooks from Nadar's studio, in which the catalogue number of the Clésinger portrait is accompanied by the word "reproduction."[43] Indeed, this work has all of the characteristics we associate with Nadar's most successful portraits: mastery of chiaroscuro,

39 H. de Lacretelle, "Beaux-Arts: Revue photographique,"*La Lumière* (February 28, 1852).
40 *Bulletin de la Société française de photographie* (September 1855): 265.
41 U. Keller, "Mise au point sur Nadar: Un Tri dans son legs photographique," in *Nadar: Les Années créatrices, 1854–1860,*

exh. cat. (Paris, 1994), 146–47; A. Jammes, *Nadar*, 2nd ed., Photo poche series (Paris, 1983), fig. 30.
42 Private collection.
43 EST, BNF, Na 235 4°.

neutral background, tight framing, and the model captured at ease in informal attire, in this case, a corduroy suit and a colored scarf around his neck. The technique—the collodion-on-glass negative— is also the one that Nadar adopted almost immediately.

Obviously, there is no question of challenging Nadar's status or genius in the art of portraiture. However, it is important to emphasize that, at a time when Nadar was taking his first steps, in 1854, Le Gray was already a virtuoso of the genre for which his student and friend was to become justifiably renowned. In this field, as in others, while Le Gray could have found fortune and fame by

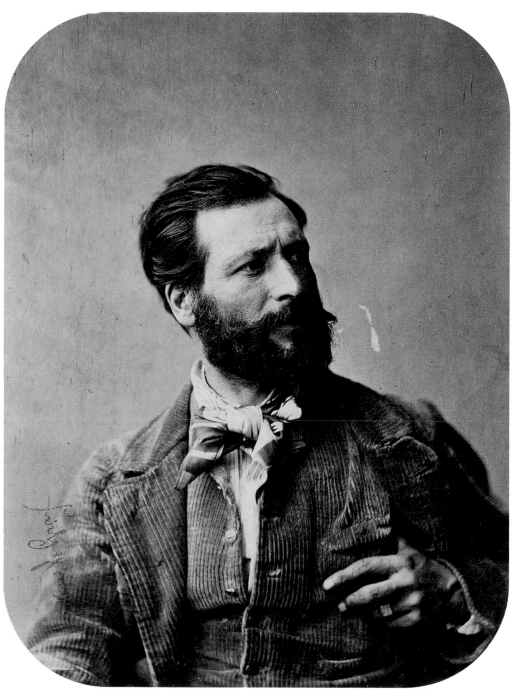

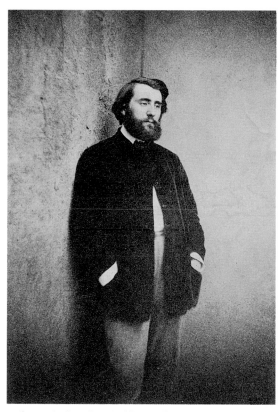

58 Gustave Le Gray. *Portrait of Edmond Cottinet*, ca. 1851/52.

59 Gustave Le Gray. *Portrait of the Sculptor Clésinger*, 1855.

60 Gustave Le Gray. *Return of the Prince-President, Place de la Concorde, Paris*, 1852.

repeating such successes, he did not seek to exploit the possibilities that were available to him.

Marketing

A studio is not a shop. So, how did Le Gray sell his prints? He must have offered them to visitors, students, amateurs, and anyone interested. In keeping with the then current practice, he must also have placed them on consignment with print merchants. In its May 1853 catalogue, the Goupil firm included a list of photographs by Le Gray and other photographers:

> Full-length portrait of Napoléon III in civilian dress, taken at the Élysée by Le Gray. Price: 6 francs, mounted on bristol board. Dimensions: 15 by 20 cm.
>
> Photographic excursions. Sites, monuments, landscapes, seascapes, overall views and details of Gothic architecture, etc., by Messrs. Le Secq, Le Gray, and the most eminent photographers. Collection of 30 sheets increasing daily.—Price of each quarto-size sheet, mounted on bristol board: 10 francs.[44]

Some exhibitions allowed visitors to purchase the exhibited works. This was true of the one held by the Photographic Society of London in April 1853, where Le Gray exhibited twenty-one works, the majority from the Mission héliographique.[45] That was also the case for the exhibitions that the Société française de photographie held every two years, beginning in 1855.

Initial Commissions

This fertile period for his personal work was also when he received his first commissions: the views of the salons of 1851–1853, commissioned by their organizer, Philippe de Chennevières;[46] the Mission héliographique with Mestral, from July through September 1851, for the commission des Monuments historiques; the portrait of Prince-President Louis-Napoléon Bonaparte (later to become Napoléon III) in the spring of 1852;[47] the distribution of the regimental standards on the Champ-de-Mars on May 10, 1852, and the arrival of Louis-Napoléon on October 16 at porte Saint-Martin and place de la Concorde (fig. 60),[48] as well as the gold-plated shield by Gaccia, which was presented to him on that occasion;[49] *The Departure of the Volunteers* (fig. 62), a bas-relief more commonly known as *La Marseillaise* by Rude on the Arc de Triomphe, seemingly commissioned by the sculptor himself in 1852 (an exceptional case, the gigantic negative was signed in his hand),[50] as well as its

44 Bordeaux, Musée d' Aquitaine, Goupil Archives. There is a similar advertisement in the June 1854 catalogue. The collaboration ended there.
45 *La Lumière* (May 28, 1853).
46 These views are already partially known; see G. Lacambre, "Un Photographe au Salon de 1852," in *Hommage à Hubert Landais: Art, objets d'art, collections* (Paris, 1987), 197–204.
47 *La Lumière* (August 28, 1852) specifies that the portrait, printed in a considerable number of copies, was found at all the major print dealers. Ten prints of this portrait (5 francs each), as well as twenty of Rude's bas-reliefs from the Arc de Triomphe (25 francs each) and ten of the grand staircase at the château de Blois (10 francs each), were ordered and paid for (650 francs) by the government in April 1853. National Archives, F^{70} 196.
48 In collaboration with Lerebours and Bertsch. Letter from Lerebours, November 1852,

National Archives, F^{21} 562; payment to Lerebours, March 25, 1853, National Archives F^{70} 237, order no. 143.
49 Cited in *La Lumière* (October 30, 1852): 179. The Bibliothèque nationale de France owns a print of a shield that may be this image: a large print in hues of green similar to those created by Le Gray, but not signed; copyright registered (April 6, 1854, no. 1891) in the name of the Bisson brothers. They may have been responsible for its distribution, as with the reproductions of the Lehmann paintings of that same date, or they may have purchased the negative.
50 In addition to the one by Le Gray, at least three other photographs of *The Departure* were published in 1852 in the albums *Mélanges photographiques* and *Album photographique* by Blanquart-Évrard and in *Paris photographié* by Renard, published by H. de Fonteny.

61 Gustave Le Gray. *The Apotheosis of Napoléon* by Jean-Pierre Cortot, the Arc de Triomphe, 1852 (cat. no. 81).

62 Gustave Le Gray. *The Marseillaise* by François Rude, the Arc de Triomphe, 1852 (cat. no. 80).

51 Submitted to the exhibition at the Society of Arts in London in 1852. The author thanks Marc Bascou for his assistance with the attempts, however unsuccessful, to locate this work.
52 *Le Propagateur* 8 (January 1854): 2–3. This magazine was the only one to mention these portraits. In an album of portraits by Le Gray (private collection), there is a fairly poor likeness of Abd el-Kader in Amboise that may be one of them.
53 A. Ferrier, *Notice sur l'Hôtel de Ville de Paris* (Paris, 1855), 75: "This series of paintings was photographed under the supervision of M. Henri Lehmann and published by him. The City of Paris purchased several copies of this magnificent collection, to offer them to the major cities of the empire." For 1854 orders and payments relating to Lehmann, see National Archives, F[70] 198.

counterpart, *The Apotheosis of Napoléon* by Cortot (fig. 61); the vanity chest of the duchesse de Parme made by Froment-Meurice;[51] the "portraits of [Emir] Abd el-Kader, his family, his retinue, and the corps of engineers commander assigned to guard them"[52] in their exile at the château d'Amboise in 1853; and the fifty-six subjects painted by Henri Lehmann[53] for the grand reception room at the Paris City Hall, completed in July 1853,[54] but probably photographed from the preparatory drawings as early as 1852, and privately published by the painter in early 1854 (fig. 266).[55] The name Le Gray is never mentioned, and only his stamp at the bottom of the photographs informs us that they are his work. There were still other artists, of equal stature, who had him reproduce their works: Ingres (fig. 63), Ary Scheffer (fig. 64), Gérôme, Labouchère, and Aimé Millet.

All of these commissions can be divided into two primary groups. First, the reproduction of works of art: painting, sculpture, and architecture. Today's historians and collectors are not much interested in this type of photography. Its practical use has become sec-

ondary, and we are no longer aware of the technical mastery that was often required to make these photographs.[56] However, at the time, the artistic stakes and possibilities for commercial development were considerable. It was commonly accepted, particularly among scholars and artists, that this was one of the best possible applications for paper photography. We all too often forget that Nègre, Baldus, the Bisson brothers, Marville, and Richebourg owed a large share of their income to this type of work, not to mention Blanquart-Évrard, whose business consisted in large part of the photographic dissemination of art. The movement received a decisive impetus from the personal interest of men such as Léon de Laborde and Philippe de Chennevières, as well as from the commission des Monuments historiques. Among Le Gray's students, Benjamin Delessert, an enthusiast of engravings, undertook to reproduce the engraved works of Marc-Antoine Raimondi.

The second specialty of those years could be termed official ceremonial photography, or, more accurately, Bonapartist propaganda.[57] The year 1852, which ended in the coup d'état of

63 Gustave Le Gray. *Don Pedro of Toledo Kissing the Sword of Henri IV* by J. A. D. Ingres, ca. 1849/50 (cat. no. 79).

64 Gustave Le Gray. *The Man Who Cut the Tablecloth* by Ary Scheffer, ca. 1849/50.

65 Gustave Le Gray. *Portrait of Louis-Napoléon Bonaparte as Prince-President*, 1852 (cat. no. 20).

December 2, was a period of turmoil and political intrigue when people were evaluating the future, choosing sides, paving the way for things to come. Le Gray, by photographing the public appearances of the prince-president and—whether by conviction or by chance (we leave out premeditation, for that was unlike Le Gray)—providing him with an already imperial-looking official portrait that would be widely disseminated after the coup d'état (fig. 65), had banked on the winner. The more prestigious commissions that he would receive in 1856 and 1857 were his reward. More generally, he would be buoyed along by the empire, by its prosperity and the expenditures of the first part of Napoléon III's reign. And his departure from Paris in 1860 would coincide with the advent of that regime's setbacks and problems.

Should he, for all that, be considered a servant of the empire, a courtier? No, probably not. Among his friends, relations, and customers, there were fierce adversaries of Napoléon III, such as the republican Nadar and the Orleanists Laborde, Bocher, and d'Haussonville. Le Gray took the portrait of at least one child of the Orléans branch of the royal family, not to mention, much later (in Egypt), that of the comte de Chambord. What determined his relationships and his clientele was, above all, the high quality he guaranteed and the prices he charged. His dominance in the field and his artistic pride explain his wealthy and fashionable customers and students, regardless of their political opinions. Be that as it may, like many of his contemporaries, Le Gray may have had a real liking for the imperial dynasty. On the wall of his last house, in Cairo, was a painting of General Bonaparte on horseback, perhaps an evocation of the Egyptian campaign.[58]

The Mission Héliographique

The undertaking that is now known as the Mission héliographique was the first large-scale attempt to fulfill the potential that had been attributed to photography from the time of its inception: a figurative census of artworks.[59] It was the response to a combination of different motivations that happened to mature at the same time, in related spheres; a still young and evolving medium, eager for artistic and scientific legitimacy, encountered a profound intellectual and aesthetic movement derived from Romanticism—the discovery and preservation of ancient and, particularly, medieval monuments.

Everything happened in the early weeks of 1851: the birth of the Société héliographique (January) and the magazine *La Lumière*

54 Letter from Lehmann, July 1853, Archives of the Académie des beaux-arts, 5E 37, Related documents, 1853.

55 H. Lehmann, *Peintures murales de la galerie des Fêtes à l'Hôtel de Ville de Paris, planches photographiques* (Paris, 1854). The preface is dated February 15, 1854. The ministry immediately ordered six copies at 300 francs each from Lehmann. Record of orders of Lehmann's artworks: 50,000 francs for the decoration of the Festival Hall and 3,000 francs for ten copies of his album, Archives of Paris, Pérotin 72/1, packet 113.

56 On the reproduction of artworks in general, see A. J. Hamber, *A Higher Branch of the Art: Photographing the Fine Arts in England, 1839–1880* (Amsterdam, 1996).

57 See McCauley, "Conclusion: Bonapartism and Photography," in *Industrial Madness*, 301–14.

58 See "Death-Date Inventory" in the appendix to this volume.

59 The pictures from the Mission héliographique were first shown in an exhibition organized by Philippe Néagu, *La Mission héliographique: Photographies de 1851,* and published in a catalogue of the same name (Paris, 1980). These images are now under the care of Anne de Mondenard, who analyzed them in a research paper for the École du Louvre, "Le Fonds de photographies du Musée des Monuments français: Les Épreuves révélées de la Mission héliographique," 1996; in an article, "La Mission héliographique: Mythe et histoire," *Études photographiques,* no. 2 (May 1997): 60–81; and in a forthcoming book. The lines that follow are based on these earlier works; we hope they are not contradicted by the forthcoming work. We also used the article by A. Carrez, "La Commission des Monuments historiques de 1848 à 1852," *Histoire de l'art,* no. 47 (November 2000): 75–85; and her thesis, "Les Procès-verbaux de la commission des Monuments historiques, 1848–1852" (Diploma of advanced studies in art history, advisers Bruno Foucart and Françoise Hamon, Université de Paris IV, 1999).

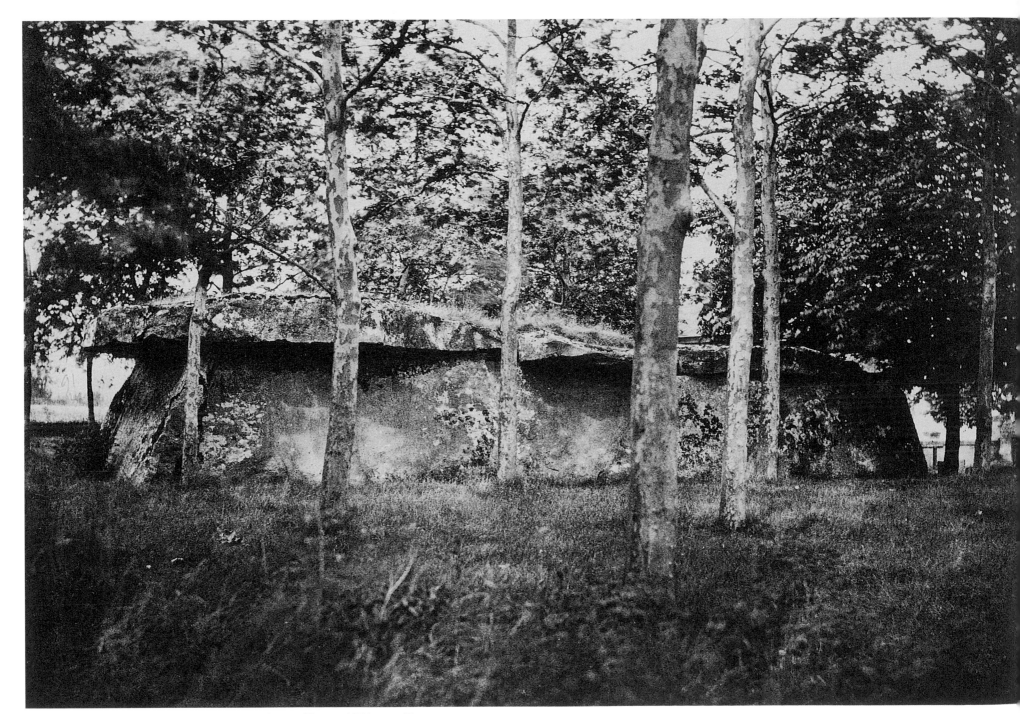

66 Gustave Le Gray. *The Dolmen Known as "La Grande Allée Couverte," Bagneux,* 1851 (cat. no. 40).

(first issued on February 9), as well as the communal voice of all those who were interested in the progress of photography. It was at that time that the commission des Monuments historiques, founded in 1837 by the ministère de l'Intérieur (Ministry of the Interior) and directed by Prosper Mérimée, decided to entrust several photographers with a vast inventory of monuments. These three events were closely connected. Among the founding members of the Société héliographique were the five photographers of the future Mission héliographique, as well as Léon de Laborde, a ranking figure on the commission des Monuments historiques.[60] *La Lumière* would publish the progress and the results of the mission, through the pens of Henri de Lacretelle and Francis Wey, who had used his influence on the commission in favor of the project.[61]

The first photographer selected at the session of January 10 was Le Secq, who submitted a sample of "daguerreotype prints on paper."[62] The following week, on January 17, "the commission decided that Messrs. Baldus and Mestral shall receive a mission similar to the one given to M. Le Secq at the last session. A subcommittee shall be appointed on February 14 to designate the monuments of which each of the persons sent on the mission is to make daguerreotypes, and to determine the number and type of prints to be made of each edifice."[63] On February 28, "on the report of M. de Laborde, it is the opinion of the commission that the persons who have produced the best heliographic prints of the monuments are Messrs. Baldus, Le Secq,[64] and Bayard.[65] Consequently, it has decided that there is reason to give those gentlemen missions along the lines indicated at either of the last sessions. Of these three missions, one shall be directed toward Normandy, the second to the south, and the third to the east."[66] Finally, on May 9, there was one last change: "On the motion of the secretary, the commission has decided that a mission similar to those already given to Messrs. Baldus, Le Secq, and Bayard, whose objective is to collect photographic sketches of a certain number of historical edifices, shall be given to M. Mestral and another to M. Le Gray."[67]

This belated choice of Le Gray, along with his student Mestral—who had already been appointed on January 17 and then eliminated on February 28 in favor of Bayard—may be explained by several occurrences that had recently attracted attention. Unlike the other photographers who were selected, Le Gray had not yet produced any architectural views suitable for submission to the commission.

60 Eugène Durieu also participated. Regarding his possible role, see Néagu, *La Mission héliographique*, 20–21; on Laborde, ibid., 21–22.

61 F. Wey, "Comment le soleil est devenu peintre," *Musée des familles* (July 20, 1853): 294. Regarding the man and his place in criticism (but not in the mission), see de Mondenard, "Entre romantisme et réalisme: Francis Wey (1812–1882), critique d'art," *Études photographiques*, no. 8 (November 2000): 22–43. His role in the creation of the mission appears to be less significant than he claimed; see Néagu, *La Mission héliographique*, 17–20.

62 Price: 6 francs each and 50 francs for ten. Archives of the direction du Patrimoine, procès-verbaux de la commission des Monuments historiques (hereafter "Archives of the direction du Patrimoine"), January 10, 1851.

63 Archives of the direction du Patrimoine, January 17, 1851. The subcommittee was composed of Laborde, Mérimée, Vaudoyer, Lenormant, and Courmont. In February (after the meeting of the 14th?), Prosper Mérimée wrote to Laborde: "We at the commission are astonished and indignant that you did not come for the matters of the daguerreotypes and the stained-glass windows." P. Mérimée, *Correspondence générale*, ed. M. Parturier (Toulouse, 1941–64), vol. 6 (1947), 167.

64 Henri Le Secq had submitted views of the cathedrals of Amiens, Reims, and Chartres to the commission. He was assigned the northeastern quarter of France, which includes a great number of Gothic cathedrals.

65 In 1849 Hippolyte Bayard had received from the commission an order for six daguerreotype views, in which Laborde already played a primary role. Archives of the direction du Patrimoine, August 17, 1849: "M. Bayard should come to an agreement with M. de Laborde about the selection of the views that he is to take." As has been noted, it was in August 1849, after the Paris Exhibition of Industrial Products, where Bayard

67 Gustave Le Gray. *Portrait of O. Mestral*, ca. 1856 (cat. no. 162).

and Le Gray received awards, that Laborde practiced photography with Le Gray.

66 Archives of the direction du Patrimoine, February 28, 1851.

67 Ibid., May 9, 1851.

68 See Aubenas, "To Unite Science with Art."
69 On September 7, 1849, Laborde was a judge on the commission appointed by the Académie des inscriptions et belles-lettres "to write the instructions for the voyage of M. Maxime Du Camp," in which it was clearly indicated, "It is no longer a matter of charming our eyes with the attractive effects of light in the camera, but of copying faithfully and with results the subjects belonging to science." Institut de France, Library, MS 3720, vol. 1, file 1, fols. 19–20.
70 M. Du Camp, *Lettres inédites à Gustave Flaubert*, ed. Giovanni Bonaccorso and Rosa Maria Di Stefano (Messina, Italy, 1978), 163, 173.
71 *La Lumière* (June 29, 1851): 83.
72 Ibid. (July 6, 1851): 87.
73 Ibid. (July 20, 1851): 94.
74 As is apparent when comparing the list of photographed monuments and the minutes of the commission.
75 See F. Bercé, "Duban et les monuments historiques," in *Félix Duban, les couleurs de l'architecture*, exh. cat. (Paris, 1996), 64; and Carrez, "La Commission des Monuments," 79.
76 This was photographed by both Le Gray/Mestral and Baldus, since their itineraries crossed at that point.
77 This change of program is perhaps the reason their itineraries were not published in *La Lumière*.
78 Pyrénées-Orientales. Private collection.
79 On the left bank of the Tech, near Amélie-les-Bains in Pyrénées-Orientales. Thanks to Hélène Sorbé for identifying this site.
80 Formerly in the Koch collection (print destroyed in a fire). The brochure accompanying the 1987 Le Gray exhibition in Chicago provides a description.
81 Paris, Société française de photographie.
82 *La Lumière* (February 25, 1854): 29.

However, in January / February 1851 he had perfected the invention of the waxed-paper negative, and he had just presented it, on April 17, to the Société héliographique. His experiments had been followed closely by Victor Regnault,[68] who was able, along with Laborde, to use his influence on the commission in favor of the photographer. The mission was truly the ideal testing grounds to take the full measure of the new process. Lastly, in the final days of that same month of April, Du Camp, a fellow student of Laborde's at Le Gray's studio, had returned from his expedition to Egypt—which was largely made possible by Laborde[69]—and he immediately put his photographs, which were destined to cause a sensation, into the hands of the barrière de Clichy studio for printing.[70]

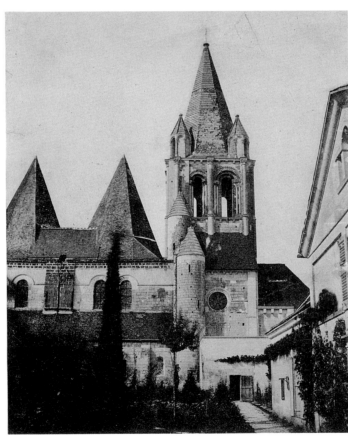

68 Gustave Le Gray. *Church of Saint-Ours, Loches*, 1851 (cat. no. 35).

On June 29, 1851, *La Lumière* finally announced these "photographic missions."[71] There followed the publication of the itineraries of Bayard and of Le Secq,[72] then of Baldus;[73] only that of Le Gray and Mestral was not printed. The commission had assigned to each photographer a list of monuments corresponding to roughly a quarter of the country, except to Le Gray and Mestral, who shared the southwest. The edifices in question were those whose historical importance or urgent need of restoration had been particularly remarked by the commission and those on which work was in progress or had recently been completed[74]—for example, the château de Blois,[75] where, in 1848, Duban had successfully restored the François I staircase; Carcassonne, whose restoration had been assigned to Viollet-le-Duc; and the pont du Gard.[76] Le Gray was to travel from Paris to Poitiers, and Mestral from Angoulême to Clermont-Ferrand by way of Perpignan, Albi, and Cahors. Each was in charge of a separate list of monuments. Why, indeed, would they, on a limited budget, have paid the expenses of two artists for the same pictures?

Nevertheless, the two friends deemed it more useful and pleasant to travel together, although it meant financing the liberties that they were taking, perhaps with the idea that they would reimburse themselves out of the profits on the prints sold to the commission or to other customers.[77] They left together on July 1 and returned to Paris in October. In addition to the contemporary documents, the photographs themselves bear the traces of this joint journey. Well outside the prescribed program, Le Gray took his self-portrait in the cloister at Elne;[78] he signed a print of the bridge at Palalda,[79] and another of the pont du Gard (fig. 95). In addition, two views, one of Carcassonne,[80] the other of the cloister of Notre-Dame-du-Puy (fig. 291), were signed by both Le Gray and Mestral. There are also an even greater number of unsigned negatives. Finally, in one case—the François I staircase at the château de Blois—there is a negative signed by Mestral[81] and at least five prints, two of which bear Le Gray's blindstamp. As if to confirm its dual paternity, a print of the staircase was exhibited under the name of Mestral at the Photographic Society of London in 1854,[82] while Le Gray, as is discussed later, sold other seemingly identical prints on his own in 1853. At first glance, there is no difference between these photographs. The viewpoint is identical, as is the framing, as far as can be discerned after cross-checking the prints. Only a more in-

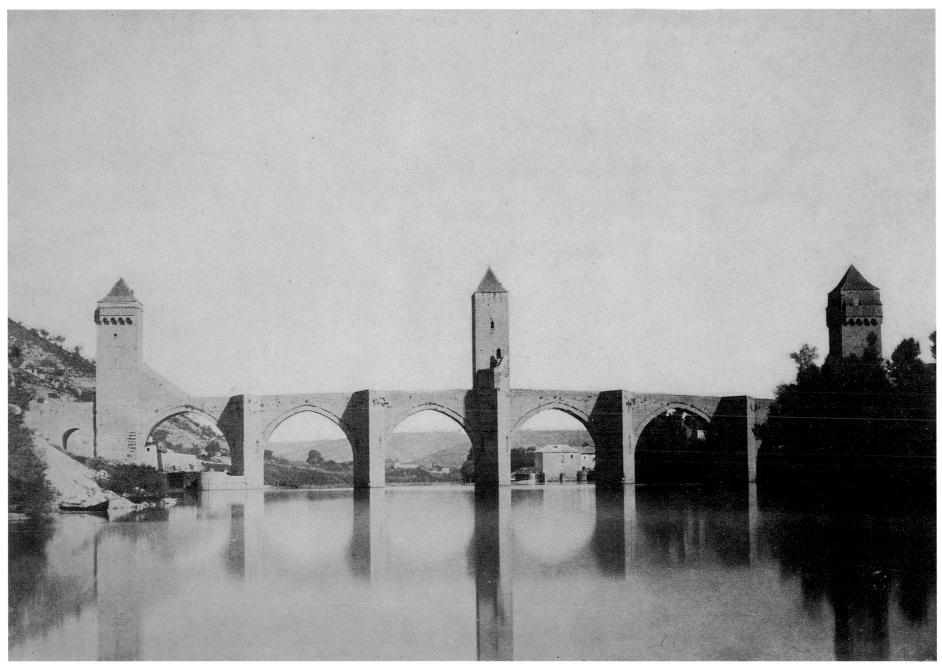

69 Gustave Le Gray. *The Valentré Bridge, Cahors*, 1851 (cat. no. 48).

83 Some of these were donated to the Société française de photographie by Moutrille in 1889. Another print is in the collections of the J. Paul Getty Museum.

84 H. de Lacretelle, "Album photographique, no. 3: M. Mestral," *La Lumière* (March 19, 1853): 45–46.

85 Deepest gratitude to Alain Paviot for providing this lead, based on the sculptor's accounts. The items were forwarded to Anne de Mondenard, in the hope that she will settle the question in her forthcoming book.

86 The man remains a mystery, despite the author's research with Anne de Mondenard. We do not even know his first name, his origin, or his dates of birth and death. He was very important in the Parisian photography milieu between 1850 and 1853 but then disappeared around 1856, when the lease on his apartment at 48, rue Vivienne expired. Marie-France Smith kindly did research on the Mestral de Combremont family in the Swiss archives, which was forwarded for analysis to de Mondenard, but this relationship is still hypothetical.

depth examination shows that the shadows have imperceptibly moved. Therefore, the photographers indeed signed and used two different negatives; but such a minimal difference, far from encouraging other attributions, shows how risky this can be. Nor does this case allow one to extrapolate any general conclusions as to the method of their collaboration. Based on the shadows on the château, Mestral's negative was made several minutes later than Le Gray's, but how can we assert that one was the decision maker and the other just followed suit?

In such intensive work, side by side, a certain symbiosis of styles must necessarily occur. Even so, we would have to know Mestral's style, but few of his works have survived. Those that he brought back from a solitary trip to Brittany in the fall of 1852,[83] although highly praised by Henri de Lacretelle,[84] seem poorer than those from the mission. Perhaps attributable to him, however, is a series of much finer workmanship commissioned in 1853 by the sculptor Geoffroy-Dechaume, representing the statues that the latter furnished for the restoration of the Sainte-Chapelle in Paris.[85] It would obviously be tempting to sidestep the issue by lending to the rich, as it were, and depriving the elusive Mestral,[86] reducing his role to that of the supernumerary, in order to give credit for the entire series to the genius of Le Gray. On the contrary, our ignorance of their relationship and our unfamiliarity with Mestral's work, which was highly regarded in his day, should urge our circumspection.

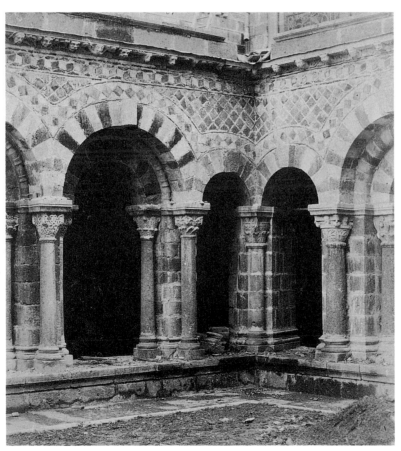

70 Gustave Le Gray. *Corner of the Cloister, Cathedral of Notre-Dame, Le Puy*, 1851 (cat. no. 62).

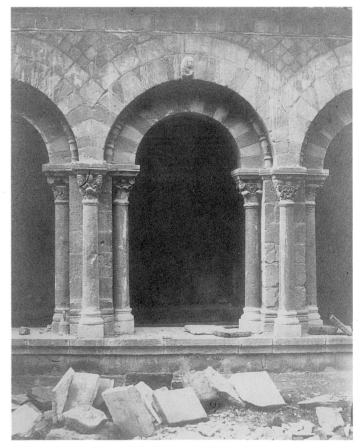

71 Gustave Le Gray. *Cathedral of Notre-Dame, Detail of the Cloister Arcade, Le Puy*, 1851 (cat. no. 63).

Consequently, for this entire journey—both before and after Poitiers—it is impossible to be certain about the attribution of the works. To make a determination, it would be essential to know whether the trip and the views were taken entirely together, or only in part. The expense accounts submitted on their return do not enlighten us, since they maintain the administrative fiction by reproducing the itinerary that was initially indicated for each of them.[87]

We may at least note that Francis Wey, reporting in early October on the photographs that had already been received in Paris from the two associates, presents as an obvious fact that they traveled together, but also that Le Gray was the person in charge for the entire journey: "M. Le Gray, in the company of M. Mestral, is covering the southern regions, from the Loire to the Mediterranean: he has not yet returned, but he has made some invaluable submissions, his plates are enormous."[88] Admittedly, Le Gray's prominence in the Société héliographique may explain the fact that *La Lumière* was more interested in him; however, of the two negative formats used in the series (approximately 30 by 40 cm and 24 by 34 cm), the larger, which was indeed spectacular for the period, does show the stamp of his technical mastery from the beginning.

The two photographers did experiments in the field for more than three months on the potential of the waxed-paper negative, which, according to Le Gray, was capable of producing up to twenty-five or thirty prints per day. Roger Fenton, who encountered them on their return, spoke of hundreds of negatives,[89] and his testimony is confirmed by the numbering of the negatives, since the highest number,[90] found on a view of the church of Saint-Austremoine in Issoire, was 605. This sequential numbering is another proof of joint planning and implementation.

Their itinerary (without listing all of the places they stopped) took them through Blois and the châteaus of the Loire to Saumur and then through Poitiers, Saint-Savin, Angoulême, Melle, Aulnay, Bordeaux, Moissac, Cahors, Albi, Toulouse, Carcassonne, Elne, Amélie-les-Bains, Arles-sur-Tech, over the pont du Gard, and through Le Puy and Issoire, at which point they finally went back up toward Paris. The travelers notably lengthened the list that had been given to them, and the official archaeological census en route doubled as an artistic excursion. Their quarter of France contained Renaissance châteaux, Romanesque churches, and the ramparts of Carcassonne, but not many Gothic churches. Therefore, their series represented a sample of French

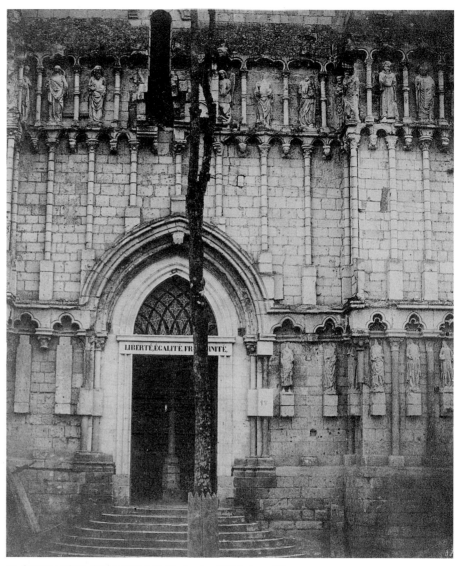

72 Gustave Le Gray. *Church of Saint-Martin, Candes*, 1851 (cat. no. 38).

87 Reported by de Mondenard, "La Mission héliographique: Mythe et histoire," 81, n. 35; National Archives, F⁴ 2771, file 2098. On November 5, Le Gray submitted an expense account for

602.50 francs; on November 10, Mestral submitted an expense account for 887.60 francs.
88 F. Wey, "Des progrès et de l'avenir de la photographie," *La Lumière* (October 5, 1851).

89 See Aubenas, "To Unite Science with Art."
90 On Le Gray's numbering systems, see "Signatures, Stamps, and Commercial Marks" in the appendix to this volume.

architecture that was very different from the one illustrated by Le Secq, for example, and that difference in subject is indissociable, in the final results, from an aesthetic difference among the photographs themselves. The southern monuments, in the simplicity of their curves, call for a refined vision, the capture of volumes of apses, towers, and arches in a powerfully calculated construct. However, the rubble and the weeds, the wind-lashed trees and laundry poetically temper the "Cubist" harshness of the documentation of the monuments. Sometimes, the landscape tends even to prevail over the architecture; in the views of the bridge at Palalda, the pont Neuf at Cahors, and the pont du Gard, it is the overall composition that matters most. We perceive the legacy of the picturesque views lithographed for Baron Taylor but also the Barbizon influence. The Moissac cloister (fig. 282), which Henri de Lacretelle thought he saw by moonlight,[91] prefigures the dramatic lighting effects of the seascapes; a parallel emerges with *The Brig* (fig. 128). It is a borderline case of alteration of the original mission, of the triumph of the artist over the servant of architecture. Finally, as we shall see,[92] the prints made by Le Gray on his return provided the opportunity to enrich his palette with new colors, to achieve results that are all the more felicitous since the hue is influenced by the subject.

The quantitative and qualitative broadening of the scope of the original mission vindicates the fact that only a portion of the photographs brought back by Le Gray and Mestral were sold to the commission (approximately one-fifth—i.e., 120 negatives and the corresponding prints) for the considerable sum of 9,220 francs.[93] The fact that the lump sum was paid to the two companions is a final proof of the closeness of their collaboration. The conjoint presence of two cameras—one sometimes visible in the field of view of the other—and the precaution of duplicating the views, or at least some of them (such as those at Blois), was no doubt justified in anticipation of the need to sell a large number of the negatives to the commission.

The commission did not publish the prints that it amassed. The members of the Société héliographique were indignant about this, and Wey even went as far as sarcasm:

> This collection of the ancient monuments of our France, we owe, as it has been said, to the comité Monuments [*sic*], which, upon the return of the photographers, congratulated them, took their prints, and locked them up in a drawer, without authorizing or even tolerating their publication. Thus the public is deprived of these prints, which have become an object of contention for all; the photographers have been deprived of the publicity that they had expected, and our country will be unable to reap the rewards of the most beautiful work that has yet been produced. We had asked for more and we had hoped for better.[94]

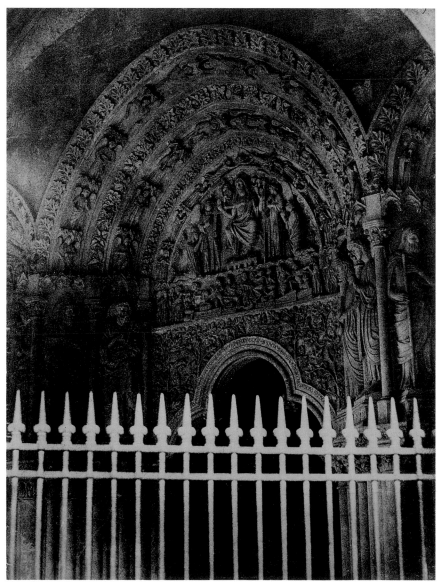

73 Gustave Le Gray. *Church of Saint-Seurin, Bordeaux*, 1851 (cat. no. 45).

The Société héliographique viewed the combined works of the five photographers as a manifesto and would have liked to show it off through exhibitions and publications. For the commission, these were working documents intended for the files on monuments, to help architects determine project priorities.[95] This contradiction was not surmounted until the belated rediscovery of this nineteenth-century photography, when, in 1980 (*année du Patrimoine*, or "Heritage Year"), Philippe Néagu had these documents retrieved from their files and gave them new life.[96]

In the absence of any organized, collective exploitation, the photographers were free to fully profit from the negatives that had not been given over to the commission. In 1852, Le Gray submitted to the exhibition jury the views of the Narbonne gate at Carcassonne (fig. 82) and of the main portal of the cathedral of Tours, specifying that these had been commissioned by the ministère de l'Intérieur, but they were rejected nevertheless.[97] However, his prints were regularly exhibited at photographic exhibitions until 1855, particularly in London. In 1852 these included the pont du Gard, the bridge at Palalda, and the Moissac cloister, as well as a large number of other images from the mission;[98] in April 1853 twenty-one prints were shown at the Photographic Institution[99] and, twice in 1854, a print of the bridge at Palalda was exhibited at the Society of Arts.

In addition to the repeated exhibition of his most "artistic" works, he also marketed them. After the initial, very well compensated delivery to the commission, Le Gray sold still other photographs to the ministère d' État (Ministry of State),[100] in 1853, including ten prints of the grand staircase at the château de Blois. For a broader clientele, he continued—in all likelihood, until his departure from Paris[101]—to print from those negatives that he had not sold to the commission, such as that of the pont du Gard, embellished after the fact with a cloudy sky (fig. 95).

However, the main benefit Le Gray derived from the journey exceeded its immediate results. The mission was, for him, a unique opportunity to devote himself intensely and exclusively to his art for an entire season, to put the characteristics of the waxed-paper-negative process fully to the test, and to refine his concepts and techniques of taking and printing pictures. He then temporarily abandoned the genre of architectural views, with the exception of a few disparate calotypes that must be dated to the early 1850s: a view of the château de Boisy (fig. 74),[102] two of a factory at Terre-Noire

91 See the quotation in the entry for cat. no. 47.
92 See Aubenas, "To Unite Science with Art."
93 Following is the itemization by format: 69 negatives at 50 francs (prints at 15 francs), 49 at 75 francs (prints at 20 francs), 2 at 30 francs (prints at 10 francs). Invoice signed by Le Gray and Mestral, September 8, 1852 (copy provided by Anne de Mondenard), National Archives, F⁴ 2782, file 2263.
94 Wey, "Comment le soleil est devenu peintre," 294.
95 It is important to note that the commission had not lost interest at that time in disseminating its documentation in order to spread knowledge of the monuments, but it does not ever appear to have considered publishing anything but the "plans, sections, and elevations" of the architects. Report by Mérimée to the minister of the interior, December 27, 1850, in Carrez, "Les Procès-verbaux," 71–74.
96 Néagu, *La Mission héliographique*. The exhibition presented modern prints from these negatives.
97 National Museum Archives, Louvre, *KK 110.
98 *A Catalogue of an Exhibition of Recent Specimens of Photography Exhibited in the Rooms of the Society of Arts in December 1852* (London, 1852). The imprecise titles do not tell us more. The catalogue was kindly pointed out by Roger Taylor.
99 Information also provided by Roger Taylor.
100 Price: 10 francs per unit. National Archives, F⁷⁰ 196, payment no. 518.
101 The prints now preserved in various collections bear either his first blindstamp or his wetstamp, which he used from ca. 1853 to 1860.
102 Département des Cartes et Plans, BNF, Archives of the Société de géographie. This identification is due to the kindness of François Lepage and Paule Charbonneau-Lepage.

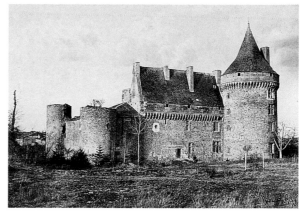

74 Gustave Le Gray. *Château de Boisy*, ca. 1851–1855.

75 Gustave Le Gray. *Factory at Terre-Noire*, ca. 1851–1855.

76 Gustave Le Gray. *Railroad Yard*, 1851–1855.

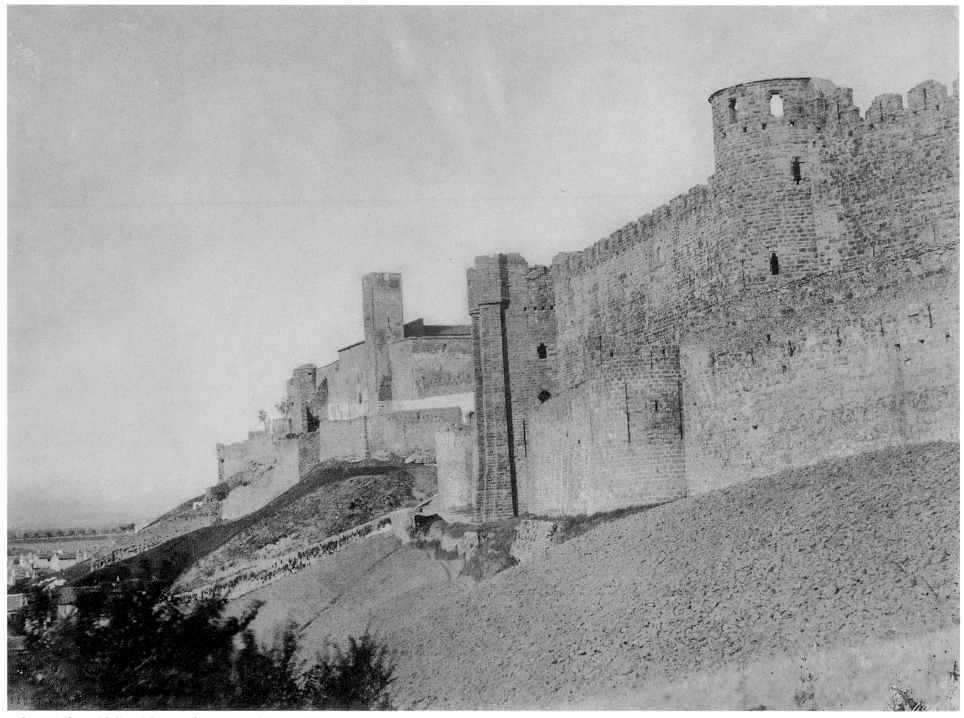

77 Gustave Le Gray and O. Mestral. *Ramparts, Carcassonne*, 1851 (cat. no. 58).

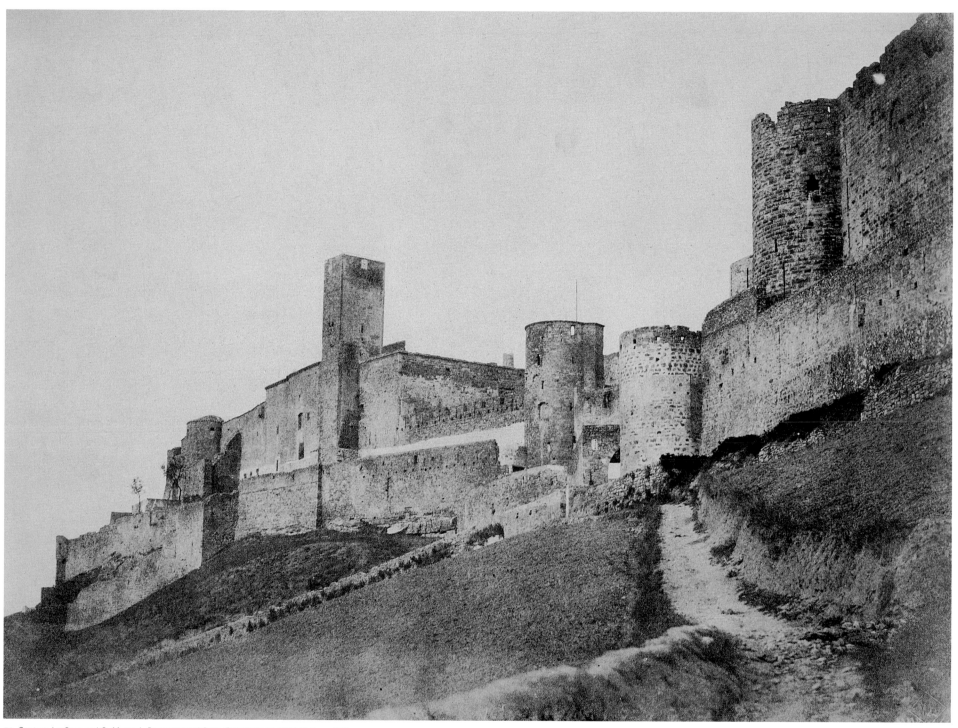

78 Gustave Le Gray and O. Mestral. *Ramparts and Gate, Carcassonne*, 1851 (cat. no. 57).

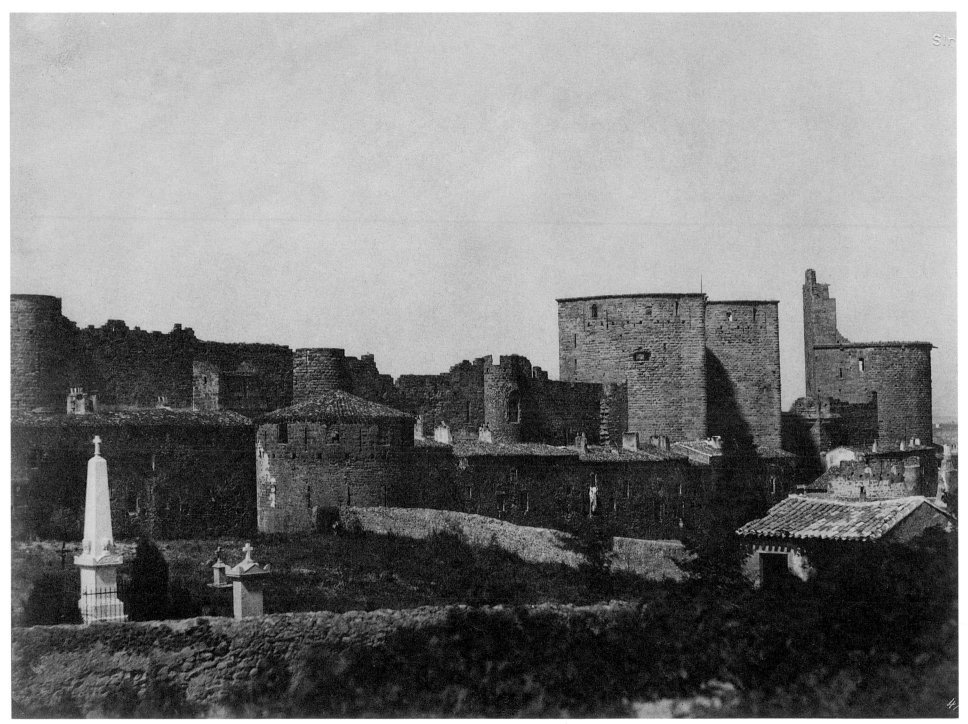

79 Gustave Le Gray and O. Mestral. *The Cemetery and Ramparts, Carcassonne*, 1851 (cat. no. 54).

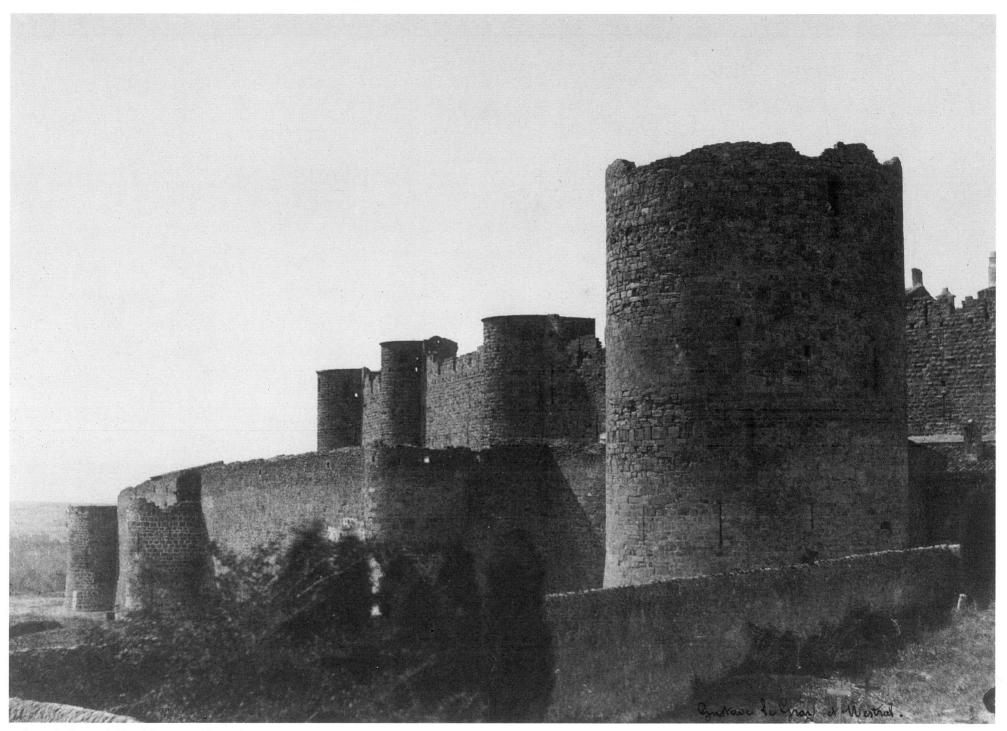

80 Gustave Le Gray and O. Mestral. *Ramparts and Towers, Carcassonne*, 1851 (cat. no. 53).

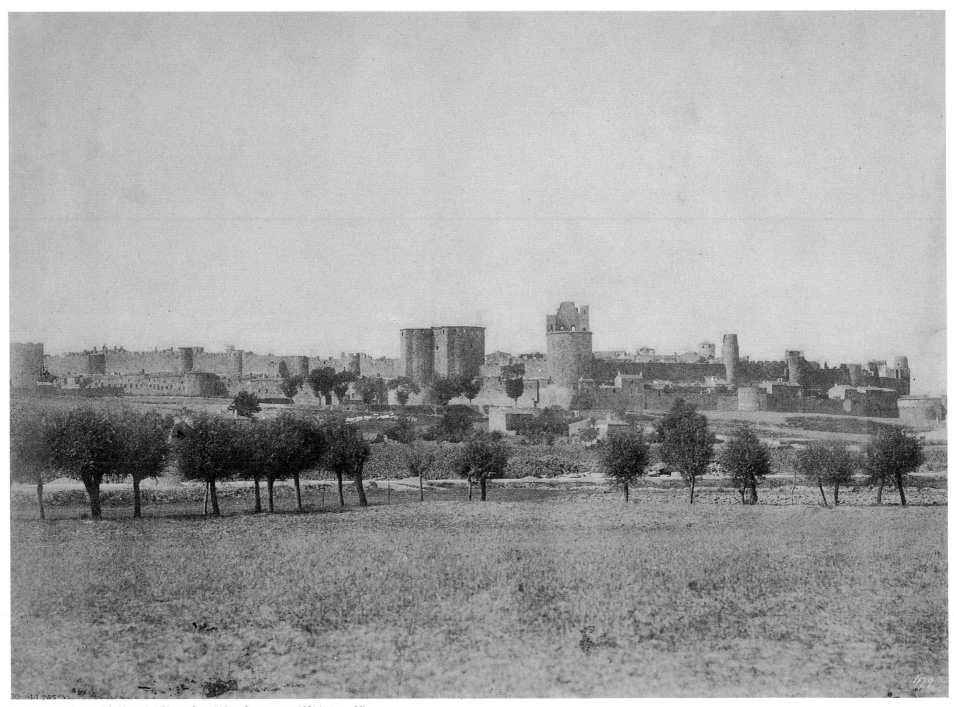

81 Gustave Le Gray and O. Mestral. *A Distant Overall View, Carcassonne*, 1851 (cat. no. 55).

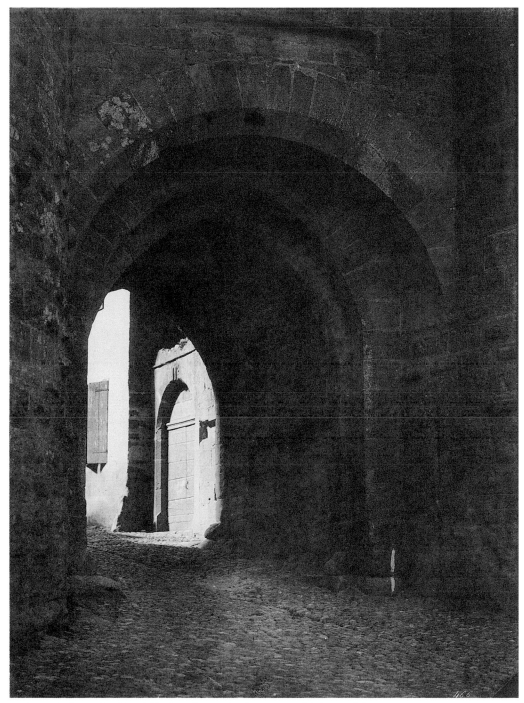

83 Achille Devéria. *Gothic Detail, Auvergne*, watercolor, ca. 1840.

82 Gustave Le Gray and O. Mestral. *The Porte Narbonnaise, Carcassonne*, 1851 (cat. no. 52).

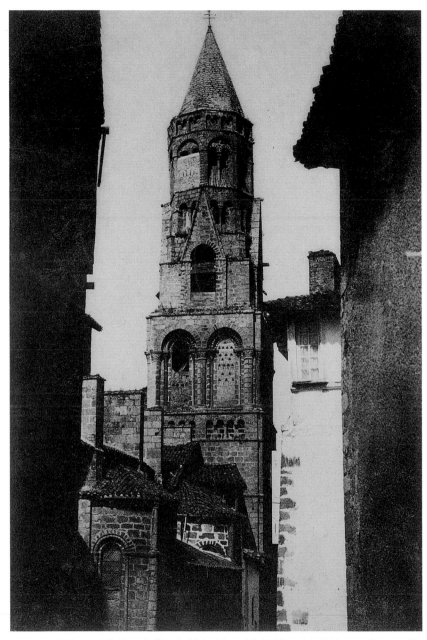

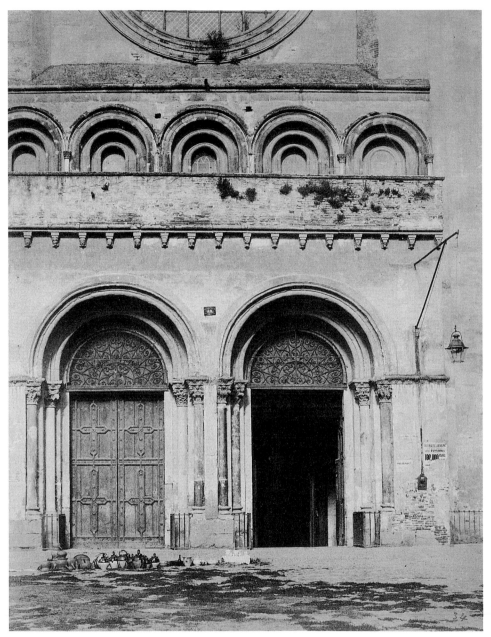

84 Gustave Le Gray and O. Mestral. *Church of Saint-Léonard, Saint-Léonard-de-Noblat*, 1851 (cat. no. 43).

85 Gustave Le Gray and O. Mestral. *Basilica of Saint-Sernin, Toulouse*, 1851 (cat. no. 50).

86 Gustave Le Gray and O. Mestral. *West Portal, Church of Saint-Ours, Loches*, 1851 (cat. no. 36).

87 Gustave Le Gray and O. Mestral. *Church of Saint-Nazaire, Carcassonne*, 1851 (cat. no. 51).

88 Gustave Le Gray and O. Mestral. *Church of Saint-Pierre, Melle*, 1851 (cat. no. 44).

89 Gustave Le Gray and O. Mestral. *Church of Saint-Pierre, Chauvigny*, 1851 (cat. no. 42).

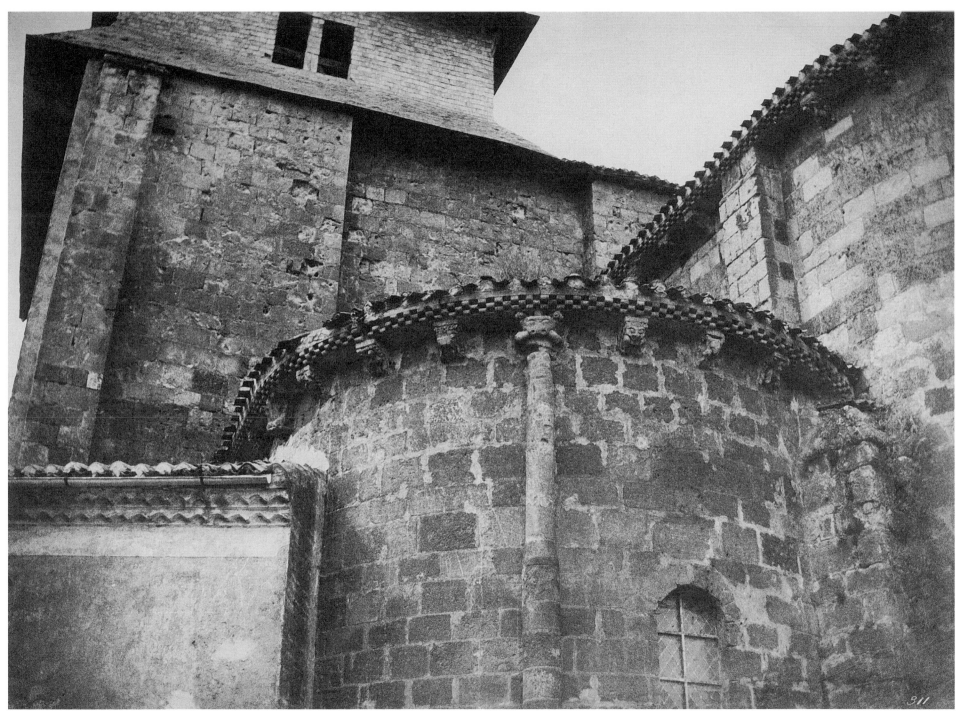

90 Gustave Le Gray and O. Mestral. *Church of Saint-Vincent, Le Mas d'Agenais*, 1851 (cat. no. 46).

91 Gustave Le Gray and O. Mestral. *Louis XII Wing, Château de Blois*, 1851 (cat. no. 31).

92 Gustave Le Gray and O. Mestral. *Staircase of François I, Château de Blois*, 1851 (cat. no. 32).

93 Gustave Le Gray and O. Mestral. *Roofs and Lantern, Château de Chambord*, 1851 (cat. no. 33).

94 Gustave Le Gray and O. Mestral. *Pont Cabessut, Known as the Pont Neuf*, Cahors, 1851 (cat. no. 49).

95 Gustave Le Gray and O. Mestral. *The Pont du Gard*, 1851 (cat. no. 60).

96 Gustave Le Gray and O. Mestral. *Château de Chenonçeaux*, 1851 (cat. no. 34).

near Saint-Étienne (fig. 75),[103] and an image of an unidentified network of railroad tracks (fig. 76).[104] He did not return to this subject matter until 1859, when he did a series of very large views of Paris in the style of Baldus and the Bisson brothers.[105] Above and beyond the discipline of monument photography, the extensive series done for the mission marked an essential step in the photographer's development, both in his abilities and in his artistic ambition.

The Photographic Print Shop

It is impossible to estimate the total income that Le Gray may have earned from his works, his manuals, and his lessons. Although no doubt appreciable, this money must have slipped through his fingers. In the early 1850s he began to contemplate operating on a larger scale by setting up a photographic press—along the lines of the business run by Louis Désiré Blanquart-Évrard in Lille—from the summer of 1851 until Blanquart-Évrard's bankruptcy in 1855.[106] He would benefit from the high reputation of his proofs, producing by request a large number of prints from his own negatives, as well as from those brought to him by others.

The conditions for setting up this type of establishment were the subject of passionate debates within the Société héliographique, which were transcribed in *La Lumière*.[107] In the issue of March 21, 1851, in particular, the society took up the question and turned it over to two members, one of whom was Le Gray:

> We should not postpone founding an establishment of this type. The time has come. The commission des Monuments historiques is providing an outlet for the work of our heliographers, and we must be in a position to satisfy it. The albums of the Société héliographique and the now general desire to own beautiful prints are powerful motives for attending to such an establishment.... Messrs. Renard and Le Gray have been asked to prepare an estimate for the said establishment, a document to be used for the work of the commission.[108]

So Le Gray's ambitions were known, and there was reason for high hopes. He himself announced in 1852:

> I have put these processes into practice in my studios on the chemin de ronde, barrière de Clichy, where an efficient organization allows me to supply the market with one hundred positive prints per day, sturdy enough to withstand the effects of time. No care and no expense have been spared by myself in achieving the perfection of these products.

> Therefore, I urge publishers who wish to produce beautiful and lasting works to come visit my establishment.[109]

But, the perfect print has its price, and Le Gray, even while speaking of commerce, stuck to his artist's creed: "Progress in photography does not reside in low prices, but rather in print quality. If a print is beautiful, complete, and durable, it acquires an intrinsic value in view of which its unit cost vanishes entirely."[110] That insignificant unit cost he figured to be between one and two francs.[111] Blanquart-Évrard, by contrast, did not promise unalterable masterpieces, but, rather than the hundred prints per day boasted by Le Gray, he could produce four to five thousand prints per day with a staff of thirty to forty employees. The unit price: approximately ten centimes.[112]

Had Le Gray at least acquired the resources for a "top-of-the-line," semi-industrial business in terms of organization, discipline, and profitability? What we know of his personality suffices to cast some doubt on this, and at least one account by a dissatisfied customer increases that suspicion. The photographer Lerebours, an associate of Le Gray's and of Bertsch's, had photographed the ceremonies of 1852 (the distribution of the regimental standards on May 10 and the return of the prince-president on October 16) and entrusted their printing to Le Gray. No doubt he hoped to provide to the Ministry of Fine Arts the most flattering of prints. In November, ashamed, embarrassed, and vindictive, Lerebours wrote to his sponsor at the ministry, M. de Montour:

> You cannot imagine what a state I am in and how furious I am at M. Le Gray. So that things would go more quickly, I entrusted him with the task of making the prints and, admittedly, I did not think I could do better in all of Paris, since his is the best organized studio for this! Well, I went to see him personally *5 or 6 times* and I wrote to him as many times, and he has yet to make me *one good print*. One of the young people told me yesterday that *14* had been ruined in a single day by the rain; they printed three of them *in reverse*. Finally, yesterday, I was so annoyed that I took back from him the two negatives to print them at home. I thought it would be much faster to go to him and here they have wasted two weeks for me! I had wished to show you proof of my zeal and my work in this small matter for which I accepted responsibility and, thanks to that wretched Le Gray, you will think me negligent and incompetent. I am sick about it. I am bringing you 2 of the prints that he made. One is *much too dark*, from the poorer of the 2 negatives, the other *much too*

103 Collection of J. Paul Getty Museum, Los Angeles. Thanks to Françoise Hamon for this identification.
104 Canadian Center for Architecture, Montreal. Erroneously identified as the train station at Tours by Janis, *Photography of Gustave Le Gray*, 43.
105 See Aubenas, "Boulevard des Capucines: The Glory of the Empire" (this volume).
106 I. Jammes, *Blanquart-Évrard et les origines de l'édition photographique française . . .* (Geneva and Paris, 1981), 115–18.
107 Ibid., 34–40.
108 "Séance de la Société héliographique," *La Lumière* (March 21, 1851).
109 Le Gray, *Photographie: Nouveau traité* (1852), 71; (1854), 68.
110 Le Gray, *Photographie: Nouveau traité* (1852), 70.
111 This was the price of a print when a large number were produced. For prints sold individually by Le Gray or retailers, it was much higher—on the order of 6 to 10 francs for the prints offered by Goupil, for example (see also note 47).
112 Jammes, *Blanquart-Évrard*, 40.

113 National Archives, F²¹ 562. Lerebours's emphasis.
114 *La Lumière* (January 22, 1853): 13.
115 M.-A. Gaudin, "Visite à l'atelier de M. Le Gray," *La Lumière* (December 10, 1853): 198–99.
116 *La Lumière* (January 22, 1853): 13.
117 See Aubenas, "On Photographic Collaboration: Firmin Eugène Le Dien and Gustave Le Gray" (this volume).
118 See Aubenas, "From One Century to the Next: The Fate of Le Gray's Work in Photographic Collections" (this volume).

light, from the *better one*. It is with this one that I am going to make more.[113]

This was a far cry from the organization, consistency, and reliability of a professional like Blanquart-Évrard. On the contrary, we note the practical effects of the "wasteful, idle, very unpunctual" character attributed to Le Gray by Du Camp, and the "wasteful practices of M. Le Gray's establishment that caused his ruin," according to the severe judgment of Colonel Langlois (March 1856). The printing project could scarcely prosper in the hands of the man Du Camp further called "scatterbrained."

Customers must not have flooded in, and the business struggled to get off the ground. In early 1853, in *La Lumière*, Marc-Antoine Gaudin was still lamenting the lack of a photographic press in Paris.[114] In December of that same year, he again named Le Gray the man of the hour, with praise that strongly resembled an advertising campaign:

M. Le Gray is a young painter who, by combining his artistic skills with his knowledge of chemistry, was one of the first in France to devote himself to photography; his numerous discoveries have greatly contributed to the progressive steps the art has taken over the past few years.

He occupies an isolated house on the Tivoli plain, accessible to light from all sides, comprising large studios—in short, combining the best conditions for a photographic press.

M. Le Gray has primarily devoted himself to the teaching of photography; nearly all of today's renowned photographers have been his students. His studios, on a grand scale, are chock full of all types of cameras and all of the materials necessary for producing large prints; the basins for the preparation of waxed paper and for making positive prints are nearly a square meter in size. . . . In sum, M. Le Gray's establishment is very useful to photography; it is a practical school, always completely up-to-date, for which its young director has spent much without concern for future profit.[115]

Furthermore, Gaudin emphasized the difference in quality that should indeed have placed Le Gray and Blanquart-Évrard in a situation not of competition (to be realistic), but of complementarity. He made a distinction between "two classes of prints, i.e., the pricey prints by the photographers who produce them one at a time and treat them with love, and the good, standard prints by M. Blanquart-Évrard, less polished, yet still superior to engraving and lithography."[116]

Around 1853 we find other sporadic but sure signs of the beginnings of a business: a blindstamp, "Photographic printing, 7, chemin de ronde, barrière de Clichy," and also the probable start of the use of the numerous waxed-paper negatives brought back from Italy by one of Le Gray's students, Firmin Eugène Le Dien.[117]

However, the promised and expected success did not arrive, and it was other photographic printing shops that, while they never rivaled Blanquart-Évrard either, were established in Paris: those of Henri de Fonteny, Joseph Rose Lemercier, and the Bisson brothers. No albums or other large-scale commissions were given to Le Gray. His own students went elsewhere—Du Camp and Greene to Blanquart-Évrard, Félix Teynard to Henri de Fonteny, and so on. And there is more: the series of photographs that Le Gray himself took in 1853 of the paintings by Henri Lehmann in the reception rooms of the Paris City Hall were distributed on mounts stamped with the mark "Bisson Brothers Photographic Printing," even though the prints had unquestionably been made by the photographer himself; the variety of their hues—from soft beige to olive green to vivid orange—are enough to prove this, even if they did not bear his signature.

As previously noted, Le Gray's first business card on the boulevard des Capucines added "Photographic printing house and chemistry laboratory, 7, chemin de ronde, barrière de Clichy." Yet there is no trace left of any printing work for third parties from before that time. This activity had probably already succumbed to the impossibility of reconciling an "artistic" ideal of photography and the need to earn money that was spent all too fast. A similar contradiction would lead Le Gray to catastrophe on the boulevard des Capucines.

The failure of this initial commercial phase—or rather, the complete flop—is reflected by the extreme rarity of the surviving prints. From the studio that was supposed to produce dozens of prints every day, there is little left. The only fairly prevalent works are a few "successes" that were carried by their subject, such as the portrait of the prince-president and some individual commissions, such as the Lehmann reproductions. Since there are ten known copies of a lovely view of Fontainebleau, such as oak tree no. 809 (negative number), that would already seem to be the sign of a notable success.

Yet it was the common fate of photographs from the period before 1855–1860, even the commercial ones—be they portraits by Nadar, studies by Vallou de Villeneuve, or architectural views by Baldus—to become extremely rare. Produced in quantities that were, all in all, modest, since printing them was a long and tricky process, and therefore expensive, they were nevertheless neglected and destroyed by successive generations as photography became commonplace. They were preserved only under particular circumstances by some families that placed greater value on their memorabilia than others (Nadar, Nègre, Le Secq) or by public institutions, primarily the Bibliothèque nationale with its system of copyright registration (Vallou de Villeneuve), along with other libraries that acquired them for their documentary interest. It will never be possible, unless by some miracle, to evaluate the whole oeuvre of an artist like Mestral; so appreciated in his day, his work is now known only through a few remnants (with the exception of the photographs from the Mission héliographique). A figure as essential as Aguado is barely better off. And how many early photographers—professionals or amateurs—do we know simply by name? As for Le Gray, who did not comply with copyright registration (except for a few works in 1860), whose family line has died out, and whose studio collection has twice disappeared, he has been just as affected as anyone else by the passage of time. Only success with his contemporaries, manifest by his inclusion in public collections and those of some important families,[118] has, in spite of everything, allowed a relatively abundant—if incomplete—opus to be preserved.

The year 1855—the date of the first exhibition by the Société française de photographie and of the Universal Exposition in Paris—marked a turning point in the life of Le Gray, this time for reasons that were not specific to him, but that stemmed from a more general context. The interest in photography that so many had long wished for was at its zenith. In addition to wealthy amateurs, this affected those who were influential in society and artistic circles, including bankers and investors. Le Gray, a central figure in Parisian photography since the very beginning of the 1850s, heard the siren call of the capital, left his facility on the outskirts to return to the lights and crowds of the grand boulevards, and embarked on a fatal adventure. It carried him rapidly to the height of celebrity and then, even more abruptly, made of him a man drowning in debt, exiled, repudiated, and forgotten.

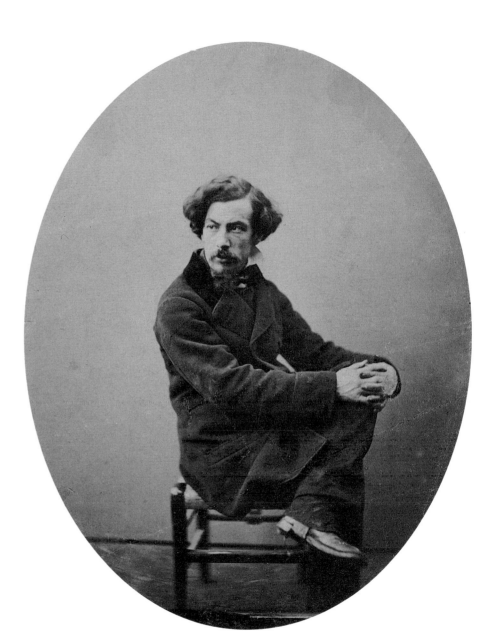

97 Gustave Le Gray. *Self-Portrait*, ca. 1850–1852 (cat. no. 17).

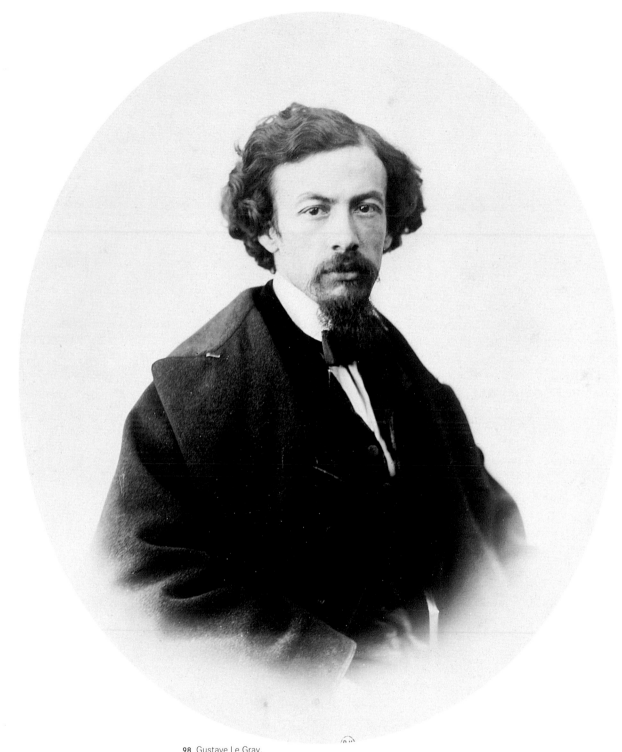

98 Gustave Le Gray.
Self-Portrait, ca. 1856–1859
(cat. no. 161).

Boulevard des Capucines: The Glory of the Empire

Sylvie Aubenas

The final and most brilliant period of Le Gray's life in Paris, before his forced exile to the Near East, began with his move into an immense and splendid studio at 35, boulevard des Capucines, one of the fashionable new meccas of Paris. How did the young painter, fervent chemist, and master technician extricate himself from his isolation at the Batignolles and hurl himself into the very crucible of Parisian frivolity and luxury, the scene of the most resounding, but often fleeting, commercial success?

1855–1860: The Rise and Fall of Photography

For photographers, 1855 was the year of two exhibitions: the Universal Exposition, in which photography attracted a great deal of attention, and the first exhibition of the Société française de photographie. Le Gray exhibited on both of these occasions, but for him, above and beyond these individual successes, that year marked a particular turning point in his Parisian career in the context of the commercial development of the medium on which recent studies have shed more light. Elizabeth Anne McCauley has recounted in striking detail the social, economic, and political circumstances of the dizzying propagation of studios in Paris at the beginning of the Second Empire.[1]

When the process of Niépce and Daguerre was revealed in 1839, the curiosity of scientists and artists was coupled with what seemed, at the time, a veritable "daguerreotypomania," and the middle class flocked to the early photographers. The positive/negative paper process invented by Talbot in 1840, then taken up by Blanquart-Évrard, Guillot-Saguez, and Le Gray, did not immediately cause a similar stir, and its use—even when commercial—was socially and aesthetically confined to an essentially artistic realm.

It was the large-scale use of the collodion-on-glass negative, combining the precision of the daguerreotype with the advantages of reproducibility, that brought together all of the necessary ingredients to make photography on paper an activity that can be called industrial. The public already had a taste for photography, and the prosperity of the Second Empire incited people to consume—recreationally and narcissistically—to excess. The eminently popular inventions of the stereoscope (1851) and the carte-de-visite portrait (1854) arrived at just the right time to stimulate sales. The profession, which previously harbored only modest financial ambitions, experienced a sudden massive influx of money.

This taste for photography was obviously an epiphenomenon of the more general explosion in the arts, bolstered by official commissions, the growth of private collections, the construction projects of the empire, and the Universal Expositions. Escaping from its circle of aesthetes, scientists, and the curious, photography became an investment opportunity, and financiers placed their bets on its future and on its most talented practitioners. The favor of the court—of the emperor himself—distinguished a few studios. Finally, from the increasing fervor of the columnists, it is clear this was a true Parisian fashion. The brief period of sudden adoration that was showered upon the medium corresponds precisely to the years when Le Gray was working on the boulevard des Capucines.

Just as abruptly at the end of the decade, however, a veritable rejection by the elite once again left photography, for a time, to the middle class, the technicians, and the scientists, who from 1860 through 1880 provided it with a more solid prosperity. This reversal precisely coincided with Le Gray's fall. Baudelaire sounded the alarm in 1859 in his lampoon *The Modern Public and Photography*, which is too often read as the isolated testimony of a frustrated aesthete exasperated by the irresistible triumph of photography and not often enough as an early sign of a more general distaste. A parallel can be drawn here to a note that was more modest but even more explicit in its dryness, written by Champfleury to Alcide Dusolier on August 24, 1860, when Le Gray had just left France for good. After the alarm bell, a death knell: "M. Burty, who has been handling the market for photographs, must have told you, and I charge you with repeating this to M. Bresdin, that photographs are not salable. The curious, the collectors, and the artists loathe this inept art."[2]

1 E. A. McCauley, *Industrial Madness: Commercial Photography in Paris, 1848–1871* (New Haven and London, 1994).
2 P. Lafargue, *À la recherche de la vérité à travers les mythes et légendes de la vie de Rodolphe Bresdin* (Bordeaux, 1969), 10. Thanks to Maxime Préaud for informing me of this document. Philippe Burty was a well-known critic, and Rodolphe Bresdin was an engraver, who must have rejoiced as much as, if not more than, his colleagues at the discrediting of the competitive medium.

3 Death of Jean-Martin Legray, age eighty-seven, on January 25, 1855, at 7, chemin de ronde, barrière de Clichy, Archives of Paris, reconstructed vital statistics.
4 E. P. Janis, *The Photography of Gustave Le Gray*, exh. cat. (Chicago and London, 1987), 100.
5 Liquidation of M. Legray's estate, February 28, 1855, Departmental Archives of Val-d'Oise, 2 E 21077.
6 F. Robichon and A. Rouillé, *Jean-Charles Langlois, la photographie, la peinture, la guerre: Correspondance inédite de Crimée (1855–1856)* (Nîmes, 1992), 159.
7 *Revue photographique*, no. 4 (February 5, 1856): 51. In September 1856, the magazine mentioned "MM. Le Gray et Cie."
8 See the briefs from the lawsuit against M. and Mme Tarbé des Sablons in 1834 and, in 1855, the Le Roy de Chabrol Bank (in bankruptcy), where he had deposited nearly 400,000 francs, Bibliothèque nationale de France (BNF), L&A, 4° FM 181 (4469 and 4470).
9 There remains no trace of this partnership in the incorporation records (Archives of Paris), nor in the records of the marquis's only known solicitor (Yver). It is possible that the document already included the marquis's sons, but the new document, drawn up after his death, leads us to suppose the contrary (see next paragraph). Thanks to Dominique Barjot for explaining the legal conditions for forming a limited partnership, and Marc Durand for verifying the records of the Central Paris Solicitors' Archives.
10 The lease was renewed in 1856 and 1858. For the lawsuit between the Briges brothers and Mme de Parazza over Nadar's studio, see *Gazette des tribunaux* (December 8, 1860), article kindly provided by Claude Schopp (see note 68).

The Move to Boulevard des Capucines

By 1855 the photography craze was in full swing. Le Gray, a prime example, bolstered by the financial support of high society and a beacon of the Société française de photographie, decided to move to boulevard des Capucines (fig. 99). Because his father's death came in January 1855,[3] there has been speculation regarding an inheritance that may have aided him to make this move.[4] However, the liquidation of the estate leaves no room for doubt: his parents' capital was insignificant. His mother, who would die in May 1861, meanwhile retained the income from what little remained, and in 1855 Le Gray himself received only a few hundred francs.[5]

Colonel Langlois confirmed, "He did not have a penny to put into it; all he had was debt."[6] So the money came from elsewhere.

99 Félix Nadar. *Studio at 35, Boulevard des Capucines, after 1860.*

Le Gray's commercial labels are sufficient proof of the formation of a company in the fall of 1855 (earlier than was believed before now); at that time, the labels bore the trade name "Gustave Le Gray et Cie." The magazine *Revue photographique* was more explicit; commenting in February 1856 on the opening of the studio, the magazine asserted that Le Gray had been "backed by a limited partnership."[7] It has now become clear: one hundred thousand francs in cash were made available to Le Gray by Barnabé Louis Gabriel Charles Malbec de Montjoc, the marquis de Briges, a former elected representative and wealthy landowner who had retired to his castle of Dampierre in Normandy. The marquis de Briges's fortune, which he had acquired through marriage, was considerable.[8] The limited partnership between the two men must have been the subject of a private contract, for no legal instrument seems to have been preserved.[9] The premises were leased in the name of the silent partner and intended for Le Gray "to practice the industry of photography there," in a lease (also private) executed on October 18, 1855, with the baronne de Parazza, the owner of the building.[10]

After the death of the marquis de Briges on April 17, 1857, his two sons, Marie Antoine Albert Malbec de Montjoc, the new marquis, and Ernest Charles Malbec de Montjoc, the comte de Briges, formalized the limited partnership, on August 19, 1857, in a new contract, also private, but this time recorded on August 28 at the commercial court.[11] It was expressly retroactive to October 1855, which tallies with a renewal of the initial limited partnership entered into with the father, and confirms its date. As for who introduced the old businessman and the young artist, Le Gray's contacts in Parisian high society were already sufficiently extensive for the introduction to have been made through any number of channels.[12]

The real estate negotiations for such a sought-after location were very tough. The building that was to accommodate Le Gray, and, shortly thereafter, the Bisson brothers, had just been built in 1854/55, and construction had not even been completed. Having received nothing but raw space, Le Gray completed the work in early 1856 at great expense.[13] As Nadar recalled:

> Le Gray was even less favored than our Bisson brothers. He did not even have to wipe down the plaster work, since for him, there was none; he had to provide it himself. They leased him, on that bare roof, only the place to put it—a patch of atmosphere, of open sky, from which he had to create his establishment, of fine and decent materials if you please, and duly weighed by the owner's architect, a most severe judge![14]

At least that way he got the floor of the building with the best light; the Bisson brothers, who had moved into the ground floor, had the advantage of display windows.[15]

Regarding these events on the boulevard—the setting up of these new studios—there is fortunately a series of accounts by a worthy eyewitness, the wife of Colonel Langlois.[16] Her husband was in the Crimea at the time, with his assistant, Léon Méhédin, a young photography student of Le Gray's, who was there to take photographs of Sebastopol. The name Le Gray was often mentioned in the wife's letters, since Mme Langlois was responsible for purchasing supplies from him, which she then forwarded to the Crimea. She commented at length on Le Gray's new facility, as well as that of the Bissons. On January 28, 1856, Mme Langlois wrote to the colonel:

> You have no idea how the desire for a quick fortune has spread and invaded everyone's minds. That is no doubt what has induced the Bisson brothers to open a magnificent shop for photography and objets d'art on the boulevard des Capucines, right next to Giroux. While passing by the other day, I noticed, above the Bisson brothers, the portrait studio of M. Le Gray.[17]

On February 22, she went up to Le Gray's studio to buy paper and collodion and commented, "His establishment is nearing completion and will be quite handsome."[18] If one is to believe her gossip, which is more valuable for providing the atmosphere of the time than for the actual details, the photographer was already having problems with his neighbors that perhaps foretold of things to come:

> He is good and trusting, and those are detrimental qualities in business. The Bisson brothers and M. Dollfus, who is their silent partner, asked his permission to rent out some space in the building, since his lease gives him the right to prevent them from doing so. They offered him the advantage of exhibiting in their display windows, in exchange for a small, undetermined payment. He gave his consent and, when they had obtained what they wanted, they demanded 25% of his sales. He refused, and the two establishments, instead of cooperating, are competing with each other. However, M. Le Gray says that this is nothing to him, and that he is certain of his success; I hope this is true, for he is, I believe, an upright and particular man.[19]

The time was right. The profession was booming, but space was expensive. The lithographer Alophe, who was also in the building, was affected by the contagion; on March 15, 1856, he asked Nadar for photography lessons, which he evidently couldn't request of his neighbors.[20] These were nevertheless watchful and Alophe soon wrote to Nadar again in frustration, "I have just been obliged by my vile landlord, at the request of *M. Le Gray*, to vacate the building where I had developed a clientele of sorts and where everything was going fairly well, after having surmounted quite a few problems."[21]

The result of Le Gray's expenditures, according to his contemporaries, was sumptuous. After months of work, the opening was hailed in the periodical *L'Illustration* with an enthusiastic report:

> Since photography has become an art, establishments devoted to such operations have necessarily had to adapt. The studio superseded the laboratory, and the studio was soon replaced by the salon. M. Le Gray has taken this even further and created quite the curiosity shop, with its richly adorned antechamber. From the center of the foyer, whose walls are lined with Cordoba leather, reminiscent of the rich Flemish interiors of Miéris and Metzu, rises a double staircase with spiral balusters, draped with red velvet and fringe, leading to the glassed-in studio and a chemistry laboratory. This staircase offers the interested visitor a *Moses Saved from the Waters,* a canvas painted in 1777 by François de Mura, and a Venetian mirror surrounded by a frame of carved wood, consisting of very handsomely modeled twisting cupids.
>
> In the salon, lighted by a large bay window overlooking the boulevard, is a carved oak armoire in the Louis XIII style, whose paneled doors depict various biblical scenes and conceal the multitude of drawers and secret cubbyholes that are the distinctive characteristic of that sort of furniture. Opposite, over the mantelpiece, is a Louis XIV–style mirror, curiously outlined and embellished with intaglios, the subjects of which are borrowed from the battles between European and Oriental cavaliers. Among the various paintings arranged on the rich crimson velvet hanging that serves as a backdrop, there is a portrait of Isabella the Catholic from the school of Bronzino. Another portrait of a Flemish woman is attributed to Mervelt. Lastly, on a Venetian table of richly carved and gilded wood, in mingled confusion with Flemish plates of embossed copper and Chinese vases, are highly successful test proofs of the eminent personages who have passed before M. Le Gray's lens, and of whom other tinted prints adorn the walls of a small boudoir adjoining the salon. However, the principal merit of the establishment is the incomparable skill of the artist [and] the invaluable natural illumination of the studio, where light comes to work under M. Le Gray's knowledgeable direction, like a diligent employee who hastens to his daily task at sunrise.[22]

11 Limited partnership of Le Gray et Cie, Archives of Paris, D31 U3, box 204, excerpt 2174.
12 Thanks to Claude Schopp for his assistance in researching the Briges family. Some details are provided in McCauley, *Industrial Madness,* 59–60. However, McCauley considers the 1857 document a deed of foundation, and he is supported in that by the *Bottin du commerce,* where the words "et Cie" do not appear prior to 1858.
13 Assessment rolls, Archives of Paris, D1 P4, box 184. The previous building was nearly entirely demolished in September 1854. Parcels 16, 17, 28, and 37 were leased to Le Gray.
14 F. Nadar, *Quand j'étais photographe* (1900; rev. ed., Arles, 1998), 93.
15 See B. Marbot, M.-N. Leroy, and E. A. McCauley, *Les Frères Bisson photographes, de flèche en cime, 1840–1870,* exh. cat. (Paris, 1999).
16 Robichon and Rouillé, *Jean-Charles Langlois.*
17 Ibid., 268.
18 Ibid., 270.
19 Ibid.
20 Alophe, letter to Nadar, département des manuscrits (MSS), BNF, NAF 24260, fols. 172–73, letter 97.
21 Ibid., fol. 175, letter 99; assessment rolls, Archives of Paris, D1 P4, box 184. Alophe leased parcel 17, he returned in 1857 to parcel no. 18 (see "The Final Year," this chapter).
22 *L'Illustration,* (April 12, 1856), reproduced in *Revue photographique* (May 5, 1856): 98–99.

23 Nadar, *Quand j'étais photographe*, 91. On the evolution of studio decor, see J. Sagne, *L'Atelier du photographe, 1840–1940* (Paris, 1984).
24 *Revue photographique* (September 5, 1856): 161–62.
25 H. d'Audigier, *La Vie de garçon: Souvenirs anecdotiques d'un chroniqueur parisien* (Paris, 1859), 255–57.
26 *Catalogue d'un mobilier . . . de Briges*, sale cat., (Paris, Hôtel Drouot, July 2, 1886).
27 "Courrier de partout," *Le Nord, journal international* (Brussels), no. 269 (September 25, 1859). Deepest gratitude to Xavier Demange for bringing this article to my attention.
28 Nadar, *Quand j'étais photographe*, 91.
29 Janis, *Photography of Gustave Le Gray*, 103.

This "artistic" interior, which would later be found at Nadar's studio, was still a novelty for a large photography studio. It must have been quite a contrast with the certainly noteworthy but less original luxury of the Bissons' studio (on the subject of their furnishings, Nadar especially recalled a large, circular, velvet, "primrose-colored" couch).[23] In September 1856 Le Gray spread out into the ground floor of the building:

> We were quite surprised the other day to encounter, on the boulevard des Italiens [*sic*], a photography boudoir crowded with admirers. To halt and captivate fanciers, Messrs. Le Gray et Cie have transformed a room on the ground floor of the building that houses their magnificent studios into a veritable boudoir, decorated with extreme elegance, incredible richness, perfect taste. We shall not stop here to describe the charming ornaments that are so artfully grouped. We shall remark only that, however brilliant and sumptuous, they take nothing away from the beautiful prints of photographic portraits that cover the paneling and do the greatest honor to M. Le Gray. As we watched him embark on this gigantic enterprise, we must admit, we trembled; today, we are virtually reassured.[24]

Henry d'Audigier, columnist for the newspaper *La Patrie*, when publishing his memoirs in 1859, situated the misadventure of a naive private at that address:

> On April 13, a young soldier appeared at the establishment of Gustave Le Gray, photographer to the emperor, whose studio is located on the boulevard. Upon opening the door, he gave a military salute and halted, as though bedazzled by the luxury of the premises. He seemed to say to himself:
>
> — I am in the wrong place. It is too beautiful here; I should like to go away.
>
> But a brown-haired young man, dressed in an elegant blue suit with gold buttons, approached the fusilier and inquired as to the reason for his visit with very engaging courtesy.[25]

Let us leave the young serviceman to his tribulations and take away from this episode only the journalist's penned image of Le Gray's studio as the epitome of Parisian luxury, capable of stupefying a passing provincial.

The furnishings, whether originally paid for by Le Gray or by the marquis de Briges, seem to have been kept, at least in part, by the marquis's two sons after the liquidation: in July 1886 the sale catalogue of the comte de Briges's "artistic furniture"[26] contained a number of items whose descriptions make this a near certainty.

If this is a mere coincidence, a reflection of the taste of the period, it can be said nonetheless that the studio was furnished with exactly the same extravagance as the salons of the photographer's wealthy sponsors.

A final, unmistakable, and distinguishing sign of the trendy portraitist: society gossip with a whiff of scandal, involving a well-known lady. This was reported in 1859 by the periodical *Le Nord*, in its Sunday column, "Letters from Everywhere"; in it, the anonymous Nemo, chronicling the carte-de-visite fad, begins by relating an event that was already fairly old news, which can be dated to around 1856:

> The first to thus scatter her person like petty change to the four corners of Parisian society was a very beautiful blonde, now somewhat ageless, who had her portrait taken by the eminent artist Gustave Le Gray, in twenty-five poses and twenty-five different costumes. From a ball gown to intimate dishabille. How much or little you knew her determined how much or little she was decked out in the photograph she gave you.[27]

Alas, no picture of the blonde has yet been found to confirm this anecdote.

A Portrait Studio

From 1856 through late 1859, in a Paris that had become the international rendezvous for wealth, the arts, theater, and the demimonde, Le Gray's lavish salons were indeed in vogue. Nadar witnessed the influx of a literary and artistic clientele at boulevard des Capucines—a clientele that matched his own—and, before the dissolution of their company (in the spring of 1857), the Bissons also had their share:

> It was in truth like a rendezvous of Paris's intellectual elite: Gautier, Cormenin Louis, Saint-Victor, Janin, Gozlan, Méry, Préault, Delacroix, Chassériau, Nanteuil, Baudelaire, Penguilly, the Leleux brothers—Everyone! . . . And all of these individuals of high estate, on leaving the Bisson brothers' establishment, finished their rounds by trekking upstairs to the studio of the portraitist Le Gray.[28]

This clientele cherished by Nadar was not the only one, however, as witnessed by existing portraits. In 1987, when Eugenia Parry Janis broached the topic of Le Gray's studio portraits, she was able to establish and lament only the small number of known prints.[29] Since then, enough of them have been found to confirm what had only been a hunch: his clientele was, above all, wealthy,

aristocratic, and international. There was Olympe Aguado (fig. 292); the superintendent of fine arts, the comte de Nieuwerkerke (fig. 112); Horace de Viel-Castel (fig. 100); Prince and Princess Menchikov; Princess Branitska; Princess Czartoryska; Countess Pzedestka; Mlle Troubetskaïa; the Duke of Hamilton and his sons; Sykes, an "English gentleman," and his children; the son of Prince Murat; Prince Danilo of Montenegro (fig. 101); Princess Clotilde; the ambassador of the Ottoman Porte, Fuad Pasha (fig. 102); the viceroy of Egypt, Saïd Pasha; President Mesnard; Baron Gros; the papal legate, Cardinal Patrizzi (fig. 103); and the former bishop of Troyes, Monsignor Coeur. Alongside these, supplementing Nadar's testimony, were writers and journalists: Alexandre Dumas, Victor Cousin (fig. 104), Roger de Beauvoir, Édouard Fournier, d'Audigier, Henri Delaage, Théodore de Banville; and finally, artists, musicians, and actors: Rossini, the pianist Frédéric Brisson, the mime Charles Deburau, the architect Émile Trélat (fig. 170), actresses such as Mlle Doze (the wife of Roger de Beauvoir),

100 Gustave Le Gray. *Portrait of Horace de Viel-Castel*, ca. 1856.

101-103 Engravings after Le Gray: Prince Danilo of Montenegro, Fuad Pasha, and Cardinal Patrizzi (from *L'Illustration*, June 12, 1858; July 10, 1858; and July 12, 1856, respectively).

30 Collection of the Institut catholique, Paris.
31 As we note from the prints that have come to us framed.

Mélanie of the Délassements-Comiques (a comedy troupe) (fig. 109), Alice Théric, Cornélie Arnold, and Judith Lion. The list includes many more "ordinary" customers, such as Dr. Barth (1806–1877)[30] and Mme de Séverac. In addition to these, there were those close to Le Gray: his wife, his children (figs. 7, 8, and 107), his early companion Mestral (fig. 67), and his attorney friend Léon Maufras (figs. 108, 177).

So the establishment on the boulevard des Capucines was, first and foremost, a portrait studio. There, Le Gray adopted a fairly uniform style, abandoning the paper negative in favor of the collodion-on-glass negative, which was better suited to commissioned portraits, and the salted paper print in favor of the albumen print, which was easier and faster, with less-varied color tones, but offering more interesting possibilities with respect to density of hue and chiaroscuro.

It is in this context of adapting artistic demands to commercial constraints that we should analyze a particular aesthetic choice: that of the oval-shaped portrait. In these, only the face and the outline of the head were sharp, while the décor was reduced to a fragment of a seat or a bit of a carpet, with the whole surrounded by a soft halo. The overall tonality was light, soft, and flattering to the sitter; and the abundance of white easily allowed the portrait to be enhanced with watercolors or oils, if the customer so desired. This shape was intended for an oval frame, generally bordered by a gilt fillet, with a cream-colored mat edged in gold.[31] It is known that the oval format was subsequently widely used for commercial portraiture, and that it survived until the middle of the twentieth century, to such an extent that it is now perceived as a sign of banality or even mediocrity. That is undoubtedly why it is rarely mentioned that even Nadar used it during his early period, when he did his best portraits.

It has long been agreed that known prints of rather mundane portraits are unworthy of Le Gray's talent. It is undeniable that some of them are hardly convincing, products rather than creations, smacking of studio routine. It has yet to be determined what part Le Gray played in their making, aside from the ethical responsibility conferred upon him by the trade name of "Le Gray et Cie." It is possible to plead that he was often absent from boulevard des

104 Gustave Le Gray. *Portrait of Victor Cousin*, ca. 1856 (cat. no. 163).

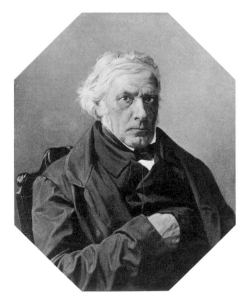

105 Henri Lehmann. *Portrait of Victor Cousin*, oil on canvas, 1868.

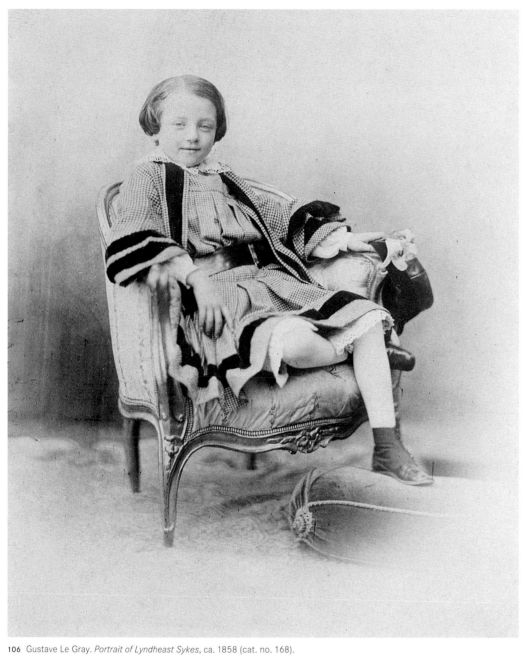

106 Gustave Le Gray. *Portrait of Lyndheast Sykes*, ca. 1858 (cat. no. 168).

107 Gustave Le Gray. *Portrait of Alfred Le Gray*, ca. 1858.

108 Gustave Le Gray. *Portrait of Léon Maufras*, ca. 1857–1860.

Capucines during these years, spending long weeks on the coasts of Normandy, Brittany, and the Mediterranean, or at the camp at Châlons. However, whether he was present or not, many portraits must have been made by his assistants, using the conventions and techniques considered to be a trademark of the company, whose clientele was predominantly satisfied. Nadar and Disdéri did no differently. Conversely, it would not be right to seek to reassure ourselves by attributing all of the rubbish to employees and only the successes to their master.

Fine successes there were, indeed. Their poses, calculated for the oval format, are most often simple and graceful. Young Lyndheast Sykes, seated in a Louis XV armchair with the smiling spontaneity that one associates with childhood, holding his little cap and a big white lily in his hand, is a spirited gem of a society portrait. As for young Mélanie of the Délassements-Comiques, the look she has of being slightly lost in her lace finery gives her a touching air of delicacy (fig. 109), a far cry from the crudeness suggested by the theater where she performed; it is tempting to compare this to Nadar's portrait of the dancer Finette, draped in a paisley shawl.

By doing this kind of studio portrait, in large format only, Le Gray completely abandoned the style he had used at the barrière de Clichy—salted paper prints from paper negatives, prints that were sophisticated in color choice—in favor of an excellent product of his own invention. This meant not conforming with the current norm of commercial portrait photography but rather resigning himself to a calculated compromise, giving up neither the pictorial references of the pose nor the theory of sacrifices.

His haste, use of assistants, and standardization are primarily explained by a concern for profitability mandated by his heavy investment. The requirements of his partners, as stipulated in the instrument of incorporation in August 1857, theoretically allowed the artist but little room to maneuver. Le Gray was to turn over all profits from sales of the photographs, except "a monthly deduction limited to 300 francs for his personal needs."[32] The studio's account books and the liquidation records have, unfortunately, been lost; we are therefore confined to suppositions. However, we will later see that Le Gray did not comply with the provisions of the limited partnership. How could he? The initial investment in construction and improvements must have been very heavy. His staff was large; in addition to the brown-haired young man with the gilt buttons described by d'Audigier, a group portrait[33] shows that the

32 Excerpt from the records of the commercial court, February 1, 1860, Archives of Paris, D31 U3, box 219, excerpt 437.
33 Private collection.

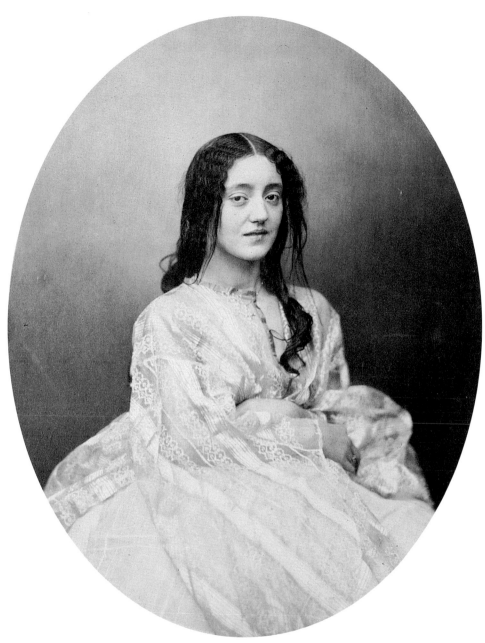

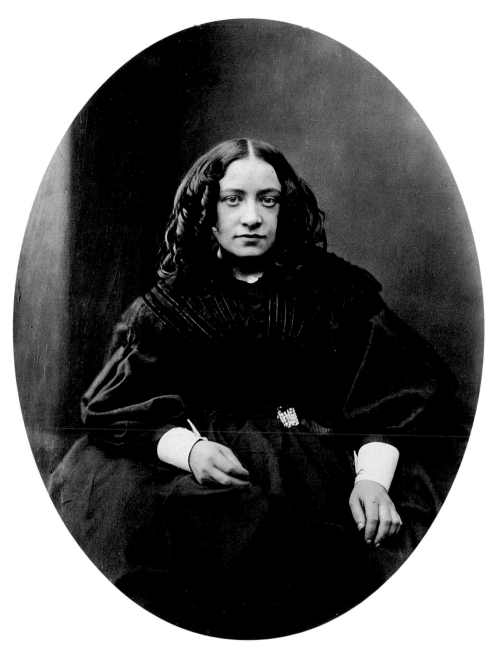

109 Gustave Le Gray. *Portrait of Mélanie, of the Délassements-Comiques*, ca. 1856–1858.

110 Gustave Le Gray. *Portrait of a Woman*, 1860.

111 Gustave Le Gray. *The Darkroom Staff*, ca. 1857/58.

112 Gustave Le Gray. *Portrait of Émilien de Nieuwerkerke*, 1859 (cat. no. 170).

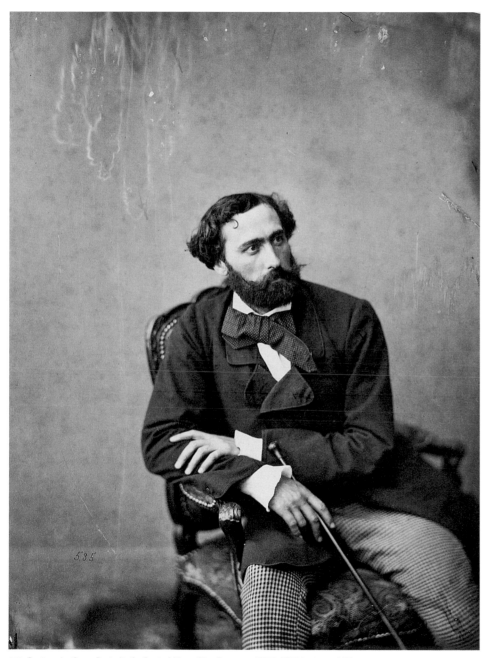

113 Gustave Le Gray. *Portrait of a Seated Man with a Cane*, ca. 1857–1859 (cat. no. 167).

114 Gustave Le Gray. *Portrait of Victor Cochinat*, ca. 1855 (cat. no. 164).

115 Gustave Le Gray. *Portrait of a Young Girl*, ca. 1857–1859 (cat. no. 169).

finishing workshop alone employed a half dozen young people (fig. 111). There may have been at least twenty people on the staff, as a whole, which added all the more to the operating expenses.

Personal Work: Fontainebleau and the Seascapes

Nevertheless, Le Gray did not shut himself away in his studio. He continued his personal work, true to his desires and to his past subjects, but with updated techniques and formats, due, at least partially, to more pressing commercial ambitions.

Up to this point, as noted earlier, the bulk of his production consisted of high-quality paper negatives and salted paper prints, closely related to his chemical research. Around 1855/56 he clearly abandoned experimentation in favor of exploiting his accumulated know-how. He participated only now and again in the meetings and debates of the Société française de photographie, and he no longer published manuals; but he did exhibit, sell, and—above all—produce his most spectacular works, primarily using the collodion-on-glass negative that he had developed.

He continued to photograph the forest of Fontainebleau, but in an entirely different manner. His choice of subjects and camera angles tended toward simplification and refinement, limited to studies of individual trees, in their entirety or in detail. The strength of the framing, the larger format, the sensitivity and sharpness of collodion, the subtlety of the light whose slightest vibrations he captured, make these pieces the absolute reference standards of a genre that others, such as Quinet and Famin, would later expand upon with pleasing dexterity.

Above all, what made his reputation during that period were his seascapes, made only between 1856 and 1858—in 1856 on the coast of Normandy, in 1857 on the Mediterranean, and in 1858 in Brittany. The choice of such a subject could not have been a random one for a photographer who was simultaneously preoccupied with painting and chemistry. The seascape, a classic in painting, was not a new genre in photography but had yet to earn its patent of nobility. The choice of collodion, advantageous in large part because it shortened exposure times, allowed Le Gray to confront a subject that his use of the calotype had not allowed.

Among the earlier efforts were a series of daguerreotypes taken in 1851 by Cyrus Macaire in association with Warnod (fig. 123), which caused a sensation. "Notably, they produced views of rough

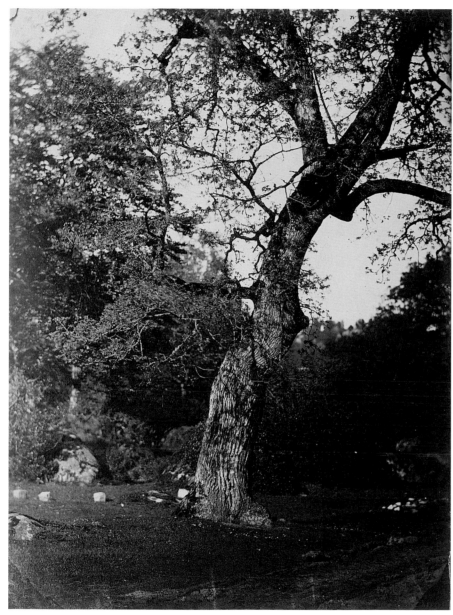

116 Gustave Le Gray. *Study of a Tree in a Clearing, Fontainebleau*, ca. 1855–1857 (cat. no. 98).

117 Gustave Le Gray. *Study of Tree Trunks, Fontainebleau*, ca. 1855–1857 (cat. no. 99).

118 Attributed to Gustave Le Gray. *A Rising Sandy Road, Fontainebleau*, ca. 1855/56 (cat. no. 96).

119 Gustave Le Gray. *Beech Tree, Fontainebleau*, ca. 1855–1857 (cat. no. 92).

120 Gustave Le Gray. *Old Oak Tree, Fontainebleau*, ca. 1855–1857.

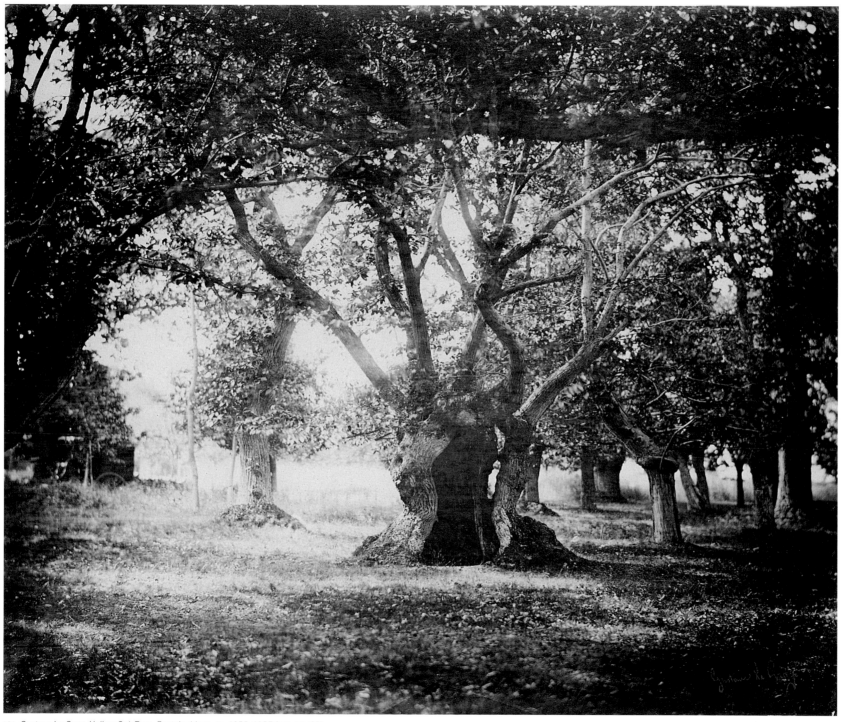

121 Gustave Le Gray. *Hollow Oak Tree, Fontainebleau*, ca. 1855–1857 (cat. no. 95).

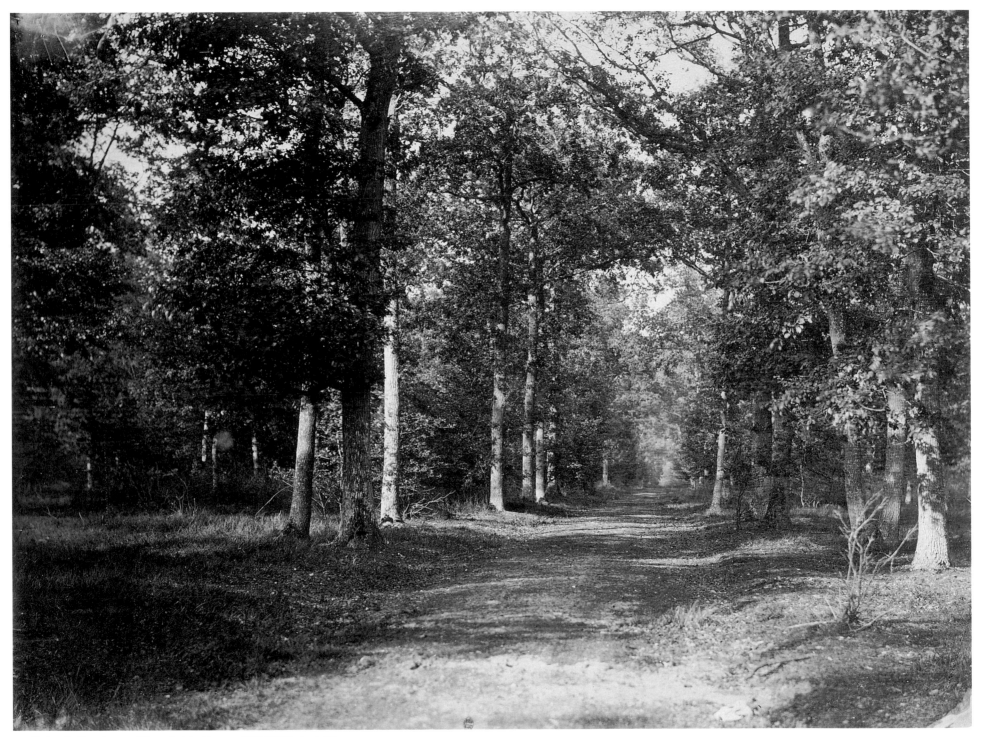

122 Gustave Le Gray. *Avenue of Trees, Fontainebleau*, ca. 1855–1857 (cat. no. 97).

seas, skies, moving ships, etc., which aroused astonishment and extreme interest."[34] Aimé Millet carried the news to Paris, and Francis Wey reported it. "M. Millet has just returned from Le Havre; he admired M. Macaire's surprising collection and personally acquired two subjects, which he showed to us." Seascape painters Gudin and Isabey purchased some also.[35] An enthusiastic recommendation by that same Gudin to the minister of fine arts in June 1852 resulted, the following year, in the acquisition by the government of thirty daguerreotypes of seascapes at the noteworthy price of one hundred francs each.[36] At this turning point, movement was simpler to capture on a daguerreotype than on paper. The paper negative and the glass negative were limited by their sensitivity, except in very small format. However, the daguerreotype remained a unique and costly image, and a subject as changeable as the sea did not lend itself to serial photography.

In March 1855 Cyrus Macaire again sold "two hundred miscellaneous photographs executed on paper, depicting studies of the sky, sea, ships, seascapes, etc.," for the price of four thousand francs.[37] In August 1856 there was another payment of five thousand francs, specifically for views taken during Queen Victoria's trip to France,[38] from which the lithographer Sorrieu made at least two prints: *The Disembarkation of H. M. the Queen of England at Boulogne* and *The Departure from Paris of H. M. the Queen of England*.[39] It would have been interesting to compare these with the photographs taken by Le Gray in Brest and Cherbourg in 1858, and with his seascapes in general, but the Macaire series is known today only through a few rare remnants of work in a small format (fig. 124). It is quite possible that these sizable orders from Macaire in 1855/56 gave Le Gray the idea of embarking on what may have seemed to him a technical and aesthetic challenge, as well as good business.

Luck or a stroke of genius in 1856 induced Le Gray to tackle this genre at just the right time. He made it a dazzling illustration of his skill with large-format collodion negatives, and his studio

34 File on acquisition of daguerreotypes of seascapes by Macaire and Warnod, National Archives, F²¹ 112.
35 F. Wey, "Des progrès et de l'avenir de la photographie," *La Lumière* (October 5, 1851): 139.
36 These daguerreotypes are not currently located; see file on acquisition of daguerreotypes, National Archives, F²¹ 112.
37 Expenses for acquisitions of works of art, fiscal year 1855, National Archives, F⁷⁰ 199. See also payment of 1200 francs for eighty "miscellaneous views," which may contain additional seascapes, expenses for acquisitions of works of art, fiscal year 1856, National Archives F⁷⁰ 201.
38 Regarding Baldus's commission during that same voyage, see *Édouard Baldus, photographe*, exh. cat. (Paris, 1995), 41ff.
39 Expenses for acquisitions of works of art, fiscal year 1856, National Archives, F⁷⁰ 202.

123 Warnod and Macaire. *Entrance to the Port of Le Havre* (image reversed by the daguerreotype), 1851.

124 Warnod and Macaire. *Entrance to the Port of Le Havre*, 1855–1856

40 *Journal of the Photographic Society* 3, no. 148 (November 21, 1856), 155. Regarding the seascapes, see K. Jacobson, *The Lovely Sea-View: A Study of the Marine Photographs Published by Gustave Le Gray, 1856–1858* (Petches Bridge, 2001). We do not subscribe to Jacobson's hypothesis that questions the attribution of these seascapes to Le Gray and assigns them to Macaire.
41 See cat. nos. 112 and 113, 111, and 123, respectively.
42 See S. Aubenas, "From One Century to the Next: The Fate of Le Gray's Work in Photographic Collections" (this volume).

provided him with the means for immediate distribution, as soon as his photographic series was completed. But beyond the amazing achievements of Warnod and Macaire in 1851, which he himself expanded on and transformed, he produced works of art by successfully transposing to photography a subject treated for centuries by Flemish, Dutch, French, and English painters, but in a manner that links him to Courbet and later to the Impressionists.

One could suppose that, at this time, a sojourn with his backer, the owner of the château of Dampierre in Calvados, may have facilitated his implementation of the project. An initial seascape, *The Brig* (fig. 128), was exhibited on November 6, 1856, in London at a meeting of the Photographic Society of London.[40] Among the other studies of the Normandy coast dating from that same year

are *The Sun at Its Zenith* (fig. 130), *The Haloed Sun* (fig. 131), and views of the beaches of Sainte-Adresse (figs. 138–140) and Cabourg (fig. 129), and of the port and museum at Le Havre (fig. 134).[41] The immediate success of *The Brig*,[42] in particular, and of that first series in general, undoubtedly allowed Le Gray to glimpse the possibility of reimbursing the Briges family and of pursuing his personal work while continuing to run his boulevard studio.

Fortified by his achievements, he took his camera to the Mediterranean coast the following year, taking advantage of the extension of the Bordeaux-Toulouse railroad to Sète.[43] For *Le Monde illustré*,[44] he photographed the inauguration of the Toulouse train station on April 2, 1857 (fig. 125), and then the one at Sète. Finally, he set up his tripod facing the sea. This second series

125 *Inauguration of the Toulouse-Sète Railway Line . . .* , engraving after a photograph by Le Gray, *Le Monde illustré*, May 9, 1857.

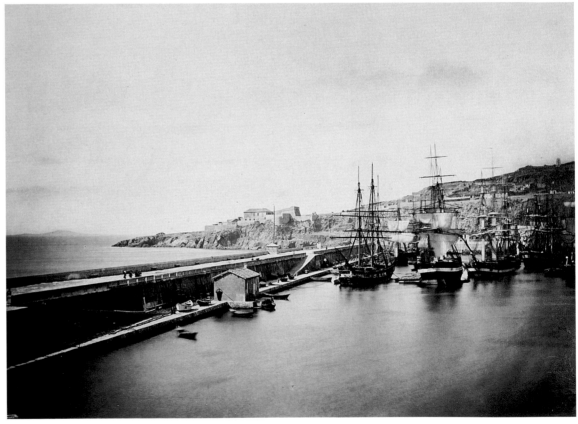

126 Gustave Le Gray. *The Jetty at Sète*, 1857 (cat. no. 130).

contains some of his most admired seascapes: *The Great Wave, Sète* (fig. 145); *The Breaking Wave* (fig. 144); and the views of Mount Agde; not to mention the numerous views of the port at Sète.[45] Once again, was this series done of his own accord or at the instigation of the marquis de Briges before the marquis's unexpected death in April of the same year? Or was it done to provide the heirs with renewed proof of Le Gray's abilities? If we reflect on the series that he produced in response to official commissions in France (the Mission héliographique and the camp at Châlons) and later in Egypt, it is tempting to speculate that this temperamental spirit never worked so diligently as when under external pressure, even with the most rigorous constraints.

The triumph of his seascapes in France and England in 1857 and 1858, the enthusiastic reviews, and the numerous purchases by admirers throughout Europe would indicate that Le Gray had finally found the balance between creativity and commerce that tormented the Bissons, Nadar, Disdéri, and several others. A columnist, writing on the novelties he had seen at the exhibition of the Société française de photographie—held, as it turns out, at 35,

boulevard des Capucines in 1857—gave top ranking to "the astonishing seascapes of M. Gustave Le Gray," about which he concluded, "We are not in the least surprised that these enchanted scenes are all the rage, to the point that their gifted creator has already received more than 50,000 francs in important orders."[46]

His work, which was particularly intense during this period, extended in several directions. First of all, his prior works became more popular than ever; his entire stock of negatives was being used in the studio, reprinted and signed, particularly the negatives from the Mission héliographique and the first Fontainebleau series. At the same time, he filled individual orders, the specifics of which are not always clear.

Without question, the most intriguing session from those years was a sequence of female nudes, all of the same model, including three images that are known today (figs. 148–150). The subject was a full-figured, brown-haired young woman, photographed once standing with drapery around her hips, lifting up her hair, and twice lying on a chaise longue, from the front and from the back. This was probably a special commission from an artist. In any event, the

43 At that time, spelled Cette.
44 *Le Monde illustré* (May 9, 1857): 8–9, engraving captioned "Inauguration du chemin de fer de Toulouse à Cette d'après une photographie de M. Le Gray."
45 Ibid. (May 23, 1857): 8–9, engraving captioned "La ville et le port de Cette," after a photograph by Le Gray (cat. no. 134).
46 *Revue photographique*, no. 16 (February 1857): 213.

127 *The City and Port of Sète*, engraving after a photograph by Le Gray, *Le Monde illustré*, May 23, 1857.

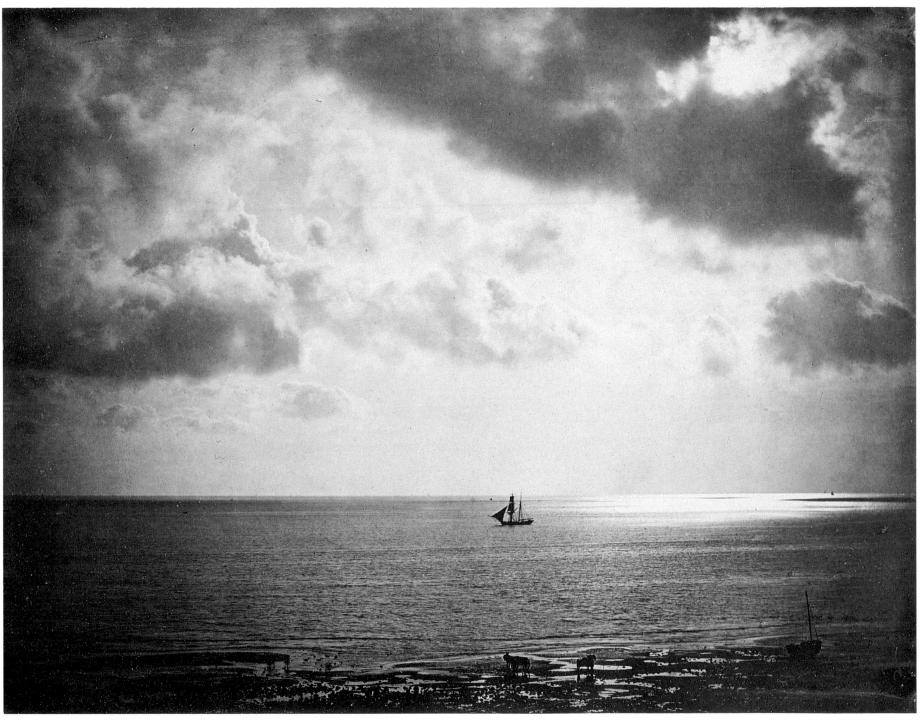

128 Gustave Le Gray. *The Brig*, 1856 (cat. no. 109).

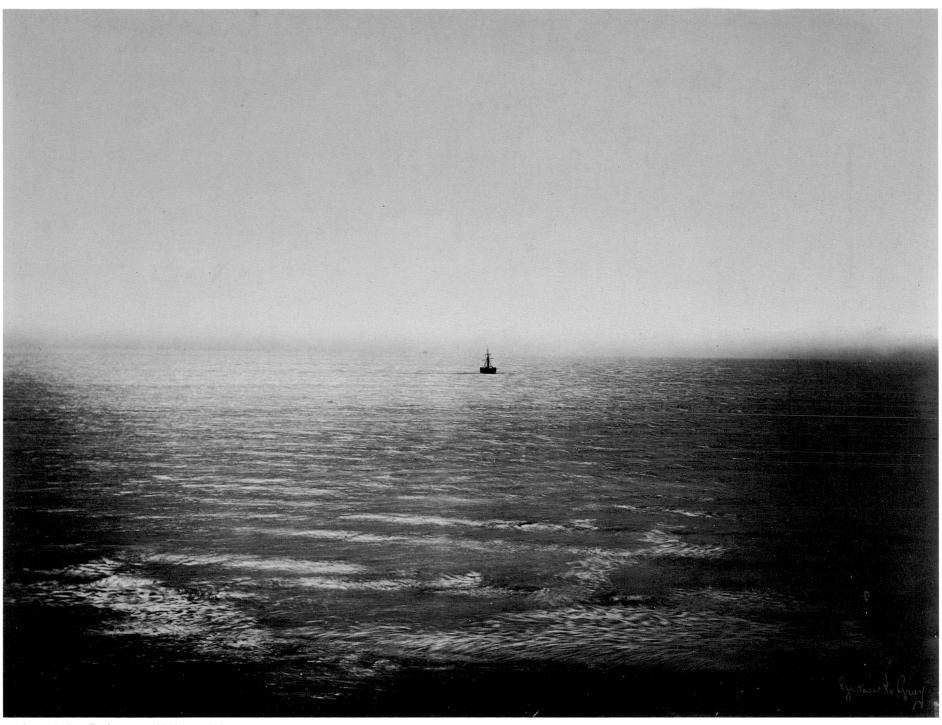

129 Gustave Le Gray. *The Steamboat*, 1856 (cat. no. 111).

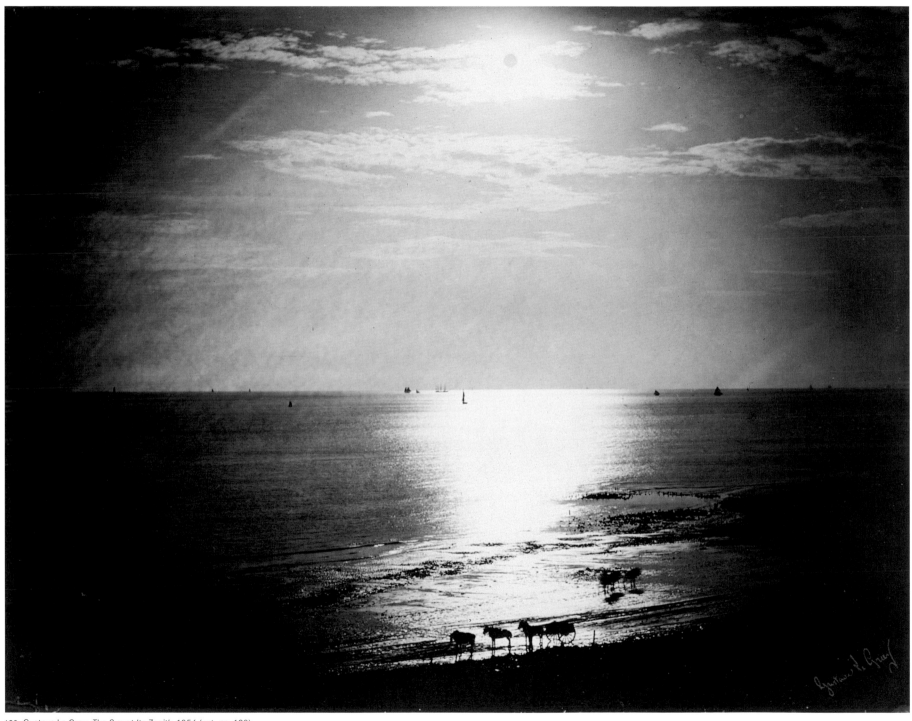

130 Gustave Le Gray. *The Sun at Its Zenith*, 1856 (cat. no. 120).

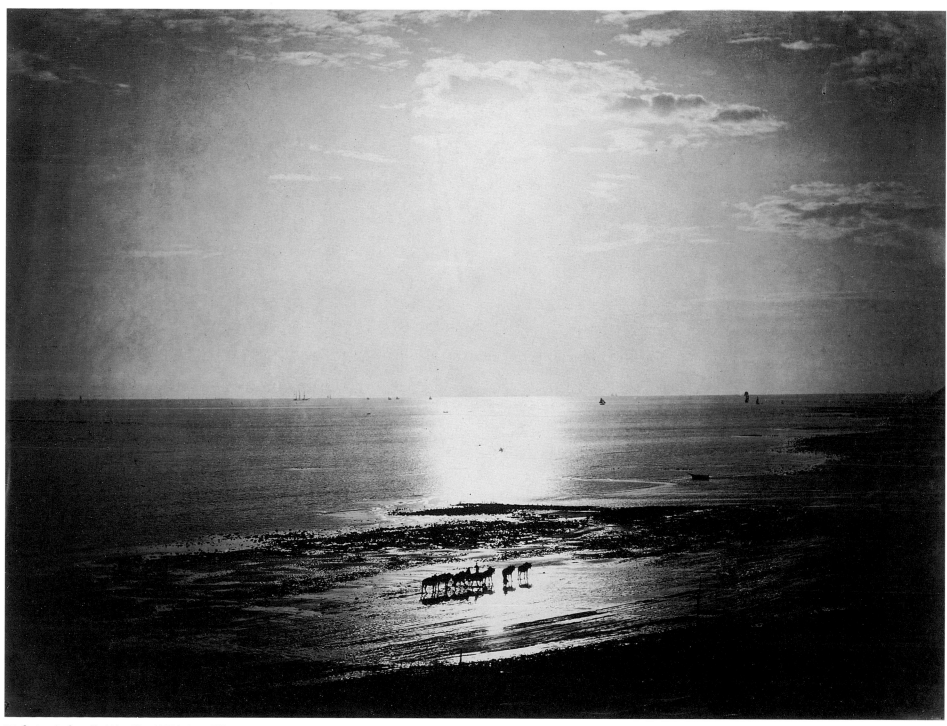

131 Gustave Le Gray. *The Haloed Sun*, 1856 (cat. no. 119).

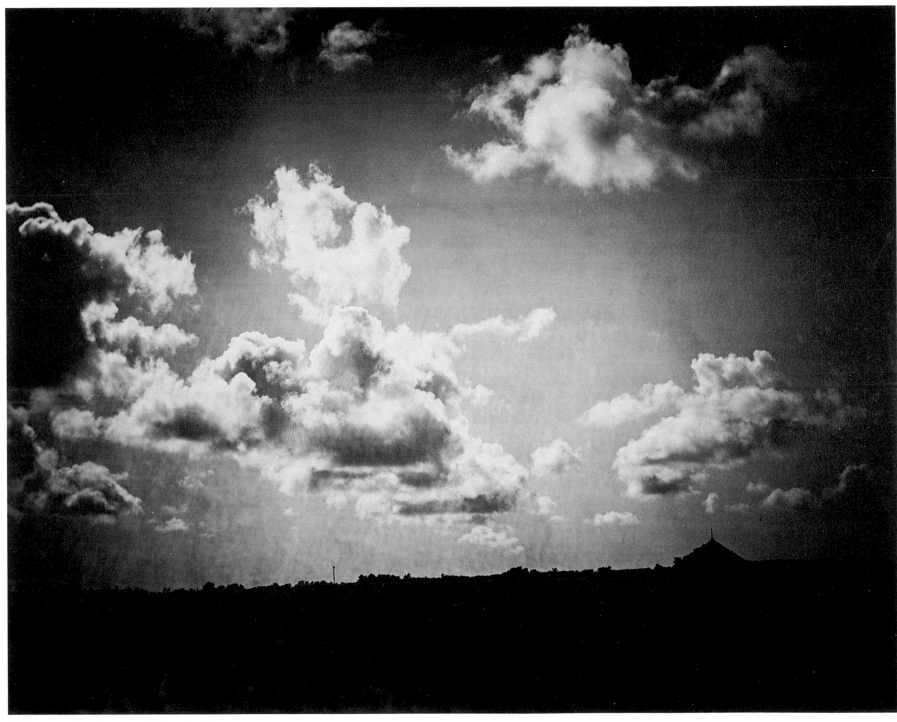

132 Gustave Le Gray. *Clouds*, ca. 1857 (cat. no. 141).

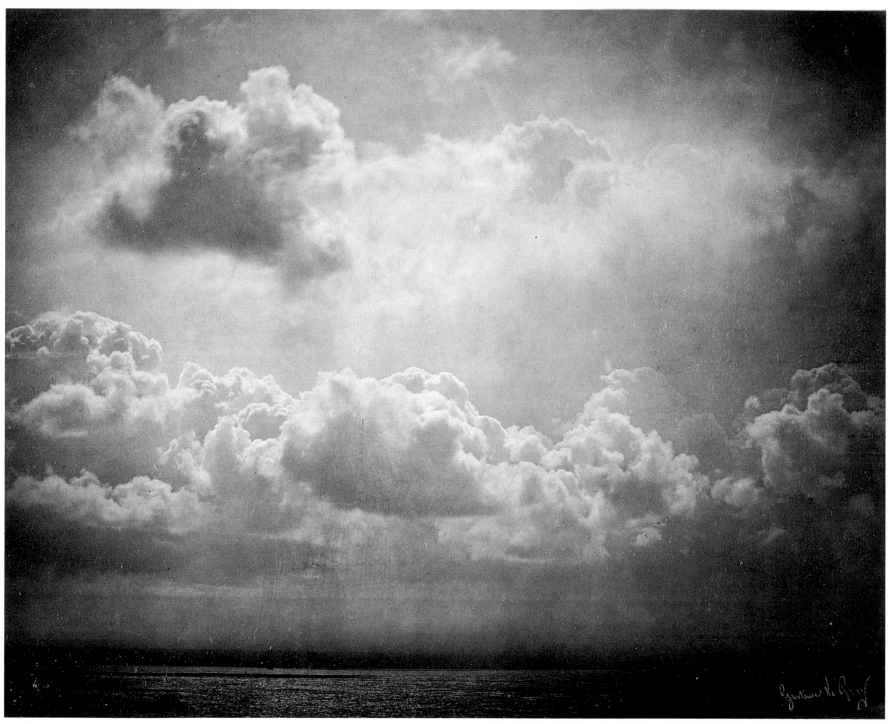

133 Gustave Le Gray. *Seascape with Cloud Study*, 1856 (cat. no. 117).

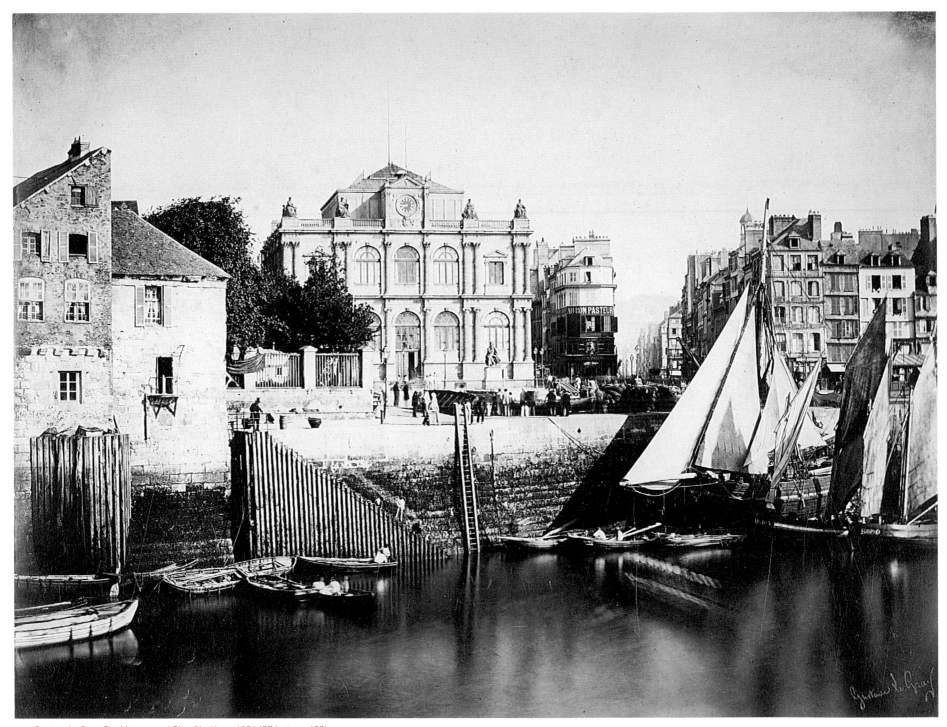

134 Gustave Le Gray. *The Museum and City of Le Havre*, 1856/57 (cat. no. 123).

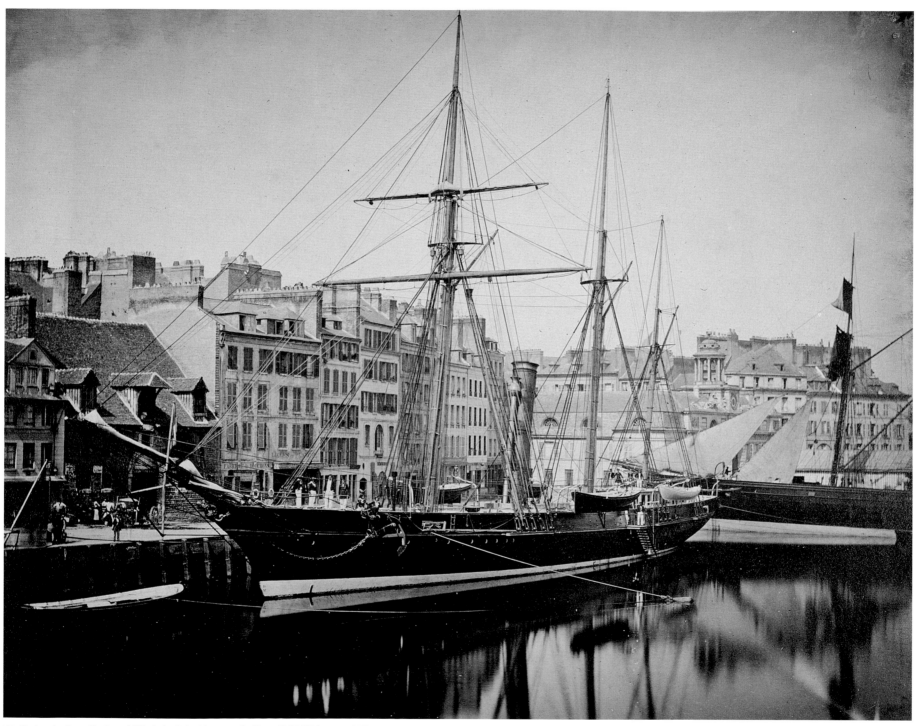

135 Gustave Le Gray. *The Imperial Yacht,* La Reine Hortense, *Le Havre*, 1856/57 (cat. no. 118).

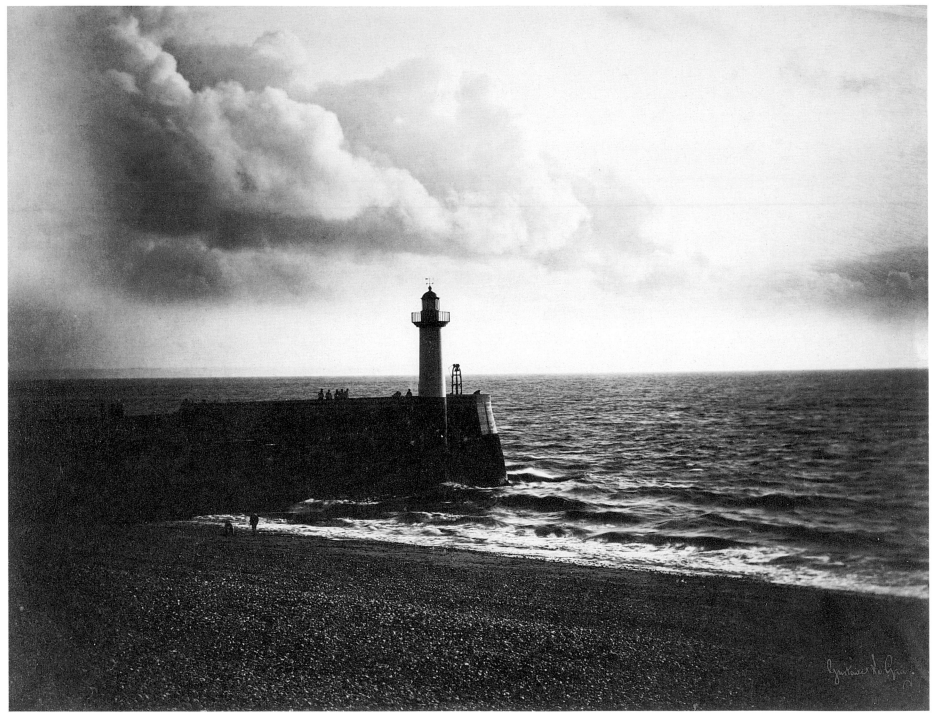

136 Gustave Le Gray. *Lighthouse and Jetty, Le Havre*, 1856/57 (cat. no. 124).

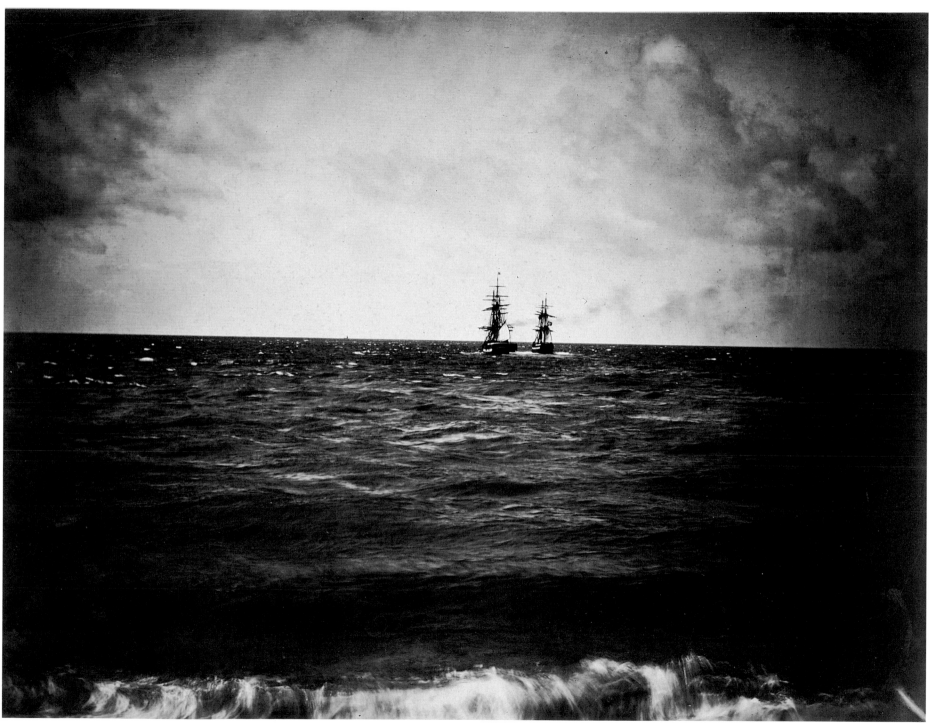

137 Gustave Le Gray. *Two Ships Heading Away from Shore*, 1856/57 (cat. no. 115).

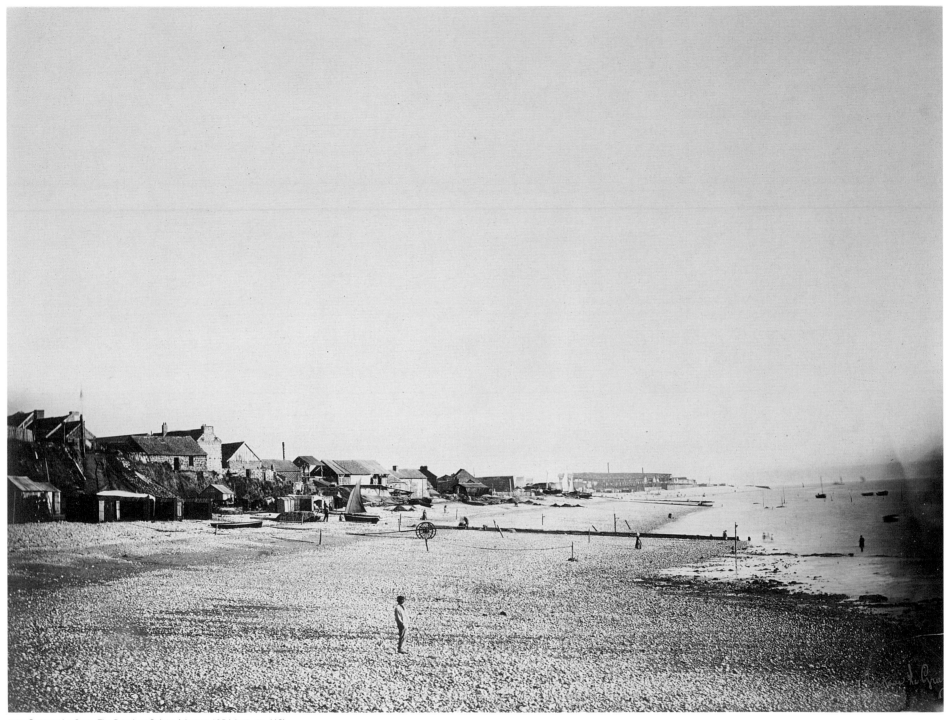

138 Gustave Le Gray. *The Beach at Sainte-Adresse*, 1856 (cat. no. 112).

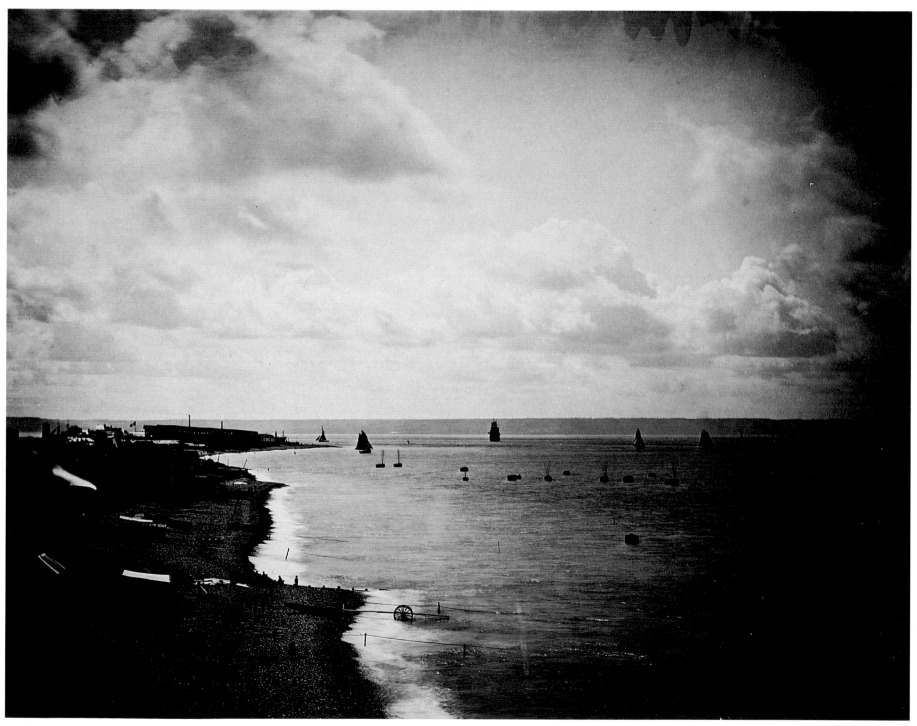

139 Gustave Le Gray. *The Beach at Sainte-Adresse, High Tide*, 1856 (cat. no. 113).

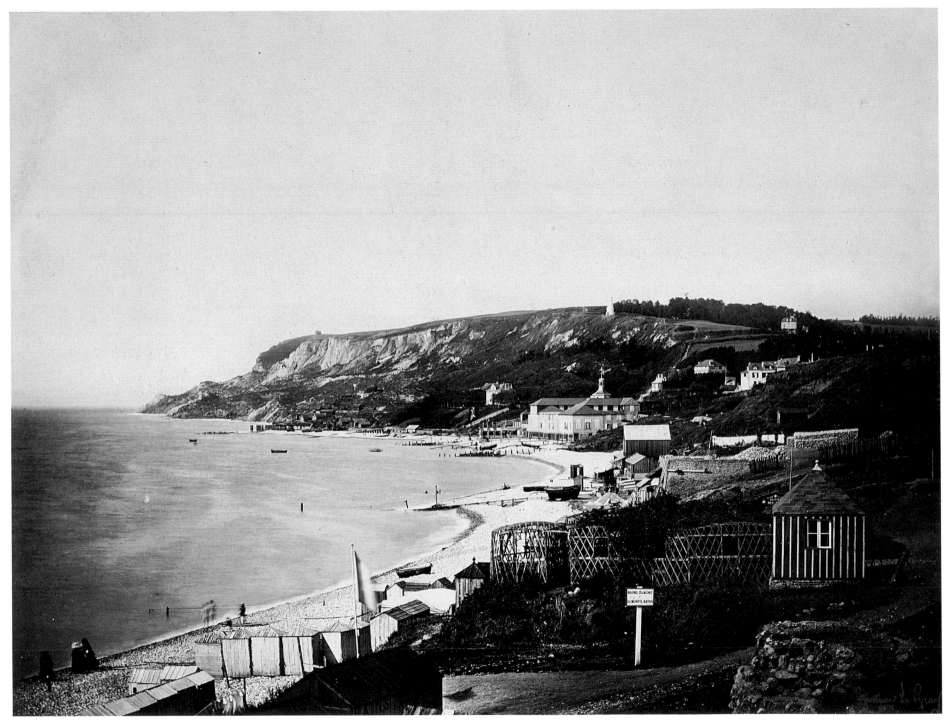

140 Gustave Le Gray. *The Beach at Sainte-Adresse, with the Dumont Baths,* 1856 (cat. no. 114).

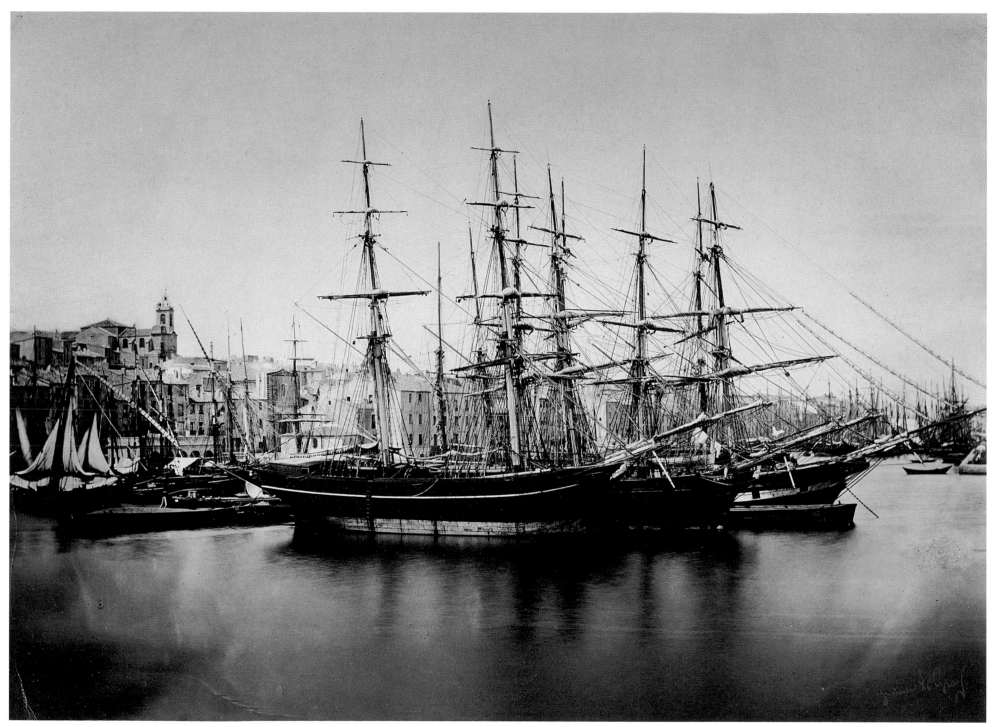

141 Gustave Le Gray. *Ships in the Harbor at Sète*, 1857 (cat. no. 128).

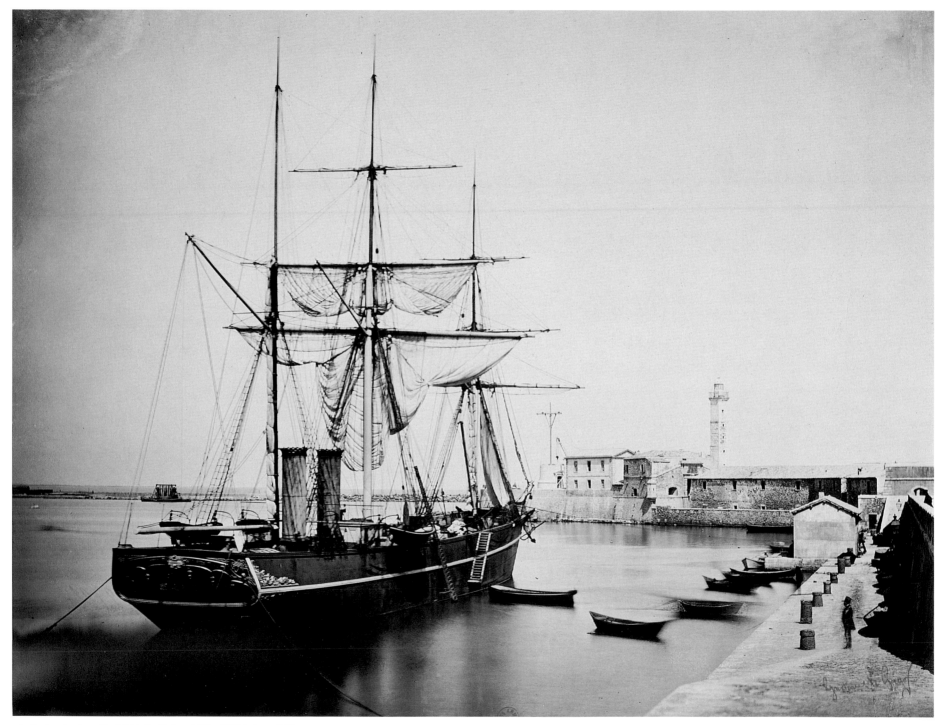

142 Gustave Le Gray. *The Saïd in the Harbor at Sète*, 1857 (cat. no. 127).

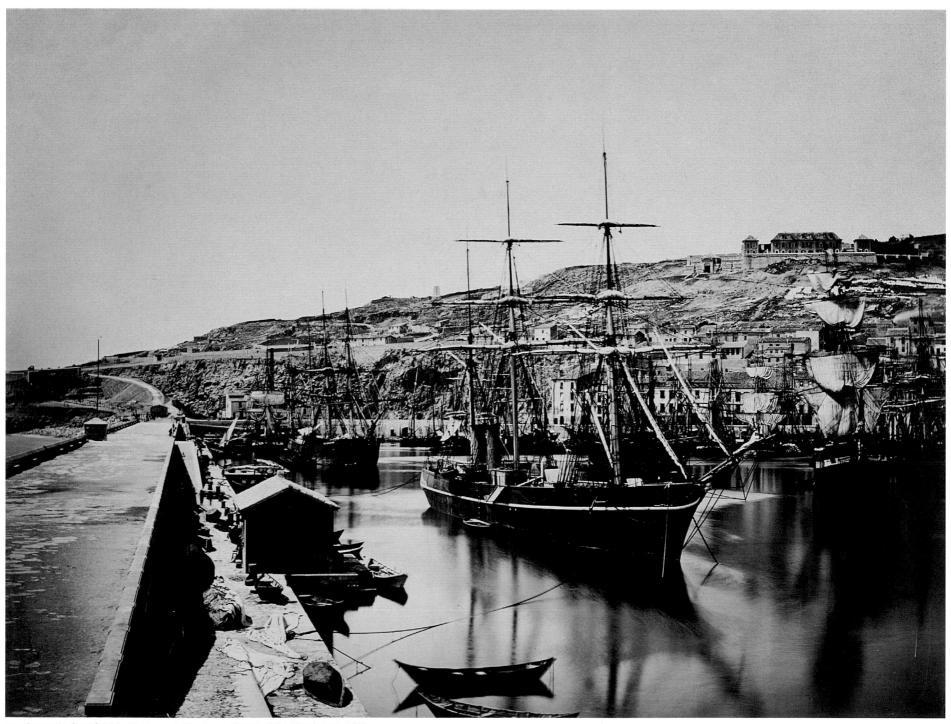

143 Gustave Le Gray. *Ships in the Harbor at Sète, Among Them the* Saïd, 1857 (cat. no. 129).

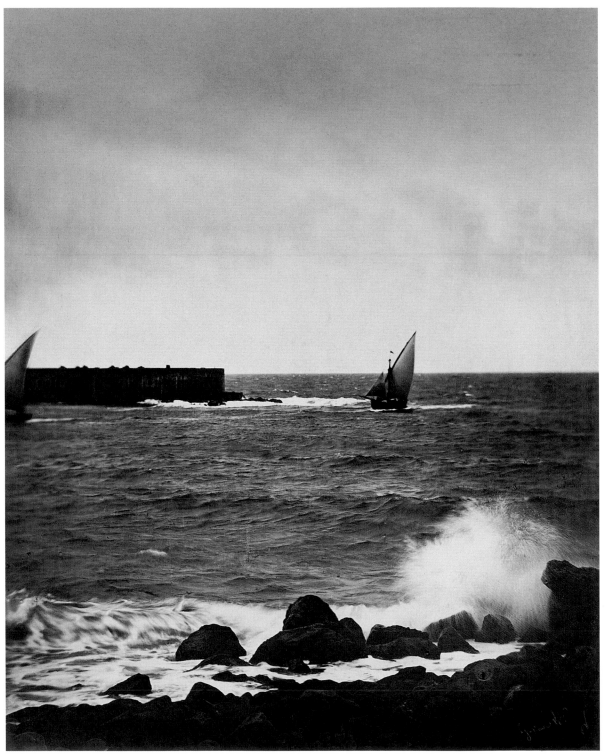

144 Gustave Le Gray. *The Breaking Wave*, 1857 (cat. no. 131).

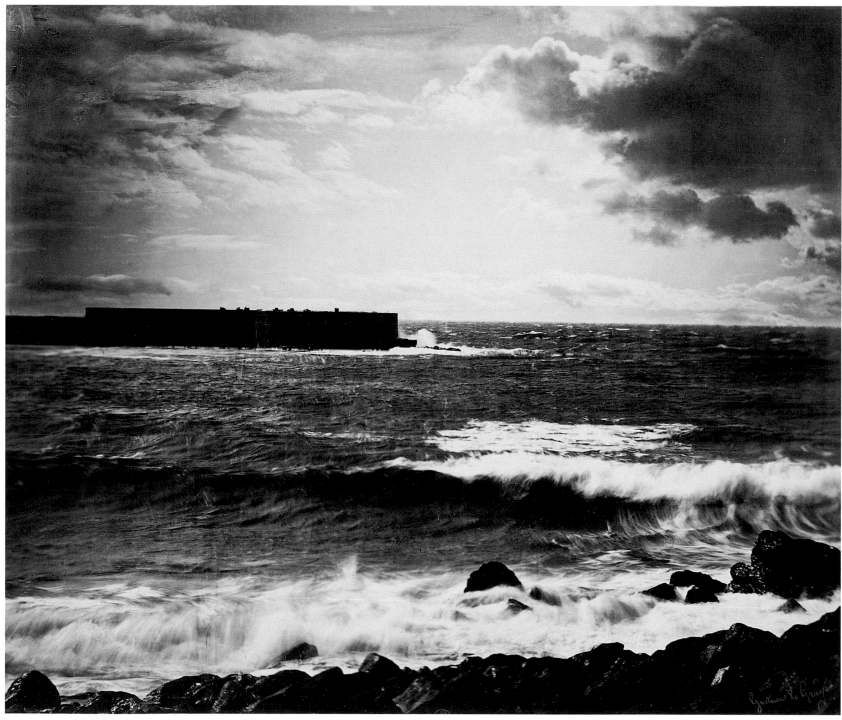

145 Gustave Le Gray. *The Great Wave, Sète*, 1857 (cat. nos. 133–136).

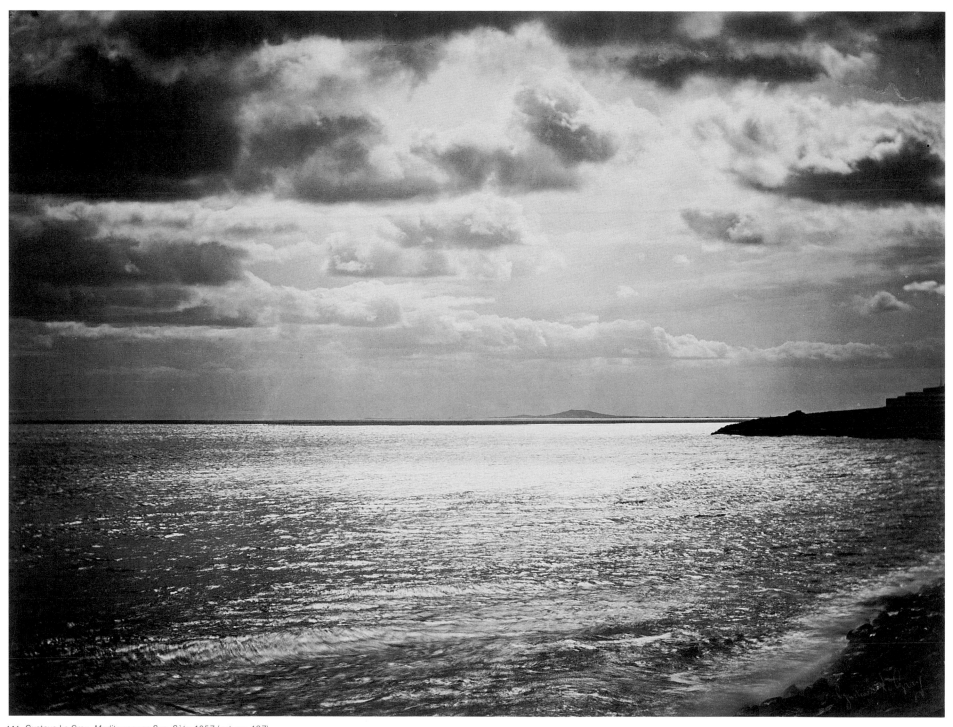

146 Gustave Le Gray. *Mediterranean Sea, Sète*, 1857 (cat. no. 137).

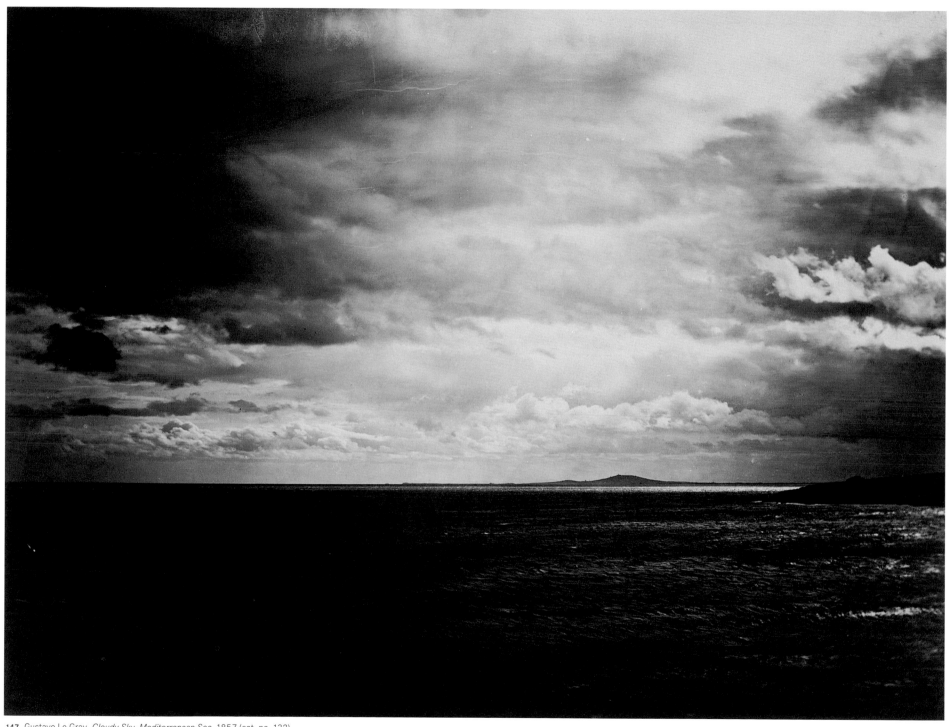

147 Gustave Le Gray. *Cloudy Sky, Mediterranean Sea*, 1857 (cat. no. 132).

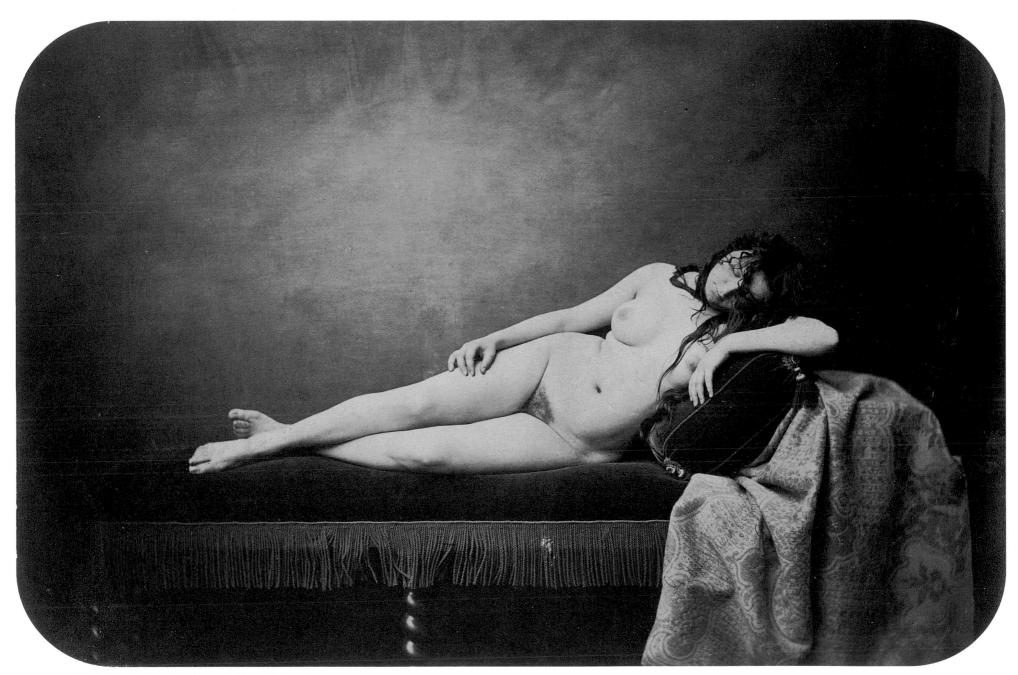

148 Gustave Le Gray. *Reclining Nude*, ca. 1856 (cat. no. 105).

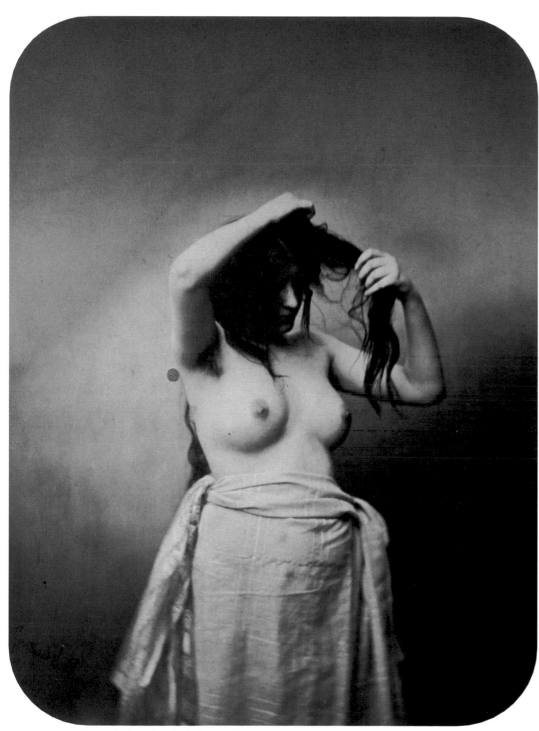

149 Gustave Le Gray. *Standing Nude*, ca. 1856.

negatives were not intended for commercial distribution. Had they been, they would have been subject to mandatory copyright registration in order to make it past the censors at the ministére de l'Intérieur. However, we cannot exclude the possibility of a personal exploration, an exceptional, spontaneous encounter with the genre of the nude—exceptional at least with respect to his extant works.[47] There is only one known print of each of the three images, but rarity, as with many photographs of the period, is not an indicator of the context of their creation. Attention should also be directed to a fourth nude from the same period but of a much more classical nature and using a different model. The image shows a frontal view of a young woman, standing on a flowered rug, with a white fabric stretched across the background (fig. 151). This is a more ordinary nude, indicating, at the very least, that Le Gray tackled all genres on request.

47 Sole precedent: the nude on the studio floor preserved in the album of Victor Regnault (see cat. no. 11).

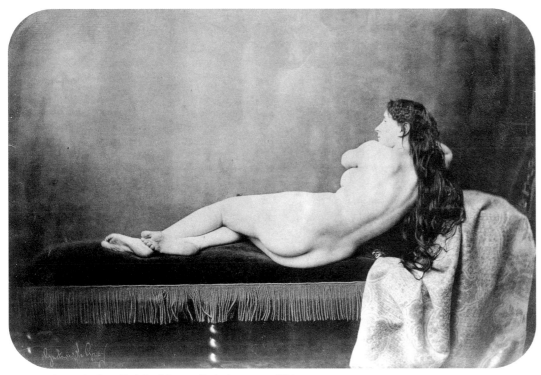

150 Gustave Le Gray. *Nude Reclining on a Chaise Longue*, ca. 1856.

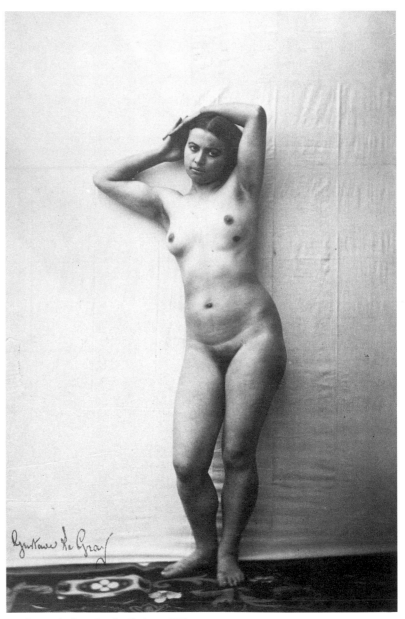

151 Gustave Le Gray. *Standing Nude*, ca. 1859.

Official Commissions:

The Baptism of the Imperial Prince **and the Camp at Châlons**

Gustave Le Gray also received commissions directly from the court. In 1852 he had photographed stages of the march toward the empire. In March 1856, after the marriage of Napoléon III to the beautiful Eugénie de Montijo (January 30, 1853), the preeminent dynastic event came to pass: a male heir was born. The baptism was celebrated at Notre-Dame de Paris on June 14, with all the appropriate pomp; and, to immortalize this solemn occasion, the painter Thomas Couture, a former student of Delaroche's like Le Gray, was charged with producing an important painting.[48] This work was not the sole commission but one of an imposing list of those given to the most renowned painters of the day to commemorate the significant civil and military events of the new reign. *The Baptism of the Imperial Prince* was one of a group of paintings of "the highest order," with respect to both the amounts budgeted (between twenty and fifty thousand francs) and the quality of the artists chosen (who included Winterhalter, Lehmann, and Vernet). The portraits of Empress Eugénie taken by Le Gray during the summer of 1856 at the château of Saint-Cloud (five are known)[49] (figs. 153, 156) were preparatory studies for Couture's large painting, which was never completed. Eugénie's pose exactly matches the one selected by the painter to be at the center of his composition. It seems that Couture commissioned and paid Le Gray for these studies, intended to avoid tedious posing sessions; Couture must have included their cost in the expenses that were amply covered by the imperial munificence.

In addition, there is a previously unknown photograph of the crown prince at just a few months of age, naked and asleep, his head on a cushion, a portrait no doubt taken under the same circumstances and for the same purpose (fig. 152).[50] Couture had chosen to depict a precise moment of the baptism, thus described by Mérimée to the empress's mother: "The emperor also seemed very happy, and when, after the ceremony, he picked up the kid and held him up in his arms to present him to the crowd, there was a moment of true enthusiasm."[51] The child, brandished by his father, was painted in approximately the same position as in Le Gray's photograph.

Having become close to the imperial family, whose interest in photography requires no further proof, Le Gray received a commission in 1857, the year when his seascapes and the fame of his studio carried him to the pinnacle of his career. No trace of this commission can be found in the archives, but it may have been instigated by the emperor himself. It consisted of documenting, in September and October 1857, the military camp at Châlons-sur-Marne, whose inauguration had just taken place on August 30. This training camp—intended by the emperor to correct the deficiencies in the organization of the French army that had become apparent during the Crimean War (1854–1856)—lasted as long as the Second Empire. The summer visits there by the imperial family were frequent and regular, but it was obviously the particular splendor of the inauguration that explained Gustave Le Gray's commission, as well as that of the painter Bénédict Masson:

> His Majesty charged those gentlemen with the photographic representation of the main military scenes of which the camp was the theater, along with a panoramic view of the camp, picturesque scenes of each of the guards' encampments, and portraits of the generals and field officers, both French and foreign, who were sojourning at the camp at Châlons, either as commanders or as guests of the emperor. . . . This collection of photographs will form a magnificent album, which the emperor, they say, will present to several generals.[52]

48 Miscellaneous, file 4, National Archives, F²¹ 487.
49 Three at the château de Compiègne, one in the Bibliothèque nationale de France (formerly in the Nadar collection), and one in the collection of Gérard Lévy.
50 Thanks to Mme Françoise Maison for her help in identifying the model.
51 P. Mérimée, *Correspondance générale*, ed. M. Parturier (Toulouse, 1941–64), ser. 2, vol. 2 (1955), 53 (letter of June 14, 1856).
52 C. Bousquet, *La Garde impériale au camp de Châlons en 1857* (Paris, 1858), 246.

152 Gustave Le Gray.
Portrait of the Imperial Prince, 1856 (cat. no. 104).

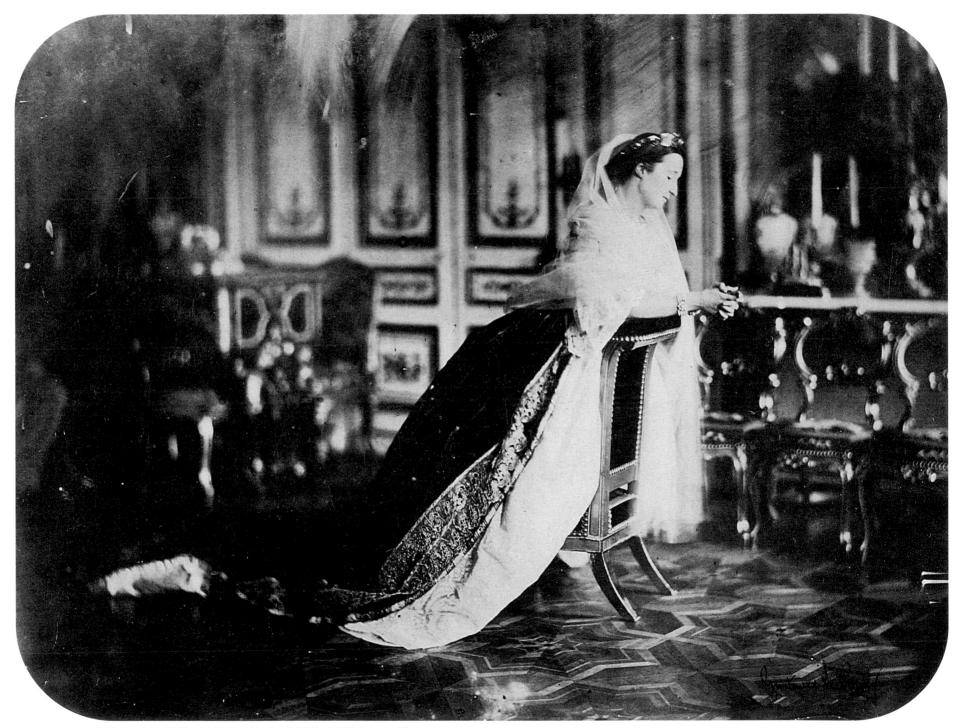

153 Gustave Le Gray. *The Empress Eugénie Kneeling, Saint-Cloud*, 1856 (cat. no. 102).

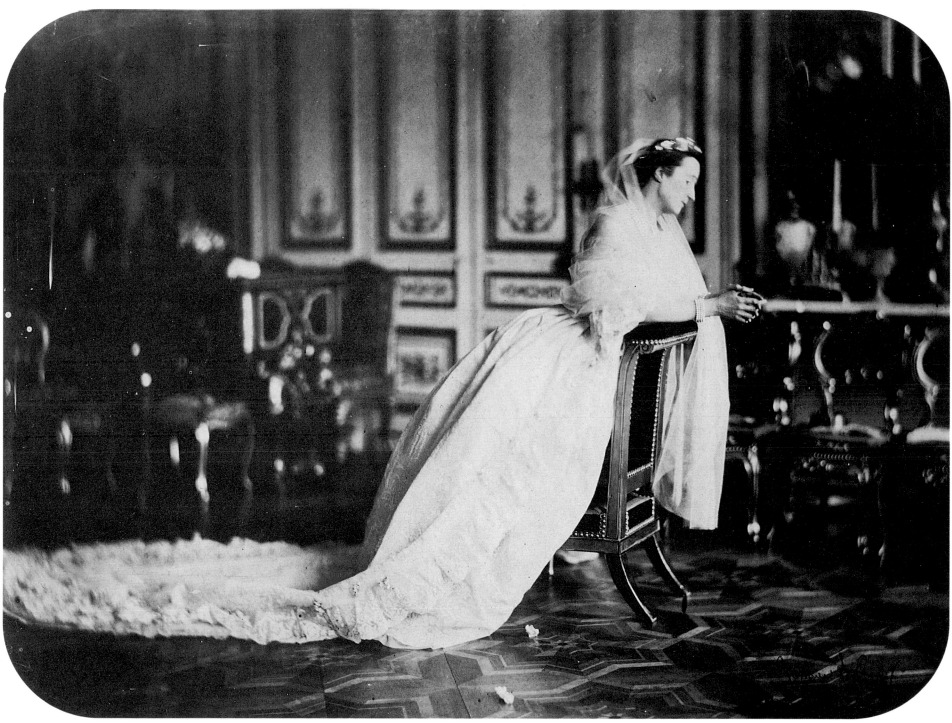

154 Gustave Le Gray. *The Empress Eugénie Kneeling, Saint-Cloud*, 1856 (cat. no. 103).

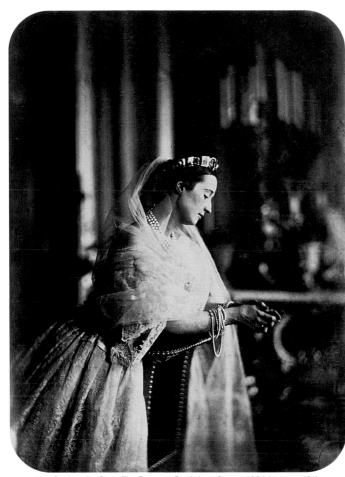

155 Gustave Le Gray. *The Empress Eugénie at Prayer*, 1856 (cat. no. 101).

156 Gustave Le Gray. *The Empress Eugénie at Prayer*, 1856 (cat. no. 100).

The *Revue photographique* confirmed that intention. "The other day, I saw, at the studio of one of our most knowledgeable photographers, an immense album that could not have been completed in ten years by drawing and etching. It is a superb gift that the emperor intends to present to each of his staff officers and the generals who were present at the camp at Châlons."[53]

From her in-depth study of this evidence, Florence Le Corre has become convinced that it was indeed an imperial commission, despite the obstinate silence of the archives of the ministére de la Guerre (Ministry of War) and of the imperial household. The possibility remains that this was a commission financed directly from Napoléon III's privy purse, for which we have no itemization. The fourteen albums accounted for to date, bound with the imperial arms and bearing the names of the main officers from the camp at Châlons, do have the appearance of being personal gifts from the emperor.[54] Other copies must have existed; at least all of the soldiers photographed by Le Gray—twenty-five in all—must have received one, not to mention the emperor and several civilian dignitaries. Despite the inevitable losses, it seems probable that we will see more of them reappear sooner or later.

There is also an atypical portfolio composed solely of portraits—which belonged to the abbé Misset, private tutor of the imperial prince—that is embossed with the arms of his military household.[55] Undoubtedly made somewhat later, it includes some of the portraits that are found in all of the albums, which were taken at Le Gray's studio (we recognize its decor) after October 1857, as well as portraits of General Bosquet (based on the miniature painted in 1856 by Maxime David), the English general Lovestyne, and, camped out at a single, undetermined location, Marshals Randon and Pélissier (fig. 159) and Major Lepic. Le Gray's signature on all of these portraits indicates that this was a group done after the camp at Châlons, so that those who had not been there, for whatever reason, could be added to the gallery of portraits.

The sixty-some different views, plus the twenty-five portraits, in the albums are found in varying order and content (none of the albums are identical and none contains all the images), which indicates that each of the recipients of the imperial gift had a say in the composition of the copy he or she was to receive. Finally, the large number of individual prints found in public and private collections[56] indicates that Le Gray also had permission to market prints on his own account, including those that were selected for the albums, as well as others that existed only as individual plates. During his monthlong sojourn at the camp with Bénédict Masson, the photographer had the leisure to expand beyond the assigned program.

53 J. de Prémaray, "Défense de la photographie," *Revue photographique*, no. 30 (April 5, 1858): 46.
54 *Une Visite au camp de Châlons sous le Second Empire: Photographies de messieurs Le Gray, Prévot,* . . . exh. cat. (Paris, 1996), 130–31, 134–47.
55 Thanks to M. Gérard Lévy for information on its existence in his collection.
56 Particularly in the Bibliothèque nationale de France (formerly in the Armand collection) and the Musée de Troyes (formerly in the Clausel collection).

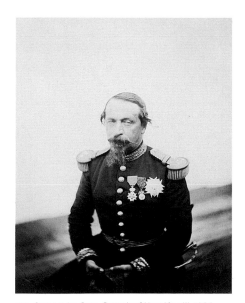

157 Gustave Le Gray. *Portrait of Napoléon III*, 1857 (cat. no. 142).

158 Gustave Le Gray. *Napoléon III on Horseback, the Camp at Châlons*, 1857 (cat. no. 143).

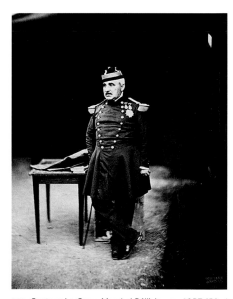

159 Gustave Le Gray. *Marshal Pélissier*, ca. 1857/58.

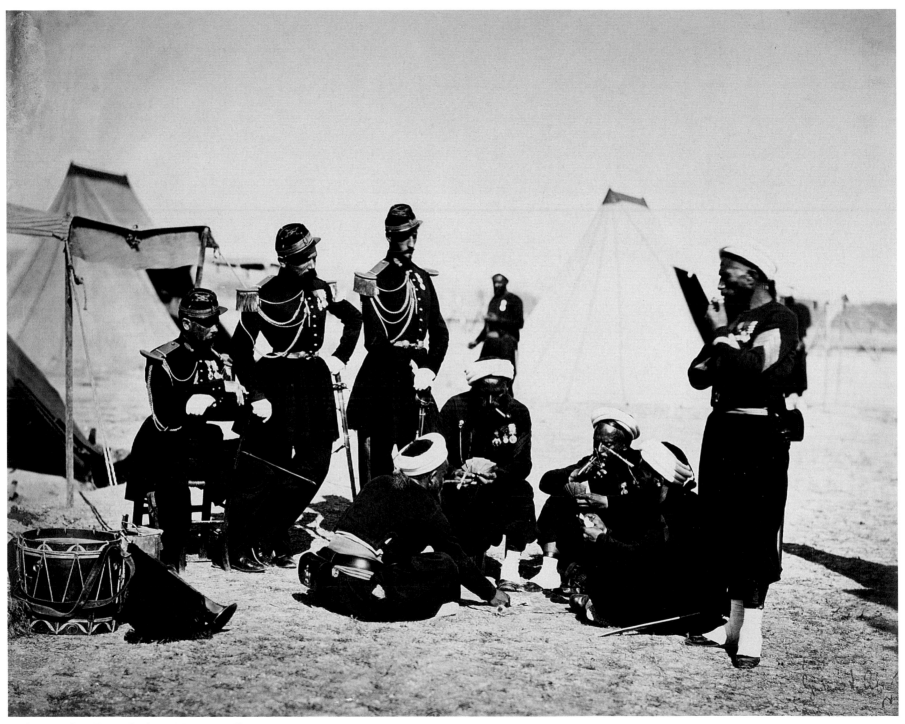

160 Gustave Le Gray. *Zouaves Gambling*, 1857 (cat. no. 145).

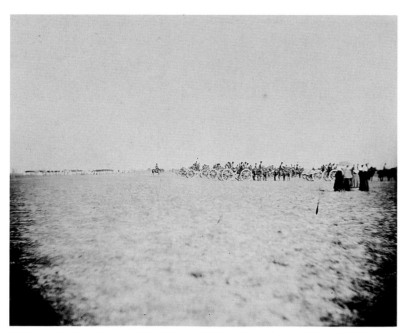

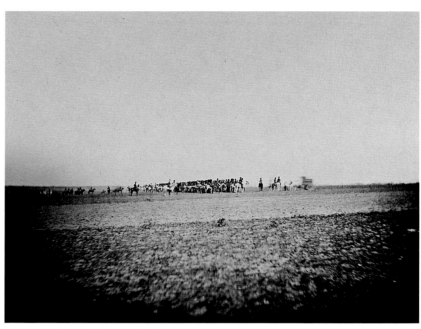

161 Gustave Le Gray. *Maneuvers: The Artillery and Light Cavalry of the Imperial Guard*, 1857 (cat. no. 154).

162 Gustave Le Gray. *Maneuvers: The Cavalry of the Imperial Guard*, 1857 (cat. no. 152).

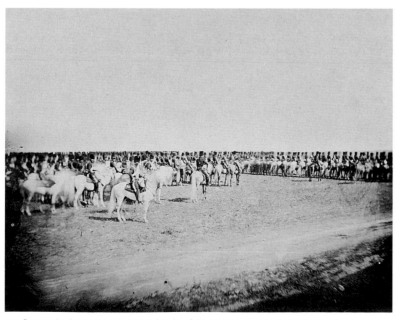

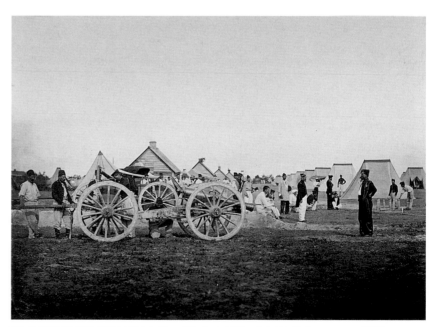

163 Gustave Le Gray. *Maneuvers: The Cavalry of the Imperial Guard*, 1857 (cat. no. 153).

164 Gustave Le Gray. *Camp of the Artillery of the Imperial Guard*, right half of a panorama, 1857.

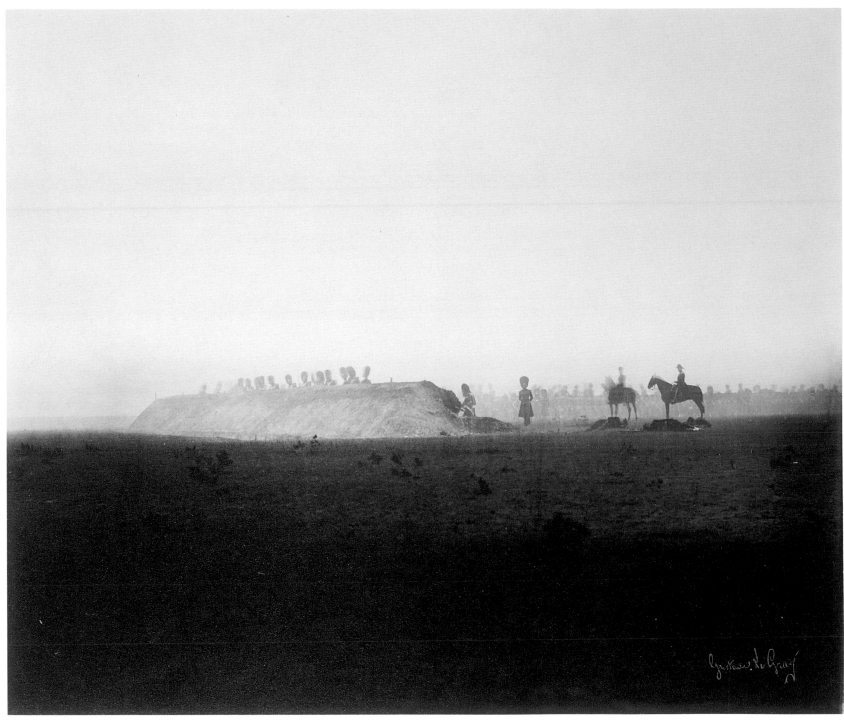

165 Gustave Le Gray. *Cavalry Maneuvers, October 3*, 1857 (cat. no. 146).

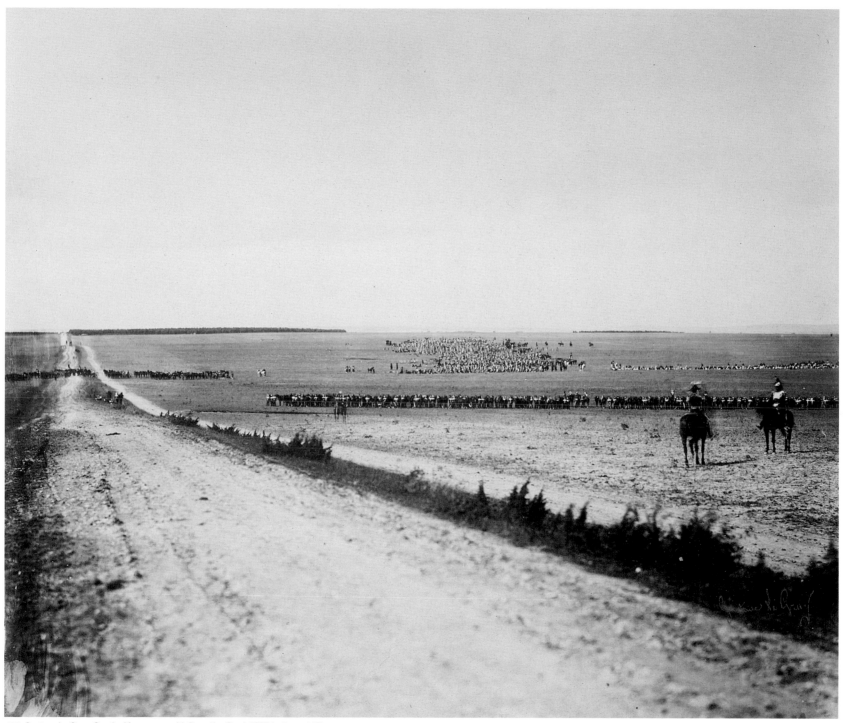

166 Gustave Le Gray. *Cavalry Maneuvers, with Receding Road*, 1857 (cat. no. 147).

167 Gustave Le Gray. *The Bivouac*, 1857 (cat. no. 148).

168 Gustave Le Gray. *Setting the Emperor's Table*, 1857 (cat. no. 149).

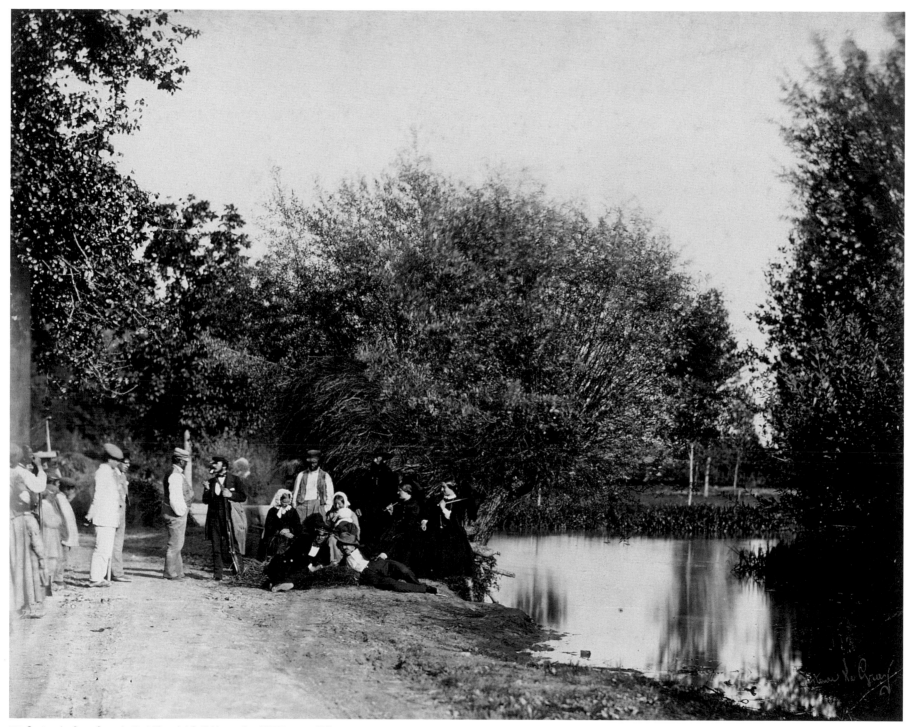

169 Gustave Le Gray. *Group by the Millpond at Petit-Mourmelon*, 1857 (cat. no. 150).

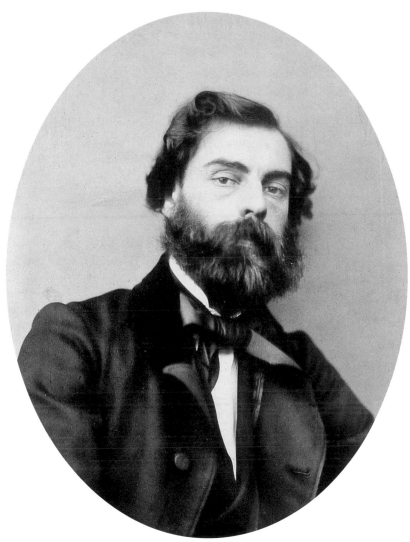

170 Gustave Le Gray. *Portrait of Émile Trélat*, 1859.

57 As confirmed by the orders from the Ministry of Fine Arts to the prefects of La Manche and Calvados "to facilitate this artist, whenever possible, in accomplishing his assignment" (Artistic and literary assignments, National Archives F²¹ 2284²). Regarding these photographs, Malcolm Daniel (in *Édouard Baldus, photographe*, 74–76) is rightly surprised that the commission went to Baldus rather than to Le Gray, who would have seemed the obvious choice. Moreover, Baldus's views were not particularly successful. As we know, like Le Gray (and even more so), he received major official commissions. However, we do not know the ministry's selection criteria, other than an apparent concern for fairness in distributing the bounty.

Less than a year later, it is probable that Le Gray was officially sanctioned to follow the court's travels through Brittany and Normandy, and especially to photograph the meeting of the French and British fleets in early August at Brest and Cherbourg. This time, however, he had apparently not been commissioned, since the official photographer for the event was Édouard Baldus.[57] To his already renowned Norman and Mediterranean seascapes, he added another series, whose beauty was coupled with newsworthiness. In them, we see the ports of Brest and Cherbourg, with the French and British fleets, flags flying and cannon salvos firing.

Le Gray displayed the full measure of his talent and skill. He alternated among topographic views, events, and images where the beauty of the naval scenes quite outmatches their historic content. Encouraged by the success of his large, six-plate panorama of the camp at Châlons with the emperor, he also attempted panoramic seascapes. His overall results were much superior, from every point of view, to those of Baldus and the many other photographers who were present (sixty was the figure mentioned), including Furne, Tournier, and Mme Disdéri.

The Final Year

The year 1859, the last spent in Paris, was both glorious and fertile. Le Gray exhibited numerous works at the third exhibition of the Société française de photographie at the Palais de l'Industrie (Industry Exhibition Hall) on the Champs-Élysées and was a member of the jury.

He created an important series of views of Paris—a genre in which photography was superseding printmaking, especially early in the Second Empire, on the occasion of the upheavals in the capital caused by the major works undertaken by Baron Haussmann. He photographed the major monuments—the Louvre, the Paris City Hall, Notre-Dame, Saint-Étienne-du-Mont, the Pantheon, and the tour Saint-Jacques—but also took broader cityscapes, such as the place de la Bastille and the place de la Concorde, as well as views of the Seine and its bridges. The subjects were the same ones treated during that era, and in analogous formats, by Baldus and the Bissons, but Le Gray, in addition to the unsurpassable richness of his prints, achieved in every view a composition in which the absolute beauty of the whole was enhanced by his sometimes almost excessive concern for detail.

In the spring of 1859, he was called upon, doubtless by the architect Émile Trélat (fig. 170), to photograph the "carriage" offered to the pope by the Italian railroad line, Pio-Latina. Made in Paris from designs by Trélat, this "rolling chapel" had been decorated by a host of stellar artists, including Gérôme, Millet, Cambon, Réveillon, and Toussaint. Hailed as "a new honor for Parisian industry, another proof of its superiority in works of art and luxury,"[58] it was exhibited in February at the Palais de l'Industrie on the Champs-Élysées, where it aroused much curiosity.

Le Gray spent that entire year in Paris, perhaps pressured by the Briges brothers, who must have been worried that the artist was devoting too much time and energy to his personal work, to the detriment of the portrait studio from which they were anticipating profits. Despite this last-ditch effort, the results remained insufficient and the backers were "manifesting a degree of agitation and the early signs of worried fatigue at always paying out and never receiving."[59] On December 20, 1859, "fatigue" prevailed over patience. They empowered their attorney, Buisson,[60] to liquidate the company. Nadar, quite lengthy in writing about the causes of Le Gray's failure, deserves to be liberally quoted:

The installation expenses had already exceeded conventional projections, since the vacant premises where we found ourselves merited, more than any other, the epithet "vacant". . . . Even with such early *impedimenta,* including such formidable installation costs—which follow and pursue you to the end, as implacable as original sin—it may yet have been possible to make a go of it, but on the prime condition of having a high degree of that *je ne sais quoi,* that earthly and divine gift that we call business sense. And it was precisely that trait that was lacking in our good Le Gray and our no less excellent Bissons. . . .

And this lack was so pervasive that, while Le Gray depleted his resources by pressing armloads of free prints on his flood of visitors, the two Bissons, completely intoxicated with the sudden exhilaration of a

58 C. de Chatouville, "Le Wagon de Pie IX," *Musée des familles* 26, no. 20 (February 1859): 160.
59 Nadar, *Quand j'étais photographe,* 92.
60 Archives of Paris, D31 U3, box 219, excerpt 437.

171 Gustave Le Gray. *The French and English Fleets, Cherbourg,* August 1858 (cat. no. 160).

172 Gustave Le Gray. *The French and English Fleets, Cherbourg,* August 1858.

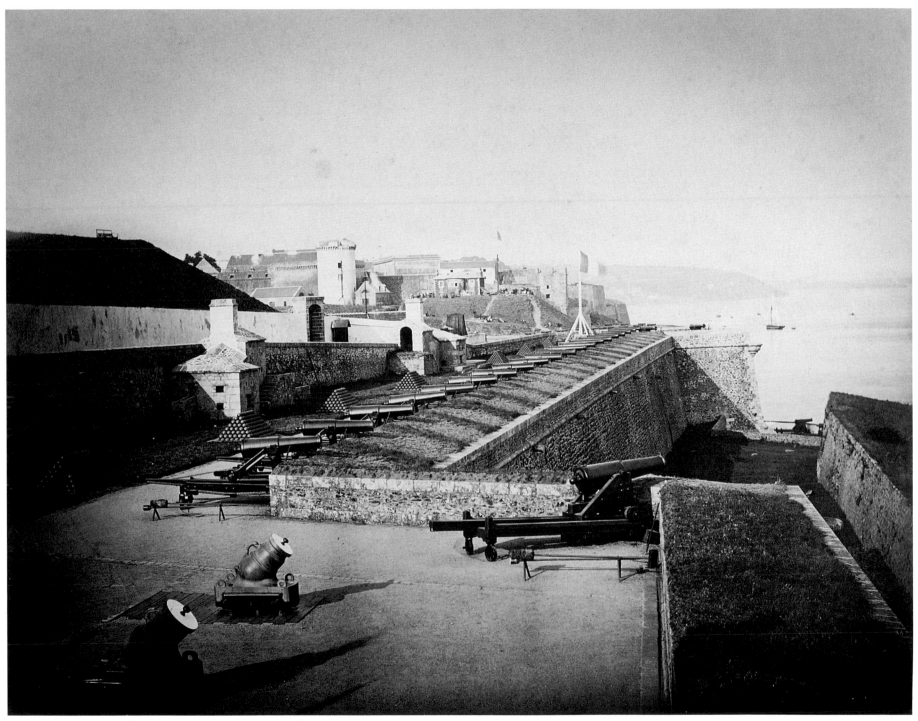

173 Gustave Le Gray. *Battery of Cannon at Brest*, August 1858 (cat. no. 156).

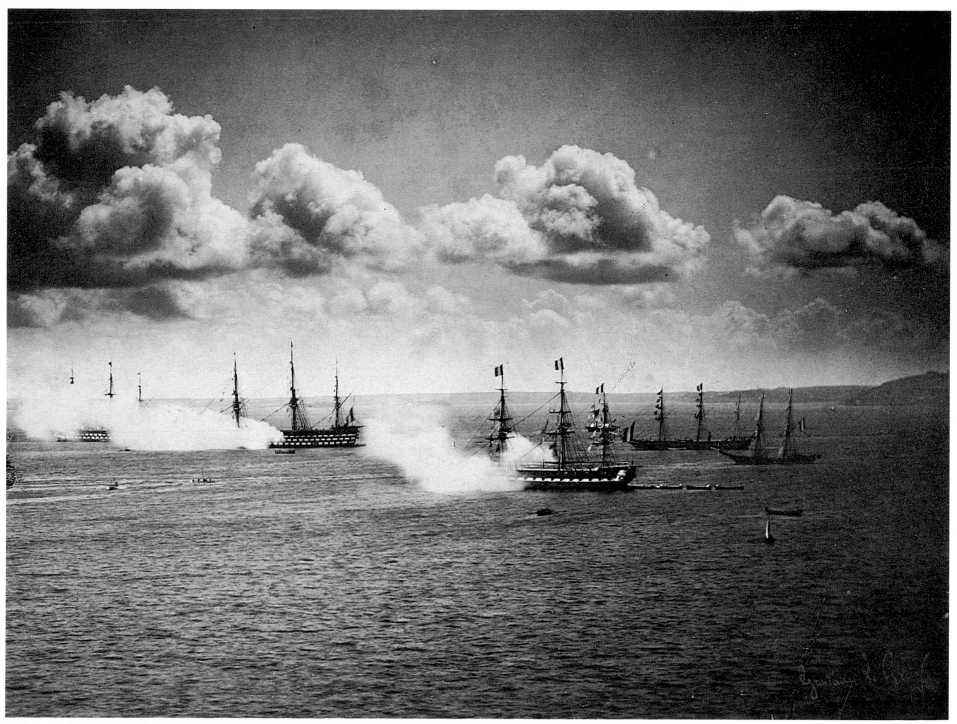

174 Gustave Le Gray. *Salvos of the French Fleet, Cherbourg*, August 1858 (cat. no. 157).

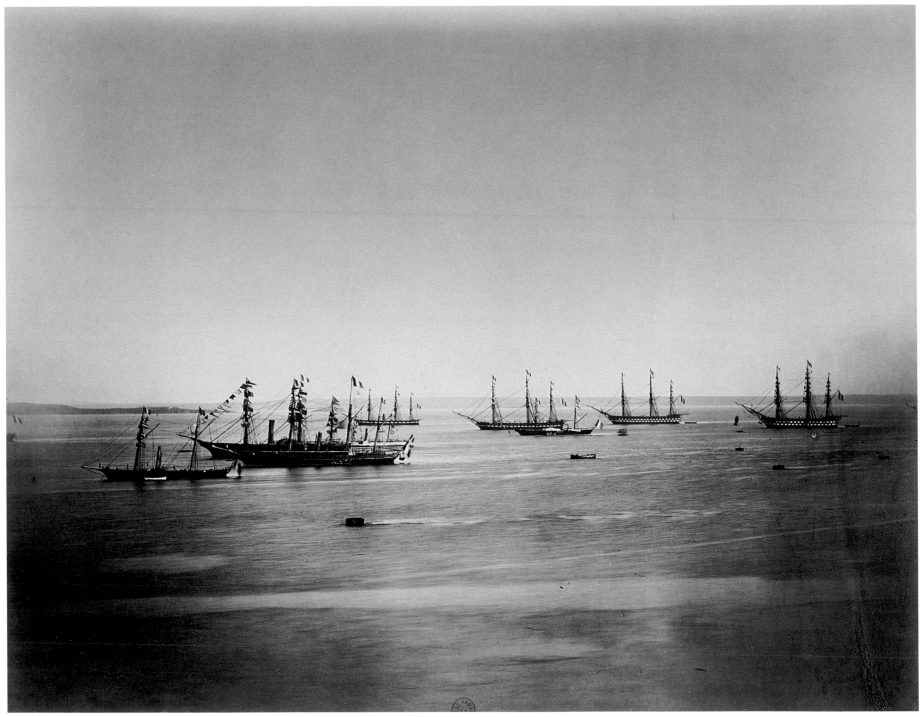

175 Gustave Le Gray. *The French and English Fleets, Cherbourg*, August 1858 (cat. no. 159).

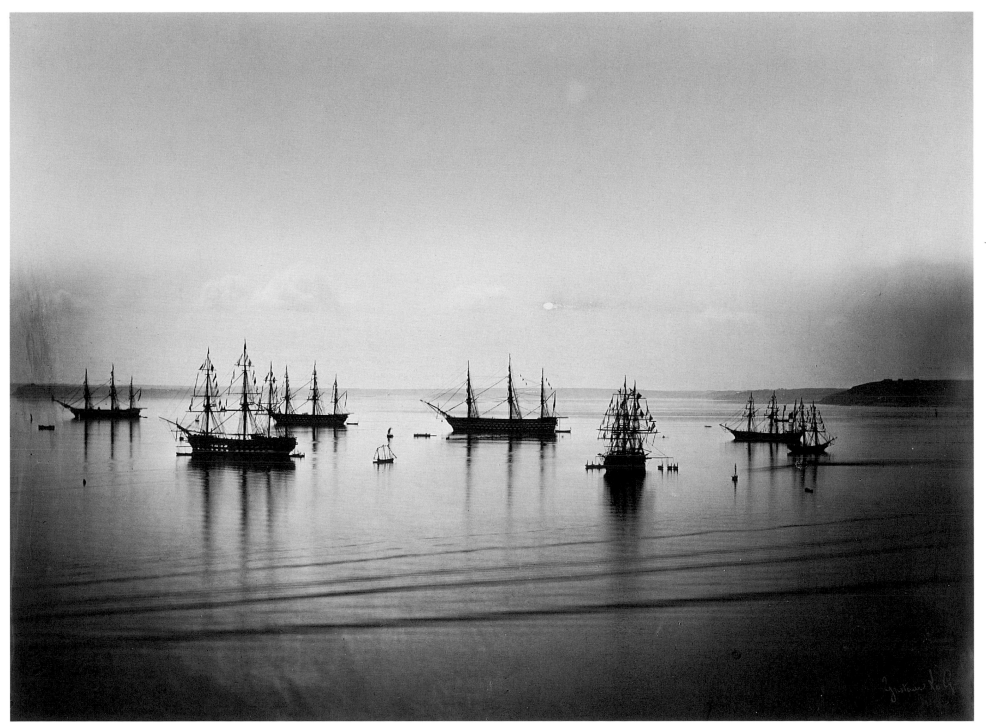

176 Gustave Le Gray. *The French Fleet, Cherbourg*, 1858 (cat. no. 158).

61 Nadar, *Quand j'étais photographe*, 92–93. See also MSS, BNF, NAF 24989, fols. 511–12.
62 Archives of Paris, D31 U3, box 219, excerpt 437.
63 Prints filed with the Cabinet des estampes de la Bibliothèque impériale, where they were recorded on February 16, 1860.
64 "What I later learned was that it was Briges who had urged him [Dumas] to take me with him." Correspondence of Félix Nadar, MSS, BNF, NAF 24275, fols. 665–66.
65 Document dated June 25, 1877, Departmental Archives of Val-d'Oise, 2 E 21167.
66 Nadar, *Quand j'étais photographe*, 93.

new situation, had immediately imagined building, in Saint-Germain, on the banks of the Seine, two charming twin cottages. . . .

Then, a decisive blow, the advent of Disdéri and the carte-de-visite photograph, which provided twelve portraits for some twenty francs, when people had previously been paying fifty or one hundred francs for just one.

It was a rout. One had to give in—in other words, follow the trend or quit. Le Gray's obsession with art had directed him toward photography; he could not resign himself to turn his studio into a factory; he gave up.[61]

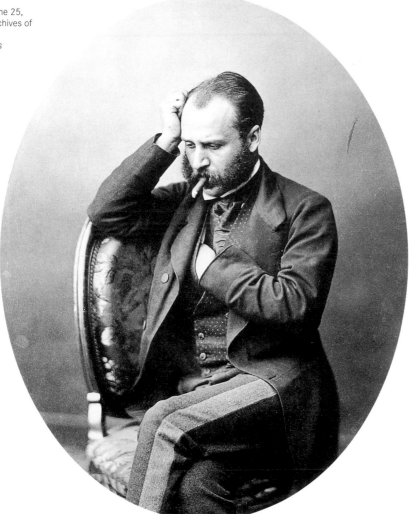

177 Gustave Le Gray. *Portrait of Léon Maufras*, ca. 1857–1859.

On February 1, 1860, the company was dissolved by petition of the Briges brothers:

The company in question was entrusted to Le Gray under precise and specific condition; and whereas, in addition to the obligations common to all associates with respect to their backers, he was subject to specific obligations, including a monthly deduction limited to 300 francs for his personal needs.

Whereas, despite that limit, it has been established that his deductions reached a considerable figure; whereas that application to his private affairs of a portion of the company's capital constitutes, on the part of Le Gray, a flagrant violation of his duties to his backers.

Whereas it has been further demonstrated and proven by the extrajudicial instruments served upon Le Gray, that he has refused, on several occasions, to open his books to his associates.

Whereas, since the year 1857, when the company came into existence, he has not paid the plaintiffs the interest on their investment in the company pursuant to their contract. Whereas all of these facts justify the petition for dissolution filed against him, and for the appointment of a liquidator.[62]

In the days that followed, Le Gray put the affairs of his studio in order and—for the first time—filed with the Ministry of the Interior for copyright registration of three works, chosen according to an unknown criterion, but which the preferences of posterity have not contradicted. These were *The Great Wave, Sète; The Breaking Wave;* and *Zouaves at the Camp at Châlons*.[63] He was already anticipating a possible departure for the Near East with Alexandre Dumas, whom he had met in December 1859. This was a plan that would not be finalized until April but, as Le Gray himself would later understand, was instigated by the Briges brothers,[64] whether to get rid of him or to procure the opportunity for him to pay his debts by means of a photographic cruise that would be both exotic and newsworthy.

Having been forced to leave the boulevard des Capucines and the studio on the chemin de ronde, Le Gray supplied a provisory address of 15, rue Saint-Lazare.[65] He experienced the bitterness of being immediately replaced by a neighbor whom he did not like and who was a mediocre photographer. "His extremely well equipped establishment did not run the risk of remaining empty for a second in that consecrated building. The name of Le Gray was immediately replaced by that of another artist, Alophe."[66] As

178 Gustave Le Gray. *The Pont du Carrousel Seen from the Pont des Arts*, ca. 1859 (cat. no. 184).

179 Gustave Le Gray. *The Pantheon, Paris*, ca. 1859 (cat. no. 177).

180 Gustave Le Gray. *The Obelisk, Place de la Concorde*, ca. 1859 (cat. no. 179).

181 Gustave Le Gray. *The Tour Saint-Jacques, Paris*, ca. 1859 (cat. no. 176).

182 Gustave Le Gray. *The Cathedral of Notre-Dame, Paris*, ca. 1859.

noted earlier, this same Alophe had been thrown out of the building at Le Gray's behest in 1856, but he had returned to another studio there in 1857.[67] In 1860 his revenge was complete; even before Le Gray left Paris, probably in the spring, the Briges brothers set Alophe up with Le Gray's furniture and joined with him to form a new company. To finish filling the void, to erase from that building "dedicated" to photography the memory of the era of Le Gray and the Bisson brothers, Nadar himself—a circumstance he omits from his memoirs—hastened to the prestigious address; on March 27, he signed a twenty-three-year lease on a large studio.[68]

On whom could Le Gray count in the midst of the collapse of his finances, his ambitions, and his relationships? On a thirty-year-old attorney, in practice a short distance from the boulevard des Capucines (29, rue Godot de Mauroy), who advised him on his affairs: Léon Maufras (fig. 177).[69] Numerous portraits of Maufras by Le Gray from 1858 through 1860 confirm that he was a friend.

Posing, cigar in hand, he gives the impression of being a prosperous, even elegant, young man. There is also an album that belonged to Maufras,[70] composed of photographs taken by Le Gray between 1857 and 1860, another clue to the date of their meeting, in the absence of any information about its circumstances.

If Maufras deserves a place of honor in the biography of Le Gray, it is as the author of an extraordinary text, unknown until discovered by Claude Schopp in the first issue (1860) of the *Monte-Cristo*, Alexandre Dumas's magazine. Maufras, as his friend and attorney, must have been more aware than anyone of Le Gray's difficulties. Before Le Gray's ruin became public, at the very moment when the Briges brothers were authorizing their attorney to bring liquidation proceedings, Maufras wrote—one is tempted to say for posterity—a dramatic plea for Le Gray in the form of a premature obituary. In it, the artist is described as the classic inventor, a benefactor of humanity, envied, fleeced, and sacrificed to the baseness of men. The portion that summarizes his biography up to 1860, as

67 Parcel no. 18, painter's studio, Archives of Paris, D1 P4, box 184.
68 Nadar papers, EST, BNF, Yb³ 2340 4°, case 9. According to the rolls, this was parcel 39. See also *Gazette des tribunaux* (December 8, 1860), for the matter of the Briges v. the baronne de Parazza, owner: they accused her of having allowed Nadar to compete with Alophe contrary to the terms of their lease, but their petition was dismissed.
69 Birth certificate for Jean-Baptiste Léon Maufras dated April 11, 1829, Departmental Archives of Charente, RP no. 3 E 48/5; death certificate dated December 13, 1861, Departmental Archives of Hauts-de-Seine, 5 MI/NEU-16 (vital statistics).
70 Private collection.

183 Gustave Le Gray. *The Sully Pavilion, the Louvre*, ca. 1859.

184 Gustave Le Gray. *The Arc du Carrousel and the Tuileries, Paris*, ca. 1859.

bitter as it is admiring, shows the eloquence typical of the legal pro-
fession but also an accuracy in the facts symptomatic of a proba-
ble collaboration between attorney and client. The disturbing tone
of the piece is scarcely redeemed by the epilogue invented by
Maufras: a premature death (in 1880) followed by public mourn-
ing. This was intended to serve as a notice to his contemporaries,
to warn them that they would one day regret what was about to
happen—something never specified.

It is possible that the inspiration came to Maufras (to Le Gray?)
during the first half of December, on the day when Alexandre
Dumas showed up at the studio. The writer claimed that he received
Maufras's text without notice shortly after that visit, but the possi-
bility cannot be ruled out that he had already promised his sup-
port. When all of Le Gray's friends and colleagues were beginning
to distance themselves from him, the hospitality granted to such a
text in the *Monte-Cristo*—a periodical theoretically written "by
Alexandre Dumas alone"—is in and of itself exceptional. In a warm

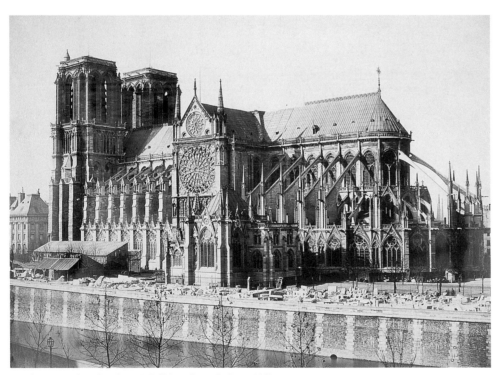

185 Gustave Le Gray. *The Cathedral of Notre-Dame, Paris*, ca. 1859.

and reassuring foreword, which he added, but in which there was
also no mention of the matters in progress, Dumas seemed to want
to further assure the artist of his support, but without compromis-
ing himself.

Nor did Dumas make any allusion to the plan to take Le Gray
along to illustrate his upcoming Mediterranean voyage, and per-
haps the idea did not germinate until the early months of 1860.
Until the liquidation, it was possible to hope that the difficulties
would be surmountable. The voyage planned by Dumas seemed
to provide an unexpected opportunity to accumulate hundreds of
photographs that would be both artistic and eminently commer-
cial. The foremost Parisian photographer to follow the great
writer's grand tour through the most illustrious sites of the
Mediterranean civilizations—this would be a repeat of the news-
worthy voyage of Du Camp and Flaubert, but with ten times the
luxury, panache, and publicity. The Briges brothers had best con-
tain themselves.

Departing for a long voyage was perhaps more than just a means
of forgetting his extremely muddled business affairs. Was Le Gray
also relieved to distance himself temporarily from his family?
During the decade of 1850–1860, in regard to his private life, we
know only about births and deaths, including that of his father. After
the deaths of two of his three daughters during the epidemic of 1849,
three more children were born: Alfred, born in 1851; Berthe in 1853
(she probably died shortly thereafter);[71] and Émile in 1858. That
same year (on July 27), the eldest, Eulalie, born in Rome in 1845,
died at the home of her grandmother in Villiers-le-Bel while her
father was following the imperial court in Brittany; Sykes, the
English aristocrat, served as a witness.

In all, Le Gray had six children, only two of whom were still alive
in 1860. This was a situation that, while not exceptional, must nev-
ertheless have been painful, unless we consider Le Gray an ego-
centric, grown-up child. It is true that he gave no signs of
inconsolable mourning. Barely one month after the death of his
eldest daughter, in September 1858, a photograph shows him at an
inn in Ville-d'Avray, lying on a table drinking champagne (fig. 186).
An early marriage sealing a transient love affair, a prolific but
mournful family life, and intense artistic work must have habitu-
ated him to spending little time at home, leading him to take refuge
in his studio, his travels, and his friendships.

Maufras's fervent article was published in a marginal periodical and then fell into dead silence. Of Le Gray's fall and his departure for the Near East, the photographic press said not a word, either before or after. At best, his friends may have been convinced that he was going through difficult times but was awaiting new successes to collect himself; at worst, without being completely ruined, he already appeared to be a failure. Maufras took on the heavy responsibility of seeing to matters left pending and looking out for the family: the old mother, the wife, and the children. Shortly thereafter, events occurred suddenly, and Le Gray's fate hung in the balance; his desertion and failure to return eased all consciences of their remaining doubts.

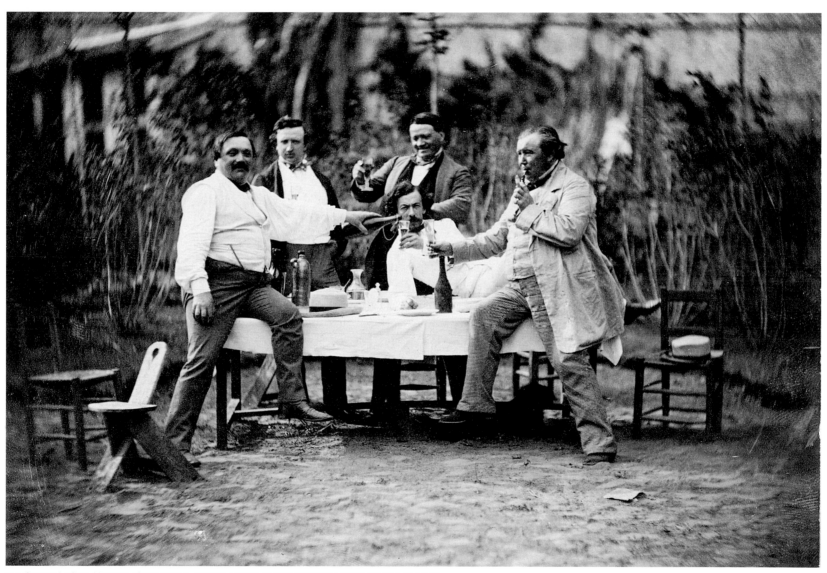

186 Gustave Le Gray. *Memento of Ville-d'Avray, September 1858*, group portrait with Le Gray reclining on a table.

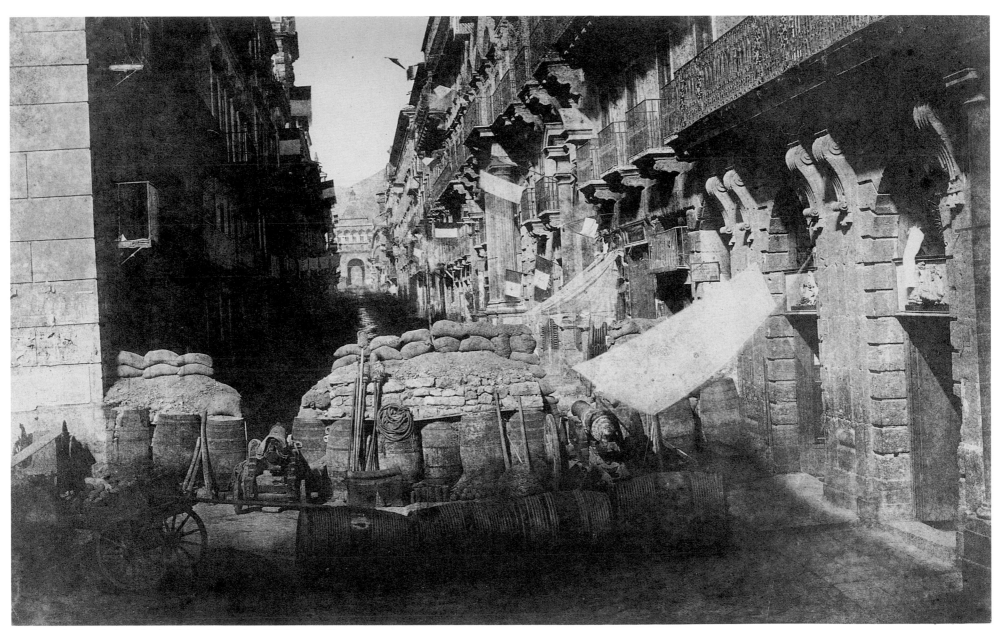

187 Gustave Le Gray. *Barricade, Strada di Toledo, Palermo*, June 1860 (cat. no. 191).

The Unfinished Odyssey

Claude Schopp

When Gustave Le Gray boarded Alexandre Dumas's schooner, the *Emma*, on May 9, 1860, he became an unwitting participant in one of the writer's dreams. It was a dream Dumas had toyed with for so long, one might have suspected the *Count of Monte-Cristo*'s author of refusing to implement it for fear the reality would be inferior to his fantasy of a slow voyage through the origins of civilization. "What I wanted most of all was to raise with my feet the dust of two or three civilizations. Therefore, my aspirations turned toward the splendid Orient."[1]

Le Gray momentarily exchanged the role of protagonist for a supporting role. His job was to photograph the great men and the ruins. However, this voyage was the fundamental event of Le Gray's life, dividing it into two parts. While the association with Dumas seemed to offer the photographer the hope of a spectacular comeback, on the contrary, an unforeseeable chain of events precipitated his downfall.

Yearning for the Orient

Dumas's plan to explore the ancient world was fully formed in 1834 and had already been announced as a publication.[2] By 1835 the escort of eight artists and scientists that had been touted in the prospectus had been reduced to a single painter, Geoffroy Jadin, and the voyage to an excursion to Italy and a circumnavigation of Sicily. All things considered, if we are to believe Ida Ferrier, his former mistress and new bride, "this voyage to Italy . . . was nothing more than a mistake. For this voyage, he created shares, which cost a goodly sum; he remained absent for a year without working, which already represents a deficit of some thirty thousand francs. He ordered and paid for drawings; I have no idea where they are now, and they will never be of any use anyway."[3] Nevertheless, that first postponed voyage remained an indefinitely deferred dream. Thus, when the old Ulysses embarked on his 1860 odyssey, he announced his voyages to Spain and North Africa as the continuation of his original plan.[4]

When he had left for Russia in June 1858, he indeed had informed the readers of his periodical *Le Monte-Cristo*, in a "Notice to those friends who would like to come with us,"[5] that this trip was only the preface to an exploration of the Mediterranean and that he was awaiting delivery of a small cast-steel barkentine. So, on his return from the Caucasus, he did not put in at Constantinople, reserving that visit for his next voyage.[6] Aboard the *Sully*, he found Apostolis Podimatas, the pilot for his future ship; and, after putting in at Athens, he continued on to the island of Syra (now Syros) where he had read that the Greeks built inexpensive ships;[7] on February 28, 1859, in Hermopolis, he signed an agreement on the spot with shipbuilder Nikolaos Paghidas.

However, a year separated his "passage through the world of barbarism from [his] passage through the world of civilization."[8] The ship, christened the *Monte-Cristo*, arrived in Marseilles on July 29, 1859.[9] In the end, the expected schooner was "only a fairly decent pleasure craft, with a big belly and an appearance that revealed its direct descent from one of the thousand vessels that had carried the Greeks to the siege of Troy and required ten years to return Ulysses from Pergamum to Ithaca."[10] This was the prelude to a series of costly, tragicomic contretemps, in the midst of which Dumas was also ensuring the future of his works. On December 15, 1859, he formed a twelve-year partnership with Raphaël Félix for the performance of his dramatic works. On December 20, he

1 A. Dumas, "Une Odyssée en 1860, chap. 7," *Le Monte-Cristo, journal hebdomadaire de romans, d'histoire, de voyages et de poésie, publié et rédigé par Alexandre Dumas, seul,* no. 15 (February 18, 1862): 120. "Odyssée en 1860," recomposed and expanded upon Dumas's "Impressions de voyage: Autour de la Méditerranée," written as a log for the *Constitutionnel*. The Marseilles to Villafrati portion of the manuscript of "Autour de la Méditerranée" has been conserved, under the inaccurate title "Les Garibaldiens," in the Auckland Public Library, New Zealand, RDMS 2193; added to it are the handwritten pages of Dumas's "Révolution de Naples"

(RDMS 2194), a rewritten account intended for the Italian public and published in the *Indipendente*, a periodical founded by Dumas in Naples. Never published in French, "Autour de la Méditerranée" was published in English as *On Board the* Emma: *Adventures with Garibaldi's "Thousand" in Sicily*, trans. R. S. Garnett (London, 1929); it was apparently from a complete manuscript, although the political and military portion (23 chapters and an epilogue) had been removed by Dumas for *Les Garibaldiens: Révolution de Sicile et de Naples* (Paris, 1860). Dumas shortened or eliminated the rare passages in "Odyssée en 1860" relating to Le Gray and

Albanel; see Dumas, *Viva Garibaldi: Une Odyssée en 1860,* edited with a preface and annotations by Claude Schopp (Paris, 2002).
2 See Dumas, letter to Louis-Philippe, July 11, 1834 (Charavay catalogue, October 1905); the planned itinerary for the voyage, August 1834 (sale cat., Paris, Drouot-Richelieu, December 16, 1992, no. 67); and the brochure *La Méditerranée et ses côtes,* 1–3, reproduced in *Revue et gazette musicale de Paris* (February 15, 1835).
3 Ferrier, letter [Florence, November 2, 1840], Jean Tainon collection.
4 Dumas, "Odyssée en 1860, chap. 7," *Le Monte-Cristo,* no. 15 (February 18, 1862): 120. On the actual continuity of this dream of the Orient, see especially the following letters: Dumas to his son [Florence, July 8 or 9, 1842], département des Manuscrits (MSS), Bibliothèque nationale de France (BNF), NAF 14669, fol. 123; Arnaud Vayssière to Dumas, Kassala, November 2, 1856, Société des amis d'Alexandre Dumas, Glinel collection, R 8 no. 21; ship owner François Mazeline to Dumas, Le Havre, December 3, 1858, Société des amis d'Alexandre Dumas, Glinel collection, R 6 118; Dumas to Vanloo [Saint Petersburg, July 30, 1858], Pierpont Morgan Library.
5 *Le Monte-Cristo,* no. 9 (June 17, 1858): 137.
6 Dumas, *Le Caucase* (Paris, 1990), chap. 64: 572.
7 E. About, *La Grèce contemporaine* (Paris, 1854), 178.
8 Dumas, "Odyssée en 1860, chap. 1," *Le Monte-Cristo,* no. 1 (January 1, 1862): 7.
9 "Mouvement du Port," *Le Sémaphore de Marseille* (July 30, 1859).
10 Dumas, "Odyssée en 1860, chap. 1," *Le Monte-Cristo,* no. 1 (January 1, 1862): 14. Pergamum was the citadel of Troy.

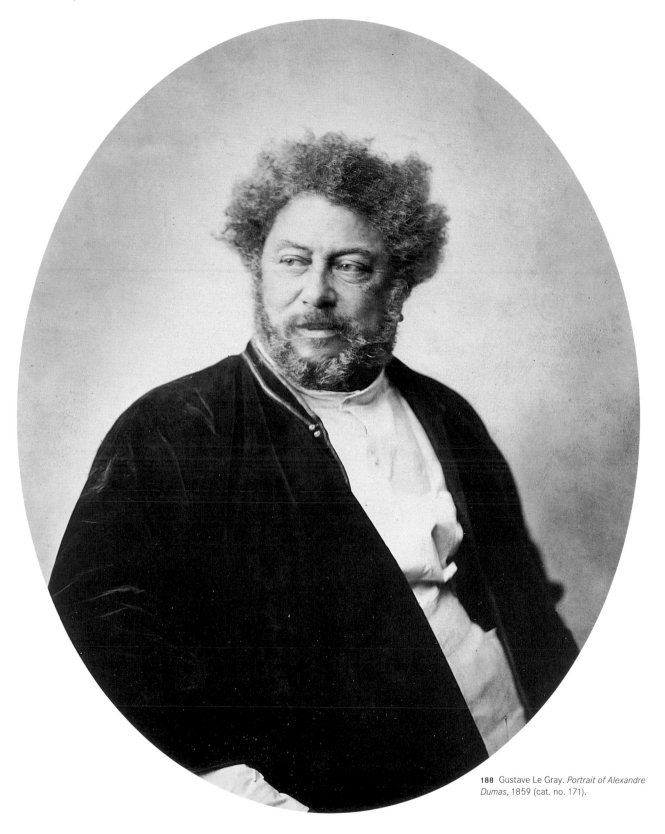

188 Gustave Le Gray. *Portrait of Alexandre Dumas*, 1859 (cat. no. 171).

signed an agreement with his publishers, the Lévy brothers, which extinguished a series of lawsuits and gave them the right to reprint his *Complete Works* for ten years.[11] It was as if, at the moment of his grand departure, the old writer did not want to leave behind any unfinished business.

Gustave Le Gray Enters the Stage

It was in the midst of this profitable settling of accounts and multiple round trips from Paris to Marseilles that an initial encounter took place between Alexandre Dumas and Gustave Le Gray. This very first meeting was reported under the heading of "Chat" in the January 5, 1860, issue of *Le Monte-Cristo*. The issue was adorned with a portrait of Dumas, engraved by Henri Linton and Eugène Morin, from a photograph by Le Gray (fig. 188).

Dear Readers, As I depart for the South of France—perhaps for Nice, perhaps for Turin, perhaps for Venice, since "perhaps" is the only rule for all of my voyages—as I was saying, as I depart, I leave behind, along with these lines, so that it may all be given to you in one of the coming issues of *Le Monte-Cristo,* the most true-to-life of all the portraits that have been taken of me. Of the portrait's qualities, I wish to affirm only the first and most essential: likeness. It is up to you, dear readers, to decide whether photography has ever gone further, whether more naturalness, gentleness, and truth have ever been found in a portrait executed as a photographic print.

Consequently, I must tell you that I did not allow chance to be my guide in the selection of the photographer, and that, in M. Le Gray, I have quite simply found a most welcome artist. Go and see him, I was told by excellent judges in matters photographic, and you will be satisfied. I went and saw him, and I was filled with wonder. I understood what—after having a hundred portraits taken by a hundred different photographers, you perhaps do not yet suspect, dear readers—I understood that a photographer like Le Gray is both an artist and a scientist.

What I had understood, after a fifteen-minute chat in Le Gray's studio, was proved by fate two weeks later: written proof, and eloquently written at that, as you will soon be able to judge for yourselves. That proof was nothing less than the true story of all the work, all the study, all the research that a man who had made a name for himself in painting had to accomplish in order to perfect a discovery whose initial products had charmed him. Thus, Le Gray is not a makeshift photographer, not a photographer by chance.

Are all scientists, all researchers, all inventors, as Le Gray's historian asserts, destined by tradition and the eternal egoism of society to an inescapable and appalling martyrdom? The proposition seems to me somewhat distressing and, in any event, does not aptly apply to the hero of this story. Le Gray will perhaps never be let into the Academy, that I grant; but what does that prove? His position is no less distinguished among scientists, and I predict for him that fortune shall not leave his knowledge in an awkward predicament. So take heart, my young artist. Your historian does not have you die until 1880. Those twenty years should benefit photography and indeed give it the color that it is still reduced to borrowing. And so to work, but without discouragement or respite. It is up to you more than anyone to achieve this latest progress for your art, since you, as much as anyone, have served it, and it has already delivered to you its most precious secrets.[12]

This lighthearted "Chat" was the preface to Léon Maufras's somber "Biographical Essay" of Le Gray (see appendix). Today, Dumas's encouraging exhortations ring with bitter irony. The writer was unaware that, in a tragedy that surpassed the biographer's darkest presentiments, he would assume the role of the boatman responsible for ferrying Le Gray out of the world of the living.

When this issue of *Le Monte-Cristo* was published, Dumas had temporarily left France for Italy.[13] So the page had been written prior to his departure, on December 24 or 25, upon receipt of the Maufras article; this implies that the "fifteen-minute chat" in the studio of the photographer "two weeks" earlier took place approximately December 10. From that visit, two superb portraits of Dumas have survived, one a bust and one full length, both well known, although often attributed to Alophe (who only reprinted them). The writer, mustachioed and bearded, thin from his voyage through Russia, is dressed Russian-style in a white *rubashka*, topped with a jacket with no lapels.[14] The engraved portrait at the beginning of *Le Monte-Cristo* is reversed, depicting the subject in a less exotic vest and jacket.

Additional information we may deduce, by its omission from the "Chat," is that Le Gray's participation in the voyage to the Middle East had not yet been considered. However, in addition to the "perhaps" rule that guided his voyages, Dumas had another that was more or less constant: that of a fellowship with painters devoted to illustrating the indispensable narrative. Jadin followed him to Italy; Louis Boulanger, and then Eugène Giraud and Adolphe

11 Agreement with Raphaël Félix, copies, MSS, BNF, NAF 11918, fols. 59–69, 70–73; handwritten agreement with Lévy Brothers, formerly in Calmann-Lévy archives. Regarding the negotiations, see a letter from Noël Parfait to his brother Charles, Brussels, January 20, 1860, Fessard collection; partially published by J.-Y. Mollier, "Noël Parfait (1813–1896): Biographie littéraire et historique" (doctoral thesis, Université de Paris III, 1978), vol. 1: 294–95. Mollier was kind enough to send the author a copy of that letter.
12 Dumas, "Causerie," *Le Monte-Cristo*, ann. 3, no. 38 (January 5, 1859 [*sic*, i.e. 1860]): 593–94.
13 He was in Marseilles on December 26 ("Chronique locale," *Le Sémaphore de Marseille* [December 28, 1859]: 1), and embarked on the 29th for Genoa.
14 Paris, Musée d'Orsay: reproduced in *Nadar: Les Années créatrices, 1854–1860*, exh. cat. (Paris, 1994), 89, cat. no. 142.

15 Sixty-two plates by Giraud were recently acquired by the Musée de Castres. Drawings by Moynet were reproduced in *Le Tour du monde: "Voyage au littoral de la Mer Caspienne,"* text and illustrations by M. Moynet (first half of 1860), 113–28, 305–36, and "Le Volga," nos. 369–71 (1867), 49–96.

16 Dumas, *Montevideo ou Une nouvelle Troie* (Paris, 1850), 84–91; first published as "Une nouvelle Troie," *Le Mois,* nos. 25–26 (January–February 1850).

17 *Le Monte-Cristo,* no. 40 (January 19, 1860).

18 Ibid., no. 42 (February 2, 1860).

19 Dumas, "Odyssée en 1860, chap. 2," *Le Monte-Cristo,* no. 42 (February 2, 1860): 39.

20 Ibid.: 55.

21 É. Lockroy, *L'Île révoltée* (Paris, 1877), 8.

22 Parfait, letter to his son Paul, March 21, 1860, Fessard collection; partially published by Mollier ("Noël Parfait," vol. 1: 297), who kindly sent the author a photocopy of it.

Desbarolles, escorted him to Spain and North Africa; and, finally, Moynet traversed Russia with him. Admittedly, Jadin's drawings would "never be of any use anyway"; those of Boulanger and Giraud were parsimoniously used in *Adventures in Algeria;* and those of Moynet were never more than plates.[15]

However, the decision to include Le Gray, whose photographs were to be the basis for the engravings that would illustrate Dumas's text of *Voyage through Sicily and around the Mediterranean* seems to have been made gradually and only after the voyage to Italy. That trip, which ended on February 17, 1860, was essential, for it determined the future. In fact, having gone off to search for a flag for his Greek schooner, Dumas hastened to Turin to finally make the acquaintance of Garibaldi, whom he had praised ten years earlier in *Montevideo ou Une nouvelle Troie* (Montevideo or a new Troy)[16] as "the man who received from Providence a mission to watch over [the] awakening of the masses."[17] The new revolutionary of the old and new worlds who was preparing to awaken the peoples of the Kingdom of the Two Sicilies offered to give the writer his journal so that, once translated and edited, it could be published.[18] Dumas thereby would contribute to favorably disposing French opinion to the imminent great feat. At the same time, Garibaldi apparently promised to inform him of the outbreak of war. "And will you join with us in the campaign?" he purportedly added. "Why not?" was Dumas's ostensible reply.[19]

In Rome, the outbound Ulysses allowed himself to be persuaded by the French ambassador Agénor (duc de Gramont) to substitute for the wretched *Monte-Cristo* the *Emma,* the ambassador's previous yacht, which was for sale in Marseilles. "A delightful little seventy-eight-ton schooner, built in Liverpool," Gramont assured him.[20] On February 15, the day after his return to Marseilles, Dumas purchased this marvel and, at the recommendation of the crafty Podimatas, engaged Captain Beaugrand, whom Édouard Lockroy, in *The Rebellious Island,* described using the transparent name of Schengross. "Fat, short, the color of gingerbread and, in any event, dim-witted. His greatest fault was to have literary pretensions."[21]

On his return to Paris, Dumas likely contacted Le Gray, and he probably even urged him to accompany him on his Mediterranean travels. However, that invitation to the most renowned photographer in Paris could not have helped but annoy the writer's future agent, Noël Parfait (alias "Jamais-Content," Never-Content), who was already concerned about this voyage that "will obviously cost Dumas some hundred thousand francs." He lectured Dumas on a more economical solution, which he then shared with his son, Paul:

Today, Dumas set his departure for the twentieth of next month; . . . nevertheless, *it is probable that I will contact you again sometime in early April* because Dumas wants Édouard Lockroy and you to learn a bit about handling the photographic instruments that he intends to take with him. It was I who dissuaded him from taking a professional photographer with him, thinking that, with a few lessons from a good teacher, Édouard Lockroy and you could take some pictures for him that, even if not masterpieces, will suffice to give the Paris engravers some subjects for illustration. A photographer would have cost Dumas very dear and, furthermore, would have occupied space on the vessel, which is not set up to accommodate a regiment.[22]

So, scarcely more than a month before the departure date, Le Gray was apparently uncertain about his fate, unless—and this was probably the case—Dumas, who could never say no, said yes to Parfait and yes to Le Gray. Of course, none of this wavering surfaced when Dumas, several hours before leaving Marseilles, introduced to his readers the heroes of the future odyssey, commencing with Le Gray. This was the sole specific allusion to the ample harvest of images that Dumas hoped to reap from his photographer. In return, Le Gray was no doubt counting on this anticipated work—once popularized by widespread publication—to bring him fortune and fame.

Of the eleven, you know four or three, at least by name. . . .

You know Le Gray, do you not? He is simply the leading photographer in Paris. His knowledge as a chemist and his skill as a draftsman assure us of a magnificent series of historic views and famous figures. As for myself, he has been forewarned, he will not be set free until he has produced at least two thousand photographs.

Later—and significantly, it seems—the name Le Gray recurred in relation to the fourth passenger:

A young doctor named Albanel, who learned medicine, not to practice it as a profession, but in order to know it as a science. . . . During the long hours of leisure that we will allow him, he will herbalize, geologize, and chemicalize with Le Gray. If our fresh water spoils, they have committed to disinfect it with bone black. And if there is none at all, seawater passed through their alembic will become more pleasant to drink

than the famous *aqua virgo* of Rome. It is always reassuring to know that one will not die of thirst.[23]

In this prologue, where they are sketched as a pair of scientists, prefiguring Bouvard and Pécuchet,[24] the able chemist Le Gray and the young physician Natalis Albanel[25] are linked, a fact not belied by the sequel to the tale, and certainly not by its catastrophic ending. It may have been the photographer himself who recommended taking along the young physician, who was perhaps one of his friends.[26]

Embarkation: Ulysses' Other Companions

Dumas then went on to review the crew, which—in addition to the Greek interpreter, Théodore Kassapis, and the Georgian servant, Vasili—included two Telemachuses, entrusted by their respective fathers to a mentor who was everything but wise. The first was Édouard Lockroy:

You know Lockroy, do you not? In the past, an eminent artist of the stage, now a distinguished author. . . . Well, one of my passengers is his son, a child I saw born, educated, grow up. A student of Gleyre, he will apply the serious studies he did in the studio to the nature drawings he will make with me. He is tall, thin, and dark, with black eyes and black hair that, at age twenty-one, is already mixed with white. It is the restoration of his health that I shall see to, rather than his education, which I promised to complete.[27]

Then there was Paul Parfait:

Son of our good and dear Noël Parfait. . . . For the past year, in preparation for this voyage, we sent him to England, to our mutual friend Esquiros. . . . I say we . . . because, in a way, he is the child of us both; I first saw him when he was very tiny, and I loved him from the day I saw him. On board, he will be one of my secretaries.[28]

For these young people, the odyssey would be a voyage of initiation and education. To the crew, this triumph of youth, old Dumas assigned a nearly adolescent queen, his young and imperious mistress at the time, Émélie or Émilie Cordier, whose whimsical uniform earned her the nickname of "the Admiral."[29] Dumas and his entourage alighted from the train in Marseilles on April 29,[30] immediately setting in flight the flock of "canards" that never missed an opportunity to greet the writer's arrival:

Marseilles, May 1.—The illustrious author of *Monte-Cristo* is in the news. He intends to serve lunch on board his yacht to various representatives of the Marseilles press. However, as the captain's lounge does not have

much headroom, the guests will be obliged to bend over to enter it and to squat like Turks during the meal. Alexandre Dumas has had a space hollowed out so that his majestic head does not hit the ceiling. . . . The panels that decorate the lounge are quite remarkable. There are twelve of them, created by the brush of a young painter, M. Régnier, whose neo-Greek works have drawn much attention when exhibited. A multitude of the most disparate objects are being loaded aboard the *Monte-Cristo*.[31] This past Sunday [April 29], Alexandre Dumas was assailed by a throng of youngsters, who were astonished to see a young woman in masculine dress take his arm. The famous novelist was obliged to sharply address those children, who carried their ignorance to the point of mistaking him for a Negro.[32]

Several hours before its departure, on board the *Emma*, which, for some ten days, had become the city's center of attraction, Dumas put the final touches on the itinerary for the voyage:

What I wish to see, and what I especially wish to have you see, dear readers, are the places made famous by history and even by fable. It is the

23 Dumas, "Les Garibaldiens," vol. 1, fols. 57–58. The introduction of Le Gray and Albanel was considerably shortened in Dumas, "Odyssée en 1860, chap. 5," *Le Monte-Cristo*, no. 13 (February 11, 1862): 102.
24 Dumas, "Les Garibaldiens," vol. 3, fol. 48: "June 18. Our two scientists took their watch and calculated, based on the time between the flash and the explosion, that the battle must have been taking place at a distance of 15 or eighteen nautical miles"; fol. 58: "June 22. The doctor and Le Gray, the expedition's two scientists, are to return and make a report on the nature of the water."
25 David Jérôme Natalis Albanel (Niort, September 30, 1832–Paris, April 14, 1914). His passport, issued at the consulate general of France in Beirut for Jerusalem on November 23, 1860, at the same time as that of Le Gray, described him as follows: "Age 27, 1.6 meters tall [5'3"], brown hair, average brow, brown eyebrows, brown eyes, average nose, average mouth, black beard, round chin, oval face, dark complexion." Albanel's great grandson, Dr. Jean-

Paul Dardel, wrote a biography of him, "Esquisse de la vie de Natalis Albanel."
26 A possible but tenuous clue: Among Albanel's closest fellow students at medical school was Jules Marey, the future inventor of chronophotography. Albanel would later be his estate executor.
27 Dumas, "Les Garibaldiens," vol. 1, fol. 57. Édouard Étienne Antoine Lockroy (Paris, July 18, 1838–November 22, 1913), son of actor and playwright Joseph Philippe Simon, known as Lockroy, was a student of Eugène Giraud, then of Gleyre at the Beaux-Arts. At the time of the voyage, his father was working with Dumas on two plays that were nearing completion, *L'Envers d'une conspiration* and *Les Gentils-hommes de la montagne*. Abandoned by Dumas in Malta with Le Gray, he reached Beirut, where he was a regular correspondent for *Le Monde illustré* on Syrian affairs. In late October, Ernest Renan, who led the scientific mission to Phoenicia, hired him as his secretary. Lockroy did numerous drawings, some of which were used for the album of Renan's

Mission en Phénicie, as well as photographs.
28 Dumas, "Les Garibaldiens," vol. 1, fol. 58; Dumas, "Odyssée en 1860, chap. 5," *Le Monte-Cristo*, no. 13 (February 11, 1862): 103. Paul Léon Parfait (Paris, October 23, 1841–October 24, 1881), son of Noël Parfait, actually spent a year in London with Esquiros, as Pierre-Jules Hetzel had advised. After his return from Naples, he embarked on a career in journalism, contributing to *Le Rappel*, *Le National*, and *La République française*, and in literature, commencing with *Le Zouave est en bas!* a one-act comedy in collaboration with É. Lockroy. Other theatrical works followed, in addition to novels, novellas, and antireligious pamphlets.
29 Émélie or Émilie Cordier (Paris, July 13, 1840–November 20, 1906). See her biography in "Alexandre Dumas, ses filles et leurs mères," *Cahiers Alexandre Dumas*, no. 24 (1997): 5–98.
30 *Le Sémaphore de Marseille* (April 30, 1860): "M. Alexandre Dumas père arrived yesterday in Marseilles, and stopped at the Hôtel du Louvre. M. Alexandre Dumas was accompanied by painters and photographers."
31 These included numerous gifts from admirers (or rather manufacturers seeking publicity): champagne, wine, vermouth, perfume.
32 L. Neyret, "Correspondance particulière," *Le Messager de Nice* (May 4, 1860). See also *Le Messager de Nice* (May 2, 1860): "M. Alexandre Dumas has definitively left Paris to undertake his famous voyage on the schooner the *Monte-Cristo*. [. . .] He is taking with him a photographer, M. Le Gray, the son of M. Lockroy, the son of M. Noël Parfait, and another person whose name is not known. I have been told that M. Dumas will be engaging three typographers and one pressman in Marseilles to print his serials or books as they flood from his pen. [. . .] M. Dumas's voyage will last fifteen months."

33 An ample itinerary followed: "The voyagers will stop in Genoa, Ajaccio, Monte Cristo (of course), Marsala, Malta, Brindisi, and Venice, whence they will commence their exploration, which is essentially a pilgrimage to the historical meccas of occidental civilization"; Dumas meticulously listed all of the sites, both lowly and imposing, that, from Italy to Egypt, were to highlight their antiquarian quest.
34 Dumas, "The Garibaldiens," vol. 1, fols. 72–76.
35 Dumas, "Odyssée en 1860, chap. 8," *Le Monte-Cristo,* no. 17 (February 25, 1862): 135.
36 In a letter (see note 44), Dumas wrote to his mistress, Emma Mannoury-Lacour, "I expressly disembarked at Nice to see [Alphonse Karr]," to obtain his critique on a volume of her poems, *Les Asphodèles* (Paris, 1860).
37 Louis or Luigi Crette (Paris, 1823–Turin, 1872), photographer who worked on the via della Rocca in Rome, in the early 1850s, portraitist of King Victor-Emmanuel. During the London exhibition of 1852, his work was sponsored by Claudet along with the works of Le Gray, Le Secq, Piot, Flacheron, and Bianchi. Around 1858 he moved to Nice, where his photographs testify to his great mastery. In 1862 his

address was 5, rue Saint-Étienne (G. Calmette, *Annuaire des Alpes-Maritimes,* 1862). In 1866, he opened a studio at 39 via Po in Rome. He spent the last years of his life in Turin.
38 T. de Banville, *La Mer de Nice: Lettres à un ami* (Paris, 1861), 211. Also present, among others, were musician Léopold Amat, historian César Lecat, Baron de Bazancourt, and Doctor Lubansky.
39 Dumas, "Odyssée en 1860, chap. 8," *Le Monte-Cristo,* no. 22 (March 14, 1862): 176.
40 Banville, *La Mer de Nice,* 210.
41 Dumas, "Odyssée en 1860, chap. 8," *Le Monte-Cristo,* no. 22 (March 14, 1862): 176. "Jeanne" was Joséphine Alphonsine Jeanne Verger, natural daughter of Alphonse Karr, born in Honfleur on April 8, 1852.

42 Banville, *La Mer de Nice,* 214.
43 *Le Siècle* would begin publishing the *Mémoires de Garibaldi* on June 1.
44 Dumas, letter to Mannoury-Lacour, château Plassy, Czechoslovakia, 285/1833; reproduced and published by M. Ullrichová, *En suivant les traces d'Alexandre Dumas père en Bohême* (Prague, 1976), 303–4, 246–47.
45 Dumas, letter to Charles Robelin, formerly in Simone André-Maurois collection; fragment published in A. Maurois, *Les Trois Dumas* (Paris, 1957): 319; published in English, variously, as *The Titans: A Three-Generation Biography of the Dumas; The Extraordinary Lives of the Three Dumas;* and *The Three Musketeers.*

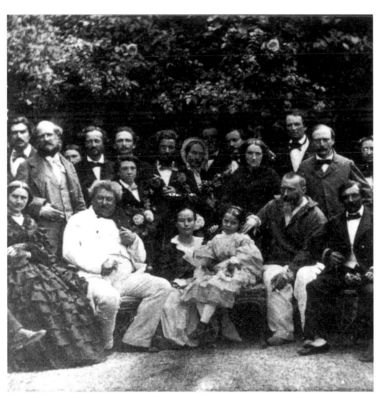

189 Gustave Le Gray. *Guests at the Home of Alphonse Karr,* May 1860.

Greece of Homer, of Hesiod, of Aeschylus, of Pericles, and of Augustus. The Byzantium of the Eastern Empire, and the Constantinople of Mohammed. The Syria of Pompey, of Caesar, and of Crassus; the Judea of Herod and of Christ; the Palestine of the Crusades. The Egypt of the Pharaohs, of Ptolemy, of Cleopatra, of Mohammed, of Bonaparte, of Mohammed Ali, and of Saïd Pasha. . . .[33]

Is this not a voyage worthy of the twenty-five years that I worked to accomplish it! We are raising anchor; the captain is calling me to the bridge to answer the salute of our friends and the population that is crowding the dock. The schooner is obedient to the impetus of its sails. We are leaving.

> *Au vent la flamme*
> *Au Seigneur l'âme!*
>
> [Into the wind, the flag
> And to the Lord, the soul!][34]

From Marseilles to Genoa

The early days of the voyage resembled a pleasure sail, barring the seasickness that—on leaving Marseilles—overcame the passengers, especially the photographer:

> [Le Gray], who whilst among the living, had allowed Valdin [one of the shipboard dogs] to take all sorts of liberties with him, was dead—or the next closest thing. He lay facedown on the deck, and Valdin took advantage of his state of torpor to treat him like a hydrant. . . . In the evening, they had to carry Le Gray down to his room; but to do him justice, since his voyages had made him familiar with seasickness, he complained of naught but Valdin's improprieties. . . . The following day [May 12], Le Gray alone continued to remain in a horizontal position, and Valdin to persecute him.[35]

So, to perk up the traveling party, they headed for the little port of Hyères, where they dined on the delightful terrace of the Hôtel de l'Europe. The next day, at the invitation of Chappon, a former banker from Marseilles, they went ashore at Brégançon to savor a bouillabaisse in a Neo-Gothic mill. On May 14, in Nice, they set off in search of Alphonse Karr,[36] who ran a farm and a shop there, selling fruits, vegetables, and fresh eggs. Le Gray rang a doorbell during this search and cried out in surprise before throwing himself into the arms of a lantern-bearing stranger. It was none other than Louis Crette, "the Le Gray of Nice,"[37] who guided them to

the Saint-Étienne farm. The next day, lunch was served for sixty guests in the garden under an arbor of roses. One of the guests, Théodore de Banville, compared the feast at the house of flowers to a moment from *The Thousand and One Nights*.[38] Before leaving, Dumas engraved his initials on the champagne glasses, using a diamond from Princess Apraxine's finger.[39] Then Louis Crette and Gustave Le Gray, "that daring photographer who is able to capture in an instant the caprices and furies of the elusive sea,"[40] set up their cameras. In all, they took "three or four photographs of the rose arbor, of the guests that it sheltered, of our host, [and] of charming little Jeanne."[41] Banville would later admire the group portrait, a "marvelous miniature, the size of an ordinary letter, which contains a hundred portraits of striking likeness (fig. 189)."[42]

The noble yacht did not head out to sea again until the next day. Half by carriage, half by schooner, they went to lunch in Monaco. On the morning of May 18 the *Emma* finally entered the port of Genoa, where it was rumored that Garibaldi, after debarking at Marsala, was heading toward Palermo. Three days later, Dumas wrote to his Norman Penelope, Emma Mannoury-Lacour:

> I will stay five or six days in Genoa to write those cursed *Memoirs*,[43] which, half completed, are already half translated. . . . I do not really know what to tell you about where we are going upon leaving Genoa: it depends on how the Garibaldi business shapes up; the newspapers have stupidly announced that I was going to join him in Sicily, so here I am, personally at war with the King of Naples. . . . Not only will I send you flowers, but all sorts of photographs to view in the stereoscope.[44]

On May 28 the writer received news of the capture of Palermo. After completing the second volume of Garibaldi's *Memoirs* that night, he decided to join his hero. The next day, Dumas wrote a letter to the architect Charles Robelin announcing his imminent departure, as well as a felicitous event that would nevertheless have disastrous consequences for the quest for the Orient:

> The dear child you saw at the house, a boy during the day, turns into a woman again at night. During a moment when he was a woman, an accident occurred that became apparent the following month. M. Émile has disappeared and Mlle Émilie is pregnant and, therefore, in two months, will be obliged to let me continue the voyage alone. She will be in Paris from July 15 through the twentieth. At that time, would you find her a small furnished apartment in the country near you? . . . Send your reply by post to Malta, dear friend. We leave tomorrow or the next day for Palermo.[45]

190 Gustave Le Gray. *The Castres Quarter, Palermo*, June 1860 (cat. no. 193).

191 Gustave Le Gray. *Palermo Cathedral*, June 1860 (cat. no. 189).

192 Gustave Le Gray. *General View of Palermo*, June 1860 (cat. no. 188).

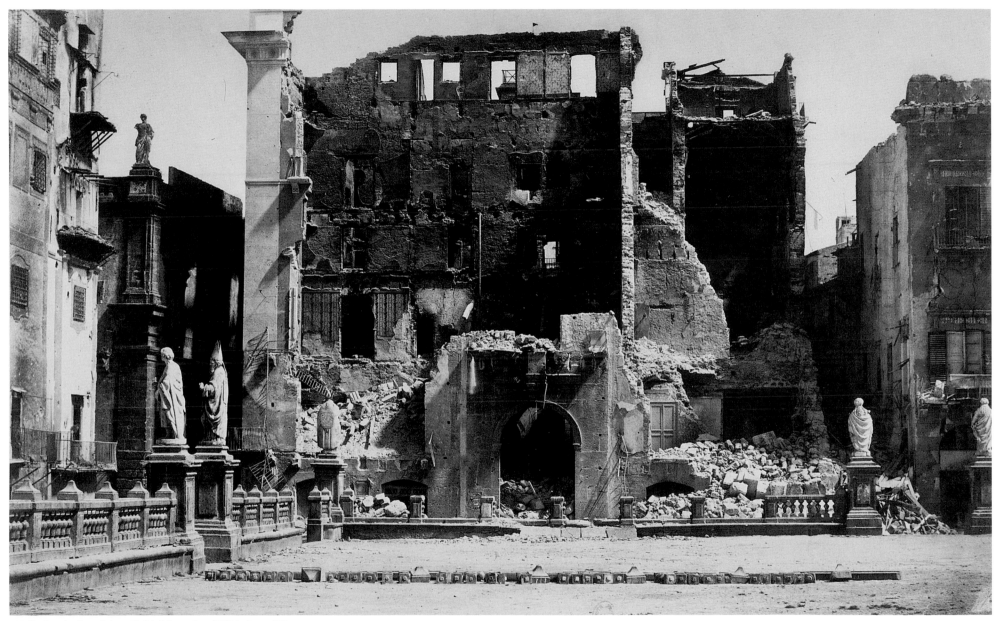

193 Gustave Le Gray. *Palazzo Carini, Palermo*, June 1860 (cat. no. 190).

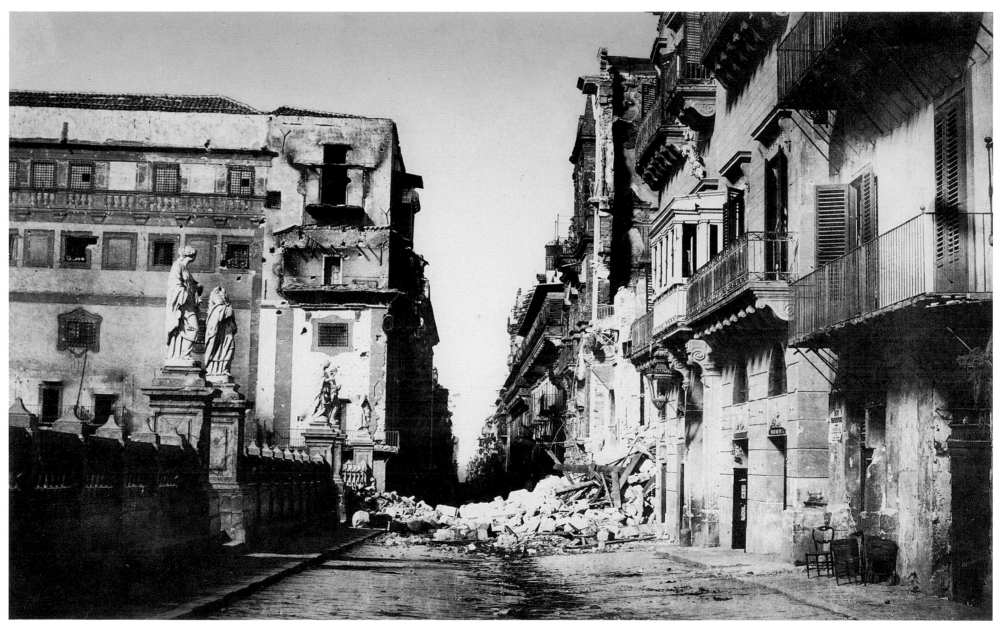

194 Gustave Le Gray. *Strada di Toledo, Palermo*, June 1860 (cat. no. 192).

Palermo and Sicily

On May 31, at three o'clock in the afternoon, despite atrocious weather and opposing winds, the *Emma* left Genoa for Palermo and traded pleasure sailing for epic making. Nonetheless, the group still allowed itself a few pleasures. On June 4 they dropped anchor in a bay in northern Sardinia, and the master permitted his youthful troop, outfitted with rifles, to disperse along the coast and take pot-shots at anything that moved. Le Gray and Albanel, the only ones who knew how to handle a rifle, went in vain pursuit of some unco-operative boars who refused to let themselves be killed. In the end, Le Gray managed only to shear in half an unfortunate fish.[46] On the evening of the fifth they set sail for Sicily. They continued to amuse themselves by capturing and then cooking a tortoise. On the ninth, with Cape Gallo in view, they heard muffled explosions, then

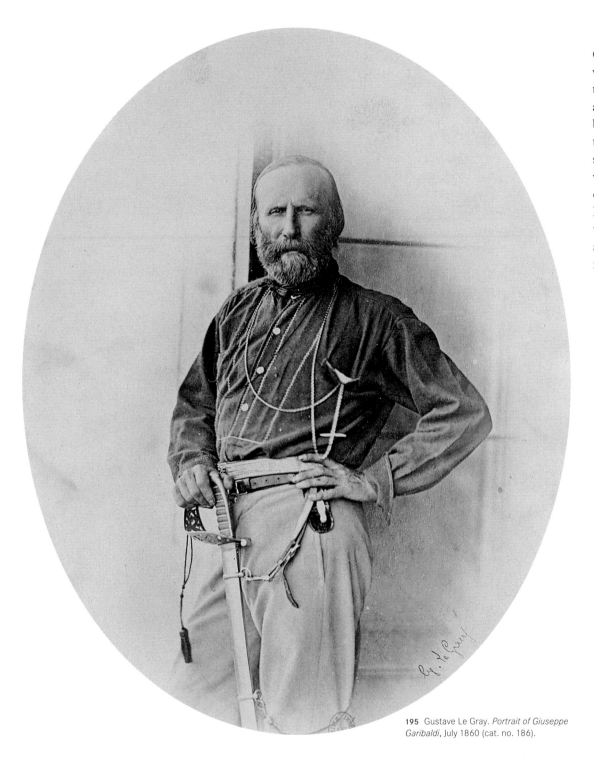

195 Gustave Le Gray. *Portrait of Giuseppe Garibaldi*, July 1860 (cat. no. 186).

196 *General Garibaldi, Dictator of Sicily*, engraving after a photograph by Le Gray, *Le Monde illustré*, July 21, 1860.

seven gun shots, which they tried to interpret. On June 10 they watched the dawn illuminate the houses of Palermo, over which the Sardinian flag flew, although the forts displayed the colors of Naples. Garibaldi had been master of the city since Pentecost (May 27). The cheerful Palermo, overrun by men in red shirts, was nothing but crumbling houses and barricades.

At the Senate building, Dumas fell into the arms of Menotti, Garibaldi's eldest son, who led him through the rubble-filled streets. In front of the cathedral, they encountered Garibaldi in person, who shouted with joy on seeing his friend.[47] Dumas and his convoy were royally lodged at the Palazzo Reale, in the viceroy's apartments, where Garibaldi himself had taken up residence. Dumas suggested that the general send him his chaplain, Father Giovanni, to have his portrait taken.

> "Do you have a photographer with you?"
>
> "Quite simply the leading photographer in Paris, Le Gray."
>
> "Well then, have him shoot our ruins; Europe must know these things: two thousand eight hundred bombs in a single day!"[48]

An immense salon was converted into a dormitory for the group. Under the balcony, there was a continual succession of dawn serenades and demonstrations in honor of Garibaldi, and even of Dumas, according to the painter Durand-Brager, correspondent for *Le Monde illustré*:

> An enthusiastic crowd arrived one afternoon, suddenly filling the square facing the windows, shouting itself hoarse with cries of *Viva Dumas! Viva l'Italia! Viva Dumas! Viva la libertà! Viva Garibaldi! Viva Dumas!*, etc.
>
> "Who is Dumas?" one of them asked his neighbor.
>
> "I don't know," said the other.
>
> "He's the brother of the king of Naples, or else a Circassian prince, rolling in riches, who has come to place his subjects and his vessel at the disposal of Sicilian liberty."[49]

During this time, Dumas wrote:

> Le Gray spends his days taking magnificent photographs of the ruins of Palermo. I will send a collection of them to Paris, which can be used to create an exhibition. I will include a magnificent portrait of Garibaldi, Türr,[50] and Father Jean. However, opportunities are lacking; the only boat that used to come to Palermo was a Neapolitan boat. Naturally, it comes no longer. For now, the imperial mail service will have to order one of its boats from the Orient to make a stop at Palermo.[51]

The viceroy's balcony offered a unique vantage point for a thousand and one scenes of intoxication and liberty. For example, on June 19, at ten o'clock in the evening, by torchlight, some fifty Palermitans rolled a shapeless object through the dust with their feet. As Dumas and Durand-Brager watched, Parfait, Lockroy, Le Gray, Albanel, and Kassapis went down to find out what the object was. It turned out to be the head of a statue of Ferdinand I, the man whom Dumas had accused of poisoning his father, General Dumas.[52]

Earlier that morning, six noble prisoners (fig. 197), whom the monarchists had used as bargaining chips, were liberated and covered with flowers by a jubilant crowd. "They are returning tomorrow at noon so we may take their portrait. We will leave their families

46 Dumas, "Odyssée en 1860, chaps. 18, 19," *Le Monte-Cristo*, nos. 30–32 (April 11, 15, 18, 1862).
47 Regarding this encounter, see G. Bandi, *Les Mille: Expédition de Garibaldi en Sicile* (Florence, 1906), 201–2.
48 Dumas, "Odyssée en 1860, chap. 21," *Le Monte-Cristo*, no. 34 (April 25, 1862): 272.
49 H. Durand-Brager, *Quatre mois de l'expédition de Garibaldi en Sicile et en Italie* (Paris, 1861), 83–84.
50 Istvàn Türr (1825–1908), a Hungarian patriot, joined Garibaldi in 1859, becoming a colonel in the chasseurs des Alpes, and participated in the conquest of the Two Sicilies.
51 Dumas, "Les Garibaldiens," vol. 3, fols. 44–45.
52 Dumas, "Odyssée en 1860, chap. 26," *Le Monte-Cristo*, no. 40 (May 13, 1862): 320.

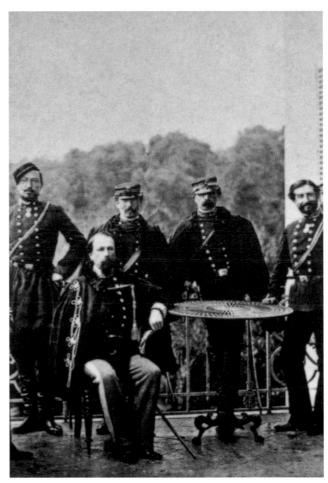

197 Gustave Le Gray. *Portrait of Princes Taken Prisoner*, July 1860.

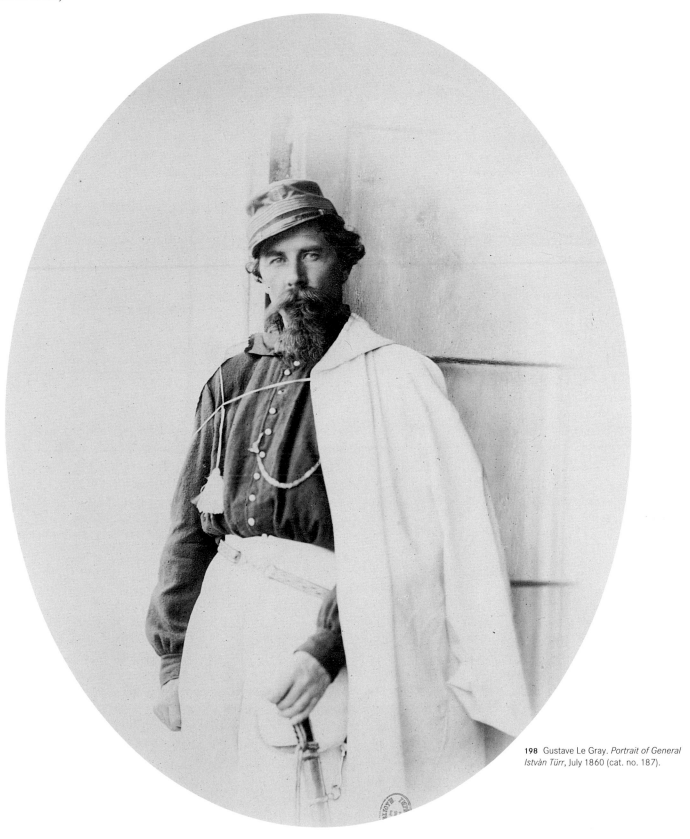

198 Gustave Le Gray. *Portrait of General Istvàn Türr*, July 1860 (cat. no. 187).

this souvenir of our passage. It is so good to give, whether from the hand or from the heart," wrote Dumas,[53] who, with this one-sided royal "we," claimed the works of his iconographer as his own. He did likewise when, on the verge of leaving Palermo, he wrote this overview of the portraits that had been taken: "We have taken a group photograph of six prisoner princes, and two magnificent portraits of Türr (figs. 195, 198) and the general."[54] The portrait of Garibaldi was admired by Durand-Brager, who promised it to the readers of *Le Monde illustré*.[55] When Dumas brought the general his copy of the print, the general persuaded his historiographer to write a note at the bottom, to commemorate their friendship. The writer obliged:

My dear General,

Avoid Neapolitan daggers, become the leader of a republic, die poor as you have lived, and you will be greater than Washington and Cincinnatus ever were.

Alex. Dumas.

Palermo, June 20, 1860[56]

Finally, if we are to believe Dumas, the portrait could have become, strictly speaking, a patriotic icon. On July 20, on his way to Marseilles, aboard the *Pausilippe*, to acquire rifles and carbines for the Garibaldians, he took his "very handsome photograph of the general" from its box in front of a Neapolitan policeman.

Tears came to the eyes of my interlocutor. He clasped his hands in a gesture of adoration; I thought he was going to fall into raptures.

"Oh, sir," he cried, "we have only abominable portraits of the general, which are sold, even so, at an exorbitant price!"

So I replied, "I greatly wish to have this one engraved and make it a patriotic gift to the city of Naples."

"Why give them away, sir, when you are sure to sell them for any price you wish?"[57]

The overall feeling this sojourn inspired in the young people of the party—a feeling undoubtedly shared by Le Gray—was nicely expressed in a letter from Noël Parfait to Michel Lévy. In the same letter, he also indicated that, from what he already knew of it (i.e., three volumes containing approximately 230 thousand or 240 thousand characters), *Voyage through Sicily and around the Mediterranean* promised to be "a most curious and amusing book."[58]

The children are delighted with their voyage. Everything they see fills them with wonder. On the morning of their arrival they breakfasted with Garibaldi. Imagine how big their eyes were! The spectacle of Palermo,

barricaded and half burnt down was, it seems, incredible. The entire population, bourgeois, nobles, priests, women, and children, armed with daggers and knives, milled about the streets day and night. They constantly pulled from beneath the rubble bodies and body parts: arms, legs, heads, and the crowd showed their fists to the royal soldiers locked up in the forts, crying, "*Gli assassini infami!*" [The vile assassins!] (I am not responsible if my son has somewhat butchered the Italian.)

Dumas decked himself out with a tricolor plume, and they call him General! Garibaldi put him and the children up in the very palace of the king of Naples. They presented arms to them when they came or went. It was a comedy mixed with drama in the tradition of the grand masters of the stage.

But already:

Dumas and his staff—that is, Le Gray, the doctor, Théodore, Édouard, and my son—left Palermo, shouldering their rifles, with a column of volunteers, commanded by Colonel Türr and headed for Catania. I have had no news since their departure. If they do not get themselves killed, they will reboard the *Emma* at Girgenti and, with the rest of the crew, are to circumnavigate Sicily.[59]

The troop left the scene of Palermo on June 21 as Durand-Brager observed:

It was quite a military departure. There was Le Gray, the photographer, and Lockroy, the draftsman, along with some forty veteran soldiers, with varying lengths of mustaches and beards, rucksacks on their backs, rifles on their shoulders, and each with a variety of gear hanging from their belts. It was three o'clock in the morning when this little party got moving, the carriages and baggage in the center, three superb English pointers leading the way, and the pilot of the yacht bringing up the rear.[60]

The column, crossing Sicily, "where paradise was everywhere," halted at Misilmeri, of which Lockroy drew a *View* (perhaps from a photograph by Le Gray) that was published in *Le Monde illustré*. They then stopped for several days (from June 22 through 28) in Villafrati (another drawing by Lockroy: *Halting of the Column of General Türr at Villafrati*)[61] because Türr was seriously ill. Their stay there was marked by the court-martial of the bandit Santomelli. On the twenty-eighth the column set off again, now commanded by Eber. Dumas went to Alia, while his companions—an initial sign of cooling relations?—awaited the column at Sottovicari. There, Lockroy and Le Gray climbed a hill in the hot sun and disappeared from view; their worried companions found them several hours later. Lockroy, his head wrapped in a turban made of

53 Dumas, "Les Garibaldiens," vol. 3, fol. 53. On the liberation of the prisoners, Giovanni Colobria, Baron Riso, the young Prince Pignatelli, Duke Francesco of Giardinelli, Duke Nosarbartolo of San Giovanni, Prince Corradino of Niscemi, the young Duke of Cesaro and the father, Ottavio Lanza, of the family of the princes of Trabia, see *La Forbice* (June 20, 1860): 58–59.

54 Dumas, "Odyssée en 1860, chap. 27," *Le Monte-Cristo*, no. 41 (May 20, 1862): 327.

55 Durand-Brager, in *Le Monde illustré*, ann. 4, no. 168 (June 30, 1860 [Palermo, June 15–22]): 422: "M. Le Gray, one of the inventors of photography, and whose very remarkable daily exhibitions every Parisian admired on the boulevards, is accompanying Alexandre Dumas. That eminent artist has promised to give me a very handsome portrait of Garibaldi, which I will forward to you with my first shipment, along with several photographs [by Billardet and Laîné] in addition to my drawings." The portrait of Garibaldi, engraved by E. Morain and L. Dumont, was reproduced in *Le Monde illustré*, no. 171 (July 21, 1860).

56 Dumas, "Odyssée en 1860, chap. 27," *Le Monte-Cristo*, no. 41 (May 20, 1862): 328.

57 Dumas, "Odyssée en 1860, chap. 43," *Le Monte-Cristo*, no. 61 (July 29, 1862): 488.

58 This manuscript, sent progressively as it was written to Noël Parfait, is conserved at the Auckland Public Library (see note 1).

59 Parfait, letter to Michel Lévy, June 28, 1860, private collection; copy kindly provided by J.-Y. Mollier. Parfait inaccurately dates this departure to June 19.

60 Durand-Brager, *Quatre mois de l'expédition de Garibaldi*, 84–85.

61 *Le Monde illustré*, no. 170 (July 14, 1860).

62 Dumas, "Odyssée en 1860, chap. 29," *Le Monte-Cristo*, no. 49 (June 17, 1862): 392.
63 Dumas, "Odyssée en 1860, chap. 32," *Le Monte-Cristo*, no. 52 (June 27, 1862): 413. Before that stop, the caravan stopped in Vallelunga (June 29–30), Santa Catarina (July 1–2), and Caltanissetta, from where Eber's column continued on to Catania by way of Castrogiovanni (Enna).
64 Dumas, *Les Garibaldiens*, chap. 11. Another version is in Dumas, "Odyssée en 1860, chap. 35," *Le Monte-Cristo*, no. 54 (July 4, 1862). Garibaldi responded affirmatively in a letter from Palermo dated July 10 or 13, of which Dumas provided three different translations: *L'Indipendente* (March 15, 1861); Dumas, *Les Garibaldiens*, chap. 11; Dumas, "Odyssée en 1860, chap. 35," *Le Monte-Cristo*, no. 54 (July 4, 1862): 428.
65 Dumas, "Odyssée en 1860, chap. 5," *Le Monte-Cristo*, no. 13 (February 11, 1862): 103: "After the bombardment of Palermo, when the ship, instead of going to the Orient, made an about-face to return to Naples, the three friends left us and departed together for Beirut."
66 Dumas, "Odyssée en 1860, chap. 35," *Le Monte-Cristo*, no. 54 (July 4, 1862). Dumas, "Révolution de Naples," fol. 2 (see note 1), contains a single sentence about the stop: "I stayed one and a half days in Malta."
67 Lockroy, *Au hasard de la vie, notes et souvenirs* (Paris, 1913), 39–44 ("In Malta").

towels that had been immersed in cold water and vinegar, was perched on a donkey that Le Gray pulled along by the bridle; a victim of sunstroke, he had suddenly fainted.[62] Dumas slipped away again on July 4 at San Cataldo leaving to "the enthusiasm of the excellent San-Cataldans the doctor, Le Gray, Vasili, Podimatas, our two Greeks, and our carriages."[63] They joined him the next day in Girgenti (the ancient Agrigento).

Epilogue: The Mysteries of Malta

They reboarded the *Emma* on July 7 to sail to Malta but were forced to put into port at Licata; the writer's travel bag had been left behind in Girgenti. While waiting to recover it—and before leaving Sicily, perhaps for good, which meant leaving in the midst of the fine drama of the resurrection of a nation—Dumas made a proposal to Garibaldi that, if accepted, might well put an end to their voyage to the Middle East:

> My friend, I have just crossed the entire breadth of Sicily. Great enthusiasm everywhere, but no weapons! Would you like me to go get you some from France? I would select them for you as a huntsman. Reply general delivery to Catania; if you say "Yes," I will postpone my voyage to Asia, and I will spend the rest of the campaign with you. *Vale et me ama* [farewell and love me].[64]

After reaching the port of Valletta (in Malta) at two o'clock in the afternoon on July 13, Le Gray, Albanel, and Lockroy left the *Emma*. (After introducing the crew in *An Odyssey in 1860*, a minor note by the author prepared his readers for this separation.)[65] On July 26 the dissident (or expelled) group left together, headed for Beirut by way of Alexandria. As for the causes of this sudden rift, the official version provided by Dumas was the following:

> This resolution that I had made to return to Sicily and to pursue the Italian campaign, if Garibaldi thought that I might be of some use to him, had thwarted the plans of three of our friends, true orientalists that they are—such that, on arriving at Malta, we parted ways. Le Gray, the doctor, and Lockroy insisted on leaving the *Emma*. I was quite insistent with the last of these three, who had been entrusted to me by his father and whom I sadly felt slipping from my grasp, but all was in vain; on their own hook, those gentlemen disembarked.[66]

However, if we are attempting to arrive at the truth of what has remained a mysterious event, we should contrast three other versions with this account. First, the direct testimony that Édouard

Lockroy recorded in *The Fortunes of Life* his bitter memories, recalled more than fifty years later, which no doubt accurately represented the sentiment that pervaded the castaways (even though, for dramatic effect, Lockroy omits mention of his companions and depicts himself as alone, poor, and naked in the middle of the Mediterranean):

> I was not yet twenty when I was abandoned in Malta, after having sharp words with the captain of the schooner that had been carrying me. I had but one louis in my pocket. The sailors took me to shore in a dinghy and said adieu. I remained standing on the dock, a bit frightened, a bit disoriented, and I watched as they rowed back to the schooner, which was at anchor near the entrance to the port of Valletta. I saw them climb up the ladder, haul the dinghy on board, and set to work at the capstan. The sails unfurled, one by one, first the jib, then the foresail. The schooner immediately tacked and offered its stern. The captain stood near the helm, very small, barely visible, and yet I recognized him. At the main mast, a red pennant unfurled, thin and long against the sky. Soon, I could no longer make out anything but a white point, no larger than a gull. Then nothing.
>
> I had lived a long time on that boat. I was then a pitiful boy, very puny, very shy, very sensitive, very intractable, readily duped, with notions of honesty taken to extremes, since they caused this abandonment. The captain had set me down, with my twenty francs, in the middle of the Mediterranean.
>
> I did not quite understand what had happened, and I was still seeking the cause as I watched the boat disappear on the horizon.
>
> I remained a long time on the dock, even after the schooner had disappeared.[67]

A second version was sent by Noël Parfait to Michel Lévy just a few days after the event, on July 21, 1860, in all likelihood on receiving a letter from Édouard Lockroy and/or Paul Parfait:

> By the way, here is the latest bolt from the blue.
>
> Dumas, on arriving at Malta, abruptly parted company with some of his travel companions: Le Gray, Doctor Albanel, and Édouard Lockroy. As you must already guess, the cause of the split was none other than the silly young thing Dumas is dragging along with him. There were some deplorable scenes, to the point where they were about to draw swords. I will tell you about it in detail when you come to Paris. Dumas tried to detain Édouard, but he was unable to do so; that good young man had been too deeply wounded. My son himself, although unused to quarrels,

was just barely brought back on board the *Emma;* he wanted to share the fate of his companions, and Dumas was obliged to remind him that he was a minor.

All of that is indeed sad! There you have it; over a miserable she-monkey, friends are at deadly odds, and a magnificent voyage nearly—if not entirely—ruined! Poor Lockroy and his wife are distraught; I saw them crying yesterday; and I cried myself on reading the touching and noble letter in which their son related to them what had happened. That letter makes you love its writer as much as it would make you detest Dumas, if we did not believe he has completely lost his head.

On leaving Malta, the *Emma* headed for Catania. Why is Dumas returning to Sicily, where he has already spent more than a month? I have no idea. Preoccupied no doubt by the incident about which I have just told you and, especially, by the regrettable news contained in the series of letters I had sent him in Malta, he neglected to inform me of his plans and even to provide me with his itinerary.[68]

The final document, a distressed letter from the elder Lockroy to Noël Parfait, dated July 31, contains more motives for resentment:

I quite fear that I have given my son and those gentlemen regrettable advice when I urged them to return to Sicily. Dumas tells us, in his letter to Carini [published in *Le Siècle* on July 31, 1860], that he saw Garibaldi again. If he spent but twenty-four hours in Milazzo, it is impossible that several of those gentlemen did not say something to him about his change of itinerary and inquire about his travel companions. God only knows what he may have replied and how those poor young people must have been described! The tone of his letter sufficiently reveals what he must have said about Édouard in particular.

I am, dear friend, inconsolable over this deplorable affair. I especially cannot reproach myself sharply enough for having allowed Édouard to leave under such conditions. Monjauze, whom I encountered, told me about the impression this has made in Marseilles![69]

These documents contradict the official version of an amicable separation due to a change of course. Lockroy even considered hiring himself out as a seaman (as his companions probably did) specifically "to thereby reach Italy and Garibaldi's army, which, despite myself, I so regretted having left." A bit later, in a dispatch to Pointel (editor of *Le Monde illustré*), Lockroy offered "to go, as a correspondent, either to Italy, to China, or to Syria."[70] This account is admittedly belated but convincingly echoes the letter

from his father urging him to return to Sicily with those misguided "gentlemen."

Clearly, the separation had resolved a violent conflict whose cause remains obscure. Lockroy was hardly prolix about the noble motives for his "sharp words with the captain of the schooner" (Dumas, not Beaugrand). Noël Parfait was more specific, pointing the finger at the woman in the mix, ascribing full responsibility to Émilie Cordier. He added that "Dumas tried to detain Édouard," while omitting mention of his companions. This might lead us to believe that Lockroy voluntarily left the *Emma* after siding with Le Gray and Albanel, whom Émilie apparently disliked.

However, the young woman could not remain with the voyage to the Middle East either, due to her pregnancy. According to Noël Parfait, Dumas even promised his son Alexandre "to very shortly send away the little runt he had brought with him," in exchange for which the son promised to join the caravan in Athens.[71] One might venture to hypothesize that the suburban Circe was prepared to use any means at her disposal to permanently interrupt a voyage that would go on without her. Is it just possible she accused one or another of them of indecent proposals (either Le Gray or Albanel, who, in his capacity as a physician may have provided Dumas with the medical justification for his desire to send Émilie back to Paris)? Thus, because it was one's word against another's, she might have succeeded in having her aging lover get rid of the photographer and the physician.

The "white sail, small as the wing of a seagull," moving away "on the horizon, along the deep blue line that separated the sky from the Mediterranean,"[72] was a great book disappearing: Alexandre Dumas's *Voyage through Sicily and around the Mediterranean*, illustrated with two thousand photographs by Le Gray. An empty space in an ideal library.

68 Parfait, letter to Lévy, July 21, 1860, private collection; fragment published by Mollier, *Michel et Calmann Lévy ou la Naissance de l'édition moderne, 1836–1891* (Paris, 1984), 360.
69 Lockroy, letter to Parfait, July 31, 1860, Société des amis d'Alexandre Dumas, Glinel collection, R 8 167.
70 Lockroy, *Au hasard de la vie*, 44.
71 Quoted in Parfait, letter to Lévy, June 28, 1860 (see note 59).
72 Dumas, *Le Comte de Monte-Cristo* (Paris, 1845), last lines.

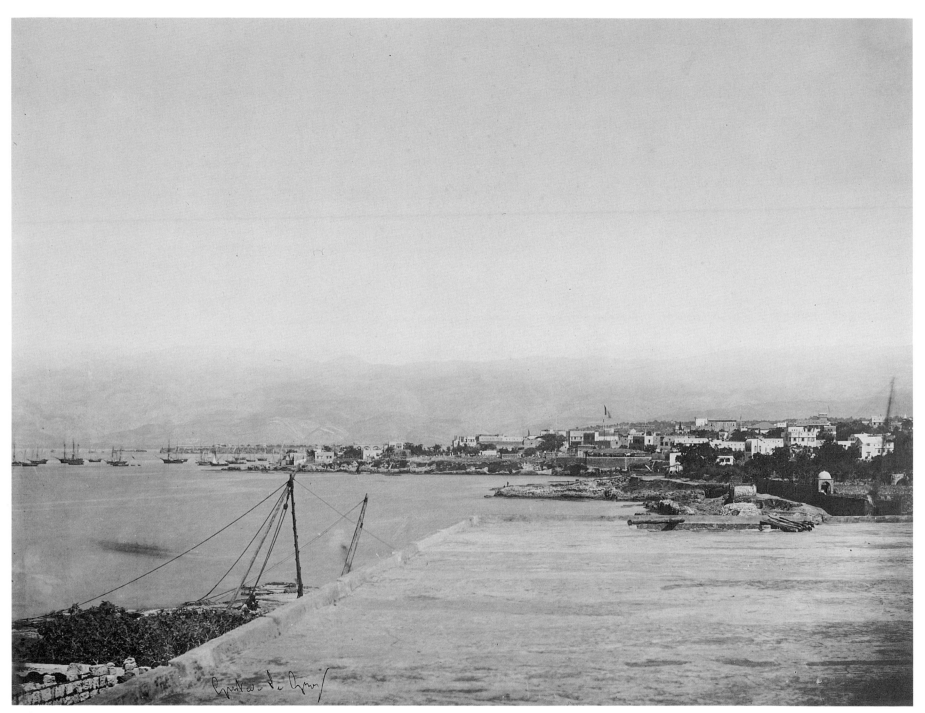

199 Gustave Le Gray. *View of the Port of Beirut from the Hôtel Bellevue* (half of a panorama?), fall 1860 (cat. no. 194).

The Flight into Egypt: An Exile without Return

Sylvie Aubenas with Mercedes Volait

Syria and Lebanon

Their abandonment on the dock at Valletta left Le Gray and his companions as helpless as they were furious, as Lockroy's memoirs indicate.[1] Bear in mind that this account was quite detailed but also belated, for it was published a half century after the fact, and its reliability is sometimes suspect. Having achieved, in the interim, an eminent societal role through politics, the author features himself alone. From the day he claims to have been put ashore alone in Malta, he sacrifices Albanel and Le Gray to his own self-aggrandizement, even more than to a literary concern for dramatic effect. So the informed reader should be sure always to correct "I" to "we."

As previously indicated, the first plan considered by the travelers was to hire themselves out as sailors in order to return to Italy and Garibaldi's army. However, due to the fighting, they were unable to find a boat to the Kingdom of the Two Sicilies. After wandering through the city, they chanced upon the shop of a certain Durand, a republican who had been banished by Napoléon III. Durand took a liking to the three lost Garibaldians and gave them shelter. Then he directed them to the nearest post office. There, according to Lockroy:

> For my twenty francs, I sent a dispatch to M. Pointel, editor of *Le Monde illustré,* offering to go, as a correspondent, either to Italy, to China, or to Syria. M. Pointel had already published one of my sketches, which had been sent to him by Durand-Brager, a seascape painter I met in Palermo. He accepted my offer and, ten days later, I embarked for Beirut aboard the cargo boat *Boetia.*[2]

Pointel's reply, received July 25, asked them to go to Syria and cover the events taking place there, which were briefly as follows: Of the diverse populations that lived in the mountains of Lebanon, the two most important groups, the Christian Maronites (numbering approximately 120,000) and the Muslim Druze (approximately 50,000), had seen their ancient coexistence unraveling since the 1840s in sporadic fighting, in which there were rival influences at work (the French, English, and Turkish governments). This tense situation was abruptly transformed into open war in early June 1860,

when the Druze, supported by the Turks, began to massacre the Maronites. Entire villages fell to the sword, and convents, churches, and Christian schools were destroyed. The French public, immediately aroused (there were many French missionaries in Lebanon), learned with horror of the total destruction, on July 9, of the Christian quarter of Damascus (25,000 inhabitants). Napoléon III, informed on the sixteenth, immediately ordered the dispatch of an army corps, which was to embark at Marseilles and Toulon on August 5. When Pointel received an offer from three qualified correspondents already in the Mediterranean, just as the decision was being made to send the expedition, it must have seemed providential to him. Consequently, on leaving Malta for Beirut on July 26, the three "special envoys" were plunging into a heated situation, to which *Le Monde illustré* would devote numerous articles from September through November 1860.

On July 31 they made a first stop in Alexandria. Two days later Le Gray went to the consulate general of France to assign to Léon Maufras a power of attorney. The entanglements with the Briges brothers were far from over and, unable to predict the date of his return or the dangers that awaited him in Beirut, the photographer suddenly became aware of the need for an agent. So he fully empowered Maufras to manage his affairs and to take possession of any inheritances he might receive.[3] The young Lockroy, taking very seriously his role as a war correspondent and already playing the protagonist, wrote to *Le Monde illustré* on August 2: "Tomorrow at four o'clock in the morning, I am leaving for Beirut. M. Le Gray, whose talent you are familiar with, is accompanying me to Syria."[4] In reality, it was not until August 5 that they boarded a Russian steamer. They stopped at Jaffa on the seventh, Haifa on the ninth, and, finally, Beirut on the tenth. Lockroy recounts:

> As soon as I arrived in Beirut, I saw that the massacres, begun three months earlier, were ongoing. The French expeditionary force had just disembarked its infantry, cavalry, and artillery. At the time, I was staying in a small, Arab house, hidden in some mulberry trees, that belonged to a good-natured fat fellow named Cakvodja Pscharra (in French, Monsieur Conception).[5]

1 É. Lockroy, *Au hasard de la vie, notes et souvenirs* (Paris, 1913), 41–44.
2 Ibid., 44.
3 Archives of the Ministry of Foreign Affairs (Nantes), Alexandria, consulate, chancellery instruments, box 34.
4 *Le Monde illustré* (August 18, 1860).
5 Lockroy, *Au hasard de la vie,* 52.

6 This was the date when Lockroy's letter was sent to *Le Monde illustré* with the photograph enclosed. The letter was published September 1, 1860: 134–35, but the photograph was not reproduced.
7 This photograph accompanied a letter from Lockroy dated September 18, and Le Gray broke his leg on the 17th. Joseph or Yousuf-Karam was in Beirut when the French troops arrived. It was published in *Le Monde illustré* (September 29, 1860): 213.
8 Département des Estampes et de la Photographie (EST), Bibliothèque nationale de France (BNF). Fouad Debbas, who is sorely missed, graciously identified the place and recommended the book by E. Louet, *Expédition de Syrie: Beyrouth, le Liban, Jérusalem (1860–1861), notes et souvenirs* (Paris, 1862), which is the most invaluable source for its recounting of these events on a day-to-day basis.
9 Louet, *Expédition de Syrie*, 87.
10 *Photographic News*, no. 114 (November 9, 1860): 336.
11 F. Nadar, *Quand j'étais photographe* (1900; rev. ed., Arles, 1998), 96.
12 Louet, *Expédition de Syrie*, 168–69.

Dumas had made Le Gray, Albanel, and Lockroy actors, or at least bit players, in a Garibaldian epic. In Beirut, where the French troops were present in August and the first half of September 1860 (fig. 200), they found themselves playing what was an entirely new role at the time: that of war correspondent for a major French weekly. Le Gray was what can be called a photojournalist. The issue of August 25 and the five issues of September, under the heading "An Exclusive Report from *Le Monde illustré*," published articles and drawings by Lockroy, as well as two engravings based on photographs by Le Gray: an overall view of Beirut, which must date to approximately August 12 (fig. 199),[6] and a portrait of Yousuf-Karam, a Maronite military leader, from before September 17.[7] Another view of Beirut, taken from the terrace of the seaside Hôtel Bellevue, where the senior French officers were billeted,[8] was sent to *Le Monde illustré* on September 18 (but not published).

The day-by-day sequence of events was reported by the paymaster of the expeditionary force, Ernest Louet:

Youssuf-Karam, seul chef Maronite qui ait tenu tête aux Druses.
(D'après une photographie de M. Legray.)

200 *Portrait of Yousuf-Karam*, engraving after a photograph by Le Gray, *Le Monde illustré*, September 29, 1860.

September 17.... At three o'clock in the afternoon, M. Scheffer, the emperor's spokesman, left for Damascus with a large caravan, in which several tourists traveled, including M. Le Gray, a photographic artist, the junior M. Lockroy, a draftsman, M. de Saint-Seine, and M. Goert, a military interpreter who had lived for two years at the château d'Amboise with Abd el-Kader.

M. Scheffer is taking to the illustrious emir a grand cross insignia of the Legion of Honor, set with diamonds, a personal gift from the emperor. His voyage commenced with an unfortunate accident that, thankfully, did not have any regrettable repercussions: at approximately two leagues from Beirut, his horse began to kick, and broke the right leg of M. Le Gray, who was unable to continue traveling. He has just been taken on a litter to the Charité hospital, where he is being well cared for by the sisters of Saint-Vincent-de-Paul.[9]

Le Gray's accident, though not covered in the French photographic press, was reported in London in early November in *Photographic News*.[10] Nadar repeated it later, summarizing his colleague's prior twenty-five years as follows: "But misfortune seemed to pursue Le Gray. He broke his leg in an equestrian accident and finally died around 1882 in assuredly undeserved distress."[11] The hopeless inaccuracy of Nadar's memories, here as in other cases, has been a source of persistent historiographic confusion (in addition to the incorrect date), which had Le Gray die in Egypt of a fall from a horse.

So Lockroy continued reporting alone for several weeks. But Le Gray was soon back on his feet. Just two months after the accident, Louet encountered him in the ruins of Baalbek:

November 17.... To the left of the Temple of Jupiter is a cultivated ravine adorned with trees whose foliage pleasantly frames this picture of ruins. We descend through it to the subterranean passages that we initially avoided entering, but which must really be visited in order to comprehend the ancient city, since these subterranean passages, which open onto the countryside, must have been inhabited; they lead to low rooms that are so spacious that several hundred horses could easily be accommodated there. One of these has become the photographic studio of M. Le Gray, who has been traveling through Syria for the past three months in the company of the younger M. Lockroy and, to the benefit of Europe, has been making an admirable collection of the renowned monuments and landscapes of the Orient.[12]

Did Louet see that "admirable collection," or did they only speak together about it? It is quite probable that at Baalbek, for instance, once his "studio" was installed in the subterranean passages, Le Gray produced more than the three known works: one panoramic overview of the ruins (fig. 202) and two compositions including the peristyle of the Temple of Bacchus (fig. 201).

As for Albanel, it is not known whether he remained with Le Gray after the month of August, but some time later, on November 23 in Beirut, both of them filed passport applications for Jerusalem.[13] If that trip took place, there remains no trace of it. The doctor resurfaced on December 10 in Alexandria, but it is not known how he arrived there, nor if he was alone or still with Le Gray.[14]

In the meantime, the clever and resourceful Lockroy followed his own path and found a new occupation. Ernest Renan had been placed in charge of leading a scientific mission to Phoenicia; seeking a collaborator, he wrote to his publisher, who also happened to be Dumas's publisher, Michel Lévy: "I need a draftsman to accompany me, to do a few sketches for me, someone capable of writing a few archaeological notes for me." Michel Lévy replied, "As a matter of fact, young Lockroy is in Beirut, sending drawings to *Le Monde illustré*. Perhaps you might take him with you."[15]

The archaeologist arrived in Beirut on October 30, met the draftsman at the French consulate, and persuaded him to accept a handsome Arabian horse as his entire salary. Thus, Lockroy spent several months with Renan, his wife, his sister, Dr. Gaillardot (who was also recruited on the spot), and the architect Thobois, who formed his team. The excavation work was protected by a company of foot soldiers from the expeditionary forces. In Djebel (Byblos), and then in Saida (Sidon), as he recalled in his memoirs, Lockroy made drawings and photographs; and among the documents and notes from the mission are prints from waxed-paper negatives, which must be his.[16] Le Gray had taught him technique, but the imperfect results betray a beginner. Renan had to be content

13 Archives of the Ministry of Foreign Affairs (Nantes), Beirut, consulate, series A, box 63.
14 Power-of-attorney filed by Albanel, Archives of the Ministry of Foreign Affairs (Nantes), Alexandria, consulate, chancellery instruments, box 34.

15 Lockroy, *Au hasard de la vie*, 45–46.
16 Correspondence of Dr. Gaillardot with Renan and photographs, Institut de France, Library, MSS 1981–83 (papers of Jules de Bertou).

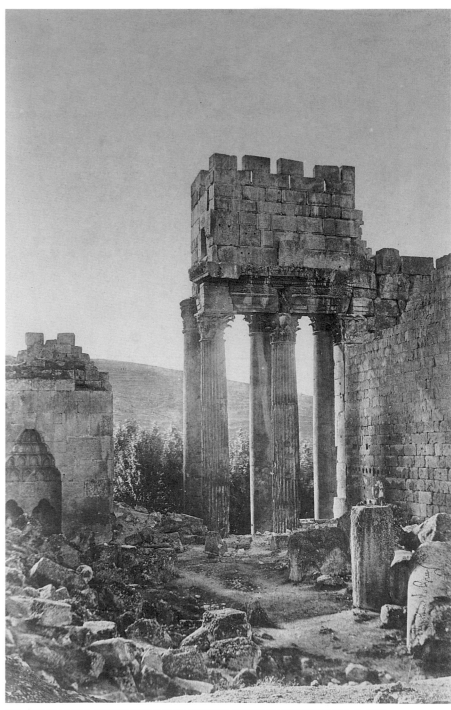

201 Gustave Le Gray. *Peristyle of the Temple of Bacchus, Baalbek*, November 1860 (cat. no. 196).

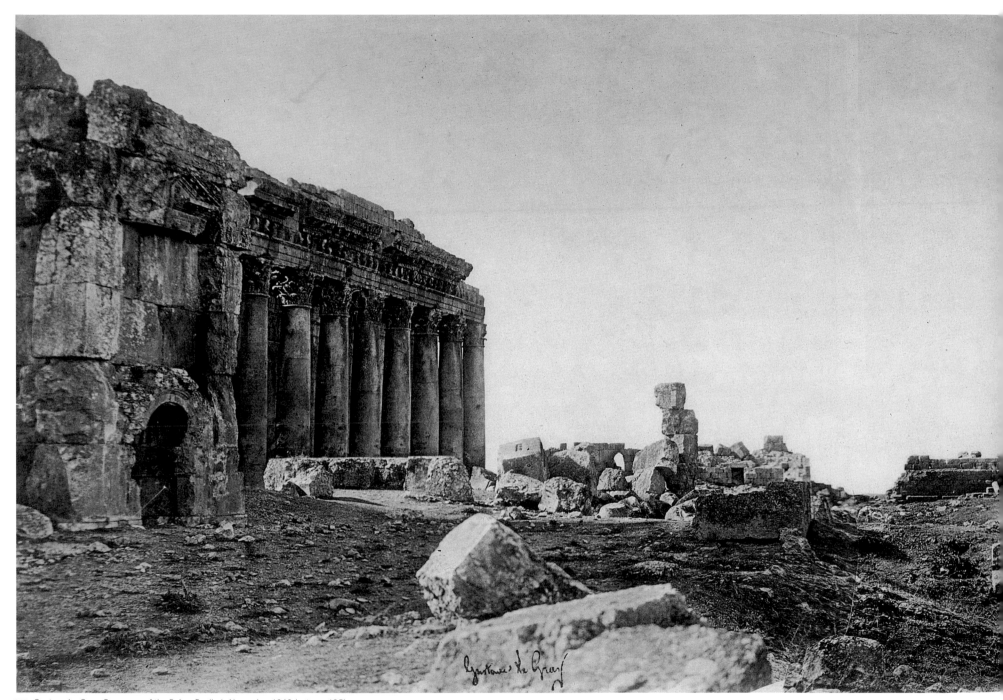

202 Gustave Le Gray. *Panorama of the Ruins, Baalbek*, November 1860 (cat. no. 195).

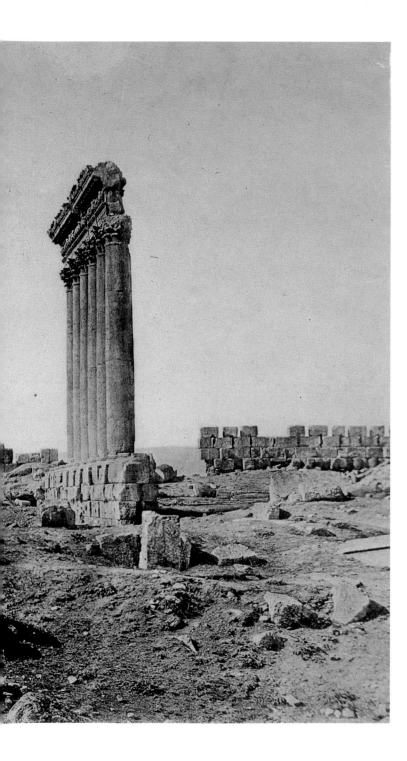

with them. He compensated young Lockroy with the pleasure of his company and a horse; he would not have had the resources to engage Le Gray, especially if the latter preferred to attend to his collection of monuments and landscapes.[17]

Alexandria

Only one other photographer is confirmed to have been with Renan and Lockroy: Raoul de Saint-Seine, an aristocratic French traveler, named as part of the Damascus expedition of September 17. But Saint-Seine took photographs to please himself, primarily stereo-scopic views from his voyage (fig. 203).[18] Around March 1861, Lockroy left Syria in his company and went to Egypt, at the expense of this new and generous friend, for a cruise along the Nile, which lasted until the fall.[19]

The date that Le Gray left Syria has not been determined. Between his application for a passport for Jerusalem in late November 1860 and his confirmed presence in Alexandria start-ing in 1861, if he did not accompany Albanel in December, he may have gone with Lockroy and Saint-Seine in the spring; but he may also have traveled alone or with other companions. By March, it was known in Beirut that the French troops—whose role was lim-ited to recording the massacres, reassuring the population, and mak-

17 There is no mention of Le Gray's participation in correspondence from Renan (*Lettres inédites d'Ernest Renan à ses éditeurs Michel et Calmann Lévy* [Paris, 1986]) or Dr. Gaillardot (see note 16), or in the accounts of the publisher Lévy.
18 Thanks to M. Jean-Marie Voignier for informing us of this series in his collection.
19 Lockroy, *Au hasard de la vie*, 108–9; Dr. Gaillardot, letter to Renan, December 3, 1861, Institut de France, Library, MSS 1981: "In the latest post, I received a letter from Lockroy dated November 11 [1861], from Alexandria: he gave me interesting details about a magnificent voyage he took in Upper Egypt, in the company of M. de Saint-Seine."

203 Raoul de Saint-Seine. *The French Consulate in Beirut*, September 1860.

20 *Le Monde illustré* (April 6, 1861): 213. The caption does not mean that Le Gray took the photograph at night; he may have taken a photograph of the site during the daytime, with a drawing and/or description of the ceremony.
21 [Henri] comte de Chambord, *Journal de voyage en Orient, 1861* (Paris, 1984), 316.
22 BNF, EST, Qe 854 4°.
23 EST, BNF.

ing their presence known to the Anglo-Turkish coalition—were to leave Beirut in early June. Le Gray had no reason to linger in a troubled country where he had already spent several months. The logical continuation of his voyage was through Alexandria, a scant two-day sail from Beirut.

His earliest existing photographs of Egypt are damaged, rather disparate prints of the Zizinia Palace in Alexandria (fig. 204) and the Shubra promenade in Cairo (fig. 220), as well as a series of picturesque Egyptian portraits taken in a studio, printed in the carte-de-visite format, in the tradition of commercial photography—unexpectedly banal work, which suggests a pressing need for money. In contrast, there are two small views in this same format, but of a very different inspiration, no doubt the sole survivors of a more numerous series: a group of children in dirty tunics in a street (fig. 218) and masons in traditional costume on a terrace (fig. 219). These extraordinarily individualistic quasi snapshots are forerunners of the vision of a few great twentieth-century photographers, who, like Cartier-Bresson, were able to avoid the stiltedly picturesque and

bring back compassionate images of daily life from faraway countries. Finally, on April 6, 1861, *Le Monde illustré* published an engraving depicting a night scene, *The Reception at Alexandria of Saïd Pasha on His Return from Mecca*, "based on documents and a photograph by M. Gustave Le Gray"; the columnist extolled "that intrepid artist who, after having his beautiful photographic prints admired for so long by Parisian fanciers, has left for the Orient to seek new subjects and sites" (fig. 205).[20]

Le Gray apparently moved temporarily to the European quarter of Alexandria. There, on December 3, 1861, he photographed the comte de Chambord and his retinue, who were staying at the Hôtel de l'Europe (fig. 208). The prince wrote in his journal:

> I am joining our companions at the Hôtel de l'Europe, where we are to be photographed, with our unkempt beards, by a Frenchman, M. Le Gray, who is skillful but expensive. There, we will meet M. Montau[l]t, whom I saw in Cairo, and who draws with talent. He was an officer in the service of the viceroy and is now working at the museum under M. Mariette.[21]

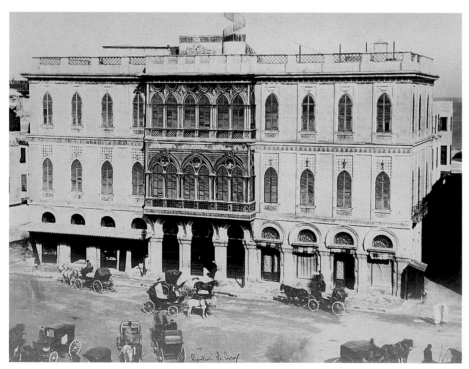

205 *The Reception of Saïd Pasha in Alexandria on His Return from Mecca*, engraving after a photograph by Le Gray, *Le Monde illustré*, April 6, 1861.

204 Gustave Le Gray. *Zizinia Palace, Alexandria*, ca. 1862 (cat. no. 201).

So Le Gray was indeed acquainted with Henry de Montault, formerly a staff officer in the Crimea (1855–1856)—of which he brought back drawings[22]—and a future illustrator of Jules Verne's. He was also a gifted caricaturist. He has left us a hitherto unknown portrait of Le Gray as comical as it is delicately executed (fig. 206). Le Gray is depicted in shirtsleeves, disheveled, flying over the sea and pyramids, straddling a camera, scattering small pictures in his wake—all in the spirit of an artist's joke, and embellished with doggerel:

> Alexandre, César, Le Gray, Napoléon,
> S'établirent en Égypte, le pays des oignons,
> Trois d'entre eux furent chassés malgré leurs bataillons,
> Le Gray seul s'y fixa grâce à son collodion.

> [Alexander, Caesar, Le Gray, Napoléon,
> Settled in Egypt, the land of the onion,
> Three were driven out despite their battalion,
> Le Gray alone stuck there, thanks to his collodion].[23]

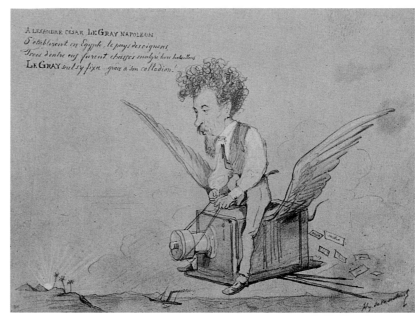

206 Henry de Montault. *Caricature of Le Gray*, ca. 1861 (cat. no. 202).

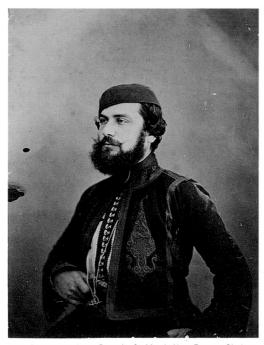

207 Gustave Le Gray. *Portrait of a Man in Near Eastern Clothes*, December 1861 (cat. no. 198).

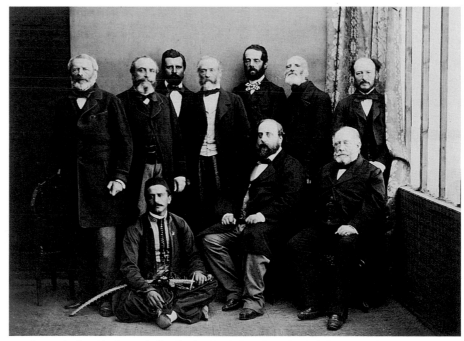

208 Gustave Le Gray. *The Comte de Chambord and His Retinue*, December 1861 (cat. no. 197).

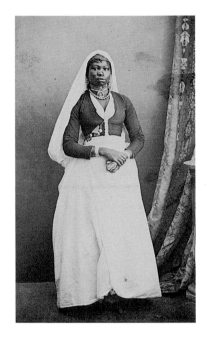
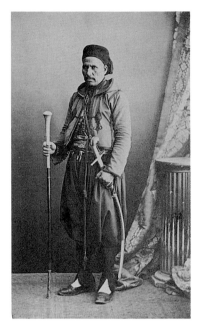
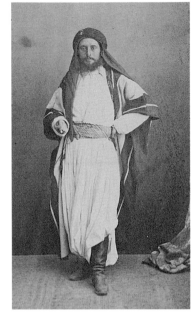
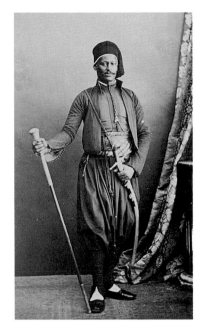
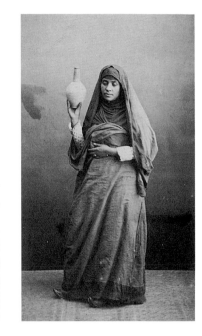

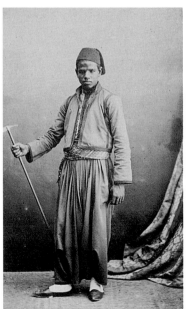
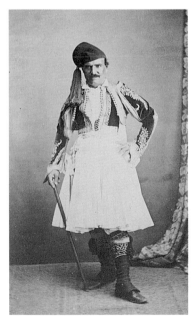

209–217 Gustave Le Gray. Portraits made in Egypt, ca. 1861/62 (cat. no. 202).

Autograph titles by Le Gray:

Négresse du Soudan (Sudanese woman)
Cavas (Policeman)
Cavas (Policeman)
Effendi (Alexandrian gentleman)
Fellà (Peasant woman)
"Says"
Drogman (Dragoman, or guide)
Levantine (Woman from the Levant)
Barbarin (Man from Barbary)

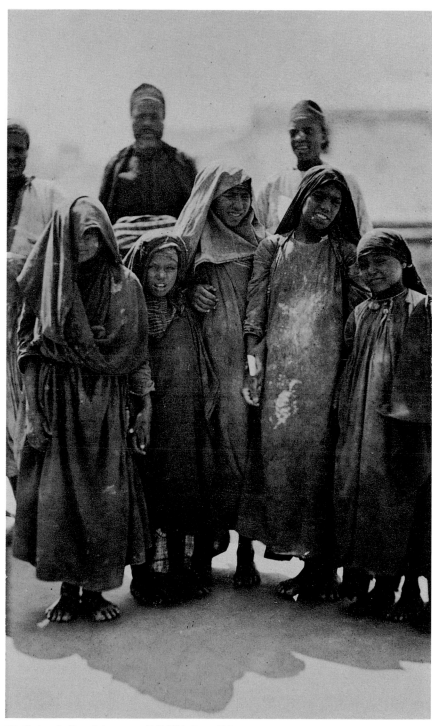

218 Gustave Le Gray. *Laborers*, ca. 1861/62 (cat. no. 202).

219 Gustave Le Gray. *Masons*, ca. 1861–62 (cat. no. 202).

220 Gustave Le Gray. *The Promenade at Shubra, Cairo,* ca. 1861–1862 (cat. no. 200).

221 Gustave Le Gray. *The Pastré Gardens, Alexandria*, ca. 1861–1868.

24 Departmental Archives of Hauts-de-Seine, 5/MI NEU-16, vital statistics.
25 F. Le Corre, in *Une Visite au camp de Châlons sous le Second Empire*, exh. cat. (Paris, 1996), 137.
26 A request for help, sent to Charles Blanc in 1872, in which he described himself as poor and old (age 62), with a ten-year-old son and a twenty-two-year-old paralytic daughter, show that the ten years spent on the boulevard des Capucines did not bring him fortune either; National Archives, F²¹ 492.

Alexandria, a rapidly expanding and cosmopolitan city, a mandatory stop for numerous European travelers, offered Le Gray acquaintances and a clientele that, all in all, were quite comparable to those of the boulevard des Capucines. France and Egypt were closely linked, with underlying, extensive financial interests. Besides the company of old pals such as Lockroy and Albanel, as well as that of Montault, and in addition to the visit by the comte de Chambord, whose portrait he had already taken in Paris, Le Gray was able to encounter various notables—artists and archaeologists, wealthy traders and engineers working on the Suez Canal, aristocrats and bankers. Therefore, this was a relatively mild exile, six days by boat from Marseilles, in a country that, like the Italy of his youth, was a traditional milestone in an artist's career.

The year 1861, spent in Alexandria, may seem to have taken up the thread of his interrupted voyage with Dumas. Le Gray's affairs in France were still not settled, and his relatives were living in unenviable conditions, but both were in the capable hands of his friend Léon Maufras. Thus, the situation might have seemed practically normal. It utterly changed on December 13, 1861, when the attorney died in Neuilly of a violent illness.[24] With Maufras gone, the exile no longer had any direct contact with France. By extending his stay under these circumstances, Le Gray demonstrated either a definitive renunciation of France or, more likely, once again, his inability to control the course of his life.

Meanwhile, in Paris . . .

The place left vacant by Le Gray's liquidation and departure did not remain for long. The studio on the boulevard des Capucines was immediately occupied by Alophe, an engraver turned mediocre photographer. He exploited the assets of his predecessor's studio on behalf of the Briges brothers. In September 1860 he filed for copyright protection, in his own name, on the carte-de-visite portraits left behind by Le Gray; he then sold them in that format, bearing the mention "Former firm of Le Gray et Cie, photographer to the emperor, M. Alophe, successor." This was less to dismiss the memory of Le Gray than to slip entirely into his shoes, for his name was still worth money. In a printed catalogue from 1861, Alophe again represented himself as Le Gray's successor and indiscriminately mixed his own work with the work he had appropriated. The following year, he authored his own manual, a collection of gener-

alities, under the grandiose title *The Past, Present, and Future of Photography: A Practical Manual of Photography*; excerpts from it were also published in the *Gazette des beaux-arts*. It is clear that he took great pains to fill a role that was beyond him.

In addition to the conventional sale of celebrity portraits in carte-de-visite format, Alophe must also have taken advantage of the large landscape negatives that had remained on the premises. It is quite possible that he printed and sold certain landscapes, seascapes, and views of the camp at Châlons. The large staff trained by Le Gray may have continued to work in the studio, printing the master's negatives. A recent analysis of one of the albums from the camp at Châlons, dedicated to General Lepic, suggests that it may have been produced in 1865.[25] With respect to reductions of portraits (to carte-de-visite format), Alophe could claim, at least technically, to have made the prints, in the hope that the confusion would attract some portrait clients who were not very well informed or not particularly concerned with such details; but he could not push ambiguity or cynicism so far as to affix his name to known works. Le Gray was perfectly well informed of these actions. Léon Maufras, perhaps to keep an eye on the interests for which he was responsible, visited the studio's new tenant; there is a portrait of Maufras with Alophe's characteristic decor—a light-colored, knit fabric adorned with dark stars—dating to 1860. Alophe occupied the premises until the war of 1870, but without managing to make the business prosper.[26] The Briges brothers then replaced him, successively, with Fontaine and Van Bosch.

In the meantime, the two brothers pursued their disputes with Le Gray. The final settlement account of the company, which had been in liquidation since February 1860, was certified on September 14 and showed that Le Gray owed 25,582.20 francs to each of the two brothers. This represented a sizable sum, but not one that was impossible for a man of his abilities to repay. Finally, on October 24, 1860, the commercial court rendered its judgment:

> . . . condemns the defendant, by all legal recourses, and as a fine . . . to pay, namely to the marquis de Briges, twenty-five thousand five hundred eighty-two francs and twenty centimes, and to the comte de Briges an identical sum . . . in settlement of all accounts with interest on said amounts at the legal rate; [and] finally condemns the defendant to pay the costs, including the cost of recording the present judgment, with taxes on the costs through this date.

[In the margin:] [The court] orders that the present judgment be executed in form and substance, and in the event of an appeal, by provision for the principal and interest alone, with the requirement to provide a guarantee or prove sufficient solvency.[27]

In short, of the hundred thousand francs advanced in 1856, Le Gray still owed a little more than half. If he were to return to Paris, he would be required to repay his creditors immediately, subject to imprisonment—unless he appealed, but the case hardly lent itself to that. The fact that he was sentenced in absentia probably indicates that Maufras, seeing that the result was a foregone conclusion, did not even appear to hear the reading of the sentence.

Unable to salvage his friend's finances, he faithfully played the role of agent for the aged mother, who was still living in Villiers-le-Bel, where she was able to take in her daughter-in-law and two grandsons, Alfred and Émile Eugène. On January 16, 1861, shortly before her death, she sold some land for ten thousand francs,[28] undoubtedly to meet the family's needs, but also to subtract that amount from her son's inheritance. This was less a matter of disinheriting him for his behavior—although it is impossible to know what the family's feelings may have been about what already appeared to be an abandonment—than of protecting the estate from the Briges brothers, armed with their very recent judgment. Mme Legray's will now favored her grandchildren, to the detriment of Gustave.[29] When she died, on May 3, 1861, since Palmira was apparently not deemed capable of ensuring the future of her children alone, it was the Villiers-le-Bel innkeeper, Emmanuel Fouquet, who was appointed their guardian by the magistrate for the canton of Écouen and charged with paying out to the children the disposable portion of the estate in the event of their father's death.[30]

The obliging Maufras, who was appointed executor of the grandmother's will, was responsible for selling all of the assets. In the estate inventory, there is a detail that reveals just how close he was to the deceased, to whom he must have provided advice and comfort during her long months of worry. He reclaimed the 135 bottles of wine found in the cellar, "having stored these with Mme Legray for his private consumption when he came to Villiers-le-Bel."[31] The proceeds from the sale of her personal property amounted to 1,989.35 francs,[32] and from the sale of real estate to 5,149.35 francs.[33] It is clear, in any event, that Le Gray could hardly

count on his inheritance to pay his debts and return to Paris with his head high.

It is probable that Maufras also looked after Le Gray's wife. It was not until after his death in late 1861 that she seems to have begun experiencing real difficulties. As evidence of this, a note from the comtesse de Valençay dated February 8, 1862, informed Mme Walewska of Mme Le Gray's address (60, rue de Bellechasse) so she could come to her aid.[34] That aid materialized on February 10 in the form of 150 francs granted by the government as assistance for an artist's wife.[35] Other undocumented aid must have been provided by her husband's friends, such as Le Secq. On June 20, 1862, she applied for a passport to return to her family in Italy, which indicates that she at least possessed the amount necessary for the trip. She arrived in Rome on July 18 with her five-year-old younger son.[36] The older son must have remained in France (with the Villiers-le-Bel innkeeper?), where he would later resurface.

But the misfortunes of Mme Le Gray were not over. Arriving in her country, she found her family in such poverty, due to the death of her father, that she was unable to stay. Not having asked anything of her husband up to that point—which reflects the deterioration of their relationship—and not even knowing the address where she might find him, she decided to write to the French consulate in Alexandria to confirm he was in Egypt. The consul, M. de Beauval, answered her on October 28: "I hasten to inform you that, as has been reported to you, he is indeed in this city, practicing his profession of photographer."[37] She finally obtained from the French consul in Rome a letter to the consul in Alexandria (January 23, 1863), whose wording shows what little benevolence they expected of Le Gray:

Since the day Mme Le Gray was abandoned by her husband, she has been without resources; she later retreated to Rome, to be close to her family, who are also living in poverty. However, M. Le Gray's profession and the talent with which he practices it allow me to suppose that he could readily come to the aid of his wife and meet her most urgent needs. Mme Le Gray's claims are far from excessive; she assures me she would be satisfied with a monthly allowance of fifty to sixty francs. I thus kindly request, M. Consul General, that you employ a suitable means of persuasion to convince M. Le Gray to come to the aid, insofar as his resources permit, of his unfortunate wife and child.[38]

27 Archives of Paris, D2 U3 2356.
28 Directory of the Lechat law office, Departmental Archives of Val-d'Oise, 2 E 21251.
29 Will, dated April 21, 1861, Departmental Archives of Val-d'Oise, 2 E 21100.
30 Departmental Archives of Val-d'Oise, 2 E 21251.
31 Estate inventory dated May 11, 1861, Departmental Archives of Val-d'Oise, 2 E 21100.
32 Sale of May 20, 1861, Departmental Archives of Val-d'Oise, 2 E 21100.
33 Sale of July 14, 1861, Departmental Archives of Val-d'Oise, 2 E 21101.
34 National Archives, F²¹ 269. Examination of the tax rolls for 60, rue de Bellechasse has provided no name known to be connected with Le Gray.
35 National Archives, F⁷⁰ 243. The intervention of these two ladies, who belonged to the highest aristocracy, indicates that the assistance must have been requested using the photographer's former connections; but the assistance was provided in an institutional context, which indicates the limits of those personal connections.
36 Passports of French citizens arriving in Rome, Archives of the Ministry of Foreign Affairs (Nantes), Rome, embassy to the Holy See, register 707.
37 Archives of the Ministry of Foreign Affairs (Nantes), Alexandria, consulate, individual file 2535 (Mme Le Gray).
38 Ibid.

It was during that same period that Le Gray wrote a long letter to Nadar, the only truly personal letter from Le Gray that still exists. It is a letter of supplication and justification, bitter and anxious, under the mask of blustery detachment that seems to have been mandatory when addressing Nadar. It is, above all, a letter rich in information, mentioning the photographer's difficult situation on leaving Paris, the circumstances of his voyage, the iniquitous dispossession of which he believed himself the victim, and his inability to manage his affairs as well as, in a more ambiguous manner, the irresolute impulse to return, which his wife's efforts with the authorities apparently aroused in him:

Alexandria, November 8 [1862].

My dear Nadar,

I am not yet dead and think often of my friends. Habib Bey gave me news of you. If you only knew how bored I am here. But in the end, I'll have my day.

Do me a favor: since the death of my agent, I have not received any news of my affairs from anyone at all. Actually, people returning here from Paris have said that I have been bankrupted, etc., etc., courtesy of my noble but unscrupulous enemies. Have they taken advantage of the death of my agent to stab me in the back? They told someone else I had been convicted in absentia. Of what? All of this makes me laugh, and I deeply despise all the gossip, whose source can only be that vile pawn of the Briges, the miserable Bailleul.[39]

Be that as it may, I have not heard officially whether the liquidation has been completed, although I do believe I am an interested party.

I do not think there is a man in the world more exploited than I. I have been fleeced; they want to make me out as a rogue. They *pity* me but would put themselves *in my place* to better exploit my name; they steal my works and my personality; it seems this is legal in my country.

You know, my dear friend, what I have done for photography; give me a boost so I may come again to pay my respects to Paris.

Do me the favor of finding out what has happened since the death of my agent; since I have run out of money, I have run out of friends. My business manager used to say he was my friend; I believe I no longer have a business manager. In any event, the business manager I had was named Cassart and his address was 8, rue de Mesnard (?).[40] They made me say I would return to Paris and they reproached me; how easy that is, but I did not have the money to come.

Finally, I believe you understand my position; inquire a bit into my present situation; find out what must be done, and give me some good advice.

I have an album that is starting to become interesting, if you would like to exhibit some prints for me. A word to the wise is sufficient.

GUSTAVE LE GRAY.

[P.S.] Write me in Alexandria.

[Vertically, in the margin:] Did you know that Dumas himself set me down in Malta without a penny? I later learned it was Briges who urged him to take me with him. Oh, what fine travel tales I am going to write upon my return![41]

How is it possible to know whether the generous Nadar (fig. 222) responded to this appeal for help? Because Nadar himself was in business at 35, boulevard des Capucines, he was a daily witness to the actions of Alophe and the Briges brothers. If he did respond, it did not give rise to any ongoing correspondence, for Le Gray did not write again. Nor did Nadar exhibit the interesting album proffered by Le Gray. It is indeed difficult to determine whether the stated desire to return was real but discouraged by Nadar, who likely painted a somber picture of the situation, or just a final small attempt

222 Félix Nadar. *Self-Portrait*, ca. 1860.

39 Probably Jean-Jacques Bailleul, attorney to the imperial court, 73, rue Neuve-des-Petits-Champs.
40 The question mark is Le Gray's. Auguste Cassart, attorney, officer of the Legion of Honor, 8, rue Ménars. Thanks to Claude Schopp for identifying Bailleul and Cassart.
41 Département des Manuscrits, (MSS), BNF, NAF 24275, fols. 665–66.

to fulfill a wish that was only halfhearted to begin with, or even no more than an attempt to justify himself in the eyes of his friends by assuming the role of the victim.

Le Gray did not return. Nor did he send for his family. If he did send them assistance, it was not sustained. In fact, in 1865 Palmira wrote a desperate letter to Le Secq from Marseilles, where she had landed on her return from Italy. She was seeking money to return to Paris. Le Secq took the appropriate action; he sent the request to Ernest Lacan, to be forwarded to the Société française de photographie—an action that certainly did not elevate the opinions about Le Gray. It is not known what help the poor woman may have received; this is the last trace to be found regarding Palmira Le Gray.[42]

However, a final account, received by Marc Leproux from the eldest son of the dying Dr. Gaillardot,[43] throws another light on the relations between Le Gray and his family. This information is, despite its many inaccuracies, troubling:

> I would have liked to speak at greater length about a Le Gay or Legay whom Gaillardot Bey spoke of on the boat during his last crossing, shortly before his death: "A curious character," he told me, "originally from Charente. Le Gay apparently worked for the staff of Napoléon III and seems to have discovered a photographic process using collodion. He undoubtedly came to Egypt while the Suez Canal was being built, or during the empress's voyage. He liked it and remained there. He lived on Nubar Street, near the *sebil* (public fountain). He had left his wife and children in Angoulême, in the suburb of Basseau.[44] Several years later, he returned for them, but when he entered the garden, he saw a family that had increased remarkably and, without going any further, he turned around and left." I had intended to further question my interlocutor on my return; his sudden death prevented me from implementing that plan.[45]

In this anecdote—if it was not totally distorted in the transmission—was there an invention by Le Gray to justify an abandonment that was less than honorable? Or does it contain a kernel of truth? In any event, it would be difficult to date this episode. Numerous children are suggested to have existed in the mid-1860s, a time when Palmira was well over forty . . .

The epilogue to her disappearance did not occur until April 1882. The elder son, Alfred, wanted to marry and had to obtain his parents' consent; but he was able only to confirm "that M. Le Gray had left . . . France to go to Cairo, that he was still living there, that, since that time, Mme Le Gray had disappeared and not been heard from, and that the younger Le Gray and his father had searched to discover the address of Mme Le Gray, and that their search had not been fruitful."[46] Consequently, he would have only the consent of his father. Alfred Le Gray, who had been left with his guardian or someone else in 1861, was apparently unaware of the tribulations of his mother and younger brother in Italy and Marseilles. This leads us to believe that the two surviving siblings probably never saw each other again. Alfred must have been unaware that his younger brother, who had become a lathe worker, had died in 1878, at age twenty-one, in a work accident.[47]

From Alexandria to Cairo, from Occident to Orient

J'en jure par ta vie, Le Caire est une vision du Paradis.

[I swear by your life, Cairo is a vision of paradise.]
—Arabic poem[48]

Le Gray had a studio for several years in Alexandria, but there is only indirect evidence of his presence there. Later carte-de-visite portraits bear the words "Artistic Photography / Le Gray Company / Ch. Nedey, successor / Alexandria, Egypt."[49] The move from Alexandria to Cairo is not easy to date from known photographs alone, for he sometimes transported his equipment between the two cities. That is how, in the spring of 1862, he came to take a strange group portrait in Cairo, at the request of an illustrious customer, the Prince of Wales and his retinue, posing seated in random order, with their polo sticks and their native servants, on the steps of a European-style residence (fig. 343).

There is proof of Le Gray's presence in Alexandria again in 1863. On February 8 he sent the editor of *L'Illustration* an article ("Amends Made to the French Consul at Alexandria"), recounting a diplomatic incident accompanied by a photograph intended for engraving (fig. 233).[50] The content of the article tells us nothing about the author. The indignant tone used to describe the harassment of Frenchmen by anti-European Egyptians is typical of its time and only allows us to imagine that Le Gray must have been fully integrated into the French community of Alexandria to so identify with the interests of his compatriots.[51] Several months later, the same paper published new engravings based on photographs by Le Gray, showing festivities held in the Pastré Garden

42 Research conducted in Marseilles to find a trace of her death or of assistance provided by a charitable institution have shown no results.

43 This is the same person who participated in Renan's digs and moved to Alexandria in 1864 as a military physician; he remained there until at least 1873; see G. Guémard, *Deux grands Lorrains d'Egypte: Les Gaillardot* (Paris, 1928).

44 Since Le Gray's father was born in Bordeaux, and Maufras in Blanzac, a few kilometers from Angoulême, the sojourn of Mme Le Gray and her children in that region is plausible. No confirmation of this anecdote has been found in the ten-year census rolls in the Charente regional archives.

45 M. Leproux, *Quelques figures charentaises en Orient* (Paris, 1939), 237–38.

46 Archives of Paris, D3 U1, bundle 489.

47 Death of Émile Eugène Le Gray, residing in Neuilly, which occurred at his workplace in Paris, at 42, rue de Sèvres, August 4, 1878, Archives of Paris, vital statistics. His parents were both wrongly indicated as deceased, which, despite the error about the father, may be a clue about the mother, since this son had remained (at least initially) with her.

48 A. Rhoné, *L'Égypte à petites journées: Le Caire d'autrefois*, new ed. (Paris, 1910).

49 For example, on a portrait of Dr. Gaillardot, Institut de France, Library, MS 1981.

50 "Réparation obtenue par le consul de France à Alexandrie," *L'Illustration* (February 28, 1863): 135–38.

51 In fact, he appeared on the "Liste des notables français pour 1863," drawn up by the French consulate in Alexandria, Archives of the Ministry of Foreign Affairs (Paris), Consular and commercial correspondence, Alexandria, vol. 37: 172, correspondence of May 1, 1863.

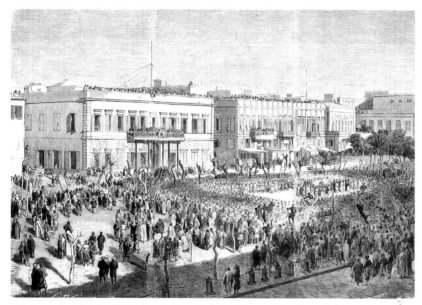

223 *Reparations Obtained by the French Consul in Alexandria*, engraving after a photograph by Le Gray, *L'Illustration*, February 28, 1863.

sit, colonial appearance, in other words, the residence of foreigners to the land. . . . When we leave the European quarter and visit the Arab quarters, it seems quite strange; once you have seen Cairo, that is no longer the case."[55]

There are endless quotes from the bedazzled and enthused travelers and artists who gorged on sensations and memories and then distilled them, drop by drop, for years, onto their paintings in their Parisian studios. Arthur Rhôné, who traveled to Egypt several times in the entourage of Mariette and of the architect Ambroise Baudry, campaigning for the preservation of ancient Arabic monuments, was perhaps the most eloquent:

> From the very first steps, you realize the great distance that exists between an illustrious and untainted capital, and a place of transit, where the mixture has altered everything. Cairo outshines Alexandria.
>
> But how to describe this environment of enchantments that you enter, this jumble of streets, of alleys, of irregular and whimsically charming squares, where every building, nearly every house, is a work of delicate originality, filled with vitality! How to depict this sense of calm in the air, this dazzling light that bathes the carved minarets, then the intimate and gentle shadow that dominates the depths of the streets! Everything is festive, perpetually joyful: color, the picturesque, movement reign undivided; everything shimmers, sparkles, and rustles; everything bustles and rises in clouds, like joyful particles in a ray of sunlight.[56]

With regret, visitors would tear themselves away to return to their European lives. Le Gray, who had only good reasons not to return home, had—in his misfortune—the good fortune to be able to abandon himself to the sweetness of life, evoked here by another traveler:

> You have to love the oriental life, the prolonged reveries and the endless contemplations, in order to enjoy yourself for very long in Cairo. . . . If you wish to imbibe its spirit and analyze its seductive charm, several months are not too many. As for me, I spent five months in nearly complete inactivity, without being bored for one second, without missing European busyness, to which you become unaccustomed quickly in a soporific climate. . . . You do not notice the time flying; it slips away without a trace; one day gently follows another and, when you want to grasp how you have lived for a week, you often notice, after rigorously examining your consciousness, that you have been busy with nothing more than a palm tree whose top swayed in the wind, or a particular hue that, each day at the same time, arrived to color with subtle nuances the undulations of the far-off desert.[57]

52 *L'Illustration* (July 11, 1863): 20.
53 This is also the date suggested by E. P. Janis, *The Photography of Gustave Le Gray*, exh. cat. (Chicago and London, 1987), 146, although with no indication of a source.
54 T. Gautier, *Voyage en Égypte*, ed. P. Tortonese (Paris, 1996), 38.
55 E. Fromentin, *Voyage en Égypte*, ed. X. Carrère (Toulouse, 1998), 15.
56 Rhôné, *L'Égypte à petites journées*.
57 G. Charmes, *Cinq mois au Caire et dans la Basse-Égypte* (Paris, 1880), 149–50.

of Alexandria, in honor of a visit by Prince Napoléon Bonaparte and his wife, Princess Clotilde.[52] So the "emperor's photographer"—for that title, along with the imperial arms, continued to adorn the stamp he used to mark his photographs—resumed his chronicling of imperial splendor, as he had in happier times at the camp at Châlons.

It seems Le Gray moved permanently to Cairo around 1864,[53] and that was the final break. In Alexandria, he was practically still in Europe, and the fiction or dream of a return to Paris could have seemed almost a reality. Cairo was a different world. Several hours by train from Alexandria, it was a genuine Middle Eastern city, where the change of culture was total and the enchantment perpetual for the eyes and mind of an artist.

Travelers of the day bore witness to the contrast. That was the case, in 1869, for Gautier and Fromentin, who had come for the inauguration of the Suez Canal. While the former sought to indulgently qualify the general opinion—"Alexandria is not a purely oriental city, but has more character than travelers allow,"[54]—the latter elaborated: "Alexandria. Heterogeneous city. True place of tran-

It would be all too convenient, in order to fill the gaps in our nearly total ignorance of what Le Gray did during his twenty-three years in Egypt, to suppose that, after twelve years of hyperactivity and tumult in Paris, he just decided to allow life to unfold. However, it seems reasonable to think that his pace of work slowed down considerably and that, able to live comfortably without breaking his back, far from his backers and his family, he produced much less.

In Alexandria his clientele included numerous European residents, as well as many visitors. In Cairo, he continued to frequent the smaller French colony, but, above all, he replaced Napoléon III with Ismaïl Pasha. The primary traces of his activity during that period are tied to the favor and the commissions of the prince.

The Photographer to the Khedives

Without giving a lesson on Egyptian political history during the years of Le Gray's sojourn, it is fitting to review a few points that clarify his situation. When he arrived in Alexandria in 1861, Egypt was in a period of unprecedented economic expansion,[58] due to the cotton boom. Cotton had become nearly a monoculture on the floodplain of the Nile in 1862, thanks to the U.S. Civil War, which had dried up the supply of American cotton. This wave of prosperity was the culmination of the modernization that had been undertaken in the 1820s by the khedive dynasty: its founder, Mohammed Ali (1805–1849); followed by his reactionary grandson Abbas (reigned 1849–1854); and then the uncle of the latter, Ali's son Saïd (reigned 1854–1863). There were several factors that contributed to living conditions that were particularly favorable to Europeans, and especially to the French: Mohammed Ali's use of predominantly French and Saint-Simonian technicians, engineers, and agronomists; the building of the Suez Canal, directed by Ferdinand de Lesseps, beginning in 1852; the strong presence of archaeologists surrounding Auguste Mariette, who founded the Boulaq Museum; and the policy of extreme westernization conducted by Saïd, and then by his successor Ismaïl (reigned 1863–1879). This atmosphere lasted until 1879, the year of the deposition of Ismaïl Pasha, who was about to give free rein to English influence. The economic fluctuations and constant changes of scene were reminiscent of the Paris of Napoléon III. Even in the most remote alleyways of Cairo, it was impossible to ignore the march of progress.

The scandal and corruption that reigned in Paris were even more grossly rampant in Egypt. Ismaïl borrowed colossal sums from banks at usurious interest rates. The fraudulent dealings, compounded by nepotism, took place in the open. Like locusts to a pharaoh, the khedive attracted all the shady businessmen, unscrupulous merchants, and adventurers who had become undesirable on the opposite shore of the Mediterranean. Admittedly, the European colony also included some honest traders, authentic scientists, and genuine artists, but overall its morality was hazy and quite indulgent, including every deviance; everyone—or nearly everyone—had a dubious past they wanted to forget or bury. Le Gray, an unworthy and indebted father, was just a petty rascal in the wake of the pasha. On the contrary, the fact that, under such favorable circumstances, he did not take advantage of his favor to also amass a tidy nest egg attests once more to his fundamental disinterest, not to mention his lack of practicality.

He nevertheless managed to survive without too much difficulty. The first certain commission, in 1866, was a series of photographs of some new military equipment for transporting artillery parts by camel from Cairo to quell the hostilities between Arab tribes in the Sudan. It was probably right before the departure of the column that Le Gray captured the astonishing spectacle of these beasts laden with cannon barrels.[59] In March of that same year, an engraving after another of his photographs, *A Column of Egyptian Artillery en Route to the Sudan,* engraving after a photograph by Le

58 See primarily D. S. Landes, *Banquiers et pachas: Finance internationale et impérialisme économique en Égypte* (Paris, 1993).
59 Three of these photographs are in the BNF, MSS, Prisse d'Avennes collection. A more important series was put up for sale by Beaussant-Lefèvre, Commissaire-priseur, Photographies, sale cat. (Paris, Drouot-Richelieu, December 13, 1995). See also A. Mariette, *Exposition universelle de 1867: Description du parc égyptien* (Paris, 1867), 93, and C. Edmond, *L'Égypte à l'Exposition universelle de 1867* (Paris, 1867), 360.

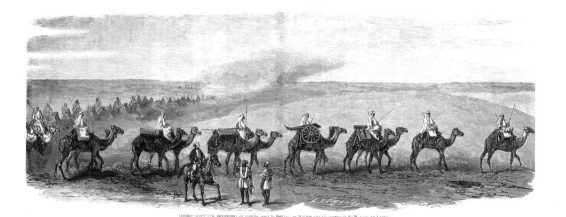

224 *A Column of Egyptian Artillery en Route to the Sudan*, engraving after a photograph by Le Gray, *L'Illustration*, March 10, 1866.

60 *L'Illustration* (March 10, 1866): 148 (article by V. Chandieu).
61 Major Haillot, letter to Riaz Pasha, January 4, 1867, National Archives of Egypt, 'Asr Ismâ'îl (reign of Ismaïl) collection, bundle 2/1, doc. 1.
62 Ibid., June 25, 1867, doc. 8.

Gray (fig. 224), was published in *L'Illustration*.[60] Without viewing this episode as an orientalist camp at Châlons redux, it is appropriate to point out the recurrent theme of politico-military propaganda in Le Gray's work, a reflection of his favor with sovereign authority.

The following year, in January 1867, he received another solid assignment. Major Haillot, the mentor to the princes (sons of the khedive) from 1866 to 1868, wrote to Riaz Pasha, private secretary to the minister, Sherif Pasha,

> His Excellency Sherif Pasha asked me to inform you of the sum it would be necessary to pay M. Le Gray immediately in order to enable him to make the trip to Upper Egypt with Their Excellencies, the princes. M. Le Gray, whom I questioned in regard to this, could, with an advance of 3,000 francs, complete his photographic preparations and meet his initial expenses. . . . M. Le Gray is full of goodwill and a desire to do well; his assistance will be invaluable to stimulate the princes to draw from nature. I would thus be very obliged to Your Excellency for measures that

will be taken to ensure the departure of this teacher. The departure is scheduled to take place on Monday, so there is no time to lose.[61]

Le Gray was to accompany the khedive Ismaïl's six sons—Tewfik (who would become khedive in 1879), Ibrahim, Hussein (future ruler from 1914 to 1918), Mohammed, Hassan, and Toussoun—on a voyage by *dahabiyeh* (a large sailing ship) and by steamboat (a sign of progress) along the Nile. So Le Gray was now their drawing teacher, responsible for getting the princes to work while at the same time doing his own sketches and taking photographs. During 1867 the princes' schedule provided for one and a half hours of drawing daily,[62] probably still under the guidance of Le Gray, but it is not known how long this situation lasted, since there was a rapid succession of teachers due to intrigue.

From his voyage along the Nile, stimulated by the thought of securing for himself the most powerful of patrons, Le Gray brought back a wealth of masterly photographic views, worthy of his best work during the splendid years of the empire. Alternating between

225 Gustave Le Gray. *Camel Carrying Cannon Barrel*, March 1866 (cat. no. 203).

226 Gustave Le Gray. *Camel Carrying Trunks and Ramrods*, March 1866 (cat. no. 204).

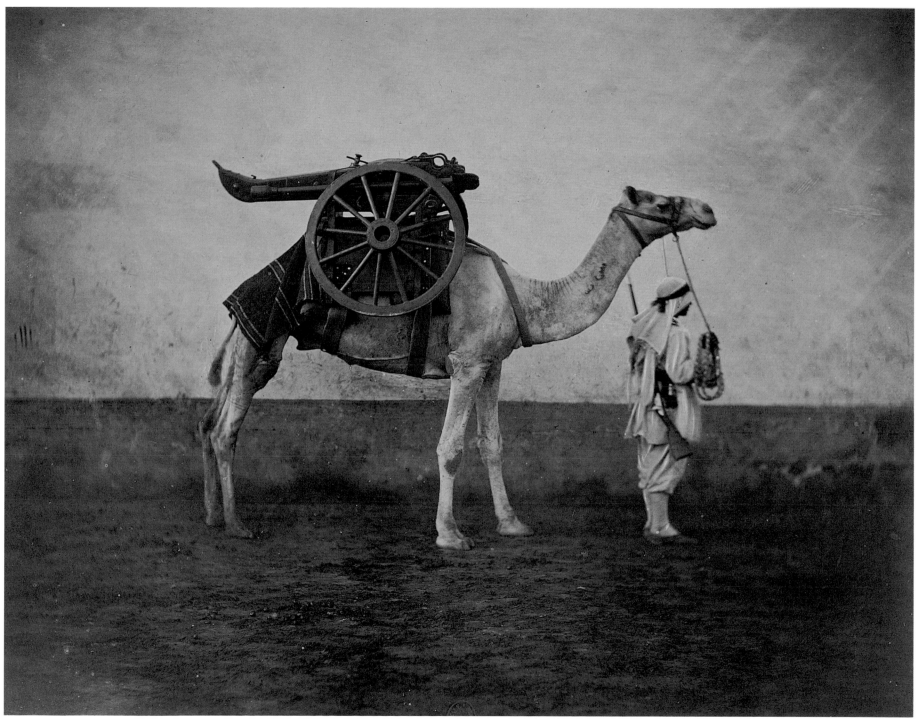

227 Gustave Le Gray. *Camel Carrying Cannon Wheel and Chassis*, March 1866 (cat. no. 205).

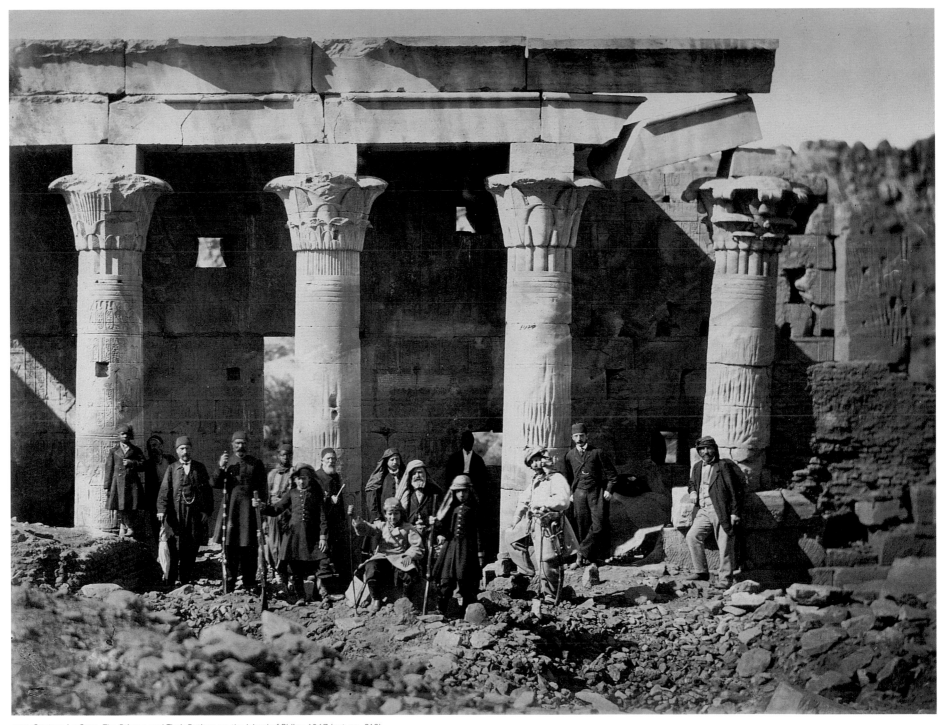

228 Gustave Le Gray. *The Princes and Their Retinue on the Island of Philae*, 1867 (cat. no. 212).

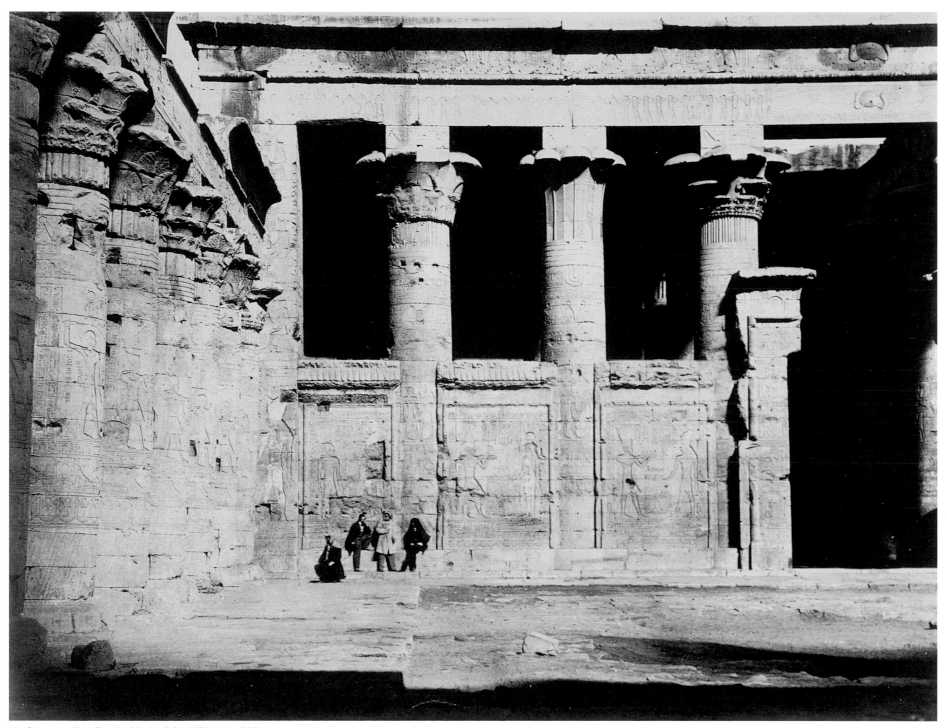

229 Gustave Le Gray. *Temple of Horus, Edfu*, 1867 (cat. no. 206).

230 Gustave Le Gray. *Obelisk in the Quarry, Aswan*, 1867 (cat. no. 211).

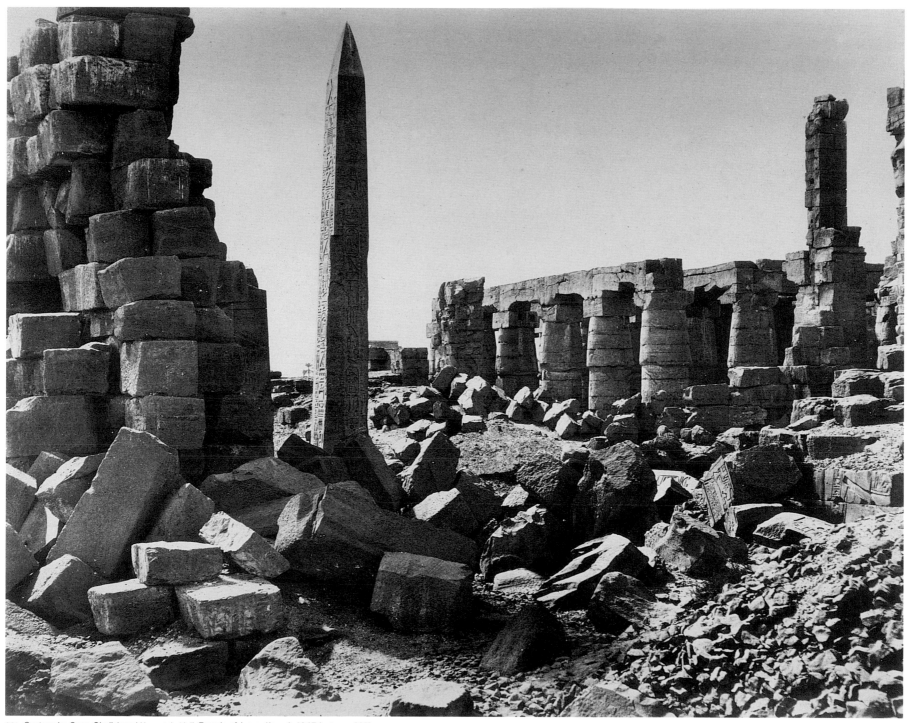

231 Gustave Le Gray. *Obelisk and Hypostyle Hall, Temple of Amun, Karnak*, 1867 (cat. no. 209).

232 Gustave Le Gray. *Party for His Highness Ismaïl Pasha aboard the Princes' Ships*, January 1867 (cat. no. 207).

negatives on glass and on paper, depending on the desired effect, he accumulated architectural views, group portraits, landscapes, and also, according to a tradition established in Europe, views of industrial installations, such as the Armant sugar factories, of which the pasha was particularly proud.

A sampling of the works brought back by Le Gray was sent in April 1867 to the Universal Exposition in Paris, to be included in the Egyptian section. The sampling comprised his photographs of the Nile (category 9), as well as twenty-six drawings presented as a consignment from the viceroy himself (category 2, fine arts): "Views of ancient monuments of Upper Egypt, drawn during the voyage of Their Highnesses, the sons of the viceroy, by M. Gustave Le Gray, employed in the service of the Egyptian government."[63] In addition, there were the photographs of the packsaddle dromedaries outfitted to transport artillery (category 61, coach work and wheelwrighting). Furthermore, there were six Islamic manuscripts,[64] exhibited in category 6, which may have belonged to the photographer. This was a consignment from an individual named as "M. Le Gay, Cairo" in the official catalogue (in which misprints were abundant).[65] Finally, just as unexpectedly, "M. Legay from Cairo" loaned to the exhibition's category 91 (books) a group of "works published by the imprimerie du Gouvernement (Government Printing Office) in Boulaq, which are no longer in print."[66] Of all this, the Parisian press—including the photographic press—said not a word.

During that period, at the latest, Le Gray also received an appointment from the viceroy as a drawing teacher in the military academies, which were run by a Frenchman, Colonel Hircher. The Dutch painter Willem de Famars Testas, who accompanied Gérôme to Egypt in 1868, encountered Le Gray in that capacity. He noted in his journal on February 18 that "M. Le Gray, renowned photographer, old friend of M. Gérôme, and, for some time now, a drawing instructor at the École militaire d'Égypte in Abbassiyeh, came to dine with us. M. Gérôme was dining at the home of Ali Pasha, who had made him a gift of one of his most handsome Arabian horses."[67] The following year, Philippe de Chennevières, who had come for the opening ceremonies of the canal, met up with his old acquaintance. Note the condescension of the following reminiscence, written twenty years later, and particularly the implicit ironic allusion to a man lingering on in photography, which, in 1869, and all the more so in the 1880s, was decidedly no longer a bona fide occupation:

That poor devil Le Gray, whom I had employed at the Salon of 1852 to photograph the major installations in the exhibition, I was to find him, seventeen years later, in Cairo, a great dignitary of the arts in the country of the pharaohs, I mean to say a teacher of drawing and painting at the viceroy's Polytechnic School—and still a photographer.[68]

In 1871–1872 he was more precisely registered as a teacher of drawing at the preparatory school for the Polytechnic School, with an annual salary of 6,240 francs, equal to the highest salaries at the Polytechnic itself, making him the best-paid teacher in the school.[69] In 1875, in the final reference to this career, he had four instructors under his authority.[70] So he must have lived in a certain degree of comfort, at least during those few years.

At the same time, he continued to produce and sell photographs to a private clientele, namely, portraits for more or less westernized families of Egyptian notables[71] and various albums for Europeans.

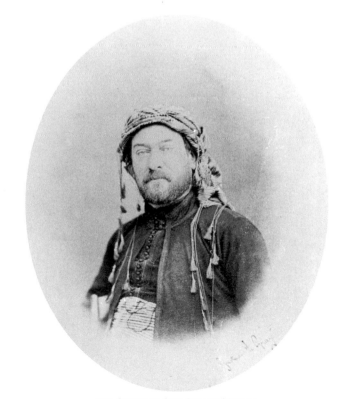

233 Gustave Le Gray. *Portrait of Auguste Mariette Bey*, ca. 1861–1868.

63 *Exposition universelle de 1867 à Paris: Catalogue général publié par la Commission impériale* (Paris, 1867).
64 These were three Arabic poems, one Persian poem, and two other Arabic literary texts. This type of collection was not very common at the time. Thanks to Mme Guesdon and M. Richard, département des Manuscrits, Bibliothèque nationale de France, for their assistance.
65 The same misspelling is found in Edmond, *L'Égypte à l'Exposition universelle*, 332, but he repeats the error on the same page relative to the photographs of "M. Legay du Caire," where Le Gray was meant. Consequently, that Legay and Le Gray were the same person is reasonable to assume; however, a directory attests to the existence in 1868 in Cairo of a "Le Gay, merchant." See F. Levernay, *Guide général d'Égypte: Annuaire officiel, administratif, commercial et industriel* (Alexandria, 1868), 189.
66 *Exposition universelle de 1867 à Paris: Catalogue général*, 370.
67 *Album de voyage: Des artistes en expédition au pays du Levant*, exh. cat. (Paris, 1993), 117.
68 P. de Chennevières, *Souvenirs d'un directeur des Beaux-Arts* (Paris, 1888), 46.
69 É. Dor, *L'Instruction publique en Égypte* (Paris, 1872), 384 (the name Le Gray is distorted to Lagrée, but there is no reason to doubt the identification). Dor was a successor to Major Haillot. A last piece of evidence, published in response to a question by Charles de Lovenjoul about Le Gray in *L'Intermédiaire des chercheurs et des curieux*, no. 597 (October 20, 1892), col. 432, says nothing more than that "He was the drawing teacher of Princes Tewfik (later the khedive), Hussein, Ibrahim, etc. Later, he held the position of drawing teacher in the government schools."
70 "Statistiques de l'instruction publique," a report by Dor Bey (December 25, 1875): 2, National Archives of Egypt, Douin papers, box 188. In the absence of a pension record, it would seem that Le Gray was still teaching at the time of his death, unless he did not teach long enough to qualify for a pension.
71 A vignetted portrait of Sherif Pasha, bearing the stamp of Le Gray, is still preserved in Cairo by his descendants.

In particular, there was one large album, the sole survivor of a locally bound series for Félix Paponot, an engineer working on the Ismailiya Canal. The album contained—until it was broken up— forty-four Egyptian views, some of which formed a panorama (figs. 234, 236, 304, and 308).[72]

Le Gray's last known commission was for the architect Ambroise Baudry,[73] who—not content solely to defend endangered ancient monuments—built structures in the local style. Among others, he constructed buildings "for a French banker, M. Delort [de Gléon], an Arabic house that is a masterpiece. One must visit it to have a real idea of an art whose original monuments are disappearing little by little."[74] When construction was completed, in 1872, Le Gray took several uninspired, now faded, views of it.[75] Their sole merit is that they represent, more or less, the last of the photo-

234 Gustave Le Gray. *Tombs of the Caliphs, Cairo*, ca. 1861–1868.

72 The Arabic-style binding was done in Egypt: the back of the album bears the name of Le Gray, followed by the title *Moyenne-Égypte, tome I,* which indicates the existence of more than one album about that region, in addition to albums that probably would have existed on Upper and Lower Egypt; Rieunier & Bailly-Pommery, Commissaire-priseur, *Photographies,* sale cat. (Paris, Drouot-Richelieu, March 19, 2001).

73 M. P. Halgand et al., *L'Égypte d'un architecte, Ambroise Baudry (1838–1906)* (Paris, 1998), 73.

74 Charmes, *Cinq mois au Caire,* 54.

75 Musée d'Orsay, Architecture documentation.

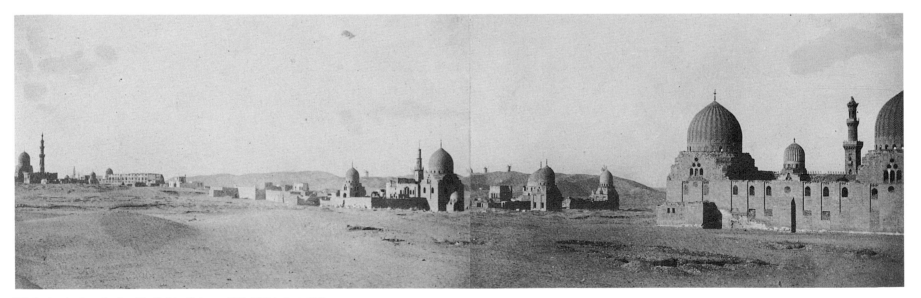

235 Gustave Le Gray. *Tombs of the Caliphs, Cairo*, ca. 1861–1868 (cat. no. 202).

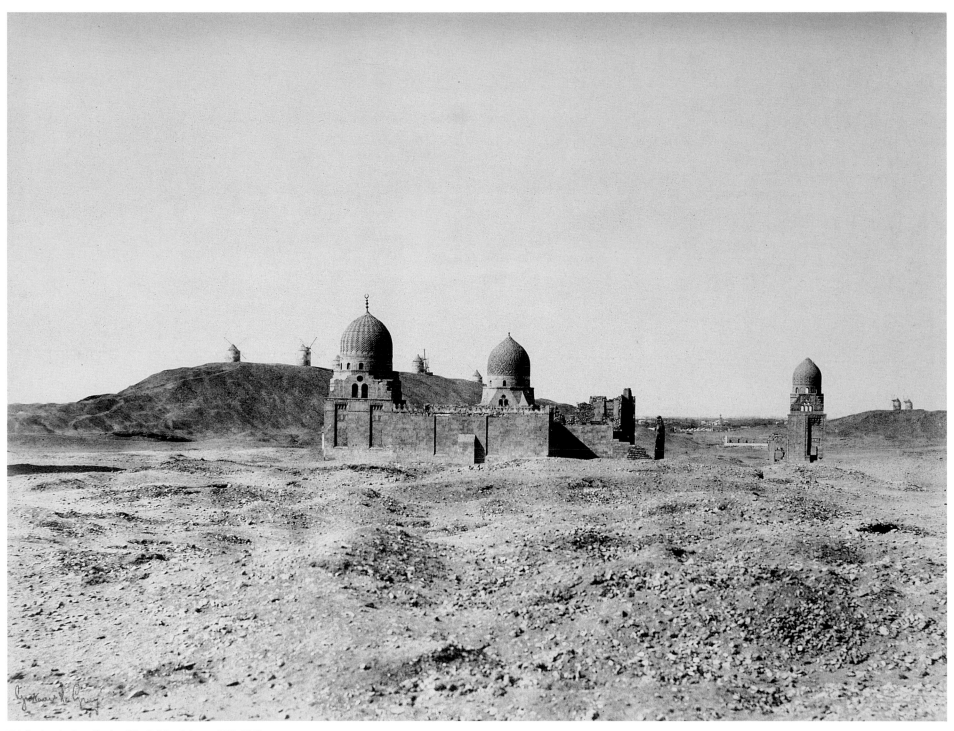

236 Gustave Le Gray. *Tombs of the Caliphs, Cairo*, ca. 1861–1868.

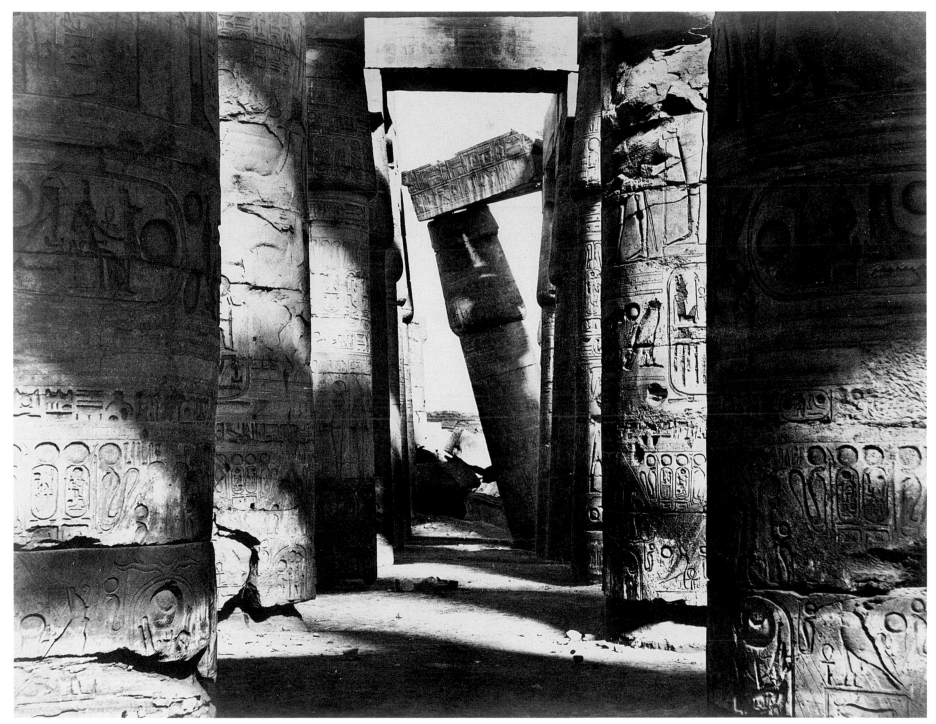

237 Gustave Le Gray. *Hypostyle Hall, Temple of Amun, Karnak*, ca. 1867 (cat. no. 210).

grapher's work, and especially the circles in which he traveled in Cairo, consisting of artists and architects who—centering around Baudry,[76] Arthur Rhoné,[77] Rochemonteix, and Artîn Bey—were conducting "a campaign to preserve Arabic monuments."[78]

Some of these views echo the tastes and concerns of that group, such as the comprehensive series of views of the tombs of the caliphs, which were included in the Paponot album. Le Gray himself had become a collector, if it is possible to rely on the loan of the manuscripts to the Universal Exposition of 1867. The residences he chose also reveal his identification with the Near East. In 1869 "he lived near the Esbekieh, in a beautiful old Arab house."[79] Then he moved even farther from the modern European quarter of Ismailiya, to a working-class alleyway in the Arab part of the city, in the shadow of a mosque, on the ground floor of a large eighteenth-century house. The beauty of the inner courtyard drew the attention of those friends of Le Gray's who appreciated such things, thanks to whom its former appearance is known today, as well as identified.[80] In an album given by

Baudry to Rhoné, composed of views of Cairo taken between 1875 and 1895 by the Italian photographer Beniamino Fachinelli, are two views titled *Coptic Quarter, Women's Side of the Courtyard of Le Gray's House* and *Coptic Quarter, Men's Side of the Courtyard of Le Gray's House*.[81] This Near Eastern courtyard was even incorporated into the repertoires of commercial photography (particularly by the Armenian Lékégian [fig. 239][82] and by Pascal Sebah [fig. 238]).[83] It was also used in orientalist paintings (the Austrian Ludwig Deutsch did several paintings of it [fig. 240]).[84]

Journey's End

It is clear—despite a great deal of new evidence—that there are still many lacunae in our knowledge of Le Gray's sojourn and work in Egypt. But his last fifteen years are the most poorly documented of all. The mid-1870s, indeed, marked the end of French preeminence; the pasha's largesse ran dry, and the French nationals there were increasingly tourists. There were no more old friends to visit the photographer and bring back to Paris

76 Concerning the photographs of the Delort house and Baudry's intervention with Prince Hussein Pasha relative to a debt for photography by Le Gray, see a copy of a letter from Le Gray to Baudry, November 11, 1872, Musée d'Orsay, Documentation.
77 Rhoné provided a good description of this circle in a letter to Lovenjoul, December 29, 1882, Institut de France, Library, G 1192, Lovenjoul correspondence, case 39.
78 Ibid.
79 Chennevières, *Souvenirs*, 46. Undoubtedly the house on Nubar Street mentioned by Leproux (see p. 189).
80 The house was declared a historical monument in 1922, but today there remain only the gate and the angled entrance, at 16 Souq-al-Zelat Street.
81 "Sites et monuments du Caire choisis et catalogués par Ambroise Baudry, architecte du gouvernement, pour son ami Arthur Rhoné," 48–49, prints 111 and 112, Max Karkégi collection.
82 Lékégian worked from the 1860s through the 1890s. A beautiful view of Le Gray's courtyard, which, through a fortunate coincidence, was used as the frontispiece in N. Perez, *Focus East: Early Photography in the Near East (1839–1885)* (New York, 1988).
83 Collection of the Bibliothèque d'art et d'archéologie Jacques Doucet.
84 L. Deutsch file (1855–1935), Musée d'Orsay, Documentation.

238 Pascal Sebah. *Courtyard of Le Gray's House in Cairo*, after 1870.

239 G. Lékégian, *Courtyard of Le Gray's House in Cairo*, after 1870.

fragmentary reminiscences. The few traces that remain of him, from several of these years, are derisory, as is evident in the following facts: In 1876 and 1877, his tenacious creditors intervened in the settlement of his mother's estate, which was still in abeyance; at the time, his agent, Ernest-Marie Brouard, was an otherwise unknown employee of the railroad company Chemins de fer de l'Est.[85]

240 Ludwig Deutsch. *The Scribe*, oil on canvas, 1912.

85 Ratification and acquittance by Le Gray's representative, September 13, 1877, Departmental Archives of Val-d'Oise, 2 E 21169.
86 Archives of the Ministry of Foreign Affairs (Paris), Consular vital statistics register, Cairo, 1883. There is also mention of Adolphe Linant de Bellefonds, a member of one of the most influential and wealthy French families in Cairo.
87 Ibid., 1880, instrument of February 24.
88 Unless he died in the cholera epidemic in the summer of 1883. The illegitimate son of a foreigner, all trace of him has been lost in the vital statistics records.
89 *L'Intermédiaire des chercheurs et des curieux*, no. 597 (October 20, 1892), col. 432. This is probably the source of Le Gray's "distress" mentioned by Nadar (see note 11).
90 See "Death-Date Inventory" in the appendix to this volume.
91 Mentioned when the premises were sealed (then missing from the inventory, but perhaps included under "flasks"; see "Death-Date Inventory").
92 By Paul Orillat, attested affidavit following the death of Gustave Le Gray, drawn up by M. Latapie de Gerval, solicitor in Paris, January 28, 1885, National Archives, Records of the Central Paris Solicitors' Archives, CIII 1633; and Le Gray estate declaration, April 13, 1885, Archives of Paris, DQ7, register 10893, no. 350. His son, Alfred, was the sole heir to a sum that finally amounted to 10,788.48 francs.
93 Death of Gustave Le Gray, Cairo, Latin Parish of the Assumption, death registry, register 7, p. 78, no. 120. Thanks to M. Dominique Escartin and Mme Nina Siag for finding this document after a long search.

In 1881 a new, less-formidable creditor—his Cairo butcher, Louis Gourjon—summoned him to appear before the consular tribunal regarding an old debt. The record contains orders for meat, wine, and liver for his cats—notes handwritten by the photographer and delivered to the butcher by his servant. This is a most banal glimpse of his daily life, but probably also of his financial difficulties.

It was not until his final year that events again began to move faster. In January 1883 an unexpected event occurred, whose strangeness recalls the Roman imbroglio of forty years earlier. Le Gray went to the office of vital statistics to register the birth of a son just born, on January 16, to him and a nineteen-year-old woman, Anaïs Candounia. The confusion that had prevailed in 1844 in his marital record was now multiplied tenfold by fraud and error. In order for the child to be registered as legitimate—and French—Le Gray represented Anaïs as his wife. In addition, there were other oddities: in the record, the son has the father's given names, and the father those of the grandfather, and Le Gray declared his age as fifty-nine, although he was sixty-two at the time. In short, the entire declaration was false, either due to the negligence of the registrar or because the declarant was covering his tracks. Subsequently, the birth record—an unparalleled event in archival history—was crossed out and annotated, "Cancelled: M. Le Gray married in France and unable to show proof of the death of his first wife."[86] Because Palmira's disappearance had not been resolved, Le Gray was unable to remarry. His exile did not free him from his family any more than from his creditors.

Of young Anaïs Candounia, it is possible to draw only a vague portrait. Her last name was Greek. As for the rest, Le Gray, once again, far from his artistic and society crowd, set his sights on a woman from his most immediate and most humble circle. Anaïs had a sister, Félicité Candounia, who, at a very young age, had married a French mechanic; and, at the declaration of the birth of their son, the witness was none other than . . . the butcher Louis Gourjon, Le Gray's unfortunate supplier.[87] The pursuit of classic beauty led the artist from the Roman to the Greek, and led the eccentric from the laundress to the butcher's neighbor. Of his love life between the first and the last of these curious romances, nothing is known.

On July 29, 1884, in a Cairo that had been deserted by the Europeans, who had fled the stifling heat, Le Gray died with a twenty-year-old woman and, perhaps, a child at his side.[88] A correspondent for *L'Intermédiaire des chercheurs et des curieux* (under the byline E. B.—perhaps the mysterious Ernest Brouard) would

add in 1892 that Le Gray died "in extreme poverty."[89] The estate inventory, drawn up on August 5 in the presence of Anaïs Candounia, did not disprove the statement.[90]

The furnishings and accoutrements of daily life were nearly totally absent from the inventory. Obviously, the possibility that some assets had already been removed for Anaïs and her family cannot be ruled out (although she was required to swear to the contrary). But, as it stands, the list is startling. The personal property, dryly listed in three hours by the substitute consular secretary, shows an interior reduced to a symbol of a monomaniacal life, a tomb for an unfulfilled passion. In the entryway, the bedroom, the two other rooms of the main house, the courtyard, and the separate "small house," there was nothing but a disorganized heap of drawings, watercolors, paintings in varying states of completion, photographs, and equipment: easels, pigments and inkstones, optical instruments, drawing boards, palettes, mannequins, tripods and camera obscuras, a rolling-press, and so on. In the bedroom, there was a handful of basic furnishings, a cast-iron bed, an alembic,[91] and a narghile (water pipe). The only books found at the deceased's bedside were dictionaries and treatises on chemistry.

The executor of the will, bankruptcy receiver Albert Castel, balanced the books, which, in spite of everything, were in the black. While the deceased had some two thousand francs in debts, his assets were estimated at four or five thousand francs after the estate sale.[92]

Even in death, he sowed confusion in the records. In the consulate's office of vital statistics, his death was dated July 30 instead of 29, and his birth was dated July 20, 1839, which was actually the date when he earned his bachelor's degree. It was also, give or take a few days, the official birth date of photography.

Le Gray was buried in the cemetery of the Franciscan fathers,[93] where the record again mentions Anaïs as his wife, which leads us to believe she was actually living with him. The sale of a portion of the cemetery to the neighboring Coptic church, early in the twentieth century, led the monks to clear the graves that were located there. Of Le Gray's, nothing remains.

241 Gustave Le Gray. *Tombs of the Caliphs* (detail), ca. 1862–1868.

242 Gustave Le Gray. *View in a Park*
(detail), ca. 1856 (cat. no. 108).

243 Gustave Le Gray. *View of the Salon of 1853* (cat. no. 86).

Gustave Le Gray, Heliographer-Artist

Henri Zerner

Two months ago, one of the most talented practitioners of the new process of photography, M. Le Gray, sent to the jury of the Salon of 1850 nine drawings on paper, representing landscapes, portraits from life and from paintings. Having admired the surprising perfection of the results, the jury had difficulty trying to classify these works worthy of rivaling the most accomplished works of art, and which nevertheless, produced by a purely theoretical process, belonged in no direct way to the practice of drawing. Placed among the lithographs, the works of the talented heliographer were announced under this heading in the handbook of the current exhibition.

But a subcommittee, viewing the question from a different angle, had M. Le Gray's drawings removed from the exhibition.

The first group considered the drawings as works of art; the second identified them as scientific works. We are at a loss as to who is right.[1]

Francis Wey thus opens the first of his numerous articles published in *La Lumière*, articles that have contributed powerfully to shaping the discourse on photography. The anecdote has a character so mythical, and poses the question of the artistic status of photography in such an exemplary fashion, that its truth was at one time questioned.[2] It is nevertheless authentic. There was indeed a first edition of the 1850 Salon handbook that announced Le Gray's entry; the announcement disappeared from the definitive edition. The minutes of the Salon jury are not detailed enough to determine precisely how things happened, but Wey's account is essentially accurate.[3]

Photography has become so omnipresent that we have difficulty imagining the confusion caused by its sudden arrival. Photography's insertion into nineteenth-century culture involved enormous stakes, and contemporaries were well aware of this. The scientific world welcomed it, on the whole, without reservation. But could this revolutionary method of producing images fit into the domain of art as it was conceived at the time? Would it compete with artists? Would it pervert art or, on the contrary, would it give it new force? These are the questions posed by Francis Wey's article: "De l'influence de l'héliographie sur les beaux-arts" (On the influence of heliography on the fine arts).

Photography: Between Art and Industry

Although ten years had passed since its invention, we can see that even the name of the newcomer had not been agreed upon. This unstable vocabulary is one of the indices that guides us in understanding the complex and changeable situation in which Le Gray found photography. We see a series of neologisms emerge, and not all of them were promoted by the inventors. Some were adopted; many others disappeared. Thus the term *daguerreotype* remains specifically attached to the positive process on metal plates perfected by Daguerre; but until around 1860 the term was applied just as often to photography in general (hence Delacroix uses the term to designate any photographic image). The term *photography*, which appeared in France with the development of processes on paper, competed for a certain time with *heliography*. *Photographer* remained to designate the operator, despite protests from Le Gray, for whom *photographer* was to be applied to the instrument used by a *photographiste*. In 1868, Louis Figuier, who played an important role as a writer of popular science, particularly in the field of photography, still used this term, which was later abandoned.[4] In our time, specialists have revived *calotype* specifically for the paper negative process, invented by Talbot and of which Le Gray was the great promoter.

These neologisms demonstrate an effort to respect the specificity of the new invention and to provide it with its own conceptual space. But the more natural tendency is to view the unknown in terms of resemblance to the known. A term like *photogenic drawing* allowed

1 F. Wey, "De l'influence de l'héliographie sur les beaux-arts," *La Lumière*, no. 1 (1851): 2–3.
2 M. Gasser, "Between 'From today, painting is dead' and 'How the sun became a painter': A Close Look at Reactions to Photography in Paris, 1839–1853," *Image* 33, no. 3–4 (1991): 25. Gasser did not find the first version of the Salon handbook. This does in fact exist, but it is more likely a preliminary proof than a first edition.

3 If the jury finally refused the works on December 12, the first printing of the handbook must have been earlier, unless the jury's results were not communicated to the printers in time. It should be pointed out that even though no. 3885 (like the submission no. 5579) mentions a frame containing nine items, the list shows only seven titles.
4 Louis Figuier had an agile but mediocre mind. His 1848 article

on photography, published in the *Revue des deux mondes*, is a technical summary. In it, he condemns—explicitly but without belaboring the point—the idea that photography can be an art, which is consistent with his idea of the "positive" value of photography for the sciences. He also declares that the process on paper is inferior "from the point of view of art." In a second, less well known, publication from 1849, "Le Daguerréotype au point de vue des arts" (*Mémoires de l'Académie de Montpellier* [1849]: 183–95), Figuier concludes in a peremptory fashion that, "although photography rates high as a modern scientific invention, it has little value from an artistic point of view." He completely reverses this judgment with the publication of *La Photographie au Salon de 1859* (1860; reprint, New York, 1979). Here he maintains almost as a point of fact that photography is a full-fledged art: "The lens is an instrument just like the pencil or the brush; photography is a process like drawing and engraving, because what makes an artist is feeling rather than process." Later, around 1868, Figuier updates the description of techniques, which had greatly evolved, but he literally repeats his earlier publications of 1849 and 1859 as far as the artistic question is concerned, leading to a perfectly contradictory text; see L. Figuier, *Les Merveilles de la science; ou, Description populaire des inventions modernes*, 4 vols. ([1867]–70; reprint, New York, 1979), vol. 3.

5 S. Bann, *Parallel Lines: Printmakers, Painters and Photographers in Nineteenth-Century France* (London and New Haven, 2001), 108, n. 53. Helmut Gernsheim had already reached the same conclusion.

6 For B. Newhall and R. Doty's translation of the manuscript, in the Cromer collection, George Eastman House, see *Image* 11, no. 6 (1962): 26; reprinted in J. Buerger, *French Daguerreotypes* (Chicago and London, 1989), 7.

7 In the seventeenth century the word *reproduce* was used in the strict sense of "produce anew," but not "reproduction." The acceptation of the renewal of lost members or organs is the only one in Diderot's *Encyclopédie*, but Buffon had already used the word in the sense of reproduction of species. *Reproduce* and *reproduction* are absent from the article on "engraving" in the *Encyclopédie* and, to clarify the concept, the author writes that the principal function of engraving is to "multiply the ideas of the composition of paintings of the good masters." In 1835, the biological acceptations are still the only ones recognized by the dictionary of the Académie—always very late in matters of usage. E. Littré (in his *Dictionnaire de la langue française*, completed in 1872) gives as the last meaning "act of reproducing; to publish a second time, by forgery, or otherwise, a book, a work of art. The reproduction of this book prohibits its reproduction." Reproduction rights was a very hot topic in the literary world of Le Gray's time because of Belgian forgeries. It was an important source of revenue for artists. The right would be claimed by photographers through a series of lawsuits such as that brought by Meyer and Pierson; photographers finally won the right despite protestations from numerous artists, which denotes the rupture between art and photography. On the complexity of the legal question, see E. A. McCauley, *Industrial Madness: Commercial Photography in Paris, 1848–1871* (New Haven and London, 1994), 32.

8 This example is cited by P. Larousse, *Grand dictionnaire universel du XIXe siècle* (Paris, 1866–90), in the article "reproduction." The complete phrase is: "Art is the liberal reproduction of beauty, and the power in us capable of reproducing it is called genius."

for the association of the process with the conventional production of images while at the same time signifying its originality. In general, the practitioners borrowed vocabulary from known fields, especially those of printing and the graphic arts—such as *photographic press, printing, proof,* and *print.*

The question of the relationship between photography and art was unambiguously posed as soon as photography appeared. Histories of photography relate how a scientist and rising politician, François Arago, became the advocate of Daguerre and the daguerreotype by organizing a campaign for which the painter, Daguerre, would receive official recognition and a pension in exchange for making his invention public. To make a better case, Arago asked Paul Delaroche for his opinion of the process. This choice is not surprising. Delaroche was a famous artist, a favorite of the public, and Arago's colleague at the Institut national de France. Furthermore, Alfred Arago, the son of the physicist, was a student in the painter's studio. Delaroche, moreover, apparently was interested in the new process from very early on. Stephen Bann demonstrated that the painter must have seen Daguerre's results before they were presented to the Académie des sciences, probably at the end of 1838.[5] The note Delaroche addressed to Arago, and quoted at length in the latter's report to the Chamber of Deputies on July 3, 1839, is cited here in full:

> M. Daguerre's process proves by its results that it completely satisfies all the requirements of art; some of its essential qualities are so perfected that it will become an object of reflection and study for even the most skillful painters. The drawings obtained by this means are remarkable both for their perfection of details and their overall richness and harmony. They reproduce nature not only coherently but also artistically. The correctness of lines and precision of forms are as complete as possible; at the same time, one finds free and energetic modeling, and an overall richness of tone and effect. The rules of aerial perspective are as scrupulously respected as those of linear perspective. Color is so truthfully translated that we forget its absence. The painter will find in this process a rapid method of assembling a collection of studies that he otherwise could obtain only with much time and difficulty, and in a much less perfect manner, no matter how talented he might be. When this process is known, the publication of imprecise views no longer will be tolerated, because it will be quite easy to obtain within a few minutes the most precise image of any site whatsoever. The engraver not only has nothing to dread in the use of this process, but will eventually disseminate the benefits by means of his art. He will have studies of the utmost interest to engrave. He will see the art with which nature is rendered, the color that is interpreted. He will undoubtedly admire the fact that the unimaginably precise finish does not at all interfere with the stillness of the masses or in any way disturb the overall effect. In short, the admirable discovery of M. Daguerre has rendered an immense service to the arts.[6]

This short text manages to recapitulate the major tenets of academic instruction. It reads as if Delaroche, professor at the École des beaux-arts, is examining a student's work, an "étude." Everything is covered: outline, modeling, value, effect, linear and aerial perspective. Only composition, which would become one of the principal battle horses of the detractors of photography as an artistic medium, is absent.

In this text, which respects the most established protocols of artistic literature, one term, *reproduce*, does not belong to the traditional vocabulary. Delaroche writes that "nature is reproduced" rather than imitated, represented, or copied. *Reproduce* and *reproduction* were to resurface continually in writings on photography, and the graphic arts in general. Although it isn't known exactly when the term was first used in this sense, or in texts about art, it was still rather new when Delaroche used it. It is important to understand its connotations at the time he was writing. The term is borrowed from the language of biology: *reproduction* is the faculty possessed by certain living species to reconstitute amputated members or organs (as, for example, crayfish, which grow new claws), and, by extension, the possibility of all living species to self-perpetuate by producing new specimens.[7] The term also maintained a rather strong connotation of "producing anew," as in Victor Cousin's well-thought-out phrase "Art is the liberal reproduction of beauty."[8] It is also interesting to consider the term *discovery*, used not only by

244 Gustave Le Gray. *View of the Salon of 1853* (cat. no. 85).

9 We only need to recall the role played by the tradition of miraculous images such as the Veronica, or *vera imago*, in the reception of photography.
10 Emphasis added. L. de Laborde, *Exposition universelle de London: Travaux de la Commission française sur l'industrie des nations. Vie groupe, 30e jury, Beaux-Arts* (Paris, 1856), vol. 8: 481.

Delaroche but also by Arago and many others after them, instead of *invention*, as if photography always had been there in nature, waiting for someone to find it. In short, Delaroche presents photography as a marvelous and almost miraculous form of drawing: nature reproducing itself.[9]

The widespread use of the word *reproduction* is tied as well to the industrial revolution and to the need for efficient multiplication of products in the face of unbridled demographics and urbanization. Léon de Laborde makes this clear in his great work on the relationship between art and industry: "The intervention of machines in the propagandizing of art was epochal and was equivalent to a revolution; *reproductive methods* are the ultimate auxiliary

of democracy." A little further in the same paragraph, he adds, "Yesterday, steam, that eloquent expression of modern society, was giving a powerful helping hand to all industrial products imbued with the influence of the arts; today photography, the perfect ideal of mechanical art, is initiating the world to the beauties of divine and human creations."[10]

The association of photography with the notion of reproduction is important to our understanding of the activity of Le Gray. *Reproduction* functions less as a true concept than as a nebulous semantic field, the multiple and sometimes contradictory connotations of which can work for or against the elevation of the status of photography within the cultural values of the time. As a natural phe-

245 Gustave Le Gray. *First-Floor Gallery, the Salon of 1852* (cat. no. 84).

nomenon, reproduction can almost sanctify photography, but by attaching it to the industrial revolution, it casts photography into the domain of commercial materialism. The alternative offered by Wey, between science and art, is in fact rather academic; the true problem is to determine whether photography is industry or art.[11]

Things can be summed up this way: in 1850 Le Gray entered the fray by submitting his photographs to the Salon, and he repeated the offense in 1852, only to suffer a new refusal.[12] For the next ten years, he constantly found himself at the head of a struggle to win for photography a place in the artistic establishment. We can consider 1859 as the symbolic date of defeat, and Baudelaire's blast-

ing diatribe as the sign of photography's annexation, not to science, but to commerce. The liquidation of Le Gray's business and his flight in 1860 were consequences of this. As far as his own profession of faith, Le Gray never wavered:

> As for me, I express the desire that photography, rather than falling into the domain of industry, of commerce, return to that of art. There it will find its only, true place, and I will continually struggle to move it along this path. The men attached to the progress of photography must imbue themselves with this principle. Trying to lower the price of proofs before finding the means to produce perfected works would be to risk the future of our very interesting art.[13]

11 The question is well presented in these terms by A. Rouillé, *La Photographie en France, textes et controverses: Une Anthologie, 1816–1871* (Paris, 1989), 7–18. See also, of course, McCauley, *Industrial Madness*. Laborde also (see note 10) understood the question in these terms but hoped to resolve the problem through a reconciliation of industry and art.
12 Le Gray sent works to the jury on March 4, 1852, and recovered his framed works on June 30 (it should be noted that there were now six of them, whereas the list of March 4 includes only four subjects). The pictures included subjects commissioned by the State for the Mission héliographique, but also portraits. For the list, see National Museums Archives, Louvre, **KK 110.
13 Le Gray, *Photographie: Nouveau traité théorique et pratique . . .* (Paris, [1852]), 70–71; reprinted in Rouillé, *Photographie en France*, 103.

246 Gustave Le Gray. *Gallery Near the Salon Carré, the Salon of 1850–1851* (cat. no. 83).

14 See G. Levitine, *The Dawn of Bohemianism: The Barbu Rebellion and Primitivism in Neoclassical France* (University Park, Pa., 1978).
15 I owe a great deal to the thesis, unfortunately unpublished, of L. MacClintock, "Romantic *Actualité:* Contemporaneity and Execution in the Work of Delacroix, Vernet, Scheffer and Sigalon" (Ph.D. dissertation, Harvard University, Cambridge, Mass., 1993).
16 On this point, it is necessary to correct E. P. Janis (*The Photography of Gustave Le Gray*, exh. cat. [Chicago and London, 1907]), who gives the approximate dates 1839–1843.
17 See S. Aubenas, "The Youth of a Painter" (this volume).
18 Gasser ("Close Look at Reactions to Photography"), who carefully searched the sources, found nothing before G. Tissandier, *Les Merveilles de la photographie* (Paris, 1874). According to Gasser ("Close Look at Reactions to Photography": 15), three possibilities exist: either Delaroche suddenly changed his mind; the story is an invention; or the phrase should be attributed to someone else. He doesn't take sides. Tissandier is not trustworthy; he places the declaration at the end of the joint meeting of the Académie des sciences and the Académie des beaux-arts: "The artists were seized with astonishment and admiration: Paul Delaroche had seen Daguerre; he tore a plate imprinted by light from his hands. He showed it everywhere, crying: 'from today painting is dead!'" As Delaroche had already seen daguerreotypes before January 1839, the melodramatic story scarcely rings true. If it is not entirely made up, Tissandier at best seems to be repeating gossip.

Art: Practice and Ideology

The text by Francis Wey that opened this essay contains a very odd statement: that the works Le Gray sent to the Salon were "produced by a purely theoretical process, belonged in no direct way to the practice of drawing." Were Le Gray's "drawings" thus not the result of any practice? How could a writer as lucid and disciplined as Wey write something so paradoxical, if not outright absurd? In point of fact, Le Gray's works were not connected in a direct manner to the practice of drawing; in other words, these "drawings" were not drawings, nor were they engravings, lithographs, or the result of any other practice known to the world of art and artists in 1850. Le Gray's ambition was precisely to have photography accepted as an artistic practice.

The designation "artiste-peintre" (painter-artist), which is often attached to Le Gray's name, signifies the ideological charge taken on by the term *artist* during the Romantic period; it was an almost sacred vocation. One became a painter but was born an artist. More than a profession, it was a "type" of human whose image Murger captured in his 1848 *Scènes de la vie de bohème*. We can even imagine an artist who never produces anything yet remains an artist nevertheless; this was almost the case, seemingly, for Maurice Quaï, leader of the so-called Primitives or Barbus (beards), the radical artists who came out of David's studio.[14] Actual practices—painting, sculpture, engraving, architecture, and so on—were only secondary, and artists could move from one to another. What linked the various practices, what they had in common, was drawing. Indeed, all of these arts presuppose a drawn project, or at least the possibility of such a project, corresponding to the "idea" that underlies the work.

Drawing was central to thinking about art during Le Gray's era. As Charles Blanc's title, *Grammaire des arts du dessin*—from which photography is emphatically excluded—suggests, all works of visual art are in a certain sense *dessin*, or drawing. Under the designation of drawing, the academic institution combined a graphic practice with what could be called visual thought or the intellectual foundation of art, in such a way that the two aspects seemed inseparable.[15] Blanc insisted on the homonymy, on which Vasari had already played, between *dessin* (drawing) and *dessein* (intention; in Italian, *disegno*, in the sense of drawing but also intention), regretting that in French the modern spelling had taken the power out of

this word play by distinguishing the two terms. It is true that around 1830 the camp of Colorists, which was sometimes called the Anglo-Venetian school, and their proponents attempted to reduce drawing to a graphic practice and deny the mystical cult of drawing that reigned at the Académie and especially around Ingres. Drawing nevertheless remained in prominence at the École des beaux-arts, at the expense of painting and other artistic practices.

Le Gray was a tried-and-true artist who faced his destiny according to the ideological dictates of his century. All eyewitness accounts and portraits of Le Gray concur to portray him as the very image of the typical artist: sensitive, anxious, impulsive, and, of course, nonconformist. And yet, we do not know very much about his artistic education. At least nothing at all that is well established. His education was necessarily brief, and Le Gray was doubtlessly largely self-taught, as was his contemporary Courbet. He himself said he was the student of Paul Delaroche, and there is no reason to doubt him. But before entering the most sought-after painting studio of the time, he must have already learned drawing and the basic rudiments of art. As far as his apprenticeship with Delaroche, it could not have lasted very long; in fact, if he was a notary's clerk in Villiers-le-Bel in 1841, then he hardly could have frequented the studio before this date.[16] It is nevertheless clear that his passage through Delaroche's studio was decisive. He formed a close-knit group of professional friends that lasted throughout his Parisian career: Charles Nègre and Henri Le Secq—whose professional photographic activity was intimately linked to that of Le Gray—Gérôme, and others. It is possible, as we saw earlier, that his 1847 collaboration in recording sunspots with Arago was arranged by the scientist's son, Alfred, who was also Delaroche's student.[17] Delaroche himself maintained very strong personal relationships with a select group of students. Indeed, when he closed his studio in rather painful circumstances in 1843 and decided to go to Italy for a while, he was preceded by Le Gray. Gérôme followed, as well as Le Gray's closest friend, Le Secq. They apparently intended to complete an education that had been interrupted too quickly.

We must pause here to consider a fact: among the great photographers of the 1850s, a good number of them studied in Delaroche's studio, the most noteworthy, apart from Le Gray, being Charles Nègre and Henri Le Secq, all three of whom remained very close. Historians generally list Roger Fenton among Delaroche's

students as well, but this is not certain. We are thus faced with the ineluctable question: Was this confluence of photographers just a coincidence or rather the result of the teaching and aesthetics that were presented in Delaroche's studio?

For historians, a widely spread anecdote for a long time signified Delaroche's attitude toward the invention of Daguerre. Having seen the first daguerreotypes, the famous painter was said to have cried, "Messieurs, from today, painting is dead." Seen as a declaration of war, this statement, which exists in multiple variations, only appeared in 1873 and is more likely than not apocryphal.[18] All accounts represent Delaroche as a thoughtful man, not at all impulsive. It is difficult to picture him suddenly enraged for or against a cause, only to completely reverse his opinion. His support of Arago in his campaign for Daguerre and in facilitating the entry of the daguerreotype into the public domain leaves no doubt. His implication in this affair was rather lengthy. Daguerre had shown him his results before the end of 1838. If the inventor approached him,

248 Gustave Le Gray. *Italian Street Musicians* (Pifferari), ca. 1851–1853 (cat. no. 21).

247 Henri Le Secq. *Italian Street Musicians* (Pifferari), etching, after 1860.

19 On Delaroche and repro
duction, see Bann, *Parallel Lines*.
20 Le Gray, *Traité pratique de
photographie sur papier et sur verre*
(Paris, 1850), 1. He is referring to
the paper negative, as is apparent
from the context. He was proven
wrong in the immediate future,
because the glass plate reigned
in the 1850s; in the long run,
however, celluloid film can be seen
as a return to the convenience of
paper, if not to the aesthetic of
the calotype.
21 Exhibition for the benefit of
disaster victims in Martinique.
22 The text of "Rapport sur les
dessins produits par le procédé
de M. Bayard" is cited in full
by J.-C. Gautrand, *Hippolyte
Bayard: Naissance de l'image
photographique* [Amiens,
1986], 193–95.

he obviously had reason to believe Delaroche was likely to be favorably disposed. Of course, Daguerre surely knocked on more than one door, but that of the painter opened, and with apparent hospitality. Delaroche's art was popular because it was accessible, less difficult than that of Delacroix or Ingres. The most popular paintings of Delaroche, such as the *Execution of Lady Jane Grey*, were sentimental and melodramatic and addressed the same public as the spectacles of the diorama with which Daguerre entertained Paris. Add to that Delaroche's interest in all forms of reproduction, to which his painting lent itself so well that one could say it was made to be reproduced.[19] For all of these motives, there is every reason to believe that, in the small world of the artistic establishment, Delaroche was the most susceptible to be sympathetic to Daguerre and his invention.

Whether it provoked amazement or skepticism, the announcement of the daguerreotype was a sensation. Given the undeniable involvement of Delaroche in the affair, it would be surprising if all the fuss had not created a particularly lively excitement in his studio. The future photographers in question were present in his studio in the years directly following the announcement, when the question of photography was still very present. Although nothing can be proved, there does seem to be a certain logic in seeing in Delaroche's studio a propitious setting for the flowering of a photographic art.

Rather than the silver plate of the daguerreotype, however, it was photography on paper that attempted to win a legitimate place in art. Le Gray was its most enthusiastic apostle: "Photography's future lies entirely with paper," he wrote in 1850.[20] Although the parallel invention of William Henry Fox Talbot (announced but not revealed in the weeks that followed the presentation of the daguerreotype to the Académie des sciences on January 7, 1839) was largely unknown in France, the question of paper photography, and of its merit compared to the daguerreotype, was immediately set forth, thanks to Hippolyte Bayard. The product of his process was a unique positive image; it therefore did not have the advantages of Talbot's negative/positive process, but the traditional paper support, also used for drawing, was sufficient to draw the endorsement of the Académie des beaux-arts. They took his side against Daguerre.

Bayard, who wanted to be known as a true inventor, was the first, even before Daguerre, to exhibit his results in public, and he did so in the context of an art exhibition in July 1839.[21] As early as May 1839, he unsuccessfully tried to interest Arago in his research. He then turned to the Académie des beaux-arts, which had refused Daguerre's invitation to a private demonstration of the daguerreotype process. Apparently, this was a means of demonstrating its disapproval, not of photography itself, but of Daguerre—who was probably not perceived as a sympathetic character—and disapproval as well of Arago's machinations on Daguerre's behalf. Having seen Bayard's works, the Académie was of "one accord as to the merit of these drawings, their positive exactitude, their pleasing aspect to the eye; and the inestimable and until now unique advantage they offer of being fixed on paper." A committee was named to examine the question more closely, and its report—presented at the meeting on November 2, 1839—was adopted by "the Académie, whose competence and authority in the arts is incontestable." The Académie recommended Bayard's process "by all the means in its power . . . to the attention and generosity of the government."[22] The report was extremely appreciative of Bayard's works. The Académie only had a slight reservation for a certain softness in the contours.

> Otherwise, we could not hope for a more satisfying effect, nor for more charm coupled with a more faithfully rendered image. M. Bayard's drawings have a pleasing quality that is due principally to the presence of light, and to the gradations of tone it produces, which are truly enchanting. To the eyes of artists, they offer the aspect of old master drawings, somewhat worn by the passage of time; they have the very same appearance, and the same merit.

Obviously, it wasn't the modernity of photography that seduced these academicians!

As early as 1839 a dividing line was drawn between artists who were favorable to paper and scientists attached to the precision of the daguerreotype and, a little later, to the glass negative. Nevertheless, paper photography did not really take off until several years later, after Blanquart-Évrard's improvements to Talbot's negative/positive process in 1847, the very year Le Gray returned to Paris after an almost uninterrupted stay of four years in Rome. Théophile Thoré, when reviewing Blanquart-Évrard's results, com-

249 Gustave Le Gray. *Italian Street Musician*
(Pifferaro), ca. 1856 (cat. no. 106).

250 Gustave Le Gray. *Italian Street Musician*
(Pifferaro), 1856 (cat. no. 107).

23 T. Thoré, "Perfectionnement du daguerréotype," *Le Constitutionnel* (February 6, 1848). Frances Jowel kindly pointed out this very interesting article, which, as far as I know, has escaped the notice of historians of photography. Despite his admiration, Thoré did not consider photographs to be works of art. The photographs (which he compares to casts from nature) "reproduce nature itself" and are a substitute for nature. If a painter uses photos of nude models, like those published by Blanquart-Évrard, "it is comparable to having had the model pose during the entire execution of the work. That is not a reason to copy the daguerreotype or the cast: art is not imitation but invention, or, put another way, the interpretation of images invented by the supreme Creator."

24 H. Gaucherand, "Beaux-Arts. Nouvelle découverte," *Gazette de France* (January 6, 1839); this article is partially cited by Gasser, "Close Look at Reactions to Photography," 12, and by McCauley, *Industrial Madness*, who paraphrases, somewhat approximately, the citation.

25 Bann, *Parallel Lines*. For a French version of the book's central theses, see Bann, "Photographie et reproduction gravée: L'Économie visuelle au XIXe siècle," *Études photographiques*, no. 9 (May 2001): 22–43.

26 The importance of photography of works of art is carefully studied in the case of England by A. Hamber, *"A Higher Branch of the Art": Photographing the Fine Arts in England, 1839–1880* (Amsterdam, 1996).

pared the works, as had the Académie, to the art of the old masters: "What is especially remarkable in the proofs of M. Blanquart-Évrard, from Lille, is that they recall the great masters of painting."[23]

Photography and Prints

As we have seen, photographic images were regularly designated as drawings up until the 1850s. Nevertheless, photography was also strongly associated with printmaking. When the system of multiple positive proofs from a negative developed after 1847, it was almost inevitable that people felt the new "art" belonged to the domain of prints. Even the daguerreotype, a unique image on a metallic plate, was immediately compared to engraving. In the first press review, appearing the day before Arago's presentation to the Académie des sciences, Gaucherand wrote in the *Gazette de France*: "If I wanted to find a comparison to describe the effects rendered by the new

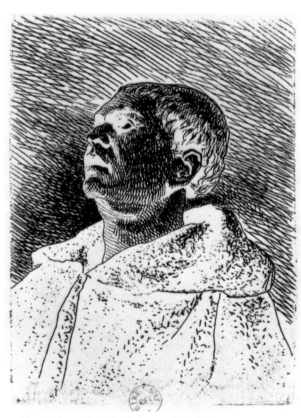

251 Henri Le Secq. *Head of a Monk*, engraving imitating the appearance of a negative, after 1860.

process, I would say that they are similar to those of engraving and of mezzotint, but much closer to the latter. As for truthfulness, they exceed everything already known."[24] Jules Janin, in a famous article from *L'Artiste*, called Daguerre the "author of universal engraving." And if Delaroche, in his note to Arago (cited earlier in this chapter), reassures engravers, it was undoubtedly because they were immediately worried the new "process" would invade their territory. Once Blanquart-Évrard established his photographic "press" and definitively succeeded in introducing the negative/positive process in France, the assimilation of photography as printed images was almost complete.

In a recent book, Stephen Bann places the invention of photography back into a framework of the graphic arts by insisting on the importance of the reproduction of works of art and on the prestige enjoyed by burin engraving and its most distinguished practitioners, such as Calamatta, Ingres's official engraver, and Henriquel-Dupont.[25] Bann takes issue with an overly linear model of modernity that sees lithography as the penultimate stage of development in reproductive printmaking leading to photography. It is essential, as Bann emphasizes in his book, to remember that the reproduction of both ancient and modern works was considered a full-fledged artistic enterprise, with its own Prix de Rome and representatives at the Académie. Today, we are passionate about the landscapes and seascapes of Le Gray, whereas his photographs of paintings hardly move us at all. Yet it was largely in this domain that the future of photography as art was played out. The principal argument against the new process was based on the idea that it was a purely mechanical operation—thus the name *operator* generally given to the photographer—and that, consequently, there was no human judgment or decision but, at best, only dexterity at work. This argument is much stronger in the domain of reproductions of art than for studies of nature, in which the choice of subject matter and the framing are evidently free and important decisions. For these reasons, it was only normal that Le Gray should focus a large part of his efforts and research on reproduction.[26]

Around 1850 the photographic reproduction of paintings involved great difficulties. Apart from the fact that the original was not always easily accessible, taking a picture of a painting involved other obstacles: reflections and, especially, the unequal sensitivity of photographic materials to different colors, which led to false val-

ues in the final photographs. Photographers thus rarely used paintings directly but rather took pictures of drawings or prints, in which the colors had already been translated into values of black and white. Le Gray did not photograph the Mona Lisa itself, for example, but used a drawing by the sculptor Aimé Millet, commissioned by the State in 1848.[27] This intermediary step between the original and its reproduction, moreover, was not new and, here again, photography was printmaking's heir; in the first part of the nineteenth century it was indeed not rare, in the case of a prestigious reproduction, to have commissioned a preparatory drawing from another artist to serve as a model for the engraver.[28]

There is no doubt about the prestige of burin engraving, at least in an academic context. Precisely at the moment when Le Gray was trying to define the role of a photographer-artist, the reproduction of works of art certainly promised a bright professional future, in emulation of engravers. The works of artists such as Calamatta, which were very expensive, provided an enviable model. At the same time, Bann underestimates some of the problematic aspects of the art of the burin. It is true, as he writes, that it was not surprising at the time that Calamatta required several years to complete his engraving after Ingres's *The Vow of Louis XIII*. All the same, this was due to the fact that burin engraving had become almost pathologically complex. How could one forget that with much simpler means, and in much less time, Marc Antonio Raimondi had rendered the compositions of Raphael with a grace that has never been surpassed. It is significant that one of the first albums of reproductive photographs was devoted to these engravings, as if—taking up the cause—photographic reproduction wished to assure its legitimacy by recalling its most noble origins.[29] And if photography was excluded from the world of art, at least temporarily, it should not be forgotten that, as time passed, it nevertheless carried off with it the much-vaunted art of reproductive engraving, which was moribund by 1900.

Whatever Bann might say, we must not underestimate the continuity that contemporaries sensed between lithography and the new process. We have seen already that Le Gray's proofs were to have been placed in the lithography section if displayed at the Salon. Francis Wey insists on the succession of the two techniques in Niépce's experimentation, and this relationship had acquired an ideological value by that time. We should note as well that, even if lithog-

raphy belonged to the domain of printmaking, as a relatively new process it was held somewhat at bay; it had a separate section at the Salon. Another thing also distinguished it: the printing of an intaglio print (burin, etching, or other) is simple, and any artist can learn in a very short time to pull acceptable proofs from plates. As for wood engraving, a press is not even required to obtain excellent trial proofs; a wooden spoon is all that is needed. But the printing of a lithograph requires more delicate procedures. If lithographic printing, based on the opposition between water and grease, is simple in principle, the production of a good print remains difficult. Once the drawing is finished, the stone must be cleaned (which makes the image invisible), and the grease must be fixed by an acid treatment—all requiring handiwork that artists did not accomplish by themselves. They did not have lithographic presses in their studios and let professionals pull trial proofs, as well as the final editions. In other words, once the direct work of the artist was finished, lithography implied a whole procedure, partly chemical, which can be seen as a parallel to the procedure of photography. The artist could express himself with the same spontaneity or the same application as when drawing, and the technician—that is to say the lithographic printer—multiplied this drawing. Thus, one could talk about lithographic "drawings" (as the Salon handbook of 1850 described the ultimately excluded works of Le Gray).

Lithography was not necessarily the most favorable of associations for raising the status of photography, which was already clearly in danger of being appropriated by commerce. Burin engraving was considered to be the noblest of graphic techniques. Mezzotint engraving, or the "English manner"—the effects of which Gaucherand found to closely resemble those of the daguerreotype—was little practiced in France but was considered to be properly artistic. Lithography had both the merit and the dangers of modernity; speedy and less expensive, it smelled of commerce and had political overtones that did not work necessarily in its favor. We know what a formidable means of protest Philipon and his caricaturists made out of lithography in the 1830s. At the same time, almost all of the Romantic artists tried their hand at it without losing face and, thanks especially to Achille Devéria, it acquired a distinguished place in the art of portraiture.

If Bann rightfully shed light on the prestige of reproductive engraving by opposing it to lithography, he left in the shadows other

27 It was not an oil copy by Jean-François Millet, as Hamber ("Higher Branch") writes. On the engravings of Mona Lisa, see H. Focillon, "La Joconde et ses interprètes," in *Technique et sentiment* (Paris, 1919). Focillon mentions neither Le Gray nor Aimé Millet.
28 G. McKee studied these often advantageous commissions; see McKee, "L'Art de dessiner l'art: Ingres, Bouillon, Dutertre, et autres copistes au service de la gravure vers 1800," *Revue du Louvre et des musées de France*, no. 5-6 (1995): 73-90.
29 B. Delessert, *Notice sur la vie de Marc Antoine Raimondi, graveur bolonais, accompagnée de reproductions photographiques de quelques-unes de ses estampes* (Paris, 1853). Le Gray is not the author of these photographs, contrary to the opinion of Bann (*Parallel Lines*, 117).

dynamic aspects of printmaking that, at the time, could have inspired a photographer, and other careers that could have served as models to be emulated by an artist like Le Gray. Besides paintings, prints could also "reproduce" nature. In this vein, Eugène Bléry, although little known today, played a role in the history of printmaking in the middle of the nineteenth century. He exhibited his studies of nature regularly at the Salon, and his somewhat myopic vision of luxurious vegetation could have inspired calotypists, Le Secq more so than Le Gray. He chose to make expensive proofs printed on a luxury paper known as *chine collé*, carefully signed by hand, which left no doubt about his artistic aspirations.[30] It was Bléry who taught etching to Méryon, whose career exactly parallels that of Le Gray. Félix Bracquemont, born in 1833, began his etching activity at the end of the 1840s. Louis Marvy, like Bléry, regularly exhibited his prints at the Salon; this forgotten artist was then well known because he was one of the main contributors to *L'Artiste,* by far the most prestigious of art reviews. He had developed a very personal and very "artistic" technique, based on softground etching, which he used both to etch his own landscapes and for reproductions of paintings, especially those of contemporary artists. In 1843 he collaborated on two landscape albums with Charles Jacque, who eventually had a true career as a painter, but who at that time was a printmaker and illustrative draftsman. Their printer was Auguste Delâtre, two years younger than Le Gray, who was also an amateur printmaker, but whose real contribution was to improve printing effects; by purposefully wiping the plate in an incomplete and sometimes uneven manner, he knew how to vary the expressive qualities of a single copper plate.

There was therefore a kind of effervescence in what could be called the world of independent printmaking, which is confirmed by the fact that the artist-engraver achieved a certain literary celebrity, thanks to Champfleury's first success, *Chien Caillou,* published in 1847. This novella, as everyone at the time knew, was the fictionalized account of the life of the young etcher Rodolphe Bresdin, who, without ever attaining great success, was well known in literary and artistic circles.[31] In short, between 1840 and 1860—that is, during the formation and artistic maturation of Le Gray—an etching renaissance took place that led, in 1862, to the foundation of the Société des aquafortistes. Le Gray's submission to the Salon of 1850, with its mix of portraits and landscapes, some after nature

and some after the work of other artists, conforms perfectly to what a young printmaker at the beginning of his career could have sent.

Le Gray, Painter-Photographer

The production of Le Gray in traditional materials has completely disappeared. This is undoubtedly due in large part to the circumstances of his life, to his more than twenty-year exile, his death in a foreign country, and his alienation from his family; the works of his friends Charles Nègre and Henri Le Secq were preserved by those close to them. They also had a more sustained production. Le Secq regularly exhibited at the Salon. We do have a few rare documentary traces of the works of Le Gray. His parents' inventory shows a certain number of paintings, drawings, and prints, some of which were most likely by their son. He showed two works in the Salon of 1848, the year of the revolution, which was, it should be recalled, an open salon, that is to say, without a jury: a portrait of a woman and a picturesque scene of Roman life like that produced by almost every artist who visited Rome. His entries passed unnoticed in this immense exhibition that contained more than five thousand works (twice the number of the previous year). He exhibited only one other time, in 1853, with a portrait of a woman. This is indeed very little. Yet, he always referred to himself as a painter, certainly to distinguish himself as an artist: "miniature painter" in the Bottin directory of 1850; "painter and photographer" on the title page of his treatises in 1850, 1851, and 1852 (but not in 1854); and, after his installation on the boulevard des Capucines, "history painter and photographer" in the Bottin directory from 1857 to 1859. It is uncertain that he ever produced history paintings, and, in these years, his work as a photographer left him very little time to devote to painting. It was most likely just a title of prestige, perhaps required by his backers.

However, once he moved to Cairo, Le Gray did take up painting and drawing again; the inventory after his death, fortunately rediscovered,[32] shows him to have been living among easels and unfinished paintings. We can imagine him painting the notable figures of Egyptian society. As we have seen, he was a teacher for the preparatory school for the École polytechnique of Cairo and also taught drawing to the young princes. He presented a series of twenty-six drawings in the Egyptian pavilion at the 1867 Universal Exposition in Paris.[33] Thus, in Egypt—without abandoning his

30 *Chine collé* was used especially in lithography and embellished the prints considerably. The technique consists of printing on an extremely thin and smooth paper, which is applied to a heavier support; adhesion of the thin sheet to the mounting is assured by passing it through a press. This certainly served as a model for the mounting of photographic proofs, which were also on very thin paper. Moreover, Le Gray himself made this association. *La Lumière* ([March 30, 1851], 30) relates a debate among the members of the Société héliographique over César Daly's proposal to introduce photographs into its architectural review: in response to one member who had insisted on the practical difficulties of inserting proofs, "M. Le Gray said that it was possible and that it had been done already as with engravings on *chine collé.*" Also, mounted calotypes recall luxury print editions. There is no reason to think Bléry's art particularly interested Le Gray, but this is not impossible in the case of other calotypists, like Le Secq.

31 On Bresdin, see, most recently, M. Préaud, *Rodolphe Bresdin, 1822-1885, Robinson graveur,* exh. cat. (Paris, 2000).

32 See "Death-Date Inventory" in the appendix to this volume.

33 "Vues de monuments anciens de la Haute-Égypte, dessinés pendant le voyage de LL. AA. Les fils du vice-roi, par M. Le Gray, attaché au service du gouvernement égyptien."

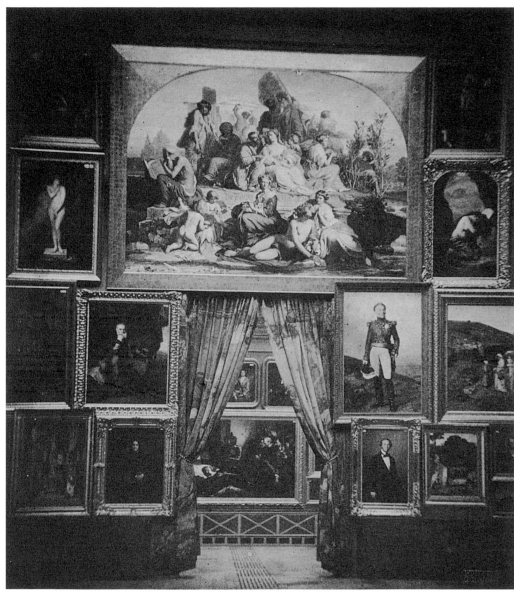

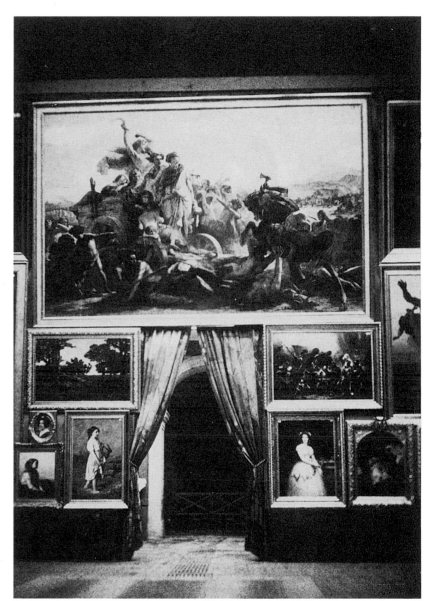

252 Gustave Le Gray. *View of the Salon of 1852.*

253 Gustave Le Gray. *View of the Salon of 1852.*

34 Raffet made this "atlas" of lithographs to accompany A. Demidov, *Voyage dans la Russie méridionale et la Crimée, par la Hongrie, la Valachie et la Moldavie, exécuté en 1837*, 4 vols. (Paris, 1840–42). These plates were published in installments between 1838 and 1848. The text (vol. 1: 417–41) describes with wonder the fourteen days of festivities during Czar Nicholas's review of the troops.

photographic activity—Le Gray had resumed work as a painter. Of all this production, absolutely nothing remains. We still have not found a single drawing. Did he have a true talent for drawing and did he try etching as did his friend Le Secq? Was he free with the paintbrush like Nègre? Our frustrated curiosity of course makes us regret these losses. At the same time, there is a certain symbolic beauty in the fact that his "heliographic" oeuvre remains so pure, making him the photographer-artist par excellence.

After all that has been said, it is clear that photography, in order to be an art, could situate itself only within the field of the graphic arts. Three consequences follow this assertion: the designation of certain sources of inspiration or formal models; giving the public a particular frame of reference; and, especially, the encouragement of a certain kind of practice.

It is not always easy to say what models Le Gray could have had in mind, but it does seem clear in at least one case. When the emperor commissioned him to produce a series of photographs of the camp at Châlons, in September 1857, Le Gray found direct inspiration from a series of Raffet's lithographs. This lithographer, so popular for his albums that had sustained the cult of Napoléon since the 1820s, had published in the 1840s an important ensemble of lithographs that made up a vast pictorial documentary on the Crimea.[34] A section of this atlas entitled *Camp de Vossnessensk* evokes the maneuvers and review of the Russian army in 1837. It opens with a portrait of the czar (fig. 254); plates follow that represent the encampment, group portraits of soldiers (fig. 255), picturesque scenes of exotic characters, and even the celebration of "camp mass" (fig. 257), which is also one of the highlights of Le

254 Auguste Raffet. *His Majesty Nicolas I, Emperor of All the Russias: The Camp at Vossnessensk, September 6, 1837*, 1842.

255 Auguste Raffet. *Circassians, Lesghiens, and Cossacks in the Escort of His Majesty the Emperor of Russia . . .* , 1842.

Gray's work (fig. 311). This lithographic suite had probably already inspired Roger Fenton during his photographic reporting on the Crimean War, the first of its kind, which Le Gray knew (the series was sold downstairs from his studio by Bisson in 1856). But he certainly thought back to the lithographic model, which constituted an exact precedent for his mission. The composition of certain photographs, with their uninterrupted horizon giving the impression of a vast space against which the camp stands out, shows an obvious lineage to Raffet, as well as to Fenton (fig. 256). Other specific details are evident as well. But it is the very constitution of the suite that ties the work of Le Gray so powerfully to Raffet's model.

The seascapes of Le Gray engendered genuine enthusiasm when they were shown in London in November 1856. We understand this phenomenon better when we take into consideration the English landscape tradition, and in particular mezzotint engraving, (known—as already mentioned—as "the English manner" in

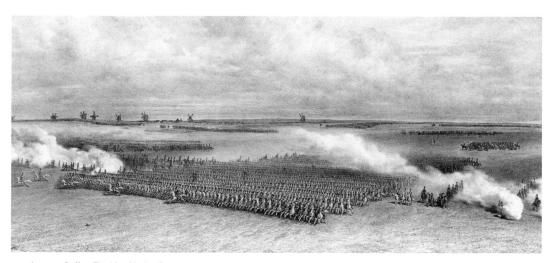

256 Auguste Raffet. *The Line Moving Forward, Maneuvers of September 14, 1837*, 1844.

257 Auguste Raffet. *Mass at the Camp at Vossnessensk, September 11, 1837*, 1844.

France). Turner had already published an important body of his work under the title *Liber studiorum,* a large ensemble of very diverse landscapes engraved in mezzotint over a foundation of etching. But even closer to Le Gray were Constable's landscapes, engraved by David Lucas under the artist's strict supervision. Upon photography's first apparition, people had noticed a direct lineage to mezzotint, which can be explained by the fact that this technique is built upon tints without outlines. It is not unlikely, moreover, that Le Gray was interested in the mezzotints of Constable and Lucas. The new school of young French landscapists greatly admired Constable from the time that he first exhibited in the Salon of 1824. It is difficult to know whether the series *English Landscape* (fig. 260) or other plates of Constable's circulated widely in France, but in 1848 *The Rainbow,* the most ambitious of the engravings produced from the collaboration between Constable and Lucas, was finally published—twelve years after the painter's death—simultaneously by E. Gamber and Co. in London and by

Goupil et Vibert in Paris. Whatever the possible influence of these prints on Le Gray, they certainly prepared London critics and art lovers to appreciate the astonishing economy of light that animates the seascapes of Le Gray, which Constable himself referred to as the chiaroscuro of nature.

For Le Gray, what made photography an art was not at all "a purely theoretical process," but a specific and complex hands-on practice that he visibly shared with the domain of printmaking. He elaborated his work in two distinct stages, both of which required a great number of choices and decisions: the preparation of the negative, and the printing of positive proofs. The exposure marks only one moment in this process, even in the process of making the negative. The choice of a lens, the quality and preparation of the paper, and the development of a negative, not to mention the choice of subject, the viewing angle, the framing of the view, and so many other factors, affect the appearance of the negative. The printing of positive proofs offers in turn multiple occasions to affect the

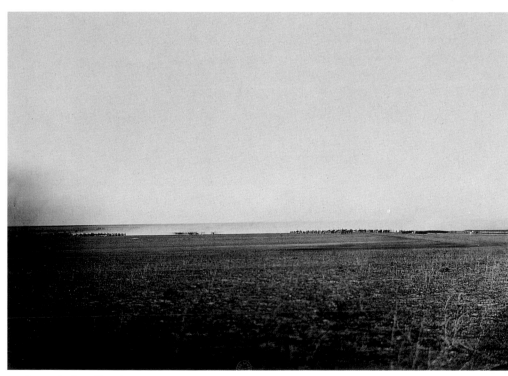

258 Gustave Le Gray. *Troop Maneuvers,* 1857 (cat. no. 155).

259 Gustave Le Gray. *Zouave Storyteller,* 1857 (cat. no. 144).

visual characteristics of the final image. To counter the "objective" instrumentation and the instantaneity of exposure, Le Gray relied on handling and duration; the long and laborious elaboration of a photograph allows the photographer to hand-tailor his product, in the manner of a true artist, who is a poet shadowed always by a practitioner.

Le Gray published four successive versions—each one more extensive than the last—of his *Traité pratique de la photographie sur papier et sur verre*. Beginning in 1851, he added *théorique* to the title, but the theoretical aspect is reduced to a minimum, and it is more or less a recipe book.[35] These texts are nevertheless important in understanding the approach of Le Gray. Two elements should be emphasized: first, the multiplicity and complexity of the chemical treatments and manipulations utilized, and second, the intention of the art, at once implicit and explicit, that underlies the results. Le Gray periodically reminds his reader that these complicated recipes are what allow him to achieve both the desired "effect" and the beauty of his proofs.

It is especially in the printing of the positive proofs, to which Le Gray devoted loving care, that the full force of his originality is apparent. Certainly, he labored minutely over framing while taking his pictures. His Fontainebleau landscapes are in this respect of great perfection in the manner in which the photographer adapted the dis-

coveries of the Barbizon painters, in particular Théodore Rousseau, to whom he is quite close in sensibility. But Le Gray varied the framing yet again at the moment of printing, subtly adjusting the composition of different proofs from the same negative. He also played freely with the exposure of the positive proof. One forest view, somberly printed, gives an impression of depth and mystery, with details suppressed, whereas another proof, printed out for a shorter length of time, insists on the foliage of trees, the rendering of trunks,

35 Le Gray published the first article of a series titled "De l'état actuel de la photographie et des perfectionnements restant à y apporter," *La Lumière* (March 30, 1851); this article essentially repeats ideas already expressed by Wey. Le Gray's second article (April 20, 1851) presents a "scientific" theory of light that must have seemed hazy even at the time. The rest of the series never appeared. It is in Le Gray's practice that one must search for his line of thinking.

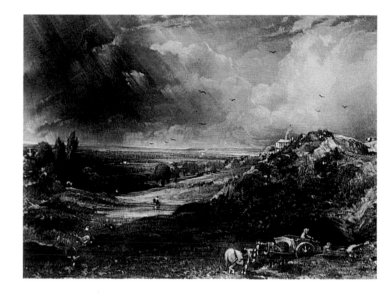

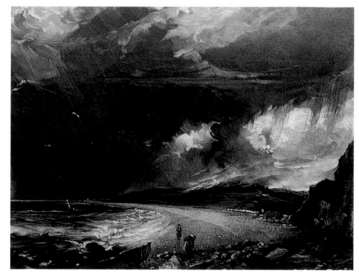

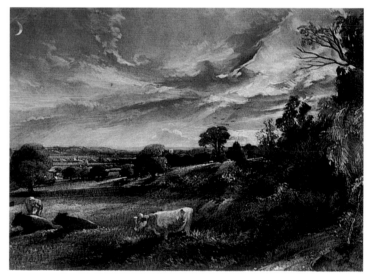

260 a–c David Lucas, after John Constable. *A Heath (Hampstead Heath: Branch Hill Pond)*, 1831; *Weymouth Bay, Dorsetshire*, 1830; *Summer Evening*, 1831 (*English Landscape Scenery*, first and third fascicles).

261 Gustave Le Gray. *Study of an Oak Tree*, ca. 1852 (cat. no. 70).

262 Gustave Le Gray. *Study of an Oak Tree*, ca. 1852 (cat. no. 71).

263 Gustave Le Gray. *The Road to Chailly, Another Cloudy Sky*, 1852–1856 (cat. no. 68).

264 Gustave Le Gray. *The Road to Chailly, Cloudy Sky*, variant, 1852–1856 (cat. no. 67).

and the plasticity of forms. Finally, by varying and combining chemical substances, he produced a very wide repertoire of tones, with which he sometimes played in a single proof (figs. 261, 262).[36]

Like the other members of the Société héliographique, Le Gray was strongly opposed to retouching. It was necessary to preserve the "truth" of photography. That did not prevent him or the other members from occasionally resorting to the practice—innocent enough lies.[37] More radical, but also more ambiguous, is the use in certain landscapes of two negatives for the same proof in order to obtain a better balance between the ground and the sky.[38] By matching, from one proof to another, different skies for the same view, he radically altered the expressive content of the same landscape. These atmospheric effects are of course in perfect harmony with the investigations of contemporary landscape painters. The most important point is this: for Le Gray, the crucial work of the landscape photographer did not take place out in the field, seizing the immediacy of nature, but in the studio, as the material practice of making art, informed and inspired by imagination (figs. 263, 264).

Le Gray brought the same virtuosity and the same care to the photography of works of art. The different proofs of the *Mona Lisa* vary considerably in tonality, from olive to darker, warmer blackish browns. Even a cursory examination of the collection published by Henri Lehmann (fig. 266) of his compositions for the Hôtel de Ville shows care in the printing, a subtle variation of tints. Le Gray placed his stamp on the proofs of this collection, but his role is not recognized in the title of the album. By contrast, a proof after *Le Coupeur de nappe* (The man who cut the tablecloth) by Ary Scheffer (fig. 64) carries the handwritten signature of both artists, as was often the case for expensive engravings reproducing art from other media. Another photograph after Scheffer, a detail from *The Temptation of Christ* (fig. 265), recently found in a private collection, reveals that there was perhaps a sustained relationship between these two artists, although we can't say whether it resulted from a commission or disinterested collaboration.

Le Gray in the Colorist Avant-Garde

If, by his artistic education and the choice of the painters whose works he reproduced, we can place Le Gray within what might be called "academic Romanticism" (Delaroche, Lehmann, Scheffer), his independent work ties him to the art of the Colorists, in particular the new school of landscape artists. The key word that punc-

tuates his long and fastidious technical descriptions is *effect*. At the end of the brief 1850 version of his treatise, we find his "Observations for the Good Execution of Portraits and Reproductions of Daguerreotypes and Oil Paintings," which begins: "The effect is one of the absolute conditions for an agreeable portrait. Nothing should be neglected in order to achieve it."[39] The effect is the overall impression that a work produces, but more precisely, in studio terms, it designates the economy of light. There are not only different effects; *the* effect is also an absolute value that a work either has or has not. Le Gray also writes, a little further on: "Without these precautions, the effect will always be lacking."[40] In the debate between draftsmen and Colorists in the nineteenth century, *effect* was the strength of the latter, as style was the great weapon of the first. Again, Wey was right when he wrote about Le Gray's proofs for the Mission héliographique:

> What struck us about these prints, at first glance, was the efforts of our travelers to introduce an impression of color in their works; and certainly,

we do not mean the more or less brownish coloration of the proofs: a vermilion- or licorice-colored drawing can be pale and cold. The feeling of color in an image, modeled with the help of gradations of the same tone, is the kind of accentuation that allows us to perceive disparate nuances on the same plane and helps us to discern from what material the subject is made. When a drawing reproduces the age, nuances, and texture of stones, when it reveals both the striking and harmonious oppositions between the tones of trees, grass, water, and earth, the work of a Colorist is indicated; our heliographers, if they have both taste and science, succeed through trial and error to introduce these essential qualities into their positive proofs, just as much as lithographers and engravers.[41]

Colorism does not reside in coloration, but in the science of relations and transitions. Wey, it seems, insisted too exclusively on what is called rendering.[42] Both Thoré and Baudelaire insisted instead on the air that circulated in a painting, the impression given by Colorist works of the atmosphere surrounding depicted objects.

36 See S. Aubenas, "To Unite Science with Art" (this volume).
37 Janis (*Photography of Gustave Le Gray*, 80–81) gives an obvious example; for a variation of a seascape, *The Sun at Its Zenith,* he suppressed a detail that was hard to read (probably two immobile carts) to tidy up the composition.
38 Again, see Aubenas, "To Unite Science with Art" (this volume).
39 Le Gray, *Traité pratique de photographie,* 38.
40 Ibid., 39.
41 *La Lumière* (October 5, 1851): 138. Notice the use of the word *print* (*estampe* in French) to designate photographs.
42 In studio terms, this has to do rather precisely with giving the impression of the texture of the materials. Littré (*Dictionnaire de la langue française*), giving an example of noun usage, writes, "The precision of the rendering of an object, in photography."

265 Gustave Le Gray. Photograph of a study by Ary Scheffer for *The Temptation of Christ*, ca. 1851.

266 Gustave Le Gray. Photograph of a mural painting by Henri Lehman for the galerie des Fêtes, Hôtel de Ville, Paris, 1853 (cat. no. 82).

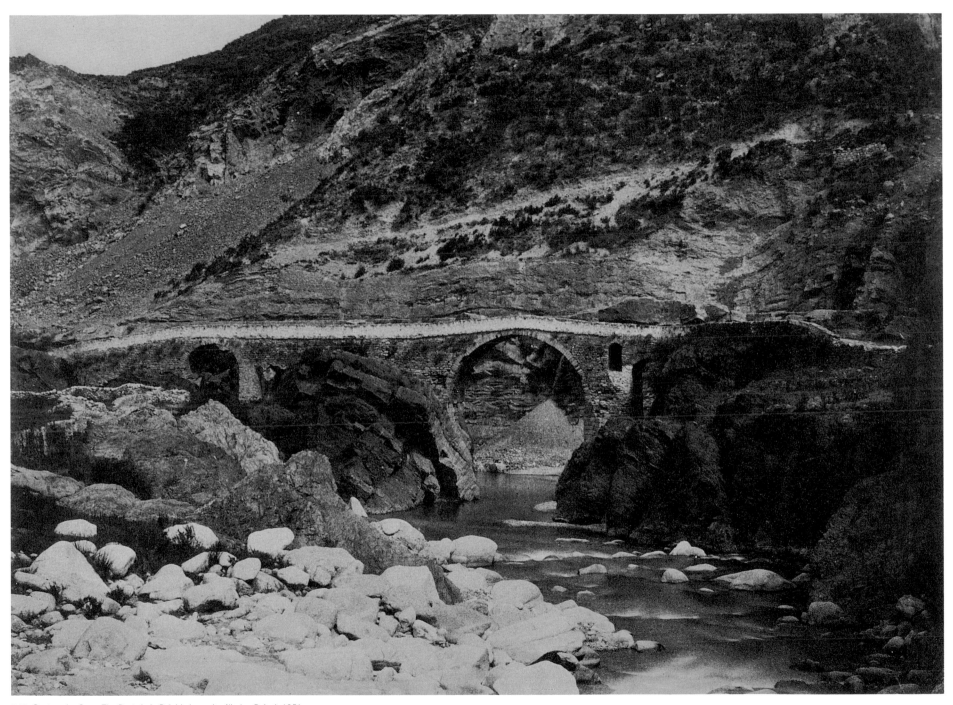

267 Gustave Le Gray. *The Pont de la Palalda* (near Amélie-les-Bains), 1851.

Baudelaire's text in the Salon of 1846, obviously reflecting studio conversations, is even more revealing than that of Wey. At the very moment when Delacroix became visibly obsessed by drawing, on the one hand, and, on the other, by the unity of the entire work so that no detail should stand out, Baudelaire reflected this thinking by stating, for example, that because "art is only an abstraction and a sacrifice of the detail for the whole, it is important to be concerned especially with massing."[43] What made photography fascinating for Delacroix, at least briefly around 1854, was the idea that it represented the "true drawing of nature," as he wrote to Dutilleux.[44] In 1846 Baudelaire had already noted: "The Colorists draw as nature does; their figures are naturally demarcated by the harmonious struggle of colored masses." The idea that there are no lines in nature is an old one, but it became a major concern of Delacroix at a time when, due to outside pressures, he found himself increasingly defined in opposition to the fanatical linearity of Ingres. When Baudelaire wrote that "color certainly does not exclude overall design . . . which always proceeds according to the ensemble and masses, but rather the drawing of details, the contour of the smallest object, where brushwork inevitably devours the line," he anticipated Le Gray's aesthetic just as much as he defined that of Delacroix.

Of course there is no brushwork in photography, but the slight fuzziness due to the grain of the paper negative, to which Le Gray was so attached, takes its place. One only need glance at Le Gray's most independent landscapes and seascapes—uncommissioned and with no specific documentary function—to realize to what extent he was conscious of the abstraction possible in photography through the positioning and harmonization of masses. His student Greene undoubtedly took such abstraction further, whereas Le Gray preferred more balance between abstraction and the "richness," the "finesse" of detail. In 1851 Le Gray's practice was in perfect harmony with the aesthetic articulated by Wey, and by Baudelaire before him, and this aesthetic is essentially that of Delacroix. In spite of his sympathies and friendships in the "juste milieu" and in the camp of the proponents of line, maybe even in spite of himself, Le Gray belonged, as did Charles Nègre and Henri Le Secq, to the Colorist avant-garde by dint of his most accomplished and seductive works.[45]

43 C. Baudelaire, *Salon de 1846* (Paris, 1846), sec. 3, "De la couleur."
44 On Delacroix and photography, see H. Zerner, "Delacroix, la photographie, le dessin," *Quarante-huit/Quatorze* (*Conférences du Musée d'Orsay*), no. 4 (1997): 7–14; Aubenas, "Les Photographies d'Eugène Delacroix," *Revue de l'art*, no. 127 (2000): 62–69.
45 Thanks to Sylvie Aubenas for having generously made all of her reference materials available to me for the writing of these pages—which also owe much to our conversations.

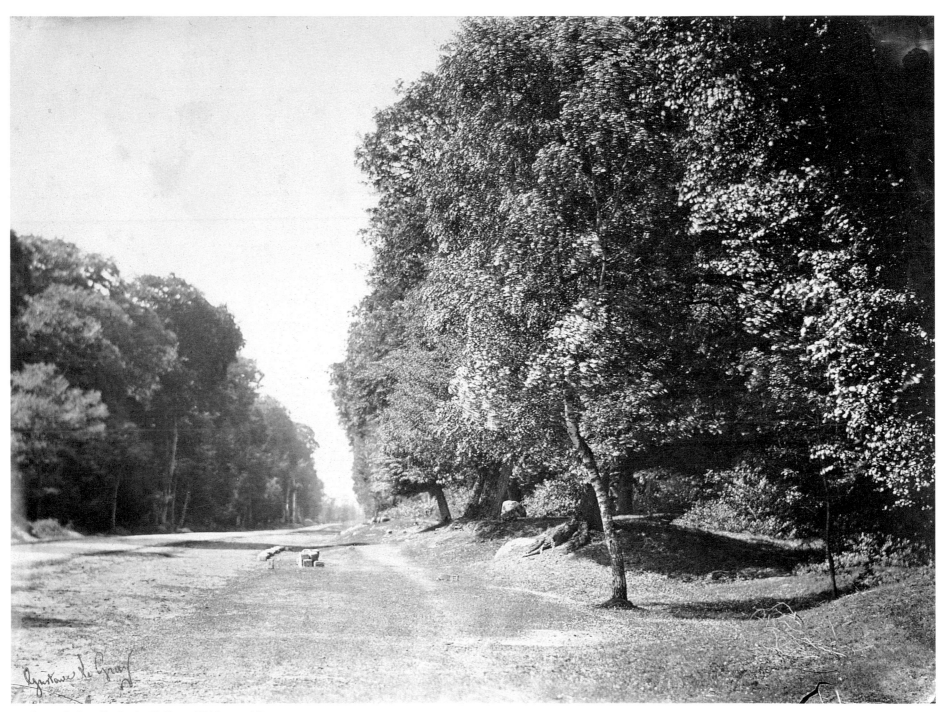

268 Gustave Le Gray. *The Road to Chailly*, ca. 1856 (cat. no. 93).

From the Point of View of Painting

Barthélémy Jobert

Among the views of the forest of Fontainebleau made by Le Gray between 1849 and 1852, *The Road to Chailly* stands out. The image itself is idiosyncratic, notably in its framing, presenting an apparently haphazard view that opens into the distance, whereas the artist, in this period and place, seems generally to have favored views that are frontal and shallow. More important, however, it readily evokes, for a modern viewer, an early composition by Monet of the same title (Paris, Musée d'Orsay)[1] painted around 1865 (fig. 270), at about the same time as Manet's *Déjeuner sur l'herbe*. The similar vantage points, the fact that Le Gray and Monet stood in the same spot to create their respective *Road to Chailly* images—a clearing in the forest beside the road—invites comparison of the two works. Is the similarity the result of direct influence? It seems very unlikely that Monet and Le Gray encountered each other in Fontainebleau; by 1863, when Monet began to frequent Chailly, Le Gray had left France. It is quite possible, however, that Monet was familiar with photographic prints by Le Gray and that, intentionally or otherwise, they influenced his paintings, although the spirit of his two canvases, the way they convey an impression of being captured in the open air, is somewhat at odds with this hypothesis. Are we then dealing with mere happenstance? Le Gray, like Monet after him, might simply have taken up a subject that was popular with artists who frequented the forest—both men, without great originality, having opted for a vantage that offered the best view of this particular motif. But this is a facile explanation of a tricky and vexing problem—that of possible influence, an elusive notion in any case—that is difficult to resolve in the absence of pertinent documentation. It leaves unaddressed the possibility that there is a relationship of a different order between Le Gray's works and nascent Impressionism.

Some years later, in 1858, Le Gray photographed the fleet of Napoléon III leaving the port of Le Havre. The composition is deftly organized around a central horizontal axis, parallel to the horizon, traced by the jetty at right and the two ships at left, and interrupted by the verticals of the three vessels in the center (fig. 273). Here again, the scene irresistibly brings to mind a famous canvas, *The*

Stages of Life (fig. 272), painted by Caspar David Friedrich in 1834–1835 (Leipzig, Museum der Bildenden Künste).[2] Now, it is virtually impossible that Le Gray—or, indeed, most of his French contemporaries—knew this composition. During Friedrich's lifetime, his fame was essentially limited to Germany and the other countries of northern Europe, and he had begun to fall into obscurity during the last years of his career, precisely when he produced this painting. His rediscovery in Germany dates from the late nineteenth and early twentieth centuries, and in France it began much later. The painting was not engraved; no old photograph of it is known; and, like all of the artist's paintings, it was never exhibited in France (only a few watercolors circulated there, thanks to the sculptor David d'Angers). It remained in the possession of Friedrich's heirs until 1932, when it was acquired by the museum in Leipzig. Of course, one might explain this new coincidence by maintaining that both artists merely painted similar sailing vessels, and that it is only natural for the ships closest to shore to have their sails more furled than do those already on the open sea. But it is my

1 D. Wildenstein, *Claude Monet: Biographie et catalogue raisonné*, 5 vols. (Lausanne and Paris, 1974–91), vol. 1, no. 56; larger version, Copenhagen, Ordrupgaard Museum (Wildenstein no. 57). Henri Loyrette has noted the possible influence of Le Gray on another Monet canvas painted at Fontainebleau, *The Bodmer Oak* (1865; New York, The Metropolitan Museum of Art; Wildenstein no. 60), in G. Tinterow and H. Loyrette, *Origins of Impressionism*, exh. cat. (Paris and New York, 1994), 422–23.
2 H. Börsch-Supan and K. W. Jähnig, *Caspar David Friedrich: Gemälde, Druckgraphik und bildmässige Zeichnungen* (Munich, 1973), no. 411. The comparison between the two works was first suggested by E. P. Janis (*The Photography of Gustave Le Gray* [Chicago and London, 1987], 64), who essentially linked them to the weighty Romantic tradition, already very much present in the photography of the 1850s.

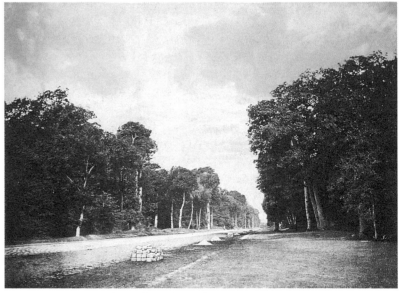

269 Gustave Le Gray. *The Road to Chailly, Cloudy Sky*, 1852–1856 (cat. no. 73).

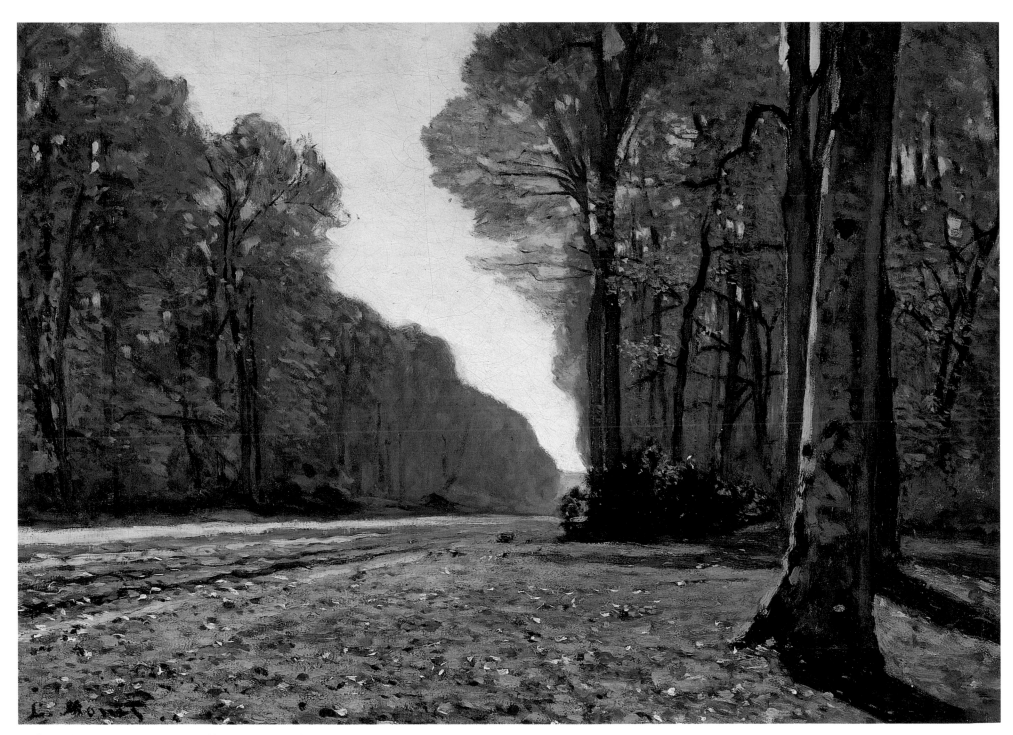

270 Claude Monet, *The Road to Chailly (Forest of Fontainebleau)*, ca. 1865.

271 Gustave Le Gray. *The Road to Chailly, Another Cloudy Sky*, 1852–1856 (cat. no. 74).

272 Caspar David Friedrich. *The Stages of Life*, 1834–1835.

273 Gustave Le Gray. *Ships Leaving the Port of Le Havre*, 1856 (cat. no. 125).

3 On this question, see H. Zerner, "Gustave Le Gray, Heliographer-Artist" (this volume).
4 See "Death-Date Inventory" in the appendix to this volume.
5 To complicate matters further, Le Gray's known photographic output continues to grow as new images and new prints of previously known images surface.
6 On the Barbizon school, see first J. Sillevis and H. Kraan, eds., *L'École de Barbizon: Un Dialogue franco-néerlandais*, exh. cat. (The Hague, 1985). See also S. Adams, *The Barbizon School and the Origins of Impressionism* (London, 1994), and, especially, C. Heilmann, M. Clarke, and J. Sillevis, eds., *Corot, Courbet und die Maler von Barbizon: "Les amis de la nature,"* exh. cat. (Munich, 1996). In a gesture characteristic of the recent literature, this last volume allots considerable space to photographers who worked in the forest of Fontainebleau, a question first addressed in D. Challe and B. Marbot, *Les Photographes de Barbizon: La Forêt de Fontainebleau*, exh. cat. (Paris, 1991). See also M. Stuffmann, "Between the Barbizon School and the Beginnings of Impressionism: The Landscape Photography of Gustave Le Gray," in *Pioneers of Landscape Photography: Gustave Le Gray, Carleton E. Watkins; Photographs from the Collection of the J. Paul Getty Museum*, exh. cat. (Frankfurt am Main and Malibu, 1993), 90–106.
7 D. C. Thomson, *The Barbizon School of Painters* (London, 1890).
8 For a synthetic discussion of this question, see Sillevis and Kraan, *L'École de Barbizon*, 47–52.

contention—a view supported by these two examples—that approaches centered on the notion of models and duplications are inadequate to the problem.

Not considered here are the questions, so important in the period, of photography's relationship to the fine arts, of whether its character is industrial or aesthetic, of the place of painting and printmaking in this debate, and of the specific role played in the latter by Le Gray.[3] However, one point seems crucial: Le Gray's having been a painter as well as a photographer. As is well known, he received a solid foundation in painting from his studies with Delaroche and continued to paint throughout his life. He exhibited paintings at the Salon only twice, in 1848 and 1853, so his public career in this domain was hardly extensive, but he continued to paint nonetheless, and a great deal. The posthumous inventory of the effects in his Egyptian residence lists many paintings, both finished and unfinished, and it is quite likely he painted, on commission, many canvases representing Middle Eastern subjects.[4] No examples are known today (the same holds for his French paintings); the research undertaken along these lines for the present exhibition has proved fruitless. This is a regrettable lacuna, one that hopefully will be filled eventually, for until such time all discussion of the relationship between painting and photography in Le Gray's work must remain conjectural.[5] Nonetheless, it seems quite clear that in his case the two are closely connected. We must remember that Le Gray's circle was by no means limited to photographers. His friends, the government officials with whom he came in contact, and even his client pool consisted mostly of painters, critics, and amateurs of painting. Living and working as he did in Paris, he found himself in one of the principal art centers in Europe, between the end of the July Monarchy and the middle of the Second Empire, until 1860, when he left for Egypt. Given these factors, it is only logical to conclude that contemporary painting deeply informed his photographic practice. The comparisons proposed here are intended only to lend support to this assertion and not to demonstrate that Le Gray, in a given print, followed a given painting, drawing, or etching more or less closely. As has been noted, such causal relationships are difficult to prove. Furthermore, full understanding of the import of such relationships will be possible only after establishing a clear sense of Le Gray's production as a whole, something that continues to be elusive. The dossier also lacks testimony from the artist himself and

from his contemporaries. What works did Le Gray know, and which ones did he like? We really can't say. An accumulation of similarities, resemblances, and analogies can never lead to incontrovertible conclusions, although it does provide a context for the assessment of Le Gray's work.

One notion appears essential here: that of genre. It is not that Le Gray, in his photography, reproduced the hierarchy that—despite the blows leveled against it first by the Romantics, then by the Realists—continued to shape both the practice of art and critical response in France. But his photographic work is structured around several large, well-defined, readily identifiable categories in contemporary painting, each of which evolved separately: landscape painting, seascape painting (arguably a subdivision of the former), portraiture, the nude (four such photographs are known), views of monuments, military painting, and, finally, orientalist painting, at least in its topographical aspect. To compare photographs by Le Gray with paintings and prints from the same period in an analogous genre is not only to retrieve, or attempt to retrieve, some portion of the context within which Le Gray worked; it is also to suggest, or propose, a few ways of defining the originality of his photographic work, namely, his search for an aesthetic specific to photography, a project that simultaneously sets him apart from painting and identifies him with it.

Le Gray probably began to work in the forest of Fontainebleau in June 1849, when many Parisian landscape painters, following the example of Jean-François Millet and Charles Jacque, settled there—and for the same reason, namely, to avoid the outbreak of a new cholera epidemic in Paris.[6] Thus was born what would later become known as the "Barbizon school," which was actually a purely historiographic construction, as the term first appeared in a book by David Croal Thomson, published in London in 1890,[7] before first being used in a French publication by Georges Lafenestre in 1907.[8] Thomson had a very restrictive view of the school, assigning to it only a core of eight painters (Corot, Daubigny, Diaz, Dupré, Jacque, Millet, Rousseau, and Troyon). Others, however, welcomed into this school more or less all of the artists who resided in Barbizon between 1800 and 1900. This definition is obviously too broad, for it encompasses Le Gray along with Monet, and even Renoir.

This question is less important than the concentration in a single place of a certain practice of landscape painting—which for sim-

plicity's sake could be called naturalist or realist—that favored working from the motif. Such studies after the motif had always been made, even by the most traditional landscape painters. The master of French classical landscape painting, Pierre-Henri de Valenciennes, author of a theoretical treatise and teaching manual that was read, used, and pondered throughout the nineteenth century,[9] worked first in the open air, as evidenced by the large ensemble of oil compositions on paper from his hand now in the Louvre. These were small, rapidly executed studies that allowed him to both constitute a repertory of forms and learn to render nature truthfully.[10] But these sketches, as seductive as they seem to us today, with their immediacy, vivacity, and brio, were not meant for public consumption; neither were his small oils on canvas, which were

in the same genre (fig. 274). In his mind, they were only preparatory studies for "composed landscapes," finished landscape compositions executed entirely in the studio. As he himself wrote,

> The necessity incumbent upon the landscape painter to study nature in its most picturesque accidents, under its most varied aspects, and in all its vegetal productions, always inspires in him a taste for the country, where the pure air and the spectacle of nature, simultaneously simple and noble, elevates his ideas and produces delicious sensations. It is through his studies that he learns to select objects with which he can later compose paintings that retrace the charm of rural habitations and romantic sites.[11]

This plein air practice, which in its essentials remained that of Corot, would evolve considerably between 1830 and 1840, first with

9 P. H. de Valenciennes, Élémens de perspective pratique à l'usage des artistes, suivis de réflexions et conseils à un élève sur la peinture et particulièrement sur le genre du paysage, 2nd ed. (Paris, 1820). Two books by J. B. Deperthes, Théorie du paysage . . . (Paris, 1818) and Histoire de l'art du paysage depuis la renaissance des beaux-arts jusqu'au XVIIIe siècle (Paris, 1822), were also quite influential. On the question of the evolution of landscape painting in France in the nineteenth century, see V. Pomarède, "Il paesaggio romantico francese: Metamorfosi del Classicismo e del Realismo attraverso la passione della natura," in Romanticismo: Il nuovo sentimento della natura, exh. cat., ed. G. Belli (Milan, 1993), 181–97. The role of Valenciennes in the creation, around 1800–1820, of an equivalent to what became the "photographic gaze" some decades later has been emphasized by P. Galassi, Before Photography: Painting and the Invention of Photography, exh. cat. (New York, 1981).
10 On the history of this ensemble, see, most recently, Pomarède, "Michallon et la famille de l'Espine," in Achille-Etna Michallon, exh. cat. (Paris, 1994), 81–85.
11 Valenciennes, Élémens de perspective, xvi.

274 Pierre-Henry de Valenciennes. *Twisted Tree Trunks*, n.d.

12 On Huet, see R. P. Huet, *Paul Huet (1803–1869) d'après ses notes, sa correspondance, ses contemporains* (Paris, 1911).
13 The most recent synthetic text about Rousseau, a volume full of interpretative discussion, is G. M. Thomas, *Art and Ecology in Nineteenth-Century France: The Landscapes of Théodore Rousseau* (Princeton, 2000). But see also M. Schulman, with M. Bataillès, *Théodore Rousseau, 1812–1867,* [vol. 2] *Catalogue raisonné de l'oeuvre peint* (Paris, 1999).

Paul Huet,[12] then with Théodore Rousseau,[13] to the increasing annoyance of official and academic circles, notably the Salon jury. Their repeated rejections of works by Rousseau led to his being nicknamed "le grand refusé" (the most rejected one). What was so scandalous about his practice as a landscape painter? Setting aside the purely technical aspects that clearly played an important role in these rejections (color, assertive handling, surface roughness, intentional lack of finish), Rousseau's radically new conception of landscape painting must be underscored; what previously had been regarded only as a study—an "impression"—of a moment became for him the object of a painting intended for exhibition. By and large, these paintings continued to be executed in the studio; nonetheless, this approach represented a complete subversion of the scale of values that justified the preeminence of the "composed landscape." To this was added the representation of rural life, envisaged not in terms of the picturesque but rather as an accurate description of contemporary social reality. The forest of Fontainebleau, which was very close to Paris and readily accessible, offered countless motifs consistent with all of these criteria. Furthermore, beginning with the July Monarchy, this forest was the

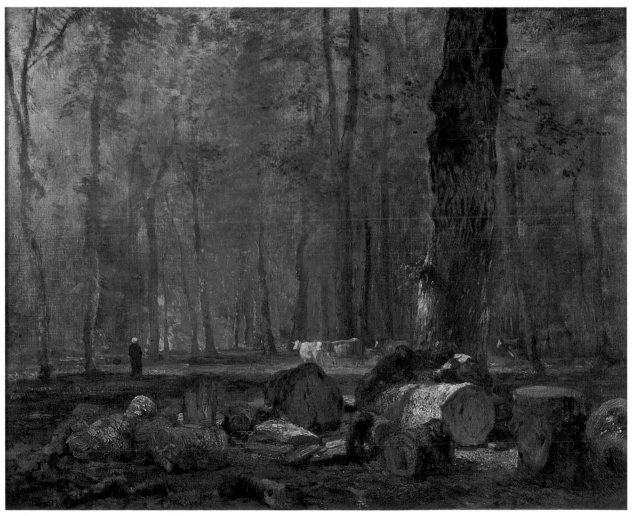

275 Constant Troyon. *Forest Scene*, ca. 1855.

object of renewed attention, becoming under government oversight one of the country's first natural parks—a protected reserve, certainly, but one that was fully alive, inhabited and cultivated, as were its immediate environs.[14] Also, in the second half of the century it would become a favored site for a new generation of landscape painters who, after the model of Rousseau but expanding on his example, would render it in detailed studies as well as in general views, in depictions of the work and days of the peasantry in the manner of Millet and Troyon (fig. 275), in genre and hunting scenes in the manner of Decamps, and in animal studies in the manner of Jacque. And these are only the most famous of such artists. There is no way of measuring precisely the number of painters—amateurs as well as professionals—who worked in the forest, but the activity there must have been incessant, and the discussions constant. Such was the Fontainebleau of Le Gray, his second important field of experience, after the one made available to him by the Mission héliographique. The area was being transformed into a veritable artists' colony, but it was in its early stages; nothing had as yet been fixed, nothing had settled into mere habit.

Le Gray's views of Fontainebleau are at once close to and distant from contemporary production, revealing the degree to which he shared the preoccupations of other artists working in Fontainebleau and its environs (Le Gray was not an isolated genius), but also revealing how his own thought processes led him to different, almost marginal, notions about the perception and treatment of his subjects. Many of his photographs—close views of the rocks surmounted by trees and/or bushes so characteristic of the area—are consistent with the genre of the study as practiced by Valenciennes, a tradition that Corot and later generations continued to pursue. Other, rarer, compositions—*The Road to Chailly,* for example—show sites that were identified and well known, constituting a type of "landscape portrait" common in the period. Still others take as their motifs, more anonymously, tree-lined paths and forest underbrush, another current landscape type. But in no case are the results wholly consistent with these well-staked-out genres. The "studies" lack the informal quality of details arbitrarily isolated from the whole. Indeed, in most instances they are very carefully composed, organized symmetrically around a central motif, with the various planes of depth clearly distinguished, although without true perspective (fig. 276). Paths and underbrush are similarly

treated. Furthermore, there are no indications of human presence. In a canvas such as Troyon's *Forest Scene* (ca. 1855; Rotterdam, Boymans-Van Beuningen Museum),[15] almost contemporary with Le Gray's photographs, we find the same way of organizing the space with tree trunks, their solid forms standing out against blurry foliage. But we will never find in Le Gray's work anything equivalent to the woman and the herd of cows in the middle ground, nor, especially, to the felled and partly sawed tree trunks in the foreground, which attest to human occupation and exploitation of the forest. If humankind is present here, it is so only through the photographic act itself, not by what it registers. True, occasionally we glimpse in the forest depths a camera on a tripod, evidence of the presence of a fellow photographer. But this is an exceptional case that, in the end, only legitimizes photography.

Le Gray's strongest Fontainebleau work, his images of eccentrically shaped trees, has no real equivalent in contemporary painting (figs. 119–121). Admittedly, there are some "portraits of trees" analogous to "landscape portraits," paintings of trees that had become well-known because of their great age or the associations they had accrued—for example, in Fontainebleau, "The Enraged One," often depicted by Corot (*Fontainebleau Forest: The Rager,* 1830–1835; Philadelphia, The Pennsylvania Academy of Fine Arts), or the oak of Vercingetorix, painted by Courbet in 1864 (Tokyo, Murauchi Art Museum).[16] Rousseau also painted isolated trees in *Group of Oaks at Aprémont* (1850–1852; Paris, Musée du Louvre),[17] a work precisely contemporary with Le Gray's images. However, we should not put too much stock in these compositional analogies, for the spirit of Le Gray's work differs markedly from that of the paintings. There are no narrative overtones, no historical implications in his images, nor does he provide much in the way of topographical context for the trees. Instead of incorporating distant views, like Courbet and Rousseau, he impedes recession into depth by choosing points of view that are low and quite close, or he leaves the background out of focus. Sometimes we can see a bit of sky through the foliage, but it remains secondary. The focus is squarely on the tree—on its silhouette, thanks to the overall composition, but also on its visual particulars. Even so, these are not mere studies; the compositional monumentality of these photographs elevates them to the level of finished works, adding aesthetic quality to their purely documentary value. Here Le Gray

14 See Thomas, *Art and Ecology,* 149–95.
15 Inv. no. 2159.
16 On the painting by Courbet, see H. Toussaint, *Gustave Courbet, 1819-1877,* exh. cat. (London, 1978), 149, no. 73, and Tinterow and Loyrette, *Origins of Impressionism,* 358; the picture's historical and political implications were emphasized by L. Nochlin in 1967, and revisited by Nochlin in "*Le Chêne de Flagey* de Courbet: Un Motif de paysage et sa signification," *Quarante-huit / Quatorze,* no. 1 (1989): 15–25.
17 Inv. RF 1447.

276 Gustave Le Gray. *Gnarled Oak near l'Épine Crossroads*, 1852 (cat. no. 69).

shows himself to be as much a painter as a photographer: first, in the choice and treatment of his subjects, which evoke known paintings and genres but propose another way of approaching them; second, in terms of technique—the trees correspond to the moment when, shifting to the wet collodion process, he began to obtain more refined effects by working with paper negatives combined with glass negatives. Furthermore, comparison of various surviving prints reveals that even a work as significant as *The Road to Chailly* underwent several modifications in Paris. Notably, Le Gray used combination printing to alter the sky, which means he combined print exposures taken at different moments—specifically, a paper negative produced around 1852 (for the landscape) with glass negatives produced in 1856 (for the sky), the resulting combination prints having been made between 1856 and 1859. Ultimately, this procedure is closely related to the execution of "composed landscapes," for the resulting images are a synthesis of work in the open air and work in the studio, where the final composition is created—a procedure that he also used in his seascapes.

Le Gray's seascapes were among his greatest public successes, and they remain among his most popular works. More or less by chance, he first exhibited them in Great Britain.[18] Their reception there was enthusiastic, a response soon repeated in France. In addition to epitomizing a phase in the history of photography, they represent photography's intrusion into a pictorial genre characteristic of English painting. Not that there hadn't been French seascape painters; during the period of Le Gray's education and early exhibitions, two names in particular stand out: Eugène Isabey[19] (1803–1886) and Théodore Gudin[20] (1802–1880). Squarely within the Romantic tradition, they loved to paint rough seas, tempests, the unbridled elements, beached vessels, picturesque seacoasts, teeming ports, and wharves bustling with activity. Some of Le Gray's seascapes are comparable to these canvases but only very loosely. His views of Brest and Le Havre, for example, are more geometric in composition, with aligned masts and triangular sails interacting with the houses, stairs, and extended horizontal lines of the embankments and the ships. This choice of synthesis brings him close to certain paintings and sketches of the young Corot; Le Gray's *The Breaking Wave* and *Lighthouse and Jetty, Le Havre* are quite similar to Corot's *End of the Jetty and the Sea, Dieppe* (fig. 277), painted in 1822.[21] If there is any picturesque component here, it is

limited to the vague silhouettes of a few strollers or sailors. The views of Sète are systematized to an even greater extent, with an almost abstract alignment of masts set against the horizon line. As for the images of the French fleet at Cherbourg, these show only an isolated row of vessels. The cannon salute of the French and English squadrons is limited to two plumes of smoke that echo the clouds in the sky, and whose effect is thus essentially formal. The ample space accorded this last motif, coupled with its arbitrary cropping at the sides, brings Le Gray close to Turner, whose work had been widely disseminated in France in reproduction since the 1820s, and a selection of whose paintings and drawings, taken from the artist's estate, was on exhibit in London beginning in 1857. Le Gray certainly was influenced by Romanticism, but he nonetheless set himself completely apart from it; to become convinced of this, one need only compare his photographs of waves with analogous paintings, almost contemporaneous in date, by the "Delacroix of landscape,"

18 See, most recently, K. Jacobson, *The Lovely Sea-View: A Study of the Marine Photographs Published by Gustave Le Gray, 1856–1858* (Petches Bridge, 2001).
19 On Isabey, see, most recently, P. Miquel, *Eugène Isabey, 1803–1886: La Marine au XIXe siècle*, 2 vols., L'École de la nature, vols. 9, 10 (Maurs-la-Jolie, 1980), as well as A. Curtis, *Catalogue de l'oeuvre lithographié de Eugène Isabey* (Paris, 1939).
20 On Gudin, see E. Béraud, ed., *Souvenirs du Baron Gudin, peintre de la Marne (1820–1870)* (Paris, 1921).
21 *Dieppe: End of the Jetty and the Sea*, 1822; Brussels, Musées royaux des Beaux-Arts.

277 Camille Corot. *End of the Jetty and the Sea, Dieppe*, ca. 1822.

22 See especially *Spring Tide at Equinox near Honfleur* (1861), a replica with slight variations of a painting by Huet exhibited at the Salon of 1838 (Paris, Musée du Louvre, inv. RF 1066 *bis*), and *Breakers at the Pointe de Granville* (ca. 1852), exhibited at the Salon of 1853 (Paris, Musée du Louvre, inv. RF 1064), both of which are obviously similar to photographs by Le Gray, although there is a marked difference in spirit between the works produced by the two artists.

23 A. M. Young, M. F. MacDonald, and R. Spencer, with H. Miles, *The Paintings of James McNeill Whistler*, 2 vols. (New Haven and London, 1980), no. 41.

24 Whistler, letter to Fantin-Latour, J. and E. R. Pennell collection, Library of Congress, Washington, D.C.; as cited by R. Dorment in *Whistler, 1834–1903*, exh. cat. (Paris and Washington, D.C., 1995), 111.

Paul Huet (fig. 278).[22] Le Gray seems to have been more deeply influenced by the example of panoramas, with their two or three superimposed horizontal zones—sky, sea, shore—and their lack of constraining borders on the sides. Furthermore, he fully anticipated in works of his own those executed a decade or so later—also in Normandy—by artists as diverse as Whistler, Courbet, Manet, Boudin, and Monet, who, as a group, constitute one of the most important episodes of the "new painting," otherwise known as Impressionism.

In 1862 Whistler painted *Blue and Silver: The Blue Wave, Biarritz* (Farmington, Conn., Hill-Stead Museum),[23] a work that in several respects resembles certain photographs by Le Gray—for example

The Breaking Wave and *The Great Wave, Sète.* A passage in a letter from Whistler to Fantin-Latour is singularly illuminating as to what Le Gray's work might have meant at the time:

> I seem to learn so little! Moreover, painting from nature done outside can only be large sketches—it does not work. The end of a floating drape, a wave, a cloud, it is there one minute and then gone for good. You put down the true and pure tone, you catch it in flight as you kill a bird in the air—and then the public asks you for something polished.[24]

Japanism made it possible for Whistler to simplify and purify his technique, synthesizing representation by separating sky, sea, and sand into long, horizontal bands, often painted with a single, broad brushstroke applied right across the canvas without lifting his hand

278 Paul Huet. *Breaking Waves, Pointe de Granville*, ca. 1852.

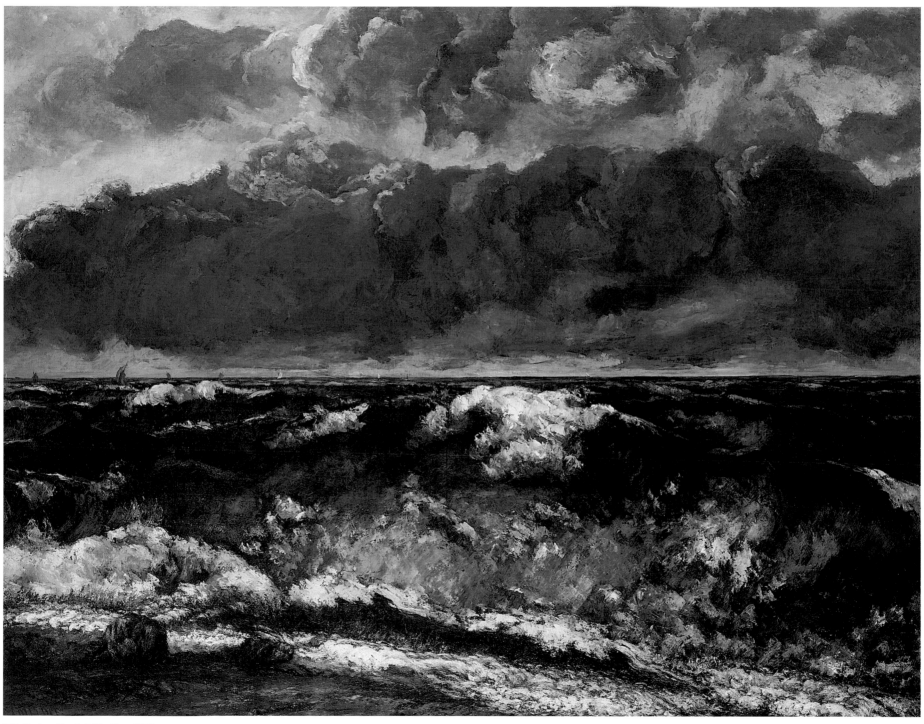

279 Gustave Courbet. *The Wave*, 1870.

25 Young, MacDonald, and Spencer, *Paintings of Whistler*, no. 69; see also ibid., no. 42.

26 See Toussaint, *Courbet*, nos. 112 (*The Wave*, 1870; Berlin, Staatliche Museen, Preussischer Kulturbesitz, Nationalgalerie) and 117 (*The Sea*, 1872; Caen, Musée des Beaux-Arts); and Tinterow and Loyrette, *Origins of Impressionism*, 235–43 (a synthetic discussion of the various influences at play in early Impressionist marine painting), and no. 44.

27 J. Castagnary, "Fragments d'un livre sur Courbet (troisième article)," *Gazette des beaux-arts* 1 (1912): 22. Readers should not be misled by the posthumous publication date of this text: Castagnary, a fervent supporter of Courbet, died in 1888; these reflections are either contemporary with or postdate only slightly the works discussed.

28 A preoccupation with the representation of clouds and skies was common to both painters and photographers in the nineteenth century. On this question, see Marbot, *Quand passent les nuages*, exh. cat. (Paris, 1988).

29 D. Rouart and Wildenstein, *Édouard Manet: Catalogue raisonné*, 2 vols. (Lausanne, [1975]), vol. 1, no. 143.

30 Wildenstein, *Claude Monet*, vol. 1, no. 71.

31 See J. Adhémar, *La France romantique: Les Lithographies de paysages au XIXe siècle* (1937; reprint, Paris, 1997).

32 See J. Plazaola, *Le Baron Taylor: Portrait d'un homme d'avenir* (Paris, 1989), esp. 55–77.

(*The Sea*, 1865; Montclair, N.J., The Montclair Art Museum).[25] This last painting—along with comparable seascapes—was executed during Whistler's 1865 sojourn in Trouville, where he worked in the company of Courbet. The latter, in ensuing years, himself turned out a number of such "sea landscapes," including numerous *Waves* that have long been compared to those by Le Gray, so similar are they in conception.[26] Apparently, Courbet often used photographs as departure points for his compositions; given the nature of the medium, they must also have fed his reflections about realism, and it is quite likely he knew Le Gray's seascapes, whose circulation was by no means limited. To what degree was Courbet directly inspired by Le Gray's seascapes? That is a question that perhaps can never be answered with full certainty. These paintings were eminently marketable; Courbet made no secret of their having been painted rather quickly, for the most part, and of their having sold well—something else they have in common with the Le Gray images. Did these two artists have the same public? We cannot be certain. But surely it is relevant that contemporary critics, who responded quite favorably to Courbet's seascapes, did not emphasize their relationship to those by Le Gray (fig. 279). The latter, it is true, predate Courbet's paintings by some ten years. They also belonged to another category, and, at the time, the debate about the nature of the relationship between photography and painting would still have been present in people's minds. Castagnary, in his *Fragments d'un livre sur Courbet* (Fragments of a book on Courbet), characterized the originality of the painter's seascapes in the following terms, which are also applicable to Le Gray:

> The sea also occasioned many triumphs. A swimmer as well as a hunter, [Courbet] loved it for its own sake; but he never forgot that empty space takes up more room than occupied space, and from the start he hit upon the right proportions of the three elements of these pictures: earth, water, sky. Except for a few distinct seascapes, like the admirable *Stormy Sea* in the Salon of 1870, now in the Louvre, it is almost always the sky that is the subject of these pictures. Throughout these mists, these downpours, these rays of sunlight, all of these atmospheric shifts, his palette knife is surprisingly agile.[27]

Moreover, the *Waves* are not the only paintings by Courbet that directly evoke photographs by Le Gray; this is also true of his *Waterspouts*, and of seascapes like *Calm Sea* (New York, The Metropolitan Museum of Art), painted in 1869, where the sky occupies two-thirds of the canvas: a cloudy sky, with effects of light and shadow very similar to those found in Le Gray's combination-

printed seascapes.[28] Here again Le Gray meets up with Boudin, who after studying in Paris between 1851 and 1854 resettled in Le Havre, and whose career really began to take off in 1859/60. The formula that led to his success is well known: a combination of cloud studies with depictions of elegant seaside sociability, of crowds on the Normandy beaches, a genre that he developed in Trouville beginning in 1862. Connections of a different kind can be made with the seascapes of Manet and Monet, most of which also date from the last years of the Second Empire. There, compositional resemblances, global or partial, are less significant than the intentionally dark, saturated palette and the role of contrast between light and shadow. *Moonlight at Boulogne-sur-Mer* by Manet (1868; Paris, Musée d'Orsay)[29] and *A Seascape, Shipping by Moonlight* by Monet (1866–1867; Edinburgh, The National Gallery of Scotland)[30] cry out for comparison with Le Gray's cloud studies and wave images, just as *The Tugboat* (fig. 280) immediately brings to mind Monet's railroad paintings and, especially, his several versions of *The Railroad Bridge at Argenteuil*, where smoke similarly stands out against the sky. Does it follow from all of this that Le Gray was a precursor of the Impressionists? I prefer to draw a more provisional conclusion, namely that the modernity generally accorded the Impressionists is even more applicable to Le Gray, who, ten years before them, cleared the path they later followed.

In Fontainebleau, in the Midi, and on the Normandy coast, Le Gray essentially worked as a painter, and, at least in the first case, in the midst of painters. The experience of the Mission héliographique was also connected with a practice that became widespread in the nineteenth century among French artists, after the model of British "sketching tours"—trips lasting several days, several weeks, or several months, during which artists accumulated studies of landscapes or monuments. The studies then served, in the studio, as raw material either for the production of paintings and watercolors (Rousseau frequently worked this way) or for the execution of albums of engravings or lithographs.[31] Sometimes several artists worked as a team, at the initiative of a publisher who had commissioned such an album. A case in point is the project that became the model for all such publishing enterprises, the *Voyages pittoresques* (Picturesque voyages) series that began to appear in 1820 under the aegis of Baron Taylor, Alphonse de Cailleux, and Charles Nodier.[32] The photographs taken for the Mission héliographique were not intended for inclusion in an analogous "Voyages monumental," for their purpose was primarily

280 Gustave Le Gray. *The Tugboat*, 1856 (cat. no. 122).

281 L. J. M. Daguerre. *People Visiting a Romanesque Ruin*, 1826.

282 Gustave Le Gray. *Cloister of the Church of Saint-Pierre, Moissac*, 1851 (cat. no. 47).

33 J. Taylor, C. Nodier, and A. de Cailleux, *Voyages pittoresques et romantiques dans l'ancienne France*, 18 vols. in 20 (Paris, 1820–78), part 1, *Ancienne Normandie*, 3 vols. (1820–25, 1878), part 2, *Franche-Comté* (1825–29), part 3, *Auvergne*, 2 vols. (1829–33), part 4, *Languedoc*, 2 vols. in 4 parts (1833–38), part 5, *Picardie*, 3 vols. (1836–47), part 6, *Bretagne*, 3 vols. (1843–46), part 7, *Dauphiné* (1843–54), part 8, *Champagne*, 2 vols. (1844–57), part 9, *Bourgogne* (1863).
34 The photographs in the *Bourgogne* volume were realized by means of the "Poitevin process," in which a photographic image printed in greasy ink is pressed against a lithographic stone, from which prints are then pulled in the usual way.
35 On this artist, see *Horace Vernet, 1789–1863*, exh. cat. (Rome and Paris, 1980).
36 Private collection (ibid., 110, no. 91); replica dating from 1854 in Lausanne, Musée des Beaux-Arts.

administrative and documentary. The way the project was organized, however, the itinerary followed by Le Gray and his colleagues irresistibly brings it to mind. The very purpose of the enterprise, the photographing of ancient and medieval monuments in urgent need of repair and restoration, makes it closely related to the *Voyages pittoresques,* whose main purpose was indeed to provide a "voyage d'impressions" (trip of impressions), as Nodier put it in his preface. But these publications also made readers newly sensitive to the value of the French architectural patrimony of the medieval and Renaissance periods, which was beginning to be rediscovered after the destructive excesses of the French Revolution, which were partly responsible for this new awareness. In fact, the role played by the *Voyages pittoresques* in this development was not insignificant. Volumes in the series continued to appear until 1878—the last one, like the first two (published in 1820), being devoted to Normandy. In the meantime, other provinces had been treated, only some of which were on the itineraries of the Mission héliographique.[33] Note that photography, which made its first appearance in the series with the *Champagne* volumes, became a standard feature beginning with *Bourgogne,* published in 1863. In any case, from the perspective of the Mission, the prime value of the volumes edited by Taylor and Nodier lay not so much in their having dealt with the same monuments, or in their having used the same family of technical procedures.[34] It was largely a matter of their approach to the monuments—the way they situated them, even dramatized them. Architectural details were not a concern—having been the focus of a preliminary campaign of detailed measurement—but overall appearance was often distorted: eccentric points of view were chosen, with buildings being shown in odd perspectives or in ways that otherwise exaggerated their dimensions. Moreover, the monuments are represented either as "living," shown within the context of contemporary daily life (a church transformed into a stable, an artist sketching in the moat of a ruined château, a market in a street retaining its medieval appearance), or as reconstituted historical settings, in conjunction with figures wearing period costume, this constituting, by and large, their "picturesque" aspect (archaeological scruples were satisfied in plates of architectural details that complemented the overall views).

Le Gray must have been influenced by this model. The different plates representing Carcassonne, for example, are a series of variations in which the line of the ramparts alternates with an iso-lated detail of a tower or a wall, and in which views taken from a low angle, exaggerating the structure's dimensions, alternate with other views taken from higher up. No figures animate these sheets, but churches and portals are subtly linked to their contemporary surroundings by telling details: a tree of liberty, a pile of stones, the inscription on a door. Le Gray did not underestimate the realist implications of photography, but he somehow inflected his images with the subjective, picturesque look that was a legacy of Romanticism. At first glance, nothing could be more nondescript than his *Cloister at Moissac* (fig. 282). Nonetheless, its resemblance to a much earlier painting by Daguerre, *People Visiting a Romanesque Ruin* (fig. 281) (1826; Paris, Collection Gérard Lévy), underscores its theatricality. This quality of theatricality is obvious in Daguerre's canvas (it is even the principal object of the painting); it irresistibly brings to mind a scene from Romantic opera, with its triple arch in the foreground, the landscape visible through the arcade, the snow that has blown through it, the damaged pavement, which accentuates the building's ruined character, and, above all, the two figures in colorful costume, whose small size accentuates the monumental scale of the architecture. In Le Gray's image, the background is either blurry (the garden) or in darkness (the more distant gallery of the cloister). The camera on a tripod, the upside-down top hat on the floor, the dark cloth casually tossed aside—all of these elements, subtly but with a gentle wit, strike a decidedly contemporary note, the cloth interrupting what might otherwise have been a compositional scheme of excessive rigor and abstract geometry, constructed by Le Gray around a row of small columns isolated between shadow and sun. The means are purely photographic, but the effect is pictorial and dramatic. And the result is less distant in spirit from Daguerre's painting than one might at first think.

The photographs for the camp at Châlons albums (September 1857) and those taken by Le Gray during his trip to Sicily (June 1860), consisting mostly of views of Palermo after the battles there, stand very much apart in his work. Here he transcends the categories of landscape painting—whether of land, sea, or monuments—to broach head-on the genre of history painting. In the annual Bottin trade directory, between 1856 and 1860, which is to say precisely when he was working on the two projects that were intended to be albums of photographs, he is listed as "history painter and photographer." Admittedly, history remains a bit hollow in his

work: the soldiers in the camp at Châlons are preparing for combat, as opposed to actually engaging in battle; and the streets of Palermo seem deserted by the redshirts and insurgents, like a stage set waiting for the actors, the barricades and damaged buildings being the only evidence of the preceding hostilities and, for those familiar with the events in question, of the advancing reunification of Italy. It is nonetheless true that, in both cases, Le Gray was treating contemporary history. In this respect, just as much as with landscape painting, he did not lack for models in the painting of his time.

Since the First Empire, military painting had continually occupied an important place in French art: representations of battles and other great events in which the army took part, evocations of life in the barracks or in billets, portraits exploiting the richness and diversity of military uniforms, depictions of various military types. The possibilities were almost limitless, and some artists built their reputations on treatments of such subjects. Some of these artists must have been emulated consciously by Le Gray, for their fame at the time was enormous. The influence on his work of Nicolas Toussaint Charlet (1792–1845) and Auguste Raffet (1804–1860), most active as printmakers, has been noted in the literature and will not be revisited here. However, another great painter of military history whose career was reaching its end when Le Gray's was just beginning must be emphasized: Horace Vernet (the father-in-law of Delaroche, with whom Le Gray had studied) had just completed, for the Versailles of Louis-Philippe, a large ensemble treating the conquest of Algeria, a campaign of which Vernet was, in the eyes of many, the official visual chronicler.[35] This was the most important external conflict in which France became involved in the years just before the Crimean War. But Vernet, who went to Sebastopol, painted only a few episodes of this latter conflict, which occasioned no work—either from his hand or another's—as emblematic as *The Capture of the Smala of Abd el-Kader,* completed ten years earlier. However, at the Salon of 1855 Vernet exhibited a painting on an "Algerian" subject, *The First Mass in Kabylie* (fig. 283),[36] that created a sensation, and that Le Gray must have known; one of Le Gray's photographs of the mass celebrated in the presence of Napoléon III at the camp at Châlons clearly derives from it, notably in its point of view (although Vernet's vantage is closer than Le Gray's) and in the moment selected for representation, one in which the troops present arms. Although the salute of the soldiers is readily discernible in Le Gray's photograph, it is not possible say

whether this is the beginning or the end of the ceremony. If what is being shown is the elevation of the host, Vernet made this much clearer than did Le Gray, who isolates a row of figures in the center of the field, proceeding from the emperor and his general staff at left to the altar at right, with the front line of the troops visible in the background, the better part of the composition being given over to sun and sky. In other prints, however, Le Gray, like Vernet—and following the example of Charlet and Raffet—is more attentive to the precise description of uniforms, the specifics of camp life, and the picturesque aspect of the troops (*Lancers and Dragoons with Colonel Pajol, Officers Seated at a Tent, Setting the Emperor's Table,* various photographs of groups of Zouaves).

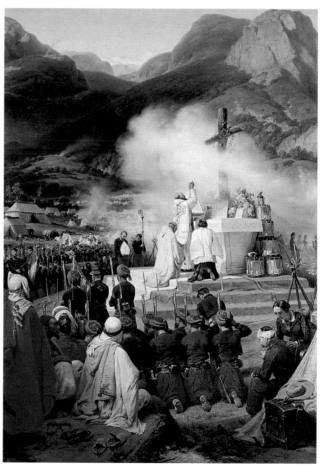

283 Horace Vernet. *The First Mass in Kabylie,* 1854.

The wide panoramic views, however, are more original, as if Le Gray wanted to populate the six large sheets of his *Panorama of the Camp at Châlons*. Here the army is reduced to silhouettes, often shot in fog or dust that makes them even less distinct. The fur busbies sometimes make it possible to determine the identity of the corps in question, but in most cases the units remain indeterminate collectivities; they exist only as masses, lost in a landscape that itself is reduced to the essentials of a plain and a neutral sky. The officers, the general staff, and the emperor himself are recognizable by their bicorne hats and by their isolation on horseback at the head of the troops. This is an innovative vision of the army, even of combat (in the various *Maneuvers* compositions, troops are arrayed in combat formation, lines facing off before confronting each other in anticipation of real battlcs). But the men constitute masses, large

blocks, rather than evoking the individual, hand-to-hand combat that was the focus of battle painting in its prime, even when the artist aimed for a global vision. The soldiers become anonymous; war is depersonalized.

Two years after the publication of the camp at Châlons photographs, Meissonier began work on *Napoléon III at the Battle of Solferino* (1863; Musée national du Château de Compiègne) (fig. 285).[37] When this painting was exhibited at the Salon of 1864, many critics saw in it a new conception of the representation of war, one aiming to show strategies as opposed to combatants per se, and, most important, in a manner that is realistic, authentic, without elevating the actors to the heroic, quasi-mythic status accorded to them in the Neoclassical tradition, in the work of a painter such as Adolphe Yvon.[38] But the similarity between the compositions of Le Gray and

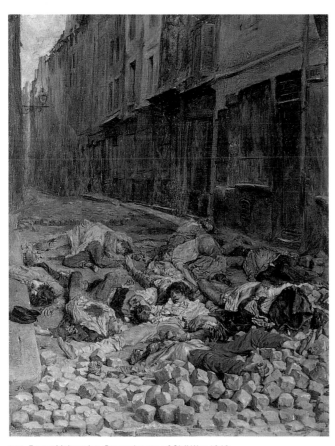

284 Ernest Meissonier. *Remembrance of Civil War*, 1848.

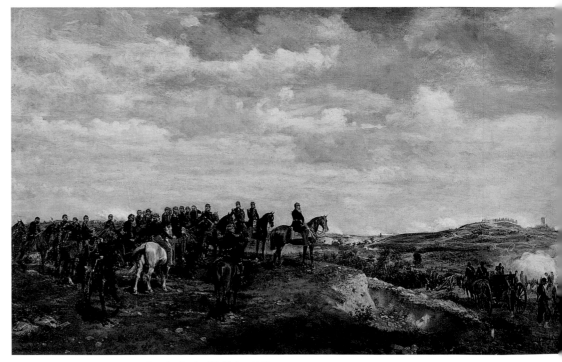

285 Ernest Meissonier. *Napoléon III at the Battle of Solferino*, 1863.

Meissonier (as well as a similarity in format; Meissonier's canvas measures 43.5 by 76 cm) dissimulates the completely different approaches they exemplify. Le Gray photographed the ensemble, and if he manipulated the negatives, this was only in view of fine-tuning the contrasts, especially between the sky and the ground. Meissonier, by contrast, first made sketches of details (for example, individual portraits of members of the general staff) and then combined them in a landscape painted from sketches made at the site a year after the battle took place.[39]

Napoléon III at the Battle of Solferino (fig. 285) is not the only point of correspondence between Meissonier and Le Gray. There is another, perhaps subtler, instance in which the painter preceded the photographer: *Remembrance of Civil War* (fig. 284), also known as *The Barricade* (1848; Paris, Musée du Louvre).[40] This canvas was painted by Meissonier to memorialize the murderous struggles of June 1848 and exhibited by him at the Salon of 1850–1851—the same Salon in which Le Gray tried to exhibit his photographs in the lithography section, a request that the jury initially accepted but ultimately rejected. This is one of Meissonier's strongest and most singular works. Like Delacroix's *Liberty Leading the People*, this depiction of a heap of bloody bodies strewn over and around a paving-stone barricade in a deserted street bears witness to the revolutions and uprisings that punctuated the nineteenth century. Le Gray was a witness of, if not a participant in, some of these uprisings in Paris and Italy. His views of Palermo show one of numerous urban conflicts in which history was in the making, at least as much as it was in pitched battles. As already noted, these views of Palermo are conspicuous precisely for their complete lack of figures. But most of them are conceived around barricades—barricades almost military in the science of their construction, ordered piles of sandbags and smooth stones with loopholes for cannons (*Barricade, Strada di Toledo*), or reduced to accumulations of earth and paving stones (*Royal Palace, Palermo*), or to simple mounds of debris (*Strada di Toledo*). Even the ruins of the Carini Palace evoke barricades to come. Is it necessary to look to the Hugo of *Les Misérables* to get some sense of what barricades might have signified for Le Gray and his contemporaries? By centering his images of a devastated Palermo on the barricades blocking its streets as much as on the destruction wrought by the bombardment, Le Gray participated in the mythology of the popular uprising in the same way

as had Meissonier, for whom the terrible June Days came down to a futile and useless pile of paving stones. Here he reveals himself to be a real history painter (what can be said about the statues, silent witnesses to the destruction they survived?) but without neglecting the fact that he was preeminently a photographer. In his views of Palermo, we find effects similar to the ones he had used some ten years earlier in his work for the Mission héliographique, including high contrasts that deliberately isolate parts of buildings—a concern for the telling architectural detail. And don't these barricades also recall all the piles of stones scattered throughout Le Gray's work, beginning with *The Road to Chailly*, and all the buildings he saw restored or built anew, from the ramparts of Carcassonne to the Louvre and the Paris of Napoléon III?

Painter or photographer: for Le Gray, these terms were not diametrically opposed. He was both of them at once, informing his photographic practice with his training in, and reflection about, his practice as a painter. Although the other side of his work, his painting, continues to evade us completely—and with it, the degree to which his photography did or did not influence it—it is nonetheless clear that, in his case, there can be no separation of the two. Among all his contemporaries, Le Gray seems to have gone the furthest in integrating the two techniques, which some regarded as alien to each other, even contradictory in their respective means and aims. He nourished the one with the other, not in view merely of imitating painting in order to accrue to photography something of painting's nobility, but with the ambition of expanding, through the example of painting, the formal means available in photography. Thus differences emerge that are more or less pronounced when we undertake a point-by-point comparison of established genres of painting and Le Gray's recensions of them. The question of the influence of Le Gray's photography on the work of his painter-contemporaries remains open. A few possible examples of such influence have been suggested here. There is no doubt that investigation along these lines should continue, despite difficulties posed by the absence of relevant documentation, and thus by the fragility of hypotheses based solely on formal resemblance and a certain similarity of spirit. But if it is legitimate to suppose that Le Gray left a little of himself in works by such artists as Whistler and Courbet, Manet and Monet (and perhaps, later, even Degas), this is first of all because he truly was a "history painter and photographer."[41]

37 Inv. MI 756.
38 *The Battle of Solferino, June 24, 1859*, 1861; Versailles, Musée et domaine du Château, inv. MV 5016, MI 273.
39 On Meissonier's execution of *Napoléon III at the Battle of Solferino*, see C. C. Hungerford, "'Les Choses importantes': Meissonier et la peinture d'histoire," in *Ernest Meissonier: Rétrospective*, exh. cat. (Lyon and Paris, 1993), 166–71.
40 Inv. RF 1942-31. On this painting, see ibid., 162–66. The photographic model was used by the critic Étienne-Jean Delécluze, defender of the great classical tradition in the *Journal des débats*, when *Remembrance of Civil War* was exhibited at the Salon; see P.-L. Roubert, "Les Caprices de la norme: Photographie et critique d'art au XIXe siècle," *Études photographiques*, no. 10 (November 2001).
41 I would not have ventured into the history of photography without the encouragement of Laure Beaumont-Maillet and, above all, Sylvie Aubenas. I would like to thank them for having provided me with this opportunity, and especially for the interest and advice of Sylvie Aubenas throughout the writing of this essay. My many discussions with her, and her careful readings of various drafts, made it possible for me to clarify my ideas, and to avoid many errors and approximations.

286 Gustave Le Gray. *Corner of a Garden with a Rake*, ca. 1851–1853 (cat. no. 23).

To Unite Science with Art

Sylvie Aubenas

The positive print is the final result to which photographists should direct their entire attention, and it is not possible to place too much emphasis on the need to extend both its tones and its modulations.

—LE GRAY[1]

The history of early photography is also—and especially—the history of its technical progress.[2] Niépce, Daguerre, Poitevin, Niépce de Saint-Victor, Blanquart-Évrard, and, to a lesser extent, Talbot and Bayard were, first and foremost, inventors. Humbert de Molard, Martens, Guillot-Saguez, Nègre, Baldus, Belloc, Nadar, Disdéri, and many others did research, invented a process, suggested an improvement, or filed for a patent. Current studies, as much as the predilections of collectors, tend to separate technique from aesthetics, creating an artificial barrier between the work and the means by which it was made. Reading photographic journals and reviews of exhibitions from the 1850s shows just how anachronistic such a distinction is. In their aesthetic evaluation of a print, these writings assess the difficulties that were overcome, to the extent that complexity of execution was sometimes sufficient to deem a work a masterpiece, where modern judgment, made blasé by a century and a half of technical progress, would see nothing more than a commonplace photograph. It is no doubt with respect to reproductions of works of art that the modern perspective has changed the most, since current aesthetic criteria demand such consideration only for works where the artist's freedom and individuality manage to express themselves with greater latitude. The reproduction of Rude's bas-relief of *La Marseillaise* on the Arc de Triomphe, taken by Le Gray in 1852 using a paper negative of exceptional size (40 by 50 cm), aroused enthusiasm at the Universal Exposition of 1855; it was proclaimed one of the most beautiful photographs ever seen.

The Scientific Artist

Gustave Le Gray, without having had any specific scientific education, at least had the basic knowledge of a college graduate. The connection between the artistic career he embarked on in 1842 and his interest in color, chemical agents, and, later, paper quality, may

have had as its catalyst his long friendship with Binant "the younger," the son of an important merchant of art supplies whose establishment was located at 7, rue de Cléry in Paris, very close to the rue Saint-Denis, where Le Gray's own parents had a shop. When his mother wrote to him in Italy in early 1844, she mentioned this friend. It was at that establishment that Le Gray subsequently purchased all of his supplies, and he even recommended it as a supplier in his treatises. Also a great collector of paintings, particularly by Courbet and Corot,[3] Binant was undoubtedly someone with whom the photographer had many conversations.

The testimonies of Maufras and Nadar, as previously discussed, concur in attributing to Le Gray an early affinity for research. According to Nadar, "He had always been attracted to chemistry, and painting did not cause him to abandon the laboratory next to his studio, where he pursued the secrets of making permanent, immutable colors, whose manufacture he felt had been left for too long to the avaricious indifference of merchants."[4] Maufras dates this interest in photographic chemistry more accurately to Le Gray's sojourn in Rome, where he apparently spent all of his time bent over his alembics.[5] On his return in the spring of 1847, he knew enough about the properties of fluorides to suggest their use to Martens, a colleague of Niépce de Saint-Victor, for his experiments with albumen prints of collodion-on-glass negatives.[6]

On occasion, Le Gray would suggest adjustments to the optical mechanisms of the camera, but his field of choice was always chemistry. He was constantly held up as the epitome of the scientific artist, at least in artistic circles; it would be interesting to know what actual chemists thought about this. It is probable they thought his work was less than empirical. Le Gray's four increasingly fleshed-out editions of his treatise, first published in 1850 as *Traité pratique de photographie sur papier et sur verre* (Practical treatise of photography on paper and glass), then retitled *Nouveau traité théorique et pratique de photographie sur papier et sur verre* . . . (New theoretical and practical treatise of photography on paper and glass) for the editions of 1851, 1852, and 1854, seemed difficult to use for those who did not have as much experience as the book's author.

1 G. Le Gray, *Nouveau traité théorique et pratique de photographie sur papier et sur ver . . .* (Paris, 1851), 160.
2 Thanks to Martin Becka, without whose help this chapter would not have been written.
3 *Tableaux modernes et anciens*, sale cat. (Paris, Hôtel Drouet, April 20–21, 1904).
4 F. Nadar, *Quand j'étais photographe* (Paris, [1900]), 85.
5 See Maufras, "Étude biographique," *Le Monte-Cristo* (January 5, 1860): 594–98 (translated in the appendix to this volume).
6 Based on his own account; Le Gray, *Nouveau traité théorique et pratique*, 86–87. He took the opportunity to challenge Blanquart-Évrard's precedence relative to the idea of using potassium fluoride.

7 Ibid., 61.
8 R. Hunt, "Photography: Recent Improvements," *The Art Journal* (July 1, 1851): 188–89. In that article, Archer's process was described very accurately. Archer himself published articles in 1851, in March in *The Chemist*, in November and December in *The Athenaeum*, where he failed to mention the name of Le Gray. However, he did mention it in the manual that he published in March 1852.
9 See J. M. Eder, *History of Photography*, trans. from the German (New York, 1945), 344–47; R. Lécuyer, *Histoire de la photographie* (Geneva, 1945), 80–82; and H. Gernsheim, *History of Photography from the Camera Obscura to the Beginning of the Modern Era* (London, New York, and Toronto, 1955), 155–58.
10 Le Gray's emphasis. This statement of the obvious was explained at the time as a misprint: "avant de marcher" [before working] should have been "avant M. Archer" [before M. Archer] (or rather "avant ceux de M. Archer" [before those of M. Archer]?); see É. Fournier, *Le Vieux-Neuf: Histoire ancienne des inventions et découvertes modernes*, 2 vols. (Paris, 1859), vol. 1: 338–39.
11 Le Gray, *Photographie: Nouveau traité théorique et pratique* (Paris, [1852]), 89–91 (Le Gray's emphasis). At the 1857 exhibition of the Société française de photographie, he exhibited "a positive from a negative on collodionized paper, taken in 1848, depicting the studio of M. Gérôme," so it should read 1849 instead of 1848, if Le Gray is to be relied on in 1852. See *La Lumière* (May 29, 1852).
12 Le Gray, *Photographie: Nouveau traité théorique et pratique . . .* (Paris, 1854), 90.
13 Moreover, this support was not unanimous: see the French individuals quoted by Gernsheim, *History of Photography*, 155–58.
14 *Journal of the Photographic Society* (November 21, 1857): 97; reprinted in the *Revue photographique*, no. 26 (December 5, 1857): 401–2.
15 *Bulletin de la Société française de photographie* 6 (December 1860): 316–18.

Nevertheless, with the help of the available major works on chemistry and considerable perseverance in practice, Le Gray played a leading role in the technical progress of his time.

The Collodion Negative: A Controversy

A chronology cannot be re-created for Le Gray's experiments before June 1, 1850, the date of first publication of his treatise. The instructions he provides therein already evidence a great facility with the manipulation of photographic materials. They were essentially practical, fueled by his personal experience.

However, from that time, the seasoned practitioner also became an experimenter, an inventor. His first modest brochure provided, in an appendix, the results he had already achieved by substituting collodion for albumen to cause silver salts to adhere to the glass plate. This brief page, which summarily cites all of the agents he had tried (albeit without proportions) and the effects he had obtained from them, would be reduced to a simple allusion in the second version of the treatise in July 1851. Not having reviewed, perfected, or used his process in the meantime, Le Gray, with his habitual naïveté, did not yet seem concerned with his competitors, who were overtaking him; on the contrary, he prided himself on the successes that he believed favored "collodion, which, as I indicated in my previous brochure, when applied to glass, produces very good results, and more rapidly than albumen. The English have implemented this process and are fully successful in using it."[7]

But controversy erupted that year, triggered by a detailed publication of the collodion process by Frederick Scott Archer that failed to mention Le Gray's pioneering role.[8] The controversy lasted several years, and a fair amount of ink was spilled over it, as was the case with many other angry skirmishes in political, scientific, and commercial rivalries that pitted the Frenchman and the Englishman against each other. Historians are well aware of what took place and have acknowledged only that Archer was the first to provide photographers with full and effective instructions. So it is appropriate to limit the discussion here to events from Le Gray's point of view.[9] When priority was claimed on the English side of the Channel, beginning in 1851, Le Gray bitterly summed up his claims in his treatise the following year:

> I was the first to apply collodion to photography. My initial experiments date back to 1849. At the time, I used that substance primarily to give paper more sharpness and evenness. . . .

> On continuing these studies, I was led to apply that substance to glass plates in order to obtain more sharpness, and I soon possessed an extremely rapid process, which I documented at the end of the brochure I published in 1850, which was translated in England during the same period. . . .

> Therefore, I believe I have the right to claim, for my country and myself, the invention of this allegedly English process, having been the first to specify collodion and to provide the most sensitive method that has been found to date. . . .

> From the publication of my process until my return from the voyage I took on behalf of the ministry [the Mission héliographique], I have practiced it but little, for my work on dry paper has occupied all of my time. This has been made into a weapon against me, to say that *the initial trials, before working, had surely been fruitless*,[10] since they had no impact.

> However, I gave my complete discovery over to the public, and if I practiced it very little, leaving to others the task of further developing it, this was only to attend to other work, from which the public has derived benefit once again. Consequently, this endeavor to deprive me of the credit for my invention is all the less generous.[11]

By 1854 his bitterness had passed. "Moreover, I shall no longer insist on this priority, which, after having been contested for some time, has since been acknowledged by the most eminent promoters of photography."[12]

In reality, while the support of his compatriots, expressed especially in *La Lumière*, may have sufficed to appease Le Gray's self-esteem, the debate was not over.[13] In November 1857, shortly after Archer's death, his widow again wrote to the Photographic Society to clear her husband's memory of the suspicion of having stolen someone else's invention; she persisted in describing the significant details provided by Le Gray in 1850 as a vague suggestion.[14] Until his departure from Paris and his disgrace, the Frenchman received patriotic support. In December 1860 another summary of the facts was put forward, in his favor, by the photographer Humbert de Molard.[15] In 1869 the opposing party returned to the subject at length in the journal *Photographic News*. Inevitably, the controversy finally lost its sting.

As often happens in such cases, it is possible to consider that the inventors both contributed to the development of the process in good faith, and that they simply suffered in a rivalry with higher stakes, stirred up by those around them. Neither profited from it. Archer did not file for a patent (thus contributing to the dissemi-

nation of the process) and died in almost total obscurity. His widow's letter, which eloquently defended the memory of an honest man who had been unjustly insulted, matched Maufras's defense of the martyred inventor Le Gray, supported by the verdict of "princes of science" such as Arago[16] and the chemist Gerhardt.

Should these two men be added to the list of victims of the inevitable concomitance of inventions, of those accursed pairs such as Niépce and Daguerre, or Charles Cros and Louis Ducos du Hauron?[17] What should be remembered here is only that Le Gray was very closely involved in one of the major inventions in the history of photography. His main fault was not to immediately realize the scope of his intuition. He relentlessly returned to the paper negative, which was more convenient to use and which, although "less rapid than the collodion-on-glass process, achieved more artistic effects."[18] This single reason was sufficient to justify his credo, which he ceaselessly repeated during this time: glass is the "wrong track"; "the future of photography lies entirely with paper."[19]

The Waxed-Paper Negative: "More Artistic Effects"

That is why, after his experiments of 1849–1850, he set aside collodion and worked on developing another, equally important, invention, whose authorship no one was ever to challenge: the waxed-paper negative. Here is how he described it in 1852:

> The process I am placing at the beginning of this book, under the title of dry process, is the one I work with on a daily basis. I most especially

16 Maufras is referring to *Notes scientifiques*, vol. 1: 516. (See Maufras, "Biographical Essay," in the appendix to this volume.)
17 See *Les Multiples Inventions de la photographie: Cerisy-la-Salle, 29 septembre–1er octobre 1988* (Paris, 1989).
18 Le Gray, *Photographie: Nouveau traité* (1854), 16.
19 Le Gray, *Nouveau traité théorique et pratique*, 9.

287 Gustave Le Gray. *The Dolmen Known as "La Grande Allée Couverte," Bagneux*, negative, 1851 (cat. no. 41).

20 Le Gray, *Photographie: Nouveau traité* [1852], 19.
21 "Séance du 7 juin 1889," *Bulletin de la Société française de photographie* (1889): 143–44.
22 *La Lumière* (February 7, 1852): 28.

would like to bring it to the attention of photography aficionados, as it gives the most satisfactory results, both with respect to ease of processing and the beauty of the proofs.

More than one year of satisfying results gives it an inviolable place, such that it is no longer possible to doubt its value.

The power to preserve sensitized paper for more than a fortnight, ready to be placed in the camera, is not the only advantage offered by this process. One of its primary qualities is that it provides perfect halftones, as one will understand by glancing at the collection of prints of historical monuments that I made for the Ministry of the Interior.[20]

The genesis of this invention undoubtedly dates back to late 1850 or early 1851, and the initial idea, as is often the case, was the result of an accident. This was related in 1889 by the photographer E. Moutrille (as told to him by Mestral, a friend of Le Gray's), in an account that has already been mentioned in this work:

> While working one day with Le Gray, with whom he was in daily contact, [Mestral] accidentally placed a bar of white wax on the bromine container they used for daguerreotypes, which they often made. They were surprised to see, emerging on that bar of wax, which was covered with bromine vapors, the outline of the window casement of the room in which they were working. Immediately, they rubbed a sheet of paper with wax and treated it like a daguerrean plate; they thereby obtained a semblance of an image.[21]

Moutrille added that the two friends continued along this track on the advice of Victor Regnault, a member of the Académie des sciences and a founding member of the Société héliographique, as well as an amateur photographer. In fact, Regnault followed their progress closely. Having been burned by the collodion affair, this time Le Gray proceeded with the greatest circumspection. He filed with the Académie des sciences a sealed envelope, dated February 25, 1851, containing a description of his waxed-paper process. He then continued perfecting it that spring and presented it on April 18 to the Société héliographique.[22]

So when Le Gray left Paris with Mestral in July 1851 for the Mission héliographique, he had just spent several months perfecting a technique that would revolutionize travel photography. Its enormous advantage was that it allowed for the preparation in advance of negatives that were easy to carry. From July through September 1851, he was able to put the process to the test in the field. He had already acquired sufficient mastery to make it his sole method of procedure for the Mission (figs. 287–290).

On their return from their journey through the south of France, Le Gray and Mestral displayed their harvest. Above and beyond aesthetic considerations, amateur and professional photographers alike were particularly struck by the rapidity of the process, which

288 Gustave Le Gray. *Tours Cathedral*, negative, 1851 (cat. no. 37).

289 Gustave Le Gray. *The Dolmen Known as "La Petite Pierre Couverte," Bagneux*, negative, 1851 (cat. no. 39).

290 Gustave Le Gray. *Cloister, Elne*, negative, 1851 (cat. no. 59).

made it possible to take an unprecedented twenty to thirty photographs per day. Roger Fenton, having passed through Paris in October 1851, reported:

> I was shown, in October last, by M. Le Gray, the author of the wax process, and M. Mestral, an ingenious amateur, several hundred negatives, made by them for the government, during a tour in the provinces, from which they had just returned. The subjects were mostly such as were equally interesting to the antiquarian and the lover of the picturesque.[23]

On November 17 Le Gray had Victor Regnault file with the Académie des sciences, on his behalf, a second sealed envelope, dated the twelfth of that month, containing a complement to the invention of the waxed-paper negative (i.e., "Notes on positive proofs on paper; new procedures for obtaining positive prints on paper with widely varied coloration and more thorough fixing than was achievable using the old processes"). This was, more precisely, a description of the prints from the Mission héliographique:

> In the highlights as in the shadows, nothing is overexposed nor printed too darkly, regardless of the contrast in the negative. . . . With the following process, I have succeeded in obtaining black and white, blue black, sea green, and inky black on China paper, with clean whites and a general appearance of freshness that could not be achieved with the earlier processes.[24]

The Mission héliographique, which came along at just the right time to serve as the testing grounds for his negatives and prints, represents one of the aesthetic and technical peaks of Le Gray's artistry. The variety of his colors, as brilliantly illustrated in the above description, goes from deep black to orangish yellow, by way of deep brown, olive green, and slate blue (fig. 291).

The waxed-paper process was now perfected. On December 8 Le Gray filed for a patent "for a type of paper prepared for photography,"[25] containing exactly the same information as his February envelope. That same day, at his request, Victor Regnault

23 R. Fenton, "Photography in France," *The Chemist* 3, no. 29 (February 1852): 222.
24 "Séance du 8 décembre 1851," *Comptes rendus de l'Académie des sciences* 33, 2nd semester (1851): 643–44.

25 Institut national de la propriété industrielle, patent no. 12738; document kindly provided by Martin Becka.

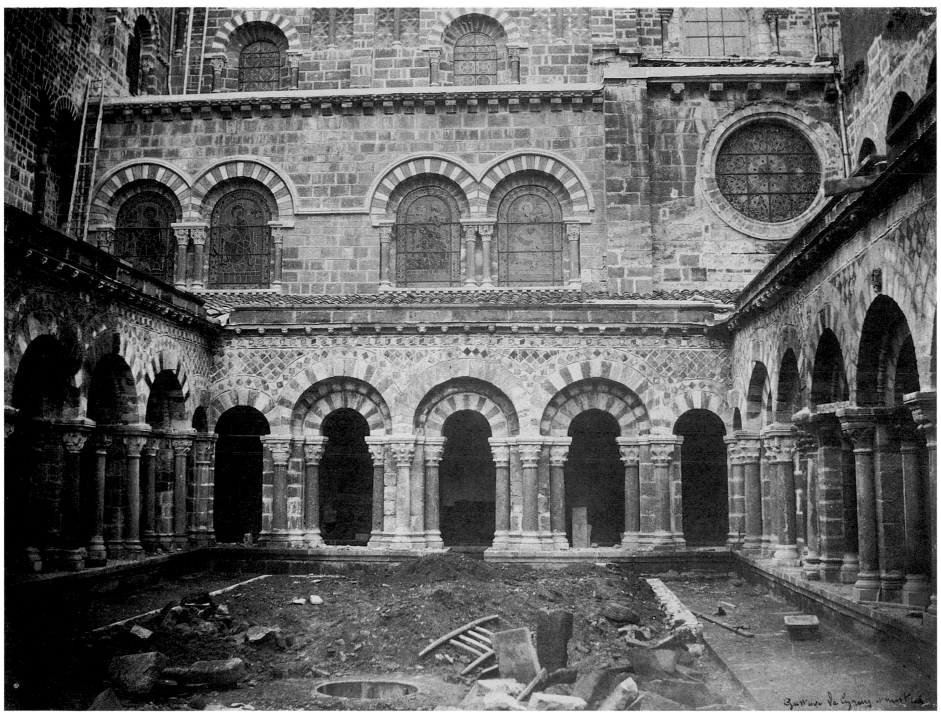

291 Gustave Le Gray. *The Cloister of the Cathedral of Notre-Dame, Le Puy*, 1851 (cat. no. 61).

had the two filed envelopes unsealed, thereby giving the invention the publicity it deserved.[26] Thus protected, Le Gray finally published the full description in 1852, in the third edition of his trea-

292 Gustave Le Gray. *Portrait of Olympe Aguado*, ca. 1857 (cat. no. 165).

tise. This time, no one could accuse him of publishing a process without showing its results.

However, it is not known whether Le Gray capitalized on his discovery other than by teaching it to his students. In 1852 he provided a list of those who had already successfully tried it: "Messrs. the vicomte Vigier, the comte Olympe Aguado (fig. 292), Mestral, Le Secq, Sauveur, Girard, Benjamin Delessert, the comte d'Haussonville, Avril, Piot, Peccarère, all of whose prints are admirable."[27] After that, waxed paper would be in high favor with amateurs and adopted by all traveling photographers in the 1850s and 1860s.

Final Improvements

After 1854 Le Gray no longer published technical manuals. Public success and commercial production followed his period of experimentation and teaching in a select circle. The studio on the boulevard des Capucines was not a place for laboratory research. There, he worked especially from collodion-on-glass negatives, and his photographs were printed on albumen paper.

However, on January 13, 1858, he filed another sealed envelope with the Académie des sciences, containing a process for fixing photographic prints on paper by placing them in a gold chloride bath, imparting a bluish black or purplish black tone, depending on the amount of time they remained in the bath: "I find that prints created with this process, in addition to their beautiful qualities of tone, have the advantage of not altering over time, a result that I noted in portraits that I fixed using this method more than eight months ago."[28] Here again, the discovery stemmed from a daily practice that, despite the need for profitability, was, above all, based on producing beautiful and lasting works of quality.

Le Gray's final episode as an inventor must have left him with a more bitter taste. In February 1860, at the very time his backers obtained authorization to dissolve the company, compelling him to leave his studio on the boulevard, he sent the Société française de photographie "the description of a new camera that he wishes to call to the attention of manufacturers, which will make it possible to achieve four stereoscopic pairs or eight carte-de-visite prints at will, on a single glass plate, by a simple shift of the plate holder."[29] This belated interest of Le Gray's in small-format prints, the commercial small change of the photographic art, may have been the

last-ditch effort of a man in dire straits. His concession to fashion came too late, and Le Gray left France shortly thereafter.

Aboard the *Emma*, he was always thought of as a scientist, as a dilettante associated with Dr. Albanel's chemical, geological, and botanical curiosities.[30] However, once he had settled in Egypt, during the twenty-two years of his sojourn, it is unknown whether he continued his experimentation. Several pieces of evidence lead to the conclusion that he remained the same man. His estate inventory mentioned a small chemistry library in his bedroom: Berzelius's *Treatise on Chemistry*, Rose's *Treatise on Chemical Analysis*, Gerhardt's *Treatise on Organic Chemistry*, Laboulaye's *Dictionnaire des arts et manufactures* (Dictionary of crafts and fabrication), next to his own annotated treatise, and a "brochure by Niépce." There was no trace of an actual laboratory, but several flasks and an alembic were also at the foot of the bed. Until the very end, he was the person described by Maufras who "devoted a part of his nights to all manner of alembics and retorts." In 1884 his bedside reading consisted of the same reference works he used in Paris in the 1840s and 1850s, either brought with him aboard the *Emma* or purchased again later. Admittedly, during the period when he taught at the preparatory school for the École polytechnique of Cairo, he may have had access to a library and to a chemistry laboratory for the pursuit of his experiments. If that was the case, and if he made any discoveries, they should be sought in the scientific periodicals published in Egypt during those years. In any event, nothing reached Europe.

Conversely, should not the frequent mediocrity of the prints during his Egyptian period be attributed to Le Gray's progressive disinterest in the intense discipline for which he had been so poorly compensated? Or was it rather an effect of the Egyptian climate, which was less suited to the preservation of photographs than of mummies? In any event, while some prints were still of the highest quality, a new laxity seems to have arisen, both in his choice of certain camera angles and in chemistry.[31]

Le Gray's Work: Paper and Glass

Le Gray's research was done primarily between 1845 and 1854. That fertile decade of his youth corresponded to the most effervescent period for photography in France and in England, buoyed along by a vast current of interest. The most renowned scientists—

François Arago, Edmond Becquerel, Antoine Balard, Sir John Herschel, Victor Regnault—took an interest in the work of the photographers, encouraging and guiding them. The meetings of the Société héliographique and then the Société française de photographie were the point of convergence for a shared passion. In 1852 Le Gray was pleased that the generosity of Baron Benito de Montfort, a founding member of the Société héliographique, made it possible for its members to work under the best possible conditions:

In closing, I would also like to point out a very felicitous innovation, the founding of a laboratory for chemical products specific to photography, run by M. Puech, at 15, rue de l'Arcade.

Photography is once again indebted to the generous attentions of the comte [*sic*] de Montfort, founder of the Société héliographique, who has rendered enormous services to photography.

Let us all pay tribute to our new art and multiply our experiments, and photography will soon achieve its final degree of perfection, through the addition of extreme rapidity, of instantaneity, to the subtlety of execution.[32]

A striking example of this shared interest was the creation of a collective album by the members of the Société héliographique, at the instigation of the decidedly generous baron, who paid for its binding.[33] This was a compilation of everyone's most interesting work, intended to be enriched and consulted by all; in it were prints by Le Gray, Mestral, Le Secq, Bayard, Vigier, and many others. In accordance with the bylaws of the society, this document, a fundamental record of the history of French photography from 1851 through 1853, was to be placed in the print department of the Bibliothèque royale in the event the Société héliographique was dissolved. When that did, in fact, occur, a letter was sent to the library, on March 31, 1853, to announce the imminent gift.[34] However, there is no trace of the album itself in the collections or the donation ledger, where it would normally have been recorded at the time of receipt.

Fortunately, the Société française de photographie has another album to witness those years of research. It is the album of Victor Regnault, who, besides his own photographs, assembled works illustrating the birth of the paper process. In the album are, notably, Talbot, Blanquart-Évrard, Guillot-Saguez, and Le Gray, from whom there are six prints, an invaluable survey of his research circa

26 Record of the session of December 8, 1851, Meeting files, 1851, Archives of the Académie des sciences.
27 Le Gray, *Photographie: Nouveau traité* [1852], 20. Peccarère was also quoted by Lerebours, in *La Lumière* (May 1, 1852): "Paper processes are becoming simpler as they are improving; now one can leave Paris with a camera obscura, a tripod, twenty-five or thirty sheets of prepared paper in a box, and nothing more! We have seen M. Peccarère return from Chartres with twenty-five excellent photographs; he had been gone for twenty-four hours."
28 *Bulletin de la Société française de photographie* 5 (January 1859): 15, and *La Lumière* (February 19, 1859): 30–31, relative to request for Regnault to open the sealed envelope.
29 *Bulletin de la Société française de photographie* 6 (February 1860): 33.
30 See C. Schopp, "The Unfinished Odyssey" (this volume), 160.
31 While the vast majority of the views taken for the pasha in 1867 were excellent, the mediocrity of certain plates in Félix Paponot's album (sale cat., Paris, Drouot-Richelieu, March 16, 2001) and certain views taken in 1872 for the architect Ambroise Baudry (Musée d'Orsay) is surprising and disappointing.
32 Le Gray, *Photographie: Nouveau traité* [1852], 176.
33 *La Lumière* (April 27, 1851): 46.
34 Letter 928, Bibliothèque nationale de France, département des Estampes et de la Photographie, Ye 1 rés. Archives (1847–1880).

293 Gustave Le Gray. *Stacked Paving Stones in front of the Studio* (detail), ca. 1849 (cat. no. 25).

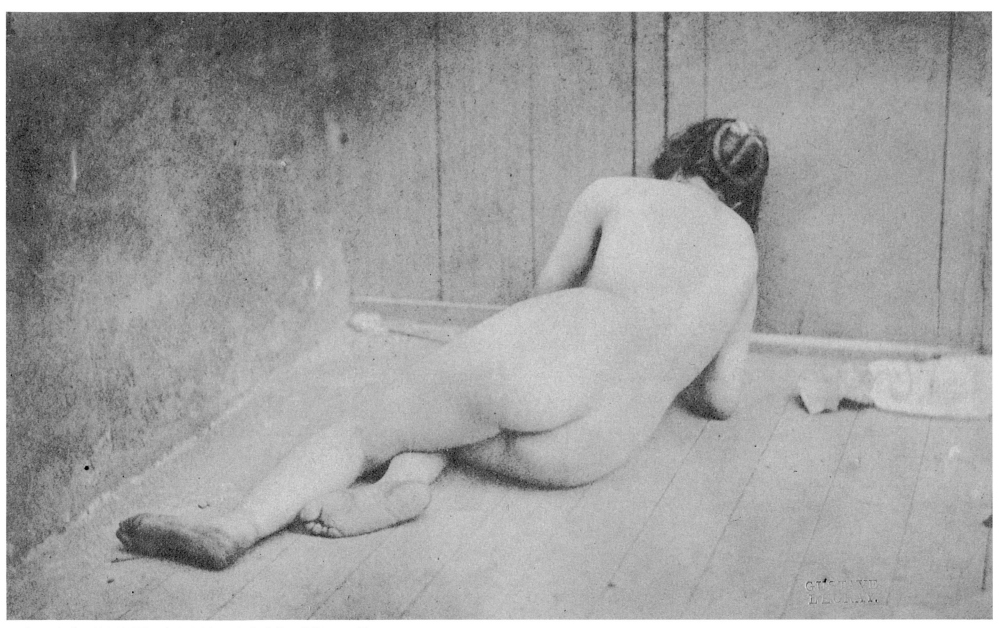

294 Gustave Le Gray. *Nude Model from the Back, Lying on the Studio Floor*, 1849 (cat. no. 10).

35 Le Gray, *Nouveau traité théorique et pratique*, 158.
36 Le Gray, *Photographie: Nouveau traité* (1854): 38.
37 "Première distraction de M. Le Gray," *Le Cosmos*, no. 42 (1854): 3; "Seconde distraction de M. Le Gray," *Le Cosmos*, no. 43 (1854): 3; "Troisième distraction de M. Le Gray," *Le Cosmos*, no. 44 (1854): 3.
38 A. Jammes and E. P. Janis, *The Art of French Calotype, with a Critical Dictionary of Photographers, 1845–1870* (Princeton, 1983), 38–39.

1850/51 (figs. 293, 294). The captions, which very accurately designate operating procedures, exposure times, and so on, confirm the accounts in his manuals: his negatives were produced as often on glass as on paper, and he used only potassium iodide, potassium bromide, potassium fluoride, and potassium cyanide.

An examination of these few precise documents makes it possible to assess just how oversimplified are the four or five categories currently being used to classify prints from this period: negatives on paper or glass, prints on salted paper or paper that has been lightly or completely albumenized. Numbers 62 and 63 in the album, portraits of Félix Avril and of a girl (figs. 35, 17), are so similar in appearance that only the caption makes it possible to distinguish two different types of negative: the former on glass coated with albumen, and the latter on paper coated with collodion—an exceptional process. Because Le Gray freely juggled various methods (such as the use of collodion or albumen on paper or the transfer of a collodionized negative from a glass plate to a less breakable sheet of paper), it is impossible now, without his help, to discern the method used for a given print. Great humility is a must when analyzing the works of this period, with respect to both how a view was photographed and how it was printed.

The extreme subtlety of the prints made from negatives on paper impregnated with various substances is the best justification for Le Gray's obstinate predilection for that support, which was otherwise more prevalent in the art world. The finicky precision with which he analyzed the qualities of the various papers—the different weights of Canson d'Annonay, Whatman, Lacroix d'Angoulême—and their respective merits, according to the subject matter, was not useless superficiality.

The ultimate goal of this dogged research was to provide prints of high aesthetic quality. Le Gray never introduced a new process, an ingenious bit of mastery, without having deduced its effect on the beauty of the images. Examples of this are not lacking. In 1851, when describing acidic gold chloride toning, he concluded, "I highly recommend this method to those who love beautiful prints."[35] In 1854 he recommended gallic acid: "If the time has been adequate, you achieve a superb print, which should have well-defined and quite transparent black and white contrasts."[36] The care necessary to achieve rich and varied tones and depth in the halftones, and the adequacy of certain processes for rendering certain subjects—all of these aesthetic concerns return as leitmotivs

in his writings. The lexical palette he used to describe the colors he obtained is that of a painter.

Le Gray's virtuosity could not help but irritate some of his imitators. While *La Lumière* and the *Bulletin de la Société française de photographie* were on his side, the popular science magazines *Le Cosmos* and *Le Propagateur*—in articles written by Abbot Moigno and by Herling, respectively[37]—were much less kind. They accused him of publishing only formulas that did not work, in order to better guard the secrets of his know-how, and of describing his processes too casually, too unscientifically, thereby obliging amateurs to pay him for lessons. This was the reflection of a more general rivalry between *La Lumière*, which gladly regarded photography as related to the fine arts, and *Le Cosmos*, which always held it on the side of scientific progress. Le Gray was the "artistic" photographer incarnate, honored by some and derided by others. The hostile exchanges that occurred from 1852 through 1854 have been described to perfection by Eugenia Parry Janis.[38] Despite the virulence of these attacks, Le Gray never deigned to respond.

While he almost entirely abandoned paper for glass during the period that his studio was on the boulevard des Capucines, this was in part a concession to the commercial dictates of fashion and the need for speed of execution. However, contrary to the banality into which collodion caused many of the photographers around him to sink, the work accomplished by Le Gray between 1856 and 1859 took advantage of it to tackle new subjects, with complex lighting—subjects that lent themselves much better to the glass-plate negative, which was faster, more sensitive, and clearer than the calotype.

His views of the camp at Châlons would have been more difficult and risky on waxed paper. As seen earlier with the views of the forest of Fontainebleau, changing the negative support also changed the framing; glass did not allow the necessary sacrifice of details that were too intrusive, so Le Gray tried his hand at close-ups, such as the geometric study of three tree trunks (fig. 117) and, even closer in, the base of a massive beech, with the focus leaving the surroundings a luminous blur (fig. 119). His seascapes are a perfect example of the collodion technique in the service of aesthetics. In 1857, at the exhibition of the Société française de photographie, Le Gray simultaneously exhibited two different prints of one image, *The Brig* (fig. 128)—one on albumen paper and one that was a positive print on glass—a pure demonstration of virtuosity.

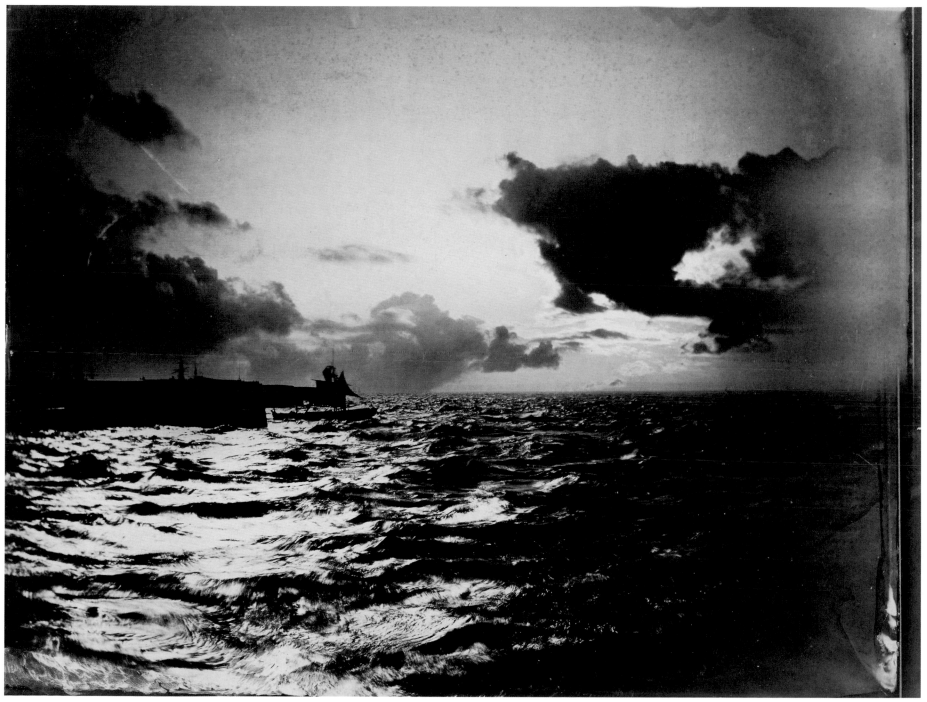

295 Gustave Le Gray. *Seascape with a Ship Leaving Port*, 1856/57 (cat. no. 126).

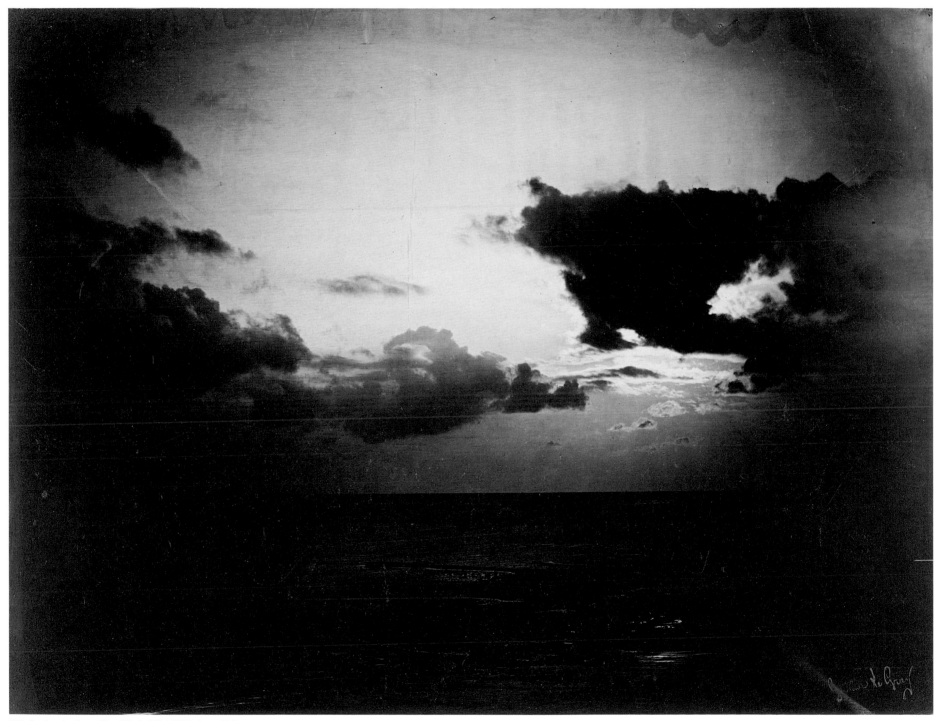

296 Gustave Le Gray. *Cloud Study*, 1856/57 (cat. no. 116).

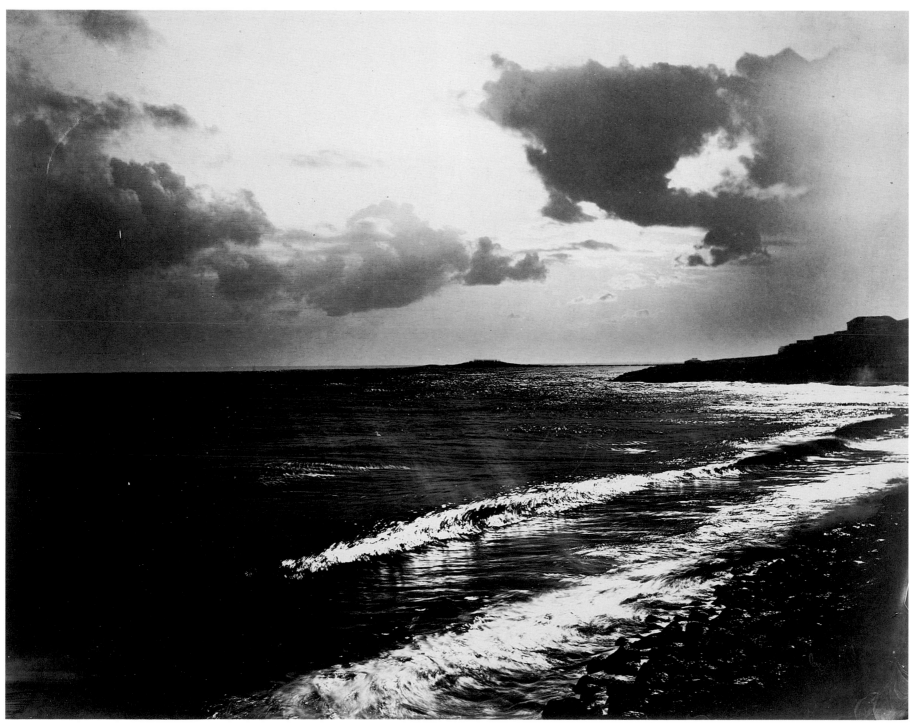

297 Gustave Le Gray. *Large Wave, Mediterranean Sea*, 1857 (cat. no. 138).

298–301 Gustave Le Gray. *The Mona Lisa* (drawing of Leonardo da Vinci's painting by Aimé Millet, 1848), 1854/55 (cat. nos. 88–91).

39 This process was addressed by F. Wey, "Des progrès et de l'avenir de la photographie," *La Lumière* (October 5, 1851): 139.
40 For more details about this technique, see B. Marbot, *Quand passent les nuages*, exh. cat. (Paris, 1988).

Submitted to the Académie des sciences in early 1858, as already discussed, his last important invention, gold chloride toning, was intended for printing proofs on albumen paper. The exceptional solidity and the richness of tones of his photographs from the period, particularly his seascapes, were therefore due to his use of that technique between 1857 and 1859.

But the personal stamp that Le Gray imparted to collodion was the combination printing of negatives.[39] With exterior views, the constraints of exposure times generally meant sacrificing the sky, which was constantly overexposed; the result was a dull, leaden gray. So photographers used to paint the sky black on the negative in order to obtain a clean white on the print; at best, they also added a few painted-on clouds to the negative. Thanks to increasingly shorter exposure times, in some photographs Le Gray managed to simultaneously capture the sky and the land (or sea), both satisfactorily exposed. But his particular innovation was to successively print, on a single proof, the complementary portions of two negatives: the landscape (or sea) and a sky of his choosing, luminous and lively with clouds, which he had photographed separately.

This so-called patched-in sky procedure[40] applied especially to seascapes, where the flat horizon line facilitated the juncture. That was the case, for example, with his most romantic seascape, *The Great Wave, Sète*. But he did not shrink from the more complex montage of landscapes. The inauguration of the Toulouse train station, taken for *L'Illustration* in 1857, received the benefit of a beautiful Mediterranean sky. Some views of Fontainebleau exist both with and without sky; an image of the road to Chailly and an image of the château de Boisy (near Roanne) have identical skies, and a particularly successful cloud is found in numerous images (figs. 295–297). Even better, always adapting the technique to the subject, Le Gray printed landscapes from negatives on paper with superimposed cloud-fleeced skies derived from the more sensitive glass-plate negatives. His taste for experimentation—acrobatic in this case—did not conflict with the dictates of commerce: Le Gray's seascapes and landscapes sold well.

When he left France, he took with him the necessary materials to do work both on glass and on paper, depending on what he might encounter. In the images he took in Sicily, the portraits of Garibaldi and General Türr were taken on glass, and the views of Palermo on paper. In Egypt, he continued to use both processes; the inventory of his estate enumerated 222 negatives on glass and an unspecified number of photographs on paper, which must have included both negatives and prints. This quantity of negatives on glass, which seems quite small for twenty-two years of work, may be distorted by a multitude of circumstances about which it would be vain to conjecture. However, there remains the possibility that it constitutes the entirety of his work on glass from that period, which brings us back to the question of what portion of his work was devoted to creativity, or more accurately the taking of pictures, as compared to laboratory research. Would not the extreme care and endless time that Le Gray devoted to printing have commensurately limited the number of images he produced during his entire career?

Science at the Expense of Art?

As previously discussed, Le Gray worked in fits and starts, whether during the Mission héliographique in 1851, at the camp at Châlons in 1857, or in the course of the voyage with the young Egyptian princes in 1867. These were all irresistible, flattering, and lucrative commissions that pried Le Gray away from his laboratory in order to realize some imposing series of photographs. Conversely, the small quantity, all things considered, of his spontaneous personal work (such as the views of Fontainebleau, the seascapes, and the landscapes) is perplexing. Once again (as with his work on the Le Dien photographs), the photographer emphasized the supreme importance of the final phase of production in his conception of photographic creativity.

Until 1855 the chemist may even have done a disservice to the artist, in the opinion of his contemporaries. Having decided to assert his role as inventor and initiator (the collodion affair was still fairly recent), Le Gray was not afraid to exhibit at the Universal Exposition his old experiments amid the more recent, more artistic, more attractive works exhibited by other photographers. At the opening of the photography section, even his friends were dismayed at such inability to show the scope of his capabilities:

> The injustice that strikes this undisputed talent, enhanced by great services rendered, is becoming a general pity: it is practically shameful; but, assuredly, it is a grief as well as a threat, and all of his colleagues, imitators, rivals, and disciples should oppose it in unified protest.

M. Le Gray may claim the lion's share of the successes and renown of most photographers, especially the travelers. . . . One might believe that a conspiracy of silence has been created surrounding his name in recent times. The official, juried critiques, like the critiques elsewhere, have often exalted even his students, leaving the master in shadow. . . . It is indeed appropriate that we explain ourselves a bit, we and others at the same time, and show M. Le Gray that he would be wrong to fear an impossible ostracism.

It happened that, unconcerned with new kinds of proofs, from which he thought himself excused, imprudently leaving out this extraneous adornment, M. Le Gray especially concerned himself with showing the progression of his works, either in order of priority or by the tried and true application of several methods that are all the rage right now. He believed it was quite opportune to act thus for an industrial exhibition, in other words, a competition where the judgment should, above all, be based on the priority of the processes and on their improvement. However, was it not dangerous not to even allow that intention to be perceived by any clue, and not to inform a single one of his intimate colleagues of this?

What happened to him? In view of his personal absence, and combining that absence with the untidiness and the all-too-negligee appearance of his framed works, and even, let us have the courage to say so, with the relative inferiority of some of them, we considered M. Le Gray's appearance for roll call as provisional and for the record; we treated his submissions in good faith, like the glove that the member of the audience next to you leaves on his seat at the theater, a symbol that proper men respect, without questioning the qualities of the absentee.[41]

The artist, wishing to be recognized as a scientist, already denounced by Abbot Moigno in *Le Cosmos,* doubled here as "the absentminded professor," deaf to anything that was not his obsession, his casualness and maladroitness greeted with perplexity. All the more striking was the contrast the following year with the enthusiasm aroused by his collodion work—the spectacular seascapes and the views of the camp at Châlons—everywhere they were exhibited.[42]

So the scientist and the artist did not always get along; scarcely more than did the artist and the businessman. The chemistry laboratory and then the portrait studio held Le Gray back to the detriment of his photography, and the photographer showed but little gift for making money. However, the rarity of his negatives, in combination with the splendor of his prints—endowed by their chemistry with an uncommon stability—makes them all the more sought after today. Whether Le Gray relied on posterity, which consecrates masters, or whether he simply followed his inclination to always do better, it was at the end of the twentieth century that his uncompromising worship of perfection finally bore fruit.

41 P. Périer, "Exposition universelle, 4e article: Photographes français," *Bulletin de la Société française de photographie* 1 (August 1855): 226–27.
42 On this sudden change, see S. Aubenas, "From One Century to the Next: The Fate of Le Gray's Work in Photographic Collections" (this volume).

302 Gustave Le Gray. *Panorama of the Seine from the Quai de l'Horloge*, ca. 1859 (cat. no. 185).

The Expansive Soul of Gustave Le Gray: The Panorama

Joachim Bonnemaison

The panorama, invented in 1787 by the English landscape painter Robert Barker, arrived in France at the very beginning of the nineteenth century. This viewing configuration, improved in 1822 by the diorama and its elaborate lighting effects, presented the public with "spectacular" visions of colonial adventures, landscapes featuring Gothic or Near Eastern ruins, urban views, and the martial epic of the empire. Daguerre, Colonel Langlois, and Frédéric von Martens tried their hand at dioramas before turning to photography. Beginning in 1845, Martens adapted the panoramic principle to the new technique of photography, notably for sweeping views of Paris.

The transition to paper negatives and the turn toward commercialism in the 1850s opened new perspectives for panorama photographers. They retained the same subjects but henceforth found it easier to combine individual exposures, creating wider formats. Baldus produced such images using glass negatives, and Langlois using paper negatives. The panoramas devised by Gustave Le Gray beginning in 1856 are wholly consistent with this trend, and their subjects—urban views, seascapes, and images glorifying the Second Empire—are direct heirs of the early history of the genre.

The earliest manifestations of Le Gray's panoramic vision are unique, "wide-field" images, simply constructed along a strong horizon line. Reframed vertically during the printing process to accentuate the effect, they became what might be called "protopanoramas" (fig. 303). The results are not very different from classic Euclidean projections. This procedure is first encountered in two views of the harbor at Sète (April 1857; figs. 309, 310), then repeatedly in the camp at Châlons albums (September 1857), where troops marching or resting on the perfectly flat Châlons plain presented him with many opportunities for such emphatically horizontal compositions.

This same series contains the earliest true panoramas composed by Le Gray using several negatives (fig. 303). The general view of the camp in six exposures (fig. 307, foldout) is, through its perfection alignments, a tour de force of technique to showcase French military might after the Crimean War; Napoléon III was especially pleased by it, and with good reason. It is worth emphasizing that the difficult craft of juxtaposing these images is not a matter merely of framing, but also of the control of movement, light, backlighting, and so on. These six exposures are the most spectacular demonstration of serial imagery, but there are also other examples of true panoramas using two exposures.

I reconstituted another panorama: a view of the mass celebrated in the presence of the emperor.[1] Two views of this event figure separately in an album that was recently sold, but in isolation they seemed strangely unresolved, lacking in the central balance characteristic of Le Gray's compositions.[2] Joining them together produced a triangular composition of great visual and symbolic force. From left to right, first the general staff is seen, led by the emperor (power); in the center, the clergy officiates below a raised pavilion topped by a cross (God); and, on the right, troops are arrayed in formation and led by a general (force) (fig. 311).

This suggests that other views that seem inconsistent with Le Gray's compositional principles may be demipanoramas lacking their complements. As an example, the view of Beirut taken in 1860 from the terrace of the Hôtel Bellevue (visible in the foreground) appears to be the right half of a panorama lacking its complementary image, the restoration of which would reestablish compositional balance (fig. 199). Apparently, the descriptive character of the right-hand view led the artist to grant it independent existence.

After the camp at Châlons, in August 1858, Le Gray conceived a two-part maritime panorama in the harbor of Cherbourg, on the occasion of the parade of the French fleet before Queen Victoria. An absence of clouds facilitated their conjunction, which would have been too difficult with an added sky, but this same absence depoeticizes the scene, which remains descriptive. In exposures taken from the same position several hours later, strong backlighting of the same ships is more consistent with his most admired seascapes (fig. 176).

The seascapes taken between 1856 and 1858 are the most fully realized expressions of Le Gray's simultaneously expansive and sensitive vision. A difference in density, largely the result of

1 Auctioned in Bièvres, June 1, 1994.
2 Thanks to Roger Thérond, who made my reconstruction of this panorama possible.

backlighting, surrounds certain images with a dark circle, giving them an aspect halfway between a tondo and an oval panoramic view (fig. 303). With this "halo" emphasizing the central motif, the work functions like the natural view of a stationary eye; the diffused perception of the edges adds an emotional charge to the principal object. We find the same optical effect in *The Promenade Shubra, at Cairo* (fig. 220), from about 1862, where the central motif is not a ship but a small group of figures.

The imperial city, then undergoing rapid transformation and expansion, was a major subject for panoramic photographers of the Second Empire, a group that included Le Gray, Marville, Baldus, and the Bisson brothers.

The chosen views of the very heart of the city are not specific to Le Gray; they are known to lend themselves to wide horizontal compositions: views of the Seine with its bridges receding into the distance, and monuments arrayed on both banks. The view toward the west, taken from the studio of the optician Lerebours on the quai de l'Horloge, with Vert-Galant square in the foreground (fig. 302), also appears in panoramas by Baldus and the Bissons. Likewise, the view taken from the windows of the library of the Louvre corresponds to a very large-format image taken by the Bissons (two 38 by 85 cm images, juxtaposed) and to a view by Baldus, both taken along the very same axis as in the Le Gray (figs. 305, 306).

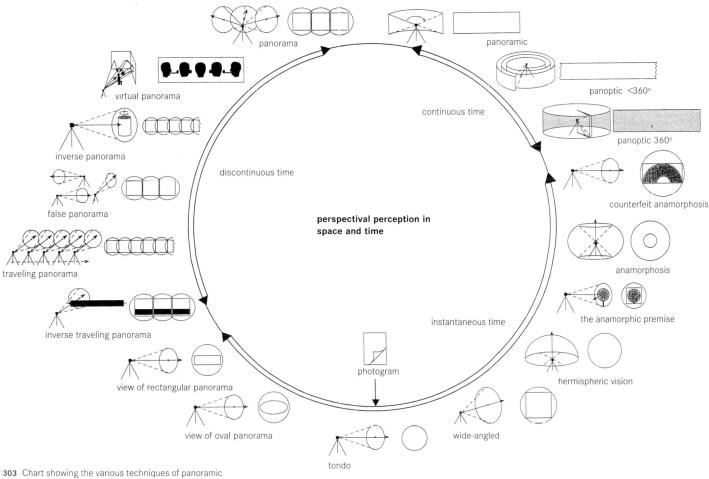

303 Chart showing the various techniques of panoramic photography (conceived by Joachim Bonnemaison).

The two-exposure panorama realized in the ruins of Baalbek in the autumn of 1860 again presents a wide, monumental vision but with a different compositional tack: avoiding the kind of frontal view that he so often chose—Le Gray here sets up a dialogue between two monuments—one massive and "leaning" against the left edge, the other erect and isolated—within a receding perspective and across a large central void that is rarely found in panoramas. An existing version of this work that has been painted over in oil is signed and dated "Gustave Le Gray Baalbeck 1863"[3] and is thus from the Egyptian period; at present, this is the only known example of Le Gray's painting (fig. 312).[4]

At the end of the 1860s, in Cairo, Le Gray produced several new panoramas. A wide view of the pyramids (fig. 304) from three negatives in the album that belonged to Félix Paponot, seems like a distant echo of the composition of the mass in the camp at Châlons. Here again there is a play on triangular composition, centrality, and horizontal development. One is tempted to read it as an evocation of the battle won at the foot of the pyramids by Bonaparte as a last, allusive homage to the glories of the empire. Unfortunately, the only known example of this magisterial work is too faded to convey accurately the effect of the play of light over the simple, powerful forms of the pyramids.

Five exposures constitute a view of Cairo (fig. 308) by contrast with the two exposures that make up the Paris panoramas. On the central axis, we glimpse the studio of the French photographer Désiré, doubtless an acquaintance of Le Gray's. The shifting positions of the shadows—which change from one panel to the next, registering the course of the sun from noon to sunset as one moves from left to right—reveal this to be a "traveling" panorama. This is the first occurrence where the time elapsed between the successive exposures is clearly visible in the (composite) image.[5]

Another, small, panorama realized in Cairo, consisting of two carte-de-visite formats joined horizontally, shows the tombs of the caliphs (fig. 235). The sumptuous monuments, threatening to collapse amid a vast, desolate expanse, seem like a new meditation in images on the history and transience of glory. Of the many photographs of these tombs included in the Paponot album, ten or so seem to cry out for juxtaposition; they were probably taken as parts of one or several wide panoramas that have yet to be reconstituted.

Finally, the conflict between the pasha and the rebel tribes of the Sudan presented Le Gray with an occasion to transpose the art of military photography to the expanses of Egypt. The wood engraving titled *A Column of Egyptian Artillery en Route to the Sudan*,

3 The photographic print in the Rijksmuseum bears a wet stamp in blue ink in the center but lacks both title and date.
4 Thus it would seem that Le Gray, like many others, made paintings over photographs (as distinguished from merely coloring them; anyone unaware of the existence of the photograph would not suspect its presence underneath the paint layer). Note that Le Gray's posthumous estate inventory (see "Death-Date Inventory" in the appendix to this volume) lists a "*Vue de Bulbecq* [*sic*]," apparently painted, but not necessarily the one now in Amsterdam.
5 Curiously, in all the photographic panoramas, the constituent exposures were taken from left to right, which means that the incremental progress of the shadows recording the course of the sun becomes clear as one reads the image in the same direction.

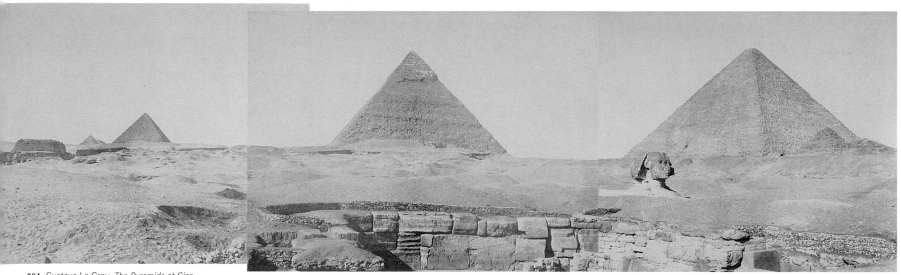

304 Gustave Le Gray. *The Pyramids at Giza*, three-part panorama, ca. 1865–1869.

6 *L'Illustration* (March 10, 1866): 148.

engraving after a Photograph by Le Gray[6] (fig. 224), is obviously based on a two-exposure panorama; through a startling exercise in fidelity, the engraver reproduced the central juncture. The corresponding photograph is unknown, but the same camels appear stationary in other exposures (figs. 225–227). This broad composition allows for hope that other panoramas from Le Gray's Oriental period may surface, in particular nonarchitectural panoramas like the one taken in the camp at Châlons.

The composition and aesthetic of panoramas were determined in large part by technical and material considerations that set them apart from other works by photographers. Martens invented cameras capable of producing panoramic views in a single exposure, by expanding the angle of vision in accordance with a curvilinear perspective (fig. 303). Beginning in 1852, Baldus, using a swiveling camera developed by Garella in 1851, photographed the Louvre and the banks of the Seine in perspective views that differ markedly from his usual practice.

Le Gray's panoramic vision appeared relatively late (1856) in a body of work whose formal criteria were already firmly established. Deployed first around two subjects, seascapes and the camp at Châlons, it does not diverge from his general conception of image composition but rather is a further development of it. A man of order, Le Gray was rigorous when it came to the placement of monuments, figures, and landscape elements. But this cerebral approach to composition was transfigured by his artful use of frontal light and backlighting, of tonal contrast and density. As his shift to the panorama coincided with his use of the collodion-on-glass negative, Le Gray exploited the finesse and transparency of these materials to render especially highly diffused light with an unprecedented degree of subtlety, creating soft nimbuses around his large geometries. Among panoramic photographers, he alone went beyond technical facility to achieve lyric vision. Beyond the grandeur of his chosen subjects, his own grandeur of soul reveals itself in these images.

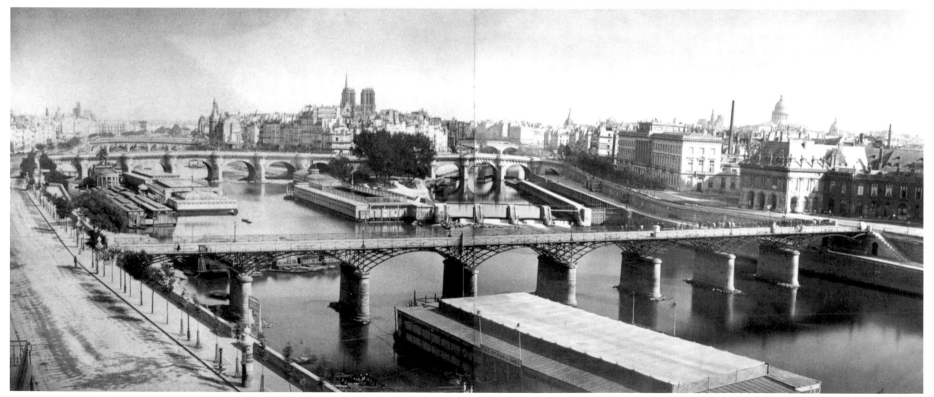

305 Gustave Le Gray. *Panorama of the Seine from the Windows of the Library of the Louvre*, ca. 1859.

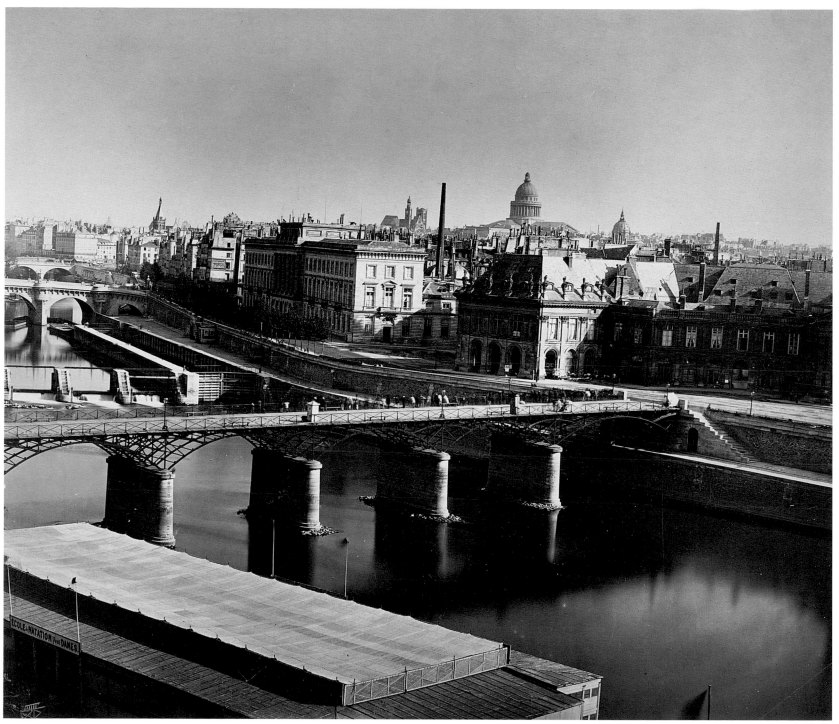

306 Gustave Le Gray. *The Footbridge and the Quai de Conti*, right half of two-part panorama, ca. 1859 (cat. no. 175).

307 Gustave Le Gray. *Panorama of the Camp at Châlons*, six-part panorama, 1857 (cat. no. 151).

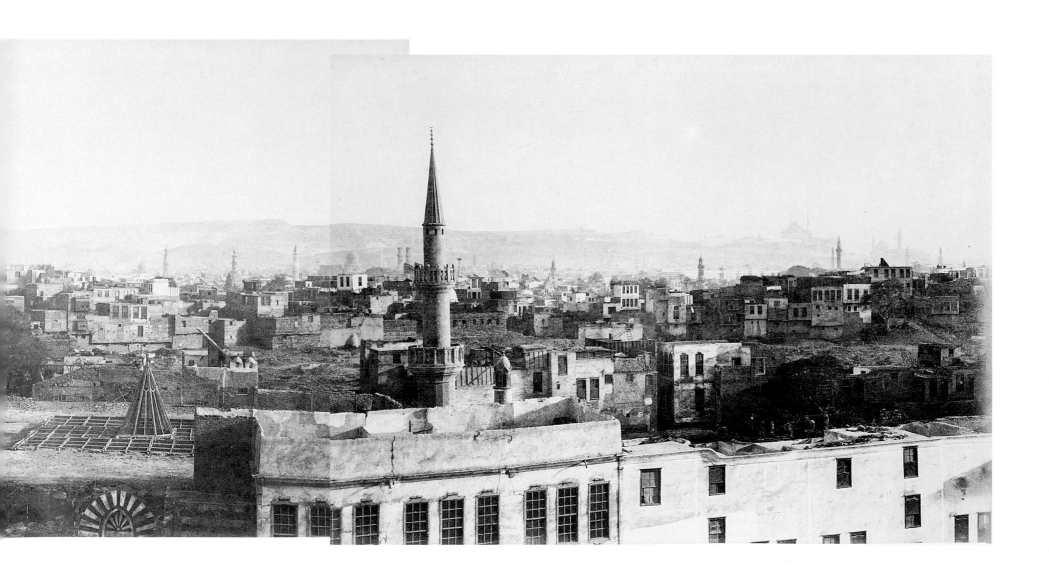

309 Gustave Le Gray. *Panorama of the Port of Sète*, 1857 (cat. no. 140).

310 Gustave Le Gray. *The Port of Sète*, 1857 (cat. no. 139).

311 Gustave Le Gray. *Mass at the Camp at Châlons*, two-part panorama, 1857.

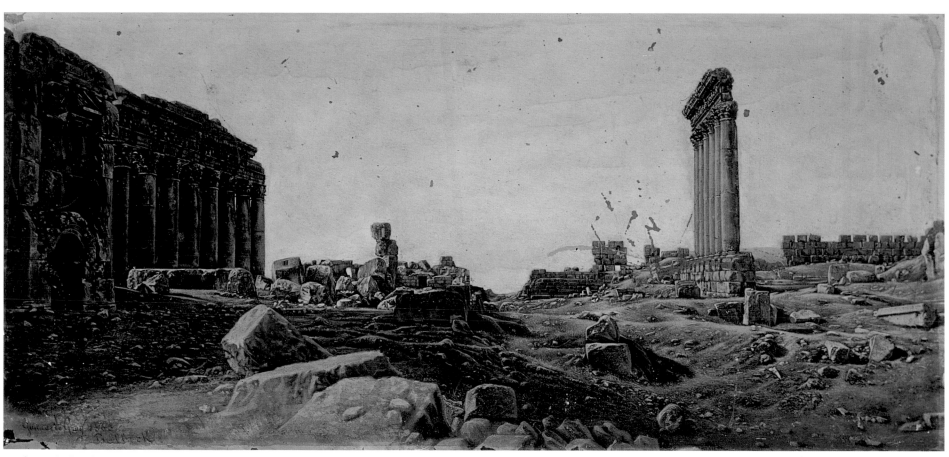

312 Gustave Le Gray. *Ruins at Baalbek*, painted photograph: photograph, 1860; painting, 1863.

313 Gustave Le Gray. *The Place de la Bastille, Paris*, negative, ca. 1859.

The Negatives of Gustave Le Gray in the Bibliothèque Historique de la Ville de Paris

Anne Cartier-Bresson

Prints of Parisian views by Gustave Le Gray are poorly represented in the municipal collections, but this is no longer the case for his collodion-on-glass negatives. A corpus of thirty-one of his negatives—unique in the world—was recently discovered in the photographic holdings of the Bibliothèque historique de la Ville de Paris. The library owns eight vintage prints of images by Le Gray that correspond to the glass negatives, some of which have old numbers on the back. The remaining negatives have been authenticated in the course of research undertaken for the present exhibition by the discovery of corresponding signed prints. Such comparisons shed light on the photographer's ongoing work, but they also present us with an opportunity for in-depth study of the alteration of such negatives over time, and thus for improvement of our understanding of the material structure of these objects, which are as rare as they are complex.

The Origin of the Plates

Along with information gleaned from studying the evolution of Parisian topography, comparison with the vintage prints originally organized and numbered by Le Gray himself has made it possible to date the rediscovered prints to between 1858 and the end of 1859.[1] The library's collodion-on-glass negatives attributed to Le Gray all bear old labels of identical provenance that are inscribed with numbers ranging from 4 to 52. The negatives are also identical in format, the glass supports being roughly 40 by 50 cm, with a thickness of 3 to 4 mm, and weighing approximately 2 kg. Furthermore, they all have the same iridescent cream coloration, and all of the images are coated with a protective varnish. Analysis performed by the Getty Conservation Institute has determined that this varnish is gum lacquer, a product used by Gustave Le Gray in alternation with copal.[2] The varnish is very decomposed in places and is flaking along the four edges. Alteration of the supports and the sensitive coatings is relatively consistent throughout the group. In a few cases, it has been possible to compare prints pulled from the same plate at various dates and thus track the evolution of the

crazing in the collodion coating.[3] Alterations of a different kind, more circumstantial in character, indicate the plates come from a single lot. Brown burns in the collodion coating—which is carbonized toward the upper edges—as well as traces of streaking suggest the plates, at some undetermined time, were exposed to fire, sprayed with water, and then rubbed with an abrasive material.

Although the presence of these Parisian views in the collections of this library seems logical enough, given their subject matter,[4] there are several hypotheses as to how they came to be there. In most cases, old entries in the registers of the Bibliothèque historique record negatives only as quantitative lots. Indications as to subject, author, and origin are usually approximate and require further research.[5] The plates might have been acquired directly from Le Gray when he liquidated his Parisian studio; then again, they might have passed through an intermediary and been kept in various city departments before finding their way to the Bibliothèque historique.

In 1866 the City of Paris acquired the Hôtel Carnavalet to serve as a depository for works of art and objects relating to the city's history.[6] In 1869 the photographic workshop of the Ville de Paris—created in 1858 in the Bois de Boulogne and initially operated by the Bisson brothers,[7] then by Charles Marville—moved to the quai de Béthune, on the île Saint-Louis, with Louis Emonts at its head. Thus a great many negatives, stored on the quai de Béthune, were saved from the fire in 1871 that burned the archives of the library of the Hôtel de Ville, along with the rest of the building, during the Paris Commune. From late 1871 the collections were rebuilt

1 According to Sylvie Aubenas, Le Gray's collodion-on-glass negatives are numbered continuously from the beginning of 1856 until the end of 1859. The numbers inscribed on the views of Paris cover a range extending from 17768 to 24200, the latter number being the latest one inscribed.

2 G. Le Gray, *Photographie: Nouveau traité théorique et pratique* . . . (Paris, 1854), 108–9.

3 In certain cases, the beginning of separation of the coating, indicative of craquelures to follow, are clearly associated with traces of water streaks and thus with high humidity (*Panorama of the Seine toward the Southeast,* neg. no. GLG 41); this humidity is sometimes the cause of decomposition of the varnish, doubtless itself linked to an alteration in the glass support,

identifiable by the presence of a white powder originating from corrosive alkaline products. On this subject, see M. H. McCormick-Goodhart, "Glass Corrosion and Its Relation to Image Deterioration in Collodion Wet-Plate Negatives," in *The Imperfect Image: Photographs, Their Past, Present, and Future; Conference Proceedings*, papers presented at the Centre for Photographic Conservation's first international conference at the Low Wood Conference Centre, Windermere, April 6–10, 1992 (London, 1992), 256–65.

4 See *Collections parisiennes: Bulletin des conservateurs et des personnels scientifiques de la Ville de Paris*, no. 5 (July 2000), an issue devoted to the photographic collections of the Ville de Paris.

5 Preliminary examination of the old archives and invoices of the Bibliothèque historique carried out by Liza Daum, who is in charge of the library's photographic holdings, has as yet proved fruitless in this regard.

6 On the history of the photographic collections of the Bibliothèque historique de la Ville de Paris, see M. de Thézy, "Collections de la Bibliothèque historique de la Ville de Paris," *Photographies*, no. 3 (December 1983): 79–81; and "Les Collections photographiques de la Bibliothèque historique," *Bulletin de la bibliothèque et des travaux historiques* 11 (1986).

7 The atelier of the Bisson brothers was on the ground floor of 35, boulevard des Capucines, during the period when Le Gray occupied the top floor; see F. Nadar, *Quand j'étais photographe* (1900; reprint, Paris, 1979), vol. 2, 1173. Thus the Parisian negatives might have come into the possession of the city through the Bisson brothers, who could easily have obtained them.

314 Gustave Le Gray. *View of the Seine toward the East*, negative, ca. 1859 (cat. no. 181).

beginning with the personal library of Jules Cousin.[8] Soon thereafter, photographic documents joined the other holdings, along with prints, maps, and albums. The photographs came from various sources, one of the first being the commission municipale des Travaux historiques (Municipal Commission for Historic Works). Created in 1860, this commission was charged with documenting the monuments of a Paris that was then disappearing. Also, municipal architects had already been commissioning photographs to record the new Parisian buildings that were rising in conjunction with Baron Haussmann's urbanist projects.[9] It is in this context that the city's acquisition of the holdings of Charles Marville—an illustrator and a collector, as well as a photographer for the City of Paris—is of interest to us, for he may have purchased the views by Le Gray with the intention of using them commercially.[10] In 1898, when the city's holdings were divided between the Musée Carnavalet and the Bibliothèque historique, the latter was entrusted with the photographic negatives and moved into the Hôtel le Pelletier de Saint-Fargeau; it remained there until 1968, when it moved into its present quarters in the Hôtel de Lamoignon.[11]

Le Gray and the Collodion-on-Glass Process

Although associated with the history of photography on paper, Gustave Le Gray always practiced, adapted, and taught glass-plate-negative photography, as well. The choice, for Le Gray, of one support over the other was determined by the nature of the effects he sought to achieve and by difficulties specific to the site in question. His methods of obtaining negatives and prints, as well as his research into the sensitivity and long-term stability of sensitive coatings, were widely disseminated by both him and his colleagues.[12] In his treatises—beginning with that of 1852—Le Gray was concerned with a twofold problem: on the one hand, the quality and

8 See J. Dérens, ed., *Constitution d'un patrimoine parisien: La Bibliothèque historique depuis l'incendie de 1871*, exh. cat. (Paris, 1980).
9 Thézy, *Charles Marville* (Paris, 1993); Thézy, *Charles Marville: Paris disparu* (Paris, 1994), 18–19.
10 The negatives in the library's Marville holdings consist primarily of collodion-on-glass plates that measure 30 × 40 cm and are not as thick as Le Gray's.

11 According to a survey carried out in 1987–88, in view of assessing their state of conservation, the photographic holdings of the Bibliothèque historique consist of several tens of thousands of negatives, including roughly 2,200 collodion-on-glass plates in formats ranging from 18 × 24 cm to 40 × 50 cm.
12 It would be difficult to name a French photographic manual from the 1850s that does not cite the technical information provided by Le Gray.

315 Gustave Le Gray. *The Arc de Triomphe*, negative, ca. 1859 (cat. no. 180).

316 Gustave Le Gray. *The Rohan Pavilion, the Louvre*, negative, ca. 1859.

stability of images; on the other hand, their production and commercialization.[13] As a fine chemist and a fine teacher,[14] he was ever attentive to the quality and durability of his images.[15] The period of Le Gray's production that concerns us here corresponds to his final months in his studio on the boulevard des Capucines, when the photographer, in financial straits, had to try to produce views combining his usual high level of technical and aesthetic quality with subject matter likely to be readily marketable—for example, views of Paris.[16] His research into short exposure times and the meticulous detail desirable in a photograph of this subject (not to mention the proximity of a Parisian studio, which facilitated the preparation of his materials and the transport of his glass plates) led him, as it had his contemporaries, to use the collodion-on-glass process.[17] In addition to having the advantage of appealing to contemporary taste, this technique was better suited than paper processes to the documentary photography of monuments.

Given the likely date of the Parisian glass negatives, this essay focuses for present purposes primarily on Le Gray's last treatise, published in 1854.[18] One of the questions raised by a reading of these texts concerns the precise nature of the process. Did he use the dry collodion tech-

13 "I put these techniques into practice in my studios on the chemin de ronde de la barrière de Clichy, where savvy organization permitted me to provide the market with a hundred positive prints each day, the stability of which is proof against the ravages of time"; Le Gray, *Photographie: Nouveau traité théorique et pratique* . . . (Paris, [1852]), 71.
14 The 1854 Didot trade directory lists him under the heading "*artistes photographes*," with the indication "*leçons de photographie*" (893).
15 Le Gray, *Photographie: Nouveau traité* (1854), 331–33.
16 See S. Aubenas, "Boulevard des Capucines: The Glory of the Empire" (this volume).
17 It is well known that Le Gray was an important pioneer in the use of collodion as a binder of sensitive salts in photography, which he advocated initially in connection with paper negatives. Its use here is confirmed by analyses carried out by the Getty

Conservation Institute, which reveal the presence of cellulose nitrate, an essential component of collodion. It would have been impossible to attain the degree of sensitivity necessary for these subjects with albumen glass plates.
18 See S. Aubenas, "To Unite Science with Art" (this volume), which discusses the successive versions of the treatises published by Le Gray as well as his role in the discovery of photographic collodion.

nique, which would have allowed him to defer use of the plates he had prepared for "one or two days,"[19] or did he use the wet collodion technique, which was more widely used at the time? In effect, despite the inconvenience of having to expose the plate "immediately" after sensitizing it, the wet collodion technique made it possible to take "portraits in thirty or forty seconds in the shade."[20] Analysis performed by the Getty Conservation Institute would support this, indicating an absence of sugars, hygroscopic products generally linked to formulas for the fabrication of dry preparations. Nonetheless, Le Gray also advocated the use of a dry collodion recipe without sugar-based products, through prolonged immersion in distilled water to which acetic acid had been added.[21] The presence of blurred figures and even "ghosts" in most of the Parisian negatives leaves open this possibility. The frequency of separation and flaking, readily visible on the collodion coatings, might be linked to the use of acid. Indeed, Le Gray emphasizes the capacity of acetic acid to separate the collodion from the glass plate when glass negatives are transferred to paper.[22]

In his treatise, Le Gray otherwise expresses his preference for the iron sulfate development process over the pyrogallic acid process, which he used only for portraits and in cases where he wanted high contrasts; the cream color of the collodion coatings on the library's glass negatives seems to corroborate his having used this first developer.[23] Finally, examination of certain prints and the corresponding negatives raises the question of intentional manipulation, and of Le Gray's treatment of skies. The cloudy trails present in many images must have resulted from manipulation of the negatives, either at the moment of exposure, by masking part of the plate from the light (facilitated by the lengthy exposure time and the size of the negative), or through chemical treatment of that area of the sky.[24] These practices differ from that of the "patched skies" obtained through the use of two negatives printed in tandem. But other kinds of interventions are also visible on the negatives. Examination of one negative reveals that the photographer masked with gouache a sign reading "latrines publiques" on the customhouse in the foreground, doubtless for reasons of decorum.[25]

Study of the Le Gray negatives rediscovered in the collection of the Bibliothèque historique has only just begun. The project itself, however, has shown that there is a general understanding of one of the givens of photography: that it usually requires two distinct but

inseparable operations for the photographer—exposure and printing—each of which can provide complementary information.[26] When it is possible to examine prints of the same negative made at different times, further information emerges. That is why, within the framework of the restoration and conservation campaign by the Atelier de restauration et de conservation des photographies de la Ville de Paris (City of Paris Photographic Conservation and Restoration Workshop), new prints of the finest possible quality have been made on albumen paper, trying to approximate the procedures used by Le Gray.[27] Almost a century and a half later, we are in a position—and herein lies the great richness of this corpus—to investigate, thanks to the various tracks he left behind, the relationship between what he said, what he did, and what remains of his work.[28]

19 Le Gray, *Photographie: Nouveau traité* (1854), 335–36.
20 An exposure time that drops to "between one and ten seconds with a 50 centimeter lens" in "light of medium intensity" (Ibid., 101).
21 An equivalent "dry" collodion formula was published by E. de Valicourt, *Nouveau manuel complet de photographie sur papier et sur verre,* . . . vol. 2, new ed. (Paris, n.d.), 187. In fact, this is a formula halfway between the wet and dry processes that makes it possible to retain the wetness of the collodion coating for a certain time.
22 Nonetheless, he attributes these "tears" in the collodion to various other phenomena linked to the process (the nature of the collodion and its preparation, the rapidity with which it dries, etc.).
23 Note that X-ray fluorescence spectrometry by the GCI revealed the presence of low concentra-

tions of iron. On the effect of the developing solution on the coloration of collodion-on-glass plates, see S. Esmeraldo, "Étude de vingt-six négatifs sur papier de Désiré Charnay et reproduction du procédé négatif au collodion humide" (Graduation paper, Paris, Institut français de restauration des oeuvres d'art, 1993), 46.
24 In photographs from the period, skies, which are very rich in blue light and ultraviolet rays, are overexposed by comparison with monuments. This effect might have been caused by a chemical attenuating agent that quickly attacks the silver of the image or by a deliberate withholding of a reinforcer from the area in question.
25 *View of the Seine toward the West* (neg. no. GLG 39).
26 On the recent interest in the historical analysis of negatives and of period prints, see *Louis Robert:*

L'Alchimie des images, exh. cat. (Paris, 1999).
27 These albumen prints were made by Daniel Lifermann, photographer of the Atelier de restauration et de conservation des photographies de la Ville de Paris (ARCP).
28 This investigation would have been impossible without the help of many collaborators. I would like especially to thank: Jean Dérins, director of the Bibliothèque historique de la Ville de Paris; Liza Daum, Marie de Thézy, and Sylvie Aubenas, for historical information; Dusan Stulik, of the Getty Conservation Institute, for his analysis of the constituents by IRTF spectrometry and X-ray fluorescence spectrometry; and Georges Monni, Marsha Sirven, Ragounathe Coridon, and Daniel Lifermann, of the ARCP, who have assisted our interns throughout this project.

317 Gustave Le Gray. *The Pont du Carrousel Seen from the Pont Royal*, negative, ca. 1859 (cat. no. 182).

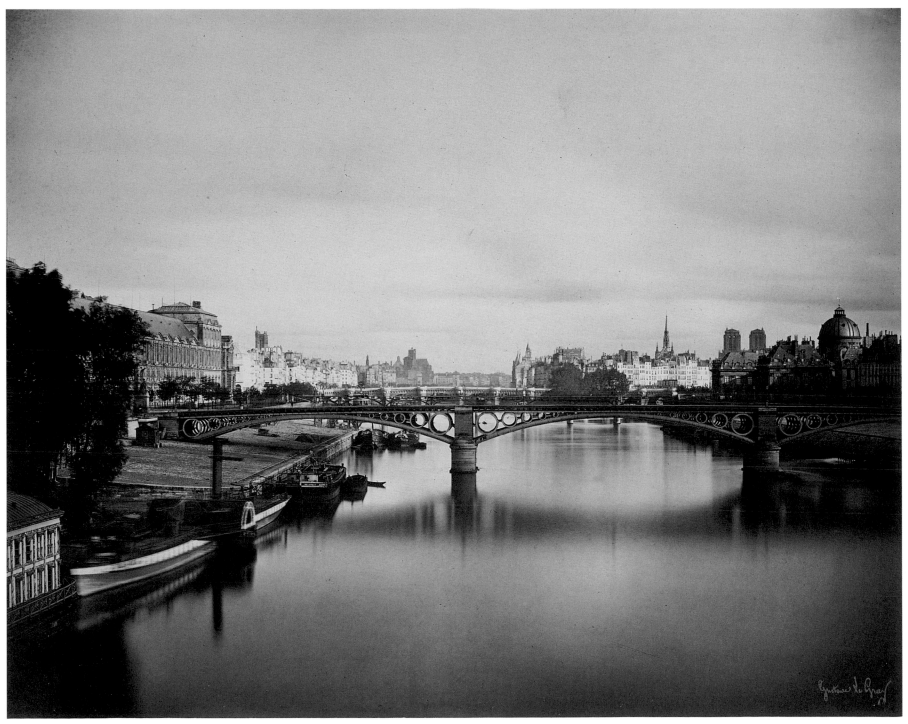

318 Gustave Le Gray. *The Pont du Carrousel Seen from the Pont Royal,* ca. 1859 (cat. no. 183).

319 Gustave Le Gray. *The Quai de l'Hôtel-de-Ville and the Pont d'Arcole*, negative, ca. 1859 (cat. no. 174).

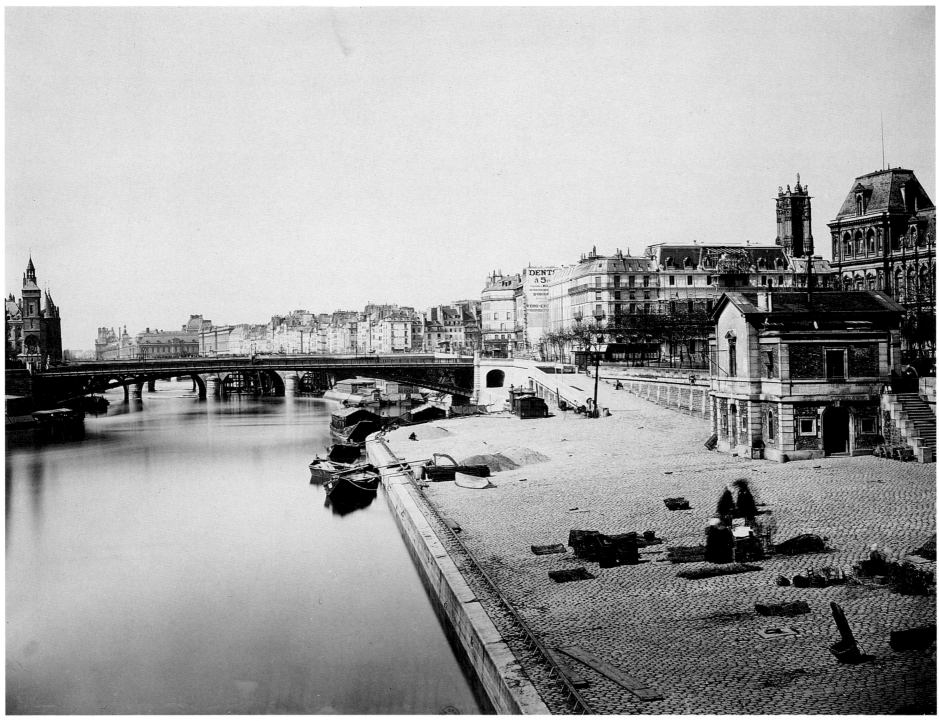

320 Gustave Le Gray. *The Quai de l'Hôtel de Ville and the Pont d'Arcole*, ca. 1859 (cat. no. 173).

ACQ. 11257

321 F. E. Le Dien. *The Valley of the Mills near Amalfi*, 1853 (cat. no. 219).

On Photographic Collaboration:
Firmin Eugène Le Dien and Gustave Le Gray

Sylvie Aubenas

Le Gray was not an aloof and solitary artist. This was true at least for his Parisian period, about which the most is known. He liked to share his discoveries, his experiments, and his know-how most of all with his friends Le Secq, Nègre, and Mestral, but also with his many paying students. He also enjoyed going on photographic excursions to Fontainebleau, with Le Secq and Nègre in 1849, and with Greene in 1852 (fig. 322). In 1851, during the three summer months, he traveled with Mestral throughout a portion of France for the Mission héliographique. Many other episodes of artistic and photographic camaraderie quite probably enriched that period of his life, but without leaving any trace. The studio at the barrière de Clichy was, from 1849 through 1855, a meeting place and a point of departure for numerous collaborative works. As previously discussed, the teacher who was so generous with his students, who published the fruits of his relentless research practically every year, and who—through his meticulous works—proved the inexhaustible potential of photography on paper, gathered around him talented and enthusiastic individuals.

The newness of the medium eliminated the generation gap that usually exists between the educator and the neophyte. It was not his years of experience and official recognition that made him the photographic master; it was his own genius and his determination to triumph over the pitfalls of chemistry that made the studio comrade, the friend, the young man of twenty-nine into the leader of the French school of calotypists.

In the works by the members of this "university" (Tournachon, Aguado, Nègre, Le Secq, Greene, Méhédin, Salzmann, who became in turn masters), we can follow, from their common beginnings under the tutelage of Le Gray, the individual development of each. Thus, young Greene, before coming into his own as a photographer, took a view during a joint excursion to Fontainebleau that was practically identical to the one Le Gray took right beside him.

Over time, students as important as Mestral (fig. 324), the vicomte Vigier, and Henri de La Blanchère—whose merits were extolled in the issues of *La Lumière*—have been forgotten due to the nearly total disappearance of their work. None of Mestral's portraits, which were so prized, has been identified; Vigier's sumptuous views of the Pyrenees (fig. 325) live on only in rare examples that provide but a glimpse of the scope and mastery of his talent; and, of La Blanchère's work, there remain only three handsome studies of ruined castles,[1] in which the aesthetic heritage of the Mission hélio-graphique is apparent. Still others are known only by name; their strictly private works remained with their families, whether preserved, destroyed, or forgotten. We are at the end of neither our discoveries nor our regrets.

Firmin Eugène Le Dien occupied a special place in that circle. He was never mentioned in the photographic periodicals of the 1850s. He never exhibited and never attended meetings of the Société héliographique or the Société française de photographie. Consequently, he was not included in the pioneering surveys of the French calotypists.[2] His name did not exist. And yet his work was

1 These are of Pierrefonds, Tiffauges, and Clisson; Institut de France, Library, fol. N 64 A.
2 For example, A. Jammes and E. P. Janis, *The Art of French Calotype, with a Critical Dictionary of Photographers, 1845–1870* (Princeton, 1983).

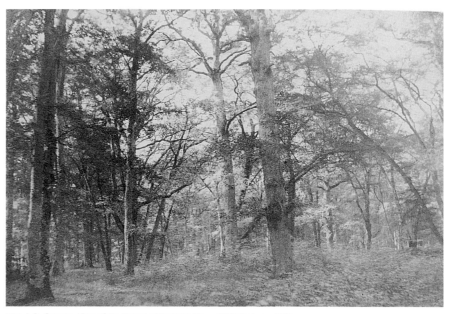

322 J. B. Greene. *View of the Forest of Fontainebleau*, 1852 (cat. no. 233).

3 *L'Âge d'or de la photographie française (1849–1854): Exceptionnel ensemble de 91 calotypes français*, Beaussant-Lefèvre, commissaire-priseur (sale cat., Paris, Drouot-Richelieu, June 1, 1990).
4 Now in the Bruno de Bayser collection.
5 Now in the Manfred Heiting collection.

indeed present in numerous public and private collections, filed among the anonymous or under an erroneous attribution. No one was aware of the scope and beauty of his opus until fate stepped in.

The Emergence of Le Dien

In 1990 a Parisian auction offered, in a unique occurrence, a group of photographs that had clearly been collected by a student of Le Gray's.[3] The core of that collection comprised thirty-eight calotypes, views of Pau and its environs, signed W. H. G. The subject matter, coupled with the initials, led to the recognition of an as-yet-unidentified English photographer. Among the other artists in that collection, there figured several students of Le Gray's—Greene, Salzmann, and Janneau—as well as the master himself.

Item 79 in the catalogue from that sale attracted particular attention. It was a calotype of the Capuchin monastery at Amalfi, marked with a mysterious blindstamp: "LE DIEN ET GUSTAVE LE GRAY."[4] Furthermore, item 80 showed a broader view of the same site, which was unsigned but was clearly connected to the previous one. Since the name Le Dien was unknown, his enigmatic pairing with Le Gray immediately aroused the curiosity of specialists and collectors.

With the help of a clue—calotypes of southern Italy, whose negatives were numbered in a very distinctive hand—it became possible to group together a growing number of scattered images, including item 41 from that same sale catalogue, a view of Naples.[5] Various-sized groups of photographs were identified in the

323 J. B. Greene. *The Arc de Triomphe*, Paris, 1852.

324 O. Mestral. *Landscape*, ca. 1851–1853 (cat. no. 236).

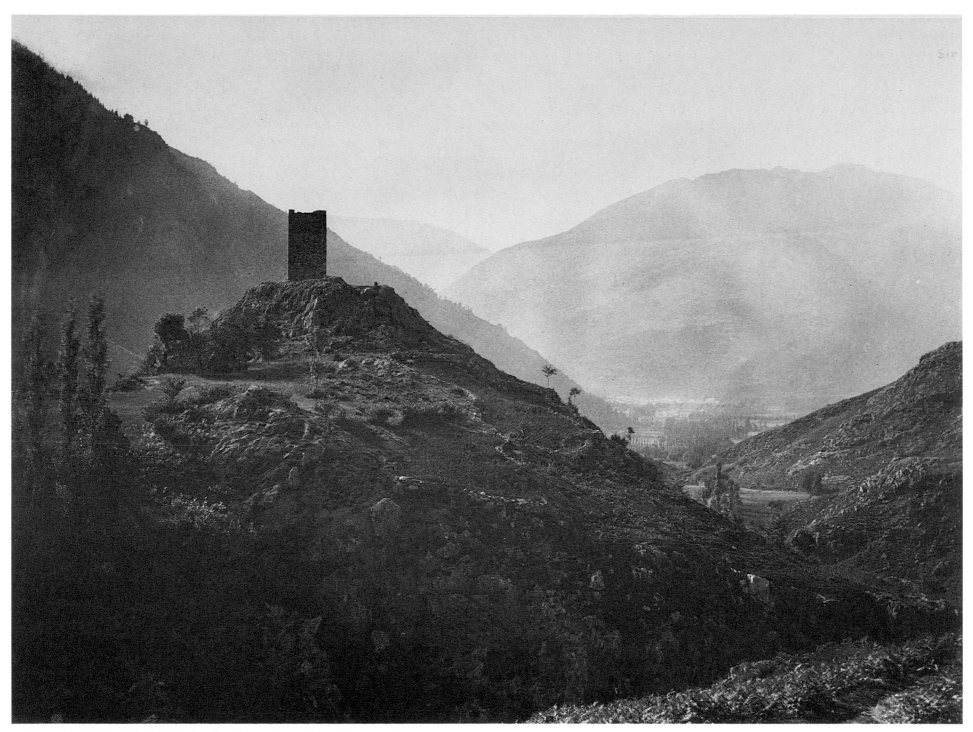

325 Vicomte Joseph Vigier. *The Luchon Valley Seen from the Tower of Castelvieil*, 1853 (cat. no. 248).

326 F. E. Le Dien. *Landscape along the Tiber, North of Rome*, 1852/53 (cat. no. 213).

collections of the Bibliothèque nationale de France and the Canadian Centre for Architecture (by Maria Antonella Pellizzari), as well as in the library of the Musée des arts décoratifs, the J. Paul Getty Museum, the Jammes collection,[6] and various other public and private collections. In all, there are now several hundred prints that trace the itinerary of a classic voyage through southern Italy, from Rome to Naples and beyond, including the Campagna, Baiae, Pompeii, Amalfi, and Salerno. The technique used was invariably Le Gray's: the waxed-paper negative. The composition of the images is often admirable. The printing varies from mediocre to masterful. The benchmark blindstamp of 1990 is found only on a small number of other examples.

If all of these views had never before been linked together as the work of a single, unknown artist, this was because most of them had been attributed to the Paduan painter and photographer Caneva (1810–1890). He had indeed practiced photography on paper in Rome and its environs, in the 1850s, drawing on the techniques published by Le Gray, and his high-quality works were not always signed.

Le Dien had yet to be identified, and his relationship with Le Gray, revealed but not made explicit by the blindstamp, had yet to be understood. In this uncertainty, and in view of the quality of the prints, the most disparate conjectures were made, the most daring of which were not the least tempting. Were the photographs the product of an unknown voyage by Le Gray, marketed (in Rome?) by one Le Dien, a print seller? Was Le Dien, on the contrary, the author of the photographs, and perhaps one of the painters who bore that name? Or was it (a last resort) a pseudonym, or even a double for Le Gray himself, invented for obscure commercial reasons?

The true Le Dien surfaced in an unexpected place, working for the magistracy in Algeria, which, however, leads back to a familiar circle: that of Léon de Laborde and the Delessert family. Actually, it was Charles Bocher, the brother of Édouard Bocher (husband of Aline de Laborde, Léon's sister), who, while traveling in Algeria in 1850, mentioned in passing, upon running into a society acquaintance from Paris, the young deputy magistrate for Algeria, Le Dien.[7] A simple coincidence of last name? No: the evidence provided by Bocher exactly tallies with a photograph of Algiers, alike in every way—in technique and type of numbering—to the already known views of Italy.[8]

A magistrate is less elusive than an imaginary print merchant. The personnel file on Firmin Eugène Le Dien in the National Archives provides the essential facts about his life through 1851.[9] Born in Paris on December 17, 1817, he was the scion of a family of powerful Legitimist landowners from Huppy in the Somme region. At the time of his birth, his father was a fabric merchant in Paris[10] and a member of the commercial court. Le Dien studied law, earned his degree in April 1840, and did a clerkship in Paris until 1843. He initially worked as an unpaid assistant magistrate, in Senlis in April and May 1843, in Château-Thierry from May 1843 through September 1847, and then in Compiègne. In 1848 his brother Émile, also a magistrate, fell ill, and Le Dien asked for a leave to accompany his brother during his convalescence in Algiers. So they were both far from Paris when the revolution erupted, preventing Le Dien from taking advantage of the changes that were taking place in the magistracy at the time. Therefore, he requested a post in Algiers, where he was appointed deputy magistrate in September. But the climate did not suit him, and he was constantly ill. He was granted leave in 1850. It was no doubt during his sojourn in Paris that he heard from the "Passy colony" (i.e., the Delessert, Bocher, and Laborde families) about the studio on the chemin de ronde in the barrière de Clichy. In fact, when he returned to his post, he had already been introduced to photography, since the aforementioned view of Algiers dates to that period. This is the only such view, but because it bears the number 46, it proves the existence of an already quite abundant group of photographs that is now lost.

Le Dien fell ill again in early 1851. This time, he convalesced in Algiers, but when his leave expired, he requested a post in France, preferably in the Amiens jurisdiction, near his family roots. His request was officially granted in April 1851 with his appointment as deputy magistrate in Doullens. He responded with a haughty letter of resignation; compared to the position he was leaving, the one offered to him was too modest.

An Artist's Voyage

Le Dien returned to Paris and settled at 3, rue Jacob. His comfortable income (seven thousand francs per year) and his situation as a bachelor freed him from having to seek additional income from a profession. He renewed his ties with old acquaintances he had made in the early 1840s during his pursuit of a law degree and a

6 Archives of Charles Nègre.
7 C. Bocher, *Mémoires de Charles Bocher (1816–1907), précédés des Souvenirs de famille (1760–1816)* (Paris, 1907), vol. 2: 120.
8 Print from the Marc Pagneux collection, perceptively attributed to the entourage of Le Gray; see M.-C. Adès and P. Zaragozi, eds., *Photographes en Algérie au XIXe siècle*, exh. cat. (Paris, 1999), 33.
9 National Archives, BB⁶ II 249. Thanks to Marc Smith for having conducted this research.
10 For details about the Le Dien family, see also the Departmental Archives of Somme, 3 Q 17/38 (schedules of settled inheritances), 3 Q 41/272 (schedules of inheritances and presumed deaths); the transcription of the mortgage register from the Abbeville office, vol. 168, record 455. Thanks to François Giustiniani for conducting this research.

327 F. E. Le Dien. *Study of a Tree in the Valley of Poussin, near Rome*, 1852/53 (cat. no. 218).

social life. The omnipresent writer Arsène Houssaye, also from Picardy,[11] mentions Le Dien as one of his best friends at the time.[12] Houssaye also had strong ties to the vicomtes de Montbreton,[13] lords of the manor of Corcy (named by Alexandre Dumas—a native of the nearby Villers-Cotterêts—as the best local aristocracy). As noted, among the students of Le Gray was the vicomtesse de Montbreton, along with her son-in-law Odet de Montault; the vicomtesse's work at the barrière de Clichy studio is confirmed by a family album in the collections of the J. Paul Getty Museum. So, among the students of Le Gray, there was a circle from Picardy, composed of Montault, Montbreton, and Le Dien, as there was a Norman circle of Chennevières, Avril, and Bocher.

With his time freed up, did the unemployed magistrate take more lessons from Le Gray? Perhaps he practiced photography with the Delesserts—Benjamin and his cousin Édouard[14]—who were particularly active during the summer of 1851, as Prosper Mérimée recounted to Léon de Laborde: "I went to Passy the day before yesterday [June 28]; they were doing wonderfully, up to their elbows in chemistry."[15]

In any event, Le Dien met up again with the painter Léon Gérard,[16] with whom he had made an initial trip to Italy (Rome and Naples) in early 1846.[17] It is not known whether Le Dien had had the opportunity to meet Le Gray in Rome during this youthful sojourn, but one can imagine that a shared love of Italy contributed to reinforcing the ties between the two men in Paris.

To occupy his time, Le Dien decided to return to Italy for a much longer stay. He was again accompanied by Léon Gérard, but also by another painter, Alexandre de Vonne. Born in 1821 to owners

11 Houssaye was born in 1815 in Bruyères, near Laon.
12 A. Houssaye, *Les Confessions: Souvenirs d'un demi-siècle, 1830–1880* (1885–91; reprint, Geneva, 1971), vol. 2: 146.
13 Ibid., vol. 1: 203. The vicomte and vicomtesse de Montbreton owned an estate in Corcy, near Villers-Cotterêts. They divided their time among Laon, Corcy, and Paris.
14 Édouard was the son of Gabriel Delessert and Valentine de Laborde, sister of Léon de Laborde. His sister Cécile was married to Alexis de Valon, who accidentally drowned in August 1851; his calotype portrait, probably by Eugène Piot (also a student of Le Gray's, as previously

discussed), appears in an album of portraits from the Piot collection (Institut de France, Library, MS 2230).
15 P. Mérimée, *Correspondance générale*, ed. M. Parturier (Toulouse, 1941–64), vol. 6 (1947), 222.
16 Gérard, born in 1817, exhibited at the Salon of 1847 (National Museums Archives, Louvre, *KK 18), traveled extensively in Europe, and practiced photography in the 1860s.
17 For passports and arrivals of Le Dien and Gérard, 1846, see Archives of the Ministry of Foreign Affairs (Nantes), Rome, Embassy to the Holy See, register 696.

of a vast estate in Saché near Tours, this idle but witty young aristocrat was a student of the painter William Wyld.[18] Gérard and de Vonne had previously painted together in 1851 in Meudon and in Normandy.[19] So the three young men packed their bags with paints, pencils, paper, and photographic equipment. To complete "the Gérard and de Vonne camp,"[20] Léon Gérard brought along his mistress, the "opera singer" from Toulouse, Zélie Vigié,[21] and a servant. The three companions shared the travel expenses.[22]

After leaving Paris in early September 1852, they arrived on the ninth in Rome[23] and leased, on the Via San Sebastianello, "a charming apartment at the foot of Pincian Hill, where the Académie française [the Villa Medici] was located: three bedrooms, a large sitting room, a dining room, a delicious garden where we will go to relax in the evening from our fatigues of the day, under the overhanging orange trees and the camellias."[24] They stayed in Rome and its environs until spring, strolling, painting, and photographing. They could be seen along the Apian Way or admiring the Villa Doria-Pamphili, the Villa Torlonia, and the Villa Conti at Frascati; the towns of Albano, Ariccia, and Castel Gandolfo; the pine forest of Castelfusano near Ostia; Tivoli; and Lake Nemi. In his correspondence, Alexandre de Vonne always called Le Dien "the photographer";[25] he was much closer to Gérard, the former magistrate remaining a traveling acquaintance. As for Zélie, the young man was carefully silent about her indecorous presence.

In late April 1853, having exhausted the charms of Rome, the companions decided to continue on to Naples, where they arrived on May 5. They leased a new house "at the seaside, near Posillipo, half a league from the big city"—the point of departure for more excursions.[26] They resumed the same good life. Outside of Naples, they visited Cisterna, Terracina, Sant'Agata, Fondi, Mola di Gaeta, and Pompeii. On July 6 Alexandre de Vonne wrote a last letter to his aunt, Mme de Fontenailles, telling her about the sketches in pencil and paint he was doing in Pompeii. Then his correspondence abruptly stopped. Violent bouts of fever, perhaps due to malaria, forced him to take a boat back to Marseilles.

Le Dien did not leave Naples for Rome until September 10, followed two weeks later by Gérard and Zélie Vigié.[27] The lovers set out for Paris on October 15, 1853, after a voyage that had lasted more than a year.[28] The date of Le Dien's return has not been found in the records.

18 The biographic information on Alexandre de Vonne, his relations with Gérard, his previous travels, and the voyage with Le Dien and Gérard are taken from A. de Vonne, *Lettres écrites en voyage* (Tours, 1865); thanks to Marc Pagneux for recommending this work. For the paintings exhibited by de Vonne at the Salon of 1848, see National Museums Archives, Louvre, *KK 19, and A. Montoux, "Deux lieux balzaciens: Vonnes à Pont-de-Ruan, la Haute-Cherrière à Saché," *Bulletin de la Société archéologique de Touraine* 41 (1986): 461–78.
19 Vonne, *Lettres écrites en voyage*, 69.
20 Ibid., 118.
21 The name of Zélie Vigié, whose passport was issued in Paris on August 14, 1852, was immediately followed in the register by that of the banker François Delessert, the brother of Benjamin and uncle of Édouard Delessert. This is a clue to a possible relationship but cannot be clarified. Archives of the Ministry of Foreign Affairs (Nantes), Rome, consulate, old passports, box 34.
22 Vonne, *Lettres écrites en voyage*, 81.
23 When Le Dien had his passport issued in Paris on August 30, he indicated his destination as Sardinia; see Archives of the Ministry of Foreign Affairs (Nantes), Rome, Embassy to the Holy See, register 701, and consulate, old passports, box 34.
24 Vonne, *Lettres écrites en voyage*, 82.
25 Ibid., 75, 81, 114.
26 Ibid., 124.
27 See passports and arrivals, 1853–54, Archives of the Ministry of Foreign Affairs (Nantes), Rome, Embassy to the Holy See, register 702.
28 For visas, 1852–54, see ibid., register 718.

328 F. E. Le Dien. *A Street in Naples*, 1853 (cat. no. 221).

29 After several years of research on Le Dien's work, Hans P. Kraus Jr. was able to establish this original classification and was generous to share it.
30 See S. Aubenas, "Barrière de Clichy: A 'University' of Photography" (this volume).
31 Unfortunately, this was not done systematically, which poses problems relative to attribution.
32 Département des Estampes et de la Photographie (EST), Bibliothéque nationale de France (BNF).
33 The pont des Blanchisseuses in Troyes; see *Olympc Aguado photographe (1827-1894),* exh. cat. (Strasbourg, 1997).
34 Marie-Thérèse and André Jammes collection.
35 A note from the scientist Georges Ville dated September 1857 was sent to Nègre (Marie-Thérèse and André Jammes collection): "So here is the negative by M. Le Gray; take good care of it and do a good job."
36 Private collection, New York.

What is certain is that when he arrived in Paris, he went to see his photography teacher—as had Maxime Du Camp on his return from the Near East in the spring of 1851—to start printing with him the calotypes he had accumulated during his travels.

The Terms of a Collaboration

Le Dien had profited greatly from his lessons. The group of negatives he brought back in his trunks was extensive—dozens of waxed-paper negatives, carefully numbered in four separate series:

Rome; the landscapes surrounding it; Pompeii; and, finally, Naples and various nearby sites.[29] From this wealth of famous and picturesque views of that country most prized by artists and "amateurs" alike, what portion did he intend to print on his return? After the pleasure of seeing his travel memories reborn in the developer, and probably offering prints to his friends, he must have received quite a lot of advice from the circle at the barrière de Clichy. At the least, they must have suggested that he exhibit them, but he never did.

329 F. E. Le Dien. *The Roman Campagna,* 1852/53 (cat. no. 217).

The probable period of Le Dien's return in the fall of 1853 was, as noted earlier,[30] the same period in which Le Gray was considering setting up a "photographic printing house," taking on the commercial work of printing and eventually distributing images from negatives provided by other photographers. Le Dien undoubtedly saw this as an opportunity to procure a series whose quality would be as interesting as its subject, while Du Camp had preferred the services of Blanquart-Évrard, who was better equipped to print the thousands of proofs required for the publication of an imposing album.

Le Gray's concept was very different from that of the businessman from Lille. Although he was also a photographer, Blanquart-Évrard's only role in the works he produced was that of publisher. He adopted the layout conventions used in albums of engravings: a title page, then, on each page, a running title, a specific title, and individual credits for the artist[31] and for the publisher. Le Gray was neither a businessman nor a publisher; he was an artist and "photographist." His selling point was artistic quality as opposed to industrial quantity. From his point of view, collaboration could not be anything other than the combination of two talents—in this case, that of an excellent photographer, Le Dien, and a top-notch printer, himself or someone else whose know-how would be guaranteed by the "Gustave Le Gray" stamp. That is how the blindstamp combining the two names, "Le Dien et Gustave Le Gray," must be interpreted (the as-yet-unknown photographer first, and then his teacher). Placed not on the mount, but on the image itself, this stamp suggests a closer collaboration than that of artist and publisher; it suggests a truly joint creation.

Collaboration between two photographers was commonplace in the early 1850s, considering the cost of material and the complexity of operating procedures, which were new to all. In the effervescence of the early days of photography, they scarcely thought about the future implications—first commercial and later historiographic—of collaborative work. The tricky lawsuit between the Tournachon brothers, who became enemies, is a perfect example. The simple loan of negatives among photographers was also quite a frequent occurrence. For example, in the collection of Alphonse Poitevin,[32] there is a waxed-paper negative furnished by Olympe Aguado[33] around 1855; Charles Nègre had the use of negatives by Greene,[34] Le Gray,[35] and even . . . Le Dien.[36]

330 F. E. Le Dien. *Olive Grove, Roman Campagna*, 1852/53 (cat. no. 216).

37 A distinction is usually made in engravings between the draughtsman (*delineavit*), the engraver (*sculpsit*), and the printer-publisher (*excudit*).

38 Leaving aside the thorny problem of identifying and dating subsequent reprints: for example, it would be interesting to know the circumstances of the cyanotype printing of the works by Le Secq, which could not be earlier than the late nineteenth century.

39 M. Chlumsky, "Espace et exactitude: La Photographie d'architecture des frères Bisson," in B. Marbot, M.-N. Leroy, and E. A. McCauley, *Les Frères Bisson photographes, de flèche en cime, 1840–1870*, exh. cat. (Paris, 1999), 83.

40 Adès and Zaragozi, *Photographes en Algérie*, 26–32.

41 Prisse d'Avennes collection, département des Manuscrits, BNF.

42 At least the prints of these views conserved at the EST, BNF.

43 In 1850, 1851, and 1852; see "Manuals by Gustave Le Gray" under "Published Sources" in the bibliography to this volume.

In the case of commercial distribution, the signatures and other references that may have been associated with an image—although not as explicit as with engraving[37]—make it possible to distinguish the participants, particularly through the placement of the names on the print or on the mount. Failure to comply with these conventions meant running the risk that photographs would be attributed to those who only printed or distributed them.[38] Thus, views of Spain (1853) recently attributed to the Bisson brothers[39] should be reattributed to the Spaniard Pablo, and views of Algeria (1851) must be attributed to Benecke, though they were published

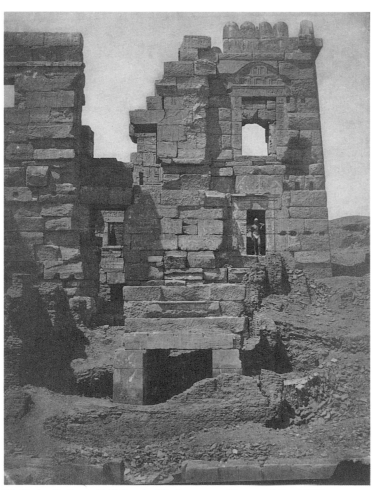

331 Maxime Du Camp. *North Facade of the Gynaeceum of Rameses II, Egypt,* 1850 (cat. no. 230).

under the name of Charles Marville.[40] This is what makes the atypical juxtaposition of the names of Le Dien and Le Gray on the same print all the more intriguing.

When Maxime Du Camp had returned from his Middle Eastern trip with Flaubert in May 1851, in a hurry to derive honor and profit from it, he did not rest until he had submitted his works to the Société héliographique and to the influential patrons at the ministry and at the Académie des inscriptions et belles-lettres. But, busy with his move to a new home, his new relationship with Valentine Delessert, and his duties at the *Revue de Paris*, he did not for an instant consider personally undertaking the long and tricky job of printing his images. He quite naturally turned to the expert in such things, Le Gray, who was about to leave on the Mission héliographique. He had him execute, from his Egyptian negatives, magnificent renderings with a great richness and subtlety of hues—precisely the olive green and orangish shades found in certain prints from the Mission héliographique; some fifty of these rare images were given to his friend, the Egyptologist Prisse d'Avennes,[41] who helped Du Camp write the historical text to accompany the album (fig. 331). It was not until later, in the fall, that Blanquart-Évrard was entrusted with their publication.

The views of the Pyrenees[42] taken during the summer of 1853 by the vicomte Vigier, who had also been trained at the barrière de Clichy, were most probably printed on his return by Le Gray or under his direction. The absolute mastery of the production and the richness of the deep purples and warm browns are sufficient proof of this.

In 1853 Le Gray had been teaching photography for nearly four years and had published three manuals explaining his methods.[43] The fourth and final version would appear the following year. These were not reiterations of the same text, but rather ceaselessly reworked, expanded, and enhanced reports on his ongoing experimentation. In the final months of 1853, he was immersed more than ever in chemistry experiments; his two primary inventions—the waxed-paper negative and the collodion-on-glass negative—had been achieved and put into use several years before. Now it was a matter of perfecting the palette of hues of salted-paper prints.

At the same time that he was working on the photographs by Vigier, Le Gray validated his capabilities as a printer with his own images of the preparatory drawings for the fifty-six decorative,

painted panels by Henri Lehmann for the grand reception room at the Paris City Hall. These were published in early 1854.[44] Their rich chromatic scale is sufficient proof that the "GUSTAVE LE GRAY" blindstamp on the prints applies to more than just the picture taking and that the name "Bisson Brothers Photographic Press" on the mounts had nothing to do with the making of the photographs, but rather with the manufacture and distribution of the albums.

So Le Dien arrived at the right time, laden with negatives that were ideal, since they had been taken by rigorously and sensitively applying the methods he had learned from his teacher. Their success and the means of circulating that series are all the more difficult to evaluate because no contemporary mention of them has been found. Even the photographic press was mute. However, the number of prints identified to date is indicative of a broader distribution than that of other amateur photographers, even excellent ones such as Aguado and Vigier. What has survived is obviously only a part of what was produced; therefore, many other copies must have been sold or given away. Likewise, the works by Le Gray, during the same period, were sold by the plate and not in albums. The disadvantage of such great care in the printing was the time it took and the very high cost; a relatively large album would have been prohibitively expensive.

However, the quality of the surviving collaborative prints by Le Dien and Le Gray is not homogeneous. Some are simple albumen prints that were produced quickly, as if to facilitate reading the image. Others—the majority—are on salted paper, of good workmanship, but of no particular distinction. Finally, a last group, of exceptional quality, was undoubtedly made directly by Le Gray or under his strict supervision. No convincing correlation can be made with the rare presence of the blindstamp, nor even any chronology relative to these categories of print quality. The group held at the Bibliothèque nationale de France,[45] consisting of an album and some unmounted photographs, contains examples of all three types, all very likely produced at Le Gray's studio. They are not signed, nor are they always numbered. The album, however, has a binding that is identical to that of an album of twelve views of Fontainebleau by Le Gray;[46] those bear neither negative numbers nor signatures. Several prints are uncropped, on paper larger than the negative, characteristic of trial proofs intended for the photographer himself or his friends and family.

If one were to hazard a hypothesis about the arrangement between Le Dien and Le Gray, one might imagine the following: Le Dien may have engaged Le Gray to supply him with the prints he needed for his private use and, in exchange, granted him the option of marketing them for his own profit. The only discernible logic in the use of the blindstamps (which indicate a commercial purpose) relates to the subjects. Those that are stamped are primarily views belonging to two of the four series—of Rome and of Pompeii—and dealing with famous landscapes and monuments, likely to attract the broadest clientele, rather than studies of trees or less well-known subjects. If this interpretation is correct, one must deduce that sales were less extensive than private distribution.

This commerce must not have lasted longer than the barrière de Clichy period. In late 1855 Le Gray moved to the boulevard des Capucines to devote himself to his own business. Thereafter, he primarily used the collodion-on-glass negative and printed on albumen paper. In early 1856 Adolphe Bilordeaux, a lithographer Le Gray had introduced to photography in 1853 and a founding member of the Société française de photographie in 1854, and who set up his own studio in 1855, deposited six prints at the copyright office; these were poor copyprints—in small format, indifferently printed and captioned in elaborate white letters on a black background—of photographs by Le Dien. This piracy (another sign of Le Gray's relinquishment of commercialization?) was, nevertheless, a failure. The only known prints are those that were filed for copyright, still held at the Bibliothèque nationale de France.

It was during this same period that Le Gray attempted, for the last known time, to increase the income from his business, as all studios of a certain size must have done, by selling photographs by another photographer—yet another of his students. Léon Méhédin had been taken along by Colonel Langlois to the Crimea to assist him by making photographs as preparatory studies for a large panoramic painting of the siege of Sebastopol, which the emperor had commissioned. Le Gray hoped to be sent views he could print at the boulevard des Capucines and offer to the Parisian public as news photographs. His neighbors, the Bisson brothers, were already distributing (once again, without having to print them) Crimean views by the English photographers Roger Fenton and James Robertson. But these dealings were cut short when Colonel Langlois indignantly asserted the exclusivity of his right to the use of the documents produced by his photographer.[47]

44 The album was published in early 1854. The exact number of privately printed copies is not known. Six copies were acquired by the ministry, three by the emperor, and ten by the City of Paris; one was filed for copyright, one was given by Lehmann to Mérimée and one to Du Camp.
45 Formerly in the Georges Sirot collection.
46 Formerly in the André Jammes collection; Prosny sale, 1945.
47 F. Robichon and A. Rouillé, *Jean-Charles Langlois, la photographie, la peinture, la guerre: Correspondance inédite de Crimée (1855–1856)* (Nîmes, 1992), 90, 104.

332 F. E. Le Dien. *Study of Trees, Roman Campagna*, 1852/53 (cat. no. 215).

The Style Is the Man

The fruitful but unprofitable collaboration between Le Gray and Le Dien is a textbook case for those who seek to understand Le Gray's influence on his students, to gauge the respective contributions of taking and printing pictures in the creation of photographs, and, finally, to judge what constitutes the style and personality of a photographer, above and beyond the technical and thematic choices that may be used to substantiate attribution. Can a photographer's style be analyzed, mutatis mutandis, like that of a painter, an engraver, or a sculptor, in which the subject is entirely reinvented by the creativity of its creator, the slightest detail of conception and execution reflecting, *volens nolens,* the reflexes and reflections learned or developed by an individual, a brain, an eye, a hand?

The mark of Le Gray on Le Dien, one of his most brilliant disciples, is strong. What might the student have known of the teacher's work before leaving for Rome in September 1852? Let us conjecture. Having returned to Paris in the summer of 1851, he may have just barely crossed paths with Le Gray, who left in July, with Mestral, on the Mission héliographique. Therefore, if he frequented Le Gray's studio, it must have been during one year, from the fall of 1851 through late summer of 1852. He could have seen Le Gray and Mestral return with the hundreds of architectural views that fulfilled their commission. He could have been present for the printing of these works in the studio at the barrière de Clichy. In 1852, when Le Gray crisscrossed the forest of Fontainebleau in the company of Greene, perhaps Le Dien was not far off.[48]

One thing is certain: an echo of the two major themes treated by Le Gray in 1851–1852 is faithfully found in Le Dien's views of Italy. Of course, no one had waited for Le Gray to inspire them to photograph Italian architecture. However, landscapes and especially studies of trees were much rarer among traveling photographers at the time. But neither should it be forgotten that Le Dien was traveling with two painters who painted any number of nature studies during their excursions; de Vonne even described himself as a furious "Corotist."

Likening the classicism of Le Dien's choice of themes to that of Le Gray—architecture, landscapes, and trees—would not be sufficient to establish the association between the two if the principles of their photographic treatment were not identical: the same rejection of the facile picturesque, the same absence of figures and portraits in their landscapes, the same rigorous composition. Also similar to the method chosen by Le Gray for the Mission héliographique was Le Dien's idea of taking the same monument or site from various angles to cover every aspect.

For Le Gray, this was also the best way of responding to the assignment from the commission des Monuments historiques, who needed complete documentation on the condition of the buildings they were considering restoring—thus the variety of the views of the ramparts of Carcassonne, and the camera angles multiplied out of necessity as much as for pleasure at Chambord, Cahors, and Elne. The inventor handled with virtuosity the waxed paper he had just perfected, an invention that allowed him the luxury of taking several dozen photographs per day.

At Pompeii, in the "valley of the mills" near Amalfi, and in the "valley of Poussin" near Rome, Le Dien imitated his teacher, moving away, moving closer, or moving to either side of his chosen subject. He went so far as to take the same subject with framing variations so fine that only close examination allows one to distinguish them. In the

40 It is noted, without making any further deductions, that Émile Le Dien, the brother who Firmin Eugène had accompanied to Algeria, was the author of a botanical booklet titled *Catalogue des mousses observées aux environs de Paris*, excerpted from the *Bulletin de la Société botanique de France*, which reported on a paper given on December 17, 1858. Many of the mosses surveyed came from the forest of Fontainebleau.

333 F. E. Le Dien. *Study of Trees, Roman Campagna*, 1852/53 (cat. no. 214).

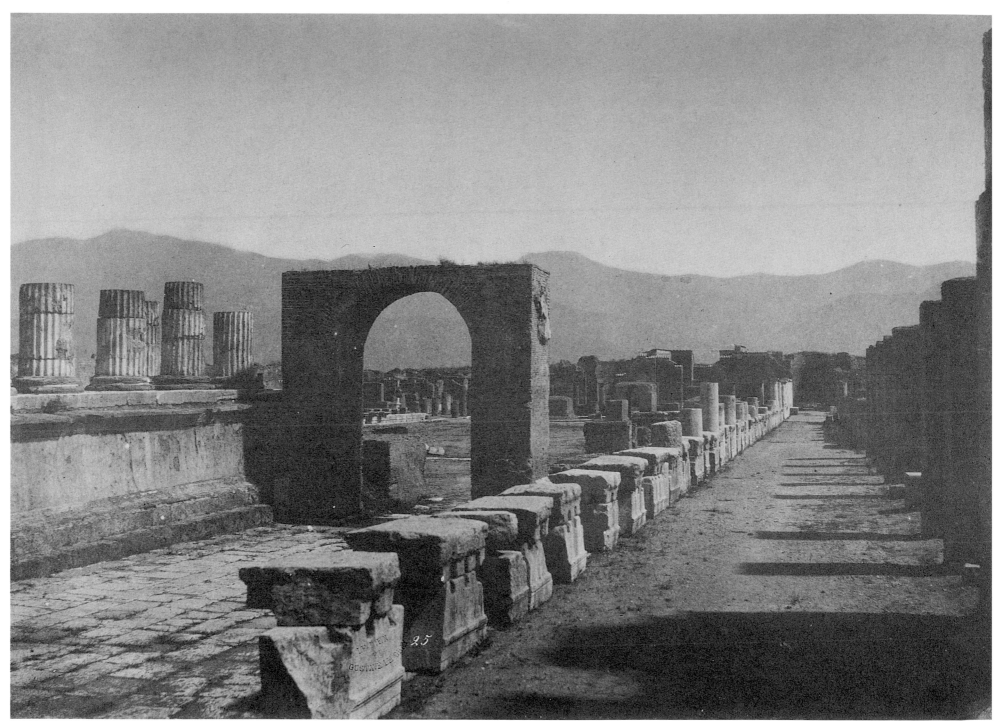

334 F. E. Le Dien. *Ruins at Pompeii*, 1853 (cat. no. 225).

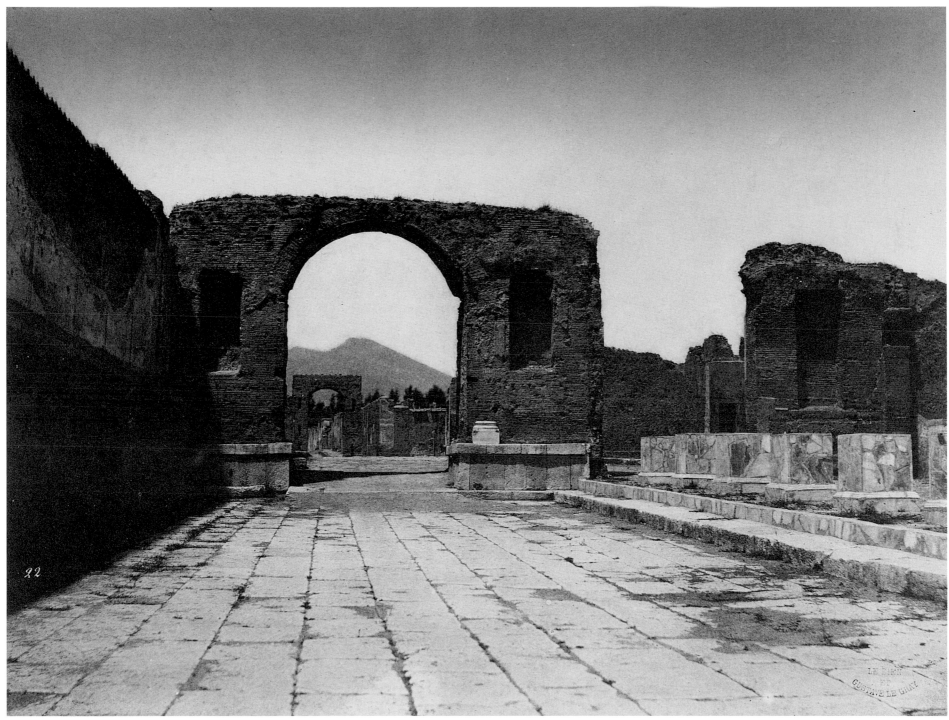

335 F. E. Le Dien. *Ruins at Pompeii*, 1853 (cat. no. 223).

49 G. Le Gray, *Nouveau traité théorique et pratique de photographie sur papier et sur verre . . .* (Paris, 1851), 35.
50 Ibid., 177.

second edition of his manual, Le Gray indeed recommended, when traveling, to take "two or three exposures of the same view, to be certain of getting a good one."[49] He hardly ever made an exception, other than for himself, and by the spring of 1851 had achieved with waxed paper "such great certainty of execution, that it is rare that I am obliged to make a second exposure."[50]

Thus, Le Dien's facility, despite occasional mistakes, allowed him to produce at a rate as sustained as that of Le Gray during the Mission héliographique. By frequenting Fontainebleau or studying the photographs brought back by Le Gray or working from the themes selected by Gérard and de Vonne for their studies, he derived his atypical taste for studies of trees. His groups of twisting cork oaks hanging on to a hillside, his pine forests, and his olive groves are remarkable in their variety, the treatment adapted by turns to the species and to the light.

Finally, working with his student's Italian negatives, Le Gray imbued those images—whose inception he had already influenced—

with his aesthetic conception of printing. The violets, the practically burnt blacks, combined with a dark green or orangish background, the delicate blues, the graduated skies—all of these nuances, described in his manuals and in his papers given at the Académie des sciences, are found here. Le Dien's prints are thereby brought to such a high level that they acquire, in these manifestations, a perturbing kinship with the teacher's work. This is a striking illustration of the relentless profession of faith in the writings of Le Gray; photography is an art that he endeavored to develop in all of its aspects at once. He was indeed doing the work of an artist when he printed Le Dien's negatives, and it was legitimate that he also sign them: the completed work had two creators.

Because it has been necessary to fill the gaps in the existing information with a certain number of hypotheses, why not go further still, so as to not leave any angle unconsidered—as far as is reasonable (the truth, after all, rarely coincides with the plausible). The general appearance of certain works by the obscure Le Dien is so close to those by Le Gray that there could be a strong temptation to associate the teacher, in some manner, with the actual taking of the pictures. The same scenario could be imagined for the photographs that were cosigned by Le Gray and Mestral from the Mission héliographique. After all, because the chronology we have laid out lists nothing in particular for Le Gray's life during the summer of 1853, he may have been in Paris or elsewhere. The documents that make it possible to track Le Dien and his companions through Italy say nothing of a trip by Le Gray, but the disappearance of the passport control records from the consulate in Naples, combined with the interruption of Alexandre de Vonne's correspondence during that period, perhaps leaves open a window in space and time through which Le Gray may have slipped in order to briefly join Gérard and Le Dien (by sea, since he was not seen passing through Rome).

The answer ultimately lies in the images. Above and beyond the teacher's influence on his student, above and beyond the appeal of some extraordinary prints, there remain irreducible differences. Le Dien, in his enthusiasm or uncertainty, took multiple shots, sometimes unnecessarily; one might say he practically "bombarded" the countryside. He put off his final choice from among these numerous attempts until the time of development. With this sometimes hastily gathered crop, it was necessary to separate the

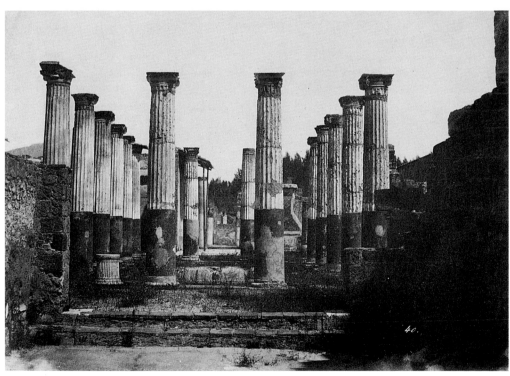

336 F. E. Le Dien. *Ruins at Pompeii*, 1853 (cat. no. 226).

masterpieces from the sketches. Le Gray was not mistaken in consenting to personally print only the best.

Le Gray's own conception of photography was different. It was profoundly influenced by his initial training at the Beaux-Arts and by his concomitant practice of painting and drawing. The mechanical rapidity of taking pictures, further accelerated by his own research, is the opposite of the slow maturation required by a painter who had been a student of Delaroche's. One could accomplish much more copious work in a shorter period of time; one could do multiple trials in order to select the best of the lot, as the photographers of the twentieth century did on a grand scale. Far from giving in to technical expediency or cautiously leaving a certain share to chance, Le Gray transposed to photography the working method of a well-schooled painter, who fundamentally dissociates composition from execution. The photograph is thought out, caressed, ripened before the exposure; it is not taken until a complex mental process of appropriating a fragment of reality is completed, at that instant when the framing and the lighting are optimal in the artist's judgment. Once the overall design is captured on the negative, it still remains to be colored in; this is the true moment for multiple trials, in the complexity of the printing process that brings the final work to fruition in all its variety.

This mastery and this thrift allowed Le Gray to concentrate the wealth of his inspiration in works that, while few in number, were of unequaled visual power. This is what explains the relative rarity of his views, even in places such as the forest of Fontainebleau, which he traversed at leisure. He delivered only what he felt was successful, nothing approximate, nothing capable of devaluing what he perceived as the artistic nature of photography. His principles, if not his processes, in every way prefigured those of the pictorialists who, in reaction against the banality of the torrent of photographs at the end of the century, chose to reaffirm the artistic nature of photography by acting precisely as Le Gray had in the early 1850s.

Epitaph

Firmin Eugène Le Dien stopped just short of this. His resurrection as being one of the most gifted photographers of his time is nonetheless an achievement of paramount importance. Among his works are many that are admirable; they are even further enhanced

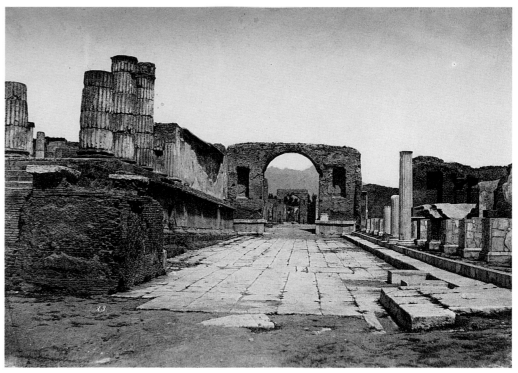

337 F. E. Le Dien. *Ruins at Pompeii*, 1853 (cat. no. 224).

by the most beautiful printing possible. Perhaps the magistrate just lacked the spark, and the dilettante more of the perseverance, required to achieve that conspicuous perfection that belongs to but a few.

Nothing is known of his life after 1853 up to the time of his death, which occurred twelve years later. He died in Paris, at his residence on the rue Jacob, still a bachelor, on July 28, 1865, at age forty-seven.[51] His frequent illnesses in North Africa and his weak constitution (in 1852 de Vonne described him as "thin as a grasshopper in Lent")[52] suffice to explain this early demise. No proof has yet emerged that he continued to practice photography after his return from Italy. He thus joined the ranks of those highly talented amateurs of the early 1850s who—caught up in the fever of novelty and, like Du Camp, Teynard, Piot, and de Clercq, often during distant voyages—immediately reached the first peaks of the photographic art with no intention of devoting the rest of their lives to it.

51 Death certificate of Firmin Eugène Le Dien, Archives of Paris, Vital Statistics, 5 Mi 3/627, death register of the 6th arrondissement.
52 De Vonne, *Lettres écrites en voyage*, 81.

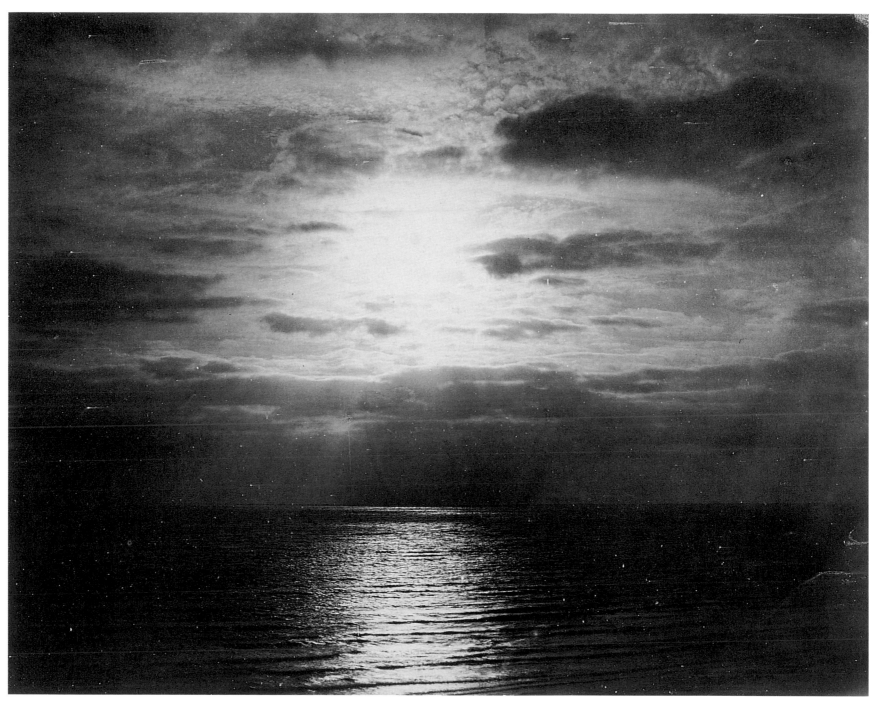

338 Gustave Le Gray. *Solar Effect in the Clouds—Ocean*, 1856 (cat. no. 110).

From One Century to the Next:
The Fate of Le Gray's Work in Photographic Collections

Sylvie Aubenas

After focusing for a long time on biographies of artists and the roots of their work, art history has more recently expanded its sights to include their audiences and their posterity. After creation and reception comes production and consumption; after the history of form and aesthetics, the history of criticism and taste. Also, the study of past collections, which served primarily to establish the origin and authenticity of works, has taken on broader perspectives. This type of endeavor extends only minimally, however, to the history of photography, with the exception of a pointed interest in the criticism and controversies of the period or rare studies on the compilation of individual collections.[1] However, at a time when photography was wavering between art, science, and entertainment, the theoretical manifestos—expressing the opinions of just a few individuals, those with an interest in the process—were far from depicting the entire social reality of the medium. The acquisition, possession, and use of photographs by contemporaries are, or appear to be, at least as revealing as their words, but the available evidence remains very difficult to gather.

Studying the "fate" of a photographer during his time and his presence in collections ideally presupposes first drawing up a descriptive catalogue of all of his works, in other words, of every known print, whether still in existence or lost, with a note on the provenance for each, whether provided by the print itself or by external documents. In that undertaking, a fundamental difficulty derives from the subordinate status of photography in the opinion of past writers of inventories and sale catalogues; they drown it, with practically no particulars, in the midst of miscellaneous lots of graphic documents. However, some past catalogues of photographic exhibitions, the English ones in particular, mention the lenders of the exhibited works, sometimes well-known people. There remain, especially, those existing prints (a minority) that are apt to reveal, above all, the most remarkable provenances, either due to a particular presentation factor (dedications, albums that bear a name or coat of arms, monograms, book plates, etc.) or due to the partial or complete conservation of a collection identified as

such by successive private owners or an institution that respects its integrity. But for many major photographers, all too few prints of a given work have been preserved for such a study to result in solid conclusions. This observation, moreover, has a value in and of itself; while it says nothing of the number of photographs that were originally distributed, it at least shows that the purchasers were not those whose collections have since turned up. This apparent truism becomes excusable when one sees that Gustave Le Gray illustrates exactly the opposite case.

More than anyone else, he sought to establish the artistic dignity of photography. The unheard-of success that he knew for a few brief years, his presence in greatly varied collections—including the most illustrious and select—the oblivion into which he suddenly fell, and, finally, his brilliant reappearance in the late twentieth century are all the more significant, both as reflections of the changing general view of nineteenth-century photography and as evidence of the singularity of his individual case. Still more of his works may remain to be discovered in many other collections, past and present, where they may lie in anonymity. For the time being, it must suffice to lay the groundwork and to outline the parallel history of these two periods of Le Gray's glory, the years 1856–1859 and the late twentieth century.

It was at the turning point of 1856–1857 that his fate was set in motion; a fashionable studio on the boulevards, the first seascapes, and imperial favor heightened his reputation, which had previously been limited to a circle of initiates. Le Gray was now known throughout Paris and London, and even in New York. This brief and intense infatuation abruptly ceased after the closure of his studio and his departure, which coincided, as discussed earlier, with the start of a long period of general disinterest in artistic photography. But his works, which were so prized, acquired by the powerful, by enlightened art lovers, and by many others, remained in family albums and portfolios, and in public institutions to which they were sometimes donated by their original owners. In the late 1970s, this latent presence allowed some insightful gallerists and

1 See especially the excellent compendium by A. Roullé, comp., *La Photographie en France: Textes et controverses, une anthologie (1816–1871)* (Paris, 1989); the articles by E. Bation-Cabaud, "Georges Sirot (1898–1977), une collection de photographies anciennes," and B. Marbot. "Du marché aux puces à la Bibliothèque nationale," Photogénies, no. 3 (October 1983); and M. Haworth-Booth and E. A. McCauley, *The Museum and the Photograph: Collecting Photography at the Victoria and Albert Museum, 1853–1900*, exh. cat. (Williamstown, Mass., 1998).

collectors to discover them and then make them known. The infatuation of the late 1850s was repeated like an echo, commencing in the 1980s and climaxing in the late 1990s, placing Le Gray—on the basis of monetary value—quite far ahead of other photographers of his time.

Initial Public Successes

Even before 1856, the quality of his students and the commissions he received—from the Mission héliographique to the portrait of the prince-president—were sufficient proof of the reputation for skill that Le Gray had established for himself in Paris, particularly among the official elite of the fine arts. However, that recognition had its limits, as expressed by the reactions to the exhibition of his works at the Universal Exposition of 1855. The previously mentioned dismay of Paul Périer[2] was echoed by the reticence of critic Ernest Lacan (fig. 342). In the volume he devoted to the event,[3] this friend of Le Gray's sang the praises of his students, with various second-rate photographs, but granted the teacher scarcely a half page out of the 219. Perplexed, as were others, by what he saw—"Truthfully, I do not know into what category to place the prints by M. Gustave Le Gray"—Lacan seemed already to assign the artist a comfortable place, *inter pares*, in the pantheon of calotypists: "He has made a name for himself that will remain in the history of photographic progress" and "most of his prints will remain among the best that have ever been produced (fig. 339)."[4]

Everyone acknowledged the artist's eminent qualities, but how many understood that he had yet to demonstrate his full capabilities? He himself, absorbed as he was by his technical obsessions, presenting his calotypes at a time when glass-plate negatives were rapidly gaining in popularity, was scarcely concerned with proving

2 See the section headed "Science at the Expense of Art?" in S. Aubenas, "To Unite Science with Art" (this volume).
3 E. Lacan, *Esquisses photographiques à propos de l'Exposition universelle et de la guerre d'Orient* (Paris, 1856).
4 Ibid., 118.

339 Portraits of significant figures in the history of photography, including Le Gray (top center); illustration for article by F. Wey published in *Le Musée des familles*, 1853.

M. Francis Wey, M. Pitre-Chevalier et le docteur X.... sous le chêne de Marly-le-Roi. Dessin de G. Janet, d'après les photographies de M. Le Gray.

340 Illustration for article by F. Wey, "Comment le soleil est devenu peintre" (How the sun became a painter), 1853.

a superiority that seemed to him self-evident. Whether he had actually botched the exhibition or whether he was piqued by the comments that were made to him about it, his crucial decision to open a large studio on the boulevards, thereby placing his back against the wall, seemed to say, "Paris, I have arrived!" The following year, the tone of the comments ran the gamut from deferential praise to enthusiasm.

Le Gray owed an essential share of his success to the English public. It was in London in late 1856 that he showed his first seascapes, taken in the preceding months on the Normandy coast. That public gave him a triumphant welcome, especially for *The Brig*. On December 22, Murray and Heath, London merchants of photographic materials, placed the following advertisement in the *Journal of the Photographic Society:* "Le Gray's famous picture of SEA and CLOUDS, admitted to be the finest photograph yet produced.

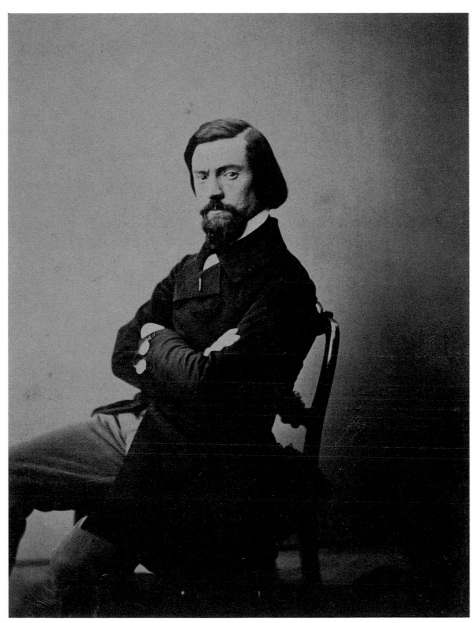

341 Gustave Le Gray. *Portrait of Pierre Michel François Chevalier, Known as "Pitre-Chevalier,"* ca. 1853 (cat. no. 22).

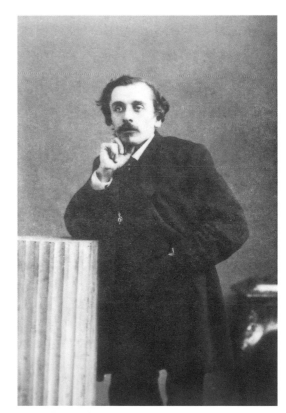

342 Eugène Disdéri. *Portrait of Ernest Lacan*, 1862.

5 Sixteen prints of *The Brig* have been found, which is consistent with the fact that this seascape is currently the most widespread.
6 M.-A. Gaudin, "1857–1858," *La Lumière* (January 2, 1858): 1.
7 A collection now held by the Bibliothèque nationale de France.
8 The one held by the Bibliothèque nationale de France is the copy that belonged to the comte de Montebello.
9 Musée d'Orsay, formerly in the Roger Thérond collection; see *Une Passion française: Photographies de la collection de Roger Thérond*, exh. cat. (Paris, 1999), 309. The photographers represented in the album include Graham, Robertson, and Ostheim.
10 *La fotografía en las colecciones reales*, exh. cat. (Madrid, 1999), 52–55.
11 See the pioneering article by N. Ramstedt, "An Album of Seascapes by Gustave Le Gray," *History of Photography* 4, no. 2 (April 1980): 121–37.
12 F. Dimond and R. Taylor, *Crown and Camera: The Royal Family and Photography, 1842–1910*, exh. cat. (London, 1987).
13 Ibid., 16–17.
14 Craven was a member of the Royal Photographic Society from 1855 through 1860 and exhibited there in 1855 and 1856. Regarding his life and his collection, see *The Craven Photographic Collection*, sale cat. (Exeter, Bearne's, May 6, 2000); it contains an interesting study by N. Chanan (ibid., 7–19).

Price 16 s[hillings]. 800 copies subscribed for in two months. Every photographer should order a copy."[5] Whether the figure of eight hundred orders was accurate or exaggerated (and whether or not it was limited to England), it is an eloquent measure of success—and of subsequent losses. Despite these, it is clear that the English infatuation with Le Gray left notable traces in collections.

His success was confirmed the following year with the second series of seascapes, taken in spring on the Mediterranean coast. One laudatory article appeared after another, evidence that devotees were scrambling for the prints. Marc-Antoine Gaudin, a photographer and owner of the periodical *La Lumière*, taking stock of the year 1857, concluded:

> With respect to great prints, the event of the year was the seascapes of M. Le Gray. M. Macaire had given us a few beginnings, but M. Le Gray was consummate from the very first. I say consummate because the sky, adorned with clouds, the fine distant silhouette, and the sailing or steam ships in full motion leave nothing to be desired.[6]

By the end of summer, Le Gray's success was crowned by the imperial commission for the camp at Châlons. The albums, a public sign of the favor the emperor accorded him, were distributed to all of the ranking officers and admired in the most upscale and exclusive salons by the very people who frequented the portrait studio on the boulevard des Capucines and who must also have purchased landscapes and especially seascapes.

This major official commission and the title of "Photographer to the Emperor," which Le Gray thenceforth put on his prints, contributed to establishing his renown and spreading his work among the French aristocracy and foreign courts. These same references undoubtedly worked in his favor, later on, in the Egyptian court, which was reputed to follow Parisian fashion avidly, and even blindly. In 1866 military photographs were his first commission from Ismaïl, before what would be Le Gray's swan song the following year in his voyage along the Nile.

The Collections of Princes and Wealthy Patrons

Evidently, nothing remains of the Le Gray works that were owned by Napoléon III. After the fires at the Tuileries and Saint-Cloud during the Commune of Paris, the only remains of the imperial photographic collections were the albums that were stored at the châteaus of Compiègne and Fontainebleau.[7] Even the presentation copy of the album of the camp at Châlons was lost.[8] There is no doubt the emperor also had possessed at least some seascapes at one or the other of the residences that burned. In fact, the seascapes were among the most frequently owned of Le Gray's works in other royal and princely collections. Acquired early on, they bear witness at the summit to an immense success, like the tip of an iceberg that has since mostly melted.

In this respect, the taste of the Orléans branch of the royal family coincided with that of the imperial Bonapartes. The duc de Chartres, the grandson of Louis-Philippe, on his return from traveling in the Near East in 1859–1860 with his brother, the comte de Paris, put together an album of 153 photographs to illustrate his itinerary. At the front of the album, he placed—as an invitation to the voyage—three seascapes by Le Gray, including *The Breaking Wave*.[9] Henri d'Orléans, the duc d'Aumale (who put together his well-known, prodigious art collections at Chantilly and then bequeathed them to the Institut de France) also amassed a photographic collection, with five of Le Gray's seascapes as its crowning jewels.

Fifteen of the seascapes (from Normandy and the Mediterranean) are found even in the royal Spanish collections—perhaps through the mediation of Empress Eugénie, who may have given some of them as gifts or extolled their merits.[10] Perhaps also associated with this collection is an extraordinary album conserved at the Art Institute of Chicago—probably also of Spanish provenance, as its title, *Vistas del mar* (Views of the sea), implies; originally composed of twenty-four views, today it contains fifteen.[11]

In England, where the seascapes met with such immediate success, they can be found today in several prestigious collections. It is thus not surprising to find in the royal collections (Windsor Castle) two views of the French and English fleets, decorated with flags, during the visit of the sovereigns to Cherbourg in August 1858.[12] It is also not surprising to come across *The Brig;* it was undoubtedly acquired in 1856 and is the print that was loaned in April 1857 by Prince Albert to the *Manchester Art Treasures Exhibition*, which he personally opened.[13]

The recently dispersed collection of William, earl of Craven (1809–1866),[14] offers a characteristic example of what could be collected by a wealthy aristocrat (who was, by the way, also an excellent amateur photographer). In addition to the photographs he

343 Gustave Le Gray. *The Prince of Wales and His Retinue, Cairo*, 1862 (cat. no. 199).

15 Haworth-Booth, "The Dawning of an Age: Chauncy Hare Townshend, Eyewitness," in *The Golden Age of British Photography, 1839–1900 . . .* (Millerton, N.Y., 1984), 11–21.
16 See the complete list in Haworth-Booth and McCauley, *Museum and the Photograph.*
17 C. Johns, *Sex or Symbol? Erotic Images of Greece and Rome* (London, 1982), 28–32.
18 The caption "Photographs from life, Paris 1863," certainly indicates the date when Witt obtained the print, since in 1863 Le Gray had already left the capital.
19 Cat. nos. 193–198.
20 This collection also includes, among others, Du Camp, Teynard, and Bedford.
21 Note that these prints are not in the royal photographic collections at Windsor. Thanks to Frances Dimond for this information.
22 "Séance de la Société héliographique du 21 mars 1851," *La Lumière* (March 30, 1851): 30.
23 On Clausel, see Lacan, *Esquisses photographiques,* 113–14.
24 Included in it are also works by Paul Berthier and Georges Balagny.

himself took between 1855 and 1857—the most remarkable of which are landscapes and studies of trees and gardens—he put together at about the same time a very interesting collection. Before its recent dispersal, the collection contained prints by Frederick Scott Archer, Roger Fenton, Charles Marville, and Olympe Aguado—again, landscapes, trees, and skies—but especially of interest here, it also contained nine seascapes by Le Gray: three taken in Normandy, including *The Brig;* two of the Sète coast, including *The Breaking Wave;* and, finally, four views of the Franco-British meeting at Brest and Cherbourg.

Another vestige of English enthusiasm is the collection of the extremely wealthy dilettante and art lover Chauncy Hare Townshend (1798–1868), collected between 1855 and 1860 (during the same period that Craven was collecting) and bequeathed to the Victoria and Albert Museum,[15] along with his collections of gems, coins, and paintings. It includes, among others, views of the Crimean War by Fenton, landscapes by Camille Silvy and André Giroux, and, most important, a magnificent selection of works by Le Gray: thirteen seascapes and four views of the forest of Fontainebleau from paper negatives,[16] as well as a view of the Richelieu pavilion of the Louvre. A parallel should be drawn between the subjects of these photographs—landscapes and seascapes—and several paintings by painters such as Théodore Rousseau, Alexandre Calame, Eduard Schleich, and François Louis David Bocion that were also bequeathed by Townshend. Even more than an amateur photographer like Craven, Townshend the art lover provides a perfect example of the purchases that may have been made by his peers during the period when Le Gray was most in vogue on the British side of the Channel.

And then there was Dr. Witt's collection of antique erotica,[17] now held by the Department of Medieval Art at the British Museum. In addition to objects, there are several albums of engravings; in the last of these, facing Ingres's *The Source* engraved by Léopold Flameng, is an academic nude by Le Gray after an Italian model. The print was clearly selected for its pose, which echoes that of the nymph.[18]

Even after Le Gray moved to Egypt, the favor of English princes followed him, as shown by five previously unknown leaves acquired in 2001 by the Bibliothèque nationale de France;[19] they had been part of the important Near Eastern photography collection[20] amassed by Prince Philippe of Belgium, the Count of Flanders

(1837–1905), third son of King Léopold I. They consist of a view of the port of Beirut and three photographs of Egypt (Cairo and Alexandria), plus an album page of other Egyptian images, but in small format. One of the photographs of Cairo, taken in the spring of 1862, depicts the Prince of Wales and his retinue (fig. 343). The prince was traveling through the Near East, accompanied by his own photographer, Francis Bedford, who took numerous views there. However, Le Gray's reputation among the English was such that they wished to commission this group portrait when they passed through and bought several other prints from him. Then, after his return home, the Prince of Wales made a gift of them to the Count of Flanders.[21]

"The Desire that Has Become General to Possess Beautiful Prints"[22] In addition to the royal courts and the powerful people, art lovers and artists (painters, architects, and photographers) constituted a much larger and more diverse clientele. While impromptu buyers have proved almost entirely elusive, others accumulated notable collections that have been preserved intact. Here are just a few examples that show that, regardless of the individual orientation of each collection, seascapes are rarely absent.

Of all the private collections of prints by Le Gray, the most important that survives was put together by Clausel,[23] a photographer from Troyes (who was often in Paris). The collection consists of seventy-one seascapes and views of the camp at Châlons, now in the Musée des beaux-arts in Troyes (fig. 338). An excellent practitioner, interested in technique, Clausel selected, from the two series, not only the most popular views but also views that are otherwise unknown. There is no doubt that he contacted Le Gray personally to obtain such a variety of prints.

The collection of architect Alfred Armand (1805–1888) was of another sort altogether. These eighteen thousand images, bound into 230 volumes and classified by themes, were intended to document an encyclopedic history of art. The project, inspired by his friend His de La Salle, was never completed, but Armand bequeathed his collection to the prints department of the Bibliothèque nationale. Forty-two prints by Le Gray have been identified in it, essentially seascapes and views of Paris and the camp at Châlons. The views of Paris were filed under contemporary architecture, and the others were part of a volume devoted to French and Italian landscapes.[24] While the pieces collected by Armand—

engravings, drawings, and photographs—were primarily reproductions of all art categories, this last volume contained only photographs depicting actual sites in nature, in other words, from a modern perspective, not reproductions, but works of art in their own right.

Other architects were interested in views of the capital, but without limiting themselves to that subject. Jean Résal (1854–1919), architect of the pont Alexandre III, owned works by various photographers, including some by Le Gray: two panoramic views of Paris with the passerelle des Arts (footbridge of the arts), as well as one of the seascapes of the coast at Sète.[25]

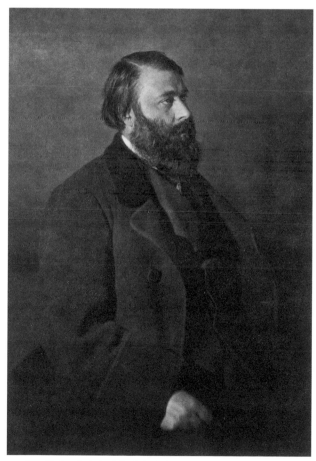

344 Félix Nadar. *Portrait of Martin Laulerie*, ca. 1855–1860.

Finally, there are traces of several otherwise unknown purchasers and owners. In the collection of the late Roger Thérond is a very large album of twenty-four leaves in which four Le Gray seascapes can be found next to portraits by Pierre Petit and architectural views by Baldus and the Bisson brothers. As for the purpose of this handsome album, it is known only that it was a gift for a girl or a woman, since the flyleaf bears the dedication "To my dear Marie, Xber [December] 1859," followed by an as-yet-unidentified signature.

In other cases, the motivations are clearer, as are the intermediary suppliers—a role notably played by the Société française de photographie. In early 1857 a M. Romberg of the Association for the Encouragement and Development of the Industrial Arts in Belgium sent two letters in succession to Martin Laulerie (fig. 344), secretary of the Société. The first was a request to ship him the recently exhibited "handsome print of the *Brig*" to "use it to enrich [his] gallery." The second, shortly thereafter, requested another for his brother.[26] These two collectors were following their taste as well as fashion; it is probable that, at first, they knew *The Brig* only by reputation. This is even clearer for another correspondent, a M. du Puymontbrun, who wrote from Toulouse. Having purchased several prints (including a view of the pont du Gard and a study of a tree) from the sale held by the Société française de photographie on June 5, 1857, at the Hôtel Drouot, he was vexed to find that the seascape had been omitted from the shipment. "Having read in the review by the *Moniteur* [*de la Photographie*] the highest praise of that admirable print, I am unfortunate indeed that it is the very one that is missing."[27]

In addition to individual seascapes, the works of Le Gray, celebrated for their intrinsic beauty, found themselves in the company of a wide variety of prints, with no single theme, in eclectic albums owned by all sorts of art lovers. Thus, the Dutchman Willet, who lived for several years in Paris, also owned a collection of seascapes, landscapes, and views of Fontainebleau by Le Gray (figs. 134, 242, and 345), alongside photographs by Bisson, Brébisson, Aguado, Nadar, Marville, Robertson, and others.[28]

In the Portfolios of Painters

Le Gray's natural customers, so to speak, as well as those of other photographers, regardless of whether they specialized in documentation for artists, were painters and, to a lesser extent, sculptors. It

25 A gift by the architect's family in 1922 to the Institut catholique, included, among others, handsome works by Baldus, Bisson, Marville, and Collard. Yves Lebrec kindly provided this information.
26 Letters dated January 7 and April 29, 1857.
27 Letter from M. du Puymontbrun (written after June 5, 1857), Archives of the Société française de photographie. Le Gray was probably also the author of the mentioned photographs of the pont du Gard (Mission héliographique) and of the tree. At that same sale (Paris, Hôtel Drouot, June 5, 1857), another Le Gray print was purchased by Alphonse Davanne.
28 Deepest thanks to Mattie Boom for informing us of this collection conserved at the Willet-Holthuysen Museum in Amsterdam.

345 Gustave Le Gray. *View of a Park*, ca. 1856.

would be nice to know more about them, but it is very difficult to identify them from the scraps of information that may indicate the provenance of a print. Jean-Léon Gérôme, Le Gray's classmate from Delaroche's studio, must have possessed a number of his photographs in the late 1840s, but there is no trace of them.[29] The Swiss painter Zuber-Buhler (1822–1896), who lived in Paris, possessed views of the forest of Fontainebleau (fig. 264).[30] Four other views of Fontainebleau belonged to the American painter Charles Henry Miller (1842–1922), who sojourned in Europe, specifically in Barbizon, between 1867 and 1870 (fig. 54).[31] Another significant collection that has just recently been discovered, consisting of ten prints (six views of the forest of Fontainebleau, two of the camp at Châlons, and two seascapes), belonged to the painter and director of the École de dessin, Horace Lecoq de Boisbaudran (1802–1897; fig. 268);[32] it is no accident these prints were among the reference materials of an artist whose teaching placed the greatest emphasis on the observation of nature and drawing from memory.

It would be possible to cite many more names, but the contents of the portfolios are still difficult to specify; while in the past sale catalogues of the contents of studios accurately described paintings, drawings, and engravings, photographs were relegated to last place and sold in lots with no descriptions, and sometimes without even being distinguished from miscellaneous papers. Conversely, current catalogues give photographs their due but often do not specify their provenance other than by mentioning that they were part of the estate of a painter.[33] The collection of the Musée Ingres contains photographs by Le Gray (representations of paintings by Ingres and views of Fontainebleau), but it is not known if they belonged to Ingres himself or to his friend, the collector Édouard Gatteaux.[34] As for the aggregations assembled by Cogniet,[35] Delacroix,[36] Courbet, and Delaroche, the portion devoted to photography is even more difficult to determine. It is possible only to suppose that, if a painter like Ingres, who was in principle not very interested in photography, made considerable space for it in his portfolios, there is all the more reason for Courbet, whose seascapes show such kinship with those by Le Gray, to have amassed a much larger number of prints.[37]

Le Gray, a Photographic "Must Have"
The history of photography, the writing of which commenced in the first third of the twentieth century, little by little gave Le Gray

his rightful place, first as an inventor and a technician, and then as an artist. The generation of collectors who were collecting then (a subject painstakingly studied by Anne de Mondenard)[38]—that of Gabriel Cromer, Victor Barthélemy, Albert Gilles, and Georges Sirot, to name just the main ones—had such an abundance of photographs to choose from between the two wars that, in the elation of discovery, they accumulated the best and the less good without distinction, having no systematic method or reference works to guide them. Collectors were focusing not yet on the individual artists, but rather on photographic representations of the fascinating nineteenth century. Thus, while the works of Le Gray were plentiful in the collections of Cromer and Sirot, this should probably be attributed not to particular tastes, but rather to the luck of the collection process.

As for institutions, the Bibliothèque nationale de France, which now owns several hundred works by Le Gray, did not show any particular interest in him until the latter half of the twentieth century, when it got into the more frequent habit of acquiring pieces based on their beauty or their rarity. The works that entered the collections in this manner nevertheless remain a minority in comparison to those acquired by being filed for copyright and from private collections, both old and recent, whether especially devoted to photography (Sirot and Cromer) or more general in nature (Armand, Le Senne, Blondel, Prisse d'Avennes).

The first critical collectors were, no doubt, André and Marie-Thérèse Jammes, who applied to photography a method, sensitivity, and visual cultivation acquired from the antiquarian book trade.[39] Assiduous reading of the periodical *La Lumière* taught them the importance of Le Gray in his time. A portion of their collection was sold to the J. Paul Getty Museum in 1984 and was further dispersed in London in 1999 and in Paris in 2002. It included some of the most splendid known prints, in particular *The Great Wave, Sète* and *The Beech Tree,* but also earlier prints with less immediate appeal—views from Fontainebleau and from the Mission héliographique. Unlike their predecessors, they took an interest in all aspects of what was revealing itself to be a body of work; the beginning of this oeuvre especially attracted their attention.

Roger Thérond, in his very personal and eclectic collection, accorded a special place to the works of Le Gray. A native of Sète, this mogul of the press, the editor of *Paris-Match,* was sensitive to the fact that many of these masterful seascapes had been taken in

29 Thanks to Gerald Ackerman and Hélène Lafon-Couturier for their assistance with this research.
30 Now at the Bibliothèque nationale de France. They bear the seal of the posthumous sale of his studio (Paris, Hôtel Drouot, March 18–19, 1897). Characteristically, the catalogue does not mention photographs, which must have been included in miscellaneous lots of studio equipment.
31 See P. Cava, "Early Landscapes by Gustave Le Gray," *History of Photography* 2, no. 4 (October 1978): 274.
32 See Millon & associés, *Photographies de Gustave Le Gray . . .,* sale cat. (Paris, Drouot-Richelieu, December 3, 2001). Unfortunately, it is impossible to know whether this set constituted Lecoq de Boisbaudran's entire collection or only the remnants.
33 Thus *Brig on the Water,* sold by Christie's in London on October 19, 1994 (cat. no. 111) apparently belonged to "a student of Ingres."
34 Deepest thanks to Georges Vigne and Florence Viguier for their assistance in studying the collection of the Musée Ingres.
35 An examination of the Léon Cogniet collection at the Musée des Beaux-Arts d'Orléans provided no results, even though Cogniet subsidized the photography studio of his student Louis-Camille d'Olivier.
36 S. Aubenas, "Les Photographies d'Eugène Delacroix," *Revue de l'art,* no. 127 (2000): 62–69.
37 All that is known about Courbet's collection is compiled in D. de Font-Réaulx, "Courbet et la photographie: L'Exemple d'un peintre réaliste, entre vérité et réalité," in *L'Art du nu au XIXe siècle: Le Photographe et son modèle,* ed. S. Aubenas, exh. cat. (Paris, 1997), 84–91.
38 A. de Mondenard, "La Ronde des collectionneurs," in *Passion française: Collection Thérond,* 17–40.
39 P. Garner, "A Magnificent Obsession," in *La Photographie: Collection Marie-Thérèse et André Jammes,* sale cat. (London, Sotheby's, October 27, 1999), 6–9.

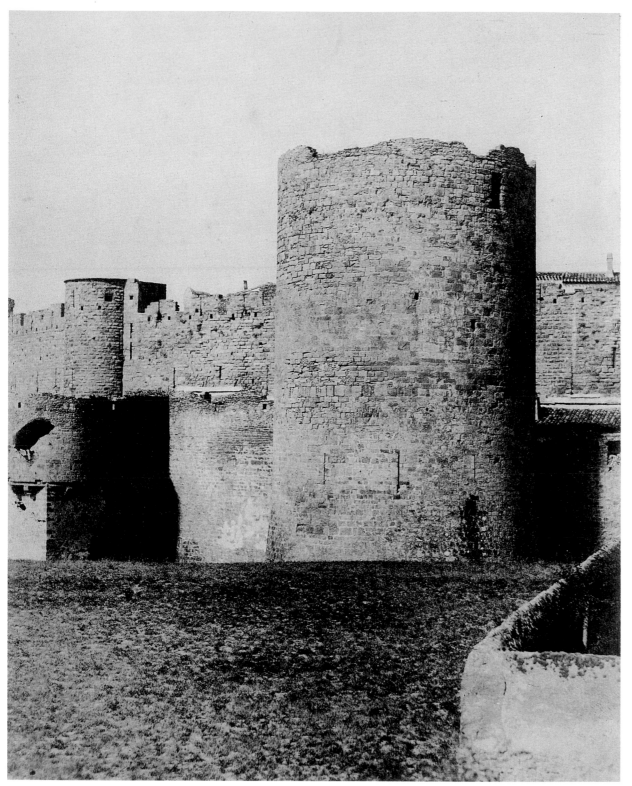

346 Gustave Le Gray. *Ramparts with Tower, Carcassonne* (detail), 1851 (cat. no. 56).

his native town. But other works by Le Gray from his beginnings through the Egyptian period also appear in the collection he formed.

The 1980s were a turning point. The Galerie Texbraun, founded by François Braunschweig and Hugues Autexier, placed an emphasis on Gustave Le Gray and thus greatly contributed to making him known to a greater number of collectors, especially Americans such as Sam Wagstaff, Suzanne Winsberg, and Pierre Apraxine (curator of the collection of Howard Gilman). New photography departments were founded; those of the Musée d'Orsay (as of 1976), the J. Paul Getty Museum (1984), and the Canadian Centre for Architecture (1978) acquired major works. Before the end of the 1980s, as an outgrowth of the research conducted by the Jammeses, by François Lepage, and by Nils Ramstedt, a first monographic exhibition was held at the Art Institute of Chicago and then in an abridged version at the Musée d'Orsay, accompanied by a brilliant essay by Eugenia Parry Janis on the artist's life and work.[40]

In the 1990s a third generation of collectors came into its own, granting a quintessential place to Le Gray. After Manfred Heiting, Ezra Mack, Michael Wilson, Michael Sachs, and Howard Stein came Sheikh Al-Thani, nephew of the emir of Qatar, who acquired the most beautiful pieces from the Jammes collection for unprecedented sums of money. Le Gray made a fleeting appearance on the front page of some of the major newspapers. His revived fame, continually covered in the press, has come primarily from the regular appearance of exceptional works and hitherto unknown images.

Thus, a sustained excitement has arisen about an artistic personality that is defining itself in the wake of new discoveries. From this point of view, the case of Le Gray is the reverse of that of Nadar, whose best work is both already known and practically absent from the market.[41]

At the time of this writing, the same great works that were extolled during the reign of Napoléon III were again being regarded as the quintessence of Le Gray's art. But appreciation for the more difficult images—which did not elude the historian sensibility of the Jammeses or the sensitive eye of Roger Thérond—has been more widespread due to the formative influence exerted on the visual cultivation of collectors by the particular aesthetic sensitivity of the founders of the Galerie Texbraun. They knew that to avoid drowning in the sea of photographic images bequeathed by the nineteenth century, it was necessary to invent reference points different from those used by art historians. With this intuition, they applied subjective criteria to the evaluation of photographic excellence, fostered by every aesthetic current but transcended by personal taste and unparalleled curiosity.[42] This conception, combining a liberated aesthetic with high standards for print quality, now inspires collectors and curators alike. These criteria always find fulfillment in the work of Le Gray, an artist who was simultaneously classical in his sources, a forerunner in his choice of certain subjects, impeccable in his chemistry, and always surprising in his tireless exploration of the beauties of photography.

40 E. P. Janis, The Photography of Gustave Le Gray, exh. cat. (Chicago and London, 1987).
41 Nadar is actually known almost entirely from his studio archive, which was the source of the works held at the Bibliothèque nationale de France (prints and studio records), the Archives photographiques du patrimoine (negatives), and others, an archive that was broken up before the majority was acquired by the Musée d'Orsay, the City of Paris, and the J. Paul Getty Museum. If scarcely any prints have been found from past private collections, despite the large numbers that were sold, this is undoubtedly primarily due to the deterioration of portraits from prolonged exposure in frames. Likewise, the known portraits by Le Gray are quite rare in proportion to his production.
42 Thanks to Suzanne Winsberg, who inspired this evocation of the Galerie Texbraun.

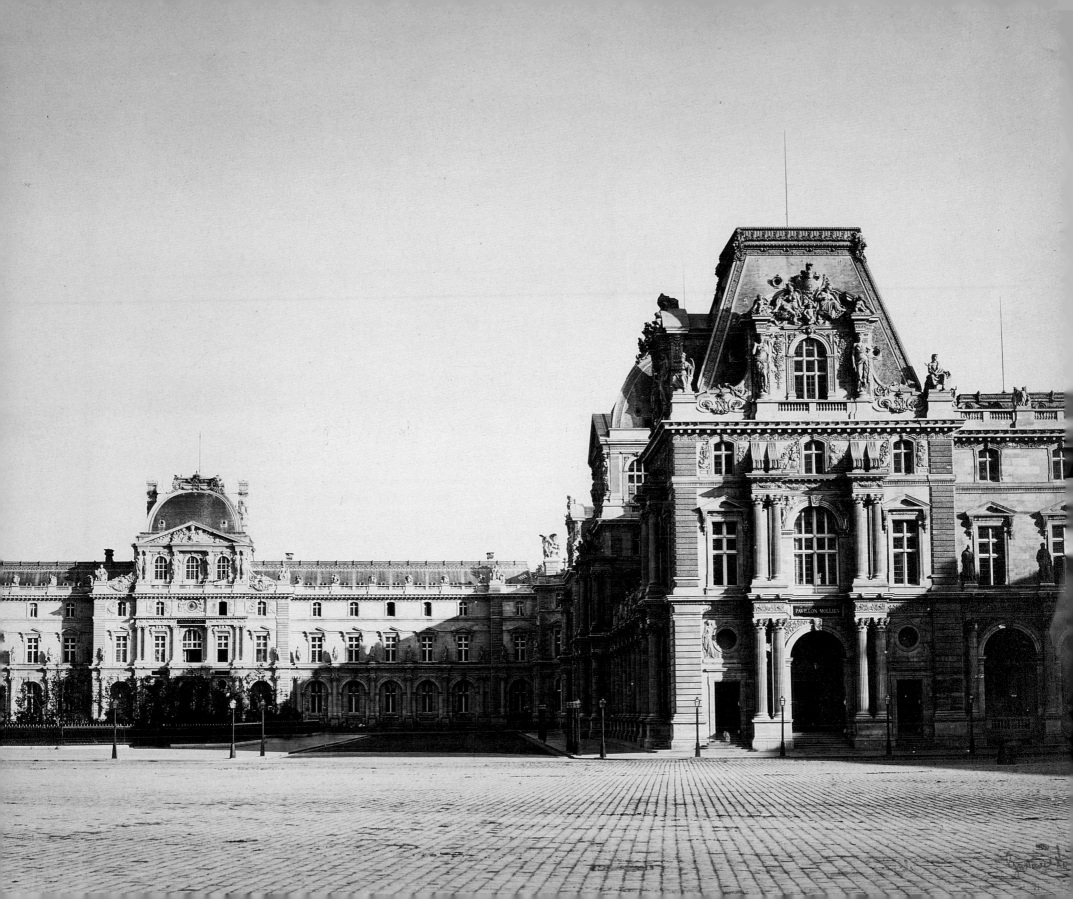

347 Gustave Le Gray. *Mollien Pavilion, the Louvre*, 1859 (cat. no. 178).

Chronology

Sylvie Aubenas

1813

June 5: Birth of Édouard Baldus.

1817

December 17: Birth of Firmin Eugène Le Dien.

1818

August 18: Birth of Henri Le Secq.

1820

April 6: Birth of Félix Tournachon, known as Nadar.

May 9: Birth of Charles Nègre.

August 30: Birth of Jean-Baptiste Gustave Le Gray, son of Jean-Martin Legray (ca. 1770–1855) and Catherine Eulalie Gay (1785–1861), in Villiers-le-Bel.

1823

March 23: Birth of Palmira Maddalena Gertrude Leonardi in Rome.

1839

July 26: Le Gray receives his bachelor's degree.

August 19: François Arago announces the invention of the daguerreotype by Louis Jacques Mandé Daguerre before a joint session of the Académie des sciences and the Académie des beaux-arts.

1840-1841

Le Gray is a clerk in the notary office of Edme Lechat in Villiers-le-Bel.

1842

Le Gray leaves Villiers-le-Bel and moves into 170, rue du Faubourg-Saint-Denis. Becomes a student of Paul Delaroche, along with Le Secq and Nègre.

February 24: Le Gray requests a copyist's pass to the Louvre.

1843

June: Le Gray leaves Paris for Italy, traversing Switzerland on foot.

October–November: Sojourns in Florence.

November: Delaroche arrives in Rome.

November 24: Jean-Léon Gérôme arrives in Rome.

1844

January 18: Le Gray arrives in Rome.

January 19: Requests visa for Naples.

February 11: Returns to Rome.

May 12: Marries Palmira Leonardi in the church of San Giacomo in Augusta.

October 17: Le Secq arrives in Rome.

1845

June 4: Birth of Elvire Françoise Eulalie (d. 1858), Le Gray's first child.

July 7: Le Gray and his family depart for France.

July 21: Le Gray family arrives at the home of his parents in Villiers-le-Bel.

September 3: Le Gray borrows five thousand francs from Louis Girault, pharmacist in Paris and property owner in Villiers-le-Bel.

September 23: Le Gray's marriage legalized at the town hall of Villiers-le-Bel.

October: Le Gray and his family depart for Rome.

October 28: Le Gray family arrives in Rome.

December 15: Léon Gérard arrives in Rome.

1846

January 25: Le Dien arrives in Rome.

February 23: Gérard and Le Dien depart for Naples.

August 2: Birth of Elvire Mathilde Julie Miriam (d. 1849), Le Gray's second child.

1847

March 9: Final departure of Le Gray and his family for Paris.

Spring: Le Gray and Arago attempt to make daguerreotypes of sunspots.

November: Le Gray and his family are living at 27, quai des Grands-Augustins. He applies for a copyist's pass to the Louvre, still identifying himself as a student of Delaroche's.

1848

Le Gray assiduously practices photography on daguerreotype plates and on paper and makes his first attempts with collodion on paper.

February 10: Registers as a reader at the prints department of the Bibliothèque royale.

February 22: Submits two paintings to the Salon jury, both refused.

February 24: Second Republic proclaimed.

February 29: The director of the Louvre decides that everything submitted to the Salon jury is to be accepted.

March 15: Opening of the Salon, which includes the two paintings by Le Gray.

After March 15: Le Gray makes a daguerreotype of a painting by Gérôme, *Anacreon, Bacchus, and Cupid,* also exhibited at the Salon.

May–June: Le Gray makes daguerreotype portraits as well as portraits on paper.

June 10: Le Gray, Le Secq, and Mestral photograph one another.

June 23–26: "June Days," insurrection in Paris.

1849

Le Gray and his family move to 110, rue de Richelieu.

April 17: The painter Boissard de Boisdenier moves to 7, chemin de ronde de la barrière de Clichy.

June 4: Opening of the eleventh National Exhibition of Agricultural and Industrial Products, in which Le Gray receives a bronze medal for his prints on paper. (Not all of the exhibitions in which Le Gray showed are named here. See the catalogues listed in "Printed Sources.")

June 15: Opening of the Salon, to which the daguerreotypist Gouin had submitted five daguerreotype portraits, all rejected.

August: Le Gray makes a portrait of Léon de Laborde, to whom he is teaching photography. Cholera epidemic in Paris.

September 6: Death of Julie Octavie (date of birth unknown), Le Gray's third child.

September 10: Death of Elvire Mathilde Julie Miriam Le Gray, age three.

September–October: Le Gray gives photography lessons to Maxime Du Camp.

September–October: Le Gray takes his first photographs in the forest of Fontainebleau, in the company of Nègre.

November 11: Le Gray receives a bronze medal for his prints on paper at the National Exhibition of Agricultural and Industrial Products.

End of year: Le Gray and his family move to 7, chemin de ronde de la barrière de Clichy.

1850

Le Gray figures in the *Bottin* (annual trade directory) as a painter of miniatures, 110, rue de Richelieu (an outdated address).

Le Dien, on leave from the bench in Algiers, probably frequents Le Gray's studio.

January: Le Gray experiments with collodion-on-glass photography.

June: Publication of his *Traité pratique de photographie sur papier et sur verre* (Practical treatise of photography on paper and on glass, 1st ed.).

October 30: Deadline for repayment of the five thousand francs that Le Gray borrowed in 1845 is extended until December 3, 1855.

December 12: Salon jury refuses a group of nine photographs mounted in a single frame submitted by Le Gray.

December 30: Opening of the Salon, of which Le Gray made at least one view.

End of year or early 1851: Begins to experiment with waxed-paper negatives.

1851

January: Establishment of the Société héliographique (Heliographic Society).

January 10: Le Secq is appointed to the Mission héliographique (a photographic expedition to survey architecture).

January 17: Mestral and Baldus are appointed to the Mission héliographique.

February 9: First issue of the photography periodical *La Lumière.*

February 25: Le Gray deposits a sealed envelope containing a description of his waxed-paper process with the Académie des sciences.

February 28: Le Secq and Hippolyte Bayard are appointed to the Mission héliographique.

March 9: Birth of Romain Gustave Alfred, Le Gray's fourth child.

April 3: Le Dien resigns from the bench before returning to Paris.

April 18: Le Gray reveals his waxed-paper process to the Société héliographique.

April 20: Du Camp returns to Paris after traveling in the Near East for a year and a half and gives his negatives to Le Gray for printing.

May 9: Le Gray and Mestral are added to the list of photographers appointed to the Mission héliographique.

Spring: Le Gray exhibits two sets of nine prints each, mounted in two frames, at the Universal Exposition in London.

July: Le Gray and Mestral depart for the Mission héliographique.

Publication of Le Gray's *Nouveau traité théorique et pratique de photographie sur papier et sur verre* (New theoretical and practical treatise of photography on

paper and on glass, 2nd rev. ed. of *Traité pratique de photographie*).

Late September: The first prints by Le Gray and Mestral for the Mission héliographique appear in Paris.

October: Le Gray and Mestral return to Paris. They meet Roger Fenton and show him their negatives.

November 17: Le Gray deposits a sealed envelope containing a text about "positive prints on paper with extremely varied coloration and greater stability" with the Académie des sciences.

November 26: Du Camp shows his photographs of Egypt to Louis-Napoléon Bonaparte.

December 2: Coup d'état of Louis-Napoléon Bonaparte.

December 8: Le Gray applies for a patent for his invention of "a kind of prepared paper for photography." The sealed envelopes deposited on February 25 and November 17 are opened and the texts are read to the Académie des sciences.

1852

Benjamin and Édouard Delessert frequent Le Gray's studio.

March: Le Gray submits a painted portrait and three photographs to the Salon jury: two views taken for the Mission héliographique and the portrait of Le Secq. All four works are refused.

Spring–summer: Le Gray photographs in the forest of Fontainebleau, in the company of J. B. Greene.

April 1: Opening of the Salon, in which Le Gray takes a series of views at the request of Philippe de Chennevières.

April 5: The comte de Nieuwerkerke, minister of arts, favorably recommends Le Gray to Count Baciocchi.

May 10: Le Gray photographs the Distribution of Eagles ceremony on the Champ-de-Mars.

Summer: Makes a photographic portrait of Louis-Napoléon Bonaparte.

September 8: Le Gray and Mestral invoice the commission des Monuments historiques for the 120 negatives and 120 prints for the Mission héliographique.

September 12: Le Dien, Alexandre de Vonne, and Léon Gérard arrive in Rome.

Autumn: publication of *Photographie: Nouveau traité théorique et pratique . . .* (3rd ed.).

In the company of Greene, Le Gray photographs bas-reliefs by Rude and Cortot on the Arc de Triomphe.

October 16: In the company of Bertsch and Lerebours, Le Gray photographs the ceremonies occasioned by the return of the prince-president to Paris at the porte Saint-Martin and the place de la Concorde.

December 2: Second Empire established.

December: Le Gray shows work in the exhibition of the Society of Arts in London, notably prints for the Mission héliographique.

End of year or early 1853: Photographs the cartoons for Henri Lehmann's paintings for the galerie des Fêtes at the Hôtel de Ville.

1853

March 25: Le Gray sells, through Lerebours, the views he took on May 10 and October 16, 1852, to the Ministry of State.

Considers transforming his studio into a photographic printing establishment.

April 15: Sells several prints of the portrait of the emperor, of Rude's relief on the Arc de Triomphe, and of the stair of the château de Blois (from the Mission héliographique) to the Ministry of State.

May: The dealer Goupil includes the portrait of Napoléon III by Le Gray as well as "sites, monuments, landscapes, seascapes, general views and details of gothic architecture, etc., by MM. Le Secq, Le Gray, and the most eminent photographers" in his sales catalogue of prints. Théophile Silvestre commissions photographs of several paintings (Corot, Courbet) to serve as illustrations in his *Histoire des artistes vivants* (History of living artists).

May 24: Le Gray shows prints of "gigantic proportions" to a gathering at the residence of Ernest Lacan.

July 23: Théophile Silvestre announces the publication of his *Histoire des artistes vivants* in *La Lumière,* listing Le Gray among the photographers he is going to include (which, in fact, he does not).

September 17: Le Dien returns to Rome after a sojourn of several months in Naples and Pompeii.

December 10: The studio and activities of Le Gray are described in *La Lumière.*

December 18: Birth of Berthe Lodoïska Palmyra, Le Gray's fifth child (date of death unknown, but prior to 1860) at 7, chemin de ronde de la barrière de Clichy. Witnesses: the painters Lodoïsch Crette Romet and Léon Delaporte.

1854

In the annual trade directory (Bottin): "Le Gray, history painter and photographer, portraits on paper, reproductions of paintings, views of France and art objects, photography lessons, chemin de ronde de la barrière de Clichy, 7" (entry repeated in the 1855 directory).

January: Mestral exhibits views for the Mission héliographique at the exhibition of the Photographic Society of London, notably a view of the stair at the château de Blois.

February–March: Lehmann publishes his paintings for the Hôtel de Ville in a set of fifty-six photographs by Le Gray. Price: 300 francs.

June: Publication of Le Gray's *Photographie: Nouveau traité théorique et pratique . . .* (4th and final ed.). The chapter devoted to collodion is particularly extensive.

August 23: Le Gray belongs to a commission charged with drafting statutes for the future Société française de photographie (French Photographic Society, hereafter abbreviated SFP).

November 15: Establishment of the SFP. Le Gray sits on its administrative committee.

1855

January 10: The administrative committee of the SFP decides to organize an exhibition of photographs.

January 26: Death of Jean-Martin Legray, Le Gray's father, at 7, chemin de ronde de la barrière de Clichy.

March 2: Le Gray signs off on proposed changes to the statutes of the SFP.

May 15: Opening of the Universal Exposition in Paris. Le Gray exhibits in the photography section.

August 1: Opening of the first exhibition of the SFP in its rooms at rue Drouot (no catalogue). The prints are for sale.

October 1: Establishment of the corporation Gustave Le Gray et Cie, presumably by private agreement, with Barnabé Louis Gabriel Charles Malbec de Montjoc, the marquis de Briges, silent partner.

October 18: The baronne de Parazza leases the studio at 35, boulevard des Capucines to the marquis de Briges in his capacity as silent partner. Le Gray retains the laboratory and residence at 7, chemin de ronde de la barrière de Clichy.

November 15: Closing of the Universal Exposition, where Le Gray was awarded a first-class silver medal.

November: Le Gray reaches an agreement with his student Léon Méhédin, in the Crimea, to obtain views of the war there. Colonel Langlois, Méhédin's employer, objects.

Late 1855–early 1856: Le Gray completes the outfitting of his new studio at his own expense.

1856

In the annual trade directory (Bottin): "Le Gray, history painter and photographist [*sic*], portraits on paper, reproductions of paintings, views of France and art objects, photographic printing works, photography lessons, chemin de ronde de la barrière de Clichy, 7."

January: The Bisson brothers, backed by the industrialist Dollfus, open a studio at 35, boulevard des Capucines.

April 12: *L'Illustration* devotes a long article to Le Gray's new studio.

Summer: Le Gray travels in Normandy; first seascapes, including *The Brig,* and sky studies.

August 23: Le Gray's works included in an exhibition at the Musée des beaux-arts in Brussels organized by the Association for the Encouragement and Development of the Industrial Arts in Belgium.

September: Le Gray's studio gains a "boudoir photographique en plein air" (an open-air photographic boudoir).

November 6: *The Brig* is presented at a meeting of the Photographic Society of London.

December 17: *The Brig* is shown at the exhibition of the Photographic Society of London.

December 22: London dealers Murray & Heath, who are offering prints of *The Brig* for sixteen shillings, indicate that they have already received eight hundred orders.

December: Closure of the exhibition in Brussels, where Le Gray was awarded a medal.

1857

In Bottin's annual trade directory: "Le Gray (Gustave) et Cie. History painter and photographer, portraits on paper without retouching and in watercolor, reproductions of paintings, views of France and art objects, fabrication and sale of collodion and iodized waxed paper, boulevard des Capucines, 35; photographic printing works, chemical works, chemin de ronde de la barrière de Clichy, 7" (entry repeated through 1859).

Early January: Opening of the second exhibition of the SFP. Le Gray exhibits

The Brig and a positive print on glass of the same work.

April 2: Le Gray photographs the inauguration in Toulouse of the Toulouse-Sète section of the Bordeaux-Sète railway line. He then makes a view of the railway station at Sète, many views of the port, and some seascapes, including *The Great Wave* and *The Breaking Wave*.

April 17: Death of the marquis de Briges.

May 5: Prince Albert inaugurates the *Exhibition of Art Treasures of the United Kingdom* in Manchester. Three seascapes by Le Gray are exhibited, one of which belongs to the prince.

June 5: Photographs from the collection of the SFP are auctioned at the Hôtel Drouot. Estimates are between 7.5 and 10 francs for Le Gray's large views and between 4.5 and 6 francs for his small views.

August 19: The sons of the marquis de Briges, Marie Antoine Albert Malbec de Montjoc, the new marquis, and Ernest Charles Malbec de Montjoc, the comte de Briges, renew the silent-partner agreement with a new contract, registered August 28 at the tribunal de commerce, for 100,000 francs. The duration of the corporation is fixed at twenty-five years, starting with October 1, 1855.

September 7: Birth of Émile Eugène Le Gray, sixth child of Le Gray (according to E. P. Janis).

September: Napoléon III commissions Le Gray to document the inauguration of the military camp at Châlons-sur-Marne.

December 12: Le Gray's works included in the second exhibition of the Photographic Society of Scotland, Edinburgh.

1858

January 13: Le Gray deposits a sealed envelope at the Académie des sciences containing a description of the gold-chloride process for toning albumen prints.

February: Le Gray's works included in the exhibition of the Photographic Society of London.

March: Le Gray's works included in the exhibition at the Crystal Palace in Sydenham.

March 15: Le Gray photographs a solar eclipse.

May: Benefit auction of photographs for the SFP, to which Le Gray contributes some seascapes and some views of the camp at Châlons.

May 20: Photographic Society exhibition is repeated in galleries on New Coventry Street.

July 27: Death of Elvire Françoise Eulalie Le Gray in Villiers-le-Bel, age thirteen.

Late July–early August: Le Gray travels to Normandy and Brittany (Cherbourg and Brest) to photograph the visit of the English sovereigns.

September: Le Gray vacations in Ville-d'Avray with his artist friends.

November: Le Gray's works included in the exhibition of the Photographic Society of Birmingham.

December: Le Gray's works included in the third exhibition mounted by the Photographic Society of Scotland, Edinburgh.

1859

Le Gray shows views of Paris in the exhibition of the British Association for the Advancement of Science in Aberdeen, Scotland. Seascapes are included in the exhibition of the Photographic Society of Glasgow.

January: Opening of the sealed envelope deposited on January 13, 1858, at the Académie des sciences.

April 15: Opening of the third exhibition mounted by the SFP at the Palais des Champs-Élysées. Le Gray sits on the jury and exhibits many works.

December: Photographs Alexandre Dumas.

1860

Some seascapes by Le Gray are presented in an exhibition of photographs in Amsterdam.

January 5: Léon Maufras publishes an article on Le Gray in *Le Monte-Cristo* in the form of an obituary.

February 1: The firm of Gustave Le Gray et Cie is dissolved.

Around February: Le Gray moves to 15, rue Saint-Lazare.

February 16: For the first and last time, Le Gray deposits photographs (two seascapes and two views of the camp at Châlons) with the dépôt légal de la Seine (legal depository of the Seine).

April 1: Nadar signs a twenty-three-year lease for his studio at 35, boulevard des Capucines.

May 9: Alexandre Dumas's schooner, the *Emma*, leaves Marseilles with Le Gray on board.

May 15: Lunch in the garden of Alphonse Karr in Nice. Le Gray and Crette photograph the guests.

May 28: Dumas learns that Garibaldi's forces have taken Palermo.

June 9: The *Emma* arrives in Palermo.

June 10: Dumas and his escort, warmly received by Garibaldi, are given lodgings with him in the Palazzo Reale.

Mid-June: Le Gray photographs the ruins of Palermo as well as Garibaldi, General Türr, Father Jean, and others.

June 19: Dumas and his companions leave for Catania with a column led by Türr.

July 13: Dumas, having fallen out with Natalis Albanel, Édouard Lockroy, and Le Gray, puts them ashore on Malta at the port of Valetta.

July 25: Pointel, editor of *Le Monde illustré*, engages Lockroy and Le Gray to cover the unrest in Syria.

July 26: Departure from Malta on board the English cargo vessel *Boetia*.

July 31: Arrival in Alexandria.

August 2: Le Gray names Maufras his legal agent, authorized to handle his affairs in France.

August 10: Le Gray arrives in Beirut.

August–September: Sends regular dispatches to *Le Monde illustré*, which publishes his photographs.

September 14: Ratification of the liquidation of the firm of Gustave Le Gray et Cie.

September 17: Le Gray, en route to Damascus with a column of French troops, breaks his leg in fall from a horse.

October 24: Tribunal de commerce de la Seine orders Le Gray to pay 25,582.20 francs to each of the two Briges brothers.

November: Le Gray sets up a temporary darkroom in the ruins of the temple of Bacchus in Baalbek. Lockroy begins to take part in Ernest Renan's excavations.

November 23: Le Gray applies for a passport for Jerusalem.

Late 1860–early 1861: Le Gray's views of the tympanum of Notre-Dame and of the church of Saint-Germian-l'Auxerrois are shown at the exhibition of the Architectural Photographic Association in London.

1861

Winter: Le Gray arrives in Alexandria.

April 6: *Le Monde illustré* publishes a print of Saïd Pasha arriving in Alexandria after a visit to Mecca, based on a photograph and documents provided by Le Gray.

May 3: Death of Catherine Eulalie Gay, Le Gray's mother, in Villiers-le-Bel.

September: A M. Oudin lends two seascapes by Le Gray to the first exhibition of the Société photographique de Marseille.

December 4: Le Gray photographs the comte de Chambord and his entourage at the Hôtel de l'Europe. He makes friends with the draftsman Henry de Montault.

December 13: Death of Maufras in Neuilly, France.

1862

Some seascapes by Le Gray are shown in an exhibition of photographs in Amsterdam.

February: Le Gray's wife requests and receives financial assistance in the amount of 150 francs.

July 18: Mme Le Gray arrives in Rome with Le Gray's sixth child, Émile Eugène, age five (precise date of birth unknown).

October 28: French consul in Alexandria confirms to Mme Le Gray that her husband is in Egypt.

1863

January: Ismaïl Pasha succeeds Saïd Pasha.

January 23: Through the French consulate in Rome, Le Gray's wife asks him to provide her with a monthly pension of fifty or sixty francs.

February 8: Le Gray photographs a ceremony in which the French consul in Alexandria obtains reparations from the Egyptian government.

May 1: Le Gray appears on a list of French notables in Alexandria.

July: Le Gray photographs a reception held in honor of Prince Napoléon Bonaparte and Princess Clotilde in the Pastré Gardens in Alexandria.

1864

Dr. Gaillardot settles in Alexandria.

October 19: Le Gray's wife and son leave Rome.

1865

July 5: Ernest Lacan transmits to the SFP a letter from Le Secq, who has received a request for help from Mme Le Gray. She is without resources in Marseilles and wants to return to Paris. After this date all track of her is lost.

July 28: Death of Le Dien in Paris.

1866

March: Le Gray photographs the camels of the pasha loaded with artillery before crossing the Sudan desert.

1867

Le Gray becomes professor of drawing at the Military Schools of Cairo.

January: Travels the length of the Nile with the pasha's sons, drawing and photographing monuments.

April: Photographs made for the pasha by Le Gray are exhibited in the Egyptian section of the Universal Exposition in Paris, along with manuscripts and books that might have been his.

1868
February 18: Gérôme and a group of painters passing through Cairo encounter Le Gray.

1869
Until at least 1875, Le Gray is professor of drawing at the preparatory school for the Polytechnic School of Cairo.

November 17: Inauguration of the Suez Canal. Philippe de Chennevières, present for the ceremonies, sees Le Gray. He is living "near the Esbekiah, [in] a beautiful old Arabic house."

1870
At some point in the 1870s (precise date unknown), Le Gray moves into an eighteenth-century Arabic house situated at 16, rue Souq-al-Zelat.

1872
October–November: Le Gray photographs for architect Ambroise Baudry the house that Baudry has just built in Cairo for Delort de Gléon.

1877
September 13: Ernest Brouard, designated by Le Gray to oversee the liquidation of his mother's estate, in process since 1861, completes his task and the estate is closed.

1878
August 4: Death of Émile Eugène Le Gray, turner, age twenty-one, in Paris.

1881
July–September: Le Gray is sued for debt by the butcher Louis Gourjon but found not liable.

1882
March 6: Le Gray consents to the marriage of his son Alfred.

April 13: Alfred Le Gray is declared to have inherited 10,788.48 francs.

April 27: Notarial act issued by justice of the peace of the 2nd arrondissement, Paris, attesting the absence of Le Gray's wife.

May 20: Marriage of Alfred Le Gray, shop clerk, in Paris.

1883
January 16: Birth of the son of Le Gray and Anaïs Candounia in Cairo.

January 17: Registration of the birth with the consulate authorities, subsequently voided due to lack of proof of the death of Le Gray's first wife.

1884
July 29, 4:00 P.M.: Death of Gustave Le Gray in Cairo.

August 5: Estate inventory drawn up.

August 18: Death registered with consular authorities.

October 18: Accounting of Le Gray's estate by Albert Castel, bankruptcy receiver in Cairo.

End of year: Contents of Le Gray's house sold.

1885
January 28: Document prepared by M. Latapie de Gerval, a Paris notary, designates Alfred Le Gray, his only surviving child, as his heir. Witnesses said to have known his father well: Louis Hallé, painter, and Vincent Philippe, boot maker.

1892
Nadar publishes his memoirs in installments in the periodical *Paris-Photographe*. Le Gray figures prominently in them.

1900
Publication of Nadar's memoirs in book form as *Quand j'étais photographe* (When I was a photographer).

Biographical Essay

Léon Maufras

This essay was originally published in French as "Étude biographique" in *Le Monte-Cristo, journal hebdomadaire de romans, d'histoire, de voyages et de poésie, publié et rédigé par Alexandre Dumas, seul*, January 5, 1860 (erroneously dated 1859), 594–98. This issue, headed by a portrait of Dumas after a photograph by Le Gray, opens with two texts devoted to the photographer: a "talk" by Dumas, which has been extensively quoted in this volume (see C. Schopp, "The Unfinished Odyssey"); and in the present essay, a pseudo-obituary by Léon Maufras. Numerous names misconstrued by Maufras have been corrected here, to the extent they could be identified. The notes have been added.

1 Arsène Houssaye (1815–1896), French writer; friend of Théophile Gautier and Gérard de Nerval, administrator of the Comédie française 1849–1856. The book was first published in 1855. Membership in the Académie française, an exclusive and prestigious literary institution established by Cardinal Richelieu in 1634, was limited to forty.
2 Site of a military hospital built by Louis XIV, later transformed into a prison for vagabonds and the insane.
3 Nicolas-Joseph-Florent Gilbert (1750–1780), French poet, member of the *antiphilosophe* camp. His tragic, early death (after a fall from a horse), as well as the passion, rebellious spirit, and faith animating his verse, fostered his construction in the nineteenth century as a *poète maudit*, or cursed poet.

A charming intelligence, Arsène Houssaye wrote *Histoire d'un quarante et unième fauteuil à l'Académie française* (History of a forty-first chair at the Académie française),[1] in which he bestowed this chair upon a whole galaxy of famous men, up to the present, whose talent or genius excited the admiration during the various periods in which they lived.

This book certainly had its uses, from a critical perspective, even as it makes delightful reading for us; but in addition to these great names, over and above the forty of the Institute, which posterity has consecrated and rendered immortal, there are yet others, humbler but no less great, whose situation is even more alive with interest: those who are disdained by their contemporaries, those who in times past were sometimes sent to Bicêtre,[2] who are the pariahs of their century even as they are its apostles and benefactors; who *always* die in poverty and are almost *always* persecuted, who, in silent study, amid straitened circumstances, give the best years of their lives, yet whose very names are often forgotten by a "grateful" humanity.

I wish to speak of *inventors*.

What could be more moving, as evoked by an eloquent and generous pen, than the picture of these obscure struggles between personal need and the requirements of the work being elaborated by their genius? What could be sadder than the ingratitude that greets the fruit of the labor and late nights of their entire existence, when it is not followed or preceded by a distressing incredulity that suddenly kills them or, hypocritically, pillages them to effect their rebirth from their own ashes?

Often, however, powerful voices from the world of letters—poets or moralists of a high order, an Alfred de Vigny or a Balzac—have defended intellectual property rights in France; alas, in vain! Do not poets, every day, see works that earned nothing during their authors' lifetimes fall almost immediately after their deaths into the public domain? They cannot even leave to those closest to them exclusive rights to their souls. Their names belong to the world like everything that issues from their brains; they are the only ones from whom society takes everything while rendering nothing in return.

Inventors, still more unfortunate, cannot take refuge in patents, which are derisory and impotent havens, because the law, which might seem to offer them some security, is more pecuniary than protective.

Often, one or another dies, taking with him, like Gilbert,[3] magnificent pages or, like Archimedes,[4] some great secret. Why?

Because society is, in respect to them, a wicked and unworthy mother whose breast is not beneficial to them, who, instead of defending them, abandons them to their own devices. Society guarantees farmers' fields, but it does not concern itself with the property of poets and inventors. So the one and the other succumb; overwhelmed and vanquished, they curse it while murmuring, often too late, the "Eureka" of Balthazar Claës;[5] or if, more happily, they have bestowed their work on the world, they leave it behind, powerless to save it from the machinations of shameless exploiters.

In support of these sad truths, unfortunately incontestable, I could cite here a thousand examples of the most striking kind and rehearse for you in turn the history of steam power, electricity, et cetera; but if I have spoken to you about these *gloriously indigent*, it is because my mind wandered, for my sole initial intention was to discuss a *celebrated photographer* whose name is familiar to you—thank God!—but whose most serious work has escaped your attention. He, too, is an inventor, which explains my reflections prior to beginning his biography, which, with your permission, I will do as if he were dead, an approach that will allow my pen greater independence and freedom.

Jean-Baptiste Gustave Le Gray was born on September 20, 1820, in the small town of Villiers-le-Bel, virtually beneath the great trees of Écouen. He was the sole and belated fruit of a cloudless union, within which this double circumstance made him the object of tenderness without compare, and all the greater for being undivided.

He attracted attention in early youth with his passion for drawing and his prodigious penchant for serious subjects treated in science books that one would have thought beyond the reach of a boy his age.

His father, a prosperous property owner, envisioned a notarial career for him; thus, as soon as he had completed his studies, he found a place for him as a clerk with the town scrivener; but young Le Gray had no vocation for civil law, and he sketched on the legal forms more often than he used them for the contracts for which they were intended. This tendency toward painting was imperious; like all old men, Le Gray's father remained deaf to the aspirations of his son, who in vain, more than once, requested permission to pursue such a career.

He wanted to be an artist, because this condition revealed to him an entire world, a chaos in his mind, but already glimpsed by him through his ardent love of form and his great admiration for the masterpieces that he could visit each time he went to Paris.

This resistance of his father, who was by no means imbued with most of the prejudices still widespread in the provinces, issued from the false ideas about everything that relates to the arts and letters among those who live in the country. This cult seems ridiculous to them, and they pillory whoever dares to enter upon that path and *follow*, so to speak, *the road pointed out to him by the Lord*, without reflecting that nations often go down in history as great only because artists engrave their glory or sing their praises in pages that live and prove eternal; when, across centuries, some traces of these same nations are recovered from the dust, and if chance has it that the authors of a book or a statue are anonymous, like those of the Venus de Milo and the *Imitation of Christ*,[6] posterity bemoans the loss of their names and searches for them ceaselessly.

Le Gray prevailed over the notions of his father—who conceded only with great reluctance—and, a bit like Balzac, he came to Paris and entered the atelier of Paul Delaroche, one of the great painters of the day. He had as his fellow students Gêrome, Ivon, Barre, Alfred Arago, Michel Carré, et cetera; and soon thereafter, as his friends and equals in different fields, Alexandre Dumas fils, Millet, Henri Mürger, Frédéric Brisson, Victor Séjour, et cetera; in sum, the whole of the great family of young and vigorous talents, a strong and powerful breed, that made this period almost worthy of comparison with another, likewise fertile in beautiful and magnificent masterpieces that remain models of their kind, and that despite everything overturn, or rather cause to disappear, the classical ruts from which literature and art have been struggling vainly to escape for more than two centuries.

His mind, ever distracted and inclined to dream, relentless in its pursuit of an idea or a line, formed itself through contact with this circle; but his nature, rich in all the heart's perfections, found in it only an occasion to develop itself, to the profit of friendship, a faith to which he remained unfailingly constant to the end of his days.

His thoughts soon changed direction, and one morning, with a staff and a sack as his only baggage, he set out, by way of Switzerland, for Rome, that land of the arts, to wrest the secrets from the canvases of the great masters, and also to visit the remains of the cradle of civilization. He traveled throughout Italy, sowing here and there small watercolors and pastiches of things ancient for which wealthy travelers were already paying very high prices, which provided him with sufficient funds to pay for his peregrinations.

He was a frequent visitor to the libraries of Milan and Rome, and it was perhaps there, upon reading pages by Leonardo da Vinci about attempts to obtain images in a camera obscura, that he resolved to study the new discovery of Daguerre, then almost in its embryonic stage; in any event, from that moment forward he added to his work—first as a sideline but soon as a new study that would seduce him more and more—the application of Daguerre's principle.

This invention suddenly revealed a whole new world to him; he already saw in it a revolution in the arts. This was all he needed for his intelligence to throw itself into it completely, and his love of things wondrous and unknown suddenly found itself transported into the element best suited to it. Henceforth he had only one ambition, *to unite science with art;* but for that, it would be necessary to delve into chemistry, to interrogate all metals, whether noble or base, all plants, whether large or small. He was not the least bit frightened by this dual syllabus, and, without ceasing to copy Michelangelo and Raphael, he devoted a part of his nights to all manner of alembics and retorts.

For four years, he lived in Rome the life of a medieval Benedictine monk, seeking in all kinds of combinations an agent that might be substituted for mercury, which was always dangerous to use but absolutely necessary to fix the image obtained on the metal plate, and also to eliminate this plate and replace it with another kind that would preserve the image and make possible multiple reproductions of it.

4 Archimedes (ca. 290/80 B.C.E.–212/11 B.C.E.), the most famous mathematician and inventor of ancient Greece. Maufras is probably referring to his *Method Concerning Mechanical Theorems*, a treatise then thought to have been lost (it was rediscovered in the late nineteenth century).
5 A character of Balzac's who seeks a ubiquitous unifying element.
6 A homiletic guide, traditionally ascribed to Thomas à Kempis.

He was, in this state, often taken for one of those poor madmen of the fifteenth century, adepts of the hermetic science, who long expended their strength in laboratories on insane attempts to transmute metals. Thus did Van Dick, too, later demand gold from lying alembics. But he nonetheless continued—with the patience of the determined and with a scientist's avidity—these laborious researches, which would soon lead him to an important discovery in this branch of art and cause him to take a giant step forward.

But while he avidly tracked on his stoves the chemical combinations that might bring about the realization of his project, and that, a hundred times renewed and a hundred times to no avail, did not attain the desired result, other minds, in France and England, had also taken up the newborn invention and sought to liberate it from its swaddling clothes. Some ideas are like great events: their advent is always preceded by a startling convergence of mental energies that flies through the air like an invisible current and thus becomes a precursor of what is to come.

The photographic art, without doubt one of the most marvelous discoveries of this century—a century fecund in inventions, moreover—could not fail to attract all those who think and study, and to produce the beginning of the intellectual commotion to which I just referred. Niépce de Châlons and Daguerre had led the way, the latter by engendering *heliography,* the former by introducing processes that reproduce the image more quickly.

The difficulty of accelerating the emergence of the image was the pitfall that had to be overcome in the processes discovered by these two experimenters, and although this is not the place for a history of photography, it seems all but indispensable to enter into a few details if this study is to be intelligible, and above all to appreciate fully the brilliant role played by the man who interests us.

M. Niépce had the ingenious idea of applying, with the aid of a swab, to either a sheet of glass or a metal plate, a coating of bitumen of Judea that he had dissolved previously in lavender oil, and, after having subjected it to moderate heat to make this coating cohere, he could submit his glass or his plate, thus prepared, to the action of the lens of the camera, but a lengthy exposure time was needed for the impression to be produced.

Talbot, for his part, had also found various processes for obtaining an image on paper and was actively seeking, in repeated attempts, more efficient and, especially, faster means than those already known. Nonetheless, we might say that the groping was general when Le Gray appeared in Paris, bearing his scientific baggage, in 1847. He was returning from Rome, married and the father of a young girl. He established his laboratory far from the center of the modern Babylon—namely in 1848, scarcely forty years ago—near what was once called the *Batignolles.* His first discovery dates almost from that moment.

The papers suggested by Talbot were difficult to use, due to their manufacture and their quality. Le Gray flattened them, an operation whose lack of precision most often led to complete failure, which became apparent only by developing the image obtained.

Le Gray obviated this problem by submersing the paper completely in gelatin and then coating it with fish glue. Having thus sized the paper, he used it and obtained infinitely superior negatives, and at the same time he substituted sodium hyposulfite for the potassium bromide that Talbot had used to fix his negatives. This first invention, which initially passed nearly unnoticed, although announced the day after discovery, sufficed nonetheless to draw attention to him, and instantly placed him in the thick of the European competition of *seekers,* even placing him at its head.

The photographic art won more sympathy every day as it was perfected in unexpected ways, and Le Gray, ceding to numerous requests, opened his laboratory to the public and admitted students into his studio. This advanced school, which was one of the most popular in Paris, shone with a brilliance that is still remembered.

The most aristocratic hands from the capital and from abroad came, without compunction, to dirty themselves there with silver nitrate, among whom we must mention: Messrs. the comte Aguado, B. Delessert, the marquis de Béranger, the marquis de Rothschild, the marquis de La Beaume, the comte d'Haussonville, the duc de Montesquiou, the comte Branitski, the comtesse d'Essertein, Mlle Dosne, Badeigts de Laborde, Dumas de Lavince, et cetera, et cetera.

Scientists and artists came there in droves as well; one encountered there Messrs. Maxime Du Camp, Piot, Bilordeaux, Greene, who succumbed to his ardor in Egypt; Le Dien, Nadar, Salzmann, Tournachon the younger, Avril, Bocher, Tranchant, Place, Mayall, from London; Crette, later photographer to the king of Piedmont;

Gueybbard, from New York; Mugnier, from Cairo; Mme Le Breton, Courtais, who died in Bordeaux from ether burns; the famous naturalist Delatre, Méhédin, et cetera, et cetera.

The *old* students made the *new* ones undergo what is known in all schools of this kind as *pranks*. Sometimes a beginner tried to depict a piece of furniture or a painting, and renewed his efforts ten times in succession without obtaining anything; in the end, like the monkey in the fable, he noticed that he had forgotten to light his lantern—in other words, that he had neglected to add a lens to his camera. Sometimes another was made to wash his hands in a silver nitrate solution, which gave them an unattractive black tone that revealed itself to the astonished eyes of the victim only the next day. These jokes, harmless for the most part, were often carried out under the very nose of the master, who was so absorbed in his experiments that he almost always failed to notice.

This student crowd was joined by the crowd for portraits, and Le Gray took those of the most celebrated figures of the day. The exhibition of 1849 recompensed him for these by awarding him a first-class medal for the examples he showed there.

We are approaching the moment when his second, greater, discovery victoriously crowned his efforts. Many improvements were brought to the art by Claudet, who found a way to shorten the exposure time in the camera; by Fizeau, who discovered a much better fixing process; by Blanquart-Évrard, who added simple and prompt methods to those already known for photographs on paper; by Niépce de Saint-Victor, finally, who, as his uncle's continuator, was also hard at it and replaced his bitumen of Judea with a coating of albumen, the use of which, it is true, produced better results than the previous ones, but the application of which presented serious difficulties, because it required extreme care at the same time as a great familiarity, and still was not always successful.

In 1850 Le Gray published a brochure—*Traité pratique de photographie sur papier et sur verre*—that was honored by being translated into several languages, and in which all of these procedures were minutely described. An appendix attached to this work revealed to science the solution long sought after, long awaited, and at last found.

Le Gray had discovered the agent that is still universally employed in productions of the photographic art. Instead of bitumen of Judea,

whose serious drawbacks have been mentioned, he substituted *collodion*, a simple, easy-to-use agent whose results surpassed all hopes while remaining wondrous, for it obtained portraits in the shade in less than two seconds.[7] Henceforth, he recommended ammoniac as an accelerator and iron proto-sulfate as a developer of the latent image. It is to this precious discovery that we owe those magnificent instantaneous prints, so striking in effect, and the secret of which was his alone. The hardworking experimenter had a real success in this invention, one so beautiful that endures until our day.

His altruism, in releasing it into the public domain the day after its discovery, ought to have protected him from the envious—that ravenous caste that attaches itself to anyone who takes a step forward, so as to hamper him or sully him with its slobber; but such was not to be. The glory of his discovery perhaps had need of the croakings of this disgusting breed so as to shine forth with greater purity and brilliance. Invaluable witnesses had encouraged him in his work and would save him in the eyes of posterity.

More than a year later, word spread that his process had been known in England a month before the publication of his book, and people went so far as to mention its author, whose name was *Archer*. This calumny, to which he did not deign to respond, was refuted for him by the princes of science, and the honor of his discovery was boldly claimed for France in works by, among others, Gerhardt, the successor of Berzelius, and by Arago himself (see *Notes scientifiques*, vol. 1, p. 516). These powerful voices, and even a posthumous letter by Archer, made public by his widow, who declined the paternity so gratuitously given to him, silenced all doubts, if any still existed after analysis of the claim.

The collodion process, then, continued to be associated with Le Gray's name, and the London Exposition of 1851 consecrated, so to speak, the beauty of his products by awarding him another first-class medal.

Almost at the same time, he published a volume about photography, *Traité nouveau* [sic] *théorique et pratique des procédés et manipulations sur papier et sur verre*, that is a summary of all his experiments and that overturned more than one acknowledged, widely accepted chemical principle. One might say that this book is the only serious and reasoned one to have been written on the subject with a sound scientific basis, and which can be consulted with confidence. Its style

7 Presumably on a glass plate.

is clear and limpid; the amateur will find in its first section all that he needs to know; the second is devoted entirely to scientific aridities—which made one illustrious member of the Académie remark that Le Gray had revealed a new secret by publishing a book in which the language of chemistry had been made as attractive to a man of the world as it was to a scientist.

This book revealed a third discovery made by him, no less important than the preceding ones. He had noticed, in the course of an excursion, how cumbersome were the preparations hitherto known, whether for glass negatives, whose fragility and weight above all inconvenienced travelers, or for paper ones that had to be prepared immediately before use, which still required an impossible amount of equipment. He tried a method that was a complete success and that entailed coating a sheet of paper with pure wax by spreading it with a hot iron so as to obtain a uniform transparency, which he then coated with an iodide solution and let dry. This procedure, known as the *waxed-paper process,* is still the only one that is practicable in very warm climates, and it is also extremely valuable when traveling.

These interminable experiments to which he had devoted himself had by no means made him wealthy; but partners avid for profit and exploitation sought him out to make him better known, in a venue where his name and his acknowledged talent were sure to attract riches.

Paris had by no means attained the heights to which it has since risen. The beginning of the reign of Napoléon III had inaugurated large-scale projects. The rue de Rivoli, the bois de Boulogne, the boulevards de Sébastopol, de Malesherbes, de Marignan, de Turbigo, and all those that followed, streets and bridges of all names, the expansion of the boundaries of old Paris, then its division into twenty arrondissements, the reconstruction of the theaters then scattered across the capital, now concentrated on the boulevard du Temple, the construction of the Opéra on the boulevard des Capucines, the creation of the place Napoléon IV on a triangular plot formerly occupied by a block of houses defined by the rue de la Paix on one side, by the rue Neuve-Saint-Augustin on another, and fronting the boulevard des Capucines—all of these changes, and many more, had not taken place when Le Gray, assisted by a powerful partner, opened his photographic establish-

ment at 35, boulevard des Capucines, on the second floor, facing the rue Basse-du-Rempart, which has since disappeared.

There, amid splendid salons furnished in Renaissance style, surrounded by a large staff organized and trained by him, Le Gray multiplied his productions, all of which bore the stamp of a true artist, and his studios became the most celebrated galleries in Europe because of the variety of people who passed through them.

Competitors tried to combat this supremacy, but in vain; they only made it appear the more estimable, by lining every street corner with muddy images, in which the grotesque sometimes vied with the ridiculous. The more such displays appeared, the greater the success of Le Gray, whose touch was unique.

Alongside these portraits, in which the light was so expertly handled, were assembled marines such as no one in France could duplicate, beautiful views of monuments, and landscapes that revealed the eminently appealing nature of their author. Emperor Napoléon III entrusted him with several delicate and important tasks, among them the documentation of all the military maneuvers executed in his presence in the camps, and as I write, the only true portrait that we have of this sovereign is the one by Le Gray.

He was simultaneously a founder and one of the most eminent members of the Société française de photographie, which has grown to such an extent that it now distributes many prizes to encourage the perfection of the art.

His last triumph dates from the Universal Exposition of 1855, where he again won a first-place medal.

From then until 1880, save for discovering a fixative made of calcium chloride and gold, in general use because it gives prints the most beautiful black tones while retaining their finesse, he divided his time between work in his studios and the composition of a large book on chemistry as it relates to the photographic art.

Everyone knows that he passed away prematurely at the beginning of 1880. His death was a loss to the public, but especially to the sciences and the arts, in which he was one of the most tireless and ardent pioneers—a loss all the greater because he left a void that has not been and never will be filled.

His intimates mourned him more than anyone, for they alone knew the full extent of their loss; this dark day nonetheless left a brilliant mark in sacred harmony, for everyone knows that Frédéric

Brisson, affected by this death, composed, in the course of the following night, a mass in music, a poem of tears and pain, that will remain some of his most beautiful pages. What greater way to praise a friend and an artist?

Such was Le Gray. Artisan of his own works, a self-made man, his entire life was untouched by self-interest; he searched, he investigated, he worked, he combined, he tormented chemistry to get it to reveal its secrets, and whenever, between his experiments and his intelligence, he obtained a victory in this struggle, he surrendered it to the world without pride, without recompense, without expectations, save for esteem and public awareness.

In his spare time, he wrote for the future and bequeathed to those who will come after him simple and eloquent lessons of work, of obstacles patiently overcome, and thus won for himself a place among the men whom the mass of humanity can forget but who are appreciated by thoughtful people. He saw petty vanities and silent intrigues all around him, sycophants seeking favors in antechambers; faithful to his art, he cultivated it with a son's love, his soul drawn only to God, the master of masters; his heart worshiped only friendship, and his intelligence warmed only to things that might help to elevate the study of light.

He died without personal regrets and without envy for those favored by fortune; he could have belonged to the Académie des sciences; a living model of honor, he should have been one of the foremost in the Légion [Legion of Honor], but he was not a member. No matter! His name will stand alone, bereft of titles, save for those bestowed by posterity on the men who struggle before them.

If that was his ambition, he achieved it!

Death-Date Inventory

Cairo, August 5, 1884

In the year one thousand eight hundred eighty-four, on Tuesday, August fifth, at four o'clock, we, Eugène GAUTHIER, acting secretary of the French consulate in Cairo, delegated by the consul, and assisted by Messrs. Albert BERTIN and Félix RADISSE, witnesses to this official act, we went to the domicile of Sieur LE GRAY, deccased the preceding July 29, in order to proceed with the breaking of the seals and a descriptive inventory of the objects that belonged to the deceased; where, upon our arrival, we recognized, broke, and removed the said seals.

Entry
An oil portrait of Ismaïl Pasha,
 idem of Chérif Pasha,
both in large gilded frames.
A miniature with 3 figures, the Le Gray family.
An oil portrait of a woman, dated 1863.
Two [oil] sketches on paper.
A stretched blank canvas.
A small marble tabletop.
A four-legged wooden table.
A pair of wild sheep horns.
A blindstamp press.

Bedroom
An iron bed frame and mattress.
A night table of painted wood.
A pedestal table with copper ornaments.
A white marble [sculpture].
A copper hookah.
A small chest.
An adjustable lamp.
A vase on a copper base.
A white wooden chest with compartments.
Three photographs in wooden frames.
Chemistry treatise, Berzelius, 7 vols.[1]

Chemical analysis, Rose, 2 vols.[2]
Organic chemistry, Gerhardt, 4 vols.[3]
A brochure, Niépce.
Two volumes in English about Egypt.
Five bound octavo volumes.
Dictionary by Laboulaye.[4]
Dictionary by Lafaye.[5]
French-Arabic dictionary.
Annotated photography treatise by Le Gray.
A set of flasks.

Room to the left [of the entry]
A roughed-out canvas, Pasha on horseback.
Portrait of a woman, roughed-out.
An old portrait of a woman.
An easel.
A white wooden chest containing drawings and photographs.
A chest painted green.
Two drawing boards.
Twenty paper-bound books, various.
Three drawings in one frame, by Darjou, Le Gray, Gérard.
A stretched gray canvas.

Room to the right [of the entry]
A marble tabletop.
A small painted canvas.
A portrait of a woman.
A portrait of a woman.
A framed photograph.
A small watercolor by Galioub.
A view of Bulbecq [sic].
A view of the Nile.
A view of the tombs of the Caliphs, watercolor.
A view of Karnak, on the wall.
Portrait of a woman, black pencil.
A photograph, on the wall.
A watercolor, Khedive in a carriage, 1880.

Inventory of the Estate of Gustave Le Gray, July 29, 1884, Archives of the Ministry of Foreign Affairs (Nantes), Cairo, consulate, series C, estate files, box 52.

1 J. J. Berzelius, *Traité de chimie*, trans. A.-J.-L. Jourdan, 8 vols. in-8° (Paris, 1829–33); 2nd rev. ed., *Traité de chimie minérale, végétale et animale*, trans. J. C. F. Hoefer and M. Esslinger, 6 vols. in-8° (Paris, 1845–50).
2 H. Rose, *Traité pratique d'analyse chimique,* . . . trans. A.-J.-L. Jourdan, 2 vols. in-8° (Paris, 1832); 2nd rev. ed., 2 vols. in-8° (Paris, 1843).
3 C.-F. Gerhardt, *Traité de chimie organique*, 4 vols. in-8° (Paris, 1854–56).
4 C.-P. Lefebvre Laboulaye, *Dictionnaire des arts et manufactures. Description des procédés de l'industrie française et étrangère*, 3 large vols. in-8° (Paris, 1845–61); 4th ed., 4 vols. in-4° (Paris, 1875–77).
5 P. B. Lafaye, *Dictionnaire des synonymes de la langue française* . . . (Paris, 1858).

A painting, gilded frame.

A photograph, black wooden frame.

A painting of a nocturnal celebration, gilded frame.

A painting, oil sketch on easel.

A glazing roller.

A portrait of Bonaparte, on horseback.

A box containing 10 negatives

 idem 35 idem.

 idem glass plates.

 idem 11 negatives.

 idem 46 idem.

 idem 11 idem.

 idem 11 idem large format.

 idem 20 idem idem.

 idem 10 idem small format.

A lens and accessories.

A small table on four legs.

A wooden classifying table and 6 acidimeters.

A set of precision scales.

An white paper album containing some photographs.

A watercolor, le Dosel.

A canvas, oil sketch, no. 16.

 idem on a stretcher.

A metal paint box.

A workbench with wheel.

Various implements and brushes.

A large wooden paint box.

A box of 13 glass plates.

A box of 25 large negatives.

 idem 43 idem idem.

A sharpening stone.

A porphyry brayer.

Painter's palettes.

A wooden tripod.

In the courtyard

A camera stand.

A large easel.

Four Arab benches.

Small house

A mannequin stand.

Two cameras.

A finishing press.

A table in poor condition.

Two paintings, Galioub, gilded frames.

An easel.

Two roughed-out canvases.

Five positive printing frames.

One negative plate holder.

[Opposite the two preceding entries:] poor condition.

A gutta-percha tray.

A combination lock.

A mannequin.

A small Prussian stove in poor condition.

All of the above was seen to during a single session lasting from four until seven o'clock; and nothing further having been found for inclusion and declaration in the present inventory, Madame Anaïs CANDOUNIA, having been in possession of the objects included in the said estate prior to the inventory, swore between the hands of the undersigned chancellor that she had removed nothing and that she neither knew of nor had noticed anything missing; after which, the entire contents of the present inventory were left in the possession of Mr COULON who is charged with determining when and to whom they will belong; and all the designated parties, as well as myself, acting chancellor, signed [this document] after having read it.

 [Signed:] GAUTHIER E. E. COULOMB.

Signatures, Stamps, and Commercial Marks

Sylvie Aubenas

348

349

GUSTAVE
LEGRAY.
350

351

352

353

A great many works by Le Gray bear none of the distinctive markings described here.

Signatures

The signature on prints by Le Gray always appears on the image itself. It is on the mount only in the views of Palermo (June–July 1860), which were printed by Colliau and Costet.

The handwritten signature "Gustave Le Gray" in black ink (figs. 348, 349) is rare; it is found on some portraits from the period 1856–1860 and on some Egyptian views.

The embossed blindstamp "GUSTAVE / LEGRAY." (figs. 350, 351) is the earliest known signature of Le Gray. Stamped like a hallmark, the blindstamp was initially used on daguerreotypes (1848). It was then used on the first paper prints (starting in 1849)—applied in black or red ink on landscapes and portraits at the beginning of the 1850s and in red ink on small-format portraits until 1860. (The blindstamp is more unobtrusive than the wetstamp).

The wetstamp imitating Le Gray's written signature (figs. 352, 353) appears around 1853. It was applied in black or red ink until his departure from Paris (May 1860), thereafter always in blue (views of Sicily, Syria, and Egypt), save for a few very rare Egyptian views where it appears in red. The choice of red or black seems to have been solely a matter of aesthetic preference. Black predominates on the salt prints (Salon of 1853, Mission héliographique, etc.), while red is used consistently on the seascapes and on views of the camp de Châlons, as well as on the majority of the portraits. Both colors were used on views of the forest of Fontainebleau.

Double Signatures:
"Gustave Le Gray et Mestral" (fig. 354). This signature in Le Gray's hand, in black ink, is on some of the views for the Mission héliographique taken collaboratively by the two photographers, especially at Le Puy and Carcassonne.

"LE DIEN / ET / GUSTAVE LE GRAY" (fig. 355). This is an embossed blindstamp, sometimes lightly inked in black, on some of Le Dien's views of Italy that were printed by Le Gray.

Commercial Marks

1. Blindstamps in relief, bottom center on original mounts:

"PHOTHOGRAPHIE [sic] / DE / GUSTAVE LE GRAY" (fig. 356): one known example, on a photograph of a painting, ca. 1851/52 (given up because of the orthographic error).

"GUSTAVE LE GRAY / 2 [sic] CHIN DE RONDE / BRE DE CLICHY / PARIS" (fig. 357): two known examples, ca. 1853–1855.

"PHOTOGRAPHIE / GUSTAVE LE GRAY & CO / PARIS," oval fillet (fig. 358): the stamp of the firm established with the backing of the Briges family, late 1855 to early 1860.

"GUSTAVE LE GRAY A PARIS / PHOTOGRAPHE DE L'EMPEREUR," round fillet and the imperial arms in the center (fig. 359): appeared in September 1857 on the camp de Châlons albums, and used until 1860; much rarer than the preceding.

"GUSTAVE LE GRAY / PHOTOGRAPHE DE L'EMPEREUR / PARIS" (fig. 360): used only in Egypt.

2. Printed label (made by the engraver Stern, passage des Panoramas), glued to the back of the frames of portraits:

First version, with addresses of both the boulevard des Capucines and the barrière de Clichy studios (fig. 361): between 1855 and 1860 (?).

Second version, with only the boulevard des Capucines address and the legend "Photographes de S. M. l'Empereur" (fig. 362): between 1857 and 1860.

3. Imprint of gold letters on dark blue satin, in cases for daguerreotypes and small-format portraits:

"GUSTAVE LE GRAY & CIE / Photographistes / 35. BOULT DES CAPUCINES, PARIS" (fig. 363): two known examples, both dating from the beginning of the association with the Briges family.

Numbering of the Negatives

The numbering of the negatives distinguishes different series according to the process used, the format, and/or the subject pictured, to facilitate filing for subsequent reprinting. Indicated here are the lowest and highest numbers known for each sequence. Note: prints often bear both their negative number and the print number.

1. Prints from paper negatives: numbered in the image.
Mission héliographique, 1851: 4 to 605.
Forest of Fontainebleau, ca. 1853 (fig. 364): 721 to 816.

2. Prints from collodion-on-glass negatives: numbered in ink, bottom right on the mount (fig. 365).
Normandy seascapes, 1856–1857: 1 to 28.
Brittany seascapes, 1858: 32 to 4[.].
Mediterranean seascapes, 1857: 9 to 19.
Forest of Fontainebleau, ca. 1855–1856: 95 to 2[..].
Studio portraits (numbered on a label on the back of the frame) (fig. 366): 1503 to 2903.

Numbering of the Prints

Prints made at the boulevard des Capucines studio between 1855 and early 1860 are numbered, irrespective of the date of the negative (fig. 367). The numbers were initially printed in black on the bottom left of the mount, but soon after were written by hand in black ink, either in the same place or on the back of the print.

The number sequence encompasses all prints from the period, ordering them in a continuous series (lowest number currently known: 50; highest currently known: 24,200, which roughly corresponds to the closing of the studio). This makes possible the establishment of a relative date for each print. A complete chronological table based on known dates for the negatives (which provide a *terminus a quo* for the corresponding prints) would provide a framework for establishing approximate real dates for each print; conversely, it would indicate a *terminus ad quem* for the undated negatives.

Printed Titles

Some of the seascapes have printed labels glued to bottom right of their mounts, bearing the title and the number of the negative (fig. 368).

Handwritten Titles

On landscapes and seascapes made in France, titles are rare, are not in Le Gray's hand, and appear in ink or pencil, generally at bottom right of the mount.

On views from the Egyptian period, titles are far more frequent, are in Le Gray's hand, and appear in black ink at bottom right of the mount.

Materials

Le Gray purchased his materials, notably his mounts (fig. 369) and his albums, from his friend Ernest Binant, 7, rue de Cléry. He chose his negative and printing papers carefully, preferring particularly those made by Whatman or by Lacroix in Angoulême.

354

355

356

357

358

359

360

363

364

365

361

362

On peut se procurer des Epreuves du Portrait, en rappelant le No. ____ de la Planche qui est conservée pendant une année.

366

14453

367

LA VAGUE BRISÉE — Mer Méditerranée
No. 15.

368

369

Catalogue Entries

Sylvie Aubenas

Notes to the Reader

Unless otherwise stated, all works are by Gustave Le Gray. The phrase "attributed to Gustave Le Gray" indicates that, although no signed prints of the work are known, Le Gray's authorship is probable. In the case of photographs taken during the Mission héliographique, it has not always been possible to distinguish Le Gray's contributions from those of Mestral.

Two types of French titles appear here: original, nineteenth-century titles are shown in italics; modern or conventional titles are shown in roman. When the source of an original title is not specified here, the title has been taken from another print of the image.

Dimensions are given in height, then width.

Works by Gustave Le Gray in the collection of the département des Estampes et de la Photographie, Bibliothèque nationale de France (EST, BNF, Paris) are designated as "Eo 13 réserve."

Cross references to illustrations in text are indicated by figure numbers in brackets.

Unless otherwise indicated, all works listed were included in the exhibition at the Bibliothèque nationale de France. Those works exhibited at the J. Paul Getty Museum are noted by the initials JPGM in brackets. In some instances, the J. Paul Getty Museum substituted a print from its collection for the one exhibited in Paris; this is indicated by an asterisk (JPGM*).

Blindstamp: Unless otherwise indicated, the name is stamped in block-letter capitals, in either red ink or black ink and on two lines, and is followed by a period: "GUSTAVE / LE GRAY."

Wetstamp: Unless otherwise indicated, this is an imitation autograph signature stamped in red, blue, or black ink and occupying a single line: "Gustave Le Gray."

Abbreviations

neg. no.	negative number
r.	right
l.	left
c.	center
b.	bottom

1844

1

Henri Le Secq (1818–1882)
**Portrait of Gustave Le Gray
(Portrait de Gustave Le Gray)**

c. r.: "Rome 1844"
Oil on panel
79 × 59 mm
Formerly Martinet collection
Musée des Beaux-Arts, Rouen, LS 3509 [JPGM]

The museum acquired from Martinet—a friend of the Le Secq family—portraits of Le Secq and his parents by Le Gray and the oil portrait of Le Gray by Le Secq. The latter is a touching memento of the two friends' first forays into art. Note the relaxed expression of Le Gray, shown as a bemused young man wearing a red scarf and romantic locks. [fig. 3]

Daguerreotypes, 1847–1848

2

**Portrait of Henri Le Secq
(Portrait de Henri Le Secq)**

Heliogravure from a daguerreotype
(probably a half plate)
Blindstamp b. r. on the plate
Formerly Martinet collection
Musée des Beaux-Arts, Rouen [JPGM]
See pp. 24–25. [fig. 13]

3

**The Father of Henri Le Secq
(Portrait du père de Henri Le Secq)**

148 × 104 mm (half plate)
Blindstamp b. r.
Formerly Martinet collection
Musée des Beaux-Arts, Rouen [JPGM]
[fig. 15]

4

**The Mother of Henri Le Secq
(Portrait de la mère de Henri Le Secq)**

148 × 104 mm (half plate)
Blindstamp b. l.
Formerly Martinet collection
Musée des Beaux-Arts, Rouen [JPGM]

In the portrait of Auguste Jean Catherine Le Secq (1791–1861) (cat. no. 3) and in this one of his wife, Anne Louise Françoise Dolly Tournaire (1799–1867), Le Gray displays the same psychological mastery as in the portrait of their son. Despite their more formal demeanor, consistent with the disposition of wealthy notables (the husband was mayor of his arrondissement, the present 4th), their faces smile benevolently on the "daguerreotypemania" that had gripped their artist son and his friends. [fig. 14]

5

**Portrait of Pol Le Coeur
(Portrait de Pol Le Coeur)**

Spring 1848
150 × 100 mm (half plate)
Blindstamp b. r.
Private collection, Paris

This is the only daguerreotype portrait by Le Gray for which it possible to establish a precise date. It is also the only one where a model from outside Le Gray's circle can be identified. Pol Le Coeur (1835–1908), shown here at age thirteen, was the son of the architect Charles Clément Le Coeur (1805–1897). The boy wears the uniform of a Second Republic schoolboy, as decreed by the new government on April 24, 1848; he was a boarding student at the lycée Henri IV, while his parents resided on the rue de Longchamp in Chaillot. His mother, gravely ill, died on June 25, 1848.

The young boy's sunny expression and the absence of any sign of mourning suggest that the image was made so that his dying mother, who saw him only on

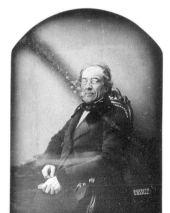

1

2

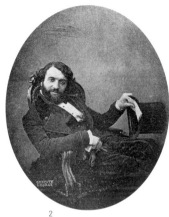

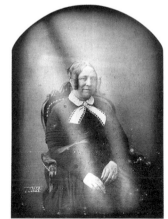

3

4

Sundays, could keep it near her. Father and son left Paris the December following her death to settle definitively in Pau. Thus the exposure can be securely dated to sometime between May and December 1848, and probably more specifically to May or June.

We do not know why the Le Coeurs chose Le Gray, who was not then an established portraitist; perhaps the young artist had been recommended to them by a common acquaintance either from Paris or from Pau, where the Le Coeur family sojourned for reasons of health from July 1843 until September 1846.

As with the Le Secq family, Le Gray here seems comfortable with the medium, producing a smiling portrait whose natural quality makes us forget both the prolonged pose and the backdrop. Although it is now known that Le Gray made daguerreotypes, we cannot say, even approximately, how many he might have produced between 1847 and 1849. Future discoveries will surely confirm what seems to be implied by the mastery in these images: that his output was large.

The biographical information about the Le Coeur family was kindly provided by Marc Le Coeur. [fig. 9]

6

Jean-Léon Gérôme

Anacreon, Bacchus, and Cupid (*Anacréon, Bacchus et l'Amour*)

Spring 1848

165 × 215 mm (full plate)

Signature inscribed b. l.: "Gustave Le Gray d'après Gérôme"

Audry and Alain Flamand collection

This unique example of a Le Gray daguerreotype that reproduces a painting also displays an impeccable mastery of the process, both in the dimensions of the plate and in the perfection of the chemistry. It shows a painting that Jean-Léon Gérôme exhibited at the Salon of 1848, where it was purchased by the state for the museum in Toulouse. The signature inscribed on the metal plate with a stylus unites the names of two friends, two painters who had both exhibited work at the Salon that year. The "division of labor" spelled out in Le Gray's hand indicates, unbeknownst to him, the career that each of them would follow. [fig. 10]

7

Portrait of Three Young Boys (*Portrait de trois jeunes garçons*)

Half plate

Blindstamp b. r.

Pierre-Marc Richard collection, Paris

[fig. 11]

Early Photographs, 1849

8

Portrait of Félix Avril (*Portrait de Félix Avril*)

Salt print from a glass negative

147 × 110 mm, oval

Blindstamp b. r.

Inscribed in the hand of Victor Regnault: "Épreuve obtenue avec un négatif sur verre préparé avec l'albumine, l'iodure, le cyanure et le fluorure de potassium en une minute à l'ombre" [Print made from a glass negative prepared with albumen, iodide, cyanide, and potassium fluoride in one minute in the shade]

Regnault Album, no. 62

Société française de photographie, Paris

Félix Avril—briefly a deputy from Calvados in 1848, a member of the Société française de photographie, and above all a student of Le Gray's—belonged to the barrière de Clichy circle. There are several portraits of him by Le Gray, all from this first period of his career as a photographer. Even posing for his friend in what one senses was an amiable, relaxed atmosphere, he remains timid and self-conscious, ill-at-ease amid the youthful high jinks. [fig. 35]

9

Portrait of a Young Woman (*Portrait de jeune fille*)

Salt print from a paper negative

120 × 90 mm, oval

Blindstamp b. r.

Inscribed in the hand of Victor Regnault: "Épreuve obtenue avec un négatif sur papier préparé avec l'alcool, le collodion et l'iodure et bromure de potassium en 40 secondes" [Print made from a paper negative prepared with alcohol, collodion, and iodide and potassium bromide in 40 seconds]

Regnault Album, no. 63

Société française de photographie, Paris

[fig. 17]

10

Nude Model from the Back, Lying on the Studio Floor (*Modèle nu allongé de dos sur le sol d'un atelier*)

Salt print from a paper negative

90 × 146 mm

Blindstamp b. r.

Inscribed in the hand of Victor Regnault: "Épreuve obtenue avec un négatif sur papier préparé avec l'iodure, le cyanure et le fluorure de potassium en 5 secondes à l'ombre" [Print made from a paper negative prepared with iodide, cyanide, and potassium fluoride in 5 seconds in the shade]

Regnault Album, no. 67

Société française de photographie, Paris

[fig. 294]

5

6

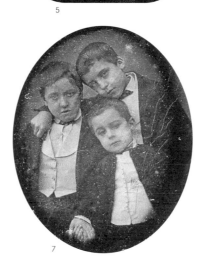

7

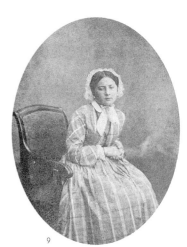

8

9

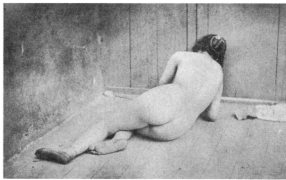

10

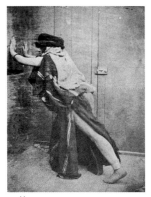

11

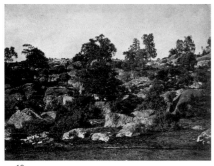

12

13

14

11
**Model in Oriental Costume
(Modèle en drapé orientaliste
dans un atelier)**
Salt print from a paper negative
140 × 103 mm
Blindstamp b. l.
Inscribed in the hand of Victor Regnault:
"Épreuve obtenue avec un négatif papier
préparé avec l'iodure, le cyanure et le fluo-
rure de potassium en 8 secondes à l'ombre"
[Print made from a paper negative prepared
with iodide, cyanide, and potassium fluoride
in 8 seconds in the shade]
Regnault Album, no. 68
Société française de photographie, Paris

This study of a model and the previous
one (cat. no. 10), like the two preceding
portraits (cat. nos. 8, 9), bear witness—as
evident in the inscriptions in Regnault's
hand—to Le Gray's intense experimenta-
tion around 1849–1851; they remind us,
as well, that this scientist was also an
artist who posed models, made studies
after the nude, and contrived the arrange-
ment of drapery. The stark studio in which
the young woman poses, with its absence
of decoration and its bare floor, evokes
the work of a painter who is just begin-
ning. The figure reclining directly on the
floor is an anatomical study without
embellishment or pretext. The only adorn-
ment: the twisted braid of hair, in which it
is tempting to discern an echo of the two
G's of the artist's signature. [fig. 16]

The First Fontainebleau
Photographs, 1849

12
Attributed to Gustave Le Gray
**Landscape with Rocks
(Paysage de rochers)**
Salt print from a paper negative
209 × 271 mm
Formerly Henri Le Secq collection
Bibliothèque du Musée des Arts décoratifs,
Paris, cat. no. 511
[fig. 42]

13
**Landscape with Rocks
(Paysage de rochers)**
Salt print from a paper negative
197 × 262 mm
Blindstamp b. r.
Formerly Charles Nègre collection, then that
of Marie-Thérèse and André Jammes
EST, BNF, Paris, acquired 1999
[fig. 41]

14
Attributed to Gustave Le Gray
**Boulders with Man Seen from the Back
(Grands rochers avec un homme
de dos au centre)**
Salt print from a paper negative
195 × 261 mm
Formerly Charles Nègre collection, then that
of Marie-Thérèse and André Jammes
EST, BNF, Paris, acquired 1999

The presence in the collections of Charles
Nègre and Henri Le Secq of these very
early studies—one of which (cat. no. 13) is
signed by Le Gray—attests, if not to excur-
sions taken together in the forest, then at
least to strongly shared interests. These
three prints—along with another, now in
the Musée d'Orsay and likewise from the
collection of Charles Nègre (a gift of
Marie-Thérèse and André Jammes)—are
the only surviving evidence of Le Gray's
first attempts at landscape photography.
Taken from afar, more interesting than
successful, they allow us, through compar-
ison with works securely datable to
1851/52, to measure the rapidity of his
progress. This man, seen from the back, is
the only known instance of a human figure
in Le Gray's Fontainebleau photographs.
[fig. 43]

Studies and Portraits,
1849–1853

15
Attributed to Gustave Le Gray
**Portrait of Maxime Du Camp
(Portrait de Maxime Du Camp)**
1849
Salt print from a paper negative
120 × 90 mm
Dedicatory inscription: "À Louis Ulbach.
Souvenir d'amitié, Maxime Du Camp." [To
Louis Ulbach. Token of friendship, Maxime
Du Camp.]
Formerly Georges Sirot collection
EST, BNF, Paris

An identical print in the Musée Carnavalet
is inscribed: "À Charles de La Rounat, son
dévoué Maxime Du Camp" [To Charles de
La Rounat, his devoted Maxime Du Camp].
This small-format image, a bit pale, typical
of the first steps of a calotypist, apparent-
ly dates from the summer of 1849,
when Du Camp took lessons from Le Gray
before departing for Egypt. The dedica-
tions to Louis Ulbach and Charles de La
Rounat—the former, like Du Camp, a
writer and journalist for *La Revue de Paris*,
the latter the author of theatrical sketches
and librettos, a collaborator of Mérimée
and Banville—provide us with information
about the friendships cultivated by the
ambitious Du Camp, and about a circle
that Le Gray seems to have associated
with in the early 1850s. [fig. 18]

16
Attributed to Gustave Le Gray
**Portrait of Michel Carré
(Portrait de Michel Carré)**
ca. 1849/50
Salt print from a collodion-on-glass negative
154 × 103 mm
Formerly Jean-Léon Gérôme collection
BNF, Bibliothèque-musée de l'Opéra, Paris

Michel Carré (1819–1872) was a student
of Delaroche's with Le Gray and Gérôme,
but he soon abandoned painting to
become a successful librettist, the author,
notably, of texts set by Gounod,
Offenbach, Meyerbeer, and Bizet, and
coauthor, with Henri Murger, of
Bonhomme Jadis (1852). Carré's friendship
with Le Gray doubtless explains the beau-
tiful portraits of men of the theater made
by the latter in the years around 1850, as
well as Léon Maufras's reference to the
friendship between Le Gray and Murger.
 This collodion portrait, which is not
unlike the early portraits made by Nadar a
few years later, shows us Carré when he
was still young and thus differs markedly
from the one taken by Le Gray in 1859
(cat. no. 166), by which time both men
were famous. [fig. 5]

17
**Self-Portrait
(Autoportrait)**
ca. 1850–1852
Salt print from a collodion-on-glass negative
200 × 147 mm, oval
Blindstamp b. r.
Formerly Georges Sirot collection
EST, BNF, Paris [JPGM]

This straightforward image is typical of photographers' self-portraits from the early 1850s: sitting in a space that, despite the complete absence of decor, we sense is a studio, Le Gray strikes a relaxed, unaffected pose. Several self-portraits by him from this period are now known, the most interesting of which were taken in front of the studio (figs. 23, 24). One senses in these images an artist content in the midst of his work and his friends. Photography for him is still only a source of unmitigated joy. [fig. 97]

18
Attributed to Gustave Le Gray
Portrait of Eugène Piot
(Portrait d'Eugène Piot)

ca. 1851
Salt print from a paper negative
157 × 102 mm
Formerly Eugène Piot collection
Bibliothèque de l'Institut de France, Paris, ms. 2230

A perfect illustration of Le Gray's pedagogic activity, this image shows Eugène Piot (1812–1890)—historian, art dealer, and collector—briefly interested in photography (between 1849 and 1852), posing in front of the large doors of the barrière de Clichy studio, leaning on his camera. Such equipment often figures in Le Gray's images; photographs taken for the Mission héliographique, in the forest of Fontainebleau, and even in Cairo offer glimpses of the cameras of students or friends. In those cases the camera functions as the unobtrusive reminder of a presence, but here, uniquely, it is the principal accessory of a true portrait. [fig. 33]

19
Three group portraits: Philippe de Chennevières, Jules Buisson, Gustave Le Vavasseur, and Anatole de Boulet
(Trois portraits de groupe: Philippe de Chennevières, Jules Buisson, Gustave Le Vavasseur et Anatole de Boulet)

1852
Salt print from a paper negative
225 × 175 mm, ovals
Blindstamp c. r. on two of the prints
Probably acquired from Léon de La Sicotière, cofounder of the Société historique et archéologique de l'Orne with Gustave Le Vavasseur
Departmental Archives of l'Orne. Société historique et archéologique de l'Orne collection, Alençon, 33 Fi

The posing session that produced these three exceptional group portraits, discovered by Marc Smith and Jean-Pascal Foucher, was previously known only through a remark by Philippe de Chennevières: "I remember having seen Benjamin Delessert printing negatives in Le Gray's studio, on the boulevard [sic] de Clichy, in 1852, on a day when we went there to pose as a group of friends, Jules Buisson, Gust. Le Vavasseur, Anat. de Boulet, and myself." Philippe de Chennevières, *Souvenirs d'un directeur des Beaux-Arts* (Paris, 1888), 46. Ernest Prarond, providing Nadar with biographical information for the *Panthéon-Nadar*, likewise wrote: "As to the portrait, see Chennevières, just as ripe for caricature as the aforementioned Le Vavasseur, from a portrait *en blouson* by Lafontan to the photograph by Le Gray," which might be a reference to yet another portrait (BNF, MSS, NAF 24281, letter 7996, November 23, 1853).

The variety of poses struck by the four friends, which change before our eyes as inspiration seizes them, allows us to witness the creation of one of the group portraits that are so important in the work of Le Gray, Charles Nègre, and Nadar. The casual gestures and the good humor lighting up their faces make this a perfect illustration of the youthful enthusiasm of the French photography milieu in the early 1850s. [figs. 30–32]

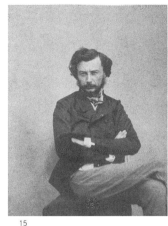

15

16

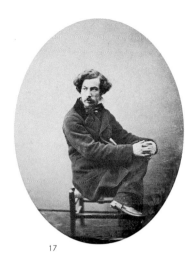

17

18

19 a

19 b

19 c

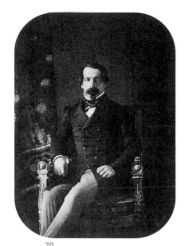

20

Portrait of Louis-Napoléon Bonaparte as Prince-President (Portrait de Louis-Napoléon Bonaparte en Prince-Président)

1852
Salt print from a paper negative
203 × 143 mm
Bibliothèque de la manufacture de Sèvres, acquired 1852
Archives of the Manufacture nationale de Sèvres [JPGM]

"Surely all of our Parisian subscribers have seen, in the shops of the principal print dealers, the portrait of the president of the Republic of which he [Le Gray] has recently made a considerable number of prints. It is a beautiful portrait of great strength and felicitous in its artistic effect." Ernest Lacan, *La Lumière*, no. 36 (August 28, 1852): 143. [fig. 65]

21

Italian Street Musicians (*Pifferari*) (Groupe de musiciens des rues italiens: *pifferari*)

ca. 1851–1853
Salt print from a collodion-on-glass negative
197 × 148 mm, oval
Black blindstamp b. c.
Tel Aviv Museum

The Italian street musicians who moved around Paris were often subjects for artists in the 1850s. They figure in photographs by Charles Nègre, posed for Louis-Camille d'Olivier, and appear in paintings by Gérôme. Here Le Gray caught them without street or studio backdrop to produce a purely picturesque motif, tempering the clarity of the collodion with a slight blur on the child's face and with the rich darks of a green-black print. [fig. 248]

22

Portrait of Pierre Michel François Chevalier, Known as "Pitre-Chevalier" (Portrait de Pierre Michel François Chevalier, dit Pitre-Chevalier)

ca. 1853
Salt print from a collodion-on-glass negative
170 × 130 mm
Blindstamp toward c. r.
Gilman Paper Company Collection, New York [JPGM]

Writer, chronicler, and contributor to many periodicals, Pitre-Chevalier (1812–1863) became in 1845 the editor in chief of the *Musée des familles*, and in 1849 one of its three owners. This is the periodical that in 1853 published a long article by Francis Wey, titled "Comment le soleil est devenue peintre" (How the sun became a painter), in which Le Gray is discussed at length. An engraved group portrait captioned "M. Francis Wey, M. Pitre-Chevalier, and Doctor X . . . under the oak tree at Marly-le-Roi" precedes the text (fig. 340). It was based on photographs of which the present one is the only one known to survive. The portrait of Wey in the engraving is quite close to one signed by Nadar. Le Gray made many photographs—landscapes as well as portraits—on commission for periodicals, which then published them as wood engravings. [fig. 341]

23

Corner of a Garden with a Rake (Coin de jardin avec râteau)

ca. 1851–1853
Salt print from a collodion-on-glass negative
250 × 205 mm
Black wetstamp b. l.
Formerly Georges Sirot collection
EST, BNF, Paris [JPGM]

This is one of Le Gray's most beautiful works, though we know nothing about the making of it. It is quite clear, however, that it dates from the early 1850s, and thus the garden could not be that of Alphonse Karr in Nice, in 1860, as was suggested by Eugenia Parry Janis. The ordinariness of the plants (cherry tree, hollyhocks, grape vines, lilacs) indicates that this humble garden could be anywhere in France. The extreme rigor of the composition does not diminish the poetry of the image—quite the contrary. Long admired by Bernard Marbot, this print inspired him to remark, "It is less the objects in their essence than their existence in a mysterious atmosphere that solicits the attention of the viewer. Each element seems to know something about a hidden presence, and to want to remain silent about it; this willed silence gives the objects themselves a peculiar intensity." "Le motif valorisé," in *L'Invention d'un regard*, exh. cat. (Paris, 1989), 156. [fig. 286]

24

View of Montmartre (Vue de Montmartre)

ca. 1849/50 (landscape), ca. 1855/56 (sky and combined printing of the two negatives)
Albumen print from a paper negative (landscape) and a collodion-on-glass negative (sky)
202 × 262 mm, oval
Blindstamp in red ink b. l.
Formerly Georges Sirot collection
EST, BNF, Paris [JPGM]

Like the preceding image (cat. no. 23), this view of Montmartre evokes the lost continent of Le Gray's more personal works, the beauty all the more poignant because our knowledge of "this continent" is limited to the few remaining islets. The artifice of combination negatives served him above all in the seascapes and in the views of Fontainebleau. As used here, it reveals his intention to extract a work of art from a motif that was still neglected by painters: the undeveloped slopes of Montmartre and the silhouettes of its windmills. [fig. 21]

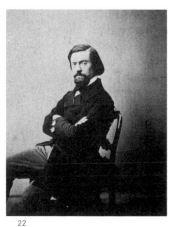

22

23

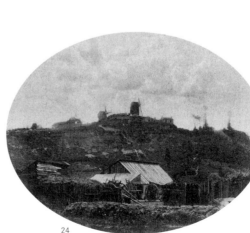

24

The Barrière de Clichy Studio, 1848–1854

25
Stacked Paving Stones in front of the Studio (detail)
(Détail d'un tas de pavés devant l'atelier)
ca. 1849
Salt print from a paper negative
152 × 213 mm
Inscribed in Le Gray's hand on the negative: "Négatif obtenu en 10 secondes avec l'objectif simple et la préparation de bromure et fluorure de potassium" [Negative made in 10 seconds with a single lens and a preparation of bromide and potassium fluoride]
Regnault Album, no. 75
Société française de photographie, Paris

Le Gray photographed piles of paving stones in front of the studio, along the road at Fontainebleau, near churches being restored during the Mission héliographique, in a Paris being rebuilt by Haussmann, in Palermo. This motif recurs in Le Gray's oeuvre as a symbol of a Second Empire born of the paving stones of the barricades of 1848, an empire that derived its economic power from the building fever of real-estate speculators. Reduced here to a pure object, the image is inscribed with technical annotations. Thus it has two aspects; a scientific experiment, it is also a work admirable for its force and its economy of means. [fig. 293]

26
Gustave Le Gray or his circle
View from the Studio Roof
(Vue prise du toit ou de l'étage supérieure)
ca. 1851–1854
Salt print from a paper negative
210 × 257 mm
Formerly Émile Le Senne collection
EST, BNF, Paris [JPGM]
[fig. 38]

27
Gustave Le Gray or his circle
View from the First Floor of the Studio
(Vue prise du rez-de-chaussée ou du premier étage)
ca. 1851–1854
Salt print from a paper negative
196 × 256 mm
Formerly Paul Blondel collection
EST, BNF, Paris

At the end of the low wall, where the roof and the fence meet, is a wooden pole stuck in a bit of plaster. This was probably a target post used to teach photography students how to center or focus their images. [fig. 40]

28
Gustave Le Gray or his circle
View from the First Floor of the Studio
(Vue prise du rez-de-chaussée ou du premier étage)
ca. 1851–1854
Salt print from a paper negative
261 × 351 mm
Gilman Paper Company Collection, New York [JPGM]

This view, also taken from the studio but at a much wider angle, is not exactly contemporary with the preceding one (cat. no. 27), for the wooden fence and target post are not there. The existence of several exposures taken from this angle indicates the intensity of Le Gray's teaching activity. [fig. 39]

29
Gustave Le Gray or his circle
The Studio at the Barrière de Clichy
(Vue d'ensemble de la maison)
Salt print from a paper negative
242 × 335 mm
Formerly W. H. G. collection
Musée Carnavalet, Paris [JPGM]
The large, north-facing windows of the studio can be seen in this image. [fig. 22]

30
Gustave Le Gray and/or Odet de Montault
(two images on one sheet)
[a] View from the Studio
(Vue prise depuis la maison)
Salt print from a collodion-on-glass negative
109 × 152 mm, oval
[fig. 29]

[b] Portrait of Odet de Montault
(Portrait d'Odet de Montault appuyé au mur de l'atelier)
Salt print from a collodion-on-glass negative
159 × 137 mm, corners cut
[fig. 26]

Montbreton Album
Los Angeles, J. Paul Getty Museum, 84.XA.923. 79 [JPGM]

25

29

26

30 a

27

30 b

28

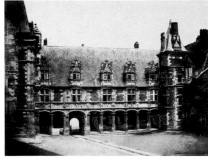

31

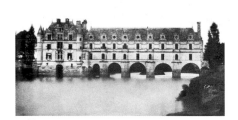

34

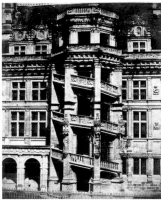

32

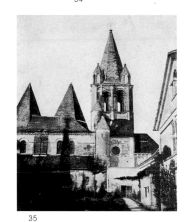

35

33

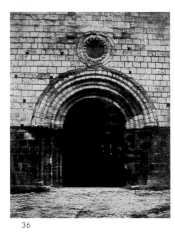

36

37

Mission Héliographique, Summer 1851

Note: All the photographs from the Mission héliographique are salt prints from waxed-paper negatives.

When a negative number does not appear on the exhibited print but is known from another source, it is placed in brackets.

On problems surrounding the attribution of these images, see pp. 62–65.

31
Louis XII Wing, Château de Blois
(Blois, château: cour intérieure)
238 × 314 mm
[Neg. no. 9]
Formerly Georges Sirot collection
EST, BNF, Paris [JPGM]
[fig. 91]

32
Staircase of François I,
Château de Blois
(Blois, château: escalier François Iᵉʳ)
376 × 305 mm
[Neg. no. 13]
Musée d'Orsay, Paris, DO 1982-290
[fig. 92]

33
Roofs and Lantern, Château
de Chambord
(Chambord, château: toits et
lanterne)
320 × 305 mm
Neg. no. "34" b. l.
Formerly Georges Sirot collection
EST, BNF, Paris [JPGM]
[fig. 93]

34
Château de Chenonceaux
(Chenonceaux, château:
vue d'ensemble)
257 × 355 mm
[Neg. no. 57 or 58]
Blindstamp b. r.
Formerly Georges Sirot collection
EST, BNF, Paris [JPGM]
[fig. 96]

35
Church of Saint-Ours, Loches
(Loches, église Saint-Ours: côté nord)
320 × 253 mm
[Neg. no. 59]
Médiathèque du Patrimoine, Paris, MH 7482
[JPGM]

This perfectly composed image is characterized by simple forms—triangles, circles, and squares—that are softened and emphasized by elements of vegetation: a young cyprus tree that rises precisely between two windows and a climbing plant whose dark course along the white wall leads the viewer's gaze to the end of the garden. [fig. 68]

36
West Portal, Church of
Saint-Ours, Loches
(Loches, église Saint-Ours,
portail ouest)
363 × 279 mm
Médiathèque du Patrimoine, Paris, MH 7484
[fig. 86]

37
Tours Cathedral
(Tours [Indre-et-Loire]. Cathédrale.
Ensemble ouest)
Waxed-paper negative
340 × 250 mm
Musée d'Orsay, Paris, DO 1982-561

In this frontal view, which might have served as the frontispiece to a contemporary publication of photographs of the Mission héliographique, note the presence of the two friends' second camera, as well as their own portrait; seated side by side in the cart at right, they confirm for us the double paternity of these images. [fig. 288]

38
Church of Saint-Martin, Candes
(Candes, église Saint-Martin)
377 × 304 mm
[Neg. no. 81]
Médiathèque du Patrimoine, Paris, MH 7481

The slender, dark trunk of a "liberty tree," planted during the recent revolution of 1848, and the sign reading "Liberté, Égalité, Fraternité"—its revolutionary character all the more emphatic because of its appearance above the door of a church—ground this image in recent political events. Beyond these historical factors, note the column that echoes the tree (again the spiritual and the temporal) and the gleam of the stained-glass window that traverses the interior to draw our gaze inside. [fig. 72]

39

The Dolmen Known as "La Petite Pierre Couverte," Bagneux
(*Bagneux [Maine-et-Loire]. Dolmen dit la Petite Pierre couverte*)
Waxed-paper negative
250 × 340 mm
[Neg. no. 88]
Musée d'Orsay, Paris, DO 1982-573

The inversion of values in this paper negative is dramatic; it transforms the dolmen, a pagan monument, into Christ's tomb at the moment of resurrection. [fig. 289]

40

The Dolmen Known as "La Grande Allée Couverte," Bagneux
(*Bagneux [Maine-et-Loire]. Dolmen dit la Grande Allée couverte*)
238 × 340 mm
[Neg. no. 89]
Médiathèque du Patrimoine, Paris, MH 7515
[fig. 66]

41

The Dolmen Known as "La Grande Allée Couverte," Bagneux
(*Bagneux [Maine-et-Loire]. Dolmen dit la Grande Allée couverte*)
Waxed-paper negative
238 × 340 mm
[Neg. no. 89]
Musée d'Orsay, Paris, DO 1982-574

This dolmen evokes the roughly contemporaneous views of the forest of Fontainebleau. The squat and primitive monument, consumed by moss and guarded by young trees, is like the large rocks of Fontainebleau amid stands of trees. Here vertical vegetal elements and horizontal mineral ones balance each other to achieve a perfect landscape. [fig. 287]

42

Church of Saint-Pierre, Chauvigny
(*Chauvigny, église Saint-Pierre*)
382 × 305 mm
Neg. no. "147" top c.
Michael S. Sachs collection, Westport
[fig. 89]

43

Church of Saint-Léonard, Saint-Léonard-de-Noblat
(*Saint-Léonard-de-Noblat, église Saint-Léonard*)
367 × 238 mm
[Neg. no. 155]
Médiathèque du Patrimoine, Paris, MH 15999

The framing elements—two dark buildings in the foreground—deftly accentuate the vertical thrust of the bell tower, which Le Gray crops precisely at the tip of its culminating cross. [fig. 84]

44

Church of Saint-Pierre, Melle
(*Melle, église Saint-Pierre*)
385 × 284 mm
Neg. no. t. l.: 262.
Suzanne Winsberg collection, New York

The beauty of this image derives from the roughness of the forms and from the lighting contrasts: the architecture is squat, devoid of ornament; the piers framing the portal are intersected with large, whitewash crosses; the statue of Christ hides its mutilation in the shadow of its mandorla. Would it be paradoxical to say that here, in this humbled edifice, Le Gray and Mestral best captured the strength of the faith that animated its medieval builders? [fig. 88]

45

Church of Saint-Seurin, Bordeaux
(*Bordeaux, église Saint-Seurin*)
312 × 228 mm
[Neg. no. 287]
Médiathèque du Patrimoine, Paris, MH 7474

This is certainly one of the most striking formal inventions of the Mission héliographique. The grille in the foreground occupies the exact lower third of the image. It underscores, defends, and protects the sacred precinct, which remains in semidarkness. Beyond these strong white lines, one discerns an abundance of delicate ornaments, a mysterious populace of statues. It is the medieval world of Victor Hugo as staged by the *Neue Sachlichkeit*. [fig. 73]

39

40

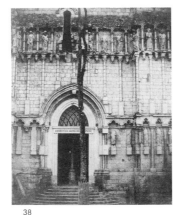

41

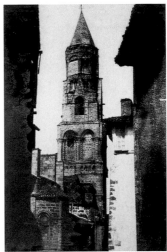

43

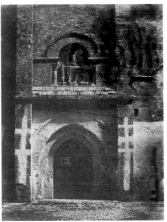

44

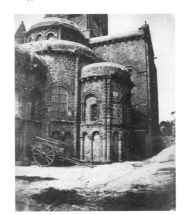

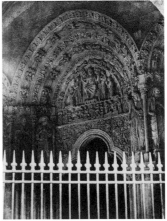

38

42

45

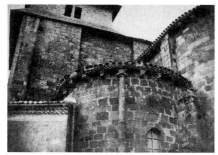

46

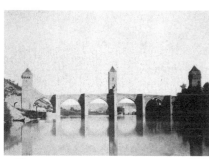

47

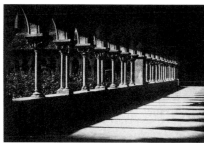

48

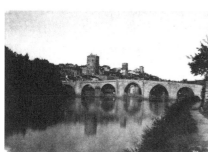

49

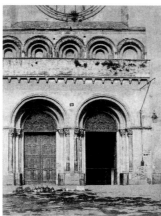

50

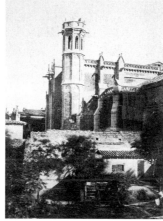

51

52

46
Church of Saint-Vincent,
Le Mas d'Agenais
(Le Mas d'Agenais, église)
276 × 382 mm
Neg. no "311" b. r.
Michael S. Sachs collection, Westport

This photograph was intended above all to document the sculpted brackets on the exterior of the end of the church, but the composition of the volume of the apses and the roofs shatters the conventions of architectural representation, opting instead for a magisterial constructivist geometry. [fig. 90]

47
Cloister of the Church of Saint-Pierre,
Moissac
(Moissac, abbatiale Saint-Pierre:
le cloître)
230 × 345 mm
Blindstamp b. r.
Formerly Brébisson collection
Musée d'Orsay, Paris, PHO 1979-20 [JPGM]

"He obtained a moonlight effect on the ruins of the silent and dreamlike cloister, so convincing that one expects to see the tombstones rise, and the caressing shrouds of the nuns turn white as in the fourth act of *Robert le Diable* [an 1831 opera by Giacomo Meyerbeer and Eugène Scribe]. The arabesques roll up, the trefoils stand forth, the ogives let the moonlight pass through them, the stained-glass window outlines its story with an accomplished transparency. M. Le Gray has a palette in photography; he varies his tints infinitely, clarity can go no further. The page becomes stone or marble." Henri de Lacretelle, *La Lumière* (February 28, 1852): 37. [fig. 282]

48
Pont Valentré, Cahors
(Cahors, pont Valentré)
232 × 333 mm
[Neg. no. 33]
Médiathèque du Patrimoine, Paris

The famous pont Valentré stands out between the water that reflects and prolongs it and the clear sky, which is cut through by the boldness of the architecture. The bridge is still untouched by the overelaborate "restoration" to follow. This symmetry encounters a perpendicular symmetry: the dark vegetation at right answers the bare, sunlit area to the left. [fig. 69]

49
Pont Cabessut, Known as
the Pont Neuf, Cahors
(Cahors, pont de Cabessut,
dit pont Neuf, et la ville)
242 × 341 mm
Neg. no. b. r.: 374
Michael S. Sachs collection, Westport
[fig. 94]

50
Basilica of Saint-Sernin, Toulouse
(Toulouse, basilique Saint-Sernin)
379 × 289 mm
Médiathèque du Patrimoine, Paris, MH 7473

In this image of the portals of Saint-Sernin, the perfect symmetry of the facade is agreeably undermined by details that animate the composition. The framing is shifted off-center to the left; one of the doors being wide open, the darkness of the interior pierces the white of the facade, summoning the faithful. The image comfortably accommodates, at right, a lantern fixed to the wall and a torn lottery poster in which the figure "100,000" is legible, and, on the ground, the display of an itinerant pottery seller, a modest, horizontal still life extended into the foreground by weeds. [fig. 85]

51
Church of Saint-Nazaire, Carcassonne
(Carcassonne, église Saint-Nazaire)
324 × 240 mm
[Neg. no. 460]
Médiathèque du Patrimoine, Paris, MH 7442
[fig. 87]

52
The Porte Narbonnaise, Carcassonne
(Carcassonne, porte Narbonnaise)
365 × 263 mm
Neg. no. b. r.: 466
Michael S. Sachs collection, Westport

The contrast of lights and darks, almost a metaphor for photography, makes this a technical tour de force; the shadows are very deep yet allow one to see the texture of the stone as well as the intense light beyond. Le Gray submitted this work and a view of the central portal of the Tours cathedral to the Salon of 1852; the jury rejected them. Assuming that Le Gray's choice of these two pieces is significant, it might have been meant to demonstrate his ability to produce both commissioned work consistent with the agenda of the Mission héliographique and—different

gate, different genre—more personal works of a kind exemplified by this view of the Porte Narbonnaise. [fig. 82]

53

Ramparts and Towers, Carcassonne (Carcassonne, remparts: perspective fuyante)
235 × 331 mm
Neg. no. 467
Signed in black ink b. r.: "Gustave Le Gray et Mestral"
Gilman Paper Company Collection, New York [JPGM]
[fig. 80]

54

The Cemetery and Ramparts, Carcassonne (Carcassonne, remparts, avec le cimetière au premier plan)
242 × 327 mm
Neg. no. b. r.: 474
Formerly Georges Sirot collection
EST, BNF, Paris [JPGM]
[fig. 79]

55

A Distant Overall View, Carcassonne (Carcassonne, remparts: vue d'ensemble éloignée)
276 × 381 mm
Neg. no. b. r.: 479
Formerly Georges Sirot collection
EST, BNF, Paris
[fig. 81]

56

Ramparts with Tower, Carcassonne (Carcassonne, remparts: détail)
284 × 381 mm
Michael S. Sachs collection, Westport (this print not exhibited)
[fig. 346]

57

Ramparts and Gate, Carcassonne (Carcassonne, remparts: perspective fuyante)
284 × 380 mm
[Neg. no. 493 *bis*]
Médiathèque du Patrimoine, Paris, MH 7446
[fig. 78]

58

Ramparts, Carcassonne (Carcassonne, remparts: perspective fuyante)
242 × 332 mm
Neg. no. b. r.: 496
Formerly Georges Sirot collection
EST, BNF, Paris

Carcassonne is by far the site most photographed by Le Gray and Mestral. Discussions with the commission during the spring of 1851 regarding the anticipated restoration, the large scale of the work envisioned by Viollet-le-Duc, and the presence of the architect during the taking of these views explain the exhaustive nature of the photographic coverage. The monumental power of the ramparts punctuated by towers allowed the artists to use an unparalleled variety of vantage points, resulting in both details and general views. [fig. 77]

59

Cloister, Elne (Elne [Pyrénées-Orientales], cloître)
Waxed-paper negative
340 × 250 mm
Musée d'Orsay, Paris, DO 1982-717
[fig. 290]

60

The Pont du Gard (Pont du Gard)
Print ca. 1856, sky from a collodion-on-glass negative
223 × 324 mm
Neg. no. b. r.: 561
Formerly W. H. G. collection
Private collection, courtesy Ezra Mack, New York (this print not exhibited)

Le Gray augmented this magnificent print, with its extremely delicate greenish yellow tints, with a sky printed from a glass negative. The number on the negative indicates that it was made during the Mission héliographique, but it was conceived as a personal work, as a landscape with the aqueduct's three superimposed rows of arches inscribed against the horizon. [fig. 95]

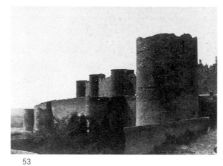
53

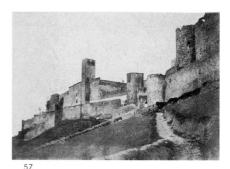
57

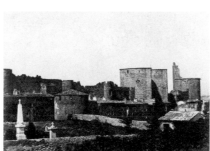
54

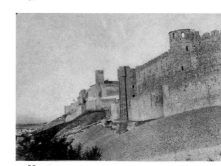
58

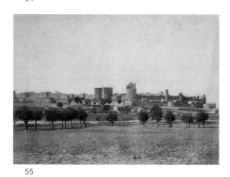
55

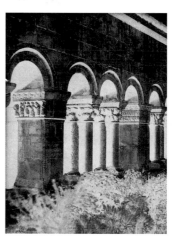
59

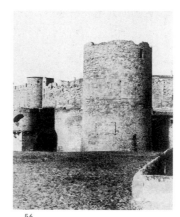
56

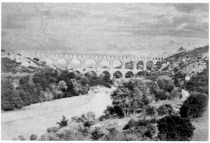
60

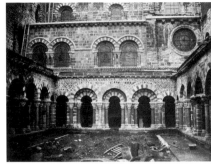

61

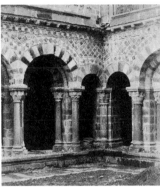

62

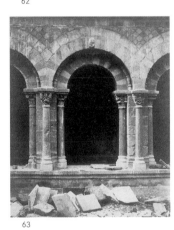

63

64

65

66

67

61

**The Cloister of the Cathedral
of Notre-Dame, Le Puy
(Le Puy, cathédrale Notre-Dame:
le cloître)**

282 × 375 mm

Signature in Le Gray's hand in black ink b. r.:
"Gustave Le Gray et Mestral"

Formerly Petiot-Groffier collection, then that
of Marie-Thérèse and André Jammes

EST, BNF, Paris, gift 1999 [JPGM]

Here one gets the most concrete sense of
the extensive restoration campaign under-
taken to save French monuments after
decades of destruction and neglect. This
skyless image, densely speckled with poly-
chrome masonry and spanned by arches,
has in its upper portion a richness of orna-
mentation that is almost Oriental, while the
garden for prayer and meditation, denuded
and transformed into a construction site, is
invaded by a chaotic still life of humble
tools that nonetheless is not discordant
with the Romanesque architecture. The
work begun in 1850 by the architect Mallay
was then at its height. The print's remark-
able slate blue tonality envelopes the whole
in a gauzy softness. [fig. 291]

62

**Corner of the Cloister,
Cathedral of Notre-Dame, Le Puy
(Le Puy, cathédrale Notre-Dame:
détail d'un angle du cloître)**

273 × 239 mm

[Neg. no. 586]

Médiathèque du Patrimoine, Paris, MH 7508

[fig. 70]

63

**Cathedral of Notre-Dame,
Detail of the Cloister Arcade, Le Puy
(Le Puy, cathédrale Notre-Dame:
détail d'une arcade)**

309 × 237 mm

Neg. no. b. c., retouched in ink on the print:
587

Michael S. Sachs collection, Westport (this
print not exhibited)

The greenish yellow print of this detail view
produces a very different impression than
does the overall view (cat. no. 61); the
rhythm of the arches and their ornament
stand out with greater clarity against the
dark recesses of the gallery. The loose
paving stones in the foreground strike a
prosaic note that interrupts the somewhat
dry harmony of this architectural docu-
ment, situating the monument within the
flow of time by recalling the restoration
work that was then underway. [fig. 71]

Forest of Fontainebleau,
First Series, 1852

64

**Trees along the Road to Chailly
(Arbres en bordure du pavé de Chailly)**

Salt print from a paper negative

239 × 330 mm

Print no. printed on the mount: 50

Manfred Heiting collection, Amsterdam,
MHC 1127 [JPGM]

[fig. 53]

65

**Trees along the Road to Chailly
(Arbres en bordure du pavé de Chailly)**

Print late 1855

Albumen print from a paper negative (land-
scape) and a collodion-on-glass negative
(sky)

200 × 280 mm

Neg. no. 743, repeated in ink b. r. on the
mount

Print no. printed b. l. on the mount: 941

Red wetstamp b. r.

EST, BNF, Paris, acquired 1997

The same combination-printed sky is found
in an image of the château de Boisy, ten
kilometers from Roanne (fig. 74); it was no
doubt photographed at yet a third location.
After he opened his studio on the boule-
vard des Capucines, Le Gray apparently
began to reprint his calotype landscape
views, adding skies from glass negatives.
This example from the Chailly series is par-
ticularly eloquent. [fig. 46]

66

**Forest Scene
(Futaie)**

Print ca. 1856

298 × 377 mm

Neg. no. b. l.: 802

Red wetstamp b. r.

Suzanne Winsberg collection, New York
[JPGM]

This superb albumen print shows the con-
tinuity of Le Gray's work between his
exposures of 1852 and the more commer-
cial uses to which he put them beginning
in late 1855. His qualities as a colorist are
still in evidence, despite his abandonment
of the chromatic range of salt prints. The
image is as remarkable for its extremely
delicate details as for its general evoca-
tion of flourishing vegetation. The fore-
ground elements—a carpet of blurred
flowers and the intrusion of a branch
traversing the upper right corner—add
vigor and depth to the principal motif: the

vertical punctuation of the space by slender, young tree trunks. The presence of a camera in the right distance, beside a road, is so discreet as to seem almost fortuitous, but it is in fact significant. It attests to the presence of a companion, perhaps J. B. Greene. [fig. 55]

67
The Road to Chailly, Cloudy Sky
(Pavé de Chailly, ciel nuageux)
Print ca. 1856
Albumen print from a waxed-paper negative (landscape) and a collodion-on-glass negative (sky)
257 × 362 mm
Neg. no. b. l.: 805
Formerly Zuber-Buhler collection
EST, BNF, Paris
[fig. 264]

68
The Road to Chailly,
Another Cloudy Sky
(Pavé de Chailly, autre ciel nuageux)
Print ca. 1856
Albumen print from a waxed-paper negative (landscape) and a collodion-on-glass negative (sky)
252 × 352 mm
Neg. no. b. l.: 805
Red wetstamp b. r.
Formerly Townshend collection
Victoria and Albert Museum, London, 68.009

This view of the road to Chailly and the preceding one (cat. no. 67) should be considered in tandem with the three others described here (cat. nos. 72–74); in these images of the dusty road reuniting with the sky between dark masses of vegetation, we find the same deft balancing of masses and materials. The three white tree trunks near the road at left and the succession of piles of sand at right give the composition a wonderful cohesion. [fig. 263]

69
Gnarled Oak near l'Épine Crossroads
(Chêne Rogneux près du carrefour de l'Épine)
Albumen print from a waxed-paper negative
252 × 373 mm
Neg. no. b. l.: 809
EST, BNF, Paris [JPGM*]

Of all of Le Gray's Fontainebleau images, the largest number of prints survive of this one, and doubtless it was the most successful. The oak—which Le Gray photographed at least twice (another image is

in the BNF collection)—was one of those oddities of the plant kingdom that inspire artists. It figures over the years in the work of other Barbizon photographers, notably Langerock in 1872. [fig. 276]

70
Study of an Oak Tree
(Étude de chêne)
Salt print from a waxed-paper negative
280 × 390 mm
[Neg. no. 812, but in fact not numbered]
Marie-Thérèse and André Jammes collection, Paris

This study belongs to an album of eleven photographs by Le Gray—all salt prints from paper negatives—taken in the forest of Fontainebleau. The very simple binding of grainy, dark green paper, with the title "Fontainebleau" in gold letters on the cover, as well as the absence of signatures and negative numbers, indicates that the owner of the album, if not Le Gray himself, was someone close to him. These prints are experiments, exploring the use of color and other effects; they are artist's proofs. This particular print is extremely dark, its details having been sacrificed in favor of a dark, vegetal jumble. [fig. 261]

71
Study of an Oak Tree
(Étude de chêne)
Printed ca. 1856
Albumen print from a waxed-paper negative
278 × 380 mm
Neg. no. b. r.: 812
Red wetstamp b. r.
Formerly Paul Blondel collection
EST, BNF, Paris [JPGM]

This print was made some four years after the preceding one (cat. no. 70), from the same negative, but in the interim the numbering of prints had begun. The two prints differ in every respect: process, color, light, and clarity of detail. This is a perfect example of what, thirty years later, would be the credo of pictorialist photographers: the negative is only the matrix for the work; it is the printing that permits the artist to fully express his vision. [fig. 262]

72
The Road to Chailly, Clear Sky
(Perspective du pavé de Chailly, ciel pur)
Albumen print from a waxed-paper negative
242 × 355 mm
Neg. no. b. r.: 816
Black wetstamp b. r.
Blindstamp b. c. on the mount: "Gustave Le Gray & Cº Paris"
Formerly Félix Herbet collection
EST, BNF, Paris

73
The Road to Chailly, Cloudy Sky
(Perspective du pavé de Chailly, ciel nuageux)
Albumen print from a waxed-paper negative (landscape) and a collodion-on-glass negative (sky)
282 × 388 mm
Neg. no. b. r.: 816
EST, BNF, Paris
[fig. 269]

70

71

68

69

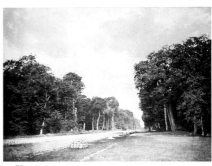

72

73

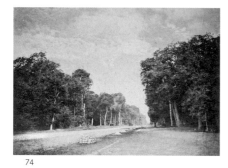

74

78

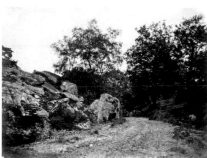

75

76

76

79

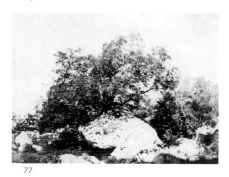

77

80

81

74

The Road to Chailly, Another Cloudy Sky (Perspective du pavé de Chailly, autre ciel nuageux)
Albumen print from a waxed-paper negative (landscape) and a collodion-on-glass negative (sky)
282 × 388 mm
Neg. no. b. r.: 816
Formerly Townshend collection
Victoria and Albert Museum, London, 68.010

Here Le Gray continues the project initiated in view no. 805 (cat. nos. 67, 68) but perfects his composition and fully realizes his idea. The piles of paving stones in the foreground (vigorously retouched on the negative so as to accentuate their details) recall other uses of this motif, dear to Le Gray, in photographs of the barrière de Clichy (cat. no. 25) and for the Mission héliographique. In addition to the point of view, the profile of the trees against the sky here is so close to the one found in the analogous composition painted by Monet some twelve years later (ca. 1865) that one cannot help but think the painter must have known this photograph. [fig. 271]

75

The Road to Mont-Girard (Route du Mont-Girard)
Salt print from a paper negative
280 × 376 mm
Marie-Thérèse and André Jammes collection, Paris

This view of a turning road flanked by rocks and trees is from the same album as the study of an oak tree (cat. no. 70). Like the view of the road to Chailly, this one attests that, by contrast with photographers like Cuvelier who ventured far from the beaten path, Le Gray rarely left the main roads, finding inspiration almost without leaving his carriage. Note the wooden pole stuck into the ground just left of the road (near the center), which must have served the teacher, and perhaps his students, as a reference point for framing. It was a bit of a tease for him to have left this in the image; the forest has been domesticated by the roadway traversing it, yet the photographer opts to underscore the human presence still more. He felt no need to create the illusion of an artist confronting unspoiled nature, for the beauty of the image derives above all from the rigor of the composition. [fig. 52]

76

View of Bas-Bréau, Forest of Fontainebleau (Sous-bois au Bas-Bréau)
1852
Salt print from a paper negative
268 × 358 mm
Formerly Cambon collection
Musée Ingres, Montauban, MI.C.61-3
[fig. 1]

77

Boulder at Cabat, l'Épine Crossroads (Roche à Cabat. Carrefour de l'Épine)
Salt print from a paper negative
195 × 265 mm
Blindstamp b. l.
Title inscribed on back of the mount
J. Paul Getty Museum, Los Angeles, 84.XM.637.23 [JPGM]
[fig. 51]

78

Curtain of Trees, Fontainebleau (Rideau d'arbres)
Salt print from a paper negative
198 × 264 mm
Black wetstamp b. l.
J. Paul Getty Museum, Los Angeles, 84.XM.637.6 [JPGM]

This view, along with three others of Fontainebleau by Le Gray, comes from the collection of the American painter Charles Henry Miller (1842–1922), who sojourned in Europe, notably in Barbizon, between 1867 and 1870. [fig. 54]

Reproductions of Works of Art, 1850–1855

79

***Don Pedro of Toledo Kissing the Sword of Henri IV* by J. A. D. Ingres (J. A. D. Ingres, *Don Pedro de Tolède baisant l'épée de Henri IV*)**
ca. 1849/50
Salt print from a paper negative
174 × 139 mm
Blindstamp b. l.
Inscribed on the mount: "J. Ingres inv. et pinxit"
Formerly Cambon collection
Musée Ingres, Montauban, MI.C.45-28

Another print in the collection of the Musée Ingres came directly from the artist. The photograph reproduces not the original version of 1814 but a variant in grisaille painted between 1824 and 1834.

The circumstances of making the photograph are unknown, but the painting always belonged to Ingres, so this was not a case of the work's having been photographed before being ceded to someone else. At a time when the chemical composition of light-sensitive emulsions precluded the accurate rendering of tonal relations, images in grisaille photographed well. [fig. 63]

80
The Marseillaise by François Rude, the Arc de Triomphe
(Arc de Triomphe de l'Étoile: François Rude, *La Marseillaise*)
1852
Salt print from a waxed-paper negative
512 × 384 mm
Inscribed b. c. on the negative: "F. Rude"
Red wetstamp b. r.
Formerly Townshend collection
Victoria and Albert Museum, London, 68.028

"M. Le Gray had brought along some artistic studies, in which the painter revealed himself in the work of the photographer, and some of his enormous prints on waxed paper and on collodion, among others the group from the Arc de Triomphe that will make Rude's chisel immortal. So well known is M. Le Gray's talent that I need not report that these prints are wondrously beautiful" (see pp. 56–58). Charles Gaudin, *La Lumière*, no. 8 (February 24, 1855): 29. [fig. 62]

81
The Apotheosis of Napoléon by Jean-Pierre Cortot, the Arc de Triomphe
(Arc de Triomphe de l'Étoile: Jean-Pierre Cortot, *L'Apothéose de Napoléon*)
1852
Salt print from a waxed-paper negative
484 × 365 mm
Red wetstamp b. r.
Formerly Townshend collection
Victoria and Albert Museum, London, 68.029
[fig. 61]

82
Mural Painting by Henri Lehmann, Hôtel de Ville, Paris
(Peinture pour l'Hôtel de Ville de Paris: Henri Lehmann, *Danse et musique*)
Salt print from a waxed-paper negative
1853
290 × 385 mm
Wetstamp b. l. on the mount: "H. Lehmann

inv. et pinx. 1852"
Registered for copyright 1854
EST, BNF, Paris, Dc 264 b folio
Henri Lehmann, *Peintures murales de la galerie des Fêtes de l'Hôtel de Ville de Paris, planches photographiques* (Paris, 1854), pl. 51 (see pp. 56–58 and 228–29). [fig. 266]

83
Gallery near the Salon Carré, the Salon of 1850–1851
(Salon de 1850–1851, galerie près du salon carré)
Salt print from a paper negative
155 × 252 mm
Blindstamp b. l.
Formerly archives of the Salon of 1852 (Musée du Louvre)
Musée d'Orsay, Paris, PHO 1984-104-9
[fig. 246]

84
First-Floor Gallery, the Salon of 1852
(Salon de 1852, perspective de la galerie du 1ᵉʳ étage)
Salt print from a waxed-paper negative
240 × 370 mm
Blindstamp b. r.
Formerly archives of the Salon of 1852 (Musée du Louvre)
Musée d'Orsay, Paris, PHO 1984-104-8

These two views—from an album of nine photographs, bearing a label inscribed "Surintendance des Beaux-Arts. Service de l'Exp⁽ᵒⁿ⁾ des Beaux-Arts," on deposit in the Musée d'Orsay from the Louvre—are part of a series commissioned from Le Gray by Philippe de Chennevières, curator in charge of organizing the Salon exhibitions. Although there is only one view of the 1850–1851 Salon (ninth in the album; cat. no. 83), there are eight of the 1852 Salon. Le Gray, whose works—paintings and photographs—were rejected by the Salon jury in precisely these years, was hired to photograph a theater of success from which he had been excluded. The commission offered Le Gray a chance at revenge, of a sort, and the results are beautiful, especially these two particular compositions, notable for their skillful handling of volume, the overhead lighting, and the whiteness of the marble. [fig. 245]

85
View of the Salon of 1853
(Vue du Salon de 1853)
Salt print from a waxed-paper negative
251 × 347 mm
Black wetstamp b. l.
Musée d'Orsay, Paris, PHO 2000-13-1
[fig. 244]

86
View of the Salon of 1853
(Vue du Salon de 1853)
Salt print from a waxed-paper negative
234 × 329 mm
Black wetstamp b. r.
Musée d'Orsay, Paris, PHO 2000-13-4

These two views of the Salon of 1853 were recently (and happily) discovered by Jacques Foucart in the documentation files of the Musée du Louvre. Were these also commissioned by Philippe de Chennevières, or did Le Gray act on his own initiative? The same year, Théophile Silvestre obtained authorization to have a few works photographed for his *Histoire des artistes vivants*, a projected publication. Le Gray was to have been a participating photographer, but everything suggests that, in the end, he did not join Baldus, Laisné, and Defonds on the project. In any event, the first of these two Salon views (cat. no. 85) is similar in spirit to those commissioned the previous year by Chennevières. This one, much more luminous but less symmetrically composed, brings to mind an artist's atelier or a collector's den more than it does an official exhibition. [fig. 243]

83

84

85

86

82

87

90

88

91

89

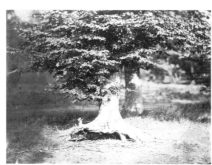

92

87

**The Mona Lisa (drawing of
Leonardo da Vinci's painting
by Aimé Millet, 1848)**
(*La Joconde,* **d'après un dessin
d'Aimé Millet de 1848**)

1854–1855
Albumen print from a collodion-on-glass
negative
283 × 190 mm
Black wetstamp b. r.
Dedicatory inscription in ink: "À Armand,
souvenir d'amitié, Aimé Millet" [To Armand, a
token of friendship, Aimé Millet]
Formerly Alfred Armand collection
EST, BNF, Paris

88

**The Mona Lisa (drawing of
Leonardo da Vinci's painting
by Aimé Millet, 1848)**
(*La Joconde,* **d'après un dessin
d'Aimé Millet de 1848**)

1854–1855
Salt print from a collodion-on-glass negative
Blue gray print
284 × 187 mm
Formerly W. H. G. collection
Private collection, courtesy Ezra Mack, New
York (this print not exhibited) [fig. 298]

89

**The Mona Lisa (drawing of
Leonardo da Vinci's painting
by Aimé Millet, 1848)**
(*La Joconde,* **d'après un dessin
d'Aimé Millet de 1848**)

1854–1855
Salt print from a collodion-on-glass negative
Yellow green print
288 × 189 mm
Formerly W. H. G. collection
Private collection, courtesy Ezra Mack, New
York (this print not exhibited) [fig. 299]

90

**The Mona Lisa (drawing of
Leonardo da Vinci's painting
by Aimé Millet, 1848)**
(*La Joconde,* **d'après un dessin
d'Aimé Millet de 1848**)

1854–1855
Salt print from a collodion-on-glass negative
Red plum print
286 × 190 mm
Formerly W. H. G. collection
Private collection, courtesy Ezra Mack, New
York (this print not exhibited) [fig. 300]

91

**The Mona Lisa (drawing of
Leonardo da Vinci's painting
by Aimé Millet, 1848)**
(*La Joconde,* **d'après un dessin
d'Aimé Millet de 1848**)

1854–1855
Green yellow print
Salt print from a collodion-on-glass negative
284 × 193 mm
Formerly W. H. G. collection
Private collection, courtesy Ezra Mack, New
York (this print not exhibited)

"The skilled artist, whose many projects
never prevent him from pursuing interest-
ing lines of research, also had in his port-
folios several prints in various tints,
obtained with coloring processes based
on the action of copper salts. These plates
are very interesting from a scientific per-
spective, and give an idea of the varied
effects obtainable through photographic
manipulation." Charles Gaudin, *La
Lumière,* no. 8 (1855): 29. [fig. 301]

Fontainebleau, Second Series, ca. 1855–1857

92

**Beech Tree
(Hêtre)**

Albumen print from a collodion-on-glass
negative
319 × 413 mm
[Neg. no. 96]
Print no. in ink b. r. on the mount: 1778
Red wetstamp b. r.
Blindstamp c. on the mount: "Photographie
Gustave Le Gray & Cᵒ Paris"
J. Paul Getty Museum, Los Angeles,
84.XM.637.22 [JPGM]

If the Fontainebleau views and the
seascapes are the two major themes that
mattered most to Le Gray, then this mag-
isterial study of a tree must be considered
a companion to *The Great Wave, Sète.* The
basic idea is the same: the artist chooses
a classic, resonant pictorial subject which
he then isolates, emphasizes by using an
extreme depth of field, and shapes by
means of light and color. The result
imposes itself on the viewer through its
sheer beauty.

The negative number is known from a
proof that once belonged to Horace Lecoq
de Boisbaudran (sold to Étude Millon,
Drouot-Richelieu, Paris, December 3,
2001, lot 5). [fig. 119]

93
The Road to Chailly
(Pavé de Chailly)
Albumen print from a collodion-on-glass
negative
246 × 337 mm
Neg. no. in ink b. r. on the mount: 103
Print no. in ink b. l. on the mount: 7805
Red wetstamp b. l.
Blindstamp c. on the mount: "Photographie
Gustave Le Gray & Cº Paris"
Formerly Horace Lecoq de Boisbaudran col-
lection
Private collection, Paris

This print, which fortuitously appeared on
the market at the end of 2001, shows that
Le Gray again took up, with a glass-plate
negative, a perspective of the road to
Chailly that he had photographed previ-
ously as a calotype. The match between
his 1852 subject and his new technical and
aesthetic preoccupations proves perfect.
He retained the basic composition but
incorporated more forest vegetation in the
right foreground, a feature that could be
combined with the distant perspective only
on a glass-plate negative. These fore-
ground elements bring us even closer to a
painting by Monet, the left side of which is
strikingly similar to another photograph by
Le Gray, as has already been noted (cat.
no. 74). [fig. 268]

94
Study of a Tree Trunk
(Étude de tronc)
Albumen print from a waxed-paper negative
261 × 200 mm
Black wetstamp b. r. on the mount
Inscribed in pencil b. r. on the mount:
"Nº 110 Fontainebleau"
Suzanne Winsberg collection, New York

"M. Le Gray allows his spirit even more
play in his views. Bolder with his effects,
he nonetheless retains a felicitous har-
mony even when at his most vigorous.
One of his forest studies, featuring a
splendidly lit tree in the foreground,
seems to have been painted by Diaz at his
most inspired." "Rapport sur l'exposition
ouverte par la Société en 1857," *Bulletin
de la Société française de photographie*
(1857): 281. [fig. 48]

95
Hollow Oak Tree
(Chêne creux dans une clairière)
Albumen print from a collodion-on-glass
negative
319 × 376 mm
Neg. no. in ink b. r. on the mount: 202

Print no. in ink b. l. on the
mount: 21663
Red wetstamp b. r.
Manfred Heiting collection,
Amsterdam, MHC 1287
[JPGM]

Tree portraiture is the
principal theme retained
by Le Gray in his second
Fontainebleau series,
photographed on glass-
plate negatives. Light
coming from the depth of
the image falls on the old
oak, emphasizing its radiating branches. In
other forest views, the artist includes
framing guideposts and cameras; here he
shows us the carriage that had brought
him to within a few steps of his subject.
[fig. 121]

96
Attributed to Gustave Le Gray
A Rising Sandy Road
(Chemin sablonneux montant)
Albumen print from a collodion-on-glass
negative
299 × 376 mm
Gilman Paper Company Collection, New York
[JPGM]
[fig. 118]

97
Avenue of Trees
(Allée forestière)
Albumen print from a collodion-on-glass
negative
310 × 410 mm
Red wetstamp b. r.
EST, BNF, Paris [JPGM]
[fig. 122]

98
Study of a Tree in a Clearing
(Étude d'arbre dans une clairière)
Albumen print from a collodion-on-glass
negative
Print no. in ink on back of print: 6788
Formerly Georges Sirot collection
EST, BNF, Paris [JPGM]
[fig. 116]

99
Study of Tree Trunks
(Étude de troncs)
Albumen print from a collodion-on-glass
negative
342 × 249 mm
Print no. in ink on back of print: 8220
Formerly Georges Sirot collection
EST, BNF, Paris [JPGM]
[fig. 117]

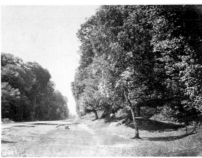
93

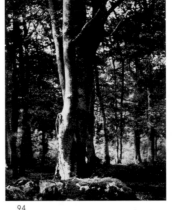
94

97

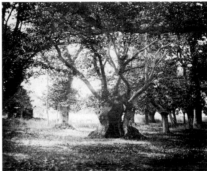
95

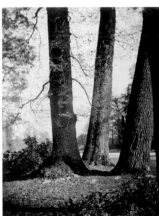
98

96

99

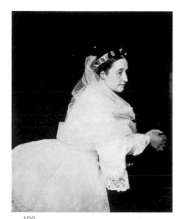

100

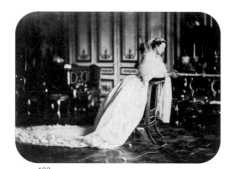

103

101

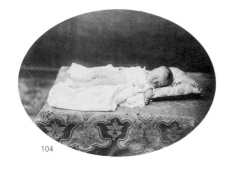

104

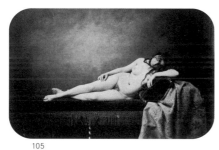

105

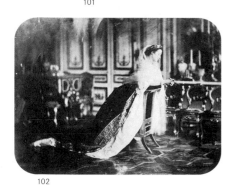

102

106

The Empress Eugénie and the Imperial Prince, Summer 1856

100
**The Empress Eugénie at Prayer
(L'impératrice en prière [en buste])**
Albumen print from a collodion-on-glass negative
300 × 215 mm
Formerly Félix Nadar collection
EST, BNF, Paris
[fig. 156]

101
**The Empress Eugénie at Prayer
(L'impératrice en prière [en buste])**
Albumen print from a collodion-on-glass negative
340 × 245 mm
Black wetstamp b. r.
Formerly Thomas Couture collection
Musée national du Château de Compiègne, Compiègne, C.64.033

"What generally distinguishes the work of this meticulous and skilled operator [Le Gray] is propriety and grace. Few pho tographists [sic] know how to render a woman's head as he does; in this difficult genre, the stumbling block and often absolute pitfall of the art under discussion, no one has yet surpassed him." Louis Figuier, *La Photographie au Salon de 1859* (Paris, 1860), 26. [fig. 155]

102
**The Empress Eugénie Kneeling, Saint-Cloud
(L'impératrice agenouillée
sur un prie-dieu)**
Albumen print from a collodion-on-glass negative
229 × 297 mm
Black wetstamp b. r.
Formerly Thomas Couture collection
Musée national du Château de Compiègne, Compiègne, C.71.153
[fig. 153]

103
**The Empress Eugénie Kneeling, Saint-Cloud
(L'impératrice agenouillée
sur un prie-dieu)**
Albumen print from a collodion-on-glass negative
230 × 306 mm, rounded corners
Black wetstamp b. r.

Formerly in the collection of the abbé Misset, the imperial prince's tutor
Gérard Lévy collection, Paris [JPGM]

This series of portraits of the empress (here and cat. nos. 100–102) was realized during the summer of 1856, at the château de Saint-Cloud, at the request of the painter Thomas Couture, who had just received a commission from the emperor for a large painting of the baptism of the imperial prince. Eugénie strikes the serene pose, simultaneously graceful and con templative, that the painter chose for his composition. Le Gray's images give us some idea of what this never-completed work might have looked like, but they are also works in their own right, composi tions in which the official photographer successfully combined majestic form and human expression. [fig. 154]

104
**Portrait of the Imperial Prince
(Portrait du prince impérial)**
Albumen print from a glass negative
193 × 221 mm, oval
Red wetstamp b. r.
EST, BNF, Paris, acquired 1996
See p. 131. [fig. 152]

Studies and Landscapes, ca. 1856

105
**Reclining Nude
(Nu féminin allongé sur un canapé Récamier)**
Albumen print from a collodion-on-glass negative
217 × 329 mm
Red wetstamp b. r.
Gilman Paper Company Collection, New York [JPGM]

This Baudelairian siren is Le Gray's mas terpiece in a genre that, to the best of our knowledge, he took up rarely: the female nude. Every detail of posture, of hand placement, of the fall of the hair over the face is considered. The pose does not really suggest repose, nor indeed any nat ural posture, and the closed eyes do not so much evoke sleep as strike a note of sensuality. Subject and object merge imperceptibly to create the image of a woman seen in a dream, herself dreaming. [fig. 148]

106

Italian Street Musician (*Pifferaro*)
(*Étude de musicien italien: pifferaro*)
Albumen print from a collodion-on-glass
negative
339 × 263 mm, rounded corners
Red wetstamp b. l.
Gilman Paper Company Collection, New York
[JPGM]
[fig. 249]

107

Italian Street Musician (*Pifferaro*)
(*Étude de musicien italien: pifferaro*)
Albumen print from a collodion-on-glass
negative
222 × 168 mm, oval
J. Paul Getty Museum, Los Angeles,
86.XM.741 [JPGM]

Exhibited in Brussels in August 1856,
these two beautiful studies (cat. nos.
106, 107) apparently show a professional
model. The noble old Italian, posing in the
costume of a *pifferaro*, has a kind of
beauty that was then much sought after
by painters for their treatments of antique
and mythological subjects. As is often the
case, the circumstances are unknown (on
commission, or spontaneous inspiration?),
but these images provide further proof
that there was scarcely a pictorial subject
susceptible to photographic treatment
that Le Gray did not explore. [fig. 250]

108

View in a Park (detail)
(*Parc [environs de Paris?]*)
Albumen print from a waxed-paper negative
274 × 387 mm
Print no. in ink b. l. on the mount: 5006
Red wetstamp b. r.
Blindstamp b. c. on the mount: "Gustave Le
Gray & C° Paris"
Formerly Abraham Willet collection
Amsterdams Historische Museum, bequest
of Mrs. S. L. G. Willet-Holthuysen [JPGM]

It is not possible to link this image with
any of Le Gray's known series, whereas
we know that Baldus, Marville, Bisson, and
Aguado made beautiful photographs of
parks. Here Le Gray used one of his
favorite compositional devices: the bal-
ance of the image is wholly dependent on
the small jet of water at left, a secret, off-
kilter center of gravity without which this
mysterious garden would be only a
deserted park. [fig. 242]

Normandy Seascapes, Summers of 1856 and 1857(?)

109

The Brig
(*Brick [dit Brick au clair de lune]*)
Albumen print from a collodion-on-glass
negative
320 × 420 mm
[Neg. no. 1]
Formerly the duc de Chartres collection
Musée d'Orsay, Paris, PHO 1985-334 [JPGM*]

With *The Sun at Its Zenith* (cat. no. 120)
and *The Haloed Sun* (cat. no. 119), *The Brig*
belongs to a trio of similar views: all three
show the same site, with a foreground
beach covered with seaweed and animated
by horses. A certain use of light, reflec-
tions, and backlighting is common to all,
with the sun photographed straight on,
making the surface of the calm sea shim-
mer. In *The Brig*, the cloudy sky occupies
more space, the ship being the central
motif, while in the two others the dominant
element is the sea, the clouds being lighter
and the horses more visible. The image
titled *Solar Effect—Ocean* (cat. no. 121)
was also taken at this site. These are the
"enchanted pictures" that would soon gen-
erate so much enthusiasm in France and
England. [fig. 128]

110

Solar Effect in the Clouds—Ocean
(*Effet de soleil dans les nuages—Océan*)
Albumen print from a collodion-on-glass
negative
310 × 405 mm
[Neg. no. 24]
Musée des Beaux-Arts, Troyes, D.46.19.583
[fig. 338]

111

The Steamboat
(*Le Paquebot—Océan—n° 3*)
Albumen print from a collodion-on-glass
negative
320 × 420 mm
Print no. b. l. on the mount: 6168
Title in pencil b. r. on the mount
Private collection, courtesy Ezra Mack, New
York (this print not exhibited)

The title is known only from this print.
Another example (Roger Thérond collec-
tion) bears the inscription, in pencil,
"Cabourg." Thus this view clearly belongs
to the first series of
Normandy seascapes
(summer 1856). In its
extreme economy of
means, it stands alone in
its genre, yet its composi-
tion is close to those of
other views: there are no
clouds; the horizon line is
obscured by sea mist;
there is a small vessel
precisely in the center of the image; and it
incorporates a study of whitecaps that
could almost be called japonism. [fig. 129]

112

The Beach at Sainte-Adresse
**(*N° 7. Les Galets [plage
de Sainte-Adresse]*)**
Albumen print from a collodion-on-glass
negative
316 × 422 mm
Print no. b. r.: 3[?]39 (one digit illegible)
Red wetstamp b. r.
Blindstamp b. c. on the mount:
"Photographie Gustave Le Gray & C° Paris"
Title in pencil b. r. on the mount
J. Paul Getty Museum, Los Angeles,
84.XM.637.25 [JPGM]

The figure in the foreground offers yet
another example of Le Gray's use of an
otherwise nondescript detail to intensify
the effect of depth and to serve as a com-
positional fulcrum. The print exhibited
here has a clear sky, but there are other
examples of the same view with cloudy
skies. [fig. 138]

107

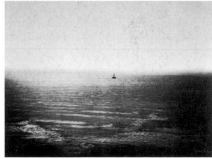

108

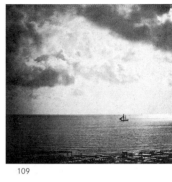

109

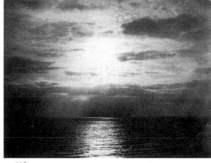

110

111

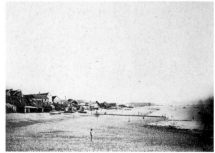

112

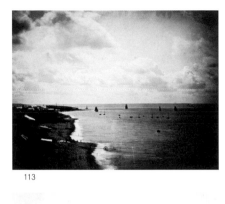

113

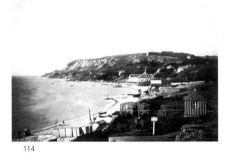

114

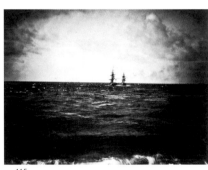

115

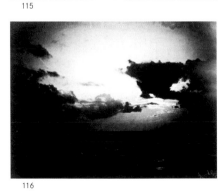

116

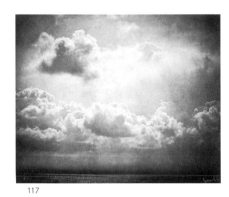

117

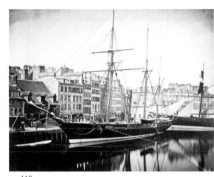

118

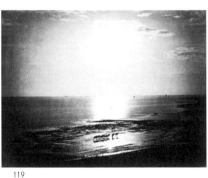

119

113

The Beach at Sainte-Adresse, High Tide (Plage de Sainte-Adresse vue de la falaise)
Albumen print from a collodion-on-glass negative
310 × 400 mm
Musée des Beaux-Arts, Troyes, D.46.19.598

This composition is a perfect complement to the two other views of the famous beach (cat. nos. 112, 114). This print, the only one of this image currently known, is remarkable for its density, and for its rich, velvety blacks. Le Gray's radical approach here marks this seascape as an artistic exercise, like some of the Fontainebleau views, as opposed to a commercial print. [fig. 139]

114

The Beach at Sainte-Adresse, with the Dumont Baths (Plage de Sainte-Adresse avec les bains Dumont)
Albumen print from a collodion-on-glass negative
313 × 413 mm
Red wetstamp b. r.
Formerly Alfred Armand collection
EST, BNF, Paris

Le Gray has placed photographic tripods to the right of the small striped pavilion—another instance of his tendency to include within his images almost imperceptible indexical traces of the ongoing act of photographic possession. [fig. 140]

115

Two Ships Heading Away from Shore (Deux bateaux s'éloignant de la côte)
Albumenized salt print from a collodion-on-glass negative
315 × 417 mm
[Neg. no. 26]
Private collection, courtesy Ezra Mack, New York (this print not exhibited)
[fig. 137]

116

Cloud Study (Étude de nuages, clair-obscur)
Albumen print from two collodion-on-glass negatives
321 × 418 mm
Red wetstamp b. r.
Blindstamp b. c. on the mount: "Gustave Le Gray & Cº Paris"
EST, BNF, Paris

In the variety and movement of their clouds, the studies of the sky by Le Gray express a large range of emotions, and this particular example is surely the darkest and most dramatic of the series. Le Gray used these same clouds, with their idiosyncratic shapes and powerful light-dark contrasts, in many of his seascapes. The negative of the sky was perhaps made on the Mediterranean, but the shore seems to be the same one as in *The Brig*. [fig. 296]

117

Seascape with Cloud Study (Marine, étude de nuages)
Albumen print from a collodion-on-glass negative
315 × 387 mm
Red wetstamp b. r.
Blindstamp: "Gustave Le Gray & Cº Paris"
Musée d'Orsay, Paris, PHO 1997-13 [JPGM]
[fig. 133]

118

The Imperial Yacht, *La Reine Hortense*, Le Havre (*La Reine Hortense—Yacht de l'empereur—Havre, nº 20*)
Albumen print from a collodion-on-glass negative
324 × 411 mm
Print no. in ink b. l. on the mount: 15388
Red wetstamp b. r.
Blindstamp b. c. on the mount: "Gustave Le Gray & Cº Paris"
Gilman Paper Company Collection, New York [JPGM]
[fig. 135]

119

The Haloed Sun (*Nº 21—Le Soleil couronné*)
Albumen print from a collodion-on-glass negative
368 × 418 mm
EST, BNF, Paris
See cat. no. 109. [fig. 131]

120

The Sun at Its Zenith (*Nº 22—Le Soleil au zénith—Océan*)
Albumen print from a collodion-on-glass negative
325 × 414 mm
Wetstamp b. r.
Formerly Townshend collection
Victoria and Albert Museum, London, 67.999
See cat. no. 109. [fig. 130]

121

**Solar Effect—Ocean
(*Effet de soleil—Océan—n° 23*)**

Albumen print from a collodion-on-glass
negative
322 × 420 mm
Red wetstamp b. r.
Formerly Alfred Armand collection
EST, BNF, Paris

122

**The Tugboat
(*Le Vapeur*)**

Albumen print from a collodion-on-glass
negative
330 × 415 mm
[Neg. no. 24]
Formerly the duc de Chartres collection
Musée d'Orsay, Paris, PHO 1985-335
[JPGM*]

With regard to this much-discussed print,
note especially the extent to which its
composition brings to mind, more than
does any other of the seascapes, the aes-
thetic of the camp at Châlons views a year
later. The relationship of sky to earth or
sea is the same in both, as is the inclusion
of a motif on the horizon. Another com-
mon feature is the use of atmospheric ele-
ments, which become essential in these
spare, monochromatic views: haze in
Cavalry Maneuvers, October 3 (cat. no.
146), here a plume of smoke. [fig. 280]

123

**The Museum and City of Le Havre
(*Musée et ville du Havre*)**

Albumen print from a collodion-on-glass
negative
320 × 415 mm
Print no. in ink b. l. on the mount: 15361
Red wetstamp b. r.
Blindstamp b. c. on the mount: "Gustave Le
Gray & C° Paris"
Formerly Abraham Willet collection
Amsterdams Historische Museum, bequest
of Mrs. S. L. G. Willet-Holthuysen [JPGM]

The sites of the Normandy seascapes are
so many and varied that it seems justified,
given the ready access from Paris, to posit
several different sojourns there, though
now difficult to identify. If the seascapes
must be classified, it seems logical to con-
sider the views of the ports of Le Havre,
Sète, and Brest as a group. The four
known images of Le Havre (cat. nos. 118,
123–125) echo the views of Sète and
could have been realized in the summer of
1857, on Le Gray's return trip from the
Midi—*Lighthouse and Jetty, Le Havre* (cat.
no. 124) being a calmer version of *The*

Great Wave (cat. nos. 133–136), and *The
"Reine Hortense"* a response to *The Saïd*
(cat. no. 127). As for the present view,
with its dialogue between the water and
the city, in which the classical rhythms of
the museum are framed in the foreground
by a discourse of triangles (roofs, pilings,
sails), it has no known analogue. However,
it has affinities with the realistic yet fan-
tastic port views of the old Dutch masters,
which makes its presence in the collection
of Abraham Willet all the more suggestive.
[fig. 134]

124

**Lighthouse and Jetty, Le Havre
(*Phare et jetée du Havre*)**

Albumen print from a collodion-on-glass
negative
306 × 405 mm
Neg. no. in ink b. r.: 28
Red wetstamp b. r.
Blindstamp b. c. on the mount:
"Photographie Gustave Le Gray & C° Paris"
Round blindstamp: "Mac Gill 7 Hanover St.,
Edinburgh"
J. Paul Getty Museum, Los Angeles,
85.XM.153.1 [JPGM]

The classical composition of the jetty and
lighthouse, reinforced by the cloud and
advancing on the diagonal to the right with
the sharply angled shoreline, recalls an oil
study by Corot (*End of the Jetty and the
Sea, Dieppe*, ca. 1822; fig. 277), but it also
finds a more general context in the large
corpus of seaside paintings produced in
the first half of the nineteenth century.
[fig. 136]

125

**Ships Leaving the Port of Le Havre
(*Bateaux quittant le port du Havre*)**

Albumen print from a collodion-on-glass
negative
300 × 414 mm
Red wetstamp b. r.
Blindstamp b. c. on the mount:
"Photographie Gustave Le Gray & C° Paris"
Formerly Georges Sirot collection
Roger Thérond collection, Paris [JPGM]

Thanks to the assiduous research of Ken
Jacobson, we are now certain of the site
pictured here (*The Lovely Sea View*
[Petches Bridge, 2001], 54, note 76). It
remains only to emphasize the grace and
majesty of these silhouetted brigantines,
the treatment of which brings to mind sim-
ilar effects favored by the painter Caspar
David Friedrich, particularly in his painting
of 1834/35, *The Stages of Life* (fig. 272).
[fig. 273]

126

**Seascape with a Ship Leaving Port
(*Marine, bateau quittant le port*)**

Albumen print from two collodion-on-glass
negatives
339 × 447 mm (including margins)
Roger Thérond collection, Paris [JPGM*]

The date and location of this view are
especially problematic. The clouds are
well known, appearing above Sète (cat.
no. 138) and a Normandy beach (cat. no.
116), while the agitated sea and the ship
leaving port bring to mind the two great
Sète seascapes, *The Breaking Wave* (cat.
no. 131) and *The Great Wave* (cat. nos.
133–136), but it is difficult
to draw any conclusions
from this. The rendering
of the sea is notably suc-
cessful, as is the baffled-
sunlight effect at left,
which makes the right half
of the sea seem even
darker; the restless
waves, not framed by
any shore, are more
Romantic, more
Hugoesque, than those
in *The Great Wave*, where
the strong composition
and the focus on a central
motif stabilize the whole.
Note the clearly visible
juncture of the two nega-
tives at right. [fig. 295]

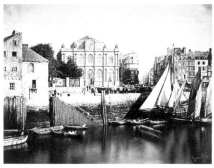

123

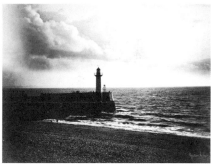

124

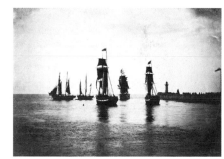

125

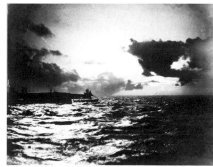

126

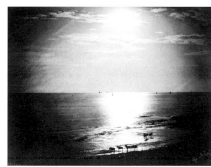

120

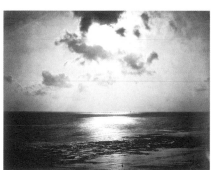

121

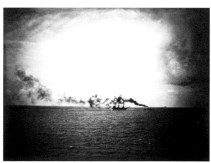

122

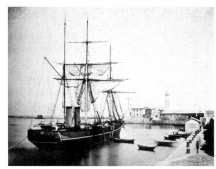

127

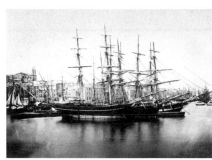

128

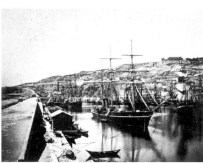

129

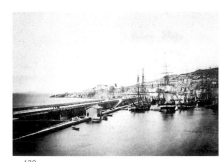

130

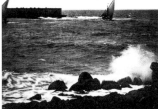

131

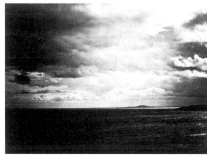

132

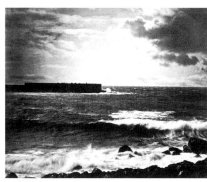

134

Mediterranean Seascapes, Spring 1857

127

The *Saïd* in the Harbor at Sète
(*Le Saïd—Rade de Cette—
Méditerranée—nº 9*)
Albumen print from a collodion-on-glass
negative
310 × 403 mm
Red wetstamp b. r.
Formerly Alfred Armand collection
EST, BNF, Paris
[fig. 142]

128

Ships in the Harbor at Sète
(*Groupe de navires—Cette—
Méditerranée—nº 10*)
Albumen print from a collodion-on-glass
negative
300 × 413 mm
Red wetstamp b. r.
Formerly Alfred Armand collection
EST, BNF, Paris [JPGM*]
[fig. 141]

129

**Ships in the Harbor at Sète,
Among Them the *Saïd***
(**Bateaux dans le port de Sète,
dont le *Saïd***)
Albumen print from a collodion-on-glass
negative
308 × 412 mm
Private collection, courtesy Ezra Mack, New
York (this print not exhibited)

There is another, somewhat busier, ver-
sion of this composition. A boat beside the
Saïd and a figure on the breakwater have
disappeared in the present view, where
the emphasis is on the beautiful reflec-
tions in the calm water. [fig. 143]

130

The Jetty at Sète
(*Jetée de Cette—Mer Méditerranée—
nº 12*)
Albumen print from a collodion-on-glass
negative
290 × 400 mm
Musée des Beaux-Arts, Troyes, D.46.19.600
See pp. 106–107. [fig. 126]

131

The Breaking Wave
(*La Vague brisée. Mer Méditerranée
nº 15*)
Albumen print from a collodion-on-glass
negative
417 × 325 mm
Print no. in ink b. l. on the mount: 11504

Red wetstamp b. r.
EST, BNF, Paris
[fig. 144]

132

Cloudy Sky, Mediterranean Sea
(*Nº 16—Ciel chargé—Mer
Méditerranée*)
Albumen print from two collodion-on-glass
negatives
304 × 398 mm
EST, BNF, Paris [JPGM]
[fig. 147]

133 [variant of 134]

The Great Wave, Sète
(*Nº 17—Grande vague. Cette*)
Albumen print from two collodion-on-glass
negatives
345 × 416 mm
Print no. in ink on back of the image: 14553
EST, BNF, Paris

134

The Great Wave, Sète
(*Nº 17—Grande vague. Cette*)
Albumen print from two collodion-on-glass
negatives
357 × 419 mm
Red wetstamp b. r.
Formerly Alfred Armand collection
EST, BNF, Paris
[fig. 145]

135 [variant of 134]

The Great Wave, Sète
(*Nº 17—Grande vague. Cette*)
Albumen print from two collodion-on-glass
negatives
343 × 409 mm
Red wetstamp b. r.
Blindstamp b. c. on the mount: "Gustave Le
Gray & Cº Paris"
EST, BNF, Paris

136 [variant of 134]

The Great Wave, Sète
(*Nº 17—Grande vague. Cette*)
Albumen print from two collodion-on-glass
negatives
339 × 415 mm
Red wetstamp b. r.
Blindstamp b. c. on the mount: "Gustave Le
Gray & Cº Paris"
Registered for copyright February 16, 1860
EST, BNF, Paris [JPGM*]

"At [Le Gray's home] there is a view of the
Mediterranean taken opposite the city of
Sète: the swells become fleecy in the dis-
tance, descend foaming toward the viewer,
and break like white powder on the rocks
along the shore. Each wave is crowned by
a little white puff whose every bitter drop,

it seems, could be counted; at the edge of the picture, an enormous swell, breaking against a large black reef, has such momentum, is so impetuous, so turbulent, that one is tempted to draw back to avoid its furious surge.

The time required to apprehend and fix on glass this little scene without human figures is, so to speak, inappreciable: a twentieth of a second. No one had yet accomplished such a prodigious feat of speed and dexterity." Henry d'Audiger, *La Patrie* (July 25, 1858).

This celebrated seascape, along with *The Breaking Wave* (cat. no. 131), is one of only three works by Le Gray to have been registered for copyright just as the studio was closing (see p. 148).

A print in the Musée des Beaux-Arts, Troyes, bears a fuller title: *Grande vague, vue du brise-lame, Cette* (Great wave, seen from the breakwater, Sète).

137
Mediterranean Sea, Sète
(*Mer Méditerranée—Cette—n° 18*)
 Albumen print from a collodion-on-glass negative
 316 × 410 mm
 Red wetstamp b. r.
 Blindstamp b. c. on the mount: "Gustave Le Gray & Cº Paris"
 Title in pencil b. r. on the mount: "Mer Méditerannée—Cette"
 Registered for copyright February 16, 1860
 EST, BNF, Paris [JPGM]
 [fig. 146]

138
Large Wave, Mediterranean Sea
(*N° 19—Grande lame Méditerranée*)
 Albumen print from two collodion-on-glass negatives
 323 × 412 mm
 Red wetstamp b. r.
 Formerly Alfred Armand collection
 EST, BNF, Paris [JPGM]
 [fig. 297]

139
The Port of Sète
(*Panorama du port de Sète*)
 Albumen print from a collodion-on-glass negative
 268 × 400 mm
 Red wetstamp b. r.
 EST, BNF, Paris, acquired 1997
 [fig. 310]

140
Panorama of the Port of Sète
(*Panorama du port de Sète*)
 Albumen print from a collodion-on-glass negative
 180 × 360 mm
 Red wetstamp b. r.
 Roger Thérond collection, Paris [JPGM]

These two panoramas (here and cat. no. 139) are skillful variations—the first contained, the second expansive—on a simple and effective visual theme: the slender band, bristling with masts, formed by the quay and the harbor halfway between sky and sea, the effect of depth accentuated by a buoy, anchored at left in one image and at right in the other. [fig. 309]

141
Clouds
(*Nuages*)
 Albumen print from a collodion-on-glass negative
 315 × 400 mm
 Musée des Beaux-Arts, Troyes, D.46.19.597

All of the other cloud studies are seascapes, but this spectacular image, made at an unknown place, shows a silhouetted landscape that evokes the camp at Châlons, in its flatness and some of its details (the top of a pavilion?). Was Le Gray interested only in the clouds, in view of reusing them in other landscapes, or did he intend this image to be an independent landscape? In the latter case, it is quite close to studies by Marville and Fenton that also feature skies above a narrow band of backlit landscape. [fig. 132]

The Camp at Châlons, September 1857

142
Portrait of Napoléon III
(Portrait de Napoléon III en buste)
 Albumen print from a collodion-on-glass negative
 198 × 152 mm
 Formerly Allard du Cholet collection
 EST, BNF, Paris

This portrait of the emperor seems oddly displaced, unfinished, not yet framed into an oval halo. The uniform, the decorations, the crisply pointed moustache anchor him in reality, while the gaze and the

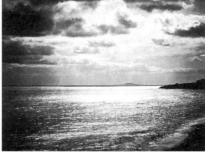
137

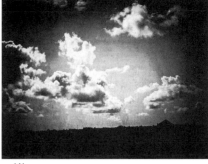
141

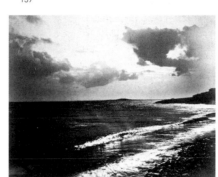
138

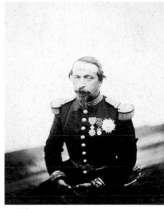
142

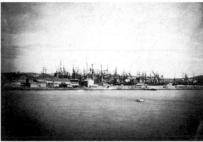
139

140

143

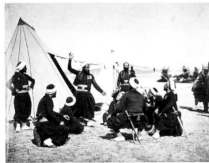

144

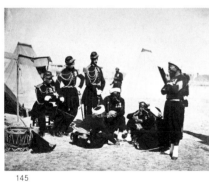

145

146

147

148

149

background are all a blur. It is not in any of the souvenir albums, the places reserved for a portrait of the emperor having all been left empty, but this image may have been intended for that purpose. [fig. 157]

143

Napoléon III on Horseback, the Camp at Châlons (Napoléon III à cheval)
Albumen print from a collodion-on-glass negative
290 × 335 mm
Musée des Beaux-Arts, Troyes, D.46.19.556

This unknown view of Napoléon III on horseback was excluded from the set of images destined for the official albums. It has obvious technical defects; it is too blurry, there is too much contrast, and the framing is awkward. But these flaws can also be viewed as aesthetic assets, elements that distinguish this portrait from more conventional military imagery of the kind found in Raffet's prints and in stock imagery from the Épinal company. [fig. 158]

144

Zouave Storyteller (Le Récit)
Albumen print from a collodion-on-glass negative
303 × 390 mm
Red wetstamp b. r.
Formerly Alfred Armand collection
EST, BNF, Paris [JPGM*]
[fig. 259]

145

Zouaves Gambling (Le Jeu de la drogue)
Albumen print from a collodion-on-glass negative
295 × 368 mm
Red wetstamp b. r.
Formerly Alfred Armand collection
EST, BNF, Paris

In this military genre scene and the one of the Zouave storyteller (cat. no. 144), Le Gray turns an assignment to his advantage. The poses, far from having been seized on the wing, were carefully staged by the photographer to guarantee a satisfying composition. The vigorous print and strong contrasts, the varied postures, suntanned figures, and picturesque dress of the Zouaves give the image charm and prevent it from being merely a pastiche of Meissonier or Raffet. [fig. 160]

146

Cavalry Maneuvers, October 3 (Manoeuvres du 3 octobre)
Albumen print from a collodion-on-glass negative
310 × 367 mm
J. Paul Getty Museum, Los Angeles, 84.XO.377.12 [JPGM]
[fig. 165]

147

Cavalry Maneuvers, with Receding Road (Manoeuvres, route en perspective)
Albumen print from a collodion-on-glass negative
295 × 343 mm
J. Paul Getty Museum, Los Angeles, 84.XO.377.20 [JPGM]

Le Gray here controls the lines that structure the landscape with a military rigor. The troop movements are reduced to a vague swarming on the vast plain. The two mounted cavalrymen at right serve to anchor the composition. [fig. 166]

148

The Bivouac (Le campement, Châlons)
Albumen print from a collodion-on-glass negative
293 × 364 mm
J. Paul Getty Museum, Los Angeles, 84.XO.377.25 [JPGM]
[fig. 167]

149

Setting the Emperor's Table (La Table de l'empereur)
Albumen print from a collodion-on-glass negative
308 × 364 mm
J. Paul Getty Museum, Los Angeles, 84.XO.377.27 [JPGM]
[fig. 168]

150

Group by the Millpond at Petit-Mourmelon (Scène près d'un étang an moulin du Petit-Mourmelon)
Albumen print from a collodion-on-glass negative
279 × 352 mm
Gilman Paper Company Collection, New York [JPGM]

Le Gray photographed this scene on the fringe of his Châlons commission. The group at the edge of the pond has been very carefully arranged by the photogra-

pher, but disorder prevails to the left, where the figures seem to await being positioned or are perhaps simply spectators meant to have been framed out, and a ghostly blur records someone who moved.

The whole suggests a group portrait transformed by an ill-advised widening of the frame into an open-air scene, an unreal episode in a country outing; to disquieting effect, it juxtaposes the two aspects of photography, artistic representation and the preservation of a fleeting moment. It might be compared to the beautiful contemporary images by Baldus of the château de La Faloise, which feature blurred figures, some posing and others in casual conversation, in a large park. In any case, the existence of at least three prints suggests that Le Gray considered the exposure a success. Part of this group appears in another view, carefully posed in front of a mill, that, unlike this one, figures in a very few of the Châlons albums. Reproduced in *Une visite au camp de Châlons sous le Second Empire: Photographies de messieurs Le Gray, Prévot . . .*, exh. cat. (Paris, 1996), 83. [fig. 169]

151
Panorama of the Camp at Châlons
(Panorama du camp)
Albumen prints from collodion-on-glass negatives
Six plates, from left to right:
Pl. I
307 × 360 mm
Pl. 2
307 × 360 mm
Pl. 3
310 × 372 mm
Pl. 4
310 × 345 mm
Pl. 5
307 × 337 mm
Pl. 6
306 × 240 mm
Red wetstamp b. r.
From the Montebello Album, formerly Georges Sirot collection
EST, BNF, Paris, folio réserve [JPGM*]

"The other day I saw, at the premises of one of our most skillful photographers, an immense album that it would have taken more than ten years to have drawn and engraved. It is a superb gift that the emperor intends to present to each officer of his household and to the officers who took part . . . at the camp at Châlons. . . .

The photographer, having observed the maneuvers at the camp at Châlons for a month, returned from them with a complete gallery, an accurate image, a general history of this extended and solemn military parade. . . . Of the most remarkable scenes, I will mention the *Panorama of the Camp*, which is no less than nine feet long and with which the emperor is particularly satisfied" (see pp. 131, 135, and 222–23). Jules de Prémaray, "Défense de la photographie," *Revue photographique* (April 5, 1858).

The foldout beginning on page 280 illustrates the six prints in the collection of Ezra Mack, New York; the present entry describes the exhibited work, which belongs to the BNF. [fig. 307]

152
Maneuvers: The Cavalry of the
Imperial Guard
(Manoeuvres. Cavalerie de la garde impériale)
Albumen print from a collodion-on-glass negative
160 × 210 mm
Musée des Beaux-Arts, Troyes, D.46.19.551
[fig. 162]

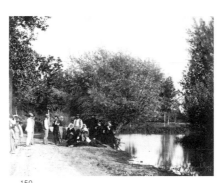
150

152

151 (1)

151 (2)

151 (3)

151 (4)

151 (5)

151 (6)

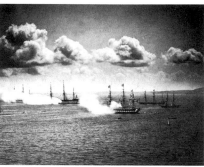

153

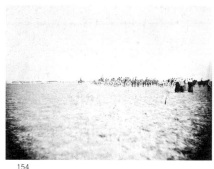

154

155

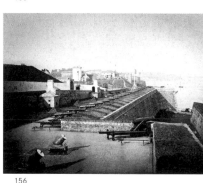

156

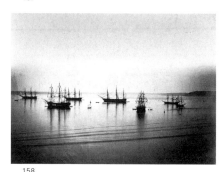

157

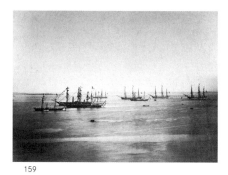

158

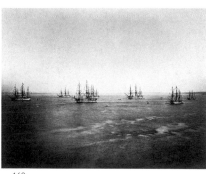

159

160

153
Maneuvers: The Cavalry of the Imperial Guard
(*Manoeuvres. Cavalerie de la garde impériale*)
Albumen print from a collodion-on-glass negative
170 × 220 mm
Musée des Beaux-Arts, Troyes, D.46.19.550
[fig. 163]

154
Maneuvers: The Artillery and Light Calvary of the Imperial Guard
(*Manoeuvres. Artillerie et chasseurs à cheval de la garde impériale*)
Albumen print from a collodion-on-glass negative
175 × 220 mm
Musée des Beaux-Arts, Troyes, D.46.19.549
[fig. 161]

155
Troop Maneuvers
(*Manoeuvres de troupes*)
Albumen print from a collodion-on-glass negative
250 × 355 mm
Formerly Alfred Armand collection
EST, BNF, Paris
[fig. 258]

Brest and Cherbourg, August 1858

156
Battery of Cannon at Brest
(*Batterie de la pointe à Brest*)
Albumen print from a collodion-on-glass negative
315 × 405 mm
Musée des Beaux-Arts, Troyes, D.46.19.590
[fig. 173]

157
Salvos of the French Fleet, Cherbourg
(*Salves de la flotte française à Cherbourg*)
Albumen print from a collodion-on-glass negative
220 × 285 mm
Musée des Beaux-Arts, Troyes, D.46.19.594
[fig. 174]

158
The French Fleet, Cherbourg
(*Flotte française en rade de Cherbourg*)
August 5, 1858

Albumen print from a collodion-on-glass negative
300 × 410 mm
Red wetstamp b. r.
Formerly Alfred Armand collection
EST, BNF, Paris
[fig. 176]

159
The French and English Fleets, Cherbourg
(*Flotte franco-anglaise en rade de Cherbourg*)
August 4–8, 1858
Albumen print from a collodion-on-glass negative
320 × 415 mm
Red wetstamp b. r.
Formerly Alfred Armand collection [JPGM]
EST, BNF, Paris
[fig. 175]

160
The French and English Fleets, Cherbourg
(*Flotte franco-anglaise en rade de Cherbourg*)
August 4–8, 1858
Albumen print from a collodion-on-glass negative
310 × 398 mm
Red wetstamp b. r.
Formerly Alfred Armand collection
EST, BNF, Paris [JPGM]

The series taken by Le Gray in early August of 1858, in Brest and Cherbourg, continues to grow as a result of discoveries; it now seems to be as large as the set of seascapes photographed in Normandy and Sète. Unlike the latter, however, these compositions are maritime echoes of the views of the camp at Châlons, additional images of great aesthetic refinement documenting French military might. Le Gray, who had been photographing the sea for two years, displays his mastery of a wide range of effects and subjects, imposing a geometric compositional rigor on a cannon battery in Brest (cat. no. 156), establishing a dialogue between the smoke of cannon salvos and the clouds above (cat. no. 157), disposing naval fleets like toys in a basin and forming panoramas (here and in cat. no. 159), and silhouetting somnolent ships on an oily sea (cat. no. 158). [fig. 171]

Portraits, ca. 1856–1859

161
**Self-Portrait
(Autoportrait)**
Albumen print from a collodion-on-glass
negative
205 × 164 mm, oval
EST, BNF, Paris [JPGM*]

This self-portrait, in the style conceived
for the clientele of the boulevard des
Capucines studio, shows an artist at the
pinnacle of success. The prosperous-
looking yet classic outfit is far from the
sartorial affectations of the art student
of 1848, and the facial expression has
become calmer. Le Gray's wealthy patrons
had confidence in him, and his seascapes
were flying off the walls. [fig. 98]

162
**Portrait of O. Mestral
(Portrait de Mestral)**
Albumenized salt print from a collodion-on-
glass negative
233 × 175 mm
Black wetstamp b. l.
Gift of Le Gray, Société française de pho-
tographie, Paris [JPGM]

Mestral, Le Gray's companion on the
Mission héliographique, remains a mys-
tery, but at least this portrait gives him a
face. A perfect antithesis of the thin, high-
strung Le Gray, he is heavy of build and
thick of feature, seemingly lost in thought
(see pp. 61–64). [fig. 67]

163
**Portrait of Victor Cousin
(Portrait de Victor Cousin)**
Albumen print from a collodion-on-glass
negative
200 × 152 mm, oval
J. Paul Getty Museum, Los Angeles,
84.XM.343.3 [JPGM]

Previously attributed to Nadar (like the
portrait of Clésinger; see pp. 54–55;
fig. 59), this likeness of Victor Cousin
(1792–1867), with its deep shadows,
served as a model for Henri Lehmann's
painted portrait of 1868 (fig. 105), com-
missioned for the Sorbonne after the
famous philosopher's death. [fig. 104]

164
**Portrait of Victor Cochinat
(Portrait de Victor Cochinat)**
Albumen print from a collodion-on-glass
negative
300 × 223 mm
Northern Light Gallery, Bronshoj, Denmark

Victor Cochinat (1823–1886), lawyer and
journalist, left Martinique for France after
1848, edited *Le Journal de Rouen,* and
worked for several Parisian dailies—*Le
Figaro, Le Tintamarre, La Liberté, Le Siècle,
Le Petit Journal, Le Mousquetaire*—before
returning to the islands to become curator
of the library in Fort-de-France. In style,
this portrait is strikingly close to the work
of Nadar, which makes our ignorance of
its date all the more regrettable. [fig. 114]

165
**Portrait of Olympe Aguado
(Portrait d'Olympe Aguado)**
1857
Albumen print from a collodion-on-glass
negative
315 × 235 mm, oval
Red wetstamp b. r.
Gift of Le Gray, Société française de pho-
tographie, Paris [JPGM]
[fig. 292]

166
**Portrait of Michel Carré
(Portrait de Michel Carré)**
1859
Albumen print from a collodion-on-glass
negative
270 × 170 mm
Signature in ink c. l.
Tel Aviv Museum

This portrait of Michel Carré (1819–1872)
was inserted into a luxuriously bound (by
Blumenthal) copy of *Le Pardon de
Ploërmel,* an opera by Meyerbeer with a
text by Carré and Jules Barbier. The book-
let bears a dedicatory inscription from the
two authors to Charles Florian Ducasse,
who traveled to Paris from Bordeaux for
the premiere—in vain, for it was post-
poned. The same volume also contains a
portrait of Barbier by Le Gray, and one of
Meyerbeer by Adrien Tournachon (another
print of which is dated September 20,
1857). Carré, looking prosperous and
smart in his checkered vest and trousers,

has gained weight since his last portrait
by Le Gray. Cigar in hand, radiating self-
confidence, he is the very picture of the
popular, successful Second Empire
author.

167
**Portrait of a Seated Man with a Cane
(Portrait d'homme assis avec une
canne)**
Albumen print from a collodion-on-glass
negative
300 × 222 mm
Northern Light Gallery, Bronshoj, Denmark

Similar to a Le Gray portrait of Jules
Barbier, both in the sitter's pose and in the
way he holds his cane, this likeness is that
of a young Parisian dandy, aristocrat, or
successful author, a member of one of
those elite cohorts that fashion led in
droves toward the boulevard des
Capucines studio. [fig. 113]

161

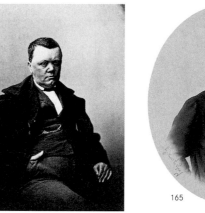

162

165

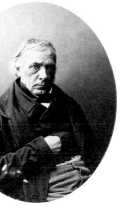

163

166

164

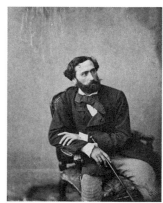

167

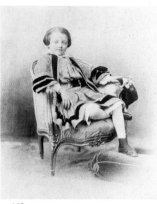

168

171

169

173

174

170

168

**Portrait of Lyndheast Sykes
(Portrait de Lyndheast Sykes)**
ca. 1858
Albumen print from a collodion-on-glass
negative
325 × 222 mm
Northern Light Gallery, Bronshoj, Denmark
See pp. 94, 154. [fig. 106]

169

**Portrait of a Young Girl
(Portrait de fillette)**
Albumen print from a collodion-on-glass
negative
300 × 225 mm
Northern Light Gallery, Bronshoj, Denmark
[fig. 115]

170

**Portrait of Émilien de Nieuwerkerke
(Portrait d'Émilien de Nieuwerkerke)**
Albumen print from a collodion-on-glass
negative
248 × 182 mm
Red blindstamp c. r.
Gift of Le Gray, Société française de pho-
tographie, Paris

"We know of no photographic portrait as
fine as that of M. de Nieuwerkerke, exe-
cuted by M. Le Gray. Fully aware of what
he was undertaking, wanting to prove to
his sitter, the director of the Beaux-Arts,
the artistic value of photography, M. Le
Gray produced a masterpiece of the
genre. Upon seeing the portrait of M. de
Nieuwerkerke, one is converted to the
cause of this new art." Louis Figuier, *La
Photographie au Salon de 1859* (Paris,
1860), 25. [fig. 112]

171

**Portrait of Alexandre Dumas
(Portrait d'Alexandre Dumas en buste)**
December 1859
Albumen print from a collodion-on-glass
negative
250 × 193 mm, oval
Musée d'Orsay, Paris, PHO 1986-11 [JPGM]
See pp. 157–60. [fig. 188]

172 [not reproduced]
**Portrait of Alexandre Dumas (full-
length)
(Portrait d'Alexandre Dumas en pied)**
ca. 1859/60
Albumen print from a collodion-on-glass
negative
355 × 260 mm
Red wetstamp b. r.

Blindstamp b. c. on the mount: "Gustave Le
Gray à Paris photographe de l'Empereur"
Dedicatory inscription: "À mon cher ami
Cherville A. Dumas"
BNF, Bibliothèque-musée de l'Opéra, Paris,
Photo fol. F, A. Dumas

This portrait was made at the boulevard
des Capucines studio, as evidenced by the
background visible in the print that is not
reduced to an oval, full-length portrait (in
carte-de-visite format) and that Alophe
sold beginning in September 1860.
However, the light cotton or linen suit worn
by Dumas does not tally with a date of
December 1859, which suggests that Le
Gray first came into contact with Dumas
earlier than the latter indicated in his
"Causerie" of January 5, 1860 (it seems
less likely that Le Gray was still using his
studio the following spring, by which time
his bankruptcy was in process).

Views of Paris, 1859
See pp. 142, 287–95.

173
**The Quai de l'Hôtel-de-Ville
and the Pont d'Arcole
(Quai de l'Hôtel-de-Ville
et pont d'Arcole)**
Albumen print from a collodion-on-glass
negative
350 × 468 mm
Formerly collection Alfred Armand
EST, BNF, Paris [JPGM]

This view of the quay of the Hôtel-de-Ville
should be considered alongside the many
canvases and photographs of "market
scenes" made at the same site by Charles
Nègre around 1852, images that Le Gray
certainly knew; the picturesque vignette in
the foreground, uncharacteristic of Le
Gray's Paris views, recalls precisely those
of Nègre. [fig. 320]

174
**The Quai de l'Hôtel-de-Ville
and the Pont d'Arcole
(Quai de l'Hôtel-de-Ville
et pont d'Arcole)**
Collodion-on-glass negative
420 × 530 mm
Paper label: "39"
Bibliothèque historique de la Ville de Paris
[fig. 319]

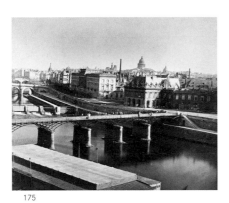

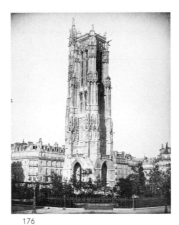

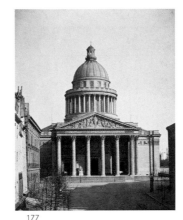

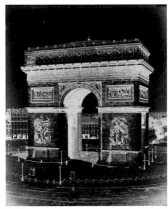

175

176

177

180

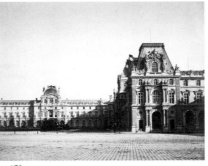

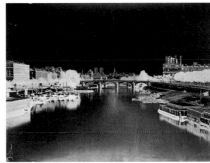

178

181

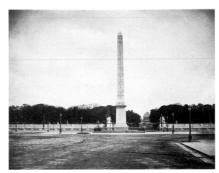

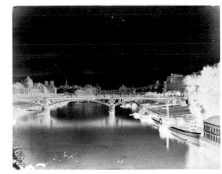

179

182

175
The Footbridge and the Quai de Conti
(Passerelle des Arts et quai de Conti)
Right half of a panorama
Albumen print from a collodion-on-glass
negative
380 × 442 mm
Formerly Alfred Armand collection
EST, BNF, Paris [JPGM]

Although the right half of a two part
panorama, this image, with its strong
zigzag pattern moving across the page,
stands on its own. Another print, in the
collection of Howard Stein (New York),
extends farther to the right to encompass
the dome of the Institut and its clock,
which indicates the time as 12:20.
[fig. 306]

176
The Tour Saint-Jacques
(Tour Saint-Jacques)
Albumen print from a collodion-on-glass
negative
500 × 430 mm
Print no. in ink on back of print: "24.2 [. . .]"
(two numbers missing)
Formerly Alfred Armand collection
EST, BNF, Paris [JPGM*]
[fig. 181]

177
The Pantheon
(Panthéon)
Albumen print from a collodion-on-glass
negative
470 × 392 mm
Formerly Alfred Armand collection
EST, BNF, Paris [JPGM]
[fig. 179]

178
Mollien Pavilion, the Louvre
(Palais du Louvre, pavillon Mollien)
Albumen print from a collodion-on-glass
negative
367 × 479 mm
Red wetstamp b. r.
J. Paul Getty Museum, Los Angeles,
90.XM.72 [JPGM]
[fig. 347]

179
The Obelisk, Place de la Concorde
(Place de la Concorde, obélisque)
Albumen print from a collodion-on-glass
negative
379 × 455 mm
Red wetstamp b. r.
Blindstamp b. c. on the mount:
"Photographie Gustave Le Gray & Cº Paris"
Manfred Heiting collection, Amsterdam,
MHC 1288 [JPGM]
[fig. 180]

180
The Arc de Triomphe
(Arc de Triomphe)
Collodion-on-glass negative
530 × 420 mm
Paper label: "34"
Bibliothèque historique de la Ville de Paris
[fig. 315]

181
View of the Seine toward the East
(Vue de la Seine vers l'est)
Collodion-on-glass negative
420 × 530 mm
Paper label: "40"
Bibliothèque historique de la Ville de Paris
[fig. 314]

182
The Pont du Carrousel
Seen from the Pont Royal
(Pont du Carrousel, vu du pont Royal)
Collodion-on-glass negative
420 × 520 mm
No. on sticker: 139
Bibliothèque historique de la Ville de Paris
[fig. 317]

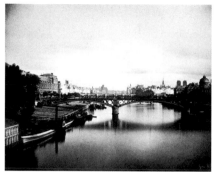

183

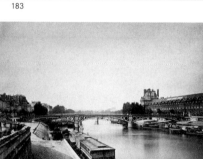

184

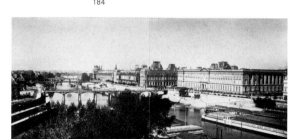

185

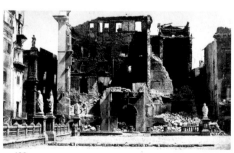

186

187

188

189

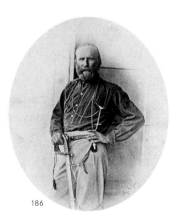

190

183

**The Pont du Carrousel
Seen from the Pont Royal
(Pont du Carrousel, vu du pont Royal)**
Albumen print from a collodion-on-glass
negative
420 × 530 mm
Red wetstamp b. r.
Howard Stein collection, New York [JPGM*]
[fig. 318]

184

**The Pont du Carrousel
Seen from the Pont des Arts
(Pont du Carrousel, vu de l'est)**
Albumen print from a collodion-on-glass
negative
420 × 530 mm
Red wetstamp b. r.
Howard Stein collection, New York
[fig. 178]

Le Gray's views of the Seine differ from
those of Baldus and Bisson, which were
made from nearly the same points of view,
in their refinement, their transparency in
the shadows, and their subtly modulated
reflections, all enhanced by the golden
luminosity of the print.

185

**Panorama of the Seine
from the Quai de l'Horloge
(Panorama de la Seine
depuis le quai de l'Horloge)**
Albumen prints from two collodion-on-glass
negatives
390 × 820 mm
Red wetstamp b. r.
CNAM—Musée des Arts et Métiers, Paris,
inv. 20685-7 [JPGM]
See pp. 276–77. [fig. 302]

Palermo, June–July 1860

Printed by Colliau (a student of Le Gray's; see
cat. no. 247) and Costet, all with the same
printed caption on the mount, with only the
title and the date varying: "G. Le Gray edité
par Colliau et Costet photographes / [title] /
d'après nature / [date] / dépôt à Paris chez
Juhan, 11 rue Poissonnière." All were regis-
tered for copyright in 1860. In the July 9,
1859, issue of *La Lumière,* Lacan reported
that Colliau opened a photographic printing
works in a "vast locale in Montmartre."

186

**Portrait of Giuseppe Garibaldi
(*Garibaldi*)**
July 1860
Albumen print from a collodion-on-glass
negative
256 × 198 mm, oval
Signature inscribed b. r. on the negative:
"Gustave Le Gray"
Blue wetstamp b. r. on the mount
Blindstamp: "Colliau et Costet / Montmartre
/ 89 rue Marcadet"
EST, BNF, Paris [JPGM*]

"Garibaldi is a man of fifty-two, of above
average height. His forehead is broad, his
features expressive, his gaze superb. He
has tawny blond hair, just beginning to
gray, that he wears halfway down his
neck; his red beard, which he lets grow in
all its abundance, frames a mouth that is
serene and prone to smiling. One senses
that there is much sap flowing though this
vigorous organism." Alexandre Dumas, *Le
Monte-Cristo,* no. 40 (January 19, 1860).
[fig. 195]

187

**Portrait of General Istvàn Türr
(*Le Général Türr*)**
July 1860
Albumen print from a collodion-on-glass
negative
256 × 198 mm, oval
Blue wetstamp b. r. on the mount
Blindstamp b. c. on the mount: "Colliau et
Costet / Montmartre / 89 rue Marcadet"
EST, BNF, Paris

The nonchalant grace of the young
Hungarian patriot contrasts with the
haughty mien and penetrating gaze of
Garibaldi. (On Istvàn Türr, see p. 169n 50).
[fig. 198]

188

**General View of Palermo
(*Palerme. 1. Vue générale de Palerme*)**
June 1860
Albumen print from a waxed-paper negative
252 × 403 mm
Blue wetstamp b. r. on the mount
Blindstamp b. c. on the mount: "Colliau et
Costet / Montmartre / 89 rue Marcadet"
[fig. 192]

189

**Palermo Cathedral
(*Palerme. 2. Cathédrale de Palerme*)**
June 1860
Albumen print from a waxed-paper negative
250 × 408 mm

Blue wetstamp b. r. on the mount
Blindstamp b. c. on the mount: "Colliau et
Costet / Montmartre / 89 rue Marcadet"
Formerly Texbraun Gallery collection
EST, BNF, Paris
[fig. 191]

190
Palazzo Carini, Palermo
(*Palerme. 3. Palais Carini*)
 June 1860
 Albumen print from a waxed-paper negative
 250 × 407 mm
 Blue wetstamp b. r. on the mount
 Blindstamp b. c. on the mount: "Colliau et
 Costet / Montmartre / 89 rue Marcadet"
 EST, BNF, Paris [JPGM]

The row of pieces of a toppled balustrade,
carefully laid out in the foreground, allows
Le Gray to use one of his characteristic
horizontal compositional accents to under-
score the devastation of the scene.
[fig. 193]

191
**Barricade
Strada di Toledo, Palermo**
(*Palerme. 4. Rue de Tolède à Palerme.
Barricade du général Türr*)
 June 1860
 Albumen print from a waxed-paper negative
 252 × 408 mm
 Blue wetstamp b. r. on the mount
 Blindstamp b. c. on the mount: "Colliau et
 Costet / Montmartre / 89 rue Marcadet"
 EST, BNF, Paris [JPGM]
 [fig. 187]

192
Strada di Toledo, Palermo
(*Palerme. 5. Rue de Tolède–Palerme*)
 June 1860
 Albumen print from a waxed-paper negative
 252 × 4–6 mm
 Blue wetstamp b. r. on the mount
 Blindstamp b. c. on the mount: "Colliau et
 Costet / Montmartre / 89 rue Marcadet"
 EST, BNF, Paris [JPGM]
 [fig. 194]

193
The Castres Quarter, Palermo
(*Palerme. 6. Quartier de Castres
à Palerme*)
 June 1860
 Albumen print from a waxed-paper negative
 356 × 252 mm
 Blue wetstamp b. r. on the mount
 Blindstamp b. c. on the mount: "Colliau et
 Costet / Montmartre / 89 rue Marcadet"
 EST, BNF, Paris [JPGM]

The images of Palermo document, at
Dumas's request, the "expedition of the
thousand" led by Garibaldi against the
Kingdom of the Two Sicilies. As at Châlons
and Cherbourg, however, Le Gray tran-
scends specific historical events to make
works that respond to his own aesthetic
requirements. The images of the devas-
tated city, of eviscerated palaces, of barri-
cades, are composed with a rigor
seemingly oblivious to the surrounding
drama. A damaged street lamp, mourning
statues, and twisted balcony railings are
the only witnesses to the destruction of
the deserted city. [fig. 190]

Syria, Fall 1860

194
**View of the Port of Beirut
from the Hôtel Bellevue**
(*Beyrouth [vue du port depuis l'hôtel
Bellevue]*)
 Albumen print from a collodion-on-glass
 negative
 310 × 402 mm
 Signed in black ink b. l. on the image
 Title inscribed b. r. on the mount
 Formerly collection of Prince Philip of
 Belgium, count of Flanders (1837–1905)
 EST, BNF, Paris, acquired 2001
 See pp. 175–76 and 275. [fig. 199]

195
Panorama of the Ruins, Baalbek
(*Baalbek, panorama des ruines*)
 November 1860
 Albumenized salt print from two waxed-
 paper negatives
 254 × 557 mm
 Blue wetstamp b. c.
 Amsterdam, Rijksmuseum [JPGM]
 See pp. 176–77 and p. 277. [fig. 202]

196
**Peristyle of the Temple of Bacchus,
Baalbek**
(*Baalbek, péristyle du temple
de Bacchus*)
 November 1860
 Albumen print from a collodion-on-glass
 negative
 394 × 252 mm
 Blue wetstamp b. r.
 J. Paul Getty Museum, Los Angeles,
 84.XM.347.15 [JPGM]
 [fig. 201]

Alexandria, December 1861

197
**The Comte de Chambord
and His Retinue
(Portrait du comte de Chambord
et de sa suite)**
 Albumen print from a collodion-on-glass
 negative
 198 × 175 mm
 Blue wetstamp b. r. on the mount
 EST, BNF, Paris, acquired 1974
 See pp. 180–81. [fig. 208]

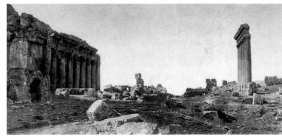
194

191

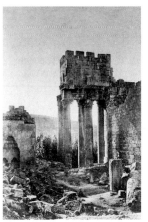

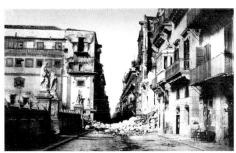
195

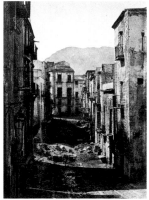
192

196

193

197

198

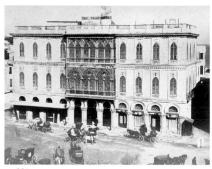

201

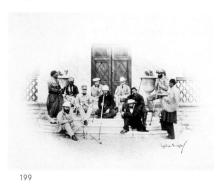

199

202 a

200

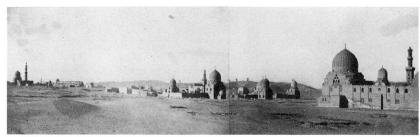

202 b

198

**Portrait of a Man in
Near Eastern Clothes
(Homme en costume oriental)**
Albumen print from a collodion-on-glass
negative
Blue wetstamp b. r.
J. Paul Getty Museum, Los Angeles,
84.XP.218.36 [JPGM]

The blue signature stamp clearly indicates
that this portrait was made after May
1860. It was taken in Alexandria: the cos-
tume (a uniform?) is identical to that worn
by the seated man with a saber in the
group portrait (cat. no. 197). The image,
which has not been reduced to an oval for-
mat, recalls the vigor of Le Gray's 1855
portrait of Clésinger. [fig. 207]

Cairo and Alexandria, 1862

These images were formerly in the collection
of Prince Philip of Belgium, count of Flanders
(1837–1905).

199

**The Prince of Wales
and His Retinue, Cairo
(Le Prince de Galles et sa suite
au Caire)**
Albumen print from a collodion-on-glass
negative
310 × 405 mm
Signature in ink b. r. on the mount
Title inscribed in Le Gray's hand b. r. on the
mount
EST, BNF, Paris, acquired 2001
See pp. 180, 320. [fig. 343]

200

**The Promenade at Shubra, Cairo
(Promenade de Choubra [Caire])**
Albumen print from a collodion-on-glass
negative
310 × 400 mm
Signature in ink b. r.
Title in Le Gray's hand in ink b. l. on the
mount
EST, BNF, Paris, acquired 2001 [JPGM]
[fig. 220]

201

**Zizinia Palace, Alexandria
(Palais Zizinia [Alexandrie])**
Albumen print from a collodion-on-glass
negative
324 × 413 mm
Signed in black ink b. c.
Title inscribed in Le Gray's hand b. r. on the
mount

Formerly collection of Prince Philip of
Belgium, count of Flanders (1837–1905)
[fig. 204]

202

**Thirteen images on one sheet
(one caricature, one panorama,
and eleven cartes-de-visite)**
Albumen prints from collodion-on-glass
negatives
Titles in Le Gray's hand

**[a] Caricature of Le Gray by Henry
de Montault**
62 × 82 mm [fig. 206]
**[b] Tombs of the Caliphs
(Tombeaux des califes)**
Panorama comprising two horizontal prints
200 × 63 mm [fig. 235]
**[c] Woman from the Levant
(Levantine)**
105 × 63 mm [fig. 216]
**[d] Alexandrian Gentleman
(Effendi)**
105 × 63 mm [fig. 212]
**[e] Peasant Woman
(Fellà)**
105 × 63 mm [fig. 213]
**[f] Masons
(Maçons)**
105 × 63 mm [fig. 219]
**[g] Man from Barbary
(Barbarin)**
105 × 63 mm [fig. 217]
**[h] Alexandrian Policeman
(Cavas)**
105 × 63 mm [fig. 210]
**[i] Laborers
(Manoeuvres)**
105 × 63 mm [fig. 218]
**[j] Sudanese Woman
(Négresse du Soudan)**
105 × 63 mm [fig. 209]
**[k] "Says"
(Says)**
105 × 63 mm [fig. 214]
**[l] Alexandrian Policeman
(Cavas [pose différente])**
105 × 63 mm [fig. 211]
**[m] Dragoman
(Drogman)**
105 × 63 mm [fig. 215]
EST, BNF, Paris, acquired 2001

This unique sheet arranged by Le Gray
presents an array of his early Egyptian
production. The series of picturesque
types is banal commercial fare, except for
the two unposed images (f and i), which
evidence an exceptional freedom of vision
(see pp. 180, 320).

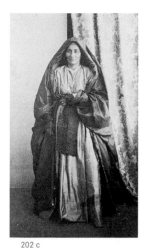

202 c

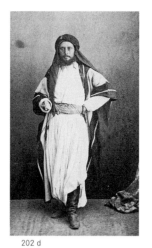

202 d

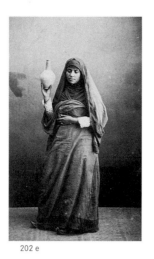

202 e

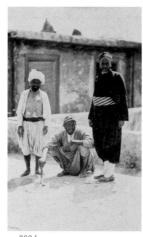

202 f

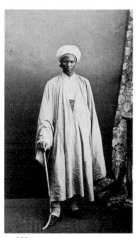

202 g

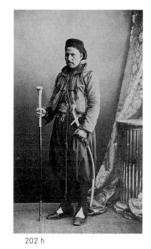

202 h

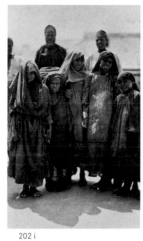

202 i

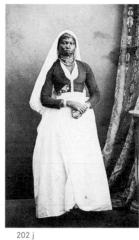

202 j

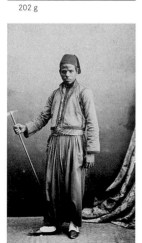

202 k

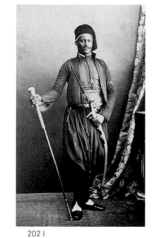

202 l

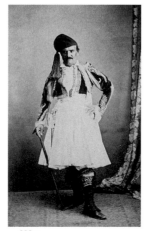

202 m

Artillery Camels, February–March 1866

203
Camel Carrying Cannon Barrel (Dromadaire chargé d'un fût de canon)
Albumen print from a collodion-on-glass negative
240 × 310 mm
Blindstamp b. c. on the mount: "Gustave Le Gray photographe de l'Empereur"
Formerly Prisse d'Avennes collection
MSS, BNF, Paris, NAF 20441 (2), 26-III-2 (1)
[fig. 225]

204
Camel Carrying Trunks and Ramrods (Dromadaire chargé de caisses et de tiges métalliques)
Albumen print from a collodion-on-glass negative
240 × 310 mm
Blindstamp b. c. on the mount: "Gustave Le Gray photographe de l'Empereur"
Formerly Prisse d'Avennes collection
MSS, BNF, Paris, NAF 20441 (2), 26-III-2 (2)
[fig. 226]

203

204

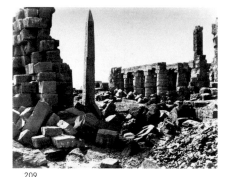
205

209

206

210

207

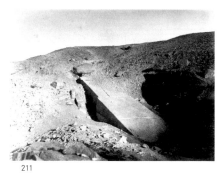
211

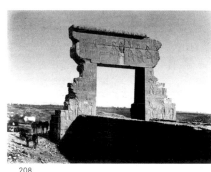
208

212

205
**Camel Carrying Cannon Wheel
and Chassis
(*Dromadaire chargé d'une roue
et d'une pièce d'artillerie*)**
 Albumen print from a collodion-on-glass
 negative
 240 × 310 mm
 Blindstamp b. c. on the mount: "Gustave Le
 Gray photographe de l'Empereur"
 Formerly Prisse d'Avennes collection
 MSS, BNF, Paris, NAF 20441 (2), 26-III-2 (3)

A collection containing views of Egyptian
monuments as well as a series of eight of
these military photographs (six of camels
and two of artillery materiel) appeared on
the market in 1995 (Drouot-Richelieu,
étude Beaussant-Lefèvre, Paris, December
13). They show military equipment newly
conceived in 1866 specifically for trans-
port via camel from Cairo to quell a revolt
of Arab tribes in the Sudan. Le Gray seems
to have photographed the startling specta-
cle of these beasts carrying cannon just
before the column's departure (see pp.
192, 199). On March 10, *L'Illustration* pub-
lished a wood engraving after another
photograph from the series, "Egyptian
artillery column marching toward the
Sudan."
[fig. 227]

Voyage on the Nile,
January 1867

206
**Temple of Horus, Edfu
(*Temple d'Edfou*)**
 Albumen print from a paper negative
 314 × 410 mm
 Title inscribed in ink b. r. on the mount
 Gilman Paper Company Collection, New York
 [JPGM]
 [fig. 229]

207
**Party for His Highness Ismaïl Pasha
aboard the Princes' Ships
(*Fête de S. A. Ismaël Pacha à bord des
bateaux de LL. AA. les princes*)**
 Albumen print from a paper negative
 306 × 402 mm
 Title inscribed in ink b. r. on the mount
 Gilman Paper Company Collection, New York
 [JPGM]
 [fig. 232]

208
**Pylon of the Temple of Hathor,
Dendera
(*Pylône du temple de Dendérah*)**
 Albumen print from a collodion-on-glass
 negative
 316 × 411 mm
 Plate 10
 Title inscribed in ink b. r. on the mount
 Blindstamp b. c. on the mount: "Gustave Le
 Gray photographe de l'Empereur Paris"
 Roger Thérond collection, Paris [JPGM]
 [fig. 2]

209
**Obelisk and Hypostyle Hall,
Temple of Amun, Karnak
(*Obélisque et salle hypostyle
à Karnak*)**
 Albumen print from a collodion-on-glass
 negative
 324 × 407 mm
 Plate 28
 Title inscribed in ink b. r. on the mount
 Blindstamp b. c. on the mount: "Gustave Le
 Gray photographe de l'Empereur Paris"
 Roger Thérond collection, Paris [JPGM]
 [fig. 231]

210
**Hypostyle Hall, Temple of Amun,
Karnak
(*[Karnak] Salle hypostyle*)**
 Albumen print from a collodion-on-glass
 negative
 324 × 410 mm
 Title inscribed b. r. on the mount
 Blindstamp b. c. on the mount: "Gustave Le
 Gray photographe de l'Empereur Paris"
 J. Paul Getty Museum, Los Angeles,
 95.XM.55 [JPGM]
 [fig. 237]

211
**Obelisk in the Quarry, Aswan
(*[Assouan] Obélisque en extraction
dans la carrière*)**
 Plate 36
 Albumen print from a collodion-on-glass
 negative
 306 × 417 mm
 Title inscribed b. r. on the mount
 Blindstamp b. c. on the mount: "Gustave Le
 Gray photographe de l'Empereur Paris"
 Roger Thérond collection, Paris [JPGM]
 [fig. 230]

212
**The Princes and Their Retinue
on the Island of Philae
(*Les Princes et leur suite
sur l'île de Philae*)**
 Plate 41

Albumen print from a glass negative
306 × 406 mm
Title inscribed b. r. on the mount
Blindstamp b. c. on the mount: "Gustave Le
Gray photographe de l'Empereur Paris"
Roger Thérond collection, Paris

Although the title of the album in the
Thérond collection (formerly in the collec-
tion of the viceroy of Egypt)—*Voyages
dans la Haute-Égypte de LL. les princes
héridataires fils de S. A. Ismaïl Pacha vice-
roy d'Égypte exécutés dans les années
1867–1868 et photographiés par Gustave
Le Gray* (Voyages in Upper Egypt of Their
Highnesses the hereditary princes, the
sons of His Highness Ismaïl Pasha, viceroy
of Egypt, executed in the years 1867 and
1868 and photographed by Gustave Le
Gray)—refers to photographs taken in
those years, there is documentary evi-
dence for only one such voyage, in 1867.
Either the title was affixed in anticipation
of two voyages or there was indeed a sec-
ond voyage, as yet undocumented. In any
event, the drawings and photographs
exhibited in Paris during the Universal
Exposition of 1867 correspond to a
voyage the whole length of the Nile,
from Alexandria to Philae. [fig. 228]

The School and Circle of Le Gray

Firmin Eugène Le Dien
(1817–1865)
See pp. 297–313.

213
**Landscape along the Tiber,
North of Rome
(Paysage au bord du Tibre,
au nord de Rome)**
1852/53
Salt print from a waxed-paper negative
223 × 335 mm
Formerly Georges Sirot collection
EST, BNF, Paris, Vf 269 boîte folio réserve
[fig. 326]

214
**Study of Trees, Roman Campagna
(Étude d'arbres, campagne romaine)**
1852/53
Salt print from a waxed-paper negative
245 × 330 mm
Neg. no. b. l.: 14
Formerly Georges Sirot collection
EST, BNF, Paris, Vf 269 boîte folio réserve
[fig. 333]

215
**Study of Trees, Roman Campagna
(Étude d'arbres, campagne romaine)**
1852/53
Salt print from a waxed-paper negative
238 × 333 mm
Neg. no. b. l.: 15
Formerly Georges Sirot collection
EST, BNF, Paris, Vf 269 boîte folio réserve
[fig. 332]

216
**Olive Grove, Roman Campagna
(Oliveraie, campagne romaine)**
1852/53
Salt print from a waxed-paper negative
339 × 247 mm
Formerly Georges Sirot collection
EST, BNF, Paris, Vf 269 boîte folio réserve
[fig. 330]

217
**The Roman Campagna
(Campagne romaine)**
1852/53
Salt print from a waxed-paper negative
245 × 330 mm
Neg. no. b. r.: 7
Formerly Georges Sirot collection
EST, BNF, Paris, Vf 269 boîte folio réserve
[fig. 329]

218
**Study of a Tree in the Valley of
Poussin, near Rome
(Étude d'arbre, vallée de Poussin,
près de Rome)**
1852/53
Salt print from a waxed-paper negative
336 × 250 mm
Neg. no. b. r.: 33
Formerly Georges Sirot collection
EST, BNF, Paris, Vf 269 boîte folio réserve
[fig. 327]

219
**The Valley of the Mills near Amalfi
(Vallée des moulins près d'Amalfi)**
1853
Salt print from a waxed-paper negative
247 × 338 mm
Formerly Georges Sirot collection
EST, BNF, Paris, Vf 269 boîte folio réserve
[fig. 321]

220
**View of the City and Port of Taranto
(Vue de la ville et du port de Tarente)**
1853
Salt print from a waxed-paper negative
220 × 280 mm
Formerly Georges Sirot collection
EST, BNF, Paris, Vf 269 boîte folio réserve

213

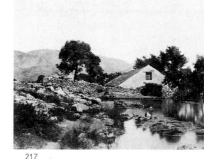
217

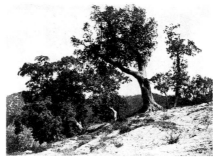
214

218

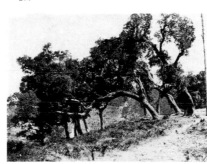
215

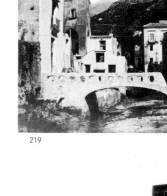
219

216

220

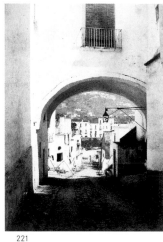

221

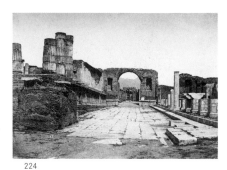

224

225

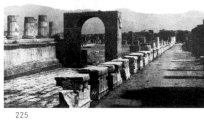

222

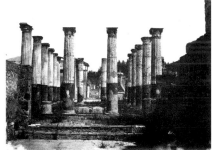

226

223

227

228

221
**A Street in Naples
(Vue d'une rue à Naples)**
1853
Salt print from a waxed-paper negative
329 × 225 mm
Neg. no. c. l.: 18
Formerly Georges Sirot collection
EST, BNF, Paris, Vf 269 boîte folio réserve
[fig. 328]

222
**Ruins at Pompeii
(Ruines de Pompéi)**
1853
Salt print from a waxed-paper negative
300 × 230 mm
Neg. no. b. r.: 13
Private collection, Paris

223
**Ruins at Pompeii
(Ruines de Pompéi)**
1853
Salt print from a waxed-paper negative
330 × 240 mm
Neg. no. b. l.: 22
Wetstamp b. r.: "LE DIEN ET GUSTAVE LE
GRAY"
Private collection, Paris
[fig. 335]

224
**Ruins at Pompeii
(Ruines de Pompéi)**
1853
Salt print from a waxed-paper negative
330 × 240 mm
Neg. no. b. l.: 23
Black wetstamp b. r.: "LE DIEN ET GUSTAVE
LE GRAY"
Private collection, Paris
[fig. 337]

225
**Ruins at Pompeii
(Ruines de Pompéi)**
1853
Salt print from a waxed-paper negative
330 × 240 mm
Neg. no. b. c.: 25
Black wetstamp b. c.: "LE DIEN ET GUSTAVE
LE GRAY"
Paris, private collection
[fig. 334]

226
**Ruins at Pompeii
(Ruines de Pompéi)**
1853
Salt print from a waxed-paper negative
330 × 240 mm

Neg. no. b. r.: 40
Wetstamp b. r.: "LE DIEN ET GUSTAVE LE
GRAY"
Private collection, Paris
[fig. 336]

Olympe Aguado
(1827–1894)

227
**Standing Self-Portrait with His Brother
Onésipe
(Autoportrait avec son frère Onésipe)**
1853
Salt print from a collodion-on-glass negative
250 × 178 mm
Formerly Gabriel Cromer collection
EST, BNF, Paris, Eo 100 b petit folio
[fig. 25]

228
**Still Life of Garden Tools
(Nature morte aux outils de jardinage)**
ca. 1852
Salt print from a paper negative
J. Paul Getty Museum, Los Angeles,
84.XP.259.1

Maxime Du Camp
(1822–1894)

229
**Medinet Habu: East Facade of the
Gynaeceum of Rameses II
(*Médinet Habou. Façade oriental
du gynécée de Ramsès Méiamoun*)**
1850
Printed May–June 1851 by Le Gray or under
his direction
Salt print from a paper negative
170 × 220 mm
Formerly Prisse d'Avennes collection
MSS, BNF, Paris, NAF 20437 (2)

Later printed by Blanquart-Évrard for
publication in *Égypte, Nubie, Palestine et
Syrie: Dessins photographiques recueillis
pendant les années 1849, 1850 et
1851 . . .* (Paris, 1852), vol. 1, pl. 48.

230
**North Facade of the Gynaeceum
of Rameses II, Egypt
(*Façade septentrionale du gynécée
de Ramsès Méiamoun*)**
1850; printed May–June 1851 by Le Gray or
under his direction
Salt print from a paper negative
220 × 170 mm

Formerly Prisse d'Avennes collection
MSS, BNF, Paris, NAF 20435 (1)
Later printed by Blanquart-Évrard for publication in *Égypte, Nubie, Palestine et Syrie,* vol. 1, pl. 49. [fig. 331]

231
Approach to the Rock Tomb of Seboua
(*Hémi-spéos de Séboua. Dromos*)
1850
Printed May–June 1851 by Le Gray or under his direction
Salt print from a paper negative
170 × 220 mm
Formerly Prisse d'Avennes collection

Subsequently printed by Blanquart-Évrard for publication in *Égypte, Nubie, Palestine et Syrie,* vol. 2, pl. 97.

John B. Greene
(1832–1856)

232
Trees near the Road to Chailly, Forest of Fontainebleau
(*Forêt de Fontainebleau*)
ca. 1852
Salt print from a waxed-paper negative
165 × 295 mm
Formerly Achille Devéria collection
EST, BNF, Paris, Eo 5 folio
[fig. 45]

233
View of the Forest of Fontainebleau
(*Forêt de Fontainebleau*)
ca. 1852
Salt print from a waxed-paper negative
203 × 302 mm
Formerly collection Achille Devéria
EST, BNF, Paris, Eo 5 folio
[fig. 322]

Léon Méhédin
(1828–1905)

234
The Italian Campagna at Valeggio: View from the Foyer of the Emperor
(*Campagne d'Italie 1859. Valeggio. Vue prise du vestibule de S. M. l'Empereur*)
1859
Albumen print from a waxed-paper negative
270 × 342 mm
Inscribed b. l. on the negative: "L. M. 11"
Formerly Georges Sirot collection
EST, BNF, Paris, VF 267 4°

Adrien Tournachon
(1825–1903)

235
Arab Horseman
(*Cavalier arabe*)
ca. 1857
Varnished salt print from a collodion-on-glass negative
295 × 218 mm
Wetstamp b. r.: "Nadar Jne"
Acquired 1998
EST, BNF, Paris, Eo 99 folio

O. Mestral
(active 1848–1856)

236
Landscape
(*Paysage*)
ca. 1851–1853
Salt print from a waxed-paper negative
Autograph signature c. l. on the negative
Musée des Monuments français, Paris, Geoffroy-Dechaume archive

The presence of this very beautiful landscape, a rare vestige of Mestral's art, among the papers of the sculptor Adolphe Victor Geoffroy-Dechaume (1816–1892) lends credence to the hypothesis that in 1853 Mestral photographed Geoffroy-Dechaume's sculptures that were earmarked for the restoration of Sainte-Chapelle in Paris (see p. 64). [fig. 324]

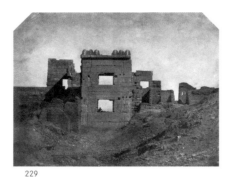
229

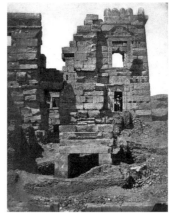
230

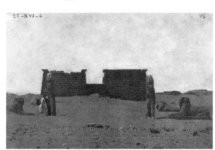
231

234

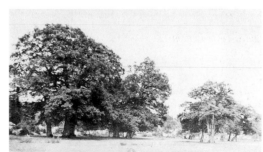
232

233

235

236

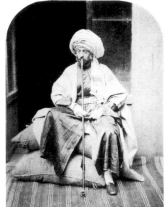

237

240

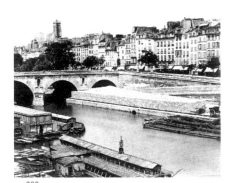

238

241

242

239

243

Charles Nègre
(1820–1880)

237
**Self-Portrait in Algerian Costume
(Autoportrait en costume algérien)**
Albumen paper print from a collodion-on-glass negative
162 × 118 mm
Acquired 1982
EST, BNF, Paris, Eo 2 b petit folio

238
**The Pont Marie and the Quai des
Célestins Seen from the Quai d'Anjou
(Paris, le pont Marie et le quai
des Célestins vus du quai d'Anjou)**
ca. 1855
Albumen print from a paper negative
394 × 438 mm
J. Paul Getty Museum, Los Angeles,
92.XM.51
[fig. 19]

Henri Le Secq
(1818–1882)

See also cat. no. 1.

239
**View of Rome, Sketchbook
(Carnet de dessins)**
Rome, 1844/45
Pen, graphite, some watercolors
100 × 134 mm
Formerly Gabriel Cromer collection
EST, BNF, Paris, Dc 2496 boîte
réserve
[fig. 6]

240
**At the Field of Cosaques,
Forest of Montmirail
(Au champ des Cosaques.
Forêt de Montmirail)**
Salt print from a waxed-paper negative
235 × 328 mm
Signed b. r. on the negative: "H. Le Secq au
champ des Cosaques"
Gift of Henri Le Secq, son of the photographer
Paris, Bibliothèque du musée des Arts déco-
ratifs, cat. 433

241
**Forest Stream
(Ruisseau en forêt)**
1854
Salt print from a waxed-paper negative
507 × 377 mm
Gift of Henri Le Secq, son of the photographer
Paris, Bibliothèque du musée des Arts déco-
ratifs, cat. 466

Auguste Salzmann
(1824–1872)

242
**Islamic Decorative Reliefs, Jerusalem
(Jérusalem. Ornements arabes)**
1854
Salt print from a paper negative
236 × 325 mm
EST, BNF, Paris, Vh 10 b folio réserve

*Jérusalem. Étude et reproduction pho-
tographique des monuments de la ville
sainte depuis l'époque judaïque jusqu'à nos
jours.* Paris, 1856, vol. 2.

Eugène Piot
(1812–1890)

243
**The Acropolis of Athens: View of the
Propylaeum from the Areopagan Rock
(L'Acropole d'Athènes / Les Propylées /
Vue prise du rocher de l'Aréopage)**
1852
Salt print from a waxed-paper negative
330 × 226 mm
Printed b. l. on the mount "Eug. Piot fecit et
excudit 1852"
Formerly Alfred Armand collection
EST, BNF, Paris, AD 34 a folio tome 4

Benjamin Delessert
(1817–1868)

244
***The Incense Burner* by Marcantonio Raimondi**
(Marcantonio Raimondi, *La Cassolette*)
Salt print from a paper negative
300 × 164 mm
Printed caption below the print: "La Cassolette / Bartsch n° 489 / L'original fait partie du cabinet de M. Gatteaux, membre de l'Institut, Paris / Marc Antoine Raimondi"
EST, BNF, Paris, Yb3 1741 petit folio

Plate from Benjamin Delessert, *Notice sur la vie de Marc Antoine Raimondi . . . accompagnée de reproductions photographiques de quelques-unes de ses estampes* (Paris and London, 1853).

Édouard Delessert
(1828–1898)

245
The Count of Riencourt
(*Le C^te de Riencourt*)
"7bre [September] 1859"
Salt print from a collodion-on-glass negative
160 × 226 mm
Blue wetstamp b. r.: "Édouard D"
Formerly Georges Sirot collection
EST, BNF, Paris, Eo mat Delessert

Emmanuel Peccarere,
Known as "Pec"
(active 1851–1853)

246
Elche (Spain)
(Elsche [Espagne])
ca. 1852
Salt print from a waxed-paper negative
228 × 295 mm
Inscribed b. l. on the negative: "Em. Pec. Elche"
Formerly Georges Sirot collection
EST, BNF, Paris, Eo 213 folio

Eugène Colliau
(active 1859–1867)

247
The Coast
(*La Côte*)
ca. 1859
Albumen print from a collodion-on-glass negative
172 × 242 mm, oval
Black wetstamp b. r. on the mount: "E. Colliau"
Registered for copyright 1861
EST, BNF, Paris, Eo 25 folio

"The frames of M. Le Gray bring us quite naturally to those of an exhibitor whose name is new, but who takes his place today next to the master; I refer to M. E. Colliau. All the qualities of the teacher are found in the productions of the student. I do not know if M. Colliau took lessons directly from M. Le Gray, but it is certain that he uses the same procedures, and that he has assimilated his manner to the point that the two exhibits could be by the same artist." Ernest Lacan, *La Lumière* (July 9, 1859): 109.

Vicomte Joseph Vigier
(1821–1894)

248
The Luchon Valley Seen from the Tower of Castelvieil
(Vallée de Luchon vue depuis la tour de Castelvieil)
July 1853
Salt print from a waxed-paper negative
272 × 365 mm
Formerly Georges Sirot collection
EST, BNF, Paris, Eo 169 a grand folio

"First, I find six of the most beautiful *Views of the Pyrenees* of M. the vicomte Vigier, which are as greatly admired here as in France. You should hear all the exclamations that they draw from the visitors who crowd in front of them: 'Oh! Beautiful indeed! . . . Capital! Splendid!!' The enthusiasm takes the form of the most expressive interjections, a veritable concert of praise." Charles Gaudin, "Compte rendu de l'exposition de la Société photographique de Londres," *La Lumière* (February 25, 1854): 29. [fig. 325]

244

245

247

246

248

Manuscript Sources

Let us gather facts to give us ideas.
—Buffon

National Archives (Paris)

Subseries F⁴. Ministry of the Interior, general accounting

F⁴ 2771. Payment records: files 2098 and 2201, Mission héliographique, travel expenses and compensation, 1852.

F⁴ 2782. Idem: file 2263, Mission héliographique, payment for 120 negatives and 120 prints to Le Gray and Mestral, September 8, 1852.

Subseries F²¹. Beaux-Arts

F²¹ 93. Commissions and acquisitions of artworks: file 34, acquisition of "six copies at 300 francs each of a collection of fifty-six photographs of paintings from the Festival Hall at the Hôtel de Ville by M. H. Lehmann," March 16, 1854.

F²¹ 96. Idem: file on acquisition of two hundred photographs, "studies of skies, sea, ships, seascapes, etc.," by L. Cyrus Macaire, February 1855–July 1856.

F²¹ 112. Idem: file on acquisition of daguerreotypes of seascapes by Macaire and Warnod, February 1853–January 1856.

F²¹ 269. Incentives to artists: request for assistance for Mme Le Gray, February 8, 1862.

F²¹ 487. Miscellaneous: file 4, report by Mercey to the minister of state on commissions of paintings illustrating the reign of Napoléon III, including Thomas Couture's *Baptism of the Imperial Prince*.

F²¹ 490. Commissions of portraits of the imperial family: Thomas Couture, *Baptism of the Imperial Prince*, 1856.

F²¹ 491. Business handled by the Beaux-Arts management staff: file I, list of 2nd and 3rd place medals from the École des beaux-arts for illustrations after antiquities and nature, 1838 (Lesecq [Flacheron crossed out], student of Delaroche's, 3rd place medal after antiquities).

F²¹ 492. Papers of Charles Blanc, director of the Beaux-Arts: letter requesting assistance and award for Alophe, 1872.

F²¹ 562. Business handled by the Beaux-Arts management: letter from Lerebours to M. de Montour complaining of services by Le Gray, November 1852.

Information in boldface represents the complete numbering for each article.

F²¹ 2284². Artistic and literary assignments: Édouard Baldus, safe conduct to accompany the emperor to the English Channel and Calvados, July 28, 1858.

Subseries F⁷⁰. Ministry of State

F⁷⁰ 196. Expenses for acquisitions of works of art, fiscal year 1853: payment no. 518, to Warnod, sixty photographs (seascapes, landscapes, etc.), 1st installment, June 6, 1853; payment no. 1796, to Le Gray, photographs, March 25, 1854.

F⁷⁰ 197. Idem, fiscal year 1854: payment no. 83, to Warnod, sixty photographs (seascapes, landscapes, etc.), 2nd installment, January 26, 1854.

F⁷⁰ 198. Idem, fiscal year 1854: payment no. 949, six copies of a compendium of photographs of the paintings by Lehmann for the Festival Gallery at the Hôtel de Ville, July 17, 1854.

F⁷⁰ 199. Idem, fiscal year 1855: payment no. 306, to L. Cyrus Macaire, two hundred miscellaneous photographs on paper (studies of sky, sea, ships, seascapes, etc.), March 15, 1855.

F⁷⁰ 201. Idem, fiscal year 1856: payment no. 53, to L. Macaire, eighty prints (miscellaneous views), January 21, 1856.

F⁷⁰ 202. Idem, fiscal year 1856: payment no. 1327, two hundred photographs by Macaire (miscellaneous subjects) and lithographs of same by Sorrieu, August 2, 1856.

F⁷⁰ 237. Incentives to artists, fund-raising, etc., fiscal year 1853: payment no. 143, twenty-five photographic prints including "one of the Arc de Triomphe from the porte Saint-Martin dated October 16 [1852] by Le Gray," March 25, 1853.

F⁷⁰ 243. Idem, fiscal year 1862: payment no. 228, incentives to various artists or their widows, including 150 francs to Mme Le Gray, February 22, 1862.

Subseries O⁵. Household of the emperor

O⁵ 2321. Liquidation of the imperial household and private estate: inventory from the Tuileries, 1870.

Subseries BB⁶. Courts of law

BB⁶ II 249. Files on replacement of justices of courts of first instance: Firmin Eugène Le Dien

Records of the Central Paris Solicitors' Archives

XXII, 177. November 26, 1806, marriage contract between Jean-Martin Legray and Catherine Eulalie Gay.

XXXVIII, 956. March 7, 1829, sale by J.-M. Legray and his wife of a house at 233, rue du Faubourg-Saint-Antoine, for 30,000 francs.

XCIII, 278. November 18, 1806, lease to J.-M. Legray of a shop at 341, rue Saint-Denis.

CIII, 1633. January 28, 1885, attested affidavit following the death of Gustave Le Gray.

Archives of Paris and the Former Department of the Seine

Vital statistics

5 Mi 2/919. Reconstructed Paris vital statistics: December 8, 1806, marriage of Jean-Martin Legray and Catherine Eulalie Gay; September 6, 1849, death of Julie Octavie Le Gray; September 10, 1849, death of Elvire Mathilde Julie Miriam Le Gray; March 9, 1851, birth of Romain Gustave Alfred Le Gray; December 17, 1853, birth of Berthe Lodoïska Palmyra Le Gray; January 26, 1855, death of Jean-Martin Legray.

5 Mi 3/504. Marriage register of the 20th arrondissement: May 20, 1882, marriage of Romain Gustave Alfred Le Gray and Marie-Léonie Le Maître.

5 Mi 3/627. Death register of the 6th arrondissement: July 28, 1865, death of Firmin Eugène Le Dien.

Subseries D1 P4. Assessment rolls

D1 P4, box 53. 27, quai des Grands-Augustins, 1849.

D1 P4, box 78. Boulevard des Batignolles: annexation of 3, chemin de ronde de la barrière de Clichy, 1852.

D1 P4, box 96. 50, rue de Bellechasse, 1862.

D1 P4, boxes 184 and 185. 35, boulevard des Capucines.

D1 P4, box 408. 170, Faubourg-Saint-Denis.

D1 P4, box 953. 110, rue de Richelieu, 1852.

D1 P4, box 1224. 48, rue Vivienne, 1852.

D2 U3 2356. Judgment of the Seine Commercial Court in the matter of *Le Gray v. the comte and the marquis de Briges,* October 24, 1860.

D3 U1, packet 489. Attested affidavit confirming the disappearance of Mme Le Gray, April 27, 1882.

D31 U3 and D32 U3. Incorporation and dissolution of companies

D31 U3, box 204. Excerpt 2174, instrument establishing the limited partnership of Le Gray et Cie, August 19, 1857.

D31 U3, box 219. Excerpt 437, instrument of dissolution of the partnership, February 1, 1860.

D32 U3, register 36. No. 2174, registration of the partnership, August 28, 1857.

D32 U3, register 39. No. 437, registration of the dissolution of the partnership, February 18, 1860.

DQ7, register 10893. No. 350, declaration relative to the estate of Gustave Le Gray, naming as his sole heir, his son Romain Gustave Alfred, April 13, 1885.

Pérotin 10624/72/1, bundle 113. File on commissions of works of art by Henri Lehmann.

National Museums Archives, Louvre (Paris)

Series *KK. Salon registers

***KK 19.** Salon of 1848, registration of entries, index: Le Gray, 27, quai des [Grands-]Augustins, painting, nos. 3167–3168.

***KK 21.** Salon of 1850, registration of entries, index: Le Gray, 7, chemin de ronde de la barrière de Clichy, lithograph, no. 4579 [i.e., 5579], a frame containing nine photographs, 110 x 120 cm.

***KK 22.** Salon of 1852, registration of entries, index: Le Gray, chemin de ronde de la barrière de Clichy, Paul Delaroche, painting, no. 4437.

***KK 42.** Salon of 1848, registration of works: no. 3167, Le Gray, a painting, *Massari of Rome*, 120 x 165 cm, returned; no. 3168, idem, a painting, *Portrait of Mme H. de V.,* 120 x 100 cm.

***KK 45.** Salon of 1852, registration of works: no. 4437, Le Gray, a painting, *Portrait of Mme G.,* 150 x 120 cm, rejected.

***KK 46.** Salon of 1853, registration of works: no. 2794, Le Gray, a painting, *Portrait of Mme G. L.,* 150 x 120 cm.

***KK 66.** Salon of 1850–1851, jury report: no. 5579, Le Gray, frame containing nine photographs (various genres), rejected.

***KK 67.** Salon of 1852, jury report: no. 4437, Le Gray, portrait, rejected.

***KK 110.** Salon of 1852, entries, painting: Le Gray, chemin de ronde de la barrière de Clichy, Paul Delaroche, 1. *Portrait of Mme G. . . . ;* 2. *The Porte Narbonnaise, Carcassonne* (photograph); 3. *Central Portal of the Tours Cathedral* (photograph); 4. *Portrait of Henri Le Secq* (photograph).

***KK 116.** Salon of 1853, entries, painting: Le Gray, 7, chemin de ronde de la barrière de Clichy, Paris, Paul Delaroche, no. 2794 A, *Portrait of Mme G. L.*

Series *LL. Registers of student-artist cards, leaves of absence

***LL 4.** April 17, 1855, Auguste Legras, painter, 7, chemin de ronde de la barrière de Clichy.

***LL 7.** February 24, 1842, Le Gray, 170, rue du Faubourg-Saint-Denis, student of Delaroche's.

***LL 8.** November 16, 1847, Le Gray, 27, quai des [Grands-]Augustins, student of Delaroche's.

2 DD 20. Commissions and acquisitions by the private estate of Napoléon III: three copies of the Lehmann Hôtel de Ville album, June 8, 1854, 900 francs.

2 DD 25. Acquisitions by the imperial household: p. 103, same acquisition.

31 DD 3. Inventory of paintings, watercolors, and engravings from the château de Compiègne, 1856.

Archives of the Ministry of Foreign Affairs (Paris)

Consular and commercial correspondence, Alexandria, vol. 37. Letter dated May 1, 1863: list of French notables for 1863.

Consular vital statistics registers, Cairo

Year 1880. February 24, birth certificate of the son of Félicité Candounia and Baptistin Dispard.

Year 1883. January 16, birth certificate of Jean-Baptiste Gustave Le Gray, son of Gustave Le Gray and Anaïs Candounia, cancelled.

Year 1884. August 8, registration of the death of Gustave Le Gray on July 30.

Archives of the Ministry of Foreign Affairs (Nantes)

Italy
Rome, Embassy to the Holy See

Register 695. Passports, arrivals: passport for Italy requested June 6, 1843, at police headquarters by Le Gray; November 25, 1843, arrival of Gérôme in Rome; January 18, 1844, arrival of Le Gray in Rome; January 19,

1844, departure of Le Gray for Naples; February 11, 1844, arrival of Le Gray in Rome; June 18, 1844, departure of Gérôme for Naples; September 10, 1844, arrival of Gérôme in Rome; October 17, 1844, arrival of Le Secq in Rome.

Register 696. Idem: November 13, 1844, departure of Gérôme for Paris; May 12, 1845, departure of Le Secq for Naples; July 7, 1845, departure of Le Gray for Paris; August 10, 1845, arrival of Le Secq in Rome; October 28, 1845, arrival of Le Gray and his wife in Rome; December 15, 1845, arrival of Gérard in Rome; January 25, 1846, arrival of Le Dien in Rome; February 23, 1846, departure of Le Dien and Gérard for Naples.

Register 697. Idem: March 9, 1847, return of Le Gray and his wife to Paris; March 26, 1846, arrival of Gérard in Rome; April 22, 1846, departure of Gérard for Venice.

Register 701. Idem: September 12, 1852, arrival in Rome of Le Dien, de Vonne, Vigié, Gérard.

Register 702. Idem: September 17, 1853, arrival of Le Dien, age 35, landowner, Paris, arriving from Naples; September 30, 1853, arrival of Zélie Vigié; September 30, 1853, arrival of Gérard.

Register 707. Idem: July 18, 1862, arrival of Mme Le Gray with her son, age 5, in Rome.

Register 718. Passport visas: April 27, 1853, departure of Le Dien, de Vonne, Vigié, and Gérard for Naples; October 15, 1853, departure from Rome of Gérard for Paris and Vigié for Marseilles.

Rome, consulate, chancellery instruments, register 222. July 5, 1845, legalization of the marriage of Le Gray, performed May 12, 1844.

Rome, consulate, old passports, box 34. Zélie Vigié, age 26, opera singer, 6, rue de Provence, passport for Italy, August 14, 1852.

Palermo, consulate, article 10. Register of French sea traffic: June 9, 1860, arrival of the schooner yacht the *Emma* from Genoa, eight crew members and eleven passengers, embarked at Marseilles; July 23, 1860, arrrival of the *Emma* from Catania, redeparture July 27 for Messina, eight passengers.

Lebanon
Beirut, consulate general, series A, box 63. Passport register: November 23, 1860, Albanel and Le Gray, passports for Jerusalem.

Egypt
Alexandria, consulate, chancellery instruments, no. 34. Power of attorney by Le Gray to Maufras to settle all of his affairs, August 2, 1860; bearer proxy by David Jérôme Natalis Albanel, doctor of medicine, residing in Paris (65, rue de Rivoli), December 10, 1860.

Alexandria, consulate, individual files, no. 2535. Mme Le Gray: letter from the consul to Mme Le Gray (Rome), October 28, 1862; letter to the French consul in Alexandria requesting a small allowance for Mme Le Gray, January 23, 1863.

Cairo, consulate, chancellery instruments
Box 118. Bearer proxy by Le Gray to settle the estate of his mother, July 2, 1877.
Box 119. Consent by Le Gray to the marriage of his son, Alfred, to the widow Lebret, née Marie Lemaître, March 6, 1882.
Cairo, consulate, series C, estate files, box 52. Estate of Gustave Le Gray, July 29, 1884.
Cairo, consular court, box 53. File 34, lawsuit in the matter of *Louis Gourjon v. Gustave Le Gray,* 1881.

Bibliothèque nationale de France (Paris)

Department of manuscripts, Occidental division
NAF 24260. Correspondence of Félix Nadar: fols. 172–175, Alophe.
NAF 24269. Idem: fol. 22, autobiographical note by Maxime Du Camp for the *Panthéon Nadar,* circa 1852/53.
NAF 24275. Idem: fols. 663–666, Le Gray.
NAF 24279. Idem: Henry de Montault.
NAF 24281. Idem: Ernest Prarond.
NAF 24379. Idem: fols. 176–177, Alexandre Marie Guillemin, 7, chemin de ronde de la barrière de Clichy, received December 29, 1842.
NAF 16800. Delaroche-Vernet family correspondence.
NAF 20420. Notes collected by E. Prisse d'Avennes.

Department of prints and photography
Yb³ 2340 4°, case 9. "Nadar Studio. Boulevard des Capucines, 35. Company incorporation, July 12, 1860. Instruments and reports." *Revendication de la propriété exclusive du pseudonyme Nadar . . .* (Claim of exclusive ownership of the pseudonym Nadar), . . . Imperial Court of Paris, 1st Division, hearing of December 12, 1857.
Ye 79 pet. fol., Rés. Copyright register, 1860–1861.

Ye 131a pet. fol., Rés. Subscription register: February 10, 1848, registration of Le Gray.

Institut de France (Paris)

Library
MSS 1981–1983. Papers of the comte Jules de Bertou concerning the assignment of Renan to Lebanon in 1860–1861.
MSS 2230–2232. Papers and correspondence of Eugène Piot.
MSS 3719–3721, 3751, 3766. Papers and correspondence of Maxime Du Camp.
G 1169 (case 16), **G 1188** (case 35), **G 1192** (case 39). Correspondence of the vicomte Spoelberch de Lovenjoul.

Archives of the Académie des sciences
Meeting files, 1851
February 25. Letter from Le Gray announcing the filing of a sealed envelope dated February 14, containing a description of dry waxed paper.
November 17. Letter from Le Gray announcing the filing of a sealed envelope dated November 12, containing a description of "New processes for obtaining positive prints on paper with very varied coloration and more complete fixation than were achievable using the old processes."
December 8. Presentation by Victor Regnault of a "Note on a new method of preparing negative photographic paper by Gustave Le Gray" and prints made by Le Gray; opening of the sealed envelopes deposited February 25 and November 17.

Archives of the Académie des inscriptions et belles-lettres
E 84 and 85. Minutes of meetings, 1849–1857.
E 370. Correspondence and memoranda, 1851.

Archives of the Académie des beaux-arts
Minutes of meetings, 1840.
5 E 36 and 37. Correspondences and memoranda, 1852 and 1853.

National Patent Institute (Paris)

Brevet 12738. Patent "for a type of paper prepared for photography," December 8, 1851.

Private Collection (Paris)

Notebooks of Charles Nègre.

Departmental Archives of Charente (Angoulême)

RP No. 3 E 48/5. Vital statistics: April 11, 1829, birth of Jean-Baptiste Léon Maufras.

Departmental Archives of Somme (Amiens)

3 Q 17/38 and 41/272. Schedules of settled inheritances: Le Dien family.

Departmental Archives of Val-d'Oise (Pontoise)

2 E 5024. Watel law office, Villiers-le-Bel: March 18, 1822, acquisition by the Legray spouses of a house at 233, rue du Faubourg-Saint-Antoine.

2 E 21077. Lechat law office, Villiers-le-Bel: February 28, 1855, liquidation of the estate of J.-M. Legray.

2 E 21100. Idem: April 21, 1861, will of Catherine Eulalie Gay, mother of Gustave Le Gray; May 11, 1861, her estate inventory.

2 E 21101. Idem: June 19 and July 14, 1861, sale of personal and real property of Catherine Eulalie Gay.

2 E 21158. Diolé law office, Villiers-le-Bel: December 24, 1875, estate of Catherine Eulalie Gay.

2 E 21159. Idem: January 7, 1876, same estate.

2 E 21162. Idem: July 25, 1876, same estate.

2 E 21167. Idem: June 25, 1877, same estate.

2 E 21169. Pingeot law office, Villiers-le-Bel: September 13, 1877, ratification and acquittance by Le Gray's representative.

2 E 21250 and 21251. Lechat law office, Villiers-le-Bel: ledgers, 1832–1861.

9 M 990/1. List of names of the inhabitants of Villiers-le-Bel, 1841.

Vital statistics. Birth of Gustave Le Gray, August 30, 1820; registration of his marriage, September 23, 1845; birth of his daughter Elvire Françoise Eulalie Le Gray, June 4, 1845; death of same, certificate dated July 27, 1858; death of Catherine Eulalie Gay, mother of Le Gray, May 3, 1861.

Departmental Archives of Hauts-de-Seine (Nanterre)

5 MI/NEU-16. Vital statistics: December 13, 1861, death of Jean-Baptiste Léon Maufras.

Municipal Library of Boulogne-sur-Mer

MS 718. Auguste Mariette collection.

Historical Archive of the Vicariate of Rome

Marriages, 1st Solicitor's Office (Angelo Monti), 1844, Volume III. File 72, marriage of Gustave Le Gray to Palmira Leonardi, May 12, 1844.

National Archives of Egypt (Cairo)

'Asr Ismâ'îl (reign of Ismaïl) collection, bundle 2/1. Residence of the princes, sons of the viceroy, year 1867: docs. 1 and 8, letters from Major Haillot to Riaz Pasha concerning the voyage of Le Gray along the Nile, January 4 and June 25, 1867.

Douin papers, box 188. Statistics on public education, report by Dor Bey, December 25, 1875.

Latin Parish of the Assumption (Cairo)

Death registry, register 7. No. 120, death certificate of Gustave Le Gray.

Published Sources (Nineteenth-Century Texts)

Manuals by Gustave Le Gray

Traité pratique de photographie sur papier et sur verre. Paris: Plon frères, June 1850.

A Practical Treatise on Photography upon Paper and Glass, Translated from the French by Thomas Cousins. London: T. & R. Willats, opticians, 1850.

Nouveau traité théorique et pratique de photographie sur papier et sur verre, contenant les publications antérieures et une nouvelle méthode pour opérer sur papier sec restant sensible huit à dix jours. Paris: Plon, July 1851.

Photographie: Nouveau traité théorique et pratique des procédés et manipulations sur papier sec, humide et sur verre au collodion, à l'albumine. Paris: Plon, [1852].

Directions for Obtaining Both Positive and Negative Pictures upon Glass [. . .] by T. H. Hennah; also, Gustave Le Gray's Recently Published Method of Obtaining Black and Violet Colors in the Positive Proofs, Translated from the French. London: Delatouche, 1853.

Photographic Manipulation: The Waxed Paper Process of Gustave Le Gray, Translated from the French, with a Supplement by James How on His Modification of the Process. London: G. Knight & Sons, opticians, 1853.

Plain Directions for Obtaining Photographic Pictures. Part 1 by J. H. Croucher; Part 2 by Gustave Le Gray. Philadelphia: A. Hart, 1853.

Photographie: Nouveau traité théorique et pratique des procédés et manipulations sur papier sec, humide, sur verre au collodion, à l'albumine, nouvelle édition renfermant tous les perfectionnements apportés à cet art jusqu'à ce jour. Paris: Plon, May 1854.

Periodicals Examined

Bulletin de la Société française de photographie, 1855–1889.
Comptes rendus de l'Académie des sciences, 1850–1860.
Le Cosmos, 1852–1854.
Gazette des beaux-arts, 1859–1861.
L'Illustration, 1856–1867.
Intermédiaire des chercheurs et des curieux, 1892.
La Lumière, 1851–1859.
Le Monde illustré, 1856–1861.
Le Moniteur de la photographie, 1861–1892.
Le Photographe, 1855–1858.
Le Propagateur, 1853–1855.
Revue photographique, 1856–1859.

Miscellaneous Works and Articles

Articles from periodicals in the previous section have not been included.

ALOPHE. *See* Menut.

AUDIGIER, Henry d'. *La Vie de garçon: Souvenirs anecdotiques d'un chroniqueur parisien.* Paris: E. Dentu, 1859.

BANVILLE, Théodore de. *La Mer de Nice: Lettres à un ami.* Paris: Poulet-Malassis & de Broise, 1861.

BOCHER, Charles. *Mémoires de Charles Bocher (1816–1907), précédés des Souvenirs de famille (1760–1816).* 2 vols. Paris: Flammarion, 1907.

CARNOY, Norbert. *La Colonie française du Caire.* Paris: Presses universitaires de France, 1928.

CASTELLANI, Charles. *Confidences d'un panoramiste, aventures et souvenirs.* Paris, 1895.

CHARLES-CHEVALIER. *Méthodes photographiques perfectionnées.* Paris: Charles-Chevalier, September 1859.

CHARMES, Gabriel. *Cinq mois au Caire et dans la Basse-Égypte.* Paris: G. Charpentier, 1880.

CHENNEVIÈRES, Philippe de. *Souvenirs d'un directeur des Beaux-Arts.* Paris: Aux bureaux de *L'Artiste,* 1888.

CHEVALIER, Arthur. "Notes sur les procédés employés actuellement en photographie." In *Photographie sur papier sec, glaces albuminées.* . . . Paris: Baillière, 1857.

COUTURE, Thomas. *Thomas Couture (1815–1879): Sa vie, son oeuvre [. . .] par lui-même et son petit-fils.* Preface by Camille Mauclair. Paris: Le Garrec, 1932.

DU CAMP, Maxime. *Expédition des Deux-Siciles, souvenirs personnels.* Ed. Maria Gabriella Adamo. Reggio di Calabria: Parallelo 38, 1976. First published in four issues of *La Revue des deux-mondes,* 1861.

——— . *Lettres inédites à Gustave Flaubert.* Ed. Giovanni Bonaccorso and Rosa Maria Di Stefano. Messina, Italy: EDAS, 1978.

——— . *Souvenirs littéraires: 1822–1880.* Paris, 1906. Reprint, Geneva: Slatkine Reprints, 1993.

DUMAS, Alexandre. *Les Garibaldiens: Révolution de Sicile et de Naples.* 1868. Reprint, Marseilles: J. Laffitte Reprints, 1982.

——— . *On Board the* Emma: *Adventures with Garibaldi's "Thousand" in Sicily.* Trans. R. S. Garnett. London: E. Benn, 1929.

DUMESNIL, Henri. *Aimé Millet, souvenirs intimes.* Paris: Lemerre and Rapilly, 1891.

DURAND-BRAGER, Henri. *Quatre mois de l'expédition de Garibaldi en Sicile et en Italie.* Paris: E. Dentu, 1861.

FÉLIX-HENRI. "Les Waggons [*sic*] du pape." *La Semaine des familles,* no. 35 (May 28, 1859).

FENTON, Roger. "Photography in France." *The Chemist* 3, no. 29 (February 1852): 221–22.

FERRIER, A. *Notice sur l'Hôtel de Ville de Paris.* Paris, 1855.

FOURNIER, Édouard. *Le Vieux-Neuf: Histoire ancienne des inventions et découvertes modernes.* 2 vols. Paris: E. Dentu, 1859.

GIFFARD, Pierre. *Les Français en Égypte.* Paris: V. Havard, 1883.

GUILLOT-SAGUEZ. *Méthode théorique et pratique de photographie sur papier.* Paris: V. Masson, 1847.

HERBET, Félix. *Dictionnaire historique et artistique de la forêt de Fontainebleau: Routes, carrefours, cantons, gardes, monuments, croix, fontaines, puits, mares, environs, moulins, etc.* Fontainebleau: Impr. de M. Bourges, 1903.

HOUSSAYE, Arsène. *Les Confessions: Souvenirs d'un demi-siècle, 1830–1880.* 6 vols. 1885–1891. Reprint, Geneva: Slatkine Reprints, 1971.

LACAN, Ernest. *Esquisses photographiques, à propos de l'Exposition universelle et de la guerre d'Orient.* Paris: Grassart, 1856.

LAZARE, Félix, and Louis LAZARE. *Dictionnaire administratif et historique des rues et monuments de Paris.* 1855. Reprint, Paris: Maisonneuve & Larose, 1994.

LE SECQ, Henri. *Les Artistes, les Expositions, le Jury.* Paris: Cadart & Chevalier, 1863.

LOCKROY, Édouard. *Au hasard de la vie, notes et souvenirs.* Paris: B. Grasset, 1913.

———. *L'Île révoltée.* Paris: E. Dentu, 1877.

———. "Mission de M. Renan en Phénicie, 1860: Texte et dessins inédits." *Le Tour du monde,* (1863): 33–64.

LOUET, Ernest. *Expédition de Syrie: Beyrouth, le Liban, Jérusalem (1860–1861), notes et souvenirs.* Paris: Amyot, 1862.

MAISON, Émile. *Journal d'un volontaire de Garibaldi.* Paris: A. de Vresse, 1861.

MAYER and PIERSON. *La Photographie considérée comme art et comme industrie: Histoire de sa découverte, ses progrès, son application, son avenir.* Paris: L. Hachette, 1862.

MENUT, Adolphe [Alophe, pseud.]. *Ancienne maison Le Gray et Cie photographe de S. M. l'Empereur. M. Alophe successeur. Cartes d'album.* Paris: 35, boulevard des Capucines, 1861.

———. *Le Passé, le Présent et l'Avenir de la photographie: Manuel pratique de photographie par M. Alophe.* Paris: E. Dentu, 1861.

MÉRIMÉE, Prosper. *Correspondance générale.* 17 vols. Ed. Maurice Parturier. Toulouse: Privat, 1941–1964.

MILLIE, J. *Alexandrie d'Égypte et le Caire avec le plan de ces deux villes.* Milan: Privately printed for the author, n.d.

NADAR, Félix. *Quand j'étais photographe.* Paris, [1900]. Rev. ed., Arles: Actes Sud, 1998. Text first published in *Paris photographe* (1892).

NINET, John. *Lettres d'Égypte, 1879–1882.* Ed. Anouar Louca. Paris: Éditions du Centre national de la recherche scientifique, 1979.

PAPONOT, Félix. *L'Égypte, son avenir agricole et financier.* Paris: Baudry, 1884.

Patents for Inventions. Abridgements of the Specifications Relating to Photography. Printed by Order of the Commissioners of Patents. London: George E. Eyre and William Spottiswoode, 1861.

PIEDAGNEL, Alexandre. *J.-F. Millet: Souvenirs de Barbizon.* Paris: Cadart, 1876.

PRAROND, Ernest. *De quelques écrivains nouveaux: G. Le Vavasseur, Ph. de Chennevières, Th. de Banville. . . .* Paris: M. Lévy, 1852.

RENAN, Ernest. *Lettres inédites d'Ernest Renan à ses éditeurs Michel et Calmann Lévy.* Ed. Jean-Yves Mollier. Paris: Calmann-Lévy, 1986.

RHONÉ, Arthur. *L'Égypte à petites journées: Le Caire d'autrefois.* Reprint, Paris: Soc. générale d'édition and H. Jouve, 1910.

SENSIER, Alfred. *Souvenirs sur Th. Rousseau.* Paris: Leon Techener, 1872.

———. *La Vie et l'oeuvre de J.-F. Millet.* Paris: A. Quantin, 1881.

VONNE, Alexandre de. *Lettres écrites en voyage.* Tours: Impr. Mame, 1865.

WEY, Francis. "Comment le soleil est devenu peintre." *Musée des familles* (July 20, 1853): 291–98.

WILBOUR, Charles Edwin. *Travels in Egypt (December 1880 to May 1891): Letters.* Ed. Jean Capart. Brooklyn: Brooklyn Museum, 1936.

Early Exhibition-Related Texts

1848, Paris.
Explication des ouvrages de peinture, sculpture, architecture, gravure et lithographie des artistes vivants exposés au Musée national du Louvre le 15 mars 1848. Paris: Vinchon, 1848.

1849, Paris.
Exposition nationale des produits de l'agriculture et de l'industrie en 1849. . . . Paris: Panckoucke, 1849.

1850, Paris.
Explication des ouvrages de peinture, sculpture, architecture, gravure et lithographie. . . . Paris, 1850.

1851, London (Universal Exposition).
Reports of the Juries, p. 279. London, 1852.

1852, London.
A Catalogue of an Exhibition of Recent Specimens of Photography Exhibited at the House of the Society of Arts, in December 1852. London, 1852.

1853, Paris.
Livret du Salon de peinture. Paris, 1853.

1855, Paris (Universal Exposition).
Visites et études de S. A. I. le prince Napoléon au palais de l'Industrie. . . . Paris: Perrotin, 1855.

1855, Paris (Universal Exposition).
Explication des ouvrages de peinture, sculpture, gravure, lithographie et architecture. . . . Paris, 1855; *Visites et études.* . . .

1856, Liverpool
[Editorial]. *The Liverpool and Manchester Photographic Journal* 1, no. 1 (January 1, 1857): 1.

1857, London (Photographic Society of London Exhibition).
"The Photographic Society." *The Atheneum,* no. 1524 (January 10, 1857): 54–55; "Photographic Exhibition." *The Art Journal* 3 (February 1, 1857): 40; "The Photographic Exhibition." *Journal of the Photographic Society* (February 21, 1857): 192–95, 213–17.

1857, London (Exhibition of Photographs held at the Crystal Palace, Sydenham).
"Photographic Notes." *Photographic Notes* 1, no. 23 (March 15, 1857): 95.

1857, Birmingham.
"Exhibition of the Birmingham Photographic Society." *Photographic Notes* 2, no. 40 (December 1, 1857): 441–42.

1857–1876, Paris.
Catalogues des expositions organisées par la Société française de photographie: 1857–1876. 2 vols. Reprint, Paris: G. Durier & J.-M. Place, 1985.

1858, London.
"Exhibition of Photographs at the South Kensington Museum." *The Liverpool and Manchester Photographic Journal* 2, no. 7 (April 1, 1858): 83.

1859, Paris.
Philippe Burty. "Exposition de la Société française de photographie." *Gazette des beaux-arts* (May 15, 1859): 215–17.

1859, Paris.
Maurice Aubert. *Souvenirs du Salon de 1859.* . . . Paris: J. Tardieu, 1859.

1859, London.
"Exhibition. Macclesfield Photographic Society's Exhibition." *The Photographic Journal* 6, no. 89 (March 1, 1859): 60.

1860, Amsterdam.
Catalogus der tentoonstelling van photographie, heliographie, enz., gehouden door de Vereeniging voor Volksvlijt in het lokaal aan de Hoogesluis, W 664. Amsterdam: Binger, 1860.

1860–1861, London.
"The Exhibition of Architectural Photographic Association." *The Photographic News* 5, no. 125 (January 25, 1861): 37.

1861, Marseilles.
Catalogue de la première exposition de la Société photographique de Marseille. . . . Marseilles: Arnaud, September 1861.

1862, Amsterdam.
Catalogus der tentoonstelling van photographie, enz., gehouden door de Vereeniging voor Volksvlijt in het lokaal aan de Hoogesluis, W 664. Amsterdam: Binger, 1862.

1867, Paris.
Charles Edmond. *L'Égypte à l'Exposition universelle de 1867.* Paris: E. Dentu, 1867.

Sale Catalogues

1858 (March 3–12), Paris.
Catalogue des livres, dessins, estampes et tableaux composant le cabinet de feu M. J.-B.-A. Lassus.

1858 (May 14), Paris, hôtel Drouot.
Tableaux. Cabinet de M. le vicomte de M[ontault].

1866 (January 25–27), Paris, hôtel Drouot.
Catalogue des objets d'art et de curiosité [. . .] composant la collection de M. Nadar.

1866 (March 5), Paris.
Collection de M. le marquis de B[ailleul]. Tableaux et dessins modernes.

1872 (January 8–19), Paris.
Catalogue des livres composant la bibliothèque de feu M. L. J. S. E. marquis de Laborde. . . .

1886 (July 2), Paris, hôtel Drouot.
Catalogue d'un mobilier artistique [. . .] dépendant de la succession de M. le comte de Briges.

1890 (May 30–31), Paris, hôtel Drouot.
Catalogue des aquarelles, tableaux et dessins par William Wyld et des tableaux, aquarelles [. . .] provenant de son atelier.

1897 (March 18–19), Paris, hôtel Drouot.
Tableaux et esquisses, pastels et dessins par F. Zuber-Buhler.

Bibliography

Studies

ACKERMAN, Gerald M. *La Vie et l'oeuvre de Jean-Léon Gérôme.* Paris: ACR, 1986.

BALDWIN, Gordon. *Gustave Le Gray.* Exh. brochure. Malibu: J. Paul Getty Museum, 1988.

BEAUGÉ, Gilbert. *La Photographie en Provence, 1839–1895: Culture photographique et société au XIXe siècle.* Marseilles: J. Laffitte, 1995.

BECCHETTI, Piero. "Due nuovi documenti fotografici sul treno di Pio IX." *Bollettino dei musei comunali di Roma* 23, no. 1–4 (1976): 62–66.

BERNUS-TAYLOR, Marthe, Marie-Laure CROSNIER-LECONTE, Marie-Paule HALGAND, and Mercedes VOLAIT. *L'Égypte d'un architecte, Ambroise Baudry (1838–1906).* Exh. cat. Paris: Somogy, 1998.

BOUVIER, Émile. *La Bataille réaliste, 1844–1857.* Paris: Fontemoing, 1914. Reprint, Geneva: Slatkine Reprints, [1973].

BOYER, Ferdinand. "Alexandre Dumas en Sicile avec Garibaldi (1860)." *Archivio storico messinese,* ser. 3, 8 (1956–57): 3–15.

CARREZ, Anne. "La commission des Monuments historiques de 1848 à 1852." *Histoire de l'art,* no. 47 (November 2000): 75–85.

———. "Les Procès-verbaux de la commission des Monuments historiques (1848–1852)." Diploma of advanced studies in art history thesis, advisers, Bruno Foucart and Françoise Hamon, Université de Paris IV, 1999.

CAVA, Paul. "Early Landscapes by Gustave Le Gray." *History of Photography* 2, no. 4 (October 1978): 274.

COLLET, Annie. *Alexandre Dumas et Naples.* Geneva: Slatkine, 1994.

DOUIN, Georges. *Histoire du règne du khédive Ismaïl . . . ,* 2 vols. Rome: Istituto Poligrafico dello Stato, per la Reale Società di Geografia d'Egitto, 1933.

GASSER, Martin. "Between 'From today, painting is dead' and 'How the sun became a painter': A Close Look at Reactions to Photography in Paris, 1839–1853." *Image* 33, no. 3–4 (1991): 8–29.

GERBER, Frédéric, Christian NICAISE, and François ROBICHON. *Un Aventurier du Second Empire: Léon Méhédin, 1828–1905.* Rouen: Bibliothèque municipale de Rouen, 1992.

HEILBRUN, Françoise. "Un Album de primitifs de la photographie française." *Revue du Louvre et des musées de France* 30, no. 1 (1980): 21–37.

———. "Gustave Le Gray (1820–1882), photographe." *Revue du Louvre et des musées de France* 38, no. 3 (1988): 266.

———. *Les Paysages des impressionnistes.* Paris: Hazan and Réunion des musées nationaux, 1986.

JACOBSON, Ken. *The Lovely Sea-View: A Study of the Marine Photographs Published by Gustave Le Gray, 1856–1858.* Petches Bridge: K. & J. Jacobson, 2001.

JAMMES, André, and Eugenia Parry JANIS. *The Art of French Calotype, with a Critical Dictionary of Photographers, 1845–1870.* Princeton: Princeton University Press, 1983.

JAMMES, Isabelle. *Blanquart-Évrard et les origines de l'édition photographique française. . . .* Geneva and Paris: Droz, 1981.

JANIS, Eugenia Parry. *See* Exhibitions, 1987.

———. "Seeing, Having, Knowing: A Rush for the Spoils. Sir Thomas Phillipps and the Photography Collection of Harrison D. Horblit." In *The Invention of Photography and Its Impact on Learning,* 1–17. Cambridge: Harvard University Library, 1989.

JOHNSON, William S. *Nineteenth-Century Photography: An Annotated Bibliography, 1839–1879.* London: Mansell, 1990.

LACAMBRE, Geneviève. "Un Photographe au Salon de 1852." In *Hommage à Hubert Landais: Art, objets d'art, collections,* 197–204. Paris: Blanchard, 1987.

LACAMBRE, Geneviève, and Jean LACAMBRE. "Tableaux religieux de Boissard de Boisdenier." *Revue de l'art,* no. 27 (1975): 52–58.

LANDES, David S. *Banquiers et pachas: Finance internationale et impérialisme économique en Égypte.* Paris: Albin Michel, 1993.

LEPROUX, Marc. *Quelques figures charentaises en Orient.* Paris: Geuthner, 1939.

MARBOT, Bernard. "Souvenirs photographiques du camp de Châlons en 1857 par Gustave Le Gray: Album Montebello." *Bulletin de la Bibliothèque nationale,* no. 3 (September 1978): 135–41.

MARGIOTTA, Anita. "I Francesi del Caffè Greco protofotografi della Roma metà '800." *Roma Comune, rivista mensile di informazione e di dibattito* (August–September 1984): 36–41.

McCAULEY, Elizabeth Anne. *Industrial Madness: Commercial Photography in Paris, 1848–1871.* New Haven and London: Yale University Press, 1994.

McLEAN, Ruari. *Joseph Cundall, a Victorian Publisher.* Pinner: Private Libraries Association, 1976.

MOLLIER, Jean-Yves. *Michel et Calmann Lévy ou la Naissance de l'édition moderne, 1836–1891.* Paris: Calmann-Lévy, 1984.

———. "Noël Parfait (1813–1896): Biographie littéraire et historique." Doctoral thesis, Université de Paris III, 1978.

MONDENARD, Anne de. "Entre romantisme et réalisme: Francis Wey (1812–1882), critique d'art." *Études photographiques*, no. 8 (November 2000): 22–43.

———. "Le Fonds de photographies du Musée des Monuments français. Les Épreuves révélées de la Mission héliographique." Research paper, École du Louvre, 1996.

———. "La Mission héliographique: Mythe et histoire." *Études photographiques*, no. 2 (May 1997): 60–81.

PILLET, M. *Un Pionnier de l'assyriologie, Victor Place. . . .* Cahiers de la Société asiatique 16. Paris: Imp. nationale, 1962.

PIOT, Charlotte. "Eugène Piot, amateur d'art et collectionneur." Master's thesis, advisers Jean Guillaume and Daniela Gallo, Université de Paris IV, 1999.

———. "Eugène Piot (1812–1890), publiciste et éditeur." *Histoire de l'art*, no. 47 (November 2000): 3–17.

RAMSTEDT, Nils Walter. "An Album of Seascapes by Gustave Le Gray." *History of Photography* 4, no. 2 (April 1980): 121–37.

———. "The Photographs of Gustave Le Gray." Ph.D. dissertation, University of California, Santa Barbara, 1977.

ROBICHON, François, and André ROUILLÉ. *Jean-Charles Langlois, la photographie, la peinture, la guerre: Correspondance inédite de Crimée (1855–1856)*. Nîmes: J. Chambon, 1992.

SAGNE, Jean. *L'Atelier du photographe, 1840–1940*. Paris: Presses de la Renaissance, 1984.

SALMON, Laura. "Nouvelle Cuisine: The Calotype Aesthetic and Gustave Le Gray." *Afterimage* 16, no. 3 (October 1988).

SAUL, Samir. *La France et l'Égypte de 1882 à 1914: Intérêts économiques et implications politiques*. Paris:

Comité pour l'histoire économique et financière de la France, 1997.

SCHAMA, Simon. *Le Paysage et la mémoire*. Paris: Seuil, 1999.

SENNEVILLE, Gérard de. *Maxime Du Camp, un spectateur engagé du XIXe siècle*. Paris: Albin Michel, 1996.

WEISBERG, Gabriel P. *The Independent Critic: Philippe Burty and the Visual Arts of Mid-Nineteenth-Century France*. New York: P. Lang, 1993.

Exhibition Catalogues

1969, Philadelphia, Philadelphia Museum of Art.
French Primitive Photography. New York: Aperture, 1969.

1974, Paris, Bibliothèque nationale.
Ernest Renan. Paris: Bibliothèque nationale, 1974.

1977, Copenhagen, Thorvaldsen Museum.
Rome in Early Photographs: The Age of Pius IX. . . . Copenhagen: Thorvaldsen Museum, 1977.

1980, traveling exhibition.
Philippe Néagu et al. *La Mission héliographique: Photographies de 1851*. Paris, 1980.

1980–1981, Arles, Musée Réattu; Paris, Musée du Luxembourg.
Françoise Heilbrun and Philippe Néagu. *Charles Nègre photographe, 1820–1880*. Paris: Réunion des musées nationaux, 1980.

1981, New York, Godwin-Ternbach Museum at Queens College.
"Un Voyage héliographique à faire:" The Mission of 1851, the First Historical Survey of Historical Monuments in France. New York: Godwin-Ternbach Museum, 1981.

1982, Rochester, International Museum of Photography at George Eastman House.
Janet Buerger. *The Era of French Calotype*. Rochester: International Museum of Photography, 1982.

1982, Rome, Museo del Palazzo di Venezia / Museo Centrale del Risorgimento.
Garibaldi: Arte et storia. 2 vols. Florence: Centro Di, 1982.

1986, Paris, Musée des Arts décoratifs.
Eugenia Parry Janis and Josiane Sartre. *Henri Le Secq, photographe de 1850 à 1860*. Paris: Musée des Arts décoratifs and Flammarion, 1986.

1987, Antwerp, Musée de la Photographie.
Steven Joseph and Tristan Schwilden. *Le Chevalier L. P. T. Dubois de Nehaut, 1799–1872: Sa vie et son oeuvre*. Antwerp: Crédit communal, 1987.

1987, London, Buckingham Palace.
Frances Dimond and Roger Taylor. *Crown and Camera: The Royal Family and Photography, 1842–1910*. London: Penguin, 1987.

1987–1988, Chicago, Art Institute of Chicago; New York, Metropolitan Museum of Art; Paris, Musée d'Orsay.
Eugenia Parry Janis. *The Photography of Gustave Le Gray*. Chicago and London: Art Institute of Chicago and University of Chicago Press, 1987.

1988, Paris, Bibliothèque nationale.
Bernard Marbot. *Quand passent les nuages*. Paris: Bibliothèque nationale, 1988.

1991, Paris, Bibliothèque nationale.
Denis Challe and Bernard Marbot. *Les Photographes de Barbizon: La Forêt de Fontainebleau*. Paris: Bibliothèque nationale, 1991.

1992, Rouen, Bibliothèque municipale.
Frédéric Gerber, Christian Nicaise, and François Robichon. *Un Aventurier du Second Empire: Léon Méhédin, 1828–1905*. Rouen: Bibliothèque municipale, 1992.

1993, Frankfurt, Städtische Galerie im Städelschen Kunstinstitut; Malibu, J. Paul Getty Museum.
Weston J. Naef, Margret Stuffmann, et al. *Pioneers of Landscape Photography: Gustave Le Gray, Carleton E. Watkins. Photographs from the Collection of the J. Paul Getty Museum, Malibu.* Frankfurt: Städtische Galerie; Malibu: J. Paul Getty Museum, 1993.

1994, Paris, Musée d'Orsay.
Nadar: Les Années créatrices, 1854–1860. Paris: Réunion des musées nationaux, 1994.

1994, Paris, Musée des Monuments français.
Anne de Mondenard. *Photographier l'architecture.* Paris: Réunion des musées nationaux, 1994.

1994–1995, New York, Metropolitan Museum of Art; Montreal, Centre canadien d'architecture; Paris, Musée des Monuments français.
Édouard Baldus, photographe. Paris: Réunion des musées nationaux, 1995.

1996, Paris, Musée de l'Armée.
Une Visite au camp de Châlons sous le Second Empire: Photographies de messieurs Le Gray, Prévot. . . . Paris: Musée de l'Armée, 1996.

1997, Paris, Musée de la Vie romantique.
Loïc Chotard. *Alfred de Vigny et les arts.* Paris: Paris-Musées, 1997.

1997, Strasbourg, Musée des Beaux-Arts.
Olympe Aguado photographe (1827–1894). Strasbourg: Musées de Strasbourg, 1997.

1998, Compiègne, Musée national du château de Compiègne.
L'Invitation au musée: À l'aube de la photographie. . . . 1998.

1998, Le Mans, Musée de Tessé (and other venues).
L'Égypte d'un architecte: Ambroise Baudry, 1838–1906. La Roche-sur-Yon: Conseil général de la Vendée; Paris: Somogy, 1998.

1999, Paris, Musée d'Orsay.
Aux couleurs de la mer. Paris: Réunion des musées nationaux, 1999.

1999, Paris, Maison européenne de la photographie.
Une passion française: Photographies de la collection Roger Thérond. Paris: Maison européenne de la photographie; Levallois-Perret: Filipacchi, 1999.

1999, Paris, Bibliothèque nationale de France.
Bernard Marbot, Marie-Noëlle Leroy, and Elizabeth Anne McCauley. *Les Frères Bisson photographes, de flèche en cime, 1840–1870.* Paris: Bibliothèque nationale de France, 1999.

1999, Madrid, Palacio Real (and other venues).
La fotografia en las colecciones reales. Madrid: Patrimonio Nacional; Fundación "La Caixa," 1999.

2000, Compiègne, Musée national du château de Compiègne.
Le Comte de Nieuwerkerke: Art et pouvoir sous Napoléon III. Paris: Réunion des musées nationaux, 2000.

2000–2001, Bordeaux, Musée Goupil; New York, Dahesh Museum of Art; Pittsburgh, Frick Art and Historical Center.
Gerald M. Ackerman, Régine Bigorne, and Pierre-Lin Renié. *Gérôme & Goupil: Art et entreprise.* Paris: Réunion des musées nationaux; Pittsburgh: Frick Art and Historical Center, 2000.

2002, Paris, Maison européenne de la photographie.
Anne de Mondenard. *La Mission héliographique.* Paris: Éd. du Patrimoine, 2002.

Sale Catalogues

1990 (June 1), Paris, Drouot-Richelieu.
Beaussant-Lefèvre, commissaire-priseur. *L'Âge d'or de la photographie française (1849–1854): Exceptionnel ensemble de 91 calotypes français.*

1993 (March 31), Paris, Drouot-Richelieu.
Beaussant-Lefèvre, commissaire-priseur. *Photographies.*

1993 (July 10), Arles.
Fleck, commissaire-priseur. *Vente aux enchères publiques dans le cadre des 24es Rencontres internationales de la photographie d'Arles: Collection d'un amateur.*

1995 (December 13), Paris, Drouot-Richelieu.
Beaussant-Lefèvre, commissaire-priseur. *Photographies.*

1999 (October 27), London.
Sotheby's. *La Photographie: Collection Marie-Thérèse et André Jammes. 19th and 20th Century Photographs.*

2000 (May 6), Exeter.
Bearne's, commissaire-priseur. *The Craven Photographic Collection.*

2001 (March 19), Paris, Drouot-Richelieu.
Rieunier et Bailly-Pommery, commissaire-priseur.

2001 (June 1), Paris, Drouot-Richelieu.
Néret-Minet, commissaire-priseur. *Collection H . . . Photographies anciennes du XIXe siècle; dont huit photographies de Gustave Le Gray. . . .*

2001 (December 3), Paris, Drouot-Richelieu.
Millon et associés, commissaire-priseur. *Photographies de Gustave Le Gray. . . .*

Index

Note: Page numbers in italics indicate illustrations. Page numbers followed by the letter n indicate notes.

Abbas Pasha, 191
Abd el-Kader, 58, 176
Académie des beaux-arts, 19, 216
Académie des sciences, 260, 262
Adam-Salomon, 48
Adventures in Algeria (Dumas), 160
Aguado, Olympe, 34, *34*, 36, 85, 91, *262*, 297, 305, 320, 321, 338
Aguado, Onésipe, *34*
Albanel, Natalis, 160, 161, 161n, 168, 169, 172, 173, 175, 177, 263
Albert, Prince, 318
albumen, with negatives, 256, 266
albumen prints, 92, 255, 262, 266, 272, 333
Alexandria, Egypt, 179–86, 189–90
Algeria, Le Dien in, 301
Ali Pasha, 191, 199
Alophe, 89, 148–53, 159, 186
"Amends Made to the French Consul at Alexandria" (Le Gray), 189–90
Anacreon, Bacchus, and Cupid (Gérôme), 24, *24*, 330
Anglo-Venetian school. *See* Colorism
The Apotheosis of Napoléon (Cortot), *57*, 58
Apraxine, Pierre, 325
Apraxine, Princess, 163
Arago, Alfred, 18, 23, 210, 214, 337
Arago, François, 22, 23, 210, 212, 214, 257, 263, 329, 339
The Arc de Triomphe (Greene), *298*
The Arc de Triomphe (Le Gray), *289*
The Arc du Carrousel and the Tuileries (Le Gray), *153*
Archer, Frederick Scott, 256–57, 256n, 320, 339
Archimedes, 336, 337n
Armand, Alfred, 320–21, 323
Arnaud, Camille d', 40
Arnold, Cornélie, 92
art, photography as, 44–45, 209, 210–13
art, works of: Mission héliographique catalogue of, 59–83; photographic reproduction of, 56–58, 218–19, 228, 255
The Art of French Calotype (Jammes and Janis), 45
Art Institute of Chicago, 325

Artîn Bey, 203
artist, definitions of, 214
L'Artiste, 218, 220
Audigier, Henry d', 90, 91, 94
Autexier, Hugues, 325
Avenue of Trees (Le Gray), *104*
Avril, Félix, 36, 38, *40*, 266, 302, 338

Bailleul, Jean-Jacques, 188, 188n
Balard, Antoine, 22, 263
Baldus, Édouard, 17, 23, 58, 61, 62, 142, 142n, 255, 275, 276, 278, 321
Balzac, Honoré de, 336, 337, 337n
Bann, Stephen, 210, 218, 219–20
Banville, Théodore de, 91, 163
The Baptism of the Imperial Prince, 131
Barbarin (Le Gray), *182*
Barbizon school, 238
Barker, Robert, 275
Barre, Désiré Albert, 18, 34, 337
The Barricade. See Remembrance of Civil War
Barricade, Strada di Toledo, Palermo (Le Gray), *156*, 253
barrière de Clichy studio, 31, *32*
Barth, Dr., 92
Barthélemy, Victor, 323
Basilica of Saint-Sernin, Toulouse (Le Gray and Mestral), *74*
Battery of Cannon at Brest (Le Gray), *144*
Baudelaire, Charles, 31, 87, 90, 213, 229, 231
Baudry, Ambroise, 190, 200, 203
Bayard, Hippolyte, 26, 61, 61n, 62, 216, 255, 263
The Beach at Sainte-Adresse (Le Gray), *118*
The Beach at Sainte-Adresse, High Tide (Le Gray), *119*
The Beach at Sainte-Adresse, with the Dumont Baths (Le Gray), *120*
Beaugrand, captain, 160
Beauval, de, 187
Beauvoir, Roger de, 91
Becquerel, Antoine César, 22
Becquerel, Edmond, 34, 263
Bedford, Francis, 320
Beech Tree (Le Gray), *101*, 323
Beirut, Lebanon, 175–76, 180, 275
Belloc, Auguste, 255
Benecke, Ernest, 306
Béranger, marquis de, 36, 338
Bertin, Albert, 342
Bertsch, 40, 83

Bibliothèque historique de la Ville de Paris, 287–91
Bibliothèque nationale de France, 323
Bibliothèque royale, Cabinet des estampes of, 23
Bilordeaux, Adolphe, 36, 307, 338
Binant, Ernest, 255, 345
"Biographical Essay" (Maufras), 18–19, 20, 21–22, 36, 159, 336–41
Bisson, Auguste-Rosalie, 17, 58, 84, 88–89, 90, 142, 276, 287, 306, 321
Bisson, Louis-Auguste, 17, 58, 84, 88–89, 90, 142, 276, 287, 306, 321
The Bivouac (Le Gray), *140*
Blanc, Charles, 214
Blanquart-Évrard, Louis Désiré, 26, 58, 83, 84, 87, 216–18, 255, 263, 305, 339
Bléry, Eugène, 220
blindstamp, 344, *344*
Blondel, Paul, 323
Blue and Silver: The Blue Wave, Biarritz (Whistler), 244
Bocher, Aline, 28
Bocher, Charles, 36, 301
Bocher, Édouard, 36, 301, 302, 338
Bocion, François Louis David, 320
Boissard de Boisdenier, Joseph Fernand, 31, 36
Bonaparte, Louis Napoléon. *See* Napoléon III
Bonapartist propaganda, 58–59
Bosquet, Pierre, 135
botany, 45
Bottin directory, 220, 250
Boudin, Eugène, 244, 246
Boulanger, Louis, 29n, 159–60
Boulaq Museum, 191
Boulder at Cabat, l'Épine Crossroads (Le Gray), *49*
Boulders with Man Seen from the Back, Fontainebleau (Le Gray), *45*
Boulet, Anatole de, 36–38, *38*
boulevard des Capucines studio, 88, 88–98; establishment of, 87, 88–90; Le Gray's replacement at, 186; liquidation of, 143–54, 188; portraits taken at, 90–98
Bourgeois de Mercey, Frédéric, 34
Bouvard, 161
Bracquemond, Félix, 220
Branitska, Princess, 91
Branitski, comte, 36, 338
Braquehais, Bruno, 27

Braunschweig, François, 325
The Breaking Wave (Le Gray), 107, *124*, 148, 243, 244, 318, 320, 333
Breaking Waves, Pointe de Granville (Huet), *244*
Brébisson, Alphonse de, 321
Bresdin, Rodolphe, 87, 87n
The Brig (Le Gray), 66, 106, *108*, 266, 318, 320, 321, 332–33
Briges. *See* Malbec de Montjoc
Brisson, Frédéric, 91, 337, 340–41
Brittany seascapes, 98
Brouard, Ernest-Marie, 204, 205
Buisson, Jules, 36–38, *38*, 143
Bulletin de la Société française de photographie, 266
burin engraving, 218, 219
Burty, Philippe, 87, 87n

Cabinet des estampes, of Bibliothèque royale, 23
Cailleux, Alphonse de, 246
Cairo, Egypt, 189–91, 220–22, 277
Calamatta, Louis, 218, 219
Calame, Alexandre, 320
Calm Sea (Courbet), 246
calotype technique, 26–27, 48, 209
Cambon, 143
Camel Carrying Cannon Barrel (Le Gray), *192*
Camel Carrying Cannon Wheel and Chassis (Le Gray), *193*
Camel Carrying Trunks and Ramrods (Le Gray), *192*
cameras, 262–63
Camp of the Artillery of the Imperial Guard (Le Gray), *137*
Camp de Vossnessensk (Raffet), 222, *222*, 223
Canadian Centre for Architecture, 325
Candounia, Anaïs, 204–5, 335, 343
Candounia, Félicité, 204
Caneva, Giacomo, 19, 301
The Capture of the Smala of Abd el-Kader (Vernet), 251
Carcassonne, France, 62, 67, 250
Caricature of Le Gray (Montault), *181*, 181–86
Carjat, Étienne, 48
Carré, Michel, 18, *18*, 337
carte-de-visite portraits, 48, 87, 90, 148, 186
Cartier-Bresson, Henri, 180
Cassart, 188
Castagnary, Louis, 246
Castel, Albert, 205

The Castres Quarter, Palermo (Le Gray), *163*
catalogue(s): of Le Gray's works, 346–83;
 Mission héliographique, 59–83; need for, 315
The Cathedral of Notre-Dame (Le Gray), *152, 154*
*Cathedral of Notre-Dame, Detail of the Cloister
 Arcade, Le Puy* (Le Gray), *64*
Cavalry Maneuvers, October 3 (Le Gray), *138*
Cavalry Maneuvers, with Receding Road
 (Le Gray), *139*
Cavas (Le Gray), *182*
The Cemetery and Ramparts, Carcassonne
 (Le Gray and Mestral), *70*
ceremonial photography, 58–59
Châlons-sur-Marne, military camp at, 131–42,
 250, 318
Chambord, comte de, 59, 180–81, *181*, 186
Champfleury, 34, 87, 220
Chappon, 162
Charlet, Nicolas Toussaint, 251
Chartres, Robert, 318
Chassériau, Théodore, 90
Château de Blois, 62, 67
Château de Boisy (Le Gray), 67, *67*
Château de Chenonceaux (Le Gray and
 Mestral), *82*
*The Chateau at Fontainebleau with Reflecting
 Pool* (Le Gray), *45*
Chemins de fer de l'Est, 204
chemistry, 255–73; Maufras on, 22, 255, 263,
 337–38, 339–40; Nadar on, 22, 255
Chennevières, Philippe de, 11, 28, *29*, 36–38, *38*,
 56, 58, 199, 302
Chevalier, Pierre Michel François, *317*
Chien Caillou (Champfleury), 220
Chine collé, 220, 220n
Chiodi, Achille, 19, 20
Christian Maronites, 175
Church of Saint-Léonard, Saint-Léonard-de-Noblat
 (Le Gray and Mestral), *74*
Church of Saint-Martin, Candes (Le Gray), *65*
Church of Saint-Nazaire, Carcassonne (Le Gray
 and Mestral), *75*
Church of Saint-Ours, Loches (Le Gray), *62*
Church of Saint-Ours, Loches, West Portal
 (Le Gray and Mestral), *75*
Church of Saint-Pierre, Chauvigny (Le Gray and
 Mestral), *76*
Church of Saint-Pierre, Melle (Le Gray and
 Mestral), *76*
Church of Saint-Vincent, Le Mas d'Agenais
 (Le Gray and Mestral), *77*
*Circassians, Lesghiens, and Cossacks in the
 Escort of His Majesty the Emperor of Russia*
 (Raffet), *222*

The City and Port of Sète (engraving), *107*
Claudet, Antoine, 339
Clausel, Alexandre, 320
Clément, Jules, 36
Clésinger, 54–55, *55*
Cloister, Elne (Le Gray), *260*
*The Cloister of the Cathedral of Notre-Dame,
 Le Puy* (Le Gray), *261*
Cloister of the Church of Saint-Pierre, Moissac
 (Le Gray), *249*, 250
Clotilde, Princess, 91, 190
Cloud Study (Le Gray), *268*
Clouds (Le Gray), *112*
Cloudy Sky, Mediterranean Sea (Le Gray), *127*
Cochinat, Victor, *97*
Coeur, Monsignor, 91
Cogniet, Léon, 323
collections, photographic, Le Gray in, 315–25
Colliau, Eugène, 36
collodion negatives: in Bibliothèque historique de
 la Ville de Paris, 287–91; combination printing
 of, 243, 272; development of, 22, 256–57,
 339; dry *vs.* wet technique, 290–91; Le Gray's
 use of, 92, 98, 256–57, 272, 289–91, 339; Le
 Gray's writings on, 40, 256; Nadar's use of, 55;
 and rise of photography, 87; and seascapes, 98
Colorism, 214, 228–31
*A Column of Egyptian Artillery en Route to the
 Sudan* (engraving), *191*, 192, 277–78
combination printing, 243, 272, 291
commerce, photography as, 45, 213, 219
commercial marks, 344, *344, 345*
commission(s), Le Gray's: in Egypt, 191–203,
 318; in France, 56–59, 131–42, 318
Commission des Monuments historiques, 34, 61
Commission municipale des Travaux
 historiques, 289
Complete Works (Dumas), 159
The Comte de Chambord and His Retinue
 (Le Gray), *181*
Constable, John, 224, *225*
*Coptic Quarter, Men's Side of the Courtyard of Le
 Gray's House* (Fachinelli), 203
*Coptic Quarter, Women's Side of the Courtyard of
 Le Gray's House* (Fachinelli), 203
copyright registration, 85, 129, 148, 186
Cordier, Émélie or Émilie, 161, 163, 173
Cormenin, Louis, 90
*Corner of the Cloister, Cathedral of Notre-Dame,
 Le Puy* (Le Gray), *64*
Corot, Camille, 238, 239, 241, 243, *243*, 255
Cortot, Jean-Pierre, *57*, 58
Le Cosmos (magazine), 266, 273
Cottinet, Edmond, 54, *55*

Coulomb, E., 343
Courbet, Gustave, 106, 214, 241, 244, *245*, 246,
 253, 255, 323
Courtais, 36
Courtyard of Le Gray's House in Cairo (Lékégian),
 203
Courtyard of Le Gray's House in Cairo (Sebah),
 203
Cousin, Jules, 289
Cousin, Victor, 91, *92*, 210
Couture, Thomas, 131
Craven, William, 318–20
Crémière, Léon, 48
Crette, Louis, 162 63, 162n, 338
Crette Romet, Lodoïsch, 36
Crimean War, 223
Cromer, Gabriel, 323
Cros, Charles, 257
Curtain of Trees, Fontainebleau (Le Gray), *52*
Cuvelier, Eugène, 46
Czartoryska, Princess, 91

Daguerre, Louis Jacques Mandé, 87, 210,
 215–16, 218, *248*, 250, 255, 257, 275, 329,
 337, 338
daguerreotypes: Delaroche on, 210, 214n,
 215–16; *vs.* engraving, 218; by Le Gray, 23–25;
 vs. paper photography, 216; use of term, 209
Danilo of Montenegro, Prince, 91, *91*
The Darkroom Staff (Le Gray), *96*
Daubigny, Charles-François, 238
David, Maxime, 135
David d'Angers, Pierre Jean, 233
death-date inventory, 342–43
Deburau, Charles, 91
Decamps, Alexandre, 241
Degas, Edgar, 253
Déjeuner sur l'herbe (Manet), 233
Delaage, Henri, 91
Delacroix, Eugène, 34, 90, 209, 216, 231,
 253, 323
Delaporte, Léon, 36, 38, *40*
Delaroche, Paul, 13, 18, 20, 23, 24, 210, 212,
 214–16, 214n, 218, 238, 323, 337
Delatre, 36, 339
Delâtre, Auguste, 220
Delessert, Benjamin, 28, 36, 58, 302, 338
Delessert, Cécile, 28
Delessert, Édouard, 28, 36, 302
Delessert, François, 303n
Delessert, Gabriel, 302n
Delessert, Valentine, 306
Delort de Gléon, Alphonse, 200

*The Departure from Paris of H. M. the Queen of
 England,* 105
*The Departure of the Volunteers. See
 La Marseillaise*
Desbarolles, Adolphe, 159–60
Désiré, 277
Deutsch, Ludwig, 203, *204*
Devéria, Achille, *48, 73*, 219
Diaz de la Peña, Narcisse, 46, *47*, 238
Diderot, Denis, 210n
dioramas, 275
discovery, *vs.* invention, 210–12
Disdéri, Eugène, 94, 148, 255, *317*
Disdéri, Mme, 142
*The Disembarkation of H. M. the Queen of
 England at Boulogne,* 105
A Distant Overall View, Carcassonne (Le Gray and
 Mestral), *72*
Dollfus, 89
*The Dolmen Known as "La Grande Allée
 Couverte," Bagneux* (Le Gray), *60*, 257
*The Dolmen Known as "La Petite Pierre
 Couverte," Bagneux* (Le Gray), *259*
Don Pedro of Toledo Kissing the Sword of Henri IV
 (Ingres), *58*
Dosne, Mlle, 36, 338
Doze, Mlle, 91
drawing(s): Le Gray as teacher of, 192, 199,
 199n; photogenic, 209–10; photographs as,
 209–10, 214, 231
Drogman (Le Gray), *182*
Druze, Muslim, 175
Du Camp, Maxime, 11, 20, 21, 27, *27*, 29, 29n,
 34, 62, 84, *304*, 305, 306, *306*, 338
Duban, 62
Ducos du Hauron, Louis, 257
Dumas, Alexandre: on botany, 45; as boulevard
 des Capucines client, 91; father of, 169;
 friendship with Le Gray, 159, 337; Le Gray on,
 188; *Monte-Cristo*, 153, 154, 157; painters and,
 159–60; portraits of, *158*, 159; son of, 173;
 travels before Le Gray, 157–59; travels with
 Le Gray, 13, 148, 154, 160–73, 188; on
 vicomtes de Montbreton, 302
Dumas de Lavince, 338
Dupré, Jules, 238
Durand-Brager, Henri, 169, 171, 175
Durieu, Eugène, 34
Dusolier, Alcide, 87
Dutilleux, Constant, 231

E. Gamber and Co., 224
École des beaux-arts, 18, 214
education, of Le Gray, 17, 214

effect, Le Gray on, 229
Effendi (Le Gray), *182*
Egypt, 179–205, 220–22; commissions
 in, 191–203, 318; panoramas in, 277–78;
 photographic techniques in, 272;
 political history of, 191; scientific
 work in, 263
Emma (ship), 157, 160, 161, 163, 263
Emonts, Louis, 287
The Empress Eugénie at Prayer (Le Gray),
 131, *134*
The Empress Eugénie Kneeling, Saint-Cloud
 (Le Gray), 131, *132*, *133*
Encyclopédie (Diderot), 210n
End of the Jetty and the Sea, Dieppe (Corot), 243,
 243
England, Le Gray's success in, 317–20
English Landscape (Constable), 224
engraving: burin, 218, 219; *vs.* daguerreotype,
 218; mezzotint, 219, 223–24; relationship
 between photography and, 210
Entrance to the Port of Le Havre (Warnod and
 Macaire), *105*
equestrian accident, 176
Essertein, comtesse d', 36, 338
Eugénie, Empress, 131, *132*, *133*, *134*, 318
Execution of Lady Jane Grey (Delaroche), 216
l'Exposition des produits de l'industrie, 28

Fachinelli, Beniamino, 203
Factory at Terre-Noire (Le Gray), *67*, 67
Famars Testas, Willem de, 199
Famin, Charles, 98
Fantin-Latour, Henri, 244
*Farmers of the Roman Campagna Closing Off a
 Side Road for the Flock* (Le Gray), 23
The Father of Henri Le Secq (Le Gray), *25*
Félix, Raphaël, 157
Fellà (Le Gray), *182*
Fenton, Roger, 17, 65, 214–15, 223, 260, 320
Ferrier, Ida, 157
Figuier, Louis, 209, 209n
Finette, 94
First-Floor Gallery, the Salon of 1852
 (Le Gray), *212*
The First Mass in Kabylie (Vernet), 251, *251*
Fizeau, Louis, 339
Flameng, Léopold, 320
Flaubert, Gustave, 29, 306
Florence, Italy, 19
fluorides, 255
Fontaine, 186
Fontainebleau Forest: The Rager (Corot), 241
Fontainebleau Landscape (Le Gray), *48*

Fontainebleau photographs: and landscape
 paintings, 240–43; Le Gray's approach to,
 45–48, 98; Le Gray's technique in, 225–28
Fontenailles, Mme de, 303
Fonteny, Henri de, 84
The Footbridge and the Quai de Conti
 (Le Gray), *279*
The Forced Marriage (Molière), 20, 20n
Forest Road, Fontainebleau (Le Gray), *54*
Forest Scene, Fontainebleau (Le Gray), 46, *53*
Forest Scene (Troyon), *240*, 241
The Fortunes of Life (Lockroy), 172
Fouquet, Emmanuel, 187
Fournier, Édouard, 91
Fragments of a Book on Courbet
 (Castagnary), 246
The French Consulate in Beirut (Saint-Seine), *179*
The French and English Fleets, Cherbourg
 (Le Gray), *143*, *146*
The French Fleet, Cherbourg (Le Gray), *147*
Friedrich, Caspar David, 233, *236*
Froment-Meurice, 58
Fromentin, Eugène, 190
Fuad Pasha, 91, *91*
Furne, Charles Paul, 142

Gaccia, 56
Gaillardot, Dr., 177, 189
Gaillardot Bey, 189
Galerie Texbraun, 325
*Gallery Near the Salon Carré, the Salon of
 1850–1851* (Le Gray), *213*
gallic acid, 266
Gamber and Co., E., 224
Garella, 278
Garibaldi, Giuseppe, 160, 163, *168*, 169, 171,
 172, 272
Garibaldi, Menotti, 169
Gatteaux, Édouard, 323
Gaucherand, H., 218, 219
Gaudin, Marc-Antoine, 84, 318
Gauthier, Eugène, 342, 343
Gautier, Théophile, 31, 90, 190
Gazette de France, 218
Gazette des beaux-arts, 186
General Garibaldi, Dictator of Sicily
 (engraving), *168*
General View of Palermo (Le Gray), *165*
Geoffroy-Dechaume, Adolphe Victor, 64
Gérard, Léon, 302–3, 312
Gerhardt, 257, 339
Gérôme, Jean-Léon: in Egypt, 199; Fontainebleau
 paintings by, 46; friendship with Le Gray, 18,
 214; photographs owned by, 323; and pope's

carriage, 143; reproduction of works of, 58,
 330; in Rome, 21, 329; as student of
 Delaroche, 18, 337
Getty Conservation Institute, 291
Gilbert, Nicolas-Joseph-Florent, 336, 336n
Gilles, Albert, 323
Gilman, Howard, 325
Giovanni, Father, 169
Girard, 36
Giraud, Eugène, 159–60
Girault, Louis, 20, 329
Giroux, André, 320
glass negatives. *See* collodion negatives
Gnarled Oak near l'Épine Crossroads
 (Le Gray), *242*
Goert, 176
gold chloride toning, 262, 266, 272, 340
Gothic Detail, Auvergne (Devéria), *73*
Goupil et Vibert, 224
Goupil firm, 56
Gourjon, Louis, 204
Gozlan, Léon, 90
Grammaire des arts du dessin (Blanc), 214
Gramont, Agénor de, 160
The Great Wave, Sète (Le Gray), 11, 107, *125*,
 148, 244, 272, 323, 333
Greene, John B.: abstraction in photography of,
 231; on Fontainebleau excursions, 46, 297;
 loan of negatives by, 305; in 1990 Parisian
 auction, 298; as student of Le Gray, 36, 297,
 338; works of, 45, 46, *46*, 298
Gros, Antoine, 31, 91
Group by the Millpond at Petit-Mourmelon
 (Le Gray), *141*
Group of Oaks at Aprémont (Rousseau), 241
Gudin, Théodore, 105, 243
Guests at the Home of Alphonse Karr
 (Le Gray), *162*
Gueybbard, 36, 338
Guillemin, Alexandre, 31
Guillot-Saguez, 26, 87, 255, 263
Gustave Le Gray et Cie: formation of, 88, 332;
 liquidation of, 143–54, 188, 333

Habib Bey, 188
Haillot, Major, 192
The Haloed Sun (Le Gray), 106, *111*
Halting of the Column of General Türr at Villafrati
 (Lockroy), *171*
Hamilton, Duke of, 91
Hassan Pasha, 192
Haussmann, Georges Eugène, 142, 289
Haussonville, comte d', 34, 36, 59, 338
Head of a Monk (Le Secq), *218*

A Heath (Hampstead Heath: Branch Hill Pond)
 (Lucas), *225*
Heiting, Manfred, 325
Heliographic Society. *See* Société héliographique
heliography, *vs.* photography, 209
Henriquel-Dupont, 218
Herling, 266
Herschel, John, 263
Hetzel, Pierre-Jules, 161n
Hircher, Colonel, 199
His de La Salle, Aimé Charles Horace, 320
*His Majesty Nicolas I, Emperor of All the Russias:
 The Camp at Vossnessensk* (Raffet), *222*
Historic Monuments Commission, 34, 61
*History of a forty-first chair at the Académie
 français* (Houssaye), 336
history painting, 250–51, 253
Hollow Oak Tree (Le Gray), *103*
horse accident, 176
Hôtel Carnavalet, 287
Hôtel de Lamoignon, 289
Hôtel de Ville, 228, *229*
Hôtel le Pelletier de Saint-Fargeau, 289
Houssaye, Arsène, 302, 336
Huet, Paul, 240, 244, *244*
Hugo, Victor, 253
Humbert de Molard, Louis, 255, 256
Hussein Pasha, 192
Hypostyle Hall, Temple of Amun, Karnak
 (Le Gray), *202*

Ibrahim Pasha, 192
L'Illustration (periodical), 89, 189, 192
The Imperial Yacht, La Reine Hortense, *Le Havre*
 (Le Gray), *115*
Impressionism, 233, 244, 246
Inauguration of the Toulouse-Sète Railway Line
 (engraving), *106*
industrial revolution, 212–13
industry: and art, 212; photography as, 213
Ingres, Jean Auguste Dominique: Le Gray's
 photographs and, 323; linearity of, 231;
 reproduction of works of, 58, *58*; Verdier and,
 31; works of, 216, 219, 320
*L'Intermédiaire des chercheurs et des
 curieux*, 205
invention: of collodion negative, 256–57, 339;
 vs. discovery, 212; Maufras on, 336, 338,
 339–40; of waxed-paper negative, 23–24, 26,
 257–62, 340
inventory, death-date, 342–43
iron sulfate process, 291
Isabey, Eugène, 105, 243
Ismaïl Pasha, 191, 318, 334

Italian Street Musician (Pifferaro) (Le Gray), *217*
Italian Street Musicians (Pifferari) (Le Gray), *215*
Italian Street Musicians (Pifferari) (Le Secq), *215*
Ivon, 337

J. Paul Getty Museum, 323, 325
Jacque, Charles, 220, 238, 241
Jadin, Geoffroy, 157, 159-60
Jammes, André, 11, 45, 323, 325
Jammes, Marie-Thérèse, 11, 323, 325
Janin, Jules, 90, 218
Janis, Eugenia Parry, 11, 12, 22, 45, 46, 90,
 266, 325
Janneau, Alexandre, 36, *36*, 46, 298
Japanism, 244
Jeanron, 23
Jerusalem, 177, 179
The Jetty at Sète (Le Gray), *106*
Jones, Calvert, 26
Journal of the Photographic Society, 317

Karr, Alphonse, 162
Kassapis, Théodore, 161, 169
khedive dynasty, 191-203

La Beaume, 36, 338
La Blanchère, Henri de, 36, 297
Laborde, Aline de, 301
Laborde, Badeigts de, 36, 338
Laborde, Léon de, 28-29; on art and industry,
 212; and art reproduction, 29, 58; Le Dien and,
 301; Le Gray's work with, 28-29; and Mission
 héliographique, 61, 61n, 62; Napoléon III and,
 59; in Société héliographique, 34, 61; as
 student of Le Gray, 27, 34, 330
Laborde, Valentine de, 302n
Laborers (Le Gray), *183*
Labouchère, Pierre-Antoine, 46, 58
Lacan, Ernest, 189, 316, *317*
Lacretelle, Henri de, 54, 61, 64, 66
Lafenestre, Georges, 238
Lancers and Dragoons with Colonel Pajol
 (Le Gray), 251
Landscape (Mestral), *298*
Landscape along the Tiber, North of Rome
 (Le Dien), *300*
landscape photography, 45-48; and landscape
 painting, 238-43; as portraiture, 241
Landscape with Rocks, Fontainebleau
 (Le Gray), *44*
Langlois, Jean-Charles, 84, 88, 89, 275, 307
Langlois, Mme, 89
Large Wave, Mediterranean Sea (Le Gray), *269*
Latreille, Édouard de, 36

Laulerie, Martin, 321, *321*
Lavince, Dumas de, 36
Le Breton, Mme, 338-39
Le Coeur, Charles, 24
Le Coeur, Pol, *23*, 24
Le Corre, Florence, 135
Le Dien, Émile, 301, 309n
Le Dien, Firmin Eugène, 297-313, 329-30;
 collaboration with Le Gray, 304-13; emergence
 of, 298-301; influence of Le Gray on, 309-13;
 life of, 301-4, 313; as student of Le Gray, 13,
 21, 36, 84, 338; works of, *296, 300, 303, 304,
 305, 308, 309, 310, 311, 312, 313*
Le Gray, Berthe Lodoïska Palmyra, 154, 331
Le Gray, Elvire Françoise Eulalie, 20, *21*, 29, 154,
 329, 333
Le Gray, Elvire Mathilde Julie Miriam, 21n, 29,
 329, 330
Le Gray, Émile Eugène, 154, 187, 189, 189n, 333,
 334, 335
Le Gray, Gustave, 12-13; birth of, 17, 329, 336;
 children of, 20, 21, 21n, 29, 92, 154, 329-35;
 chronology of the life of, 329-33; death of,
 204-5, 335, 342-43; early life of, 17-18, 332,
 336-37; education of, 17, 214; end of life of,
 203-5, 335; family of, after exile, 187 88, 189;
 marriage of, 19-20, 154, 329
Le Gray, Julie Octavie, 29, 29n, 330
Le Gray, Palmira Maddalena Gertrude Leonardi,
 19-20, *21*, 92, 187-88, 189, 204
Le Gray, Romain Gustave Alfred, *93*, 154, 187,
 189, 330
Le Havre, France, 243
Le Secq, Henri: in collective album, 263; as
 contemporary of Le Gray, 17; on Fontainebleau
 excursions, 46, 297; friendship with Le Gray,
 27, 214; Le Gray's portraits of, 24, *25*, 54; in
 Mission héliographique, 61, 61n, 62; mono-
 graphs on, 11; as painter and photographer, 23;
 and Palmira Le Gray, 189; portraits of Le Gray
 by, *16*, 21, 27; preservation of works of, 220;
 in Rome, 21; self-portrait of, *18*; in Société
 héliographique, 34; as student of Delaroche,
 18, 214; as student of Le Gray, 36, 297;
 works of, *19, 215, 218*
Le Senne, Émile, 323
Le Vavasseur, Gustave, 36-38, *38*
Lebanon, 175-76, 180, 275
Lechat, Edme, 18
Lecoq de Boisbaudran, Horace, 323
Ledoux, Claude Nicolas, 31
Legras, Auguste, 31
Legray, Catherine Eulalie Gay, 17, 19, 88, 187, 334
Legray, Françoise Navaille, 17

Legray, Jean-Martin, 17, 18, 88, 332, 337
Legray, Pierre, 17
Lehmann, Henri, 58, 84, *92*, 131, 228, *229*, 307
Lékégian, G., 203, *203*
Leleux brothers, 90
Lemercier, Joseph Rose, 84
Leonardi, Annunziata, 19
Leonardi, Augusto, 19
Leonardi, Federico, 19
Leonardi, Luigi, 19
Leonardi, Luisa, 19
Leonardi, Palmira, 329. *See also* Le Gray, Palmira
Leonardi, Ulisse, 19
Leonardo da Vinci, 219, 228, *270, 271*, 337
Léopold I, King, 320
Lepage, François, 325
Lepic, General, 186
Leproux, Marc, 189
Lerebours, Nicolas Paymal, 83-84, 276
Lesseps, Ferdinand de, 191
Levantine (Le Gray), *182*
Lévy, Michel, 171, 172, 177
Lévy brothers, 159
Liber studiorum (Turner), 224
Liberty Leading the People (Delacroix), 253
Lighthouse and Jetty, Le Havre (Le Gray), *116*, 243
*The Line Moving Forward, Maneuvers of
 September 14, 1837* (Raffet), *223*
Linton, Henri, 159
Lion, Judith, 92
lithography: and photography, 218, 219; by
 Raffet, 222-23
Littré, E., 210n, 229n
Lockroy, Édouard, 161n; on abandonment at
 Malta, 172, 175; on Beaugrand, 160; in Beirut,
 175-76; Dumas and, 161, 172; as foreign
 correspondent, 175-76; in Palermo, 169,
 171-72; as Renan's assistant, 177-79
Lockroy, Joseph Pilippe Simon, 173
London Exposition of 1851, 339
Louet, Ernest, 176-77
Louis-Philippe, King, 23
Louis XII Wing, Château de Blois (Le Gray and
 Mestral), *78*
Louvre: Le Gray as student at, 18, 23;
 photographic inventory of, 29
Lovestyne, 135
Lucas, David, 224, *225*
*The Luchon Valley Seen from the Tower of
 Castelvieil* (Vigier), *299*
La Lumière (magazine): and collodion negative
 controversy, 256; establishment of, 34, 59-61;
 and Jammes' collection, 323; and Le Gray's

chemistry, 266; on Mission héliographique, 62;
 and print shops, 83, 84
Lying in Wait (Mouilleron), *47*

Macaire, Cyrus, 98-105, *105*, 106, 318
Mack, Ezra, 325
Main Road from Chailly to Fontainebleau
 (Le Gray), *45*
Malbec de Montjoc, Barnabé Louis Gabriel
 Charles, marquis de Briges, 88, 88n, 107
Malbec de Montjoc, Ernest Charles, comte de
 Briges, 88, 143-48, 153, 186-87
Malbec de Montjoc, Marie Antoine Albert,
 marquis de Briges, 88, 143-48, 153, 186-87
The Man Who Cut the Tablecloth (Scheffer),
 58, 228
Manchester Art Treasures Exhibition, 318
Manet, Édouard, 233, 244, 246, 253
*Maneuvers: The Artillery and Light Cavalry of the
 Imperial Guard* (Le Gray), *137*
Maneuvers: The Cavalry of the Imperial Guard
 (Le Gray), *137*
Mannoury-Lacour, Emma, 163
manuals, 40-45; 1850 edition, 35, 44; 1851
 edition, 35-36, 312; 1852 edition, 289; 1854
 edition, 40-44, 290-91; advertisements in,
 35-36; chemistry in, 255-56, 339-40;
 photography as art in, 44; revisions to, 306
Marey, Jules, 161n
Mariette, Auguste, 190, 191, *199*
marketing, 35-36, 56
Maronites, Christian, 175
marriage, of Le Gray, 19-20, 154, 329
La Marseillaise (Rude), 56, *57*, 255
Martens, Frédéric von, 255, 275, 278
Marville, Charles: art collection of, 289; art
 reproduction by, 58; on Fontainebleau
 excursions, 46; misattribution of
 photographs to, 306; panoramas by, 276;
 in private collections, 320, 321; workshop
 of, 287
Marvy, Louis, 220
Masons (Le Gray), *183*
Mass at the Camp at Châlons (Le Gray), 275, *284*
*Mass at the Camp at Vossnessensk,
 September 11, 1837* (Raffet), *223*
Masson, Bénédict, 131, 135
Maufras, Léon: "Biographical Essay" by, 18-19,
 20, 21-22, 36, 159, 336-41; death of, 186;
 friendship with Le Gray, 11, 153; on invention,
 336, 338, 339-40; as Le Gray's agent, 175,
 186, 187; and Le Gray's liquidation, 11, 153-54,
 155; on Le Gray's research, 21-22, 255, 263,

337–38, 339–40; portraits of, 92, 94, 148, 153, 186
Mayall, 36, 338
Mayer, Ernest Léopold, 27
McCauley, Elizabeth Anne, 87
Mediterranean Sea, Sète (Le Gray), *126*
Méhédin, Léon, 36, 89, 297, 307, 339
Meissonier, Ernest, *252*, 252–53
Mélanie of Délassements-Comiques, 92, 94, *95*
Memento of Ville-d'Avray (Le Gray), *155*
Memoirs (Dumas), 163
Menchikov, Prince, 91
Menchikov, Princess, 91
Mérimée, Prosper, 61, 61n, 131, 302
Méry, 90
Méryon, 220
Mesnard, President, 91
Mestral, O., 64n; in collective album, 263; Le Gray's portraits of, *61*, 92; in Mission héliographique, 56, 61, 62–66, 297; in Société héliographique, 34; as student of Le Gray, 36; style of, 64; and waxed-paper negatives, 23, 258, 260; works of, 67, *68, 69, 70, 71, 72, 73, 74, 75, 76, 77, 78, 79, 80, 81, 82,* 85, 297, *298*
mezzotint engraving, 219, 223–24
military painting, 251–53
Miller, Charles Henry, 323
Millet, Aimé, 31, 58, 105, 219, *270, 271*
Millet, Jean-François, 29n, 143, 238, 241, 337
Misset, 135
Mission héliographique, 59–83; exhibition of photographs from, 56, 66–67; and Le Gray's reputation, 34; and painters' sketching tours, 246–50; waxed-paper negatives and, 258, 260
Model in Oriental Costume (Le Gray), *26*
The Modern Public and Photography (Baudelaire), 87
Mohammed Pasha, 192
Moigno, Abbot, 273
Moissac cloister, 66, 67
Molière, 20, 20n
Mollien Pavilion, the Louvre (Le Gray), *326*
The Mona Lisa (drawing by Aimé Millet, photographed by Le Gray), 219, 228, *270, 271*
Le Monde illustré, 106, 169, 171, 175–76, 180
Mondenard, Anne de, 323
Monet, Claude, 233, *234*, 244, 246, 253
Monjauze, 173
Montault, Henry de, *181*, 181–86
Montault, Odet de, *35*, 36, *37*, 38, 302
Montbreton, vicomte de, 302
Montbreton, vicomtesse de, *35*, 302

Monte-Cristo (magazine), 153, 154, 157, 159
Monte-Cristo (ship), 157, 160
Montenegro, Prince Danilo of, 91, *91*
Montesquiou, duc de, 36, 338
Montevideo ou Une nouvelle Troie (Dumas), 160
Montfort, Benito de, 263
Montour, de, 83
Moonlight at Boulogne-sur-Mer (Manet), 246
Morin, Eugène, 159
Moses Saved from the Waters (Mura), 89
The Mother of Henri Le Secq (Le Gray), *25*
Mouilleron, A. E., *47*
Moutrille, E., 23, 26, 258
Moynet, 160
Mugnier, 36, 338
Mura, François de, 89
Murat, Prince, son of, 91
Mürger, Henri, 18, 214, 337
Murray and Heath, 317
Musée d'Orsay, 325
Musée Ingres, 323
The Museum and City of Le Havre (Le Gray), *114*
Muslim Druze, 175

Nadar, Félix Tournachon, 11, 329; Adrien Tournachon and, 38–40, 305; Alophe and, 89; on boulevard des Capucines studio, 88; Clésinger portrait and, 54–55; as contemporary of Le Gray, 17; on failure of Le Gray's studio, 143–48; family of, 18; as inventor, 255; on Le Gray's character, 11; Le Gray's letter to, 188–89; on Le Gray's marriage, 20; on Le Gray's misfortune, 176; on Le Gray's photography, 22; on Le Gray's research, 22, 255; memoirs of, 22, 176, 255, 335; Napoléon III and, 59; as student of Le Gray, 36, 297, 338; studio of, 90; works of, *29*, 48, *88*, 92, 94, *188*, 321, *321*, 325, 325n, 335
Nanteuil, Célestin, 29n, 90
Napoléon III (Louis-Napoléon Bonaparte): Le Gray commissioned by, 131–42; Le Gray's portraits of, 56, 56n, 59, *59, 135,* 190; and Maronite-Druze conflict, 175; panoramas and, 275; photographic collections of, 318
Napoléon III at the Battle of Solferino (Meissonier), *252,* 252–53
Napoléon III on Horseback, the Camp at Châlons (Le Gray), *135*
Naquet, Achille, 31n
naturalism, 24
Néagu, Philippe, 67

negative(s): albumen, 256, 266; collodion (*See* collodion negatives); numbering of, 344, *345*; waxed-paper (*See* waxed-paper negatives)
negative-positive process, 26, 87, 209, 216–18
Nègre, Charles: art reproduction by, 58; as contemporary of Le Gray, 17; daguerreotypes by, 25; on Fontainebleau excursions, 46, 297; friendship with Le Gray, 214; as inventor, 255; loan of negatives to, 305; monographs on, 11; as painter and photographer, 23; in Paris, 27; as student of Delaroche, 18, 214; as student of Le Gray, 36, 297; works of, *28*, 220
Négresse du Soudan (Le Gray), *182*
Nemo, 90
New theoretical and practical treatise of photography on paper and glass (Le Gray), 255, 339–40
Niépce, Nicéphore, 87, 219, 255, 257, 338
Niépce de Saint-Victor, Abel, 255, 339
Nieuwerkerke, Émilien de, 91, *96*
Nodier, Charles, 246, 250
Le Nord (periodical), 90
Normandy seascapes, 98, 106
North Facade of the Gynaeceum of Rameses II, Egypt (Du Camp), *306*
Nouveau traité théorique et pratique de photographie sur papier et sur verre (Le Gray), 255, 339–40
nude(s), female, 12, 107–29, *128, 129, 130,* 265, 320
Nude Model from the Back, Lying on the Studio Floor (Le Gray), *265*
Nude Reclining on a Chaise Longue (Le Gray), *130*
numbering of prints, 345, *345*

The Obelisk, Place de la Concorde (Le Gray), *151*
Obelisk and Hypostyle Hall, Temple of Amun, Karnak (Le Gray), *197*
Obelisk in the Quarry, Aswan (Le Gray), *196*
obituary, by Maufras, 153–54, 340–41
"Observations for the Good Execution of Portraits and Reproductions of Daguerreotypes and Oil Paintings" (Le Gray), 229
Octavie, Julie, 29
An Odyssey in 1860 (Dumas), 172
Officers Seated at a Tent (Le Gray), 251
Old Oak Tree (Le Gray), *102*
Olive Grove, Roman Campagna (Le Dien), *305*
"On the influence of heliography on the fine arts" (Wey), 209
operator, photographer as, 218
Orléans, Henri d', 318
oval portraits, 92
Pablo, 306

Paghidas, Nikolaos, 157
painters, Le Gray in collections of, 321–23
paintings: by Le Gray, 13, 23, 214, 220–28, 238, 253; relationship to Le Gray's photographs, 233–53
Palalda, bridge at, 66, 67, *230*
Palazzo Carini, Palermo (Le Gray), *166*
Palermo, Italy, 168–72, 250–51, 253
Palermo Cathedral (Le Gray), *164*
panorama(s), 275–78, *276*
Panorama of the Camp at Châlons (Le Gray), *252, 280*
Panorama of the Port of Sète (Le Gray), *282*
Panorama of the Ruins, Baalbek (Le Gray), *178*
Panorama of the Seine from the Quai de l'Horloge (Le Gray), *274*
Panorama of the Seine from the Windows of the Library of the Louvre (Le Gray), *278*
The Pantheon (Le Gray), *150*
paper photography: *vs.* daguerreotype, 216; development of, 26–27, 263–66; rise of, 26, 216; waxed (*See* waxed-paper negatives)
Paponot, Félix, 200, 277
Parfait, Noël, 160, 171, 172–73
Parfait, Paul, 160, 161, 161n, 169, 172
Paris, comte de, 318
Paris, France: 1990 auction in, 298; Le Gray's arrival in, 18; Le Gray's return to, 23; panoramas of, 276; photographs of, 142
Paris l'Exposition des produits de l'industrie, 28
Paris Salon: of 1846, 231; of 1848, 220, 238; of 1850, 209, 213, 220; of 1850–1851, *213,* 253; of 1852, *212, 213, 221;* of 1853, *208, 211,* 238; of 1855, 251; of 1864, 252; lithography at, 219; military paintings at, 251, 252; prints at, 220; Rousseau in, 240
Parme, duchesse de, 58
Party for His Highness Ismaïl Pasha aboard the Princes' Ships (Le Gray), *198*
The Past, Present, and Future of Photography: A Practical Manual of Photography (Alophe), 186
The Pastré Gardens, Alexandria (Le Gray), *185*
patched-in sky procedure, 272, 291
La Patrie (newspaper), 90
Patrizzi, Cardinal, 91, *91*
Pausilippe (ship), 171
Peccarère, Emmanuel, 34, 36
Pécuchet, 161
Pélissier, Marshal, 135, *135*
Pellizzari, Maria Antonella, 301
Penguilly, 90
People Visiting a Romanesque Ruin (Daguerre), *248,* 250
Périer, Paul, 54, 316

Peristyle of the Temple of Bacchus, Baalbek (Le Gray), *177*

Petit, Pierre, 321

Philipon, 219

Philippe, Prince of Belgium, 320

photogenic drawing, 209–10

photographer: definition of, 209; as operator, 218

Photographic Institution, 67

Photographic News (periodical), 176, 256

Photographic Society of London, 56, 106, 256

photographiste, 209

picturesque voyages, 246, 250

Pierson, Pierre-Louis, 27

Pio-Latina, 143

Piot, Eugène, 36, 38, *39*, 338

Place, Victor, 36, 338

The Place de la Bastille, Paris (Le Gray), *286*

Podimatas, Apostolis, 157, 172

Pointel, 173, 175

Poitevin, Alphonse, 11, 22–23, 255, 305

The Pont Cabessut, Known as the Pont Neuf (Le Gray and Mestral), *80*

The Pont de la Palalda (Le Gray), *230*

The Pont du Carrousel Seen from the Pont des Arts (Le Gray), *149*

The Pont du Carrousel Seen from the Pont Royal (Le Gray), *292, 293*

Pont du Gard, 62, 66, 67

The Pont du Gard (Le Gray and Mestral), 67, *81*

The Pont Marie and the Quai des Célestins Seen from the Quai d'Anjou (Nègre), *28*

Pont Neuf at Cahors, 66

pope, Pio-Latina carriage for, 143

The Port of Sète (Le Gray), *283*

The Porte Narbonnaise, Carcassonne (Le Gray and Mestral), *73*

portrait(s): at boulevard des Capucines studio, 90–98; carte-de-visite, 48, 87, 90, 148, 186; landscape, 241; by Le Gray, 48–56, 90–98; oval, 92

Portrait of Alexandre Dumas (Le Gray), *158*

Portrait of Alfred Le Gray (Le Gray), *93*

Portrait of Auguste Mariette Bey (Le Gray), *199*

Portrait of Edmond Cottinet (Le Gray), 54, *55*

Portrait of Émile Trélat (Le Gray), *142*

Portrait of Émilien de Nieuwerkerke (Le Gray), *96*

Portrait of Ernest Lacan (Disdéri), *317*

Portrait of Eugène Piot (Le Gray), 38, *39*

Portrait of Eulalie Le Gray (Le Gray), *21*

Portrait of Félix Avril (Le Gray), 38, *40*, 266

Portrait of Giuseppe Garibaldi (Le Gray), *168*

Portrait of Gustave Le Gray (Le Secq), *16*

Portrait of Henri Le Secq (Le Gray), 24, *25*

Portrait of Istvàn Türr (Le Gray), *170*

Portrait of Léon Delaporte (Le Gray), 38, *40*

Portrait of Léon Maufras (Le Gray), 94, *148*

Portrait of Louis-Napoléon Bonaparte as Prince-President (Le Gray), 59, *59*

Portrait of Lyndheast Sykes (Le Gray), *93*

Portrait of Madame H. de V. (Le Gray), *23*

Portrait of a Man in Near Eastern Clothes (Le Gray), *181*

Portrait of Martin Laulerie (Nadar), *321*

Portrait of Maxime Du Camp (Le Gray), *27*

Portrait of Mélanie, of the Délassements-Comiques Troupe (Le Gray), *95*

Portrait of Michel Carré (Le Gray), *18*

Portrait of Mme Le Gray (Le Gray), *21*

Portrait of Napoléon III (Le Gray), *135*

Portrait of O. Mestral (Le Gray), *61*

Portrait of Odet de Montault (Le Gray or Montault), *35*

Portrait of Olympe Aguado (Le Gray), *262*

Portrait of Philippe de Chennevières (Nadar), *29*

Portrait of Pierre Michel François Chevalier, Known as "Pitre-Chevalier" (Le Gray), *317*

Portrait of Pol Le Coeur (Le Gray), *23*

Portrait of the Imperial Prince (Le Gray), *131*

Portrait of Princes Taken Prisoner (Le Gray), *169*

Portrait of Princesse Françoise (?) (Le Gray), 24, *24*

Portrait of a Road Mender (Le Gray), *40*

Portrait of the Sculptor Clésinger (Le Gray), 54–55, *55*

Portrait of a Seated Man with a Cane (Le Gray), *97*

Portrait of Three Young Boys (Le Gray), 24, *24*

Portrait of the Vicomtesse de Montbreton (Montault), *35*

Portrait of Victor Cochinat (Le Gray), *97*

Portrait of Victor Cousin (Le Gray), *92*

Portrait of Victor Cousin (Lehmann), *92*

Portrait of a Woman (Le Gray), *95*

Portrait of a Young Girl (Le Gray), *98*

Portrait of a Young Woman (Le Gray), *27*

Portrait of Yousuf-Karam (Le Gray), *176*

positive-negative process. *See* negative-positive process

Practical treatise of photography on paper and glass (Le Gray), 225, 255, 339

Préault, Auguste, 90

preservation: of paintings, 220; of photographs, 85

The Prince of Wales and His Retinue, Cairo (Le Gray), *319*

The Princes and Their Retinue on the Island of Philae (Le Gray), *194*

print(s): creation of multiple, 218–20; numbering of, 345, *345*

print shops, photographic, 83–85, 305, 306–7

Prisse d'Avennes, Émile, 306, 323

Prix de Rome, 21

The Promendade at Shubra, Cairo (Le Gray), *184*, 276

Le Propagateur (magazine), 266

Pscharra, Cakvodja, 175

Puymontbrun, du, 321

Pylon of the Temple of Hathor, Dendera (Le Gray), *14*

The Pyramids at Giza (Le Gray), *277*

pyrogallic acid process, 291

Pzedestka, Countess, 91

Quaï, Maurice, 214

Quai de Béthune, 287

The Quai de l'Hôtel-de-Ville and the Pont d'Arcole (Le Gray), *294, 295*

Quand j'etais photographe (Nadar), 20n, 22, 22n, 176, 255, 335

Quinet, Achille, 98

Radisse, Félix, 342

Raffet, Auguste, 222, 222–23, *223*, 251

The Railroad Bridge at Argenteuil (Monet), 246

Railroad Yard (Le Gray), 67, *83*

Raimondi, Marc-Antoine, 58, 219

The Rainbow (Constable), 224

Ramparts, Carcassonne (Le Gray and Mestral), *68*

Ramparts and Gate, Carcassonne (Le Gray and Mestral), *69*

Ramparts and Towers, Carcassonne (Le Gray and Mestral), *71*

Ramparts with Tower, Carcassonne (Le Gray), *324*

Ramstedt, Nils, 325

Randon, Marshals, 135

Raphael, 219

The Rebellious Island (Lockroy), 160

The Reception of Saïd Pasha in Alexandria on His Return from Mecca (engraving), 180, *180*

Reclining Nude (Le Gray), *128*

Regnault, Victor, 26, 62, 258, 260–62, *263*

Régnier, 161

Remembrance of Civil War (Meissonier), *252*, 253

Renan, Ernest, 161n, 177–79, 189n

Reparations Obtained by the French Consul in Alexandria (engraving), 190

reproduction(s): of works of art, 56–58, 218–19, 228, 255; definitions of, 210, 210n; photography as, 210–13; prints as, 220

Résal, Jean, 321

retouching, of photographs, 228

The Return of the Prince-President, Place de la Concorde, Paris (Le Gray), *56*

Réveillon, 143

Revue photographique (magazine), 88, 135

Rhoné, Arthur, 190, 203

Riaz Pasha, 192

Richebourg, Pierre Ambroise, 58

A Rising Sandy Road (Le Gray), *100*

The Road to Chailly (Le Gray), 232, *233*, 243

The Road to Chailly (Forest of Fontainebleau) (Monet), 233, *234*

The Road to Chailly, Another Cloudy Sky (Le Gray), *228, 235*

The Road to Chailly, Cloudy Sky (Le Gray), *228, 233*

The Road to Mont-Girard (Le Gray), *50*

Robelin, Charles, 163

Robertson, James, 321

Rochemonteix, marquis de, 203

The Rohan Pavilion, the Louvre (Le Gray), *290*

The Roman Campagna (Le Dien), *304*

Romanticism, 243

Romberg, 321

Rome, Italy, 18–21

Roofs and Lantern, Château de Chambord (Le Gray and Mestral), *79*

Rossini, Gioacchino, 91

Rothschild, marquis de, 338

Rousseau, Théodore, 225, 238, 240, 241, 246, 320

Royal Palace, Palermo (Le Gray), 253

Rude, François, 56, *57*, 255

rue de Richelieu, 27–29

Ruins at Baalbek (Le Gray), 277, *285*

Ruins at Pompeii (Le Dien), *310, 311, 312, 313*

Sachs, Michael, 325

The Saïd in the Harbor at Sète (Le Gray), *122*

Saïd Pasha, 91, 191, 334

Saint-Seine, Raoul de, 176, 179, *179*

Saint-Victor, 90

Salvos of the French Fleet, Cherbourg (Le Gray), *145*

Salzmann, Auguste, 297, 298, 338

Santomelli, 171

Sauveur, 36

Scènes de la vie de bohème (Murger), 214

Schanne, Aurélien, 18

Scheffer (emperor's spokesman), 176

Scheffer, Ary, 58, *58*, 228, *229*

Schleich, Eduard, 320

Schopp, Claude, 153

science. *See* chemistry

The Scribe (Deutsch), *204*

The Sea (Whistler), 246

A Seascape, Shipping by Moonlight (Monet), 246
seascape photography, 98–107, 223; panoramas in, 275–76; in private collections, 318, 320–21; and seascape painting, 243–46
Seascape with Cloud Study (Le Gray), *113*
Seascape with a Ship Leaving Port (Le Gray), *267*
Sebah, Pascal, 203, *203*
Séjour, Victor, 337
Self-Portrait (Janneau), *36*
Self-Portrait (Le Gray), *33, 85, 86*
Self-Portrait (Nadar), *188*
Self-Portrait (Piot), *39*
Sète, France, 106, 107, 243
Setting the Emperor's Table (Le Gray), *140*, 251
Séverac, Mme de, 92
Sherif Pasha, 192
Ships in the Harbor at Sète (Le Gray), *121*
Ships in the Harbor at Sète, among Them the Saïd (Le Gray), *123*
Ships Leaving the Port of Le Havre (Le Gray), 233, *237*
signatures, 344, *344, 345*
Silvy, Camille, 320
Sirot, Georges, 323
Société française de photographie, 26, 40, 87, 98, 142, 189, 263, 321, 340
Société héliographique: collective album by, 263; establishment of, 34, 59–61; members of, 34, 40, 61; and Mission héliographique, 61, 62, 66–67; on print shops, 83; waxed-paper negatives and, 258
Society of Arts, 67
solar eclipse, 23, 214, 333
Solar Effect in the Clouds–Ocean (Le Gray), *314*
Sorrieu, Frédéric, 105
The Source (Ingres), 320
Spain, royal collections in, 318
Stacked Paving Stones in front of the Studio (Le Gray), *264*
The Stages of Life (Friedrich), 233, *236*
Staircase of François I, Château de Blois (Le Gray and Mestral), *79*
stamps, 344, *344, 345*
Standing Nude (Le Gray), *129, 130*
Standing Self-Portrait with His Brother Onésipe (Aguado), *34*
The Steamboat (Le Gray), *109*
Stein, Howard, 325
stereoscope, 87
Strada di Toledo, Palermo (Le Gray), *167*, 253
A Street in Naples (Le Dien), *303*
students: of Delaroche, 214–15, 337; of Le Gray, 27–28, 31–40, 302

studio(s), barrière de Clichy, 31, *32. See also* boulevard des Capucines studio
Studio at 35, Boulevard des Capucines (Nadar), *88*
The Studio at the Barrière de Clichy (Le Gray), *32*
Study of an Oak Tree (Le Gray), 226, *227*
Study of Rocks at Fontainebleau (Devéria), *48*
Study of a Tree in a Clearing (Le Gray), *99*
Study of a Tree Trunk (Le Gray), *47*
Study of Tree Trunks (Le Gray), *99*
Study of a Tree in the Valley of Poussin, near Rome (Le Dien), *302*
Study of Trees, Roman Campagna (Le Dien), *308, 309*
Suez Canal, 190, 191
Sully (ship), 157
The Sully Pavilion, the Louvre (Le Gray), *153*
Summer Evening (Lucas), *225*
The Sun at Its Zenith (Le Gray), 106, *110*
Switzerland, 18–19
Sykes, Lyndheast, 91, *93*, 94, 154
Syria, 175–76, 179

Talbot, William Henry Fox, 26, 87, 209, 216, 255, 263, 338
Taylor, Isidore, 66, 246, 250
Temple of Horus, Edfu (Le Gray), *195*
The Temptation of Christ (Scheffer), 228, *229*
terminology, of photography, 209–12
Tewfik Pasha, 192
Teynard, Félix, 84
Thani, Sheikh Al-, 325
Théric, Alice, 92
Thérond, Roger, 11, 321, 323–25
Thobois, 177
Thomson, David Croal, 238
Thoré, Théophile, 216–18, 218n, 229
titles, printed *vs.* handwritten, 345, *345*
Tombs of the Caliphs (Le Gray), *205*
Tombs of the Caliphs, Cairo (Le Gray), *200, 201*
The Tour Saint-Jacques (Le Gray), *152*
Tournachon, Adrien, 36, 38–40, 305, 338
Tournachon, Félix. *See* Nadar, Félix
Tournier, 142
Tours Cathedral (Le Gray), *258*
Toussaint, 143
Toussoun Pasha, 192
Townshend, Chauncy Hare, 320
Traité pratique de photographie sur papier et sur verre (Le Gray), 225, 255, 339
Tranchant, 36, 338
treatises. *See* manuals
trees, portraits of, 241, 312
Trees along the Road to Chailly (Le Gray), *46, 51*

Trees near the Road to Chailly, Forest of Fontainebleau (Greene), *46*
Trélat, Émile, 91, *142, 143*
Troop Maneuvers (Le Gray), *224*
Troubetskaïa, Mlle, 91
Troyon, Constant, 238, *240, 241*
The Tugboat (Le Gray), 246, *247*
Turner, Joseph Mallord William, 224, 243
Türr, Istvàn, 169, 169n, *170, 171*, 272
Twisted Tree Trunks (Valenciennes), *239*
Two Ships Heading Away from Shore (Le Gray), *117*

Universal Exposition: of 1855, 54, 87, 255, 272–73, 316, 340; of 1867, 199, 203, 220

Valençay, comtesse de, 187
Valenciennes, Pierre-Henri de, 239, *239*, 241
The Valentré Bridge, Cahors (Le Gray), *63*
Valicourt, Edmond de, 26
The Valley of the Mills near Amalfi (Le Dien), *296*
Vallou de Villeneuve, Julien, 23
Valon, Alexis de, 302n
Van Bosch, 186
Vasari, Giorgio, 11, 214
Vasili, 161, 172
Verdier, Marcel, 31
Verne, Jules, 181
Vernet, Horace, 20, 131, 251, *251*
Vernet, Louise, 20
Victoria, Queen, 105
Viel-Castel, Horace de, 91, *91*
View (Lockroy), 171
View of Bas-Bréau (Le Gray), *10, 45*
View of Cairo (Le Gray), *277, 281*
View from the First Floor of the Studio (Le Gray or his circle), *42, 43*
View of the Forest, Fontainebleau (Le Gray), *54*
View of the Forest of Fontainebleau (Greene), 45, 46, *297*
View of Montmartre (Le Gray), *30*
View in a Park (Le Gray), *206*
View of a Park (Le Gray), *322*
View of the Port of Beirut from the Hôtel Bellevue (Le Gray), *174*
View of Rome (Le Secq), *19*
View of the Salon of 1852 (Le Gray), *221*
View of the Salon of 1853 (Le Gray), 208, *211*
View of the Seine toward the East (Le Gray), *288*
View from the Studio (Le Gray or Montault), *37*
View from the Studio Roof (Le Gray or his circle), *41*
Vigié, Zélie, 303, 303n
Vigier, Joseph, 34, 36, 263, 297, *299*, 306

Vigny, Alfred de, 336
Villa Medici, 19, 21
Ville de Paris, photographic workshop of, 287
Villiers-le-Bel, 17
Viollet-le-Duc, Eugène, 62
Vonne, Alexandre de, 302–3, 309, 312, *313*
The Vow of Louis XIII (Ingres), 219
Voyage through Sicily and around the Mediterranean (Dumas), 160, 171, 173
voyages pittoresques, 246, 250

W. H. G., 36, 298
Wagstaff, Sam, 325
Wales, Prince of, 189, *319*, 320
Walewska, Mme, 187
Warnod, Jean-Victor, 98, *105*, 106
Waterspouts (Courbet), 246
The Wave (Courbet), *245*, 246
waxed-paper negatives: development of, 23–24, 26, 257–62, 340; and Fontainebleau photographs, 48; Le Gray's writings on, 40, 257–58, 262; and Mission héliographique, 62, 65
West Portal, Church of Saint-Ours, Loches (Le Gray and Mestral), *75*
wetstamp, 344, *344*
Wey, Francis, *316*; on Colorism, 229–31; on lithography, 219; on Macaire's seascapes, 105; and Mission héliographique, 61, 65, 66; on photography as art, 209, 213, 214
Weymouth Bay, Dorsetshire (Lucas), *225*
Whistler, James, 244–46, 253
Willet, Abraham, 321
Wilson, Michael, 325
Winsberg, Suzanne, 325
Winterhalter, 131
Witt, George, 320
Wyld, William, 303

Yousuf-Karam, 176, *176*
Yvon, Adolphe, 18, 252

Ziegler, Jules, 34
Zizinia Palace, Alexandria (Le Gray), *180*
Zola, Émile, 12
Zouave Storyteller (Le Gray), *224*
Zouaves at the Camp at Châlons (Le Gray), 148
Zouaves Gambling (Le Gray), *136*
Zuber-Buhler, Fritz, 323